California Video

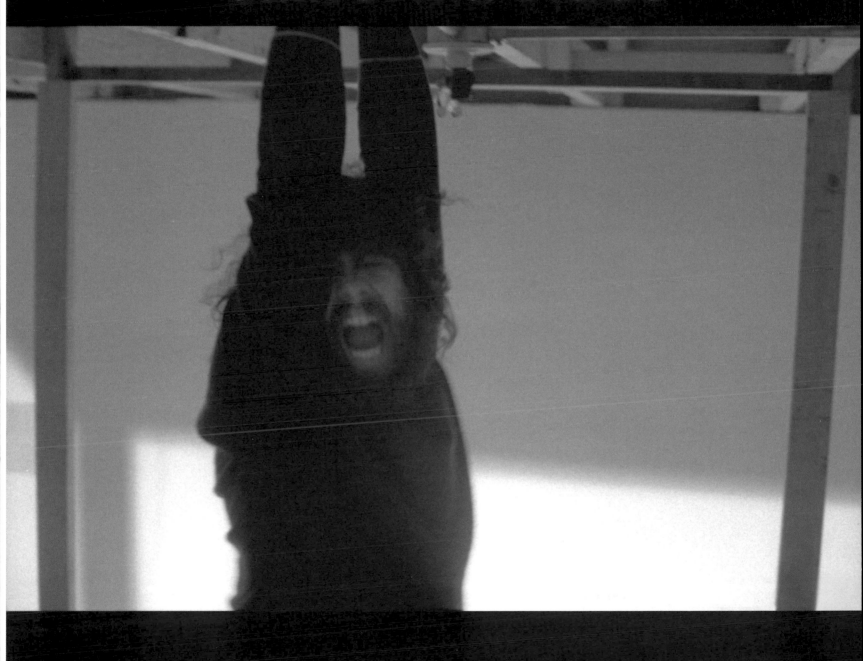

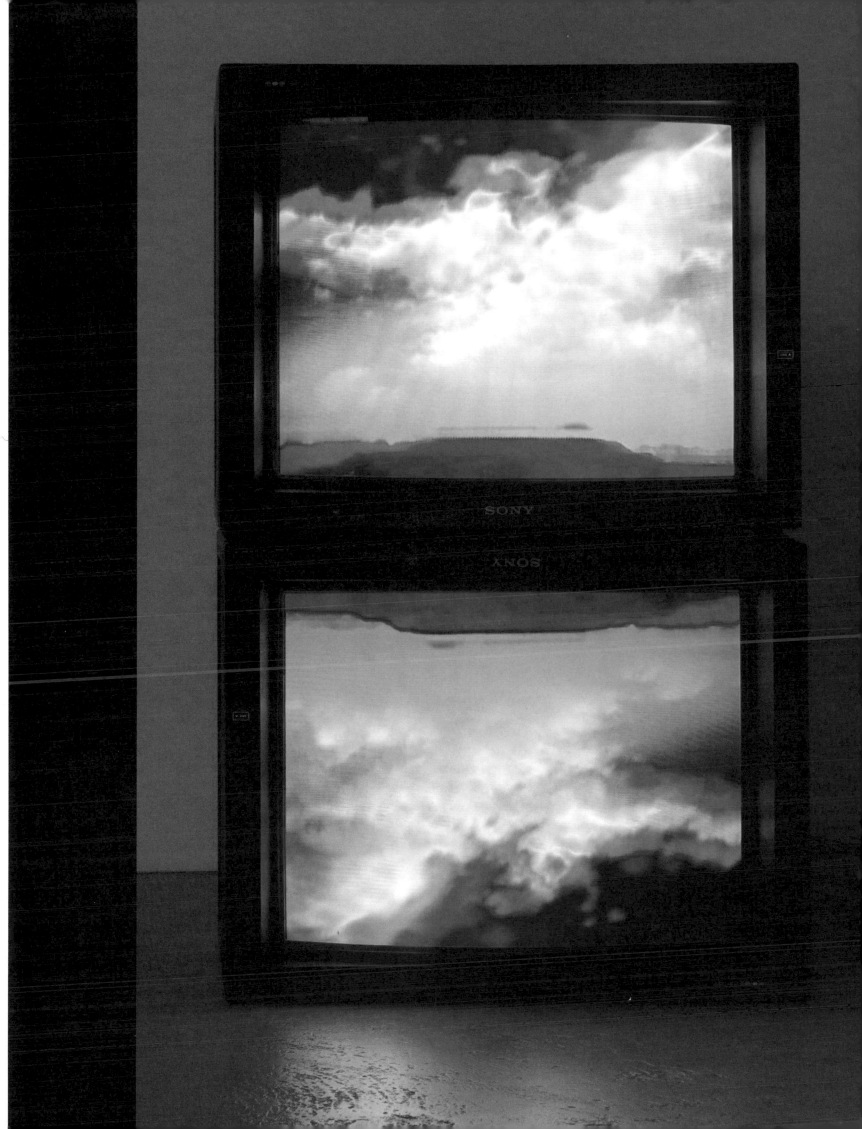

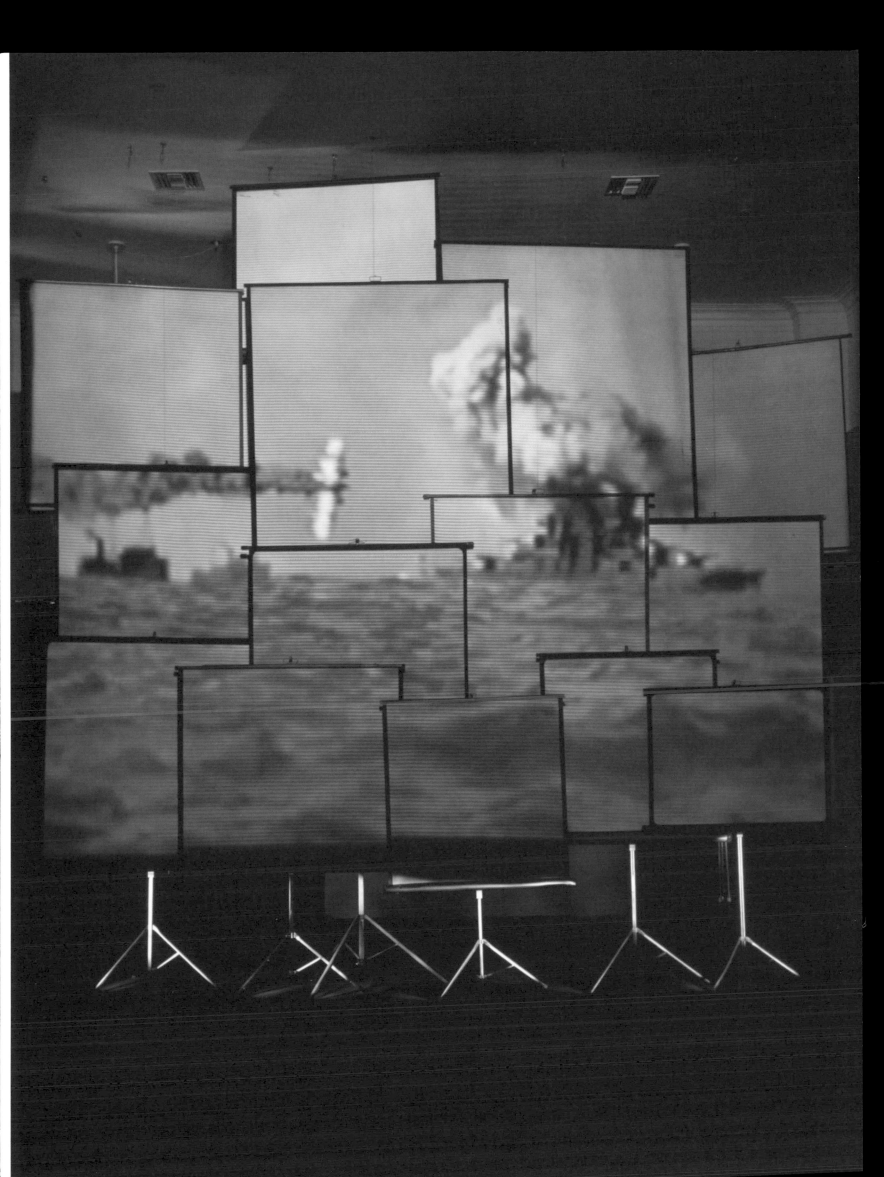

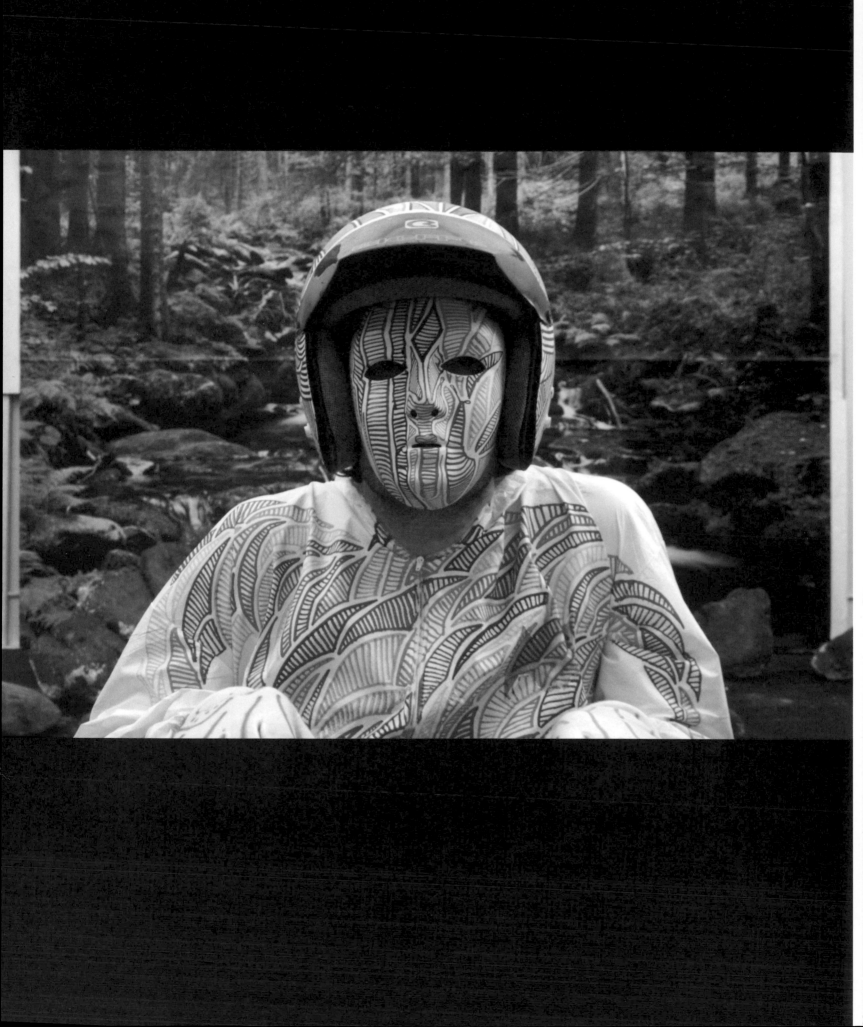

Alan Ackoff • Eleanor Antin • Skip Arnold • David Askevold • John Baldessari • Enid Baxter Blader • Stephen Beck • Cathy Begien • Ante Bozanich • Brian Bress • Nancy Buchanan • Chris Burden • Jeff Cain • Jim Campbell • Meg Cranston • Peter d'Agostino • Harry Dodge and Stanya Kahn • Terry Fox • Howard Fried • Kip Fulbeck • Arthur Ginsberg and Video Free America • Sam Green • Dale Hoyt • Ulysses Jenkins • Warner Jepson • Allan Kaprow • Hilja Keading • Mike Kelley • Martin Kersels • The Kipper Kids (Martin von Haselberg and Brian Routh) • Lynn Marie Kirby • Paul Kos • Joanne Kyger • Tony Labat • Suzanne Lacy • Euan Macdonald • Cynthia Maughan • Jay McCafferty • Paul McCarthy • Branda Miller • Susan Mogul • Bruce Nauman • Tony Oursler • Patti Podesta • Joe Rees/Target Video 77 • Martha Rosler • Ilene Segalove • Nina Sobell • Jennifer Steinkamp • Wolfgang Stoerchle • John Sturgeon • Erika Suderburg • Skip Sweeney • Diana Thater • T.R. Uthco and Ant Farm • Bill Viola • William Wegman • Bruce and Norman Yonemoto

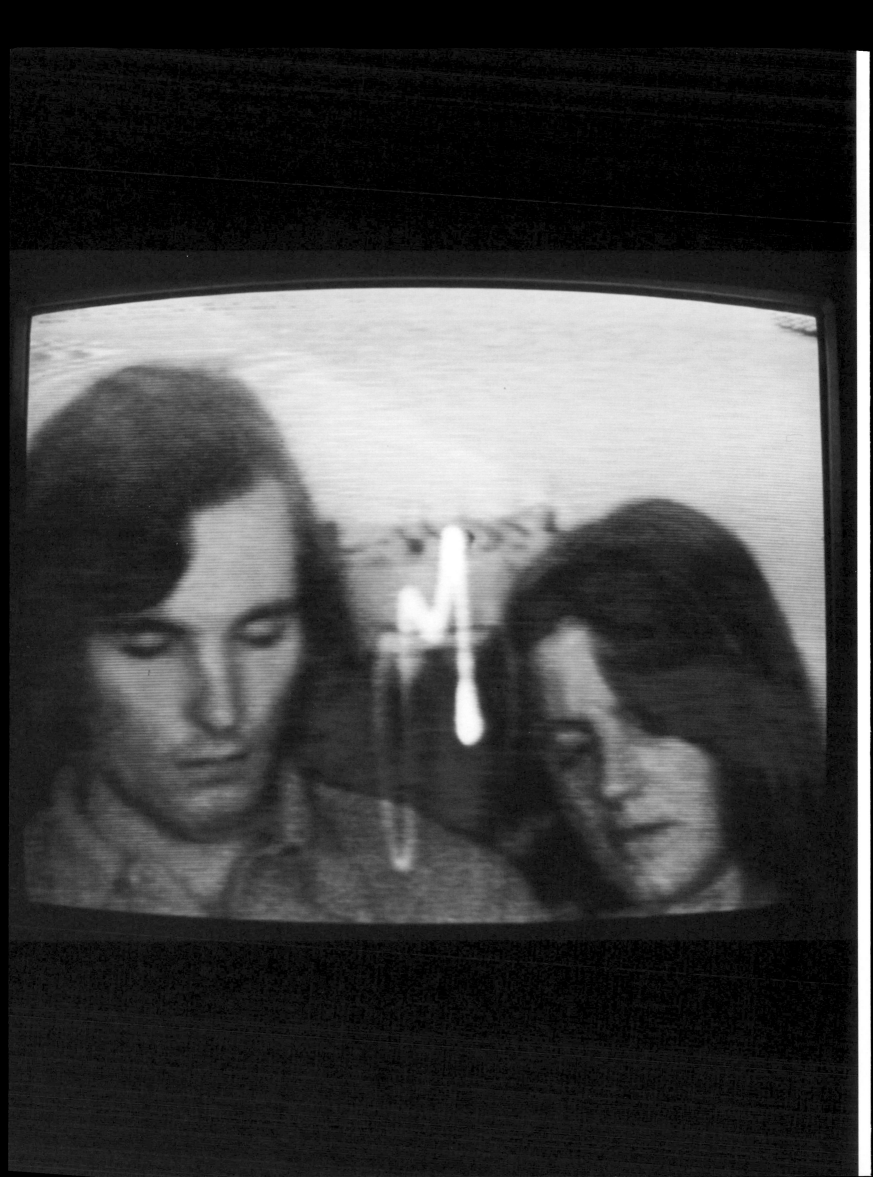

California Video: Artists and Histories

Edited by **Glenn Phillips**

Los Angeles
The Getty Research Institute
The J. Paul Getty Museum

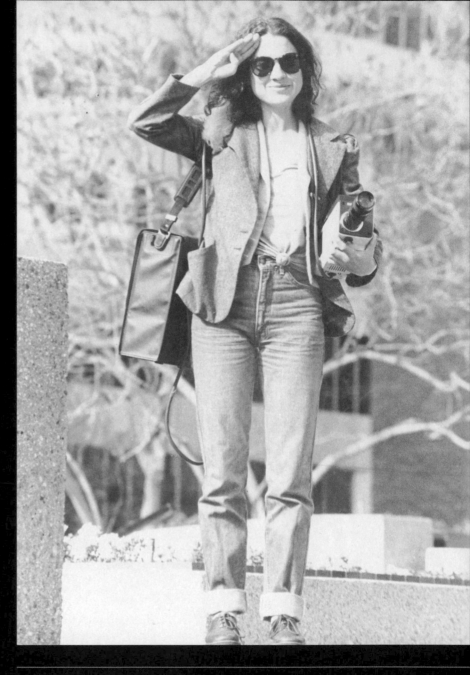

Front cover
Harry Dodge and Stanya Kahn, still from *Whacker*, 2005. Single-channel video, color, sound; 7 min., 7 sec.

Back cover
T.R. Uthco and Ant Farm, *The Eternal Frame*, 1975. Video (color, sound; 22 min., 21 sec.) and mixed media, dimensions variable. Installation view at the Long Beach Museum of Art, 1976.

Half-title page
Howard Fried, production still from *Fuck You Purdue*, 1971 (single-channel video, black-and-white, sound; 31 min., 39 sec.). Photo by Larry Fox.

p. ii
Bill Viola, *The Sleepers*,1992. Video, dimensions variable. Musée d'Art Contemporain, Montreal. Photo by Louis Lussier.

p. iii
Diana Thater, *Surface Effect*, 1997. Two-channel video installation, dimensions variable. Collection of Pamela and Richard Kramlich. Photo by Fredrik Nilsen.

p. iv
Chris Burden, still from *Poem for L.A.*,

p. v
Bruce and Norman Yonemoto, *Environmental*, 1993. Video installation: two-channel video projection, fourteen home-movie screens, and three black-and-white photographs; dimensions variable. Photo by Oggy Borissov.

p. vi
Brian Bress, production still from *Under Cover*, 2007 (single-channel video, color, sound; 13 min., 16 sec.).

p. vii
Ante Bozanich, still from *Bands*, 1977. Single-channel video, black-and-white, sound; 10 min., 16 sec. LBMA/GRI (2006.M.7).

p. viii
Jennifer Steinkamp, still from *Oculus Sinister (left eye)*, 2008. Video installation, color, silent; dimensions variable. Photo courtesy of Lehmann Maupin, New York; ACME, Los Angeles; and greengrassi, London.

p. x
Nina Sobell, still from *Interactive Electroencephalographic Video Drawings,* 1973. Interactive video installation with live video and EEG readings; dimensions variable. Photo by Ken Feingold.

NOTES TO READERS

All works designated in captions as "LBMA/GRI" are from the Long Beach Museum of Art Video Archive, Research Library, The Getty Research Institute. Transferred by the Long Beach Museum of Art Foundation and the City of Long Beach, 2005.

Forty-two new interviews with artists and curators were conducted for this project, and transcripts from those interviews are excerpted in this book. Videos and complete transcripts for all interviews are available at the Getty Research Institute, Los Angeles,

CONTENTS

FOREWORD

Since the birth of cinema, the moving image has held a place in avant-garde art. As generations of filmmakers throughout the twentieth century developed the complex language of cinematic narrative, parallel generations of visual artists created dizzying works of abstraction and experimentation that challenged every convention of the medium. It was not until the advent of the portable video camera, however, that visual artists were able to develop a form of moving-image art that could easily shift outside the "black box" of the theater and mix freely with painting, sculpture, and photography in the "white cube" of art galleries and museums. With this change—one that neatly coincided with the development of conceptual art, performance art, and other forms of dematerialized and time-based artistic production in the 1970s—video became one of the central forms used by artists in the latter portions of the twentieth century and into the twenty-first. Now—when digital technology offers us a steady stream of innovative new methods of creativity and distribution—the groundbreaking work of the earliest video artists takes on an air of Old Master authority.

California Video celebrates the achievements of artists working since the late 1960s in a specific locale, California, where generations of young artists were often supported by equally young arts institutions as they created some of the most radical and innovative video art produced anywhere in the world. The Long Beach Museum of Art had the vision and determination not only to collect cutting-edge video art but also to provide facilities where artists could create it. Over the course of three decades, LBMA amassed nearly five thousand videotapes and documents. When it realized that it could no longer maintain so large and, in many ways, fragile a collection, the Long Beach Museum of Art turned to the Getty Research Institute as a place where this art could be housed and catalogued, protected and conserved, studied and exhibited. *California Video* is the Getty's first—but certainly not its last—attempt to present this collection to the public. We at the Getty Museum are grateful to our colleagues at the Long Beach Museum of Art and, just across the plaza, at the Getty Research Institute for undertaking the intensive and imaginative work of collecting and preserving this important archive.

Our collaboration with the GRI on *California Video* reflects the desire of the Getty Museum to continue to contribute meaningfully to the promotion and showcasing of contemporary art. In the ten years since the Getty Center opened in December 1997, we have commissioned a number of new works, among them Martin Puryear's *That Profile* (1999), eleven pieces related to our collection and created by outstanding Los Angeles–area artists for our *Departures* exhibition (2000), and Bill Viola's *Emergence* (2002), jointly commissioned by the Getty Museum and Getty Research Institute, and included in the Getty's 2003 exhibition *Bill Viola: The Passions*. In 2006 we opened the new Center for Photographs, a seven-thousand-square-foot space devoted to both historic and contemporary photography, and in 2007 we commissioned four new works by Tim Hawkinson for his *Zoopsia* project, which was presented in conjunction with the West Coast debut of Hawkinson's *Überorgan*, displayed memorably in the Museum's Entrance Hall.

We at the Museum thank Glenn Phillips, senior project specialist and consulting curator in the GRI's Department of Contemporary Programs and Research, for having conceived and organized the *California Video* exhibition and for having edited and contributed to this companion volume. Inspired by the Long Beach archive, Glenn expanded the scope of the show and the publication to include works from across the Golden State. He was supported by the former director of the Getty Research Institute, Thomas Crow, and Andrew Purchuk, assistant director for contemporary programs and research, and we are grateful to them both for their involvement in this project. We also thank Quincy Houghton, assistant director for exhibitions at the Museum, and her team for the brilliant design for the installation of this challenging medium.

The work on view in the exhibition and in this publication results from the brave and fervent imaginations of the featured artists. It is to them that we owe our deepest gratitude and to whom we dedicate this book and this show.

MICHAEL BRAND, Director
THE J. PAUL GETTY MUSEUM

FOREWORD

This publication accompanies an exhibition of landmark video works from California that brings to light a story too seldom seen, even in its place of origin. Less apparent to visitors will be the background efforts of the Getty Research Institute that have allowed this story to be told with such scope and impact. The largest part of the video works in this exhibition, and the even greater number featured in this publication, are drawn from collections of the Research Library at the Institute. Abundant as they appear, these works represent only a small fraction of those stored in the Research Institute, which has assumed a crucial public role in preserving, restoring, and making accessible a record of the key artistic medium to have emerged in our lifetimes.

An artist's videotape cassette (or any of its more recent replacements) lives two lives. In the playback circuit, it is a work of art, unfolding, as it must, in the dimension of time. Switch off the machine and put the plastic vessel back on the shelf, and the work as such ceases to exist. But the creative effort of the artist remains in another and equally important form: as latent information. To keep that information intact and available on demand requires some rare skills and even rarer facilities. And, fortunately, the Getty Research Institute has both.

Most of the videos housed at the Research Institute were originally amassed by a single museum. Just as the medium was coming into its own, the Long Beach Museum of Art threw itself into supporting this emergent art form. Video artists enjoyed regular exhibition and, just as importantly, were encouraged to use the museum's editing facility at a time when such equipment lay beyond the reach of most individuals. Having retained copies of nearly every work shown or made under its auspices, the Long Beach Museum came into possession of the most important video archive in public hands. In keeping with the democratic ethos of the movement, it made the tapes available, as in a library, to anyone wanting to view them.

In recent years, however, the investments of space and staff required for this undertaking outgrew the means of a medium-size institution with many other commitments. Wear and tear on unique copies posed growing problems of long-term conservation that were likewise becoming insurmountable. Could this astonishing resource be preserved in the region where it was made? With the collaborative transfer of the Long Beach Museum of Art Video Archive to the Getty Research Institute, the physical well-being of the archive has been assured; researchers and artists who want to gain access to the medium's rich history can be served; and regular exhibition will allow visitors to witness the full creative dimensions of an artistic medium in the process of its emergence.

The holdings of the Long Beach archive are, moreover, far from being the only documents of video art preserved in the Institute: more have arrived in the personal archives of individual artists; others through the remarkable public programming and curating of Glenn Phillips, overseen by Andrew Perchuk as assistant director for contemporary programs and research. Associate director and chief librarian Susan M. Allen has championed this vital direction in art documentation. The exhibition *California Video*, along with the crucial testimony gathered in the present catalogue, provides an exciting first sampling of what will become over the years a nearly inexhaustible treasure. More wonders await.

THOMAS CROW, Director (2000–2007)
THE GETTY RESEARCH INSTITUTE

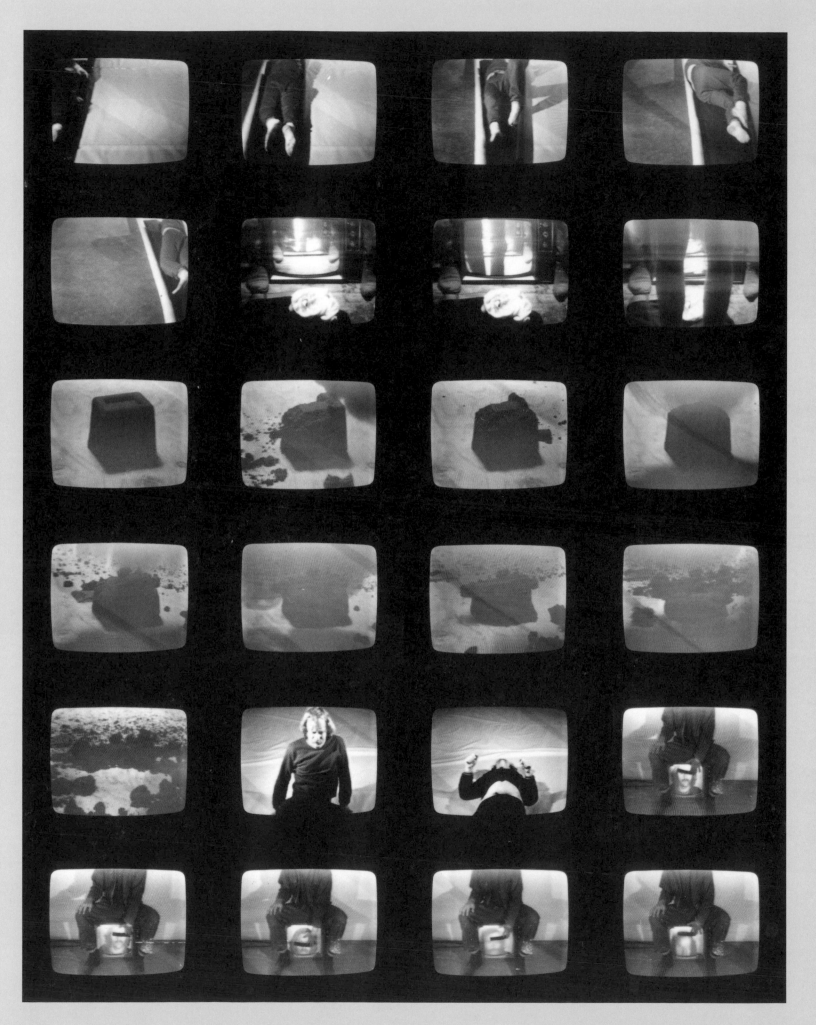

INTRODUCTION

GLENN PHILLIPS

This book traces the origins and developments of video art in California through the words and recollections of people who experienced them firsthand. California—particularly the San Francisco Bay Area, Greater Los Angeles, and San Diego—has been the site of remarkable experimentations with video over the last forty years, although the stories of these developments have rarely been compiled in one place. Envisioned as a reference tool, *California Video: Artists and Histories* presents this complex history in pieces, allowing readers to freely structure their investigations and make their own connections as they go along. The book's "Artists" section presents fifty-eight stylistically diverse entries devoted to individual artists and collaboratives. The texts in this section include biographical and interpretive information about each artist, thirty-six new interviews conducted for this project, as well as a number of commissioned essays, important and rare reprints, video transcripts, and pictorial spreads. The "Histories" section contains an in-depth group interview tracing the history of video programming at the Long Beach Museum of Art, and six commissioned essays that focus on larger, often underexamined themes. The materials in both sections represent a rich set of documentation that can be used for future research. Beyond that, they provide a new context for well-known artists, offer overdue recognition for others, and shine a spotlight on emerging talents.

Focusing on both individual artists and the institutions where they found support, this introduction broadly considers the multiple points of origin for video art in California in the late 1960s and early '70s, then turns to a smaller sampling of activities that emblematize some of the shifts wrought by a younger generation of artists in the later 1970s and early '80s. This is a story that could be told in many ways, but I have often chosen to focus on lesser known artists, artworks, and institutions, both because they are frequently more indicative of developments that occurred across the state and because I hope that *California Video* will be part of a larger historical revision of accounts of the medium. For most of my examples, I've drawn directly from this volume for the numerous and parallel histories that emerged throughout California, and many of the topics discussed in this introduction are elucidated further in the artists' entries and the essays in this book.

• • • • • • • • • • • • • • •

Video art came to California the same way as it came everywhere else: in fits and starts, and then in waves. But the isolated bursts of experimentation that occurred mostly in California's San Francisco Bay Area in the late 1960s, followed by the explosion of activity throughout the state in the 1970s, proceeded in directions unlike anywhere else in the world. Visual artists in California embraced the new medium freely and with an ease that—at first glance—appears to bear less of the detached intellectualism found in video art from New York and Europe. Of course, artists in California were every bit as serious as their counterparts in other regions, but even when West Coast artists produced the same types of rigorous formal experiments and technologically oriented investigations happening elsewhere, it was often the artists' own quirky personalities that managed to take center stage in the work, making California feel a bit lighter and more cocky in its coolness. Throughout its history, California video turns again and again to humor and the charisma of the artist to carry its ideas and hold the interest of the viewer—even when it is at its most deeply conceptual, its most stridently political, its most darkly expressive and obsessively esoteric.

By the mid-1960s, the availability of video as an artistic medium existed almost as a rumor, with news of experiments in New York and Europe spreading by word of mouth and occasionally through the press. Artists such as Wolf Vostell and Nam June Paik began experimenting with

Figure 1.
Wolfgang Stoerchle, stills from *Untitled Video Works, 1970–1972*. Single-channel videos, black-and-white, sound; 62 min., 30 sec. LBMA/GRI (2006.M.7). Courtesy of Wolfgang Stoerchle Estate/Carol Lingham.

television sets and video signals, and organizations such as Experiments in Art and Technology (E.A.T.) started working to make all types of new technology available for use by artists. At the time, access to video technology depended almost entirely upon access to the small number of institutions and lucky individuals who had managed to acquire equipment.

In California, the first such arts institution was probably the National Center for Experiments in Television, or NCET, which, loosely affiliated with the television station KQED in San Francisco, was founded in 1967 (as the Experimental Television Project), and remained active until 1975. Under the directorship of Brice Howard and, later, Paul Kaufman, NCET became a creative center where artists could experiment with a wide array of video technology without any pressure to arrive at a finished product or work for broadcast. NCET is most notable for its massively multi-disciplinary approach, inviting painters, poets, writers, musicians, dancers, filmmakers, sculptors, and other creative individuals to participate in the experimental environment.

Described as a "video Bauhaus" by artist Stephen Beck, NCET was geared specifically toward rethinking the creative possibilities of broadcast television from the ground up, without reference to any of the inherited genres (theater, film, radio, and print advertising) that network television was so prone to imitate. The result was a type of work that seemed completely alien at the time of its creation—and still looks rather alien today. NCET's works are distinguished by their focus on image processing—the electronic manipulation of the video signal—and by an equally experimental approach to sound. Works produced at the center tend to veer toward abstraction and rely heavily on the intervention of custom machinery to distort and expand the possibilities of video image making. Beck, who developed the Beck Direct Video Synthesizer while in residence at NCET, produced lush video abstractions without the use of any video camera whatsoever (see pp. 42–45); other artists associated with the center, such as Warner Jepson, Willard Rosenquist, Bill Gwin, Don Hallock, Bill Roarty, Loren Sears, Richard Felciano, and many others, used the abstracting properties of the video signal to examine the human figure, movement, music, landscape, color, and light.

Among the first and most extraordinary works produced as part of NCET is poet Joanne Kyger's video DESCARTES (1968), an early—and highly successful—attempt to translate concepts of poetry into the video medium (fig. 2 and see pp. 146–48). Using nearly every type of processing, image, and sound-mixing tool available at NCET, Kyger produced a visual illustration to her prose poem DESCARTES AND THE SPLENDOR OF (see pp. 146–48). Recasting Rene Descartes's Discourse on Method in distinctly personal terms, DESCARTES uses multiple variations of the properties of video feedback as a central visual metaphor emblematizing the mind's turn toward itself in Cartesian philosophy. As Kyger recites the poem, the sound of her voice is often heavily modulated, collaged with other voices, or accompanied by an electronic soundtrack. The video alternates between highly edited sequences of the artist in a domestic setting and distorted images of the artist's head or body floating in a blank expanse. The infinitely receding imagery resulting from video feedback often seems the perfect analog to Kyger's solipsistic narrative. In one nearly abstract section, it is the fed-back imagery of the control console itself (the source of all these distortions) that accompanies not only the narrator's realization that "I think, hence I am" but also her thoughts about the existence of "Mother God"—a moment in the video that might pull the viewer out of this heady philosophical ether and plant him or her firmly back in the world of post-Beat, Bay Area bohemia. In a final self-reflexive gesture, the concluding portion of the video focuses on the stage lights and video paraphernalia on the KQED soundstage, before ultimately pulling back to reveal the sets that had been used in the making of the video. A distinctly Californian vibe pervades this work, in part through its psychedelic imagery, but even more through Kyger's words, her cadence, and her very appearance.[1]

Despite the strength of the work produced at NCET, it was mostly working in isolation from the larger community of artists in San Francisco, few of whom even knew of its existence. Within the broadcast community, NCET's professional outreach and educational efforts raised awareness about alternate possibilities for television; however, except for the artists who had the privilege of working there, NCET ultimately did not have an immediate impact on the larger development of contemporary art. In that realm, artists were thinking not about broadcast space but about gallery space, and the video works created by Bruce Nauman beginning in 1968 posited video as an artistic medium whose products could be perfectly in line with current developments in sculpture (see pp. 182–85).

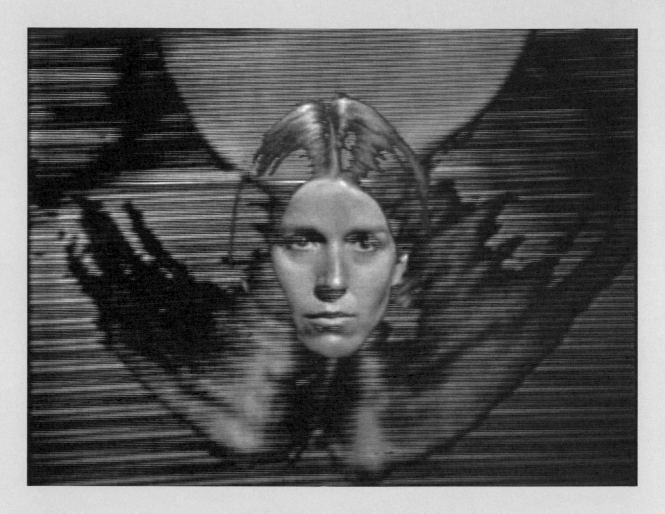

Figure 2.
Joanne Kyger, still from *DESCARTES*, 1968. Single-channel video, black-and-white, sound; 11 min., 25 sec. Courtesy of the artist and the University of California, Berkeley Art Museum and Pacific Film Archive, Berkeley, California.

Nauman had, in fact, been involved with one of the earliest works produced at NCET. In 1967, artist William Allan, who was in residence at NCET, invited Nauman to collaborate on the production of a video. The resulting work, *Flour Arrangements,* follows the format of a television interview program. As two "hosts" (Allan and artist Peter Saul) banter onstage, Nauman uses a two-by-four to manipulate a large pile of flour into various sculptural piles, as he had done in a 1966 photo project by the same name.[2] While this imitation of genre differs from any other video work ever produced by Nauman, his onscreen actions clearly indicate the direction his solo video work would take. During the time he spent in the Bay Area, from 1964 to 1968, Nauman had, in addition to his sculptural and photographic work, produced a small number of activity-based 16mm films and performance works. During a winter spent in East Hampton, New York, at the end of 1968 (before he moved to Los Angeles in 1969), Nauman acquired a Sony Portapak[3] from his New York gallerist, Leo Castelli, and he began a series of single-channel videotapes and video installations that had a nearly immediate and international impact on the art world.

Nauman's model of working with video became emblematic of a video art "look," which was based primarily on the limited circumstances of its creation. Typically, such videos feature the artist, alone in the studio, performing a predetermined action in front of a stationary camera connected to a monitor that the artist can watch as the video is being made. The activities Nauman performed tended to fill an entire reel of videotape, and there was no discernible narrative direction in the work—no clear beginning, middle, or end—which made it particularly well suited to ambient display in a gallery.

While volumes have been written analyzing the meanings, motives, and implications of Nauman's early film and video works, it can be productive simply to step back and grasp their utter strangeness and simplicity as art. With titles such as *Bouncing in the Corner, No. 1* (1968), *Stamping in the Studio* (1968), *Pulling Mouth* (1969), and *Bouncing Two Balls between the Floor and Ceiling with Changing Rhythms* (1967–68), Nauman's films and videos depict the artist doing the types of things that many people, most artists, and all children may be prone to do when they are deep in thought, alone, and sure that no one else is watching. The videos' series of bouncing, pacing, and stomping around, or pinching, squeezing, and otherwise examining the body, strike an unacknowledged familiarity in the viewer, combined with the shock

of seeing this activity on a television, in a gallery, and proposed as art. In 1968 and well into the 1970s, very few people had ever seen a video image that had not been produced by a television network, and one must imagine how strange and radical this must have felt for a viewer—and how powerful it must have felt for an artist. During the heyday of the conceptual art movement, it often seemed that each new artwork existed as a proposition aiming to expand the definition of what, in essence, art could be. Video's ability to capture an expanse of time, to present the performance of an activity as the making of an artwork, and to present the making of an artwork as the finished work itself seemed, at the time, to hold revolutionary potential.

Nauman's solo exhibition at the Nicholas Wilder Gallery in Los Angeles in January and February 1969 included (in addition to other works) a video, *Manipulating a Fluorescent Tube* (1969)—a simple work in which Nauman, sitting on the floor in a darkened room, does exactly what the title of the work says (see photo on p. 184)—and the exhibition can be said to have set off a flurry of longing among artists who saw or heard about the work.[4] For many artists, Nauman's show at the Wilder Gallery provided their first occasion to see the possibilities of video as an artistic medium, presented in the context of gallery display. As artist Howard Fried notes in his interview in this volume (see p. 90):

> When I entered the gallery, the tape where [Nauman] manipulates a fluorescent tube was playing. I was the only person in the gallery. I had come in at a point in the tape where he wasn't moving, and for a time, there was no sound. After what seemed like a long time he moved, or he moved the tube and it made a sound. I realized I had never seen television silence for more than a few seconds. It was really magical.... The aesthetic and political implications were staggering. Today, that probably sounds ridiculous; but the effect of a first encounter with a transcending technology can't be understood except in a context where it doesn't exist. At the time, commercial media was totally stilted. It was unnatural because there was no personal media to inform it, and media production was so expensive and so cumbersome that it had to be bureaucratized in order to exist.

The promise held by video, that it could create "personal media," that normal people could control the production of video imagery and bypass the tightly controlled corporate structure of commercial media, seemed like a revolutionary and democratic advance. Video was seen as a potentially radical political tool that could subvert the relationship between dominant media structures and the audience, eventually allowing artists and anyone else to directly address the public without the need for a support structure of broadcast television, museums, galleries, or other forms of distribution.

· · · · · · · · · · · · · · · ·

At the time of Nauman's Wilder Gallery exhibition, easy access to video equipment was almost nonexistent in Southern California, but that situation would change dramatically with the opening of the California Institute of the Arts (CalArts) in fall 1970.[5] Blessed with a utopian vision and extremely generous funding from founders Walt and Roy Disney, CalArts purchased more than two dozen Portapak units and set out to recruit the best teachers and students possible in all artistic fields. The initial group of faculty there included several artists who were already working with time-based art such as video, film, or performance, including John Baldessari, Allan Kaprow, Alison Knowles, Nam June Paik, Shuya Abe, and Wolfgang Stoerchle. Faculty and students alike set about freely experimenting with video, and this led to a period over the next ten years at CalArts that could be described as a mass experiment by multiple generations of students and teachers that sought to explore nearly every creative possibility offered by the simple Sony Portapak.[6]

CalArts was certainly not alone in driving a wave of artistic exploration with video. Elsewhere in Southern California, new Master of Fine Arts programs at the University of California, Irvine, and the University of California, San Diego, took similarly ambitious approaches to recruiting faculty and students. By the early 1970s, one could find students interested in video at nearly every art department in the Southland. While not every school was well equipped at this point,

artists were finding access to video equipment in other ways, often making friends with the technicians working in the various dental and medical schools and psychiatric facilities where video was being used as a tool for teaching and observation.[7] By the early 1970s, a number of smaller spaces and museums were beginning to show video as part of their exhibition program, including the artist-run F Space Gallery in Santa Ana, the Newspace Gallery in Los Angeles, the Pomona College Museum of Art, the Pasadena Art Museum, and the Los Angeles County Museum of Art.

Like Nauman, the first generation of video artists in Southern California began by working with an incredibly limited set of tools—typically a stationary Portapak connected to a monitor. William Wegman's observation—that you can always recognize a piece of '70s video art because it ends when the artist walks over to turn off the camera—was as much a necessity as a style, because artists had almost no access to the editing equipment that would allow their videos to end in any other way. And despite its revolutionary potential, the Portapak was a fussy machine. Unlike with film, with video it was difficult to make clean in-camera edits by stopping and restarting a recording—not only would the image usually distort and roll each time the recording was stopped, but the camera's microphone would record the sound of the button being pressed. The camera performed poorly in low light levels, but it was also so sensitive to direct light that overexposure could permanently damage the machine. And, while technically portable, the camera was heavy, bulky, and difficult to use while moving. Therefore, the most successful early videos in Southern California tended to be works that could be completed with a stationary camera, in a single take, and in a controlled lighting environment.

Despite these restrictions, artists used the camera in surprising and ingenious ways, and in doing so revealed a new set of formal possibilities for art making. This was certainly the case with Wolfgang Stoerchle, who, while teaching at CalArts from 1970 to '72, produced an extraordinary series of untitled videos that systematically dissect the properties of the medium. Stoerchle often turned the camera's limitations into strengths, sometimes exploiting possibilities afforded by working with multiple cameras at a time. In an early work, Stoerchle marched toward the camera in a cavernous darkened room while swinging a lantern back and forth, creating fleeting and abstracted impressions of his body that were enhanced by the camera's modest abilities to capture moving light. The effect was refined in a later work in which the artist intermittently activated a high-powered flash in a darkened room. The flash was bright enough to temporarily burn an image on the camera tube, creating what seemed to be ghostly photographs that would slowly fade again to black. In another work, Stoerchle framed an image of his head on a monitor that he used as a stool, while a second camera filmed him from the neck down as he tried to keep a black bar over the video image of his eyes (fig. 1). Other pieces involved the artist interacting with previously recorded videos, as he attempted to pause, reverse, and stack multiple layers of footage together in his increasingly complex experiments.

Stoerchle's formal innovations developed almost as a side effect of his primary artistic concern, which was to explore his own body as an object. Stoerchle was using the formal possibilities of video to create new ways to capture and contain his image, but he also used the space of the video screen to articulate a place—physically and symbolically—where the body could both struggle and be free. This included activities such as squirming his sweatsuit-clad body into a state of undress, designating the upper and lower frame of the monitor as the anchor points that hold his sleeves and pants in place, and, in another work, framing and articulating the edges of the screen based specifically on the range of motion allowed by his exuberantly bouncy penis, which, being filmed with an upside-down camera, appears to defy the laws of gravity. Stoerchle's most shocking work from this period features a series of miniature figurines of Disney characters being extruded from his foreskin—a clear indication that the culture around CalArts in the early 1970s was a far cry from the community of fresh-faced young animators-in-training envisioned by its founder, Walt Disney.

· · · · · · · · · · · · · · · ·

The explosion of video activity in Southern California in the early 1970s went hand in hand with an explosion of artists working with performance art. Like Stoerchle, artists such as Paul

McCarthy, Linda Montano, and John Sturgeon began using their bodies as sculptural material, and video was often an ideal means for recording the transformations and ordeals to which artists subjected themselves. In its more infamous incarnations, performance art in California meant activities such as Chris Burden's *Shoot* (1971), during which the artist had someone shoot him in the arm with a rifle. More universally, however, performance art was advancing a freedom and openness with the body that expanded video art into new political and expressive realms. At the forefront of this movement were feminist artists who used performance and video to, as Suzanne Lacy describes, explore "every body function, every emotional experience, every taboo, everything that we could." (See Lacy's interview on p. 155.) In Los Angeles, much of this activity initially centered on the short-lived Feminist Art Program at CalArts before shifting to the Woman's Building and the Feminist Studio Workshop, which were established by artist Judy Chicago, art historian Arlene Raven, and graphic designer Sheila Levrant de Bretteville in 1973.[8] Not only did the Woman's Building function as a school where women could be educated as artists, activists, and citizens, but it was also an important exhibition venue for video, performance, and all other artistic media.

Feminist artists took the formal tools of conceptual art and applied them to political ends, expanding an arena for narrative, personal expression, and didactic content in the realm of fine art. Video was a natural tool for feminist artists, and the political goals of this worldwide movement helped push formal developments in video art in new directions, redefining possibilities for the medium. The goal for many artists was nothing less than a reorientation of art-making toward the social and political and away from the bourgeois notions of art as high-priced collectible. Feminist artists made one of the strongest pushes to see the role of art extended as a politically relevant component of society at large, to be used as an educational medium and tool for social change. In her interview in this volume (see p. 200), Martha Rosler describes the promise of video:

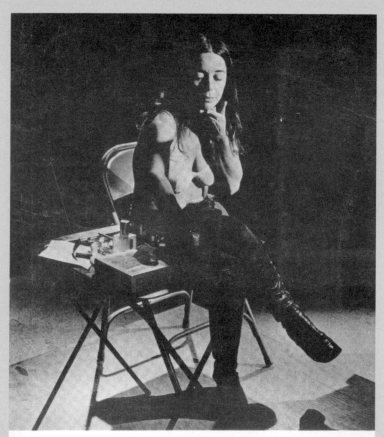

Figure 3.
Eleanor Antin, production still from *Representational Painting*, 1971 (single-channel video, black-and-white, silent; 38 min.), on a card announcing the exhibition *More Traditional Art*, February 15–March 15, 1973, at Northwood Experimental Art Institute, Dallas, Texas. Photo by Fred Lonidier.

". . . Not that the work of the modern artist must by any means resemble the past, but he must show some sense of it, a realization of its presence and attraction. Otherwise he dissipates himself in sheer quality and fails to impose that order and shaping which are indispensable concomitants of high art, and without which the truly cultivated spectator is left thirsty. High art resumes everything that precedes it, otherwise it is less than high."
Clement Greenberg
(Partisan Review, July, 1948)

Video was good for cheap, crummy-looking moving images. They were like movies made on the cheap out of toilet paper, which, therefore, could not be judged by the normal aesthetic standards. The same way performance could not be judged by theatrical standards, video could not be judged by the standards of cinema. . . . Alongside performance, video was a very important tool in the women's movement, because it was new, provisional, cheap, simple, time-based, and speaking. Like performance, it was time-based and speaking; like performance, it was provisional; like performance, it evaded expectations of professionalism and genre. But unlike performance, it was exactly repeatable and transmissible to others elsewhere. . . . Video created a community, it resided within a community, and it moved to other communities, creating a new, discontinuous "imagined community." It had many possibilities because it was new and no one was telling you what you had to do with it.

Feminist artists made a point not only to produce work that fit within the larger context of contemporary art but also to educate themselves about the power structures of mass media and to interrogate its tactics and inherent prejudices. Artists such as Suzanne Lacy, Leslie Labowitz, Martha Rosler, Nancy Buchanan, Susan Mogul, and Eleanor Antin produced stylistically diverse works that find a point of origin in performance and conceptual art (fig. 3). These artists rarely produced straightforward performance video, however, opting instead to incorporate formal aspects of other genres —news media, television, film, and fictional and autobiographical storytelling techniques. In works like Rosler's *Losing: A Conversation with the Parents* (1977), the normally vapid conventions of a middle-class "lifestyle" interview are adapted to produce a video about anorexia and global food supply (see p. 200). Suzanne Lacy's *Learn Where the Meat Comes From* (1976) uses the form of the television cooking show to collapse notions of consumption and the body (see p. 156); and in *In Mourning and In Rage* (1977), Lacy, Labowitz, and a group of collaborating artists adapted the form of a television press conference to stage a performance protest about violence against women, carefully orchestrating every aspect of the event to ensure that its imagery and words could not be twisted by manipulative television editing (see p. 156). Additionally, the international network of supportive organizations and institutions that developed in tandem with the growth of the women's movement created alternative channels for distribution and exhibition, which helped spread locally produced work to national and international audiences.

.

By the mid-1970s, the number of video artists in Southern California had reached critical mass, and when the Long Beach Museum of Art (LBMA) inaugurated a permanent video program in 1974, the stage was clearly set for interesting things to happen. Originally aiming to expand the role of the museum to include cable television broadcast as a theoretical new artistic arena,[9] LBMA recruited David Ross, a young curator from the Everson Museum of Art in Syracuse, New York, to be LBMA's deputy director and curator in charge of video. Ross immediately responded to the needs of the new program by bringing in exhibitions by established artists such as Nam June Paik and the extraordinary series of videotapes produced at Art/Tapes 22 in Florence, Italy. He showcased the range of video being produced locally in Southern California by initiating the exhibition *Southland Video Anthology*, which, in its two incarnations in 1975 and 1976–77 featured the work of dozens of artists and encapsulated the massive range of video activity occurring throughout the region. Ross describes this early period of California video as follows (see p. 253):

> [W]hen I came out here in 1974, I just felt like I'd died and gone to heaven. *Everybody* wanted to work with video. They all wanted to try it; it was in the air. If in the 1960s everyone in Southern California wanted to work with plastic and fiberglass and "Finish Fetish" and create artworks that were kind of like surfboards and kind of like sculpture, by the mid-seventies everyone wanted to work with television. And it was *not* similar to the way artists on the East Coast wanted to work with video as an alternative to conventional mass media. On the East Coast, there was an ideological

approach to the idea of an alternative community using media art to create a different political force, and to reinvent this hybrid between documentary and narrative. But that politic never came west—although in a way it was equally political, because it was artists who were just saying, "We don't need a reason to use this medium, it's just there. It's the lingua franca of our time, and we should obviously work with it—now that we can; now that these tools are available."

In 1976, LBMA received a $50,000 grant from the Rockefeller Foundation, which it used to set up a post-production facility within the museum, inaugurating a period of more than twenty years during which the museum would actively contribute to the creation of hundreds of video art pieces produced by both local and international artists. Easy access to editing and post-production assistance undoubtedly amplified both the volume and quality of work being produced in Southern California, and for the next twenty years LBMA's video archive served as one of the main educational resources in the region.[10]

·················

LBMA was not, however, the first California museum to make production services available to artists. In Northern California, video technology became available to some artists through the activities of the de Saisset Art Gallery and Museum at Santa Clara University, which acquired a Portapak in 1971.[11] Under the leadership of director Lydia Modi Vitale and artist, curator, cameraperson, and video technician George Bolling, the de Saisset set up an ambitious exhibition program that prominently featured video. In addition to video exhibitions by artists such as Douglas Davis and Bill Viola, an early survey of Japanese video art, and the annual *Saint Jude Invitational* exhibition, which included video works each year between 1972 and 1977, the de Saisset exhibited or commissioned a number of works by Bay Area conceptual artists such as Paul Kos, Tom Marioni, Howard Fried, Terry Fox, Joel Glassman, and Bonnie Sherk, in many cases providing them their first opportunity to work with video. In the extremely vibrant and somewhat self-contained Bay Area arts community, these artists were translating tactics of East Coast and European conceptual art into highly visual and often humorous artworks that often felt more connected to natural processes and the social fabric than their counterparts elsewhere.

Along with the Museum of Conceptual Art in San Francisco (founded in 1970 by Tom Marioni), the de Saisset was instrumental in the creation of a number of important video works by Bay Area artists, although its approach was also highly selective and curatorial, primarily granting access to a handful of outstanding artists working in a particular conceptual vein. Elsewhere in the Bay Area, individuals who were loosely organized around artist Skip Sweeney and a group called Electric Eye were taking a more grassroots approach (see pp. 226–29). Sweeney began working with video early in 1967 while studying at Santa Clara University, after a friend acquired a camera and basic editing equipment. Sweeney's innate technical facility left him undaunted by the camera's limitations, and he immediately began experimenting with different forms of camerawork and editing, while also producing several feedback-based abstractions. With an impromptu and often humorous style of video making, Sweeney and the other artists associated with Electric Eye headed to both the street and their own living rooms to capture footage. The resulting works exist somewhere between documentary and parody, and often perfectly capture the multitude of communities that formed San Francisco's unique counterculture. Electric Eye soon began working with another collaborator, Arthur Ginsberg, and the group renamed itself Video Free America (VFA) near the end of 1970. In addition to producing its own video works, VFA also came to function as both a post-production and exhibition space. Early VFA-organized exhibitions, such as *Tapes from All Tribes* (1971) at the Pacific Film Archive in Berkeley, were among the first exhibitions in California to attempt a survey of the wide range of art-world and underground video occurring nationally.

Electric Eye developed an early form of video installation, used solely in the service of a new conception of theater. In *The Philo T. Farnsworth Video Obelisk* (1970), an obelisk-shaped tower of seven video monitors played a synchronized mishmash of two channels of video, presented as a weekly theatrical event. Mixing experimental documentary with abstract video feedback, found footage, a "video jockey" narrator, and just plain silliness, *The Philo T. Farnsworth Video*

Obelisk stands as one of the most genuinely creative early experiments with multichannel video display.[12] This approach was later refined in the wildly successful *The Continuing Story of Carel & Ferd* (1970–75). Conceived by VFA cofounder Arthur Ginsberg, *Carel & Ferd* presents what could be considered the first reality television. Following the lives of Carel Rowe and Ferd Eggan, an addictively telegenic couple living an aggressively alternative lifestyle, *The Continuing Story of Carel & Ferd* was presented theatrically on eight monitors showing two channels of synchronized video, which could be mixed live during each performance (see photo and articles in Arthur Ginsberg's entry, pp. 98–101, and the interview with Skip Sweeney, pp. 226–29). Video cameras in the control booth allowed live footage of the audience, footage of machinery in the control booth, or zoomed-in sections from video monitors to be mixed in as well. *Carel & Ferd* toured several cities as live video theater, received national and international press, and ran continuously for more than a year at VFA's space in San Francisco before ultimately becoming all but forgotten.

As evidenced by organizations like NCET and VFA, video in the Bay Area was much more collaborative and more directly connected to the counterculture than was video in Southern California. While the Bay Area's conceptual artists were building networks of support at museums and art galleries, groups like VFA and NCET were engaged in a different sort of cultural production that did not immediately have the larger art world in mind. Other collectives, such as Optic Nerve, Ant Farm, T.R. Uthco, and, later, Target Video, produced work that straddled the worlds of fine art and mass media. Overall, the eclectic, independent, and youthful nature of most Bay Area video lends the work an energy that seems to be bubbling up from society at large rather than from the rarefied world of conceptual art. Video slowly became accessible to students across the Bay Area in the early 1970s, although schools there were a bit slower to act, and there was no equivalent to the sudden influx of resources triggered by CalArts and other new programs in the south. At the San Francisco Art Institute (SFAI), Howard Fried successfully lobbied to acquire video equipment in April 1972, although it was a painful process for Fried and one that resulted in the type of passive-aggressive bureaucratic maneuvers deployed when generations clash within an institution—including a period when students choosing to work with video received almost no support elsewhere in the school. Fried's efforts eventually led to the official creation—preceded by several years of its unacknowledged existence in Studio 9 at SFAI—of the performance/video department (later renamed New Genres) in fall 1979, which became known for its phenomenally creative faculty and students and as one of the centers of the developing San Francisco punk movement.[13]

· · · · · · · · · · · · · · · · ·

By the second half of the 1970s, the canon of techniques developed by the first generations of video artists was becoming tiresome to a new wave of students, who were beginning to take the lessons of early video in directions that never could have been imagined only a few years earlier. Young artists such as Tony Oursler in Los Angeles and Tony Labat in San Francisco took the prototypical video art form—the artist alone in the studio using his or her body or manipulating the image in front of the camera—and introduced cultural references specific to a new generation. In an early work by Labat produced while he was a student at SFAI, the artist dons dozens of T-shirts, one after another, until his body is made monstrously huge and mobility is impossible. While the action itself fits within the confines of typical body- and process-oriented performance from the period, the subtext lies within the T-shirts themselves, as the series of band names, logos, and messages telegraphs an altogether different meaning to those tuned-in enough to catch it. Artists like Tony Oursler used video as a space where painting, sculpture, and performance could all combine in the construction of cheap yet elaborate sets and props wherein suburban myths and childhood traumas could be played out by the most minimally anthropomorphic set of objects, with the artist using the opportunity to virtually reach inside the TV screen as a means to meaningfully manipulate culture at what, for many, is its source (fig. 4).

On the margins of this scene, Los Angeles artist Cynthia Maughan was creating some of the most under-recognized video works of the period, producing nearly three hundred short videos between 1973 and 1980 alone (see the list on p. 14).[14] Producing feminist work despite an

inclination not to, Maughan undermined nearly every trope of feminist art while nonetheless producing subtly political work that borrows liberally from a multitude of genres—although it most directly follows the model, established by William Wegman several years earlier, of producing short, humorous vignettes. Drawing from a range of female stereotypes that spans Victorian fiction, horror-movie bloodbaths, trailer-park drama, true-crime narrative, and everyday reality, Maughan's characters deal with both their hardships and their boredoms on screen: they have encounters with aliens; they are the victims of sexualized violence; they use fashion to hide their wounds; they take medicine with gloves on, talk to Jesus, and commit suicide; they sing, cook, exact bloody revenge, and explain the concept of jail to their cats. In a typical work, *Tamale Pie* (1978), Maughan deflates a standard feminist art tactic of taking the kitchen as subject matter. Beginning with Maughan reading a fake newspaper headline: "Family of Four Murdered!! Poisoned Tamale Pie," the artist's narrative quickly devolves to her simply reading a recipe for tamale pie and suspecting every ingredient, then turning her suspicions on each member of the dead family before exclaiming "Jesus Christ!" throwing down the newspaper, and exiting the screen (see photo, p. 165). In simple works such as *The Way Underpants Really Are* (circa 1975), the artist hikes up a sundress and rotates 360 degrees, revealing a ridiculously ratty and tattered cotton undergarment (see photo, p. 162); in *Suicide* (1973), a razor blade falls into a tub full of water and then a stream of dark liquid slowly turns the screen black. In a series of works about scars, Maughan's characters stoically and with great care apply makeup, arrange scarves, and adjust veils to cover gaping fake scars on their faces. Maughan's characters don't suffer because of media power structures or the innate injustices of society—they suffer because life sucks and is unfair for everyone.

The video works by Maughan, Oursler, and Labat from this period are important in that they employ the tactics of an earlier generation of video artists while also channeling an underground, deflationary aesthetic that ran parallel to the ascendance of punk rock as a dominant countercultural form.[15] By the end of the 1970s, the democratic potential of early video was seeming to become a larger reality, as the new generation of video and performance artists created an alternate system of exhibition and display based not only in the burgeoning world of the "alternative exhibition space" but also within an even more alternative network of nightclubs, after-hours clubs, and other performance venues. As Tony Labat describes:

> Around this time, there were a lot of alternative spaces, a lot of artist-run spaces. But I remember having these talks with artists like Karen Finley that these spaces had

Figure 4.
Tony Oursler, still from *Diamond Head*, 1979. Single-channel video, black-and-white, sound; 13 min., 52 sec. Courtesy of the artist.

Figure 5.
Poster advertising "Assault Video" at the Anti-Club, Los Angeles, circa 1984. Collection of Los Angeles Contemporary Exhibitions.

DESOLATION CENTER AND MARK WHEATON

present

ASSAULT VIDEO

THE FIRST IN A MONTHLY SERIES

WED. NOVEMBER 28 • 10 p.m.

at 4658 Melrose Ave.

THE ANTI-CLUB

The L.A. premiere of TARGET VIDEO *and* S.R.L.'s

"A SCENIC HARVEST FROM THE KINGDOM OF PAIN"

40 minutes of tightly edited, action packed live show footage from S.R.L.'s three most recent mechanical performances. Featuring mechanical constructions by **MARK PAULINE, MATT HECKERT,** and **ERIC WERNER** and music by **MONTE CAZAZZA.** Produced and edited by Jon Reis and Joe Rees.

Also Appearing:

VIDEOS by **Paul McCarthy, Johanna Went, Frank Moore, Einsturzende Neubauten, Test Dept., Cynthia Maughan, Eugene Timiraos** and others.

AND THE FILM

MONDO CANE

AND A MONTAGE OF JAPANESE ANIMATION

Survival Research Laboratories

become too established, and we started questioning "alternative to what?" At the same time, there was an amazing proliferation of punk clubs and what they called after-hours clubs in San Francisco, like Mabuhay Gardens, Club Foot—I couldn't even begin to name them all. The mixing of music and bands with films and video and performance in these spaces was very common and very organic, and it also infiltrated into academia. In Howard Fried's class in Studio 9 at the Art Institute, there was a lot of catharsis, transgressive behavior, a lot of razor blades, cutting, a lot of punk aesthetics going on, which was quite unbelievable.[16]

In California, as well as internationally, much of the raw energy of punk was emanating from art schools, and for a time the do-it-yourself immediacy and cut-and-paste aesthetic of punk seemed perfectly married to the humble production values of video art. In San Francisco, artist Joe Rees began videotaping the burgeoning punk scene, and by the end of the 1970s he had established Target Video, a group that captured video footage of punk, industrial, and New Wave bands, along with documentation of the larger social scene and many of the other performance activities that were associated as part of those same movements. Target's videos combined performance footage, homemade graphics, found footage, and the occasional special effect to produce a mix between performance and music videos years before the arrival of MTV, and their video works were frequently shown in both galleries and nightclubs well into the 1980s.

In the curatorial realm of the nightclub, all distinctions between artistic media, popular culture, and kitsch could vanish in favor of the youthful energy and ironic sensibilities of the club-goer as a new breed of arts patron. Few documents illustrate this more clearly than the poster for the inaugural evening of "Assault Video" at the Anti-Club in Los Angeles in 1984 (fig. 5). Primarily featuring Target Video footage from the violent mechanized performance art of Survival Research Laboratories, this evening also included screenings of work by artists Paul McCarthy and Cynthia Maughan, performance artists Johanna Went and Frank Moore, German and British industrial music pioneers Einstürzende Neubauten and Test Dept., Italian "shockumentary" *Mondo Cane* (1962), "and a montage of Japanese animation." By the 1980s, it was this environment, as opposed to museums and galleries, that many artists saw as more relevant and formative in their artistic careers.[17]

• • • • • • • • • • • • • • • •

Back above ground, a proliferation of technical advances gave artists access to a wider range of tools in the 1980s, including color video, better editing equipment, video projection, basic special effects, and much more sophisticated sound. This led to yet another explosion of activity, as artists set off in multiple directions, exploring new forms of performance, narrative, political activism, installation, and effects-driven presentation, with fewer of the formal and mechanical limitations of earlier periods. In many cases, the artists who had absorbed the mass media of the 1970s, rather than artists who grew up during the 1950s or 1960s, were best able to take full advantage of video's newly accessible capabilities. In San Francisco, very young artists like Dale Hoyt (see pp. 106–9) innately synthesized every new video- and sound-editing tool, producing virtuoso, acid-colored works that look as if the pop culture of the 1980s has been vomited through the looking glass and then shot into outer space (fig. 6).

Indeed, by the mid-1980s, the concerns and aesthetics of video art had undergone such a thorough transformation from the experiments of the first generations that the technologically and theoretically sophisticated work of this period practically constitutes a new art form. While this book aims to present examples from the entire history of California video, several additional books would be needed to fully cover the developments of the last twenty-five years. However, many entries in the "Artists" section cover the period, and the essays in the "Histories" section are devoted almost exclusively to the changes that occurred as video moved from the 1970s into the 1980s and 1990s. Few organizations in California embodied these changes more than the Long Beach Museum of Art, and the collection of interviews comprising "Recollections: A Brief History of the Video Programs at the Long Beach Museum of Art" provides an excellent introduction to the massive shifts that occurred in media art from

Figure 6.
Dale Hoyt, still from *The Complete Anne Frank*, 1985. Single-channel video, color, sound; 34 min., 35 sec. Courtesy of the artist.

the mid-1970s through the 1990s. At a more personal scale, Steve Seid's essay, "I Ain't Cuba: The Early Video Works of Tony Labat," describes the evolution from the punk provocations described above and in Labat's interview (see pp. 150–53) to the highly sophisticated examination of language, culture, and media in Labat's work of the 1980s. In "Everything's Important: A Consideration of Feminist Video in the Woman's Building Collection," Meg Cranston examines both the founding and later development of the Feminist Studio Workshop and Los Angeles Women's Video Center at the Woman's Building, noting the prescient and almost immediate shift toward larger preoccupations with mass media that characterized the work produced there. Similarly, Kathy Rae Huffman traces ways in which television broadcast became both a goal and a subject matter for video artists in the 1980s in "Art, TV, and the Long Beach Museum of Art: A Short History."

In "Concept, Art, and Media: Regarding California Video," Robert R. Riley explores how the bodily presence of the artist, so common in 1970s video, shifts to more abstract assertions of artistic presence, as evidenced by technical virtuosity and sophisticated uses of language and form in more contemporary works. Bruce Yonemoto's essay, "L.A. Video: Uncensored," documents the heady collision of sex, drugs, and theory that led to a remarkable group of video works that found their homes in clubs and alternative art spaces in Los Angeles. Finally, turning to the recent history of the MFA programs that played such a crucial role in the development of video art in the 1970s, Rita Gonzalez, in her essay "'I Am Teaching Video Art,'" examines the tendency of today's graduate programs to teach "professionalization" and "art politics."

I hope this project will generate renewed interest in video art's recent and distant past, inspiring new inquiries to commence where this one leaves off. California's artists and their histories far exceed what has been documented here, and the true complexity of these accounts resides with the artists themselves—in their artworks, their archives, and their memories. For most of the last four decades, video art in California has been marked by its existence within an unfettered and somewhat provisional creative environment. California artists have had the luxury of feeling they could make up their own histories as they went along, without bearing the heavy weight of tradition or the pressures of a developed art market. Like Bruce Nauman bouncing in the corner, they often behaved as if no one else was watching—and that unchecked, unrevised energy best characterizes California video. But of course the video camera not only watches but also records, and now that those made-up histories have become real ones, a new task lies ahead: to go back and figure out what the histories really were.

LIST OF VIDEOS BY CYNTHIA MAUGHAN

[See text discussion on pp. 9–10.]

Open Reel, Black and White:

1973–74 The Trunk ‖ Spider, Cat, Water ‖ I Become a Mummy ‖ My Lips Depart While Sleeping ‖ Sitting at My Table Thinking ‖ Ophelia I & II ‖ Eating Cake ‖ Two Sticks Mourning at Another Stick's Funeral ‖ Suicide ‖ Arteries & Veins ‖ A Violent Death ‖ Shooting at Balloons with Arrows All or Part of Which Are White ‖ Scar/Scarf ‖ Scar/Makeup ‖ This Is a Message of Infinite Patience from the Mind of the Universe ‖ **1974–75 (approx.)** The Magician's Cabinet ‖ Frozen & Buried Alive ‖ Baskets from My Wedding ‖ Taking Medicine ‖ How to Determine Death ‖ Against a White Tile Wall with One Eye Closed ‖ Reading Sympathy Cards ‖ **1975 (approx.)** Coffin from Toothpicks ‖ The Causes of Unconsciousness Tabulated for Ready Reference ‖ Shelly's Remains ‖ The Haunted Mausoleum ‖ Hand Reaching for Medicine ‖ Eating Cake ‖ Embroidery ‖ Abraham Lincoln's Skull ‖ Taking Medicine with Gloves On ‖ Typing Suicide Note ‖ Bug Collection ‖ Pressing a Flower ‖ In My Purse ‖ Golden Altar ‖ Marry Me Jesus ‖ History of Bandages ‖ Rock of Ages I ‖ A Picture of a Piano in a Parlor ‖ Rock of Ages II ‖ Diphtheria ‖ Charlotte ‖ Sitting on the Porch ‖ Dorthea ‖ Pyramids ‖ Statue ‖ Henna Rinse ‖ Making Biscuits ‖ A French Romance ‖ The Hat Pin ‖ All Our Quiet Violent Lives ‖ Razor Necklace ‖ Poisoned Fudge ‖ Getting Ready to Go ‖ On the Sunny Shores of Spain ‖ French Girl ‖ Hat with a Veil ‖ Black Girl ‖ Dancing with Black Stockings ‖ Putting on Nail Polish ‖ Drinking Tea ‖ How the Egyptians Mummified Their Dead ‖ A Pregnant Woman Stabs Herself While Her Cat Looks On ‖ Drinking Blood ‖ An Illustrated Story ‖ A Song ‖ Hands-Hands ‖ Still Life, Bird, Mirror, Bread, etc. ‖ Writing for Jesus ‖ Short Term Lease On Love ‖ The Way Underpants Really Are ‖ Chart of the Solar System Showing God's Home on Venus ‖ Monster Voice ‖ Zinc Shoulder Casket ‖ Sinister "Oriental" Front ‖ Chapter 1 of The Yellow Peacock ‖ Francie's Mother Dies ‖ Lily, Lily's Mother, Lily's Aunt ‖ Ripple & Poison ‖ Lost at Sea ‖ The Toast of Alabama ‖ Opal, Valeri ‖ Newspaper Trees ‖ A Dish of White Rice ‖ A Story about Working ‖ Acorns & Rushes ‖ **1975–76** Some Dreams & A True Story ‖ The Snake & the Chair ‖ Claw Hammer Murder ‖ The Suicide of Mr. Buckley ‖ Drawings Found in a Desk ‖ Working ‖ Lucy & the Outlaw ‖ She Left the Letters in the Trees ‖ A Picture & Some Dialogue ‖ The Word Pneumonia ‖ About Going to Heaven ‖ Trying Not to Breathe ‖ 100 Fans ‖ Countries of Space: Light on Venus, Countries of Space, People in the Dark ‖ Burn Masks (Potato Masks) ‖ Circle of Twigs ‖ UFOs in the Solar System ‖ The Thought of You ‖ The Fall of the House of Usher ‖ Knife or Razor ‖ **1976** Tales of the Pioneers ‖ The Mortal Wound ‖ The Forest Rushing ‖ The Forest Rushing (cont.) ‖ Smokey Joe & the Devil ‖ Daughters Be Wary (Song) ‖ D. H. Lawrence (Ghosts in the Corners of Rooms) ‖ "It Was Silly to Be Caught in a Room of Mirrors" ‖ Smokey Joe & the Devil (Tracks of My Tears) ‖ **1976** The Death of Merwin's Brother ‖ Bleeding from the Place between Your Legs ‖ Eve Arden in the Garden of Eden ‖ Alma & the Sailor ‖ Desert Museum ‖ Ida Painted Lilies ‖ The Black Death ‖ Pat ‖ A Letter to a Friend ‖ A Letter to a Friend (cont.) ‖ A Victim's Song ‖ Pig Mask ‖ Snakes & Rafts ‖ Emily's Poems & How I Miss Her ‖ It's Sad When Someone Dies, Cactus, G.P. ‖ Poodle ‖ The Black Valley ‖ Looking Down the Barrel of a Gun ‖ If the Sun Landed in My Corral ‖ The Open Refrigerator (Photograph) ‖ Gone with the Wind ‖ Candy Mexican Hats ‖ Mary & Lady Jane ‖ A Plea for the Return of the Amazon Nation ‖ Women of Religion at Bay ‖ A Dream (Artist & Gooch) ‖ The Way You Wear Your Hat ‖ Razor Blades & Black Widows in Their Hair ‖ Things on TV ‖ Behind Closed Doors #1 ‖ Behind Closed Doors #2 ‖ Communist-Munto ‖ Old Black Joe ‖ Dear (Abby) ‖ Black Widow ‖ Slum Life ‖ Women's Peace Movement ‖ **1977 (approx.)** The Riddle Song ‖ Cow Mask ‖ Beth, a Day Staying Inside ‖ Scarf/Egrets ‖ Coconut Tells Cow a Joke ‖ A Game of Checkers with Christ ‖ African Makeup ‖ Pixie Surgeons, Brain Operation ‖ It Tastes to Me Like a Chub ‖ The Sinister Black Socks ‖ If I Cut Myself I Will Bleed ‖ **1977** Trailer Life ‖ Trailer Forum: In Reply to Mr. Tatwell ‖ A Heartening Experience ‖ The Last Night ‖ Huge Trailer for Arabian Prince ‖ Serve It Nicely ‖ Cooking Cabbage Again? ‖ Three Women on Television (Working Class Women) ‖ La Contessa ‖ The Invention of Suicide ‖ Art & Democracy ‖ Over the Border ‖ Marzipan Pigs ‖ My Trip to Japan ‖ Poor Woman Goes Crazy ‖ Decorative Table Accessories ‖ Gloves & Glasses (Dance) ‖ Someday I Will Be an Angel ‖ Octopus & Zebra ‖ Prisoner of Chastity ‖ Self-Portrait ‖ It's an Atomic Bomb ‖ A Game of Cards ‖ I'll Kill You for Talking ‖ Snap Your Fingers to the China Clipper ‖ Misirlou ‖ Radioactive Sand ‖ First He Eats Bread Fruit ‖ Polka Dots ‖ Mask & Cards (Clubs) ‖ **1977–78** Zebra Skin Clutch ‖ Japanese Slippers & Black Slacks ‖ I Tell Three Cats about Jail ‖ Tsetse Fly ‖ Going to Easter Island ‖ Forever & Ever (Hula) ‖ The Four Horsemen ‖ Ma Chumba ‖ On Being in Love ‖ Aku Aku ‖ It's Money, It's All Money ‖ Salt & Pepper Day'O ‖ **1978** Sunglasses ‖ Hong Kong Blues ‖ Lotus Land ‖ Sardine ‖ Return to Paradise/Kidney-Shape ‖ Knives, Thunder, Paper ‖ Big Black Hat (Rain) ‖ Coffee ‖ It's You or Me (Grabbing the Knife) ‖ Help Me I Think I'm Falling (In Love, Strap) ‖ The Man Who Dreamed of Mutilating Women ‖ Yolanda/PCP ‖ Getting Off ‖ **1978–79** Picking Up the Scraps ‖ Concrete and Clay ‖ Object ‖ Death in Telephoto ‖ 3 Objects ‖ The Silver Basket ‖ Standing Object ‖ Wine Bottle Holder-Cone-Wine Bottle Holder & Cone ‖ Laundromat Rape ‖ Dreams about Women ‖ Challengers ‖ **1979** Knock Out Rape ‖ No. 9 ‖ Maggots ‖ Mystery (Try) ‖ Groovy Kind of Love ‖ Surfer 2002 ‖ Sunset Blvd. War ‖ Records in My Room ‖ Cafe Au Lait ‖ 3rd Stone from the Sun ‖ **Interiors (1980–81)** The Kind of Room That Makes You Be Quiet ‖ The Use of Patterns in Interior Decoration ‖ The Buddha Is a Lamp ‖ Exteriors ‖ Someone Else's House ‖ Defending the Home ‖ Enter (Entrance) ‖ Thank You Jesus (Interior Decoration in Heaven and Hell) ‖ **Undated (1974–75?)** 10 Min. ‖ Cutting Wrist ‖ My Eyes Are Bleeding ‖ Cutting Off Fingers ‖ Eating Geese ‖ Woman with Hand on Backwards ‖ Eggs ‖ Boiling Soup ‖ **"Poetry" (undated, late 1970s to early 1980s?)** Heather and Staples (Little Pig & Dish of Fruit) ‖ The Pillow ‖ The Bride Is Burning ‖ My Arms Around You (Hugging the Camera) ‖ Lima Beans ‖ Kitchen Things ‖ Dreaming of Famines ‖ I Dreamed I Was Escaping ‖ **Four Unrelated Poems** 1. The Ground Is Weak ‖ 2. The Whiter They Are ‖ 3. Stick Bone Dinner ‖ 4. Fan Over India

¾-inch U-Matic Cassettes, Color:

7/7/78 Six Pieces ‖ Tamale Pie ‖ Dramatic Devices ‖ Sex Symbol ‖ Stains ‖ Calcium Pills ‖ Browning Automatic ‖ **8/5/78** The Object ‖ **8/26/78** Objects ‖ **10/20/78** ME/POLITICS ‖ **3/8/79** 17 Records

Hi8 / 8mm Video Cassettes, Color:

10/17/86 Big Horn ‖ Sister & Brother ‖ **1986** Suicide Cont. ‖ Before/After ‖ Bavarian Barbecue ‖ Necessary Evil ‖ OVEN ‖ Laughing Bats ‖ **1987** Illustrated Stories from the Book of Mormon ‖ Summer ‖ Prey ‖ California Volume 16: A Big 9 Inches ‖ Imagine ‖ My Crippled Mind & Heart

Digital Video:

2003 Pursed (Collaboration with Nancy Buchanan)

NOTES

1. I would like to thank Steve Seid, video curator at the Pacific Film Archive at UC Berkeley, for bringing this and other works from NCET to my attention. For more information on NCET, including descriptions of work by the many other artists working there, see *Videospace: The National Center for Experiments in Television, 1967–1975* (Berkeley: University of California, Berkeley Art Museum and Pacific Film Archive, 2001) as well as, in this volume, the interview with Stephen Beck (pp. 42–45) and the essay by Warner Jepson (pp. 114–15).

2. For more information on these projects, see Constance M. Lewallen, *A Rose Has No Teeth: Bruce Nauman in the 1960s* (Berkeley: University of California Press, 2007).

3. The Sony Portapak was the first commercially available consumer-grade portable video camera. Portapaks were sold in the United States as early as 1965, but they were not widely available for purchase until around 1967.

4. All forty-three of the artists and curators interviewed for this catalogue were asked this question: "What was the first piece of video art you ever saw?" Of those old enough to be aware of art when Nauman came on the scene, nearly half referenced either Nauman's 1969 Wilder exhibition, the interviews with Nauman published in *Avalanche* magazine in 1970 and '71 (excerpted on pp. 182–85 of this volume), or Nauman's 1972 solo exhibition at the Los Angeles County Museum of Art.

5. For more on this early period at CalArts, see the interviews in this volume with Alan Ackoff (pp. 18–20), John Baldessari (pp. 34–37), Suzanne Lacy (pp. 155–57), and Susan Mogul (pp. 178–81).

6. CalArts also had an important and well-equipped school for film and animation, but this equipment was almost never made available to students and faculty in other departments.

7. Early works by artists such as Eleanor Antin, Paul McCarthy, Anthony Ramos, and Martha Rosler were all produced in this manner.

8. For more information on the video programs at the Woman's Building, see, in this volume, the essay by Meg Cranston (pp. 269–73) as well as the interviews with Suzanne Lacy (pp. 155–57) and Susan Mogul (pp. 178–81).

9. For more on the history of LBMA's experiments with cable broadcast, see "Art, TV, and the Long Beach Museum of Art: A Short History," pp. 279–84 of this volume.

10. For more information on the LBMA, see "Recollections: A Brief History of the Video Programs at the Long Beach Museum of Art," pp. 252–68 of this volume, and *Video: A Retrospective, 1974–1984* (Long Beach Museum of Art, 1984).

11. For more information on the de Saisset, see the interviews with Howard Fried (pp. 90–93), Paul Kos (pp. 142–45), and Bill Viola (pp. 238–41).

12. For more information on *The Philo T. Farnsworth Video Obelisk*, see the interview with Skip Sweeney (pp. 226–29).

13. For more information, see the interview with Tony Labat (pp. 150–53).

14. I would like to thank Nancy Buchanan for bringing Cynthia Maughan's work to my attention.

15. Maughan, Labat, and Oursler were all involved with various punk, noise, or "art" bands during this early part of their careers, including the Poetics (Oursler); Primitive State, Auto-da-fé, the Nihils, and the Shrews (Maughan); and the Assholes and the Puds (Labat).

16. Tony Labat, interview by Glenn Phillips, March 23, 2007. Video and transcript available at the Getty Research Institute, Los Angeles.

17. See, for instance, the interviews in this volume with Skip Arnold (pp. 26–29), Ante Bozanich (pp. 50–53), and Branda Miller (pp. 174–77), as well as the essay by Bruce Yonemoto (pp. 285–90).

Artists

NOTE TO READER

In the following entries, white type printed on a black background indicates material written or otherwise created by the featured artist, including original essays, reprints, and video transcripts.

ALAN ACKOFF

Born 1953, Cleveland, Ohio
Lives and works in Santa Fe, New Mexico

LAMENTING THE LOSS OF HIS CAR, Portapak, and perception of space and time, Alan Ackoff, in his video ballad *Cornceptual Art* (1976), tells the story of a young artist whose luck changes after embracing a new, less-traditional definition of art. Sung in true country-and-western style, Ackoff's tune accompanies a close-up shot of the artist blinking, snarling, and making faces for the camera. In another of his melodious pieces, *Art Bar Blues* (1976)—which chronicles a young man's fleeting romance and dreams of becoming an "Art Star"—the lone artist pensively gazes at his own image, which is reflected in infinite regress on a television monitor. Ackoff's work seems thematically allied to the playful tradition of John Baldessari singing pop-song versions of Sol LeWitt's thirty-five declarative "Sentences on Conceptual Art." And it should come as no surprise that Ackoff studied with Baldessari as a student at the California Institute of the Arts (CalArts). Although his encounters with video art primarily occurred as a student, Ackoff's short songs and video performances keenly reflect the ripples of late seventies conceptualist teachings, which challenged and amused young artists during this defining moment in art history.

As part of his expanding formal art education, Ackoff worked at the Long Beach Museum of Art as a video production intern. At the museum, he edited, exhibited, socialized, and made music with other video artists, all the while questioning the limits and meanings of an art based in ideas rather than objects. He later continued to explore his musical talents and even toured with folk musician Ramblin' Jack Elliot (whom Ackoff considers to be a conceptualist performer in his own right). Today, Ackoff works as a photographer, documenting personal moments and everyday beauty. And it seems Ackoff has finally settled on a definition of art that he likes: "Art is a moving target, meaning different things in different cultures at different times."

Catherine Taft

Interview conducted by Glenn Phillips on March 29, 2007, at Larry Bell's studio in Venice, California

GP: Do you remember the first time you saw an artist using video?

ALAN ACKOFF: Yeah. My first awareness of video art was in John Baldessari's Post–Studio Art class at CalArts, and it was kind of an accident. I went there to study painting in 1972, but some friends of mine were raving about John as a teacher. I took his class, and he became my advisor. I had been writing songs about art—kind of humorous country-and-western laments—and some friends said, "Hey, we got a video camera, let's go into town and make a movie, and we'll put one of your songs on the soundtrack." So that's exactly what we did. We went and just kind of counted off approximately how long the song would be, and we set ourselves up in front of this little tiny Greyhound bus station in Newhall that had a bench out front. Then we went back to the dorm and recorded the song. It took three video decks, because we had to switch between two decks to create a title. We made grease-pencil marks and did the editing on the fly to a third deck. This was on half-inch black-and-white Sony video, which we thought was really high tech. That was my first video, *Newhall Greyhound Depot Lost and Found* [1975]. I took the thing to class and everybody started laughing. I didn't know how they were going to react, but it was a big success. John asked to borrow it, and the next thing I knew, he had returned it to me and said, "How would you like to be in a show at the Long Beach Museum of Art?" Then, I became aware of video art, really, through David Ross.

John arranged for me to be a student intern at the Long Beach Museum, and David just started piling stuff on me: "Have you heard of so-and-so," you know, "Do you know about Fluxus?" "Do you know about Nam June Paik?" And on and on. It was a good education. It was totally different from what I would have learned had I just spent that time at CalArts. So I guess I was doing video art before I was aware of video art; to me, it was just kind of film-making, I guess.

Let's go back to John Baldessari's class—what would he make you do, or what would you look at? Well, John's class was . . . disturbing. That's the only way I can put it. I remember during the

very first class he read a suicide note from a former student, who was basically saying good-bye to the world because everything had become meaningless after giving up object art. And it wasn't a joke. I don't know if the guy actually, you know, went through with the suicide or not, but it was a very sad, depressing account of this guy's confusion and disillusionment with art in general, as a result of getting into what we were calling at the time post–studio art. And John was having us read books like Lucy Lippard's *Six Years: The Dematerialization of the Art Object* [1973], and he wasn't really giving people a lot of direction unless they asked for it. People at CalArts had different interpretations. There were people who were into rituals, people who were into public performances, and people who were into video. I shared an apartment with another artist, David Dashiell, and we just kind of went off into our own explorations. At one point, John tried to talk me into transferring over to the music school. He thought that the soundtracks of what I was doing were the important part for me. I might have done that, but I was impatient. I wanted to get out of school and find a job down in L.A., which is what I did after I graduated. I went to work for Peterson Productions making TV commercials.

How often were you seeing video work by other artists? Did John show his own tapes in class? John's classes often took place off-campus, and we would come down to his studio. I don't think he ever did show his tapes in class—I think I saw them at Long Beach. But he had some unusual ideas about teaching. He had friends who were collectors, people like Stanley and Elyse Grinstein, and he would have the class meet at a collector's house. We would view their collection and visit with them. It was interesting as a student to see where the art ends up—who buys it, what they think about the artist that they've bought work from, and what art they own. I don't think I ever had another teacher who tried to put it in context like that. Of course, being down at Long Beach gave me perspective as well, but for most of the students, the visits were their only sense of the art business.

And what was it like at the Long Beach Museum? What types of things would you have to do? Well, my first day down there I met David, and I was a little intimidated by this art museum. The

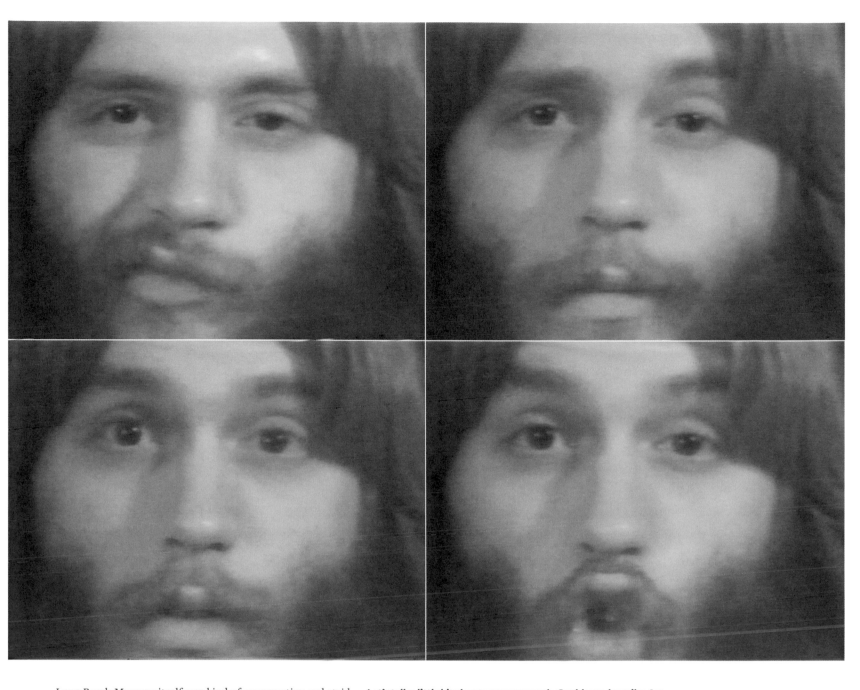

Long Beach Museum itself was kind of conservative and staid, and then here was David, this renegade with an office in the attic. He put me at ease pretty quickly. He handed me a rubber stamp, which said, "No Problem." And he said, "The paperwork needs to be done, it's stacking up." He said, "This is the 'In' basket, and this is the 'Out' basket. Take every paper that's in the 'In' basket, stamp it 'No Problem,' and put it in the 'Out' basket." And I said, "You've gotta be kidding." He said, "No, I've been doing this for six months now, and nobody has ever questioned it. I do this every day." So from that time on, it was my job, and I started realizing that this was not like other jobs I'd had. And it was really a lot of fun. The line between work and play kind of disappeared, and it wasn't unusual for us to be there all day and then break out a six-pack at the end of the day and get some guitars out, and end up being there until ten or eleven at night. I remember working with guys like Bill Wegman and Frank Gillette and Joel Hermann, and it was what school should have been, all this creativity. David was the one who was keeping it orderly and making sure that bills got paid and paperwork got from the 'In' basket to the 'Out' basket. And the people at the museum just seemed thrilled to have all this youth and energy on the premises; as far as I could tell, they were very nonjudgmental about the anarchy of it all.

Let's talk a little bit about your own work. Could you describe *Art Bar Blues* [1976]? Well, the visual for *Art Bar Blues* is basically a quote from Nam June Paik's closed-circuit video installation *TV Buddha* [1974], so it shows me in front of a television contemplating my own image lost in infinity. And then I wrote a song—which was somewhat autobiographical—about my girlfriend at the time, and meeting her at an art opening, which became the "art bar" in the song. It actually had to do with the feminist movement a little bit. Feminism was really big at CalArts at this time, and I was one of the only guys who took the feminist art classes. I took Deena Metzger's feminist journal-writing class, and I know I was the only guy in that class. And I took Miriam Schapiro's feminist painting class, and I'm glad I did. It was challenging; they were really hard on me.

We should probably talk more about being the only man in the feminist journal-writing class. [Laughter] Well, looking back, it was silly. But Deena Metzger was wonderful. I remember going in, and our first assignment was to write a story, and I wrote a story called "Pamela Had Beautiful Tits." I just wanted to see what was going to happen. The story was about this girl I knew in Montana, and— I just adored her. I mean, it was sincere, you know? It was just—she did. And I just said it. I got up in Deena's class and read

p. 19
Alan Ackoff, stills from *Cornceptual Art*, 1976. Single-channel video, black-and-white, sound; 2 min., 25 sec. LBMA/GRI (2006.M.7).

that, and I thought I was going to be torn apart, but they loved it. You know, they just took it for what it was and said, "Hey, you know, if you express yourself this way, it's okay." So it kind of opened my eyes that feminism wasn't really what I had maybe thought it was. It wasn't just for women. It was also just a different way of looking at things—to not objectify people so much; but anything that was emotionally sincere was still okay. So I think that *Art Bar Blues* was a little bit of a role reversal story, where the woman is the one cruising the art bars and picking up the guy, rather than the guy going out to pick up a girl. It just had to do with what was going on at the time; I think people were questioning everything as far as roles and gender issues, and who could be aggressive and who could be passive. And that was certainly a great time for women to be in art school, with people like Deena, Mimi Schapiro, Judy Chicago, and Lynda Benglis—really strong personalities who were very successful.

You worked closely with Lynda Benglis, right? I had two advisors while I was at CalArts—Lynda was my first one, before I sort of, by default, got thrown out of the painting school. As far as I know, I'm the only CalArts art student who was ever on academic probation.

What happened? You know, it's still confusing to me. It had to do with the feminist painting class I took with Mimi Schapiro. With Deena, we just hit it off, but with Mimi, it was like a train wreck the first time I got up in class and showed some art. The next thing I knew, I was on probation and was being threatened with getting expelled from art school, which I was sort of proud of in a backward way, but I also really didn't want to get thrown out of school. Mimi really admired Ellsworth Kelley and his drawings based on plant forms, so I got this rhododendron and put it in my dorm room, and drew it every day for a month. I went back and showed her hundreds of drawings of this plant. She looked through them very seriously, and she finally said, "It's okay, you really are an artist, you can pass my class." Deena was like a sister, and Mimi wanted to mother everybody and nurture them; they both taught me different things.

But back to Lynda Benglis—she was my first advisor, and she was the first one that got us off campus. CalArts was really isolated. It was a bunch of radical art students in the middle of a tiny little redneck community. There was very little tolerance, except that you could go into town and eat at the Saugus Café Truck Stop

at two in the morning, and you'd have long-haired hippie art students and redneck truck drivers sitting in booths next to each other. But Lynda brought us down to L.A. and Venice. I think that was the first time I met Larry Bell, and I remember Lynda taking us to Chuck Arnoldi's studio, and Peter Alexander's studio, and, of course, to her studio. You got a sense of these people, who just lived creatively all the time. At this time, Venice was really just a barrio by the beach, and people were renting vacant storefronts for a few hundred dollars a month. Lynda's studio had been a police gym, and she just put in a little loft upstairs and the rest of it was all workspace. Chuck Arnoldi had this huge studio, and there was a little cubicle where he lived, and everything outside of that was art. They did away with that sort of art school contrivance of now you're in class and now you're not in class—it was just people living their art, and Lynda certainly did that. I think that everything she did in her art, she was also exploring in her life.

Let's talk about *Cornceptual Art* [1976]. *Cornceptual Art* was, I guess, my exit. It was really meant as a kind of clowning around. It was meant to be silly. It was a comedy about a country boy who moves to the city and starts being a conceptual artist and gets lost, and doesn't know what's what anymore. And like every country song—well, there's an old joke: What do you get if you play a country record backward? You get your pickup truck back, your dog comes back to life, you get out of prison, and your mother comes back from the dead. I wanted to get all those things into this song in an art context, and I just made a video of a close-up of my face kind of twitching, just simply trying to look befuddled and confused.

I remember when Jonathan Furmanski, the Getty Research Institute's video conservator, first transferred your tapes and called me to come look at them. We were talking about how they were made at CalArts in this time when almost anything was encouraged. His idea about the piece led him to ask, "What could one possibly do to up the ante in an environment like that?" You know, how could someone challenge everyone else's conceptions? Jonathan thought that had something to do with your decision to just make a country music video. Certainly, no one had ever tried that as video art before. Well, you sort of wanted the absence of all rules. But if you were in art school, what you really wanted at that time was for somebody to tell you how you could get out of art school and be an artist. Here you had teachers, John Baldessari being foremost, saying, "I have no idea. I don't really know what I'm doing, it just seems to work," and so there it was.

Years later, I met Davidson Gigliotti. I found his Early Video Project Web site online, and I dropped him a note and said, "You wouldn't know who I am, but it's cool that you have that up and it's nice to see that I got mentioned somewhere in art history." He wrote back, and we had this dialogue going for a long time. We talked about things like the day that David Ross brought the Kipper Kids up to CalArts; and here are these two performance artists running around in ballet outfits—little tutus and leotards—having art students autograph their bodies with felt-tip pens. Davidson and I somehow got into this thing of art versus academia, and finally, after months of dialogue, I pressed him for his definition of art. He said that art is a moving target that means different things in different cultures at different times. I've always loved that. I don't know if that's something that he read or wrote, but it's the closest thing to a working definition that I've heard. It doesn't leave anything out. I would have died to have had an answer like that back in my CalArts days. That should have been written on the diploma or something.

p. 20
Alan Ackoff, still from *Art Bar Blues*, 1976. Single-channel video, black-and-white, sound; 3 min., 25 sec. LBMA/GRI (2006.M.7).

p. 21
Song lyrics from Alan Ackoff's videos *Cornceptual Art* and *Art Bar Blues*.

CORNCEPTUAL ART

I used to want to paint in oil
With a country western radio and rodeos,
Until a friend of mine turned me on to video.
Rodeo, Radio, Video, Sal Mineo.

Cornceptual Art has caused me to change
My perception of space and cornception of time,
'Cause everything's Art all the time,
When you have a cornceptual mind.

I named my pickup Mondrianne, now she's wrapped 'round a pole,
'Cause I was staring at the sunset when the stoplight turned to go.
I smacked into a Sunset Pig who hauled me off to jail.
I had to hock my Portapak and now I'm out on bail.

Cornceptual Art has caused me to change
My perception of space and cornception of time,
'Cause everything's Art all the time,
When you have a cornceptual mind.

ART BAR BLUES

I should have known when I met her in an art bar,
That I was just a thing for her to prove.
It might have been her green eyes and it might have been the booze,
And it might have been that I had nothing left to lose.

I should have known when I took her home with me;
Free spirits gotta keep on being free.
Now she's out being free and I'm alone with my TV,
And I'm thinking Jimmy Rodgers must have felt a lot
 like me.

I want to be an Art Star,
Then I'll pick whoever I choose
And they'll play me on the jukebox in the art bars,
Singing the Art Bar Blues.

Someday I'll make her sorry that she let me slip away,
And for thinking she was so highfalutin cool.
When I become a star, and drive a European car,
She'll know that it ain't me who played the fool.

I'm gonna be an Art Star,
Then I'll pick whoever I choose
And they'll play me on the jukebox in the art bars,
Singing the Art Bar Blues.

ELEANOR ANTIN

Born 1935, New York, New York
Lives and works in San Diego, California

ELEANOR ANTIN HAS ADMITTED TO BEING "jealous of the past," and her inventive video, film, conceptual actions, performance art, and photographs speak to this inclination. Through her artwork, Antin has earnestly, but sometimes awkwardly, inserted herself into history. She, or rather one of her alter egos, has danced with the Ballets Russes, been kidnapped by Rasputin, been typecast in the Pocahontas story, visited the last days of Pompeii, staged bacchanalian Roman allegories, been hijacked while flying to Saint-Tropez, escaped Victorian trappings to fight in the Crimean War, and has declared war on land developers as the King of Solana Beach, California.

Using four primary personas—the King, the ballerina Eleanora Antinova, the Nurse, and the Black Movie Star—as theatrical vehicles, Antin examines and enacts feminist identities, masculine stereotypes, American race relations, and politics, all with critical deadpan and seamless timing. Her emphasis on histrionic delivery, costuming, and set design may be a result of early training as an actress, yet throughout her career, Antin has repeatedly blurred the line between fictional constructions and realist narrative. In her video and photo series *Caught in the Act* (1973), Antin explores these two different kinds of truth using two representational technologies to capture a single event, a display of ballet postures. In the photographs, the artist, as a skilled dancer, is gracefully frozen *en pointe*. The video reveals another reality, however, as we see her struggling to move in toe shoes and using a pole to help her balance for the 1/125th of a second it takes to snap the perfectly posed photograph.

Catherine Taft

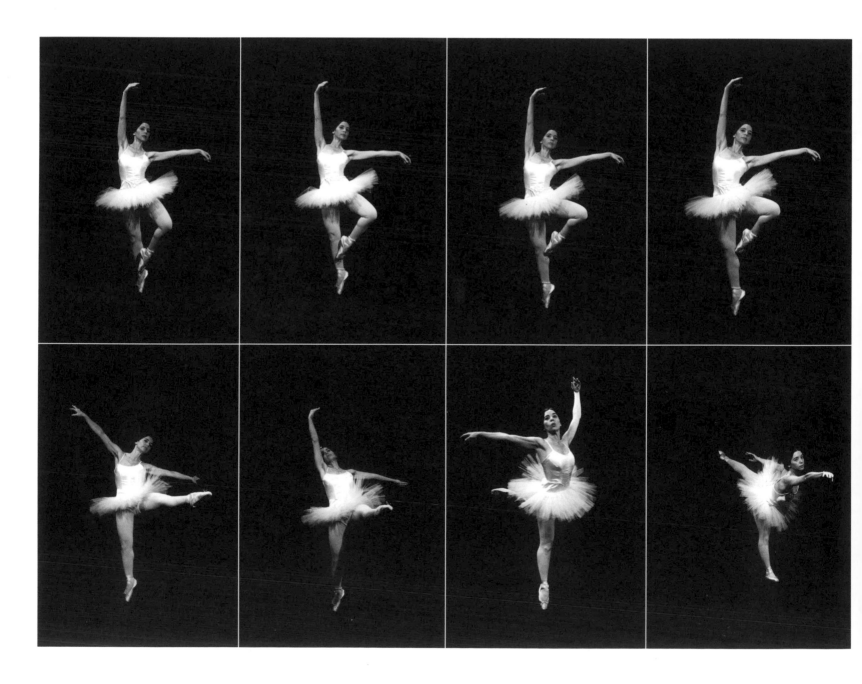

Interview conducted by Glenn Phillips on September 28, 2006, at Eleanor Antin's studio in San Diego, California

GP: Could you tell me what it was like moving from New York to Southern California in 1968—in particular, about the differences you noticed between art in California and art in New York?

ELEANOR ANTIN: I would say the first year or two I was a real New York brat. I had never been outside of New York. Moving to California was the biggest culture shock; I had never experienced anything like it. It was very profound; I was in an extreme state of depression. My doctor said I should have another child so my depression would go away. That's what they used to tell women in those days. I just ran out of there screaming—and kept on being depressed. But artistically, it was fascinating to come here because it was totally open. San Diego was a little military town. It was still gorgeous and beautiful—not like now. Not "Development Land." I could do what I wanted. I didn't know what they were doing in Los Angeles. It turned out they were doing that attractive, sleek plastic stuff. In those days, when I saw those works I thought they were the enemy, just like I thought the minimalists were the enemy. All these people that I used to attack—now I love their work. But in some ways that old war's over now, isn't it? In any case, it isn't the same war now. I started making connections with people, especially with women artists. That was, I think, one of the first really meaningful things that happened. I remember Suzanne Lacy, Arlene Raven—these people were in L.A.—and then I was also meeting people here. Martha Rosler was an old friend from New York. She came to San Diego to study in grad school, and Suzanne, Arlene, and Marty were my closest friends here. Then we had a women artists' group. We met and did these crazy sculptural performances. Ida Applebroog was from San Diego, and we were extremely close friends in those days. Eventually, I didn't feel so isolated, and that happened through our feminist and art concerns.

I really think the woman's movement, or very specifically, the woman artists' movement, absolutely changed the art world. There were some men who grew up with us that I'd put into that group, too. Like Vito Acconci and Chris Burden and Paul McCarthy—which is kind of funny because Vito and Chris like to come on macho, but that's part of the bad-boy image that they played. Not Paul, of course, he was a feminist from the beginning.

But what our work all shared was that kind of performative openness: bringing in personal material, bringing in the despised everyday—the sort of opening up of the white gallery walls to the bigger world. The conceptual art movement was doing some of that at the same time, and I was in that movement as well as the feminist movement. I think it all came together. It was the zeitgeist. The seventies were really the sixties with a more sophisticated art exploration. The sixties moved into the seventies very smoothly, and at that point everything exploded into possibility and it was such a fabulous time. But it was also a very sad time because of the war, the Vietnam War. So really, you know, I can't remember it as a happy time. The day the war finally ended, I didn't celebrate—too many dead, too much pain, heartache. I spent the whole day crying.

Artistically, it was extremely exciting from the beginning. Oh—and I didn't drive. I thought it was horrifying to drive. Nobody drove then in New York. But I hitched, and in those days you could hitch. It was great. Our little boy was in a Montessori school in the next town. David would usually pick him up because he drove, but very often I would hitch and pick him up.[1] If I just felt like walking on the 101, do you know how many cars would stop and say, "You want a lift?" And on our way home little Blaise—he was about three years old—would stand out there with his thumb out, and who wouldn't stop? Everybody would stop and then we'd go home. So it was great. I could get around anywhere. But a few years later I remember they moved his school up the hill in Solana Beach, and little Blaise and I were standing out there going like this [makes a hitchhiking gesture], and Blaise is standing there and nobody's stopping, and he said, "Nobody's stopping," and I said, "I know, nobody's stopping." And suddenly, I noticed the cars were bigger, they were newer, and the people behind the wheel were older. Development had come to California. It happened. I hadn't even noticed, but everything had changed.

What led you to make your first video, *Representational Painting* [1971]? I was interested in ironically playing with the idea of traditional art. Painting was one of the traditional arts, and I wanted to do a painting on video. I decided to go through the act of painting myself the way a woman paints herself to face the world. It's a painting, and it would be a representational painting because it's

p. 22
Eleanor Antin, *Caught in the Act*: *Choreography I—Center Stage 1–8*, 1973. Eight black-and-white photographs mounted on board, each 17.8 × 12.1 cm (7 × 4¾ in.). The collection of Margaret and Daniel Loeb.

p. 23
Eleanor Antin, still from *Representational Painting*, 1971. Single-channel video, black-and-white, silent; 38 min.

the representation with which she wishes to present herself. Or it's probably more accurate to say it's the best she can do to represent herself, to present herself as she would like the world to see her. She presents this representation, and video seemed like the perfect choice. In those days you didn't think of the video camera as anything but standing there. They were so big and clumsy, you know. You sat in front of it and did what you did. It was an action that would easily fit the frame, and I would be able to make this transformation happen and do this representational painting on video. Paint on video. But remember, this was 1971—makeup was retrograde. What representation would present me in a way that I could live with? I felt my way toward a kind of *Vogue* hippie. It wasn't suburban or bourgeois or any of the looks I hated. *Representational Painting* was a feminist piece that ironically played with the idea of traditional art forms—like *Carving: A Traditional Sculpture*—and it just started when the painting began and it ended with the final brushstroke.

But I should tell you something else that happened during that piece—I was trying to use the monitor as a mirror, and I didn't realize that video doesn't reverse the way a mirror does. I thought it would be a straightforward documentation, but what happened is the monitor became this ferocious character. Not acting like a real mirror, it was extremely invasive, and it was dictating all sorts of feelings and behavior on my part. I would take my eyebrow pencil and go up to here [pointing to left eyebrow], and the damned thing would end up over here [pointing to right eyebrow], which is extremely freaky and very disorienting, so I had to work out a way to survive with this malevolent monitor. I would bring the pencil here [pointing to left eyebrow], say, and I would—for a second, nobody would see—I would close my eyes and bring the pencil to where it was supposed to be—you know, do it tactilely rather than visually. Then I'd open my eyes, and I wasn't freaked out because the pencil was where I put it, and I could continue. The result is that the picture—the whole tape—has a slightly nervous quality. There's an angst to it, which I think most people are aware of even if they can't put their finger on it. That was one of those marvelously fortunate accidents that we artists love so much, because what I had envisioned as a fairly straightforward documentation of this everyday activity that women do—instead, this atmosphere of angst permeated the whole tape. And, of course, that is very related to how I saw things as a young feminist, how I saw the very act of changing oneself, in a culturally approvable manner— that is, with makeup, to make a representation of a pretty girl. I eventually got more used to the fact that things were in the wrong place because of the non-mirror reversible habits of the monitor, but it was still nerve-wracking. There was always a kind of tension. I don't know if I knew it while I was making the video, or if it occurred to me after—because of the rich, sumptuous blacks of the black-and-white video—but it always makes me think of *Last Year at Marienbad*, which is one of my favorite movies. I imagine that there's this man in a tux standing behind me ready to take me down to the ballroom, and I'm dressing, because if you remember, the actress is always in front of a mirror preparing herself, and, of course, she is incredibly beautiful. We have a different sense of time now. Everything is so incredibly rushed, but time felt infinitely more luxuriant in those days, and if you take the time to sit and look at this tape, there is a whole romantic, slightly distressed, I think rather elegant and strange atmosphere pervading the whole thing, which fits very well with the act of self-beautification, at least in 1971. But I must say, I still think that it's a rich and complex action, putting on makeup, especially now that I'm older. There's still a lot of angst involved, though a different angst for an older woman. It remains an interesting subject.

Your next video was *The King*? Yes, that was the next year—1972. As a young feminist, I was wondering what kind of a man I'd be if I was a man. I didn't want to be a man, but if I were, who would I be? And of course I wanted to be the most attractive, handsomest, best man I could be, and with a kind of irony, I said, "Oh well, the only difference is they have hair on their face," so I put hair on my face. You know, I could've put a whole beard on at once, but I didn't know what kind of a beard looked good on me, so the thing was to discover—just as I had with what I felt was my most attractive made-up look in *Representational Painting*—the transformation, to discover it on the monitor. What would happen when I turned into a man? I used the old-fashioned actor's method. I don't even remember how you do it anymore. You take a couple of pieces of hair, you glue it onto a small piece of sheer paper with spirit gum, then you tack it on to your face. It pulls the skin. It's really an unpleasant feeling. The major thing that I was concerned with was building up the hair so I could start trimming it. What would be the right kind of beard? I went through these different characterizations. I think at one point I looked like Jesus, which is very romantic—I thought that was so cool. Then I started cutting and trimming the beard, because I didn't think Jesus was the character that was calling me. Then there's a sort of explorer look, which was ridiculous with my small face. I looked like an imposter, and at one time, I looked like, I think it was the Smith Brothers. They were a cough drop. They looked like patriarchs from the nineteenth century. I certainly didn't think that was the best I could do, and I continued trimming it. It was almost like I was putting on makeup again, and then I saw in the monitor that with my small face and long, straight hair, I was a courtier. I had this Robin Hood kind of denim hat. I don't know what this hat was. I think I got it from Saks Fifth Avenue. It was the only one they had—it must have infiltrated there by mistake. And somewhere I got this cape that David said made me look like a dwarf policeman. Soon after, I realized I looked like Van Dyck's portrait of Charles I. I started reading about King Charlie and I realized that we were very much alike. He was also a small guy and a hopeless romantic. He was a loser, like me. Nobody I ever voted for got elected, we couldn't stop the war, they wouldn't stop bombing Cambodia or napalming people. I mean, we were all hopeless against a government determined to fight an insane war in Vietnam. What could the king of a tiny little beach kingdom do? How could I stop it? With my walking stick? Nothing's changed. Today it's the Iraq War.

There's something else I should say, though, that is really curious about this tape. The São Paulo Biennial wanted to do an exhibition of American video, but it was being paid for by the United States Information Agency [USIA]. The one thing they didn't want was anything political. They said so. They wrote to us: "No political takes allowed." I sent *The King*. It never occurred to me—I mean, I thought the tape was political in a feminist way, but there was no way they would care about that, and it's about a king. What could be wrong? No problem. But I start off in this tape wearing this army shirt, because that's what I used to wear every day, and I'm putting on a beard. Well, those were the days of Fidel and Che. They called them "the bearded ones." South of the border, that meant the revolutionaries. I got a letter from the director of the Museum of Modern Art in Buenos Aires, personally thanking me. *The King* was the most political tape they had ever shown. Apparently, there were blocks of people all around the place waiting to get in to see this tape because it was a revolutionary image about the bearded ones. And it got through the censors. Well, I had no idea that it would do this. I was delighted, of course—we were all rooting for the revolution, but I must confess my great political act was a fortunate accident. I don't know the cultural context in Brazil and what particular images meant there. Fortunately, the USIA didn't know either.

Could you describe your video *Caught in the Act* [1973] and talk about the juxtaposition of photography and video? *Caught in the Act* is one of my favorites. Unfortunately, it is often just shown as a videotape. But the way it was meant to be shown, and the way it was originally exhibited, was to have the video shown together with photographs. The videotape is a depiction of a photo shoot of me doing glamorous ballerina poses, which I practiced for months before. In the video you see that I can't really stand *en pointe* easily, or practically at all, so I grab on to a stick that a character named Help offers to me. I try to get into ballerina positions, but I have to get up on toe, so I call "Help." He shoves out a broomstick to me, I get up *en pointe* and adjust my pose as well as I can. Then I yell "Now!" He pulls the stick away and the photographer snaps the picture right then, bingo, and for that split second, I'm beautiful. I'm a ballerina. Unfortunately, I collapse immediately, and so what the piece does is show two truths; they're both true—or if you prefer to say, they're both untrue, but I think that's an unfortunate way to put it. Let's say that they're both true: the truth of the moving camera and the truth of the still camera. They're just different truths.

So you weren't specifically trying to make a rift between the two? No, no. I accept both truths.

So do you think that there are certain works for which photography is obviously the appropriate medium, and certain works for which video is obviously the appropriate medium? See, I don't think anything is appropriate. I'm not a rule follower. I don't think any medium is appropriate for anything. I think you use a medium for what it is: use the medium that will do what you want to do.

Do you think there are certain ideas that you could only get across if you were using video or using photography? Let's put it this way: if you're dealing with Margot Fontaine, then she will look as perfect on video as she will look in the stills, right? Unless, of course, you place the camera in the wrong place and she looks stunted, deformed, clutzy, or even hidden. If you're dealing with "Eleanora Antinova," it's a different matter entirely. But you must understand: there are seconds on the video when she's truly a ballerina. Help takes that broomstick away, and for one second—a split

second—I'm up there. And for that split second, I am engulfed in truth as a ballerina.

All of these pieces suggest narratives that go beyond the bare facts of the work, and, of course, narrative has continued to play a huge role in all of your subsequent work. Could you talk about your relationship to narrative? How did you think narrative fit with art, when at this point it was something that artists had tried to avoid for decades? Yes, for decades. The word is sexier now, though I think that the art world is still a little nervous about it, still scared of the big bad wolf. They're more into mini-narratives, you know, like suggestions of narrative, hints of narrative, a kind of aura of the possibility of narrative. The ghostlier the better. But for me, what I've always believed is—well, we live narratives. Our lives are many narratives. I've always said everybody lives their own novel or novels and we're all constantly transforming in time and space. I have the kind of mind that when I look at the world, I immediately see narrative possibilities. Stories inside of stories. People are characters. In seconds, I've had murderers appear, romances started, volcanoes erupt. Actually, my therapist always laughs about this because she sees it happening in my face. She'll say, "What just happened?" and then I tell it, embellishing all the way. I mean, it's a full story, and it recalls another story and another one. I just have the kind of mind that sees the world erupting into narrative possibilities. Hey, what do you think paranoia is? The only trouble with paranoids is that they're boring. Their stories are always the same. Making art wouldn't be interesting to me without my stories. Even *Representational Painting*, which I said started as a sort of documentary of a simple but politically fraught action—hey, that turned into *Marienbad*, you know? Though sometimes I think it's a Bergman movie. Maybe nobody else sees the piece that way. I think it's less politically and aesthetically complex if you see it as a mere doc. I don't know if I've answered your question. I'll be on my deathbed and all these stories will still be exploding in my mind. And then they won't. And I'll know I'm dead.

NOTE
1. Poet, critic, and performance artist David Antin is married to Eleanor.

p. 25 left
Eleanor Antin, still from *Caught in the Act*, 1973. Single-channel video, black-and-white, sound; 36 min., 10 sec.

p. 25 right
Eleanor Antin, *Portrait of the King*, 1972. Black-and-white photograph mounted on board, 34.9 × 24.8 cm (13¾ × 9¾ in.).

SKIP ARNOLD

Born 1957, Binghamton, New York
Lives and works in Los Angeles, California, and Paris, France

IN THE TRADITION of the body and endurance art of Chris Burden and the masochism of Bob Flanagan, Skip Arnold has created extreme performance art pieces since the 1980s that investigate the relationship between the body and space. His performances range from the passive to the intensely physical, as exemplified by pieces such as *Gargoyle* (1992), in which he propped himself onto a building as a living sculpture, and *Marks* (1984), a video performance in which he recklessly threw his body against the sides of an eight-by-eight-by-eight-foot white room to make marks on the walls, until he lost consciousness.

Revealing an interest in the image and nothing else, Arnold's performances are documented on what he terms the "evanescent" and "transient" mediums of photography and video. In *Activities Made for TV* (1983–92), a compilation of works, Arnold goes from using film and video merely to document his activities, to a larger group of works that combine his body performances with an exploration of the formal and technical possibilities of the video medium itself. He occasionally utilizes chroma key technology and video editing techniques to enhance the impact of the initial performance event. In *Jump* (1988), Arnold documented himself jumping off the roof of a building in Hollywood using Super 8mm film and then transferred the footage to video, adding slow-motion effects, color tinting, and editing in post-production, transforming the piece from straightforward documentation of a live performance to a work that actively directs the viewer's perception of the event.

Amy Sloper

Interview videotaped by Skip Arnold on May 2 and May 3, 2007, in Paris, France, in response to written questions from Glenn Phillips. Arnold recorded his answers in two sessions, which have been synthesized here.

GP: When was the first time you got your hands on a video camera, and what did you make?

SKIP ARNOLD: When I was in college, I transferred to Buffalo State, across from the Albright-Knox Art Gallery, and painted, believe it or not. I made action paintings. They were like twelve yards long. It wasn't really about the defined product kind of thing—I'd just throw paint and sticks. It was more about the activity and the action and the time involved in doing the whole activity, all that kind of shit. I had an 8mm camera, and I would film myself making what I did, and then I'd show the films on top of my paintings or next to them. Two of my teachers, Jack Bice and Jim Sylvia, signed papers so I could use the Portapak in the communications department. It was like a big giant trunk. It took me and a friend to carry it. So I took it down to my studio and tried to videotape myself making these giant paintings. The first time I used it, I was quite shocked when I looked at the image and I couldn't see any color—I didn't realize that it was a black-and-white camera. Then I turned around, and all of the tape was on the floor. It had recorded everything, but the tape wasn't threaded right and it never fucking spooled onto the other reel. It would take hours to roll it back together—which I did not do. I just threw it in the painting. The end of that project came when one of the canvases fell on top of me. These things were just huge, and I could not move. I really, really couldn't and I'm sitting there lookin' at this thing, and my friend came in and said, "Oh, you look great, Skip. Oh, God, cool." I go, "Man, will you take this thing off of me? I've been here for five hours. I cannot get up off the ground."

What made you decide to move to California from the East Coast?
I wanted something consistent. My health wasn't really great back then, and I couldn't live in the cold anymore. I was living in Buffalo, New York. Sometimes you go outside and it's great. And by the middle of the day, it's raining and I didn't bring an umbrella, so I'm soaking wet. And by the end of the day, it's like, "Fuck, it's snowing." My last year in New York, I had to dig myself out. We had to punch a hole in the wall of snow against the door, and we were like gophers. We had to pop our little heads out and see what's going on in the real world. So the weather in L.A. seemed to be a good deal. The other thing was Leslie Krims. I was a teaching assistant for

him at Buffalo State in the photography department, and he would show me these magazines and stuff from the West Coast. People like John Baldessari and Allan Kaprow. He said, "Skip, that's where you should be. You should be where something is happening." Also, there was a girl I really liked who moved out there. She was very nice. She dumped me, but when I got there I had a studio and she gave me a Fiat 124 that didn't work. It was all in pieces, and I put it back together and made it run. I got my driver's license in that car. It was a really cool car.

Could you talk about the video and performance scene in L.A. in the eighties and early nineties? Where were people showing? What were the important venues for you? Well, to be honest with you, there's no such thing as performance in the early eighties in L.A. I don't care what anybody says, there was nothing. We had vaudeville, burlesque, suitcase performance, and fucked up theater. It was like big, grandiose extravaganzas. I'd say by 1983, performance had turned into entertainment. You paid money to see performance. I remember once someone at a venue told me, "Skip, we've accepted your work. We have lights, and we can hold two hundred people." And it's like, "No, man, you don't understand. I'm doing a piece on the corner, down the street." "Well, how are we going to charge people?" "I don't know. It's not my deal. I don't do anything onstage." An important venue for me, definitely, was LACE [Los Angeles Contemporary Exhibitions]. In the early days, it was super cool. But the more important scene was in the underground venues and in the clubs, like Fiesta House and Anti-Club and Zero One. Jack Marquette had one on Sundays, but I can't remember the name of it. Sorry, Jack. Oh! No, no, no, it was the Theoretical. And of course you had the Atomic Café—they had the coolest jukebox. And that's where the venues were for me, whether I was reading poetry, or doing an action, or showing my videos. About half the time, I'd lug all my equipment to show all my little *Activities Made for TV* [1983–92] In another club, I'd be with Don Bolles [drummer and DJ], and we'd be doing *Music to Annoy By*. How bad could we be to make everybody leave the club? That was always kind of funny. In the late eighties, you had places like Red Square, Power Tools, the Alexandria Hotel, and the club at the Variety Arts Center.

But I think the biggest thing that influenced me during that time that really, really bothered me and was a very hurtful thing was AIDS. It took away so many people. It was horrible. It was the most torturous thing I ever went through in my entire life. It got to a point, honestly, where there wasn't a weekend that I wasn't help-

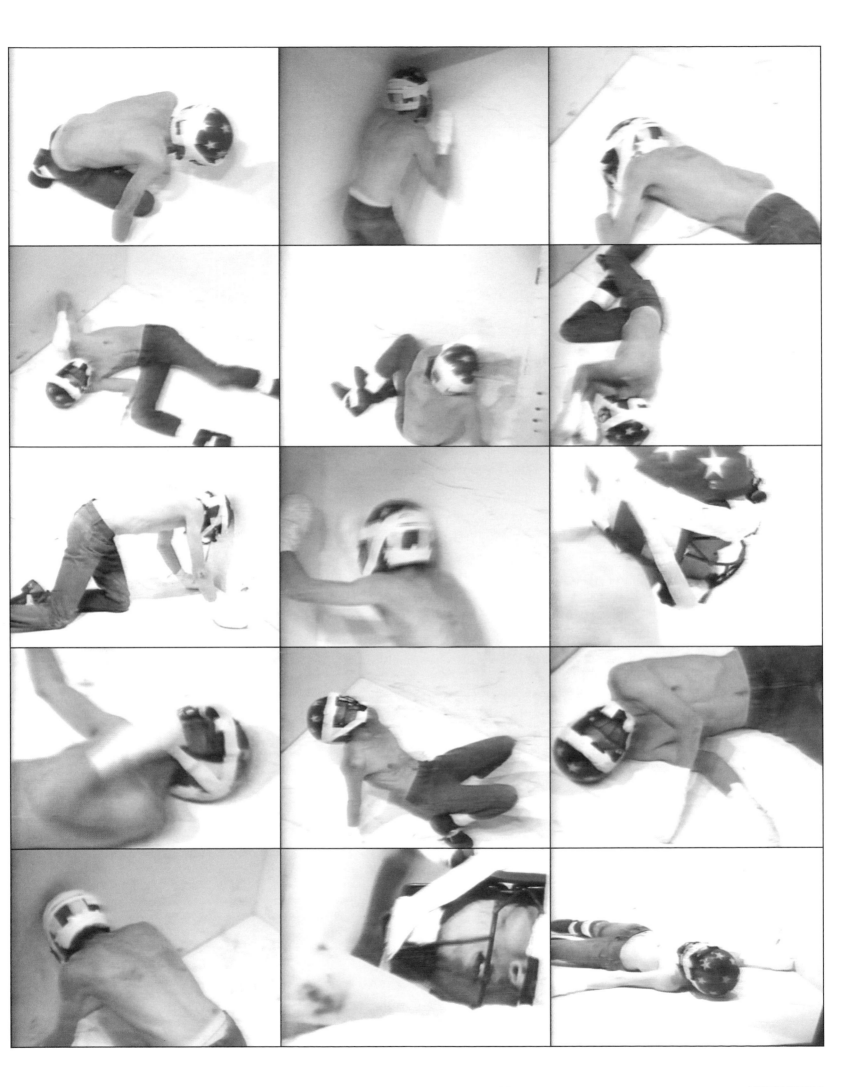

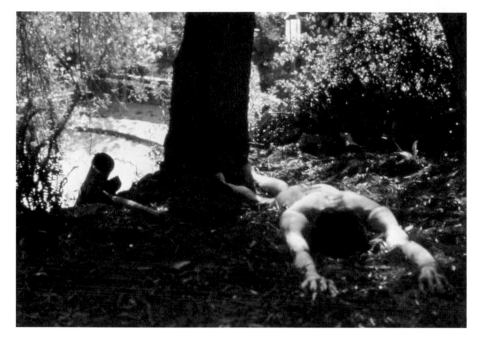

ing clean out someone's house. It was devastating. It's the worst thing that ever happened and it's still happening.

Could you talk more about *Activities Made for TV*? Were they actually broadcast? What did you think would be gained by having the work on television rather than in a gallery, and how would you want a normal person to react to seeing these very strange activities on the TV? *Activities Made for TV* were little actions you can do in front of a camera, just that simple. Did I expect them to be on TV? Yes, I did. I was that arrogant back then. I expected anything I did would be. I was at UCLA in the film department, and we had what we call Master Control; it was where everything happened. All three TV studios broadcast down to the student union. At any given period of time there were probably three hundred people looking at the student union's big video wall. I got in big trouble, but I broadcast my work down there. All you had to do was take one plug out of here and put it in there. Two years later, or maybe a year and a half later, I got on MTV. The stuff on MTV was my piece *Hey* [1984], *Hello Goodbye* [1984], and *Punch* [1984]. For *Punch*, I had two cameras, one on my head and one on my stomach. The one on my stomach is made to go on TV. I stand there and I give a guy thirty minutes to punch me, and four and a half minutes into it, he punches me in the stomach. When it's shown as a sculpture it's really cool, because you see my head go through the top monitor into the bottom monitor.

How would I want a normal person to react to these activities? What's a normal person, Glenn? I was walking down the street one day and some guy punched me in the side of the head. I fell down. It

was very awful. The police came, the ambulance came, everybody came, but they never arrested the man and I had to pay all the medical bills, so I don't know what a normal person is. When I was in Tokyo, I showed *Punch* on one of those giant video screens like in Times Square. You know, I'm getting punched in the stomach, and people were just excited. I stood there all day long going, "That's so mean." In the museum, kids cheer when they see my head hit the wall. They cheer when I get punched in the stomach. When their parents drag them away, they scream and yell. I tell you, I'm a normal guy. I'm just trying to do things that you can do. It's all about what you can do in front of a camera. I didn't think it was odd that I would be on TV or that the work itself didn't fit. I don't think it looked any different than the stuff I saw on a thirty-second commercial. They're all bizarre. I mean, you've got some guy showing you a car, some lady showing you a stain—is that normal?

Some of your performance works are also documented on video, which then becomes a self-standing single-channel work. How do you decide whether a performance work will also function as a video? I decide that before I do it. Sometimes my interest is in nothing but the picture—the photograph—like in *Appendage* (*Root to a Tree*) [1990]. But I know the only way I can get the photograph is to do the activity. Now, I know you can say, "Well, you could just lay there for a second," but it wouldn't be the same. That photograph wasn't taken the first minute I laid in the ground, and it wasn't taken the last minute I laid in the ground. It was taken at some point within the whole time period. Many times, my interest is in something other than the activity itself but the only way to get what I want is to do the activity. The activity might end up being really cool, but my interest was in the image. Other times, I only have an interest in the activity, and the photograph is just a document.

Describe *Marks* [1984]. The interest was to use my body to make marks on a wall like a pencil. I knew from the get-go that to do this piece properly, it would need to be a live activity with the audience located someplace else, meaning the piece was broadcast to them on a TV monitor. It was my first attempt at doing a piece where there's no way anybody could influence my actions within the piece. I thought that some of my actions in my performances may have been a reaction to the audience, and considering most of my work had been done in clubs and underground venues, I wanted to prove to myself that I could do a piece without any intervention, and that the piece could be authentic and be nothing but itself. I built a room that was eight by eight by eight feet out of three-quarter-inch plywood and two-by-fours. It was a solid piece. Before I set it up, I knew that I wanted three cameras: one above and two on either side of the room, and I wanted two people on a switcher. The switcher tape would be the master tape that I'd

maybe edit from. Everything was time coded. Outside of the initial performance, the interest was to make a piece that was in real time. I wanted to edit it together in real time like a boxing match where nothing is missing. During the performance itself, the biggest interest was not to die early. When I started the piece, the first time I rammed into the wall it was like, "Holy shit, I think I'm dizzy." The only thing I knew was that I'd lost all sense of time, didn't know what's going on, but had to keep going, because I didn't want to embarrass myself.

I'll tell you a story about *Marks*. I saw a girl in an elevator one day. She kind of knew who I was—she'd seen me in clubs. And I said to her, "If you want to get together, you should come and see my performance. Maybe we could have a drink afterwards." I saw her two days later in the elevator, and she called me an asshole. She went and saw the performance, and thought it was the most disgusting thing she'd ever seen. Why would somebody, you know, do such a thing?

A lot of video from the seventies ends when the tape runs out, and several of your performances—including *Marks*—end when you fall unconscious. How do you choose an ending for a work? Well, Glenn, if you fall unconscious, you fall unconscious. I don't make that choice. The pieces aren't about endurance; they're about time and what happens in that given period of time. Yes, there are a few pieces that end in that manner, but they end in that manner because that's the way they end. There's no choice about stopping it before. I mean, if you talk about real time and real work and the attitude of the body being the subject and the object at the same time, what the fuck do you expect? It ends when it ends. It's not about "this is masochism" or "this is torture." This is just what the piece did. Almost everything has a time limit, whether I go unconscious or it's the end of the day. Like when I'm on display in a little glass box. The gallery closes, so the day's over. Other pieces don't end until the show is over and they throw me out, which is usually six or seven weeks. So I usually know the barrier before it even starts.

What about your piece *Jump* [1988], where you jump off the roof of a house? Did anyone witness the performance? Why did you use film and then transfer it to video, and why did you use editing and slow motion to transfer the initial performance into something specific to the moving image? *Jump* was about three things: floating out of the sky like Jesus; the "agony of defeat" footage on *ABC's Wide World of Sports*; and the Kennedy assassination. The only people who witnessed the performance were the camera crew and the next-door neighbor who thought I was trying to commit suicide and called the police. We used three Super 8 cameras and did three takes, with the cameras rotating each time. I didn't want to have a problem like I'd had before with video—that "Oh, the camera broke, you lost your master." So I had the cameras rotate around, and if a camera broke, all the other cameras still had the information, from the long shot to the short shot to the detail shot. I transferred the film to video, and then I slowed it down. I liked the piece very much. It's kind of like Jesus floating down from the sky. My big interest, though, was the way I hit the ground. Something about it reminded me of the Kennedy assassination.

How do you mentally prepare yourself for a performance? There's not that much you can do. I don't eat or drink for like fourteen hours, eighteen hours. Also, to do the work I do, you can't be on drugs. You can't suddenly be like, "Whoa, where the fuck am I?" You've got to really be aware of what you're doing. Usually, when I have an idea to do something—I can't really call them tests, but I'll try it in my studio. Like with my piece *Spin* [1994]. When I decided

I wanted to do this piece for Jack Tilton Gallery, I spun for maybe two minutes one day in my studio, and said, "Okay. I can do this. I can do this for five hours a day, for five weeks." And I knew I could. Why? I just know. Plus, I know that if I fuck up, no one's going to invite me back again anyplace. But I knew I could do it. I didn't want to try it for two hours and then get bored or understand the pain involved. Because, you know, if you know the pain, then it's like, "Oh my god, this is an awful activity, ugh. I have no interest." But this is not a big part of what I want the audience to know. The important thing is that the audience gets to see the thing without any instruction. I don't go haywire. I'm not psycho. I haven't done anything bad. You get to see an object. You get to see a subject. You get to see an object for what it is.

More than almost any other artist of your generation, your work shares a huge amount of sympathy with performance and video work from the 1970s. Could you talk about some of your major influences, and why you found it valuable to continue this line of inquiry during a time when other artists were either turning to narrative video or more theatrical performance, or else (in the midst of the market boom in the eighties) abandoning this type of work altogether in favor of traditional forms like painting? Well, I find that really funny. I'm going to answer this all backwards. I went to school as a painter. I got a degree in painting, and I had my first shows in painting. I always find everything I've done is an extension of painting. I really do. I mean, that's where I started from and this is where I am. And narrative and theatrical performance—that's theater, okay? Take that back to Yale Drama School. That's why Karen Finley is in performance. Theater couldn't deal with her and a lot of other people. But, you know, we had this effect that happened in the early eighties, like, "You don't understand, because it's performance." Fuck you. Say what something is. Drama and narrative—that's theater, traditional film, or docudrama. I don't care that so many young curators like that. That's not what my interest is. My interest has always been with what *I* can do. I've got me. I'm the central thing. I'm the theme. I'm the subject. I'm the object. I sit there in front of you and do what I have to do. I do what I want to do. I do it for you, but I do it. I grew up in the 1970s. I graduated high school in 1975. Now, it's not that I don't have sympathy for Vito Acconci, or Chris Burden, or Joan Jonas, and so on down the line. Their work did turn me on, but I'll tell you: Lydia Lunch, Patti Smith, Iggy Pop, Lou Reed, the Germs—that's the kind of stuff that really turned me on. And I'm not doing that, but that was what I dug. Saying that, I find it extremely ludicrous that narrative video and theatrical shit is called "video art." It should be called "theatrical shit" and "narrative fucking shit video." It's taken away from anything that anybody *really* does. What are we supposed to do now, find a different video medium or a different film medium? I know what I like, and I like it stripped down. It's not sympathy for something. I don't think I've relegated myself to the past. I think what I've done is I've taken these mediums and I've done something with them.

Is there anything else you'd like to add? Yeah—I feel extremely fortunate that I'm an artist. I'm very happy that the world has let me do what I want to do. Some days I'm really saddened when people want to dismiss stuff, and I can get pissed off about certain things, but I've gotten to go to China, France, the whole world, and it's a cool place. So don't get so upset. Most of you don't vote, so it doesn't really matter that much, but I think everybody should think a little bit more about what you *can* do, instead of what can't happen. Thanks for putting me in the show, and *hasta luego*.

DAVID ASKEVOLD

Born 1940, Conrad, Montana
Lives and works in Nova Scotia, Canada*

FOR FOUR DECADES, David Askevold has been gently provoking his audiences while guiding and inspiring his students. Askevold led his famous and influential Projects Class at the Nova Scotia College of Art and Design, where he taught from 1968 to 1974. He was a legendary teacher who engaged in unorthodox and reputedly notorious antics, creating a classroom setting that challenged conventional boundaries, invited experimentation, and cultivated free-ranging exploration. For example, Askevold encouraged students to collaborate and to reconsider notions of exclusive authorship. In one instance, radical at the time, prominent conceptual artists were invited to send instructions for artworks that students would execute or interpret in a form of long-distance collaboration. In 1975, Askevold agreed to leave Nova Scotia for the University of California, Irvine (UCI), where he taught video. This one-semester stint led to five years in Southern California, spent exhibiting, collaborating, and teaching at UCI, California Institute of the Arts, and Art Center College of Design.

Like an aesthetic anthropologist, Askevold drove around Los Angeles in a 1959 Herald Triumph, listening to talk radio and finding himself inspired by accounts of contemporary cultural activity of the mid-seventies—social unrest, drug use, past-life regression, hypnotism, and physical violence, including a story about a serial killer. Askevold flourished in this climate, which provided considerable raw material with which to work.

In both his teaching and his art-making practice, Askevold defines organizing principles and creates a framework or set of instructions, allowing events to unfold within them. Thus it is chance, accidents, and the unscripted activities of others that form the content of the work. The result is often an unedited, or apparently unedited, video work that captures a climate and actions within a highly proscribed, if seemingly random, situation, as seen in *John Todd and His Songs* (1976–77).

John Todd was an older student in Askevold's class who had worked in a variety of jobs, including as a librarian and a massage therapist. Like many artists—and students of Askevold's who were experimenting with this new medium—Todd created performance works for the camera, often simply talking and singing and recounting stories in a stream-of-consciousness style. To Askevold, this student embodied the characteristics of a dawning New Age culture in Los Angeles.

Despite the liberal attitudes of Askevold's classroom, the length and demanding nature of Todd's performances disrupted the class, threatening its equilibrium; the students eventually rebelled, not wanting to sit through his performances. Askevold offered his equipment and office to Todd and suggested he use both to create his video in privacy. After several months, Todd had generated considerable footage, though he remained unsure what to do with the accumulated material. Askevold suggested they each edit the footage and compare their two versions. They also agreed that Askevold could present his edited version as "editor and presenter" of Todd's footage.

Shortly thereafter, Askevold presented a video assembled by these means at the Los Angeles Institute of Contemporary Art (LAICA); the work generated a series of spirited conversations about authorship and curatorial roles. Askevold had, in a sense, substituted an artwork of his own for one by someone else, provocatively subverting the normal hierarchy and progression of the curator/artist relationship, and simultaneously taking over the authorship of the work of both the artist and the curator. While not altogether uncommon now, this quiet but powerful strategy, first championed by David Askevold thirty years ago, still retains its power to challenge our most basic assumptions about and acceptance of the status quo.

Irene Tsatsos

*David Askevold died on January 23, 2008,
just as this book was going to press.

[TRANSCRIPT and STILLS]
JOHN TODD AND HIS SONGS

lic life separate." "I don't have a private life." But—but it ends a lot of—so maybe it ends a lot of conflict there. Private and public life. We don't have either.

pp. 30–33
David Askevold, transcript (reprinted in its entirety) and selected stills from *John Todd and His Songs*, 1976–77. Single-channel video, color and black-and-white, sound; 41 min., 25 sec. LBMA/GRI (2006.M.7). Used with permission.

[*John sitting and talking in UCI TV studio with video class*]
JOHN: You don't have a private life, it would be funny if someone says, "Do you have a private life? Tell me about your private life. Don't keep your private life and your pub-

STUDENT: But it ends it in a pretty problematic way. It sort of destroys it.

JOHN: It apparently destroys the whole thing, huh?

JOHN: [singing with headphones]—night, tonight, oh yeah. It's right.

[Close-up gesture with hand]
JOHN: The challenge is there.

1ST SCENARIO: "PINOCCHIO"

[John with puppet]
JOHN: The story of Pinocchio.

[John sitting with wood and paper objects]
JOHN: And this is a leg. I don't know where this came from, but I made it by accident. And this here is a chair, okay? Have the leg support. The whale, this is a whale I made. And I'm talking like I'm on stage. And I wanted to make a chair for some reason, because in Pinocchio, in the stomach of the whale, when Pinocchio finds a life, he follows a life through the whale. He sees Geppetto sitting at a table on a chair. So I thought I'd make a chair, because that—that's—I just felt like making a chair. And then [singing] then [talking] what I came to do, the word came "authority" for the chair. When I saw the chair, I thought of

authority. And I don't know why. It just feels like authority to me. Sit me in a chair. [Singing] And—and [talking] I had a special fun in making immortality, in making immortality. These are the walls. [A piece falls] Woop. These are the walls of immortality. And then down at this end, we have—I wrote down, "stirring movement, the beginning of fire." So somehow, see, Pinocchio had to go down into the whale. Pinocchio went down and was swallowed into the whale. And there he met Geppetto. And I'm trying to figure out what that means to me. And th—that's why I made the whale. But I don't quite know what it means to me. You're going under, you know, in the water and you go into the whale. It's a scary thing, you know, the huge thing under the wh—under the water. I mean, it was really dark, you know, and he was scared. Pinocchio was really scared. And he saw a light a long way off. Because this fish was so big, it could swallow a train whole, a big train. I mean, this is a big fish. Just think, you know, I'm be—I'd be really scared, you know. I mean, really. You're way under the ocean and you've got—so, but somehow, this has a meaning. And this is like the pyramids to me. This here on the ends, on the ends. I want to make a house, because at home, I don't really have a home.

JAMES GOREMAN (classmate): How does that tie in with Pinocchio, though?

JOHN: I don't know.

JG: Or does it?

JOHN: Well, let's say [pause], let's say this: that this was a table. But all of a sudden, it turned into something else. It turned into a swirling movement. It turned into a swirling movement. The fire. And this fire, you see, some—the pyramids, something's going on underneath there that's heavy. The pyramids. Something's going on. There's something about the pyramids.

JG: Have you thought about making a cartoon out of all these thoughts—animated cartoon?

JOHN [picking up whale and moving small props around]: No, never—never animated.

JG: Because something like that, if you like the table turning into swirling motion. The legs of it. You could—you could actually do that, I mean, visually, and have it happen, instead of just talking about it.

JOHN: Yeah, yeah, well look at—

JG: Something to think about.

JOHN: Yeah. Well, all this sawdust, I want to put down all this sawdust and I just dropped it all over. And then this more swirling motion. It's like from the tail here, we have a swirling motion. And then I wanted to put wheels on it, you know? Because wheels mean something to me. Wheels mean movement. Wheels mean, you know, and I don't even know. Because it's—it won't stand up unless it's glued, you know, to be wheeled anywhere. But there's something about wheels, putting wheels on it. And then the chair of authority which keeps falling over. [Pause] So something's k——keeps going on underneath here, where there's this gathering of this—of the—of the fire here, or this whirly, this [singing] whirly [talking] coming through there. See? That's going, too, and all this stuff is swirling. And then you have the pyramids. You have these pyramids here, you know. We—we could make them somehow like a—like a house or something. [Pause] Like a house along the pyramid. And here. Now—now we've got like—like it's almost like a one-sided, you know, like a—the Indians have against the wind out in the country. You—or you go into a house that's one-sided and you pick. And the—but you've got the pyramids mainly. You've got these pyramids. And you've got—you've got—let's point these this way. Then you've got—because you've got the fi—you've got the fire and you've got the arms and legs going every which way. Let's say that's Pino—let's say that's kind of something coming through. And something's coming through here. And something's coming through. And then when you have Geppetto here. We have Geppetto here in this chair of authority. And then when, you see, Geppetto's been in the whale many years. And it's Pinocchio who takes the candle. Geppetto has kept this candle alive for many years in the stomach of the whale. I mean, many years in the bottom of the ocean. And it's Pinocchio then that takes the candle and—and leads Geppetto out of the whale, out of the mouth of the whale. The whale has asthma and has his mouth partly open and they creep out. So Pinocchio leads the way. He somehow manages to—to get this going or something here. Where he's [pause] he's got this going. Like I make an arrow, you know. Like arrows. He's got something. Or we could have this being Pinocchio. [Sings inaudibly] Then he goes up, he goes up and he sees Geppetto. And then that's it. That's as far as I go. That's as far as I feel.

END OF 1ST SCENARIO

[Cuts to TV studio]
JOHN: Yes, so how would you—?

STUDENT: You could eliminate time if it wasn't for—

[Tape skips.]

JOHN: One could eliminate time and time and space are separate. Yes, yes. Let's go on. We have time. We have physical time. We have time.

[*A track of John singing plays over the visuals*]

JOHN [singing]: One day I sat upon a tree. And wished I knew if you'd marry me. I want you to marry me. Again. No, not again, but anew. I want to marry and marry Terry. I want to marry Terry. Want to marry.

2ND SCENARIO: "STORY OF JIMMY, MARY, CAR SALESMAN, INSIDE PHARAOH'S TOMB"

[*John sitting with James Goreman*]

JOHN: We've got a tale. We've got Jimmy who goes "Zzzzz." He goes like this, "Buzzzz." And he breaks up everything on stage.

JG: Like microphones.

JOHN: Like people who always do things the same way. 'I'm right." So, and when I'm going along and if I get up every morning at 7 o' clock and brush my teeth and always walk along a certain way and always do a certain thing and always think a certain way. Well, you know, you'll…ah…always think that ah…well ah…. "I must be right," you know. "I think along this line and I never get any outside" ah…you know, in certain patterns, you

know. That then Jimmy comes along and messes up the whole works and doesn't—and does just exactly what you didn't want or—or unex—then Mary is kickies. She does "Chu—chu—chu—" wherever she's "chu—chu,"

"I'm right. I'm on the baseball team." "Bam!" "I'm kind of spoiled and I'll spend all the money I can." That's Mary. I'd like you to meet Mary. And there is the car salesman who's got the big penis. And he's got the biggest car and the biggest house. And really talk your arm and leg off and will outdo you at anything you can do.

JG: What's his name?

JOHN: Car Salesman.

JG: But no name?

JOHN: Well, Car.

JG: That's it.

JOHN: Then we have the Megalith, who is just like steel on the outside and like soft jelly, crying on the inside. That's the Megalith. Just shiny, big shiny thing. "Shu—" a slab. "Shu." But on the inside, in—in tears coming in the inside. A faucet, tears. So we have the tears. And then we have Prissy. She's another character who's inside. A person squeezing through two buildings, trying to get through the crack, the smallest space. Live in the smallest town. And with three kids. Living for them, living in a crack and living for someone else, some other kids. So that's Prissy, who's really nice on the outside, but doing what other people want and on the inside, pissed—prissed. She's prissed …prissed about it. You can see her with a big pointy nose. But she's nice. She'd never say anything to anybody. But inside of her head, everything's "Grrr." And Megalith on the outside is going, "Rrr." But on the inside he's going, "I wish I could be a part." So, we have Mary with the kickies. And we have Jimmy going along, "Brzsh."…And we have the car salesman going, "Look at my big penis and my big car." Hmmm. But the—the big penis and the big car gets things done. He's the talkative one and he's the one who gets things done. The force, the energy of getting it done. And there's Andy the teddy bear, who's always around rocking, rocking. The fur rocking. Getting pushed around by the kickies and the car salesman. So Andy and the car salesman and Mary are inside—are inside this wall. It's the wall of "me first." This big wall of slabs, heavy brick, heavy old uhm…kind of the Egyptian slab ware on side of instead of bricks, of old brick houses. But you have Egyptian wonk, wonk. And you can't move it. No way. No way you can move these Egyptian slabs.

JG: Okay.

JOHN: And they're encircled like—like in—in England you have these circles where they say the druids played. But these—this circle were Mary and Jimmy and Andy and the car salesman. The car salesman is going in—in Mary's kickie—kickie—kickie. And Jimmy's going, "Shu, shu, shu." And Andy's going, "Eummm, eumm, eumm." You press the button and he goes, "Mmm, mmm, mmm." So Jimmy starts breaking it up. He starts breaking. In other words, he—he starts bringing in light. You see these— we've had these big slabs like in a tomb. Like in Pharaoh's tomb. And they're all down in Pharaoh's tomb. And there—there's no light. And you can just go from channel to channel, from—from the tomb to where the servants

have been buried. And where there—there's maybe jew els or—or something. A ship, something. Some traveling for the Pharaoh. And this tomb and—and they see a crack Andy says, "I see a crack. I see the crack." "No crack, no crack," says Mary. And the car salesman says, "Sell it. Sell it. Sell the crack."

END OF 2ND SCENARIO

JOHN [talking about a Vito Acconci video]: You know I'm going to do you wrong. You know I'm going to do you wrong. You know, you know if you come. You know if you come to my place, I'm going to hurt you.

[*Sequence from a longer performance,* Come on in Little Spirit]

JOHN: Ah, I'm sleepy. I'm going to go to sleep. Get some rest. [Pretends to sleep] Huh. What's this I see? I see a sort of spirit. I see some spirit coming up. I like this sleep Come on, spirit. Come into my life. Come on in. You're welcome any time. Yeah.

[*Sequence from a performance mimicking chickens on UCl campus sidewalk*]

FEMALE: "Gawk."

JOHN: "Gawk, gawk, gawk, gawk, gawk."

3RD SCENARIO: JOHN SINGING ABOUT HIS CHILDHOOD

[*Blank screen*]

JOHN: And I wandered in my childhood in the snow without a friend. Eight years old, making angels in the snow without a friend. Walking in the field in the winter. Bushes without leaves. Walking in the big field, frozen field, alone. And sitting in a tree, loving the tree, and being so alone. With mom in the hospital and dad in the bar, Chuck and Mary and I and the orphanage. It was so sad. I had ringworm in my head and my head was shaved off. I was so alone, so alone. I lay in my bed so alone. Pigged out. Had to wear a stocking cap all the time on my head. A nylon cap ladies wear on my legs I wore on my bald head. It was so sad. I was so alone. I just put up a wall, turned off.

END OF 3ᴿᴰ SCENARIO

4ᵀᴴ SCENARIO: "THE PINK BALL, THE POLE, AND THE WOOD"

JOHN: There's a wholeness of a single pole. Of, of. Of just telling it. And there isn't any [tape skips]—the person and the telling of the story. Do you see? There's no separation. There's no—in other words, there's no idea. There's no ideas. There's just that's why they call it a single pole, because all of a sudden, the consciousness comes in. I'm not worried about what I think or what people think of me or worry about anything. It's just doing this. And it's just like a single pole that—that one has. And everything in the direction's going in one thing. There isn't any social worry and there's no worrying about what if people are going to hurt me if I don't do it or if I do do it. There's a—like there's a red ball or a blue ball or a green ball or a pink ball. And we can all bounce it, but we're bouncing one of them, you know? That we're always bouncing one of these, you know, we could pick up the pink ball or the blue ball, but I

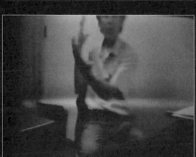

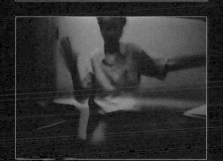

was never aware of the yellow ball. I was never aware of the gold ball. I was primarily on the—on the, say, the pink ball, see? You know? And now, now maybe I can pick up the yellow ball some, once in a while. And then I forget, because it's not really in me to bounce the yellow ball. To bounce it around, to just have fun.

[*The Song*]

JOHN: [Singing] The pink pole and the wood, playing in my tub. Playing in my tub. Playing in my tub. The pink ball. The pink ball. The wood. The wood and the pole in one direction. The pink ball, the pink ball. The pink ball. The pink ball in my tub. The pink ball, the pole in one direction. The wood. The worms crawl through the wood. And change it all to flesh. The wood is changed to flesh. The wood is changed to flesh. To flesh. To flesh. Mr. Pink Ball comes along, says hello to Mr. Wood. How's your flesh, Mr. Wood? How's your little hide, Pink? How's your pink hide, Mr. Ball, Mr. Ball? Mr. Wood, with the worms crawling all over, Mr. Wood. You look so different today, Mr. Wood. You look so different today. The wood is crawling, is moving all around. You look so different today. Mrs. Pole in the water. Mrs. Pole in the water. Hello, hello, pink ball. The wood and the pole and the little pink ball, floating in the water today. Hello, hello, Mr. Pink Ball. Mrs. Pole, Mrs. Pole, Mrs. Pole. In one direction. And the pink ball, and the pink ball, the pole and the wood. Mrs. Wood, what are you doing with your hide moving all over? You're alive. Put together with those worms crawling all over Mr. Wood. Mrs. Wood, what's your name? Are you Mr. or Mrs. Wood? Oh, you're crawling, you're crawling, oh, crawling. Changing all to flesh. Well, Mr. Wood and Mr. Pole got together in a totem pole in the Northwest of this country, where everything begins. That's the soul of America, soul of America in the totem pole in one direction, married to Mrs. Wood. And married to Mr. Pole. And the little pink ball floating in the water, the water of my pop. The top of America, top of America. That's the beginning of a song. With the mind selective, the mind, the mind. The pink ball floating in the water. Let's crawl into the little ball and go beneath the water. Let's go beneath the water in the pink ball. Mr. Wood and Mrs. Pole. Mr. Wood and Mrs. Pole, climb in the water and went in the water. Mr. Wood and Mrs. Pole climbed in the water and went beneath. What did they find beneath the water? Mr. Wood and Mrs. Pole in North America, North America, where our soul lies so open, ready to be found in North America. Ready to be found by Mr. Pole and Mrs. Wood. Mrs. Pole and Mrs. Wood in the pink ball underneath the water. They can see it all beginning. They can put it together in a log cabin. In a log cabin. In a log cabin. They go in the pink ball underneath the water. And there they seem like the fishes in the sea. Mr. Wood and Mrs. Pole in the pink ball sticking out their head underneath the water. Underneath the water of us all. Seeing the beginning, where it all began in North America, the North America. Find our roots. Find our roots. The roots of the pole. The roots of the wood. Where the life begins. Like the worms crawling over wood, crawling over pole, changing all to flesh. In the pink ball, in the pink ball. A new beginning. The worms will crawl. The worms will crawl. We found our roots. We found our roots. The roots of the pole. The roots of the wood. Roots of the wood and roots of the pole. In the pink ball we found our

beginning. We found our beginning. We found our beginning in the pink ball. In the pink ball. Mr. Wood, Mrs. Pole. All the worms are changing all to flesh. Found our soul. Found our roots. In the pink ball of North America. In the pink ball of North America. Found our roots. We found our roots in North America.

END OF 4ᵀᴴ SCENARIO

[*Credits, with David Askevold narrating over video footage shot by students in TV studio*]

DA: All of this material was filmed at the University of California, Irvine, between spring '76 and spring of 1977 by students and John Todd. During the fall of 1976, John and I talked about doing the joint projects and that I would edit one version of his production and he would edit another—so two versions would exist.

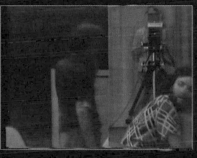

DA: An introduction to John Todd singing one song, "Pole, Pink Ball, and Wood," was shown as a video installation at LAICA in January, end of February 1977. John left during the spring of 1977 and rumors have it that he went to Pennsylvania to search out a Quaker group.

Post Production
A.P.P.S.
Long Beach Museum of Art

JOHN BALDESSARI

Born 1931, National City, California
Lives and works in Santa Monica, California

JOHN BALDESSARI'S *I Will Not Make Any More Boring Art* (1971) serves as an apt introduction to the process of art-making in the age of video. Appearing just a few years after video recording technology hit the consumer market, *I Will Not Make Any More Boring Art* simultaneously sets a goal and shrewdly explores how the new medium might be used to achieve that goal.

Contemporaries such as Bruce Nauman and William Wegman used video to examine deadpan performance, duration, and repetition; Baldessari takes these ideas and frames them as the classic schoolroom punishment—repeating the title phrase over and over again on a sheet of notebook paper for the half-hour duration of a reel of tape. This action cleverly illuminates one potent axiom of video art (and a mainstay of the looming media culture that video would soon create)—that doing something silly and boring can be incredibly interesting and important once it finds its way onto a television screen.

It appears that Baldessari's "punishment" achieved its goal; his work in the 1970s can be characterized as a continued exploration of the mandate to "not make boring art." Just one year prior to shooting the piece, Baldessari had infamously burned all of his paintings—a mock cremation designed to "clean house" of older notions of art practice. He went on to employ various methods to pull apart conventional ideas of what constituted "art." One tactic in this enterprise was to sabotage his artistic ego through collaboration with others, as he does in the photo series *Choosing (A Game for Two Players)* (1972), in which he employed the decisions of an outsider to undercut the notion of a singular aesthetic eye. Similarly, in *Ed Henderson Suggests Sound Tracks for Photographs* (1974), Baldessari orchestrates a game wherein his student Ed Henderson blindly selects musical accompaniment for stock imagery that the artist describes to him. As viewers, we witness only the stock image, while hearing Baldessari's description and Henderson's choices in a "best of three tries" scenario. What results is a work of video art that explores the successes and failures of the intersection of language, music, melodrama, and visual information. Ultimately, Baldessari shows us video's immediate and often sloppy ability to "report," used to deconstruct the hyper-controlled and aestheticized way that film "presents" images to the viewer. Film, like the bushel of paintings he had previously burned, is another authoritative model of artistic production that Baldessari found he could make less "boring."

Jonathan Furmanski

Interview conducted by Carole Ann Klonarides on March 16, 2007, at John Baldessari's home in Santa Monica, California

CAK: How did you get involved with video?
JOHN BALDESSARI: I got involved because it was there when CalArts [California Institute of the Arts] started. I think they had twenty-five or twenty-six Portapaks.

What was the atmosphere like at CalArts back then? I remember at the time I thought it was complete chaos. But in looking back, it wasn't. I'd come from the university atmosphere at UCSD [University of California, San Diego], where there's a curriculum and grades, etcetera. At CalArts, there was no curriculum, no grades. Students only went to classes if they felt like they wanted to go. You couldn't use the grades as punishment. And there wasn't a sequence of courses, so you could go or not go. The MFA students were pretty much on their own. The whole idea when I started this Post–Studio Art class was that I didn't feel the students needed to work in a classroom, because they could do their work anywhere, whatever they wanted. So the classes pretty much were just crits and visiting artists, and sometimes we'd help each other doing work.

Nam June Paik and Allan Kaprow were also teaching at CalArts during this period. What was it like having them as colleagues? I think there got to be two ways of doing video. Nam June was an engineer, and his way was tinkering and fucking things up. It was about the technology. And then Allan Kaprow and I were pretty much about using video as a tool to document something. And both turned out to be very important ways of dealing with video.

Did you actually teach video and have your students do it? What's to teach? You just have to work the on and off switch and learn how to load the reel. I believed then and I believe now that

you can't teach art. What I've said is that you can set up a situation where it might occur. I thought the closest you could get to that would be a situation where students get to actually hear, and talk with, experienced working artists. Otherwise, artists were something remote, in museums or books or magazines. But they actually had to see that art was done by humans, who were often quite fallible. So, every week I had a visitor. I pretty much sidestepped L.A., because I felt they had their own aesthetic there. I brought in a lot of artists from New York and Europe, and then students would organize shows with those artists. There was a little room upstairs, and some of my students said, "Can we make a gallery out of that?" And I said, "Fine." I got some money together for postage and sent out announcements. So every time we had an artist there, like Daniel Buren or Dan Graham or Vito Acconci,

they would do a show. And for a lot of them, it was the first show they ever had in L.A. or California. People would ask me in Europe, "What is this gallery A402?," and I said, "Well, that's a classroom."

How funny. So it was very good, and it was good for the students. I'll give you an example. I had Richard Prince there, before his ascendancy, and afterward a student came up to me and said, "Why is it that what an artist says and what I read about the artist is always different?" And I said, "Well, you know, writers have an agenda, and they're using the artist for a reason related to what they're writing about. And you've seen that person's work through that writer's eyes." So you can see right there the value of hearing the artist, what the artist has to say.

But Richard Prince would say that a good artist is always a liar, a con man, and a cheat. Well, okay. But at least you know that, then. Some artists would be incredibly articulate, like Vito Acconci. And then with other artists, like Don Judd or Ed Ruscha, it was all "Yep, no, well, whatever," you know. Sol LeWitt would not come to campus, because he was that much against art education. There was a local bar we all went to called the Irish Harp, so we just met there and he talked with the students.

I Am Making Art **[1971] is one of the tapes that everybody always uses when they want to give an example of early video. You go through a series of gestures, and each time you make a gesture, you say, "I am making art." What were you trying to get at in that work?** I wanted my students to get to the core of what art was or might be, and to question received wisdom. That's the way I ran my crits, you know, to get rid of all the clichés about art and to try to get to something fundamental, almost like Descartes trying to get back to some elemental sort of idea. So I guess if I just make a gesture, that's enough. It's enough for me, at least; we don't know what's enough for a spectator or an audience, but certainly it qualifies for art. So I just thought I would go on and do that ad infinitum. And each time I would say, "I am making art." This was about the same time as Donald Judd's statement about "If an artist says it's art, it's art." So each time, I was saying it was art.

Around the same time, you made a tape called *I Will Not Make Any More Boring Art* [1971]. My students always groan when I make them sit through the entire tape. I would groan, too.

But they're always glad afterward. Could you tell me how that piece came about? The video just consists of me writing out that phrase, "I will not make any more boring art," over and over again. That was an outcome of a show I'd done at the Nova Scotia College of Art and Design in Halifax. They had a similar program to CalArts, and I was the first CalArts person they had up there. Later on, they asked if I would do a show, but I had no money to travel, of course, so it had to be something I mailed in. I used to keep notebooks of ideas, and one of the things I had written down was "I Will Not Make Any More Boring Art." I think I had written that in response to my colleagues. I was interested in language, but not using it in an academic way. So I sent instructions that any student who wanted to could write that phrase over and over again on the gallery wall. It's like the punishment you used to get in grade school, "I will not throw rocks on the playground," or whatever. I thought it would just be an exercise in futility, but all the walls were filled. I guess a lot of students felt guilty about it all, and this was an outlet for them. And then they asked if they could use it as a print to raise money, and I let them. Then I thought I would do it as a video, because that would *really* be boring.

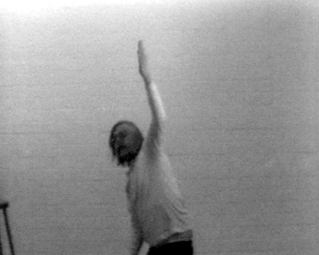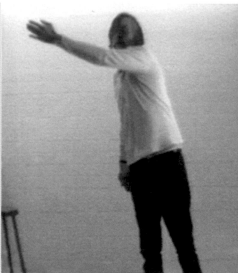

What qualities did you find particular to video as opposed to film? It has a certain look, of course, that was different than film. We'd play it on a television monitor, so it had that familiarity. You wouldn't need to set up a movie projector and screen, so it seemed very ordinary. Most of the work from that time was done in real time, because editing was just too expensive, so one edited in the camera. I remember this great comment Bill Wegman made: "You can always tell videos from that period, because at the end of the tape, the artist gets up to shut off the camera."

I think the way I was approaching video was like using Polaroid. You didn't have to rack up a lot of cost to do it, and I think you could be a little bit more spontaneous, a little bit more experimental. By that time, I had been teaching at UCSD [University of California, San Diego], where they had a great music department, and CalArts had a great music department. So I was also getting more concerned with structuring and doing art in time. I was doing film, video, and photography at that time, and I think that, in a kind of Greenbergian manner, I was trying to figure out in my own mind what the properties of all three mediums were. I've said this someplace before, but the results were that I began to do sequential photography, and my film and video began to look like still photographs.

Now, wasn't Ed Henderson one of your students? Yes.

Tell me about the tapes you made with Ed. I did several with him. He was unique in respect to his vivid imagination. He could endlessly talk about anything, and he was a good artist. He actually ended up working as a printer at Gemini G.E.L. [an artists' workshop and publisher in Los Angeles], working a lot with Jasper Johns. Jasper Johns liked him so much, he hired him to go back East and be his own printer there. He had this very active imagination, so I decided to use him like a material. We did several tapes: there was one where he looked at found photography. There was

another one where he looked at images from a newspaper. In *Ed Henderson Suggests Sound Tracks for Photographs* [1974], we're trying to match up sound effects to images. He's asked to imagine what the photograph is about, and try to match up some music to an image. And he's absolutely sure of himself, which I love. We had three passes on three different kinds of music, and then he would decide the best marriage. But he would never see the image. I would just describe it to him.

What was your interest in popular music and sound? You also did a work, *Baldessari Sings LeWitt* [1972], where you turned a LeWitt essay into songs. Sol LeWitt's *Sentences on Conceptual Art* [1969] was a very famous bit of writing in the history of conceptual art. He wrote thirty-five statements about what he was doing or how he understood conceptual art, and I just set each one of them to some popular tune and sang it. I was trying to take conceptual art off of its pedestal, so to speak. I wanted to use language in a different way. Sol was an old friend, and I was gently making fun of making pronouncements. A lot of albums at that time would say "so-and-so sings so-and-so." So I said, "Well, I'll sing LeWitt."

You've always used humor in your work. You know, I don't think I purposely do that. Someone like William Wegman purposely uses humor, in my mind. I'm just going at things in the kind of way that I see the world, which might be slightly askew. I remember reading about this painting instructor—this is when students had easels and painted away—and he asked his students to stand on one leg when they were painting, because that would set their thinking off balance. Now, that sounds funny to us, doesn't it? But it didn't to him. You see what I'm getting at? Think about all the things your mom always wanted you to do. They were funny, right?

Painfully funny. But *she* didn't think they were funny.

pp. 36–37
John Baldessari, stills from *I Am Making Art*, 1971. Single-channel video, black-and-white, sound; 18 min., 46 sec. LBMA/GRI (2006.M.7).

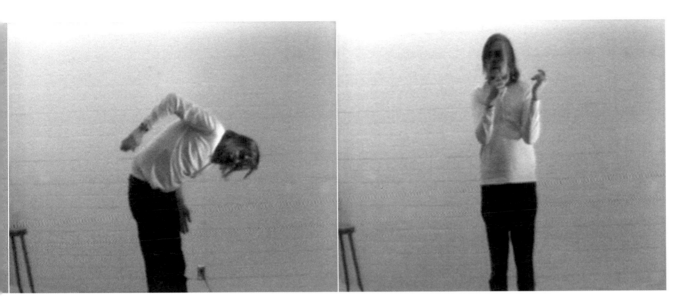

The ideas seem to be so specific in video, and so different from ideas in the other work, and that's why I'm interested in what you think video promoted. I think video allows this freedom where you can work in time—which, if you're painting or drawing, you really can't. And, in some way, you could look at it like a talking photograph, maybe. A photograph's always the idea of the decisive moment, right? If you have a whole lot of decisive moments, then it becomes a film or video, doesn't it? I think it gets interesting to compare video and film, because back then film would very much be about gluing bits of film together. But at CalArts, only if you were in the film and video department could you do editing, unless you could soft talk your way into it. I did my first color video at CalArts, but I had to pull rank and everything just to get in and do about thirty minutes of color video.

Who were the tapes shown to back then? To each other.

Did you just have people come over and look in the studio? Yeah.

Did galleries support them? Oh, no, no, no. At a certain point, Castelli Gallery decided to rent out artists' videos. But that came a little later.

You were exhibiting other works in New York pretty early on, though. My first show in New York was with Richard Feigen. In the late sixties, I just took my slides and went around and knocked on doors at galleries in New York. People laughed at me—"What the hell, what's this about?" On my very last day, I went into Feigen Gallery. I didn't know one gallery from another—I just used a gallery guide. There was a young guy there, and he was actually interested in what I was doing. I had these text and photo pieces. He had put on a show of artists that used words in their art, like Picasso and Braque, and the most recent, I think, was Lichtenstein. And he said, "I would have liked to have had one of your works." I

was just knocked out. But that was just it, interest. Then he said, "There's this downtown area called Soho and we have a warehouse down there, and if we could have a few of your works to show clients...." I had nothing else going on, so I said, "Why not?" And then they decided they would do shows there. They were the second gallery in Soho after the Paula Cooper Gallery. They were on Greene Street, as I remember. So I showed those pieces. They didn't have openings or anything, but I wanted to come in to see the show. It was one of the biggest thrills of my life, and still is: I walked in, and there's Jasper Johns looking at my work; there's Harold Rosenberg looking at my work. I said, "Well, life doesn't get better than this." So that was my first show.

Did you introduce yourself? Oh, come on. I was scared to death.

You urged your students to go East as well. I always advised my students to go. I said, "If you're really serious about art, don't hang around L.A. Go to New York." And a lot of them did. Then, after a few years, you began to hear this term "The CalArts Mafia." You know the rest. But it was very rare back then to have any artists from L.A. or California showing in New York. And a lot of it was just about resentment—that we were lotus-eaters, and they had to suffer through the winter and we didn't, and L.A. artists are just playing, and blah-blah-blah. I remember reading a review of a Billy Al Bengston show in New York, and he was trashed, just trashed. It was really brutal. I was one of the first L.A. artists showing in New York, along with Ed Kienholz and Bruce Nauman. It wasn't easy. And I remember—I won't name a name here—but a very well-known conceptual artist said to my face, "We've already divided up the pie and there's nothing for you." And I thought in my mind: "We'll see."

ENID BAXTER BLADER

Born 1974, Yardley, Pennsylvania
Lives and works in Aptos, California

THE WORK OF ENID BAXTER BLADER consistently reveals her interest in the quirky distinctions of the lives of those around her—of who they see, where they live, what they do, the stories they recount—along with an appreciation of the subtle beauty of the mundane. Made on a "Frankenstein" camera cobbled together from parts of obsolete seventies-era equipment, *The Secret Apocalyptic Love Diaries* (2003–ongoing) is an ongoing episodic tale shot in grainy black-and-white video, a fitting representation of the hazy memories and prosaic stories it recounts.

The Secret Apocalyptic Love Diaries consists of vignettes that document blinding lightning storms, violent rainfalls, and other radical, dramatic forces of nature, which are interspersed between narrative snippets that capture accidental, unscripted exchanges between friends and couples. From these vulnerable moments an intimate portrait emerges, one that depicts stumbling friendships and romantic relationships, which start up and inevitably turn disappointing. The sense of vulnerability is enhanced by the video's music, which was largely composed and performed by Baxter Blader, who is an accomplished singer, banjo player, and bluegrass musician.

Sweet and tender, and awed by the ability of others to inspire and astonish, *The Secret Apocalyptic Love Diaries* portends an inevitable, inexorable disappointment even in the most optimistic moments, such as the earliest days of a budding relationship. Its characters are vulnerable to forces of nature—both external or internal; to the affections and whims of others; to a driving rain that extinguishes one's cigarette; to the unsettling presence of a lover's former lover. From a howling dog accompanying a blues musician's plaintive harmonica, to a group of bored friends standing around drinking while casually playing with power tools, to floodwaters pouring over a country road, the quiet melancholy in *The Secret Apocalyptic Love Diaries* is as palpable as dark billows of smoke filling up a big clear sky.

Despite this melancholy, however, the diary's author persists in telling her story, and that of those around her. Embedded within the video is a determined hope and belief that it is precisely these disappointments, these "small-time," secret apocalypses, which keep us churning forward, searching for what is next.

Irene Tsatsos

pp. 38–41
Enid Baxter Blader, storyboards and sketches on paper, 2007, and stills from the following videos: *The Secret Apocalyptic Love Diaries*, 2003–ongoing; *Radio Nowhere*, 2002; *Letter from the Girl, Mailed at the Gas Station*, 2002; *Local 909er*, 2007; and *Lucille*, 2003.

STEPHEN BECK

Born 1950, Chicago, Illinois
Lives and works in Berkeley, California

STEPHEN BECK is one of the earliest innovators in video art. He continues to develop ingenious ways of sculpting light to create imagery that pushes the plasticity of the medium far beyond what was thought to be possible. From an early age, Beck had a desire to replicate the colors and forms of phosphene—or "closed eye"—vision, which led him to invent technological solutions for developing time-based abstractions and nonobjective imagery. Beck's interest in music, art, and technology began in the late 1960s, and he was a founding member of the Chicago chapter of Experiments in Art and Technology (E.A.T.) in 1968.

Initially studying electrical engineering at the University of Illinois at Urbana–Champaign, Beck fell easily into the Bay Area experimental scene. He transferred to the University of California, Berkeley (UC Berkeley), in 1970, in order to become artist-in-residence at San Francisco's National Center for Experiments in Television (NCET) while still an undergraduate. This gave him access to cutting-edge equipment and the ability to develop his ideas. NCET—a part of KQED TV that operated from 1967 until 1975—aimed to develop a research lab for a multidisciplinary group of artists to explore the relatively new medium of television. Beck describes the scene at NCET as a "video Bauhaus," with poets, dancers, musicians, filmmakers, and theorists working together in a creative environment. With NCET as a model, Beck collaborated in setting up other experimental TV research centers throughout the country, exploring new modes of expression and alternative visual languages.

During his time at NCET, Beck further developed the Beck Direct Video Synthesizer he had started in 1969, which was designed as a constructivist approach to generating real-time, kinetic color video made by using the basic visual elements of form, shape, color, texture, and motion. The first of its kind, this camera-less instrument synthesized color video electronically, much like the Moog synthesizer worked on music. Working to rewire the television circuits, Beck created a system that could create abstract color video imagery in real time. Using the television as his canvas to create kinetic abstractions, Beck is a pioneer whose musical background influences his sculptural composition of the image.

Illuminated Music, a series of live improvised performances featuring the Beck Direct Video Synthesizer, was shown across the United States on large-screen video projectors, and as a live broadcast on KQED in 1972. According to Beck, the TV broadcast of this colorful, fluidly scored, "visual jazz" piece prompted a flurry of calls to the local TV station, with one viewer even complaining that the show had "broken his television."

Beck continues to work with these designs, recently outputting his digital video weavings and other images onto canvases, reworking and discovering new patterns and designs that were locked within the moving matrix.

Rani Singh

Interview conducted by Glenn Phillips on March 23, 2007, at Casa Beck Studios in Berkeley, California

GP: How did you wind up in California?

STEPHEN BECK: Well, I wanted to be here, and I had a lucky opportunity. I was attending the University of Illinois at Urbana–Champaign in the 1960s, and clearly California, and particularly San Francisco, was the center of an American cultural renaissance. I saw what was going on out here, and I had to figure out how to get here. I was working my way through a degree in electrical engineering and electronic music by working in the Electronic Music Studio at the university. That was the second electronic music studio in the country, and I was lucky enough to work with Lejaren Hiller, Sol Martirano, John Cage, Herbert Brün, and James Beauchamp. We got the second Moog music synthesizer that came out. And while I'm a musician, I was thinking about a way of synthesizing visual images with light, because for as long as I can remember, whenever I close my eyes, I see colors, shapes, forms, and swirling movements of textures, which I later learned are called *phosphenes*, which represent the whole class of images that you see with your eyes closed—inner, internal images. I wanted to make those kinds of images.

Technology was rapidly advancing in this analog era. Color television had just come out, and I loved the color of color television, because I love emitted light. We also had technology going into space. There was a man on the moon and all this great, positive, outreaching, consciousness-expanding use of technology. Unfortunately, there was also a terrible war, the war in Vietnam, where some of the same technology was being used in very destructive ways. So I wanted to make something beautiful with the technology, and to show the technology in a way that was inspiring. This is part of what led me to the concept of the Beck Direct Video Synthesizer. If Moog could synthesize music electronically, I figured that I could synthesize color video electronically. I obtained the donation of a color television from Zenith in Chicago in 1969, which I then opened up and rewired so that I could access the red/green/blue video circuits, as well as the horizontal and vertical sync circuits. And then I built this little box that I still have today. I call it DVI-0, Direct Video Instrument Zero, which I could then connect to that prepared television and feed in audio signals as well as a controlled voltage signal, and work with three channels of red/green/blue colorizing to create the first synthesized images. I started to write letters to television networks and television companies about this exciting new concept. The only answer I got was from a gentleman at PBS in Washington, D.C., who told me, "Oh, you should go talk to the people at the National Center for Experiments in Television [NCET] in San Francisco." When I came out to San Francisco on my spring break in 1970, I went to NCET, and I was expecting to walk into this high-tech lab with all this fancy electronic video equipment. But, no—it was in an alley off of Third Street, around the corner from the KQED studios on Fourth Street, behind the *Rolling Stone* magazine office. There was a very kindly man named Brice Howard, who was the director. So I met with Brice and other people there, and they loved what I was doing. When I got back to Illinois a week later, I got a phone call from Brice saying, "We'd like you to come and be a

video artist-in-residence." What an opportunity for a kid. I was twenty years old, and by that summer, I had arranged to transfer out of the University of Illinois, come to California, re-enroll at the University of California, Berkeley, and begin working as an artist-in-residence at NCET. Brice described what I was doing as "direct video synthesis," because I was synthesizing video directly, without the use of cameras.

You have to remember that, at this time, all a computer could do was draw a monochrome dot on an oscilloscope screen, or maybe a line, and if you wanted to do anything with computer graphics in dynamic kinetic cinematic fashion, you had to use a film camera and do stop-action animation, one frame at a time. It could take even a fairly hefty IBM-1170 tens of minutes to an hour just to compute the position of one thousand dots. What I wanted was real-time, lush, rich color interpreted through manual play on a keyboardlike device, and that's what I set out to build. In the course of that next year, I built the full Beck Direct Video Synthesizer. At NCET, I had access to videotape, which I never had before, so I started to expand from a performance mode to a compositional mode where I could record what I was doing.

What was it like at NCET? Who were the other artists-in-residence there? What were the other types of activities that people were doing and making? I would describe NCET as a video Bauhaus, in the sense that it was very multidisciplinary. There were artists there, composers, musicians, filmmakers, dancers, and poets. It was part of KQED-TV, but it was sort of off in the corner, out of the influence and control of the broadcast union, which had very strict controls over who could touch equipment, because the equipment was very expensive, two-inch Quad broadcast-standard equipment. NCET had little one-inch Ampex VTRs, and half-inch 7800 Portapaks, and Sony AV-5000s, and, later, U-matics. And the idea was that the artists could get their hands right on the equipment. Richard Felciano, who is a very talented and well-known contemporary musician and composer, was there, and Willard Rosenquist, who was a professor of design at UC Berkeley. He was working with things called "light forms," where he would reflect light on curved mirrors, somewhat reminiscent of the work of Thomas Wilfred and his Lumias. There were poets, and there was a stream of visiting artists that came through over the years. For instance, James Rosenquist, the painter, came in. Warner Jepson was another musician who was there, and he and I collaborated on later versions of the *Illuminated Music* performances. Don Hallock came in, and Steina and Woody Vasulka, and Bill Etra and scholars like Rudolph Arnheim. I was very fortunate to be able to associate with these scholars and other artists. A number of people came in to see what we were doing and get ideas and stimulation. Lots of producers from all the PBS stations came in, and they were exposed to the theoretical concepts of Brice Howard, who coined another word, *Videospace*, and wrote a couple of books about his theories. The whole idea of the center was to expand television beyond what it was. We were very lucky that we got work on the air. We had programs that were nationally broadcast on PBS, like the *Videospace Electronic Notebooks*, or, in my case, getting to perform *Illuminated Music* live on the air in 1972, where I actually had direct control of the 50,000-watt transmitter from my Beck Direct Video

p. 43
Stephen Beck, stills from *Union,* 1975. Single-channel electronic videofilm, color, sound; 9 min. Courtesy of Stephen Beck.

Synthesizer. I performed that piece live on the air to the music of Yusef Lateef, with the broadcast engineering union ready to throw the switch and cut me off if I slightly exceeded the legal limits of colorations. That was an exciting moment, because the KQED people told me that the switchboard lit up like a Christmas tree once my images started broadcasting. People were calling in, going, "What is this? It's great! When will it be on again?" The call I liked the best was the guy that called in and said, "You broke my television!" We also toured the country and set up other experimental TV research centers in places like Southern Methodist University in Dallas, Texas; the Rhode Island School of Design; University of Washington, Seattle; and Southern Illinois University. A lot of this work was done with the support of Howard Klein, the arts director at the Rockefeller Foundation and, again, it was to freely spread the word and the ideas around. But if there were anything that felt like a Bauhaus might have felt, I think it was NCET, in terms of this multidisciplinary mix of talents and artists.

What did composition mean for you? When you don't have a camera, how do you compose an image? Maybe you could describe what the Beck Direct Video Synthesizer could do, how you could affect the image, and what types of images you were trying to compose. I developed this model of controlling four basic visual elements, with color being the fundamental ingredient, form and shape being a second category, texture being a third, and then motion or time variance being the fourth. This was probably one of the last analog computers, although it actually had some digital circuitry in it, so it was a hybrid analog/digital video computer that was based on these four visual ingredients. I had colorizers that I could control in red, green, and blue color space, including negative color. I invented negative color. I had voltage-to-position converters that could convert voltages into geometric positions on the screen, and extend them into linear and planar elements. I had texturizers that could create shaded and gradient effects. So that was the premise. Having studied musical composition, I had a sense of composing something in time. In this case, it's photons and colors. It was what I saw with my eyes closed.

I used to be bothered by having people ask, "How do you do this?" "What did you do?" It was interesting that, as I started to travel around and show my work, European audiences and audiences from Japan would always ask, "What does that mean?" but in America, it was always, "How did you do that?" Which was kind of funny, because I really wasn't that interested in how I did it. Believe me, if I could have found an easier way than soldering over one hundred thousand electrical devices together to get these images, I would have done it. So I had to go through a lot of sweat to get to where I could produce these real-time images and play them.

With *Illuminated Music*, the piece that was broadcast live on KQED, there was a score that I drew and I practiced. I had definite conceptual moves in mind that I would make, but, like a jazz musician, I had interpretive flexibility as I played it and performed it. And if you look at the series of *Illuminated Music* performances, of which six were actually recorded, you'll see there's a common theme and a common thread, and yet every one is different. So early on, I was a constructivist in my approach to video synthesis in that I have these four elements. Of course, I later added a camera-processing module, because there were a lot of exciting images that I could capture from optical events and also from dancers. So the ultimate issue for composition was the complexities I wanted to achieve. If you look at the latest state-of-the-art and high-resolution computer graphic animation today, none of that's real-time. Their render farms take hours. The precision is amazing and, of course, they know what they're going to get ahead of time, but I was never that patient. I wanted my cake and I wanted it now. At that point in time, 1972, '73, '74, nothing like that existed, and the only way to get the complexity of composition and the precision of timing was to record ahead of time onto videotape and/or 16mm film and do tightly controlled editing.

In a work like *Video Weavings*, your compositions became much more geometric and symmetrical. *Video Weavings* [1974] is purely about numerical color relationships and fanciful visual designs, really growing out of my attempt to answer the question people were asking about, "How do you do that?" People had no clue as to how television worked, how video worked, and the fact that there is a scanning of a horizontal electron beam and vertical scanning and so on. I was trying to come up with a metaphor to help make that association, and I realized that the way the video image is constructed has a relation to textiles. I got this idea about "Okay, if I tell people that the video screen is like a weaving, and that I'm weaving imagery on it with my synthesizer, maybe that's a good answer to 'how do you do this?'" A lady friend gave me a small loom, and I tried to weave. I set up the warps, got the shuttle going with the weft, got about three inches into it, and went, "Ack! I can't do this." It was just too frustrating. But I can do this in video. I can construct counter sequences that are associated with colors, related through Magic Square numerical patterns, which I'd been fascinated by for years. I kind of assimilated all of this and, in 1973,

came up with the concept of using 74193 logic four-bit cascaded up/down counters, because, at that time, TTL—transistor, transistor, logic—integrated circuits were starting to become available. It was a form of a digital circuit. You could buy them for a few dollars, and you could wire them together. I'd reached the fruition of the analog portion of the Beck Direct Video Synthesizer, at least to a satisfactory level, and I thought it was time to explore what I could do with digital imagery. I conceived of this video weaver as working with the warp and weft, the horizontal and vertical, through these cast-coated four-bit counters triggered by numerical sequences fed into the colorizers of the Beck Direct Video Synthesizer, where I could colorize those bit combinations, and then, voilà! All of these numerical relationships would generate different patterns, and what comes out is traditional-looking weaving patterns. So the patterns and the designs in *Video Weavings* resonate with the whole history and lineage of textile and fabric. There is one particular *Video Weavings* video that has been relatively well known. There are a lot more that have never been published, and recently, I've started transferring and painting video weaving frames onto canvases, and I'm seeing whole new levels to the imagery that I never saw before, because now I'm going back to reflected light. I'm using chromatic dye on canvas, so it's like a painting. There's a minutiae to the digital stitching that you never really see in the video, because it's scanning the subcarrier phases out of lock with the horizontal. It's exciting to repurpose images into another medium and make these new discoveries.

Could you talk about some of the ways that *Video Weavings* has been shown, because it's not just been shown on television monitors. It was first exhibited at the San Francisco Museum of Modern Art in 1974, right after its invention. It was broadcast on PBS in 1976 as part of the *Video Visionary* series on WNET, and it was shown in an exhibition at the Museum of Contemporary Art in Tokyo in 1978. In Tokyo, some executives at Mitsubishi Electric saw it. They saw the diamond chevron patterns and got very excited, because they had just invented and were manufacturing something called Diamond Vision—the first giant video screen based on plasma gas discharge tubes, which were about an inch or two in diameter. The first one they sold in the United States was to the New York Mets baseball team at Shea Stadium. They wanted to show *Video Weavings* at Shea Stadium on their Diamond Vision, so for that whole season in 1982, they showed *Video Weavings* whenever they weren't showing anything else up there. Now it is showing on large-scale LED video screens powered by biodiesel.

You were also involved with *The Videola*. I've done a lot of work with reflection and mirrors in my videos, such as a recent series

of TV kaleidoscopes. One night, when I was working at NCET in early 1972, I put the color video monitor right on the floor to try and experiment with a new relationship to the video. I had a mirror that I put right in front of the video monitor, so I was getting a single reflection of that single monitor. I realized that I could use mirrors to achieve huge numbers of virtual monitors. The next day, when I came back, one of the other artists working at NCET, Don Hallock, had put three other mirrors around it, and he'd sort of taken that concept that I left that night and extended it into a four-way set of mirrors and everyone was, like, "Whoa, this is amazing," because you had this reflective, kaleidoscopic experience. That got a lot of excitement, and there was a commission to make a really big version of *The Videola* with these mirrors that would take a twenty-seven-inch Conrac, which was probably the best color video monitor that we had at NCET, and turn it into this sphere that appeared to be something like eight feet in diameter. Don, who's an incredible craftsman and artist, built this amazing rigging of wood to hold the mirrors. The San Francisco Museum of Modern Art included *The Videola* in their first video art show in 1973. We had thousands of people come in, and we had a combination of live performances where I would bring the Beck Direct Video Synthesizer in, and other artists made specific videotape compositions for *The Videola*.

By 1975, funding for NCET was running out. These grant-sponsored projects don't last forever. Rockefeller, Ford Foundation, PBS, a change of administration in Washington and the NEA [National Endowment for the Arts]—the funds were gone, and there was nothing to sustain it. Basically, NCET just kind of faded into history. All the materials were left in a studio at KQED, and they threw them away. They threw them out into dumpsters. I was able to rescue the essence of *The Videola*, which are the key mirror pieces. I have those in my archival storage. I'd love to find a home for *The Videola*, meaning the original mirrors. Now here's the question: if you put this up today, will you still get a sphere—because the Conrac was the old-fashioned cathode-ray tube with the spherical surface—if you don't use a spherical tube? And I can tell you that, indeed, you will get something very interesting.

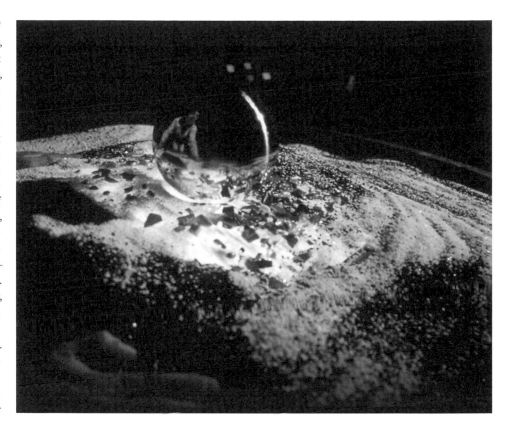

p. 44
Stephen Beck, stills from *Video Weavings*, 1974. Single-channel video, color, sound; 8 min., 30 sec. Courtesy of Stephen Beck.

p. 45 top
Stephen Beck, *Atmospheres*, 1991. Ambient video sculpture: color video cathode-ray tube, garnet crystals, silicon, sand, pebbles, reflecting sphere, with music composed and performed by Stephen Beck; 91.4 × 76.2 cm (36 × 30 in.). Installation view at ARTEC, Nagoya, Japan, 1991. Courtesy of Stephen Beck.

p. 45 bottom
Stephen Beck, still from a live broadcast of *Illuminated Music*, 1972. Single-channel video, color, sound; 7 min., 22 sec. Courtesy of Stephen Beck.

CATHY BEGIEN

Born in Toa Payoh, Singapore, 1975
Lives and works in San Francisco, California

IN THE VIDEO *Interview with the Hopeless and the Life Story of the Romantic* (2006), Cathy Begien generalizes her life in a schematic outline: "My dad's from Virginia. My mom's from Vietnam. I was born in Singapore. I lived in Saudi Arabia. My mom and I went back to California when I was eight and that was the last time I saw my dad, until he died a few years ago. I have a stepfather I don't speak to. I went to school in Santa Cruz, and after school I moved to San Francisco." Ironically, and unlike the typically distant and general first-date "interview" introduction, Begien's is effortlessly and unreservedly raw. As *Interview* progresses, the viewer is taken from a scene of Begien and actress Sarah Enid complaining about the woes of dating and thrown into the sentimental moments of love, anticipation, self-doubt, and many more heart-wrenching, yet wonderful, emotions that go along with dating.

Cathy Begien's tender, tête-à-tête vignettes are cinematic explorations whose thematic structures are heavily based on romance, identity, relationship, and sexuality. Her playful and candid personality contributes to confidently penned story lines in which the artist stars as herself. Begien, who is part of a constituent of emerging San Francisco filmmakers and artists (and regular participants at the Edinburgh Castle Film Night's public bar screenings), incorporates the city's landscape, her friends, and her life into her videos. In *My Favorites* (2004), the artist sits at her kitchen table with a bowl of Special K, Vitasoy soymilk, and a sliced banana, the city's skyline reflected in her glass cereal bowl. After eating breakfast, she walks from one establishment to another, consuming her favorite foods—"favorites" seems not only to be referencing foods but also the whole experience of living in the city.

This autobiographical view flows throughout the body of her work. In *Relative Distance* (2005), a split screen depicts Begien on one side and her family members on the other, with each person given two minutes to say whatever he or she wants about Begien. On the left, an aloof Begien performs various routine activities (working out, cleaning her shoes, and so on), while her family expresses love, concern, well wishes, and a longing to be closer. Begien, who also allows herself two minutes to say something, lectures: "Sometimes, I don't even understand you myself … you've got a great family … and they all really love you … and all they want is to know you more, and see you more … so why is it that every time you're around them you're such a brat?" Her monotone delivery bespeaks waves of emotion and imparts her own frustration with the age-old question: Why do we do the things we do?

Black Out (2004) recounts hazy recollections of a night of dining, drinking, partying, and club hopping, a social drama dutifully chronicled by Begien and a cast of mostly truncated friends. She sits in front of the camera, blindfolded, consuming (and spilling) beer after beer, cigarette after cigarette, and cocktail after cocktail. She remains seated as the events unfold around her, emphasizing her passive participation in the evening. The piece culminates with a touching moment between friends, and, like Begien, the viewer is left somewhere in between laughing and crying—a discernable sensibility inherent in her work.

Chloë Flores

p. 46
Cathy Begien, notes for *Black Out* (2004; single-channel video, color, sound; 5 min., 16 sec.), December 8, 2004. Ink on paper, 19.5 × 12.5 cm (7¾ × 5 in.).

pp. 47–49
Cathy Begien, transcript (reprinted in its entirety) and selected stills from *Black Out*, 2004. Single-channel video, color, sound; 5 min., 16 sec.

BLACK OUT

BLACK OUT

I don't really remember what happened
 last night

I know me and Jose went and had dinner
 with some friends

We went out for sushi and sake, but I
 didn't really drink that much

Everyone else was drinking

They were doing sake bombs and
 drinking beers

Anyway, we got this phone call about
 some party

I think it was a surprise party

I forget where it was, but

I don't even know who the girl was

But we showed up there and waited
 around for this girl to show up

And then it was like, Surprise!

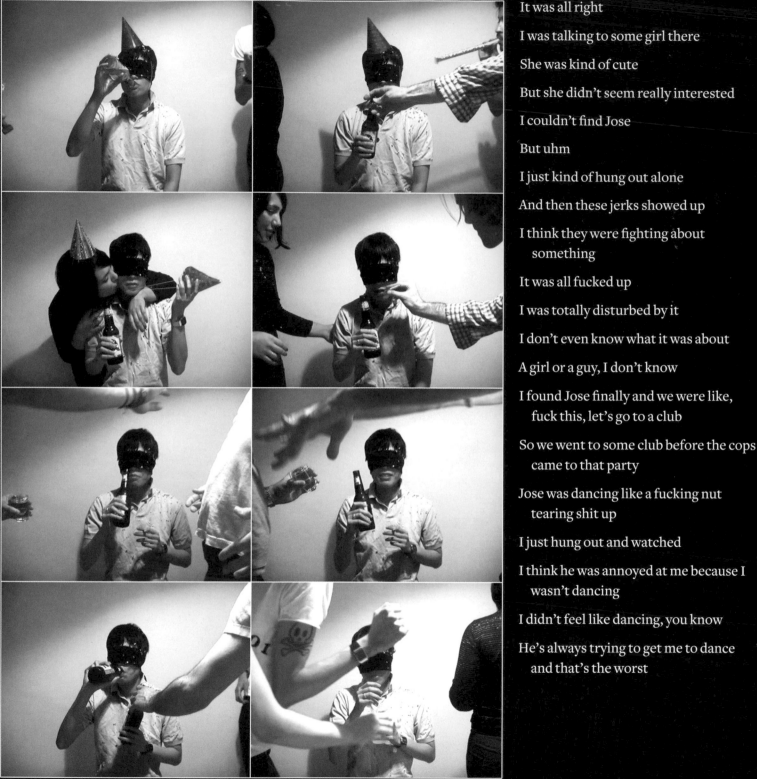

It was all right

I was talking to some girl there

She was kind of cute

But she didn't seem really interested

I couldn't find Jose

But uhm

I just kind of hung out alone

And then these jerks showed up

I think they were fighting about
 something

It was all fucked up

I was totally disturbed by it

I don't even know what it was about

A girl or a guy, I don't know

I found Jose finally and we were like,
 fuck this, let's go to a club

So we went to some club before the cops
 came to that party

Jose was dancing like a fucking nut
 tearing shit up

I just hung out and watched

I think he was annoyed at me because I
 wasn't dancing

I didn't feel like dancing, you know

He's always trying to get me to dance
 and that's the worst

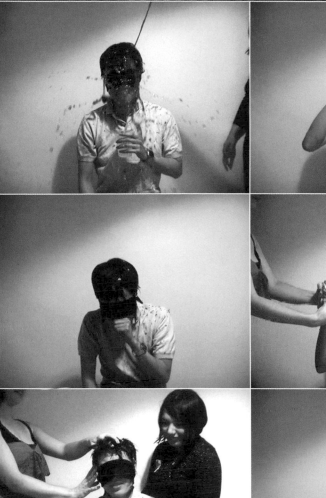
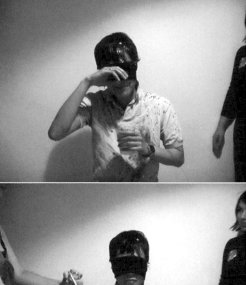
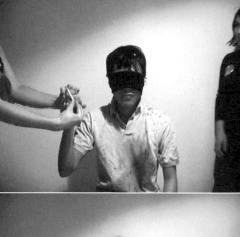
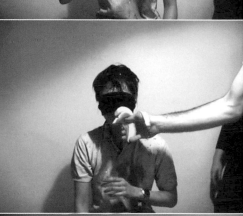

He said I was being a drip

I was glad when the club ended, because I thought we could finally go home

I felt like a mess

I just wanted to go home

But Jose made me go to this sex club with him

I told him I was just going to go home

But he said it would just take a second

So I said all right

He said he was looking for some bitch Steven

I said okay, but just for a second Jose and then we go home

So I just hung out there

There wasn't anyone really interesting

I was just watching

I lost Jose

And then some dude came up to me

I think he thought I was a guy

But I just ignored him

I couldn't find Jose anywhere

I just waited around until

Until he found whatever it was he was looking for

He finally found me

He was really fucked up and drunk

I think he was crying

We finally walked home

ANTE BOZANICH

Born 1949, Vis, Yugoslavia
Lives and works in New York, New York

THROUGHOUT THE MID-1970s AND 1980s, Ante Bozanich composed several personal but direct video works using his own body as a site of provocation and protest. Influenced by early performance and body artists, Bozanich staged visceral actions for the camera—self-inflicted injury, repetitive screaming, illicit drug use, and other acts of contortion or endurance—as reactions against the complacency and alienation of modern life. Framed through extreme close-up, dramatic lighting, and amplified sound, these corporeal events are extended into expressionistic video pieces that occupy a liminal space between tortured self-portrait and fictional psychodrama. In this respect, the raw human emotions conveyed in these works often implicate the apprehensive or empathetic viewer. In *Bands* (1977), Bozanich is depicted alone before the camera; he slowly begins to strap rubber bands around his head, compressing and distorting his facial features. He continues to add rubber bands until his taut skin begins to bleed. The piercing noise of audio feedback heightens the viewer's overall anxiety during the performed actions.

Bozanich emigrated from Yugoslavia to the United States in 1967. Although he studied medicine for three years, he turned to art and began making videos in 1974. In 1978, he received his Master of Fine Arts degree from the University of California, Los Angeles (UCLA), where he had also earned his Bachelor of Arts degree.

Catherine Taft

Interview conducted by Glenn Phillips on February 9, 2007, at the Shelburne Murray Hill Hotel in New York City

GP: Could we start by talking about how you wound up in Los Angeles?
ANTE BOZANICH: Well this is going back. This is like digging old graves, you know? We're talking about forty-year-old memories. I came from what, at the time, was Yugoslavia, which has now become Croatia. I was actually born on an island. It was the sixties and I was very much influenced by music at that time, which was the Rolling Stones, the Beatles, and flower children, and I wanted to come to the West. I had some relatives in Los Angeles, and somehow I managed to get a student visa and got to Los Angeles. To be honest, it wasn't the dreamland that I expected. I was actually hit by this brick of corporate capitalism, which you could taste in the air. And, in fact, I wanted to go back, but it was difficult and it took me a couple of years to get used to it. But I learned how to drive and I became a Californian. The smog was very high then. It was before anybody ever started doing anything about it, or even realized that it was a problem. But when you looked at the sky, it definitely wasn't blue.

I ended up working first as a dishwasher, and the exact salary was $1.25 under the table. And then, through a friend, I got a chance to work in a shipyard—building big, big ships, most likely and regretfully for Vietnam. They were as tall as a skyscraper almost; you worked with a hard hat and were bombarded with fire from welding falling on you. Then I worked in a steel mill; I changed jobs a lot. This was the late sixties, and I was a long-haired hippie. I had to work in horrible places because nobody would hire you if you had long hair. Eventually, I realized I just had to do something, so I applied to art school and got accepted at UCLA.

When you got to UCLA, was that the first time that you ever saw an artist using video? Before I entered UCLA, I was taking some night classes—painting classes—and there was a teacher there who took us to the Bruce Nauman show at LACMA [Los Angeles County Museum of Art]. That was the first time I saw video art. Then at UCLA, I remember looking for an elective, and there was one called Video Imagery. I remember walking into a room that was very different from the art studios upstairs. There were no easels. The room was dark and there was all this weird equipment there—very strange and exciting stuff—nice toys. We were given an Akai Portapak that actually didn't even have an electronic viewfinder. There was a little monitor on the deck, but the viewfinder was actually optical, like looking through

a film camera. I think the first thing I did was point the camera at myself, which is interesting. Historically, that's what a lot of people did.

This was all as an undergraduate at UCLA. At the time it was mostly a very conservative department dominated by painters, so I still had to do painting. Then I applied to graduate school at UCLA and got accepted. In graduate school, it became a struggle to somehow fulfill what they wanted me to do and what I wanted to do.

So you continued to study both painting and video? One thing that always strikes me about your videos is how much they reflect your fascination with layers and layers of light, and with veils and shadows. Do you think this relates to painting?
Maybe in my heart I'm a painter. My paintings dealt a lot with layering and, of course, with light and darkness. Actually, I remember when I had to bring all of my paintings to show at UCLA in order to be accepted into graduate school. I lived in Hollywood, and I remember driving on Sunset Boulevard with a bunch of paintings tied to the roof of an old Karmann Ghia. It was a bright California day, and as I was moving one of the paintings I remember the sunlight just went through it. And I said, "God, I could never get such intense colors and such intense light!" It wasn't so much color as just light coming through the canvas. When you work on a painting you try to get the light out of it, but the sun going right through the paint was just amazing. So I did a bunch of work where I made canvas boxes. I would put a lightbulb inside of them and would paint over them, and the light would make the colors a lot more intense. Eventually, I just did it with fluorescent lights, which allowed me to make the boxes shallower. Finally, the pieces just became fluorescent light behind fabric. I hung a lot of these and I layered them, and I had one that was on the floor like a coffin.

Talking about UCLA and my education actually connects with my earlier background, because UCLA was very much Marxist, at least in the art history department. I'm drawn toward these ideas. I grew up in a Marxist society and my entire education before coming to the United States was very much based on Marxist thought. Almost every historical course you took at UCLA was grounded in Marxism, so the social part—the idea of trying to use my art as a means of social change—was very appealing to me, but I somehow felt that this was futile, considering how powerful television was, so I always sunk back into using video as self-expression rather than as a tool for social change. I just want to mention that because I think that if you analyze some of the older tapes of mine, especially *Behind the Canvas* [1974], it was definitely what was preoccupying my mind at the time.

Could you describe _Behind the Canvas_? _Behind the Canvas_ was probably one of the most political pieces I made. I created a situation with objects, turning a stretched canvas on its face and placing a TV at a ninety-degree angle next to it, and then stacking pennies on top of the canvas while the TV was on—there was a live broadcast of _Easy Rider_ on. I was very excited that you can only stack pennies so far before they all fall down, which to me was sort of a metaphor, or hopeful thinking, about the collapse of capitalism or something. I don't know. But it definitely had to do with that flavor of capital, money, and television, all blended together.

That piece is also so formal. The imagery becomes very abstract and, of course, you're stacking the pennies high, but they look like they're slanted because of the perspective. Yeah, definitely. I always pay attention to the formal elements of my image.

It seems reminiscent of geometric abstraction—the kind that you would find in Eastern Europe. Yeah, well, a lot of these influences come through subconsciously. You don't necessarily think about it or plan it, but it comes through you. You can't get away from your background and all the things that are a part of your brain deep in there. I mean I was just an immigrant, a kid who could hardly speak or read English that ended up at this big institution surrounded by all these kids from Beverly Hills. I don't know whether this is even related to my artwork, but as I said originally, I was drawn to this country because rock and roll had a big influence on my life, and I was going to nightclubs the whole time I was in school. Later on, when punk came on, I remember going to Whisky A Go-Go to watch all of this, the first groups that were playing there like the Plugz and the Screamers. I actually remember Belinda Carlisle before she was in a band, and Joan Jett. They were pogo-ing there, dancing, jumping up right along with me and the rest of the crowd. But even before that, I was pretty much trying to be part of the David Bowie and Roxy Music glitter scene, so there's a lot of different pulls that were going on with me at that time. There were a lot of different influences, and I felt caught between a lot of things.

You started making videos that were more performative. These are works that also often seem very lonely or angst-filled. There was definitely a transition there for me. If you look at the earliest pieces, which as I was saying had some kind of conceptual and political influence, there was a drastic change for me. I think it had to do with my circumstances at UCLA, where the faculty was just unhappy with my work. They felt that my videotapes and my paintings were like part of two different people. They were telling me that. So I got very angry and depressed. I remember this piece where I got in front of the camera, which became _I Am the Light_ [1976]; I just started screaming out of anger. It was a rather spontaneous piece. Maybe some remote influence of punk was coming through or maybe the piece itself got me to go nightclubbing again. But I don't think that I saw any punk group playing before I did _I Am the Light_. It was done in 1976, so it was kind of simultaneous with all of these things. I guess a lot of that has to do with who I am and these are the things that are difficult to talk about. But definitely there was a lot of anger going on there.

That certainly seems to be the case in _Bands_ [1977], which is performative work that takes things to a very physical extreme. Yeah, it was physically extreme. I was looking for a visual effect and I guess at that time my face became a main object—or subject—of my work, and I was trying to use television

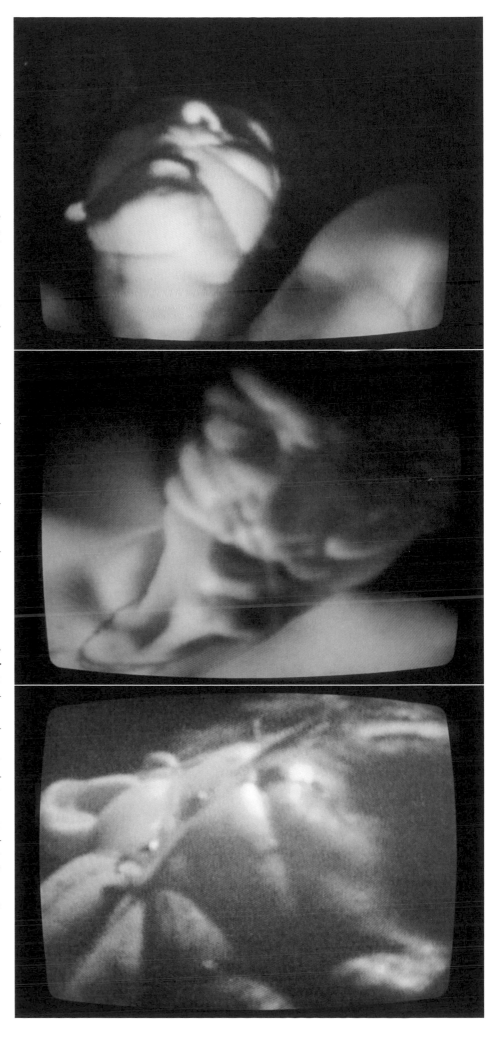

you had to move on, but it would give me a break to restructure myself—to maybe strap some more bands, to change the light. I was still able to see what was going on, but the tape wasn't running, and then when I would get to the situation or to the intensity that I wanted—when I felt it or saw it on the screen—then I would release the pause and start all over again. I was using a new Portapak where you would get a clean cut. With the old format you would get a roll whenever you paused, but with this system you could do clean editing in the camera.

But you kept wrapping the bands around your face until you were bleeding. So I guess the other question is why did you do it? Oh, it became—because I got carried away with the wave of excitement and the desire to create a more intense image. The idea was simply to create this moving image that would just come at the viewer and affect him or her in the strongest way. That was definitely my desire, to affect somebody with whatever I was doing, so that the square box of the TV could just, as I said, jump at the viewer and almost attack it.

And could you explain where the sound in *Bands* came from? It was essentially feedback, and it was generated by this howling and other noises I was making there. Not video feedback, but sound feedback. As I was moving and making the noise, things were shifting, and the pitch of the feedback was changing. It was a very irritating sound, but it very much fitted the whole, you know? It had an effect on me, and then I affected the image, and back and forth. But it was mainly feedback. The camera microphone was too close to the monitor. I was monitoring the sound through the speaker on a TV monitor. So in order for me to hear the sound, the feedback happened.

So you didn't lay the sound down later? No, not at all. Sound is what affected me a lot of the time. Sound and picture both affected me, and it was important that the sound was live while I was performing, so that the sound created the rhythm of editing, or actually helped create the moving image or the shifting of the light. You take this situation where you, the one person, are doing the lights, the sound, the camera, and performing all at the same time. So all of it is coming both from you and at you at that moment, and each element is affecting all the others. I'm observing myself on the monitor, and what I'm seeing is telling me what to do, because I want to make that image more effective. So I'm changing my movement and I'm changing the light to affect that moving image. I'm performing according to that image, but what I'm performing also creates that image. Going back to sound, the sound is part of my surroundings—it's filling my ears. It's affecting me right there, so the rhythm of the sound is telling me what to do, because I'm also editing in the camera. I'm pausing and releasing, and I'm deciding when to record and when not to, and that decision is being triggered by what I'm seeing and what I'm hearing, and again, sound is very important. It definitely creates the atmosphere and feeling, and this sound is basically a modulated feedback, which is usually very annoying. It's probably affecting my nerves at the time, and I'm hearing this while I'm also getting attacked by the bands that are cutting into my flesh. At the same time this sound, the feedback, is affecting and cutting into my ears and my senses. So as I'm trying to create an image that would affect or assault the audience, I'm also assaulting myself, through this physical act. And you have to remember that this light in my face is very bright and hot; it's not a light that comes shining from above but a light from here, in my lap. So I don't think the low angle

as something that wasn't about anything but was just a light or a force that would jump at the viewer. I think music had something to do with it too—the way that music hits you and affects you—and I wanted to do something like that with video. So I just started wrapping the rubber bands around my face. It just happened. At that time, punk was definitely in full swing, so the mutilation of the body and the safety pins and all of that was becoming a part of popular culture, so it's all mixed in there.

When I was making these pieces, I was doing it alone. I was in front of and behind the camera, and I was changing everything. Another reason why I was using my face is because in order to use your entire body you either have to have a very stationary camera or you have to have somebody shoot it for you, and I never felt comfortable bringing somebody else into the room while I was doing my videos. So in order to be able to zoom, to control the iris openings, and everything else I had to do, I would have the camera right in front of me where I could reach it. I would have a light in my lap shining in my face, and I usually also had a light above me that I could swing. I would reach my hand to manipulate the lens. I wanted to add another element to it, and I started wrapping some rubber bands around my face.

I did all the editing for *Bands* in-camera, during the performance. So I was manipulating the lights, forcing the bands around my face, zooming in, zooming out, observing all of this as it's happening on the monitor, and I was also able to edit by pausing the camera. You couldn't do it for too long as I recall, because it would automatically jump out. I think the maximum you could pause it was for about thirty seconds or something, and then

of the light was intentional so much as it was a necessity for me to be able to control it and manipulate it all with my hands. And yeah, the sound was really irritating; it was all about trying to achieve that really razor-blade edge. I don't know why I would want to assault people like that and affect them—that's a different story—but that was the intention, and I felt that the only way to do it would be by going through that myself. To achieve that sort of intensity you just have to be part of the whole thing, and it's like you almost get addicted. That's why I liked the pain. You almost don't feel the pain because you're in this sort of creative ecstasy that just won't let you stop, and you just want to go deeper into the intensity of it, because you know that the image right in front of you will be affected when you do. I think that's the thing about video, that you can create it while it's happening, right there on the spot. It's not necessarily something that you think about or imagine and then create later but it's right there, the moment when everything is happening. There's the sound, the picture, and yourself, and you're feeling everything and experiencing it in front of yourself as a moving entity. It's happening right there, and you can transform it through your action in that very moment. All of these components are affecting each other and integrating together, and it's happening and you're part of it. You sort of have control over it but you don't. It's all happening as the time progresses, so you're trying to grasp that moment in time. It's actually happening, so as you change something, you see it changing right there on the screen that same second. You see the image, and you know that you're part of the image at that same moment.

What about *Film Reel* [1975]? Could you talk about that work?
Film Reel was definitely an attempt to make conceptual art, in the sense that I decided beforehand which materials to use and how to structure it. Basically there were several reels of 35mm film on a rod right above me, and I would unwind the film so it fell down onto me, but I turned the camera upside down because I wanted to get a feeling of the film actually coming away like the loss of gravity or something. In a silly way, it was intended to be a comment on inverted Hollywood, film and art production, and the media in general. The piece was originally called *Return*, because I also wanted to create an image of a womb. I wanted to create this image, which was basically a triangle. If you look at it, the film did sort of resemble pubic hair. So it was like me becoming submerged in that womb. And again, I really liked the sound when I was pulling the film from the reel. I think the sound in my work is very primitive, but it was something that I was always very interested in and very attracted to, this very dissonant and disharmonic and irritating sound. I think that squeaking sound as I'm pulling the reel is having an effect on me, and I was hoping that it would have an effect on the viewer as well. But yeah, that's what the piece was. It was an interesting sensation having all of this celluloid touching your body, because I did take my clothes off for the piece, and being submerged in all of this film was kind of an interesting experience.

But you can't return to the womb, Ante. No, you cannot.

Is that why you changed the title? Yeah, it's—you cannot go back.

p. 52
Ante Bozanich, stills from *Film Reel*, 1975. Single-channel video, black-and-white, sound; 3 min., 45 sec.

p. 53
Ante Bozanich, *Bands,* 1977. Single-channel video, black-and-white, sound; 10 min., 16 sec. LBMA/GRI (2006.M.7). Installation at Frederick S. Wight Art Gallery, University of California, Los Angeles, 1977.

BRIAN BRESS

Born 1975, Norfolk, Virginia
Lives and works in Los Angeles, California

BRIAN BRESS'S SCRUPULOUS ART MAKING seems consumed by the material clutter of cultural castoffs, economic ebb and flow, social exchanges, and the margins of mass media. At an early age, Bress became comfortable interacting with strangers and strange objects, spending his free time at his parents' pawnshop (at one point, it was the largest shop of this type in the eastern half of the country). Among the used merchandise, cars, boats, litter, and riches, Bress cultivated unique conceptions of space and his own physical relation to things therein. He eventually began studying filmmaking and animation at the Rhode Island School of Design, building on his interests in painting and drawing (and leading to his participation in Spike & Mike's Sick and Twisted Festival of Animation). It wasn't until graduate school, however, that Bress began to bridge his investigations of two- and three-dimensional spaces. At the University of California, Los Angeles (UCLA), he discovered video, a medium that allowed the artist to negotiate painting, drawing, collage, photography, animation, performance, sculpture, and humor simultaneously, all of which appear in his wide-ranging practice. Bress's working model now includes building elaborate sets, costumes, and props; re-editing and recycling video footage, which also can transform into photographic prints or the backgrounds of layered compositions; and using the Internet as an extension of traditional exhibition spaces, streaming his videos to a broad public audience while challenging conventions of both art and entertainment.

With subtle criticality, Bress's videos cleverly poke fun at mainstream TV. In *Over and Over* (2006), the artist—wearing a makeshift mask, stuffed in a bright yellow trashcan, and set against a bamboo forest backdrop—slightly rocks as he repeats the jingle, "You do the same thing over, over and over, people won't be confused." His gestures and words channel the repetitiveness of commercials, dumbed-down programming, and wacky children's shows; and like TV, it's infectiously catchy. Similarly, *Under Cover* (2007) becomes an understated indictment of fine art and the structure of its lucrative market. In it, Bress moves through a comical series of roles loosely based on the profession's stereotypes: the clueless artist, the opportunistic collector, the analytical critic, the plastic arts personified. Contained by a complexly messy set (Bress's DIY "production studio"), the video riffs on artifice while unraveling its own crafty design.

Catherine Taft

Interview conducted by Catherine Taft on May 4, 2007, at Brian Bress's home in Los Angeles, California

CT: You were explaining to me that you worked in animation and design before you figured out how to "profit from the Web boom." How did you profit?
BRIAN BRESS: In 1998, I realized that people were getting rich off the Internet. So I locked myself in my room and taught myself HTML to make money. I got a really great job as the head Web designer at a firm on Fifth Avenue in New York City, because, for as little as I knew, the people that hired me knew even less. And in 1998, if you even knew what HTML stood for, then you got a job in New York City.

But eventually you ended up in California. What lured you away from that great job? Grad school—but I went to Chicago for two years and then came out here, to UCLA. When I applied to UCLA, Lari Pittman and Paul McCarthy were teaching. The thought that I could work with these great artists that had shaped the art world in some way seemed really amazing to me. I applied in painting. I saw my animation background as this commercial track and painting as something really personal. I always wanted them to intersect and cross over, but I really couldn't figure that out. But that was another reason I came to UCLA, because you could work between many different media and no one would care.

You eventually came to the New Genres department and started making video. Did you start using yourself in your videos right away, or did you tape other things? Well, everyone is pretty vain or a little self-conscious, and that's true of me, too. It took me a while to get used to seeing myself on camera, so I didn't use myself right away. I remember seeing some of my first videos, and I'd walk into the frame to adjust something and see myself, and I was like, "Whoa. I look like that?" But it didn't take long before I started getting in front of the camera. The first video I made at UCLA was really by accident. I had painted over a photograph of a woman, and I wanted to make a sculpture based on this figure because I was "branching out" in my mind. So I made this cardboard sculpture and thought, "Oh, that's possibly the ugliest sculpture anyone has ever made and it should be burned immediately." So I took it outside behind the studios, and I thought, "If I'm gonna light this on fire, I might as well film it burning." Burning a figure is pretty dramatic, and usually you see that in protests or when something is burned in effigy. So I went out there, and someone was playing this loud techno music, and I couldn't resist the urge to dance. I went up to the burning embers, and I started dancing on them. When I saw the footage, it looked pretty beautiful. I played it in reverse, and it looked like little things dancing around my feet. The figure was coming to life instead of being destroyed. So that was the direct transition between my painting and my time-based work.

It's interesting to hear that you were transfixed by your own image on the monitor for the first time, because that's what so many early video artists say, too. Being able to watch yourself in real time on a television set was revolutionary. That a young artist can say the same thing today is a surprise, especially when we assume that we live in such a heavily mediated world. I always feel like that. Even when you see yourself in stores on closed-circuit security cameras, you're not really sure if it's you or not. It's like coming around the corner and coming into contact with a less attractive version of yourself. That's pretty intense. Once I got used to that, I realized that it's okay to be seen and to let go of self-consciousness, if it served the purpose of telling a story.

Your work doesn't really tell stories, though. No, they're not narrative stories, but some of them have parable-like content. *Over and Over* [2006] isn't a story, but it is like a jingle, and it has a message. There is a statement and a main character in a setting, and he has a message, so it's like an advertisement or propaganda.

A lot of your work takes the advertisement, or newscast, or television format, and turns it into something else. I don't watch any TV now, but when I was growing up I watched my fair share. I'm just too susceptible to TV's power. When I hear that newscast music, I get a little excited—like they're going to tell me something really important. I totally buy into it, even when I know that's what they're trying to get me to do.

We were talking with Chris Burden, who did a series of commercial TV spots in the 1970s, which basically advertised his name. He explained that he thought TV was too monolithic—you could only receive it one way—and he wanted to reverse that system or get inside of it and mess with it. Today, we have the Internet, and YouTube, and all these other ways to get "inside" the system and make it two-way. That's true. But television content isn't really changing. There is new content on YouTube; or maybe it's not new, but we're just seeing all this stuff at once. It seems to me that YouTube is functioning in many ways. It's a place of political action, marginalized news, stunts, indie music videos, etcetera. But what it's doing for art is obviously the most interesting to me. I think it's a great place for art to seep into the mainstream. It's functioning in one way like a massive gallery for people familiar with the art world to find more art videos that might not be getting screened anywhere in their community. And on the other hand, it's introducing art videos to folks that might not be familiar with art in the context of a new type of television. This almost subversive introduction of art into and amongst so many other types of mainstream content is an exciting prospect, especially because I derive so much inspiration from the bits of entertainment that find their way onto YouTube.

Do you think YouTube gives people an excuse to videotape the mundane things in their lives that they wouldn't tape otherwise? I think having access to the video camera, and the videophone, and all these new technologies gives people the ability to film mundane

p. 54
Brian Bress, production still from *Under Cover*, 2007 (single-channel video, color, sound; 13 min., 16 sec.).

p. 55
Brian Bress, production still from *Danger*, 2006 (single-channel video, color, sound; 2 min., 28 sec.).

things. You couldn't have a YouTube chock full of mundane things if you didn't have the ubiquitous digital video camera. But I have to say that maybe it does mean that people film more odd, quiet, weird things about their lives. I mean, the "video confessional" on YouTube is pretty fascinating.

Like an eighty-year-old man in England who just discovered the Internet? Yeah, like "Hello YouTubers! I wanna talk to you all." You know, I'm more fascinated with people being fascinated with *that* than I am with watching it. I'm more interested in the idea of all these people sitting around the campfire as this eighty-year-old man talks to them. *That* is a picture. The whole way that video art is sold and marketed today turns video into these distinct, autonomous, and "limited edition" objects. It's nice that maybe there is a way for people who can't afford to buy video to still experience the work. Not all video artists are down with putting all their work online, but I am.

We are faced with an art market right now where everything has a value; there is no such thing as an artwork having no value. With YouTube, how do you value all that ubiquitous stuff? With YouTube, it might be that there is value—not quite monetary, but maybe cultural value—that you can't put a price on. The fact that some kid in the middle of Arkansas even knows me—well, the cultural value is that YouTube broadens the art world's appeal. If some guy filming his cat can get a million views, then maybe there's an artist out there that can too. It broadens the art market's reach, and that has a value. Maybe it brings more eyes to the art world, and creates more people interested in art and more people who ultimately support the arts or seek to make their own art or whatever.

But that's what commercial advertisers are hoping for. To bring more eyes— Right. There are people making money off the fact that I spent money to make my videos. But I get to have all those eyes watching me, too. Like advertisers pay for bandwidth, they get the advertisement. Hmm... that does leave a little bit of a bad taste in my mouth.

Okay, well what about the sets in your videos? They're incredible to look at, which seems to draw plenty of viewers, too. I originally made the sets just to use in the videos, but, that being said, I did treat them as two-dimensional images, meaning I wanted a fixed frame. I want to be in control of everything, and I used the monitor on live feed so I can see exactly what is happening on the set. One of the great things about video—or at least the technology that I have available to me—is that it flattens out imagery in a way that has a lot to do with painting and what fascinates me about painting and collage. I think the complaint of a lot of people who come from film is that video is too flat, it doesn't have the same space. High-definition video is really a new chapter in video, because there is a lot of space that I can discern within its frame. But in the current technology of MiniDV, the ground is still flat, and to me, that's a gift. I'm interested in making the artifice of the set—the fake backdrops or the props—compressed into a two-dimensional image. When you see the character enter the space, it feels like he's entering a painting and not the artist's studio. I also try to make more general, archetypal spaces. It's almost like the backdrop can be a lot of different characters in the way that I become a lot of different characters. That's one of the first ways I think about making a set, that it have a certain fluidity or versatility.

What sorts of things were you thinking about when you made the sets and characters for *Under Cover* [2007]? I don't want to close down any other interpretations, but I do have a loose explanation. I had just moved into a new studio and was anxious about being in the new space. I needed to quickly make art in the space to be comfortable in it. I wanted to make a longer video and really start to edit multiple scenes together to make a conversation. Also on my mind was how stressful, but fun, it is to make art and the idea of an art collector being an artist and an artist being a collector. One of the characters in the video is like a collector who is into the consumption of art and the whole game of art. The line that she uses in the video is "show me number one; now show me number two" and "it's a crapshoot anyway." It's a little cynical if taken just in this context, but this whole decision process about how you buy art is really funny, and this process about how art is made and how it's consumed is really mysterious. You take a chance when you buy art, but also when you make art. The ambiguity or transition from consuming to making is one thread that runs through the work.

The other thread that is really important to me is the psychotherapist character who sits in the chair kind of thinking about things. And there's a clock next to him, so you can see when your time is running up; it's toward the end of the video and your time is running up on this big therapy session. So the collector is the consumer and the psychotherapist is the critic, and then the character getting interrogated is the artist admitting that he doesn't know anything. To me, this interpretation holds water. When the artist character is getting dunked, it's a self-interrogation, which is the only real kind of interrogation the artist should be subject to. That scene is funny because it mocks tropes of movies and, on the surface, you can enjoy it as that. But to me, it's more important that the artist is saying, "I have no idea." Does any of that come through?

Having worked in a gallery, the collector character was spot on. I loved that and got it right away. And those color bars in the beginning are so typical of any piece of video art ever made. They really situate the viewer right into the language of video and its history. It was a conscious move to say that this thing doesn't exist in a vacuum. This might be a little cheesy, but the color bars are hand painted. I am so desperate to make paintings but they always end up as sets or props for the videos. That a hand-painted color bar can turn into a space and be interacted with is really rich. It's not only about the history of video but the history of painting, which is a really important connection for me and how I want to see the sets formally, their light and space, and flatly on a monitor.

The character with the helmet and the drawing all over his jumpsuit is like art embodied. It's almost like an artist assistant joke at this point—just the idea that you must be creative, and then you just go work for a more successful artist. When this character says, "From many I will make much," it's more like, "Yeah, if I had an army of people working for me, I'd be making a lot of art too!" [Laughter] The art drones ask the lead character, "What should we make?" But he doesn't know.

It's interesting that right when you were moving into a new studio space and starting your career as an artist, you sort of had to exorcize these roles and get them out of your system. Yeah! And now I feel like it was expulsive and cathartic. But it's scary to enter this business at any point—as a collector, curator, or critic, going in there and trying to figure things out. The scene in the video that clearly exemplifies my stress about being in this space is the collage set where the character is covered in collage materials. Originally, the impetus to make that suit and set was thinking about decorator crabs and how they just kind of take something from their surroundings and stick it on their head and try to blend

AND FROM THOSE MANY
I WILL MAKE MUCH

in. But it took on a whole new meaning when I finished making the set and costume. I set everything up and put on that suit, and at that exact moment, I could hear every sound; I could hear every train going by, every car going by, every noise next door. I had this hypersensitive sound thing going on, and all the little images that I had cut out seemed to embody every sound I could hear. It was like I was wearing the sound and I think that in the video, the character's talking about, "I can hear bip bop bip bop" and "Oh my god, it's in my head," which is about being really fucked up in your own neurosis. The visual look of that set matched exactly how I was feeling and my neurosis.

Was it like synesthesia? Exactly, and it wasn't planned that way.

Sort of like an acid trip? Well, that's another thing.

What's another thing? I don't make art on drugs. A lot of YouTube reaction—well, a lot of reaction to art in general—is that if it's off the beaten path or "weird," it must be drug induced. And I wondered why people always thought that about me. I think the general public assumes that my videos are drug-induced performances, and they are not that at all. Maybe drugs are helpful for some people to become more creative, but I think a lot of artists make pretty trippy work not tripping. So that's it. I just think the general public doesn't necessarily have the language to accept certain kinds of art forms.

I know what you mean. On the one hand, we have art in our world so we can explore other kinds of realities without altering mental states. On the other hand, a lot of great artwork is about induced states. Andy Warhol's greatest films are about time as an upper or a downer. So, you're getting this response directly from your mainstream audience on YouTube? Yeah, they say, "Dude, trip much?" Or my favorite, "Whatever he's on, I want some." I want

to compile these comments. It's not like it bothers me, but I don't want the videos to be dismissed as a kind of drug-induced oddity. When you sit down in front of a camera and you have some idea of what you might do, and you have so much going through your mind, your subconscious just lets things out.

You can get some mean-spirited comments on YouTube, but they're kind of funny. You can tell the work is affecting people, but at least they didn't ignore it. Praise and blame are different things, but they both require a certain amount of energy. I think it's also a little scary to see a person alone in a room by themselves because it's not socialized. I made a video with a friend, and there were two of us in the room; that video got a lot less criticism. It became about play. But when you're playing alone in a room, you're crazy. When you're playing with somebody else, it must be fun.

YouTube seems to generate its own kind of "art criticism," but what about the unexpected fan base that you've developed through it? That's a really rewarding facet. I eventually realized that the videos were getting this weird attention on blogs. People who didn't give a shit about art were seeing my videos and analyzing them and had ideas about them. I thought, "Wow, these people have engaged art without really caring that it was art; without having to go to a gallery." And they had some really interesting ideas about it, too. I did a video called *Being Bamboo* (2006) about a character going in front of a set with what he called bamboo, which was really six table legs screwed together. He proceeds to talk creatively about what this object could be, "It could be a hobby horse, it could be a really big pencil." On her blog, this fifteen-year-old girl was so psyched about what the video meant to her. She understood the metaphor that a kid with some blocks can imagine them to be whatever she wants them to be. That's a basic thing, but she got it and if your audience can be as broad as fifteen-year-old kids to people who are fully immersed in the art world, then that is pretty encouraging.

p. 57
Brian Bress, stills from *Under Cover*, 2007. Single-channel video, color, sound; 13 min., 16 sec.

NANCY BUCHANAN

Born 1946, Boston, Massachusetts
Lives and works in Los Angeles, California

NANCY BUCHANAN BEGAN USING VIDEO as a natural extension of performance and installation in the late 1970s and has continued experimenting with new media throughout her career. Her work explores the spaces between political essay, poetry, and performance. Likening the role of the artist to that of the canary in the coal mine, Buchanan describes her artwork as a tool for raising awareness of contemporary political and social issues. Video's reproducibility and its capacity for broad distribution have enabled Buchanan to disseminate her message outside the mainstream art establishment to a wider audience. As a student at the University of California, Irvine (UCI), in the early 1970s, Buchanan cofounded F Space gallery with Chris Burden and Barbara T. Smith. An early participant in the Los Angeles Woman's Building, she has demonstrated an ongoing commitment to making alternative voices heard through her art and her work as a teacher, community activist, and curator.

Buchanan's early videos disrupt representational stereotypes through a feminist critique of formulaic narrative genres. Many of her later works document and critique insidious operations of political and corporate power, often with a wry sense of humor. Her video polemics of the 1980s and 1990s address such issues as the government-sponsored fear tactics underpinning nuclear proliferation, American interventionist foreign policy in Latin America, and the role of exploitative real-estate speculation in the failure of the American dream. *Tech-Knowledge* (1984) examines how technology permeates society and shapes our consciousness. Electronically manipulated images of industrial technologies, with an emphasis on automated food production, point to our literal consumption and internalization of technological ideology. In a voiceover interview, a computer expert discusses the technologization of our everyday lives, culminating in information technologies and the commodification of information. In answer to the question, "Can I somehow get out of this?" he responds, "The determining factor is not the technology. The determining factor is whether we have the patience, and will—and hope—to be able to use that technology."

Andra Darlington

Interview conducted by Carole Ann Klonarides on February 1, 2007, in the video studio at the California Institute of the Arts, Valencia

CAK: I'm always curious to ask women of our generation this question: how did you get involved in art? You came out of UCI at a particularly great time in that school's history. How did you get involved in performance and alternative media?
NANCY BUCHANAN: I think performance really grew out of influences from a lot of people. Vija Celmins was teaching drawing there, but then she also taught this bizarre class in Happenings and we'd never heard of them. People did all sorts of odd events. It was extending the idea of what art could be. Robert Irwin was one of my teachers, and I think that he and Larry Bell just about literally saved my life. It was actually quite hard for me, because I had a child when I was eighteen. I had no parents—my parents had both died—and I was just out there. Barbara Rose, Frank Stella, Ed Moses, and a lot of people at Irvine were very interested in film. They were experimenting with 8mm film. We knew that there was video; I don't remember if we ever had any video equipment in our classes there, but I knew it was around. Irwin and Bell were very encouraging, and Irwin really taught me to understand that a work of art doesn't exist by itself. It's part of a whole fabric of experience that includes the space in which it exists. Later on, I was able to expand that idea to include the social and political climate of the times.

Which was? Even though Irvine was very small, we had a branch of SDS [Students for a Democratic Society]. I was involved in a guerilla theater group. We called ourselves PHUCI so that we could do obscene cheers. We also did a "garbage-a-thon," which was actually my idea. Reagan was the governor and the head of the trustees, and they didn't give any money for the arts. We put up posters saying that, in the spirit of art, we were going to make sculptures out of garbage because we didn't have anything else. We encouraged everyone to bring their garbage, and we made a big sculpture to honor the meeting of the regents.

When did you move to Los Angeles? Let's see. I moved up in 1975 or '76. I had a studio in Laguna Canyon after I finished my MFA. Actually, that was where I did my first video. I built a studio in this industrial complex. There was a car dealership, a place that made fancy food for airlines, and a number of other things. I had this fabulous space—I just adored it, and it had a big loft. That was where we slept, and I built a special room for my son with a skylight. At first, he was too embarrassed to bring his friends home. Then he finally brought one kid home. He looked at this giant empty studio with a big concrete floor and he said, "Wow! You live here? You could skateboard in here." My son, Page, said, "You like this?" And the kid said, "Yeah!" Two doors down from my complex was the cable company, and they had open reel equipment to lend. All you had to do was donate a tape after you finished it, and I was more than happy to do that. So those were the first tapes I made.

What were they? I was first interested in video as a recording device for performance. I had done a performance called *Tar Baby* [1976] in which a black friend of mine, Clifford Mabra, Jr., wore a surgeon's outfit and covered my naked body with a tarlike substance while there was an audiotape of a surgeon describing an angiogram. The tape really objectified the patient. I asked a doctor I knew to make an audiotape describing a medical procedure, and he pretended he was addressing med students. He began with: "Okay, Mrs. Gonzales. We're just going to do this little procedure." After that, the patient didn't even exist and she just became this object that he was describing to his students. It was kind of a horrifying, perfect metaphor. After the tar, Clifford covered my body with colored feathers, and then people were invited to come up and view the object. But when they approached the table I was lying on, I made eye contact with them. So it was dealing with objectification in a very direct way. Well, that really wouldn't work for a video. So we just used the tar part of the piece and had a camera directly above. That was the first video I made.

The first show that I saw you in was in 1978. You showed *With Love from A to B* [1977], a tape that you did with Barbara T.

p. 59
Nancy Buchanan, stills from *Tech-Knowledge*, 1984. Single-channel video, color, sound; 16 min. LBMA/ GRI (2006.M.7). Photos by Kira Perov.

Smith. Could you describe that piece? *With Love from A to B* was part of a wonderful experiment that David Ross did during the College Art Association meeting in Los Angeles in 1977. He decided that since a lot of delegates would be staying at the Hilton Hotel, he would invite artists to do video and performances that would be broadcast into the hotel rooms. He invited Barbara T. Smith to participate, and she in turn invited me to collaborate with her. The requirements were that you couldn't have any editing—you just had one shot at it. So we decided to make a romance that could be told just with our hands. It was a generic story of unrequited love. We collected all these small props, and Barbara had a great album of terrible dinner music. There's one edit in the video, because the hotel room power went out. Peter Kirby was shooting it, and he said, "Stop. Just don't move." Then the power went back on and we kept going.

And you also redid this tape? David Ross was so distressed by the fact that Barbara, who played the rejected lover, had pricked her index finger with a razor in the end, so there were a few drops of blood. He seemed visibly shaken by that, and he called it a "slashing." So Barbara decided that this was a very immoral action and a terrible example. She thought that we should remake the piece, and instead of pricking her finger, she would just slip the razor between two of her fingers. So we did it again, and Peter shot it for

us in color. That was the released version. For a very long time, the black-and-white version was repressed.

But it's in the collection at Long Beach? Yes, and actually, now Barbara has allowed it to be shown. I think it's much more powerful. It's more raw.

So you did a lot of work down at the museum in those days. You did a lot of editing. Talk about what it was like to work there. Well, I remember the different facilities and going up to the little attic where they had the first reel-to-reel equipment for artists. It was kind of like being in this secret clubhouse. I loved the space of that house. It was really special and I thought that it was very suited to video, more suited to video than to any other art form. Video put the Long Beach Museum on the map. Then when they moved the video facilities to the firehouse, it expanded the possibilities a bit more because there was a studio.

You made your piece *These Creatures* [1979] at the Long Beach Museum. *These Creatures* was made for a project that Kathy Rae Huffman organized called 30/60 *TV Spots* [1979]. The idea was that all the videos for the project would be shown on television, which I thought was fabulous. However, television only accepted one of the works, which was Mitchell Syrop's piece *Watch It, Think It*

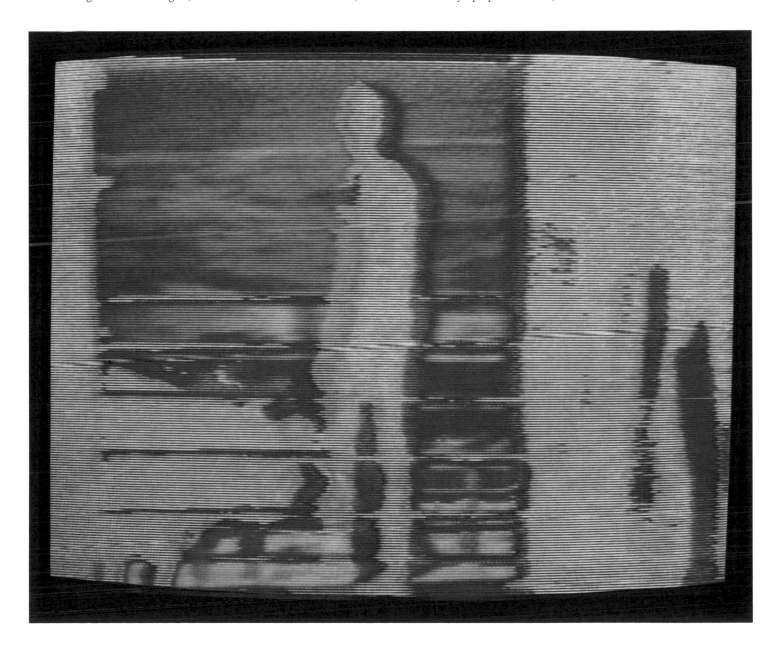

[1978]. The rest of us had to be content with museum shows, and maybe cable. *Watch It, Think It* was very slick. It looked very much like an ad, and it had absolutely no content. I don't remember if it was shown on cable. But *These Creatures* was designed as a feminist anti-advertisement, and the title came from the idea that women aren't really human beings. I had a lot of fun making some images where women looked very strange. It opens with a shot of a woman whose eyes are closed, and she has eyes painted on her eyelids, and false eyelashes up above. It makes a very odd image, as if you're making eye contact, but the person is closed off. She had terrible makeup on. She was a very beautiful woman, and the makeup accentuated every bad aspect of her face. In every shot, there was something unusual. There was a woman in a negligee, and as she turned toward the camera with her arms behind her head, she had this really ugly green facial clay on. There was a woman with a beautiful bouquet of flowers and her nose was painted red with lipstick. It ended with Linda Burnham in very white pancake makeup, accepting a bouquet of what at first appeared to be roses, but they were bones on the end of long stems with leaves—bones painted red.

In some of your tapes you used some pretty sophisticated equipment, like in *Tech-Knowledge* [1984]. You used a Paik-Abe Synthesizer? I had taken a job at the University of Wisconsin, Madison, to develop a program in nonstatic art. The Experimental Television Center in upstate New York offered a five-day residency, where you could sleep at the place if you wanted to. They would spend a day training you to use everything, and you would just pay $15 a day, which is ridiculous. I didn't really know what my work would look like. They sent me all the information, but I really couldn't understand it. I decided to use a theme that would work

with the equipment. So I thought, "Okay, I'm going to be using technology. So I'm going to foreground that." I really wanted to go down to the bare bones and think about, what is technology? And technology, of course, is any tool that we use. It doesn't have to be the most sophisticated—it can be the simplest. It can be a lever. It can be a spoon. It can be a screwdriver. I was in the Midwest, so I thought it would be interesting to visit a number of facilities that were specific to the Midwest. Some of the places that I shot were generic for that era—like cable television and video games—but beer and dairy and farming were very Wisconsin-specific, so I knew I wanted to include them. To prepare for the residency, I shot a number of different locations, and the idea was that I would learn the equipment and play with it to figure out what "look" would highlight various subjects. I wanted to make a visual comment that would run through the entire piece, so that you would realize that when you see things on television, they're not real. They are mediated by technology. Our entire life is mediated by technology. So that's why there are so many effects in the piece. It's constantly in the foreground to make sure you understand the mediation that exists. You make do with amazingly tedious technology if you have to. When I made *Tech-Knowledge*, I couldn't do AB rolls. I couldn't dissolve between two tapes. So what I did was I made some sub-tapes. I put them in a VTR, showed them on a monitor, stuck a camera in front of that. Then I could back-time everything and do a dissolve between the camera and one VTR in order to make my dissolves in that piece. Then I had to find the frame to match to go on with my edit.

Your video *The Work of Art in the Age of Electronic Reproduction* [1985–86] is kind of a sister piece to *Tech-Knowledge*. *The Work of Art in the Age of Electronic Reproduction* was a follow-up piece that

I did after my first residency at the Experimental Television Center. There was one piece of equipment that I adored. It was Nam June Paik's Wobbulator. The Wobbulator was made by meshing the coils of two color televisions. Then you could put a voltage in that would twist and manipulate the raster. My initial idea for *The Work of Art* was to use text and flip that text and make it into an object. I was very interested in the idea of Walter Benjamin's famous essay, "The Work of Art in the Age of Mechanical Reproduction" [1936]. My thought was, "Well, we have a whole new layer. There are a number of different questions now." So I went back and I looked at Benjamin's essay. The parts that I was most concerned with had to do with his more utopian ideas—that perhaps given the new era of film, which is a collaborative media, you could have some kind of revolutionary art. You could have an art that could affect change instead of an art that would, as he put it, "delight in man's own destruction." Yet there I was, all by myself, eating Spaghetti-O's in this little studio, running all the equipment and the dials—so I certainly wasn't participating in that. There was still the same condition that Georgi Plekhanov described in *Art and Social Life* in 1912, which was about the artist that doesn't care about the tremendous social transformations that are going on in the society beneath him. He's much more concerned with his own ego. Why should he bother? I guess I felt that very, very deeply, there's the pull of individuality, stardom, celebrity—struggle for yourself rather than struggle for the group. So it's a piece that is pretty pessimistic in a way.

The video kind of takes off from a cooking show. Yes. I made this metaphor of the way that the media force feeds us the information it wants us to consume. That's even more true today, now that we have so many conglomerates, and our news is more managed than ever. So the video is like a combination between Julia Child and Walter Benjamin. I thought of it like a cake within a cake within a cake. It's like a question that you can keep peeling open, but you're never going to be able to answer it.

How does it make you feel, using a tool such as video, which can be a double-edged sword? It also can be used in a negative way. Well, I think it's inevitable that any technology can be used for negative ends. That's something that Tim Haight says in *Tech-Knowledge*. He asks, "What can I do with all this stuff? It all comes from military development," which is absolutely true. That's how everything gets developed, because it has to be funded. Most of the sophisticated equipment that we have was developed with government money for defense. Of course, Bertolt Brecht wrote about the fact that when radio was developed, it could have been two-way, but it wasn't. It was one-way. And then television, again, was one-way.

That brings to mind the whole fragility of technology and how it evolves, and also our own mortality. I know that you've taken on the legacy of Christine Tamblyn, who was a video maker and a theorist. You are also a teacher, and you continue to talk about the art's history, as well as its future. I never thought I'd live this long. My parents died when I was really young. My sister is gone. I've never been unwilling to think about my own existence, but I think it's really hard to lose people. I was very devastated by the death of my friend Christine Tamblyn, who was an extremely important and brave feminist, scholar, and artist. We collaborated on a wacky little conversation called *Strata* [1989] that was talking about feminism and technology, and her imagination of an instant archive. She really thought about that, and made her last works about the way women could use technology. I think these pieces

had a very feminist interface, a kind of—as Carolee Schneemann's work has been described—messy, horrifyingly personal interface. I think it's crucial for artists to champion excellent work by other artists that haven't received the support of major collections or institutions yet. I've also felt that way about the work of Cynthia Maughan, who I included in my program for the *Scratching the Belly of the Beast* series at Film Forum [1994]. I think that Cynthia Maughan's work is some of the sharpest and funniest work from the 1970s, because she was always ambivalent about the art scene and really didn't care about success on its terms. There's a danger that her work could be forgotten. I think the other thing about art is that there shouldn't be a canon. There should just be an immense archive, a huge web, and it should be accessible to creative people to do their own browsing and see what appeals to them.

p. 60
Nancy Buchanan, stills from *Tech-Knowledge*, 1984. Single-channel video, color, sound; 16 min. LBMA/GRI (2006.M.7). Photos by Kira Perov.

p. 61
Nancy Buchanan, stills from *The Work of Art in the Age of Electronic Reproduction*, 1985–86. Single-channel video, color, sound; 7 min., 34 sec. LBMA/GRI (2006.M.7). Photos by Kira Perov.

CHRIS BURDEN

Born 1946, Boston, Massachusetts
Lives and works in Topanga, California

IN THE EARLY 1970S, Chris Burden began performing a series of extreme performance works utilizing his body as a site for artistic expression and personal danger, permanently fixing his reputation as a controversial, yet enormously influential, performance artist. While his performance of *Shoot* (1971) may have forever labeled him as the artist who had himself shot, Burden originally came to California to study architecture and sculpture, receiving his Master of Fine Arts degree from the University of California, Irvine, in 1971. His first body-performance piece, completed for his MFA thesis project, involved confining himself inside a gym locker on the Irvine campus for five days. Like *Five-Day Locker Piece* (1971), many of Burden's works were done outside of the traditional gallery space, often on the street, and mirrored his thinking about the power of institutional authority. He strictly limited the number of observers, and thus his early work is characterized by a sense of intimacy that articulates the power dynamic between the artist, the situation, and the viewer, particularly the complacency of the viewers and outside participants in response to violence. The early performances also required the use of mediating devices—film, video, photography—to document the works and allow for their secondhand reception.

Burden also pioneered the use of broadcast television as an artistic medium, purchasing ad space from stations in New York and Los Angeles in the mid-1970s to broadcast a series of shorts, which, for instance, depicted him crawling through broken glass, or listed his name as the culmination of a series of artistic geniuses such as Michelangelo, Rembrandt, and Van Gogh. In works like *Big Wrench* (1980), Burden presents a comical autobiographical narrative about his struggles to purchase, regularly use, and ultimately resell a junky and possibly cursed big rig he called Big Job. Entertaining as a narrative, the video also functions as an allegory of postconceptual artistic production, as Big Job cycles through a series of roles ranging from simple object to conceptual "vehicle" to sculptural object, before ultimately vanishing almost as mysteriously as it appeared. Burden is better known today for his sculptural and architectural installations. The uniting concept behind all phases of his work remains the potential for catastrophe for both the artist and the viewer.

Amy Sloper

Interview conducted by Glenn Phillips on May 4, 2007, at Chris Burden's studio in Topanga, California

GP: You started graduate school at the University of California, Irvine, in 1969, which was the MFA program's first year. What was the school environment like?

CHRIS BURDEN: Well, it was an interesting program. It was brand new. They didn't have any facilities, really. Everybody had to get their own studio off campus. And it was a really small class—only fifteen people. Robert Irwin taught there. A lot of minimalists taught there at the time, and they had connections to people in New York. One of the things that they said, which I really liked, was that your acceptance into the program constitutes a degree, so the mere fact that you've been accepted guarantees you an MFA. So it was kind of a tacit acknowledgment of that and a handing of responsibility to those individuals who were in the graduate program. I know in my case that there was a whole issue in the end about me graduating because I did that locker performance [*Five-Day Locker Piece* (1971)]. I only heard this through gossip and rumor, but there was a big debate about whether they were going to give me my degree. But Bob Irwin was on the committee, and he said, "Well, I'm sittin' here until you do."

When was the first time you worked with video? It was probably right around 1970 to '71. Somebody lent me one of those reel-to-reel decks, and I made a few things. I was also using Super 8 film, too. I think *Shoot* [1971] was shot with a Super 8 camera for a ten-second film clip.

You took a lot of different approaches to documenting your performances. Sometimes it was just audio, sometimes it was film or video, sometimes photography. Yeah, I didn't really film very much stuff. Most of it is happenstance footage. I had to get it back from viewers who happened to be in the audience.

In fact, I was sort of anti-taping, anti-filming, because when I was performing, I thought a still photograph was the better way to go. Seeing a tape of a performance is misleading, I think. A lot of people aren't sophisticated enough to understand that a moving image isn't the real thing.

Well, video also limits the view. You don't get the environment, you just get an image. Yeah, exactly. You think you've seen it: "Oh, yeah. I saw that performance." No, you didn't. You saw one point of view. You didn't hear the people coughing or notice the smell.

And the psychological aspect. The social aspect of the audience. Exactly. It divorces you from that. So it isn't a true experience, in that sense. It's a document. So that was one of the reasons I stayed away from filming and videotaping as a rule of thumb to document a work. It was usually documented through still photographs.

But in 1975, you did make this tape where you compiled film and video footage of your performances, and you made a narration walking through them. There's a close-up of your face, and you're talking about what the pieces are and describing them, giving some background, and then showing the footage. What led you to take that approach? There was a woman named Sandra Devlin in New York, and she was videotaping artists and doing interviews with them. She wanted to do a tape with me, and somehow Ronald Feldman linked me up to her. She had a little apartment, and I sat

could chop it up in the blender. But every time I came up with a proposal, the station manager would nix it for some reason. I got so frustrated that eventually I said to Phyllis, "Listen. We're just gonna do a straight interview, and talk about all the things that we can't do on live TV." And one of those things was a TV hijack—which I then demonstrated. But *TV Hijack* was just a demonstration of the kind of things I wanted to do. It was really about who was going to be the paint for whose palette. It was dramatic. I was just an act for the station manager's program, but I wanted to use him in some way. So after he taped, I went into the control booth and said, "Hey, can I see that thing?" He had a big two-inch Quad tape of the program, and I took the reel, rolled it out on the floor, and I sprinkled acetone all over it. It was a way to use his tape to make my work. I had my own video crew who taped the taping of the show, and the station tape's destruction.

Where's that tape? My guys forgot to push "Record," so there is no record of any of it, unless somebody taped it at home. But people didn't have VCRs at home then, so it was truly a one-time event.

Did Phyllis Lutjeans know that you were going to demonstrate a hijacking? No. But she knew me, so it was more complicated. I think that to this day, she's pissed off about it. She doesn't say it, but—

Well, you held a knife to her throat. Yeah, but it was a demonstration. So there was that funny edge, you know what I mean? "This is

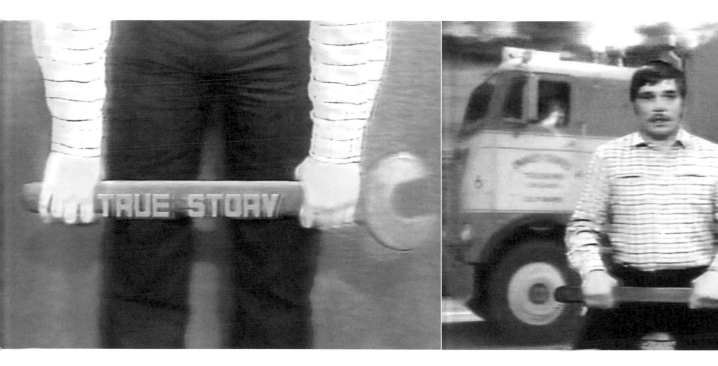

in a little hallway with some rugs in it, and that's where we made that tape and put it together.

One of the things you did that is unique compared to a lot of artists working with video, is you started thinking about broadcast pretty early on. Maybe we should talk about *TV Hijack* [1972]. The TV station was this local cable station down in Orange County; it served the Irvine community—all three thousand homes then, or something. They had a dedicated station, and there was this lady that I knew named Phyllis Lutjeans, and she ran a little art show every other week. She wanted me to do something, and it was a live show. I kept coming up with proposals trying to integrate my actions with the fact that it was a live show. I came up with this crazy idea that I would eat the tape as they were rolling it, or we

a demonstration of a plane hijacking. It is not real." But it gets kind of scary if you're on the flight.

And were you saying, "This is a demonstration. This is not real?" No. I think I said, "I'll demonstrate a TV hijack, my fantasy of what it would be." But you have to remember, hijacking was good back in those days, right? D. B. Cooper was a hero. It has a different nuance now. A lot of things change over time.

Did your friends see it, or did you run into people who saw it? Nobody saw it. I mean, come on. Who's watching community television at one o'clock in the afternoon in Irvine? I think it's all sort of hypothetical.

p. 62, p. 63 bottom
Chris Burden, stills from *Big Wrench*, 1980. Single-channel video, color, sound; 17 min., 29 sec.

p. 63 top
Chris Burden, still from guest appearance on the network television show *Philbin and Company*, 1974. Color, sound; 60 min.

You were interviewed by Regis Philbin on his show _Philbin and Company_ in 1974. That's an amazing tape. First of all, it's on Christmas Eve, and the first interview is with Snoopy—someone in a Snoopy costume—but he has to have a guy lead him out to Regis because the costume doesn't have enough holes for him to see through. And then you come out, and it's actually three whole segments. And then after I go off, the next interview is the current police chief of Los Angeles, and Regis is so upset about me that he keeps asking the police chief about this guy who shot himself. And the police chief doesn't even want to deal with it. He just wants to talk about the civilian review board or something.

Well, Regis obviously didn't know about _TV Hijack_. But it's kind of an incredible interview. It starts with Regis talking about how he's going to interview the Evel Knievel of the art world. But he doesn't get the interview that he wants. In the first segment of the interview, he's struggling. But then, after the commercial break, he's completely composed himself, and he starts asking all these hard-hitting questions. It's actually a very probing interview. At the same time, you're trying to explain to Regis Philbin about how _Shoot_ is a sculpture, but it's only sculpture for that fraction of a second when the bullet is fired and going through your arm. I know, he's having trouble adding it all up.

Surely, people saw that one. Did you ever have a case after that where someone recognized you from being on television? Not from that one, but from the TV commercials. Fifteen, twenty, twenty-five years later, people would still come up to me and say, "I remember seeing you on that commercial you did." I mean, they weren't commercials really. They were just snuck in using the commercial slot.

Describe some of those ads. Well, the first one was from a performance I did, _Through the Night Softly_ [1973]. I crawled through broken glass with my hands behind my back, but the idea was I was thrashing through the universe, and those pieces of glass are stars, so it's that sort of existential activity. When you see it on

TV, there's a Tide commercial, there's a Chevy commercial, and then this thing comes on, and it's like, "What is that?" There's a ten-second clip I repeat three times. And it's basically just this guy in a little Speedo thrashing around. The whole idea came about because of Billy Adler and, I think, Van Schley. A bunch of us were driving to San Francisco. Maybe it was Lowell Darling. We were talking about how we could get on TV. It was so unfair that it was a monolithic structure. It was a one-way street—you know, it only came at you. And I thought, "Oh, I know how to get on TV. You buy it. You pay for it, and then those minutes are yours. You put a crack in that monolithic wall and they'll be none the wiser." So I actually walked into Channel 9 with a film can in my hand. I had an appointment with a salesman, and he says, "You know, you'll have to pay up front because you don't have an account here." And I said, "That's no problem." We picked out time slots that were really cheap. The late night ones were like fifty dollars a crack, you know? Fifty dollars for thirty seconds on real TV? Come on, how can you beat that? So I wrote him a check for a certain amount of slots. I got a _TV Guide_ and circled the program that I was supposed to be on, so I would stay up and watch, to make sure my damn ad would come on. So I'm watching for a couple days, and then—bang—it isn't coming on anymore. So I call the station. "Oh, the manager of the TV station was watching last night, and he saw your ad and just flipped out. He pulled it." And I said, "Excuse me? I paid in advance. That's a breach of contract." So then I called up these lawyers that were helping artists then, and they wrote him a really nasty letter, and the station put it back on the air. They played it a bunch of extra times just to pacify me. It was so much fun. I just can't tell you. It was like David and Goliath, that I could push these guys around a little bit. But it was fun, and a great way to spend money.

The next was _Poem for L.A._ [1975]. Yeah. How does it go? "Science has failed." "Heat is life." "Time kills." Those were all slogans that street poets had graffitied on the wall of my studio on Ocean Front Walk. So I just used those as words, and there's a head shot of me saying it, and then the words come up in block type. It's a ten-second clip that's repeated three times.

p. 64
Chris Burden, stills from the TV broadcast of _Through the Night Softly_, 1973. Single-channel video, black-and-white, sound; 30 sec. LBMA/GRI (2006.M.7).

The next one, *Chris Burden Promo* [1976], also ran in New York, and I actually paid for one slot on *Saturday Night Live*. People saw it, and they thought it was part of the show. They didn't realize it was a commercial that was purchased.

Chris Burden Promo was about the phenomenon of fame. Someone showed me a survey of the most-recognized names. In other words, if you go to a man on the street and you give him a list of fifty names, these are the five names that everybody recognized as artists. So I just added my name to the list. The commercial was those five names, and then mine.

Why not print or radio ads? Was it really just the television image that you wanted? Yeah. It was the television image I was interested in. I mean, it's a great feeling. You're driving down Santa Monica freeway and looking out, and you see all those houses, and you go, "Oh, man. All those people are getting it, whether they like it or not." It's sort of force-feeding a lot of people against their will, in a certain way. You know, you watch television. Whatever comes out is what you get.

***Chris Burden Promo* is a work that a lot of other artists have mentioned because they saw it and then got mad because they didn't think of it.** Yeah, I know. A lot of people comment, and I thought that was pretty funny. I think it says something about what television is, too. A lot of artists in New York told me they got really upset, because when you go into TV mode, you're turning off, right? It's too close. If you're an artist in New York, struggling, trying to go up the ladder, and then you shut off for the night, you're trying to tune that out, right? And you're watching TV. The last thing you want to see is some other artist. It's a statement about the power of television. If I were rich enough to run that ad every day for years, then it would, in fact, become true. You'd ask the man on the street, and they'd check off my name. They wouldn't know what I did, but they would know my name. It's Pavlovian in a certain way. It just gets pounded into your head. Name the six most important artists, and my name would be right on there because they would've seen it so many times.

What about the final one, *Full Financial Disclosure* [1977]? Well, it was a parody; I was showing all my income tax forms at the gallery, as flat work. Each month was a drawing. They were my canceled checks and a little text next to each one. And my income tax returns. The commercial was a head shot of me with the stars and stripes behind me, and it goes something like, "In this post-Watergate mood and this new openness on Capitol Hill, I would like to be the first artist to make a full financial disclosure." And then it goes, "In 1976, I made da da da gross income. I got a grant for this, and my net profit was, you know, one thousand one hundred dollars. Thank you very much," you know? So it was just because there were all these financial scandals—you know, funding and the NEA and stuff like that—so it was just a parody. It was like I've come clean as to where I got all my money, where it went, and how much I made, okay? I'm clean. "Full financial disclosure," right?

Let's talk about *Big Wrench* [1980], which is a really hilarious narrative piece. I think it was a commission from the San Francisco arts organization La Mamelle. It was broadcast live on a Chinese television station in San Francisco. La Mamelle had some sort of deal with the station. It's a story about a big truck that I bought, a big tractor-trailer, which I named Big Job. It was a 1950 Ford, and it was a total wreck. The story is all these crazy fantasies of what I was going to do with the truck, which were totally unrealistic. And then I am holding a huge wrench, which is what I had to use to take

the gas cap off—not that specific wrench, I believe, but another wrench. But it was symbolic of this stupid truck that I bought. And it is just all the crazy fantasies, about shipping antiques from the East Coast in partnership with my mom. Going around and showing the *B-Car* and my handmade television, making an airplane that would fly out of it, just all these nutty fantasies. And then in the end how, you know, I could not carry any of them off. I had to sell the truck, and I lost a lot of money. I sold it to some guy who was going to move his family to Tennessee in it. I printed the story, too, and Elyse and Stanley Grinstein saw the story, and they wanted to buy it. They were going to put Big Job in the front yard of their Brentwood home. But I blew it, because it was gone. I had sold it to that guy who just moved to Tennessee. So it was no longer available as an artwork.

Did you think of this as an allegory about what the art world was like at this time? I think it was just a way of getting out my frustrations about it.

But it almost relates to the object returning from conceptual art, where it had been absent. With Big Job being this— Object.

Huge, huge object. And then at the point that someone wants it, it is not there. Right.

You do all these variations with it. It almost follows this path of what the art world had actually gone through during that time. Well, conceptual art managed to sell things even though they were not objectified. That's the nature of the business in a certain sense.

For all of its pretensions of being separated from the market and getting rid of the object, conceptual art really just put all the focus on the artist's name. It brought branding to art in a new way. I know.

And, of course, video helped that along. Someone like Vito Acconci became physically very recognizable because of his tapes. It's an interesting thing. Skipping forward, though, you recently completed a new video, which you call *The Rant* [2006]. It doesn't really have a title. I call it *The Rant* for cataloging purposes. It's about two minutes long, and it's a close-up of my face with green goggles on, lit by candles. I am talking and speaking in French, and I call myself the Preacher of the Truth. It goes something like, "I am the Preacher of the Truth, and I sense among us a foreign force, a force that violates the equilateral triangle. As you know, the equilateral triangle is composed of three forces: civilized humans, domestic dogs, and wild dogs. The danger of the other, the wild man, is that he can infect the wild dog, who can in turn infect the domestic dog, and finally the domestic dog can infect the civilized human, and the whole world can become wild. How do you recognize the wild man? Well, their cooking stinks. Their women are all ugly and whores, and their soldiers run in time like rabbits. But most important, and most profound, they have not accepted the goodness of the good God in their heart. One can never make an accord with the other, the wild man. One must always redouble one's effort to fight this fourth force, the wild man, the devil himself." And that is it. It's all a euphemism for Christianity.

What led you to make that piece? Current events, probably. Originally, it was called the Christian Imam. That was what I was going to call it, and I backed off on that because of self-censorship. It becomes too hot a topic. This way, it could be the Mayas versus

JEFF CAIN

Born 1975, Plainview, Texas
Lives and works in Los Angeles, California

IN JEFF CAIN'S *RADAR BALLOON* (2005), a simple modification to a grade-school science project triggers a dramatic response from some of the most sophisticated military equipment in the world. The video begins in an otherworldly terrain in the Mojave Desert near General Atomics, a military subcontractor that manufactures the Predator Drone Unmanned Aerial Vehicle. The landscape is nearly empty except for rattling wind, brittle sunlight, and a lone figure in the near distance conducting an experiment on the properties of heated air. Holding one end of a fifty-foot-long weather balloon, he fills it by catching a gust; with a snap, the crackling plastic assumes the shape of a cylinder, tethered on one end to keep it secure.

As grade-school science students know, dark materials readily absorb heat. The air inside the black balloon quickly becomes warmer than the air outside, and the balloon begins to float. The lone scientist moves to release the tether, and the balloon seems to come alive; it curves and bends and snakes around, floating slowly, like a prehistoric deep-sea creature riding ocean currents. We watch this ballet, this unexpectedly graceful, animated object gliding along as if in slow motion.

We are jolted from our reverie by a bit of text that notes, "The directions emphatically state that you should leave your balloon tethered, as a flying object this size registers on the FAA radar." With this information, Cain's seemingly friendly gesture—releasing a beautiful balloon in the bright sunlight of the desert to "make contact" with General Atomics—takes on a provocative and less than innocent aspect.

The force of the United States military is unleashed, and drones—apparently the type known as Predators—appear like giant bees, or prehistoric airborne dinosaurs, heading east in pursuit of the balloon; all this, despite the fact that the facility reportedly is not located under restricted airspace. The speed, cost, and intensity of this action give a new twist to the pure research of the experiment.

Radar Balloon is a project of Shed Research Institute (SRI). Two years after receiving his Master of Fine Arts degree from the California Institute of the Arts (CalArts), Cain founded and launched SRI as a platform from which to pursue artistic inquiries and develop and embed art projects in unlikely venues or situations and to document such investigations initiated by others. SRI has no fixed address but has offered programs in a variety of places that include art galleries, doughnut shops, deserts, and more. SRI grew out of the short-lived Wedge, a similarly spirited alternative enterprise (albeit one that focused more on installations) located in a small triangular-shaped space in the old Woman's Building in Los Angeles. Cain founded Wedge in the late 1990s and ran it for two years, until he enrolled in graduate school in 2001. Cain's videos and installations, as well as his work with Wedge and SRI, reflect his commitment to pursuing a solo studio practice as well as developing collaborations and productions with other artists.

Irene Tsatsos

pp. 66–69
Jeff Cain, stills from *Radar Balloon*, 2005. Single-channel video, color, sound; 7 min., 11 sec.

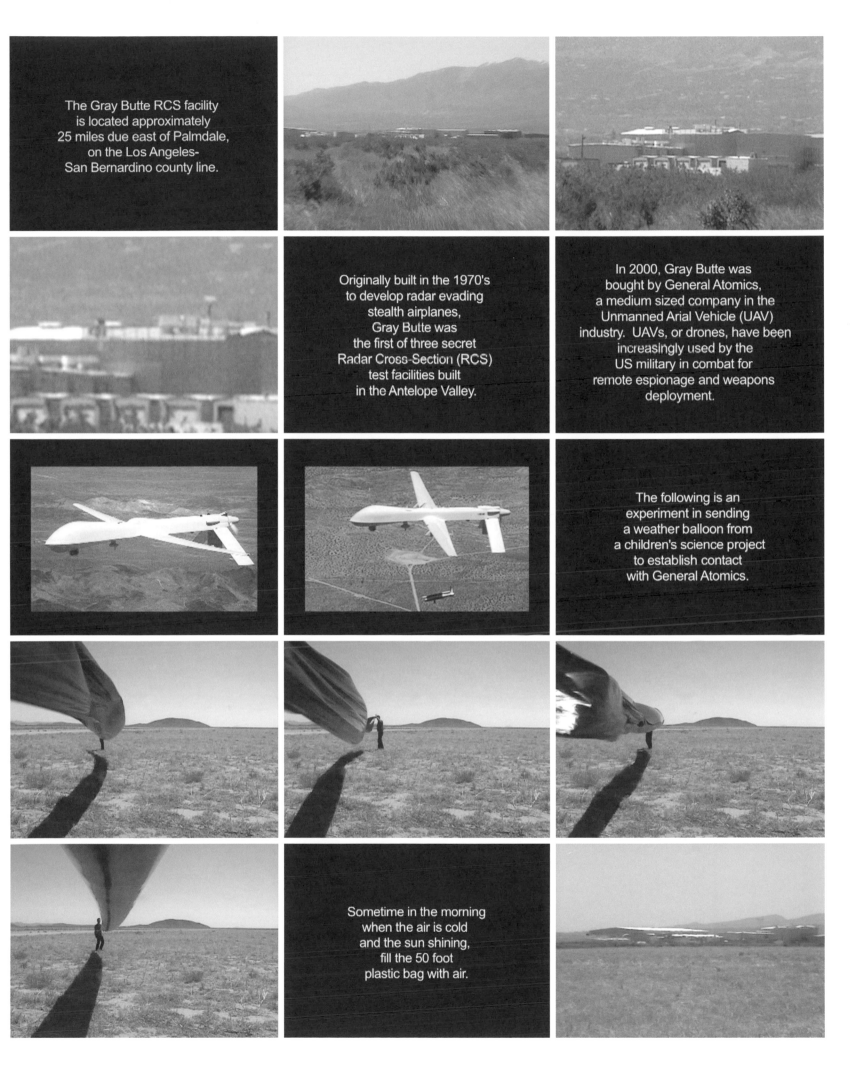

The Gray Butte RCS facility
is located approximately
25 miles due east of Palmdale,
on the Los Angeles-
San Bernardino county line.

Originally built in the 1970's
to develop radar evading
stealth airplanes,
Gray Butte was
the first of three secret
Radar Cross-Section (RCS)
test facilities built
in the Antelope Valley.

In 2000, Gray Butte was
bought by General Atomics,
a medium sized company in the
Unmanned Arial Vehicle (UAV)
industry. UAVs, or drones, have been
increasingly used by the
US military in combat for
remote espionage and weapons
deployment.

The following is an
experiment in sending
a weather balloon from
a children's science project
to establish contact
with General Atomics.

Sometime in the morning
when the air is cold
and the sun shining,
fill the 50 foot
plastic bag with air.

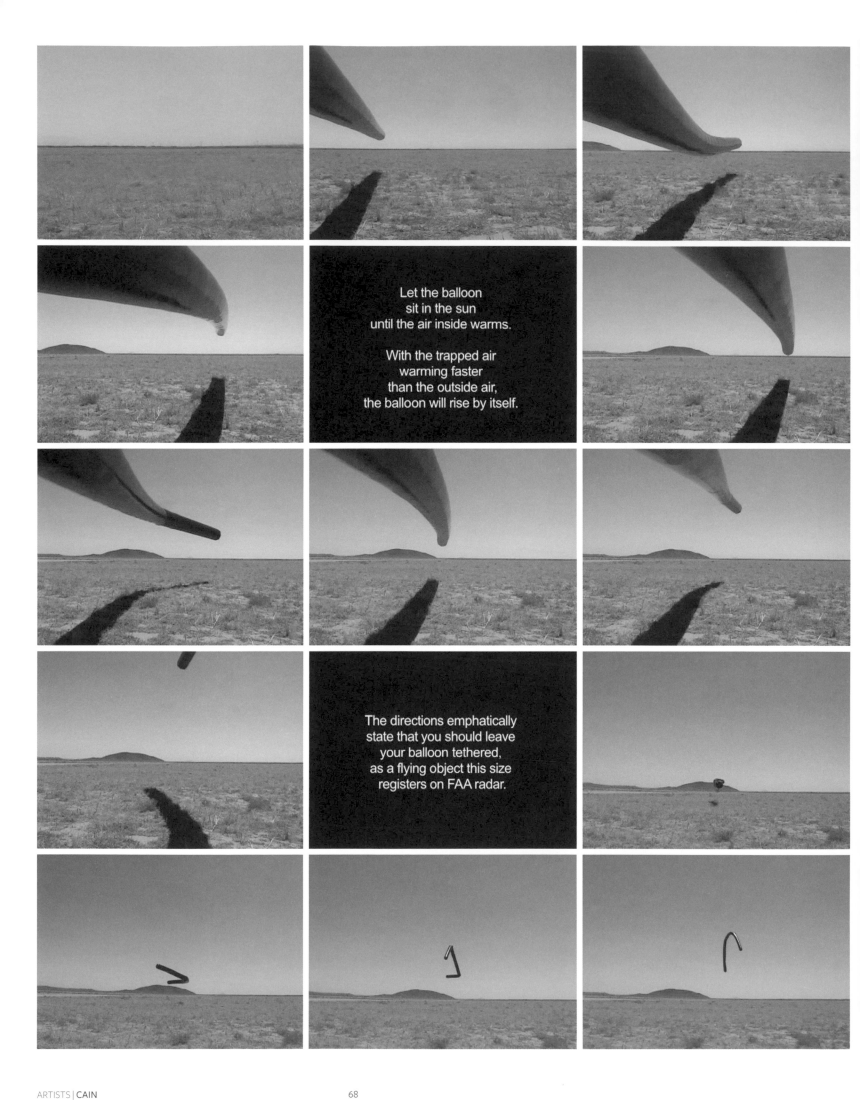

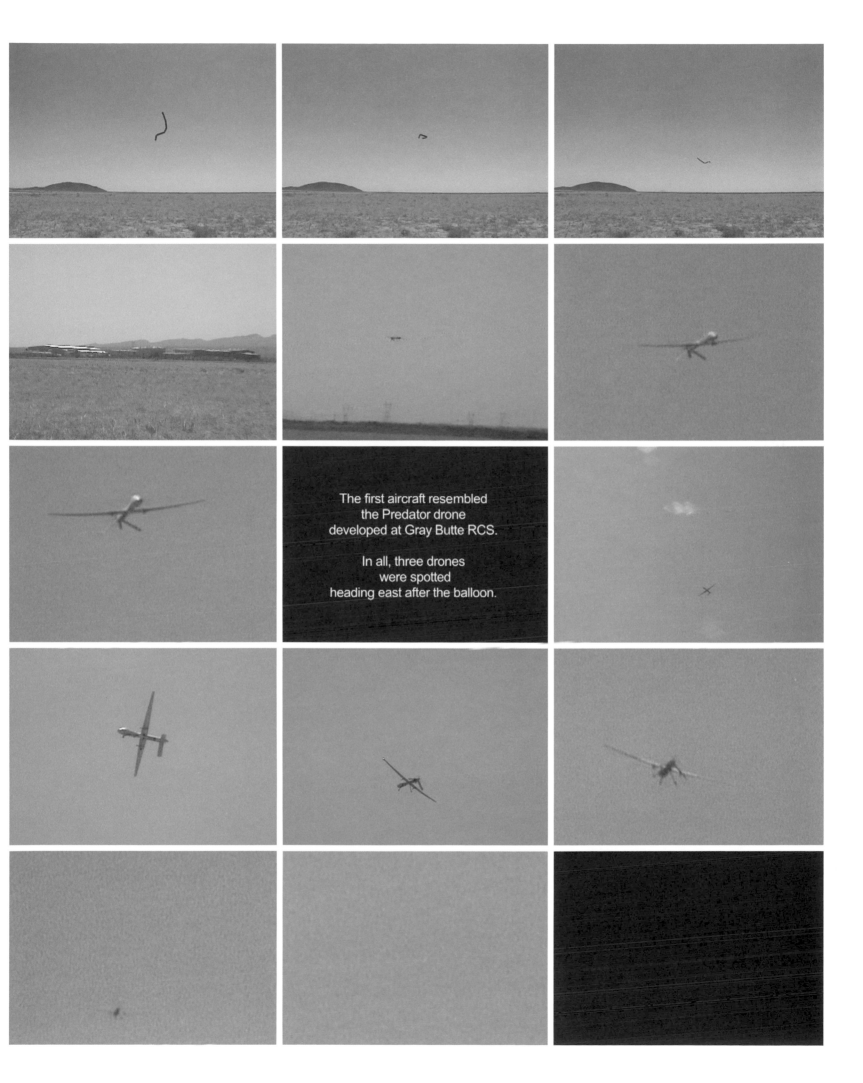

The first aircraft resembled
the Predator drone
developed at Gray Butte RCS.

In all, three drones
were spotted
heading east after the balloon.

JIM CAMPBELL

Born 1956, Chicago, Illinois
Lives and works in San Francisco, California

ONE OF THE FOREMOST ARTISTS working with computers and digital technology, Jim Campbell has produced a substantial body of work incorporating live video, real-time electronic manipulation, and light-emitting diode (LED) configurations, which replace typical video display. In 1978, he received his Bachelor of Arts degree from Massachusetts Institute of Technology (MIT) with a double major in engineering and mathematics. After three years repairing video equipment, Campbell began making his own videos and, in 1988, he began to make sculpture and installations. While many of his works begin at deeply personal departure points, his themes of time, memory, and knowledge resonate widely, particularly as the viewer often participates as a central element. In pieces like *Hallucination* (1988–90) and *Ruins of Light* (1992), the viewer is projected into the display by the layering of live footage over prerecorded material.

Although his work suggests the idea of interactivity, Campbell is quick to deny that it permits interaction with technology, believing that what is often labeled interactive is truly dictated by the design of the machine. Instead, these installations function as tools to measure the viewer's movement in time, causing the viewer to interact with him- or herself. With the *Ambiguous Icons* series (2000–2003), Campbell separates video imagery from its normal display technology, using spare grids of variably bright LEDs to explore the minimum amount of visual information required for one to perceive a moving image. With the *Home Movies* series (2006–2007), Campbell takes this exploration further by expanding the LED grids into large strands, which, turned backward, reflect light off the wall, requiring the viewer to look through the display technology in order to see the image. Despite this further obscuring of the image, large-scale depictions of conventional home movie scenes are clearly discernable. A child crawls on the ground. A car drives by the camera. These silent black-and-white images stripped to their rudimentary forms could be anyone's home videos and are at the same time familiar and elusive.

Pauline Stakelon

Interview conducted by Glenn Phillips on March 22, 2007, at Jim Campbell's home in San Francisco, California

GP: Let's talk about how you wound up in California, because I know that you got your education on the East Coast. Did you move to San Francisco shortly after college?
JIM CAMPBELL: I graduated from MIT in 1978, and I pretty much had a lousy time there, so I wanted to get out of Boston. San Francisco had Silicon Valley, and I had just gotten a degree in electrical engineering—it was a quick decision to move out here. I had taken some video art classes in college, and I wanted to figure out a way to pursue that, so I got a job at a video production company for two or three years where I was basically doing production and maintenance, but I could use their equipment for doing single-channel video work.

So you were making single-channel video back at the end of the seventies? Yes, I was. Not anything that I show anymore, really. I would call them narcissistic experimental documentaries.

Could you pick one and describe it? Sure. Ricky Leacock, who was one of the inventors of cinema verité, was one of my professors at MIT, so that was one of the directions that I had gone in. I was dating a woman for a few years, and I decided I wanted to do something with our relationship. We had a big fight, and I pointed the camera at her and said, "Say whatever you want," and I left the room for a half hour. That was one of the tapes that I showed around for a while.

Where were you exhibiting your early work? The first work that ever got exhibited anywhere was in 1980—I remember that, because the show was called *Video 80*. It was in the San Francisco Video Festival, and the video was in a different direction from the work I was just talking about. It was abstract technical colorized imagery, but image processed.

So then later, in the eighties, you went back to your engineering background? I was always doing engineering, but in different degrees. I started engineering serious design of video products in 1983. I originally worked for, and still work for, a company that could best be described as the Dolby of video. They do video noise reduction, to make video look as good as it can look.

When was the first point you felt that your engineering and your art making really joined forces? In 1988; a friend of mine and I rented a space in the Tenderloin, and for two weeks we put up a show of our work. I would say it's the biggest break that I've had. I showed a piece called *Interactive Hallucination* [1988]. Bob Riley from the San Francisco Museum of Modern Art came to that show, and he put me in his next exhibition.

When I look back on the work now, I see it as a complete failure in accomplishing what I wanted to do. It was a work where I wanted people to feel what it might be like to be mentally ill, and in this case, to see yourself set on fire. Technically, it worked pretty well. It really did set the viewers on fire relative to the room around them, but the work was much more entertaining than I expected it to be. I expected to upset people, and I didn't.

You went a little further, though, than just that visual effect. There are more things that happen. At certain points, in addition to the live video, you see it mixed with characters that aren't actually behind you. There's a whole series of other things happening that are mixed in as well. The 1988 piece was just setting

people on fire. I created a second version of the piece two years later, which was my response to the fact that it wasn't doing what I wanted it to do. I basically dropped the word "interactive," because at that point it was a very trendy word, and the work became *Hallucination* [1988–90]. I used a couple of new techniques that I was hoping would cause people to look at themselves differently. In particular, I would freeze people's images. So instead of seeing this live, wave-your-hand-at-the-camera reflection, you would see this image of yourself in the past burning, and that was much more effective. And then there were a couple other things that I added, as you pointed out. There was a figure in the space and she would do things—flip a coin for example—and, based on the things she would do, she would affect the space, and consequently affect your reflection in the work.

Did you feel that it was more successful once you had added in the other aspects? Still completely unsuccessful, but yes, it became more successful. People had to step back a little and just look at it, because it was no longer immediately responsive. There was another thing that I did that actually upset people more than seeing themselves on fire: sometimes the woman comes out and flips a coin, and based on the flip of the coin, you just disappear. I'm not sure why, but that was more disconcerting to people than to see themselves being set on fire.

Probably because it implies they're being arbitrarily judged. This notion of live feedback that you've incorporated in lots of your works is also connected to another notion that you've worked with all along, which is that of time and memory. I think it was around the time of *Hallucination*, or shortly after, that you started working with time delay in some of your pieces. Could you describe some of those works? There's a work called *Memory/ Recollection* [1990], which consists of five monitors, and essentially you see a series of still frames on the monitors and they gradually fade. An image starts on the left and slowly fades to the right, and as it fades to the right it gets noisier and noisier. It had a computer with a hard drive hooked up to it; it was a very small hard drive at the time, but it could store a thousand images, I think. The computer would not only show you this live animated representation of the present, but it also captured, based on the movement of the image, some images in a more permanent way and it would intersperse the past with the present. So the work was kind of defined by its history and where it had been.

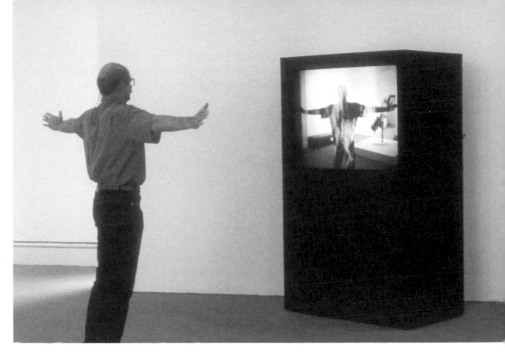

p. 70
Jim Campbell, installation view of *Home Movies 920-1*, 2006. Custom electronics, white LEDs, 457.2 × 609.6 × 7.6 cm (180 × 240 × 3 in.).

p. 71
Jim Campbell, *Hallucination*, 1988–90. Interactive video installation, black-and-white video camera, rear-projection video monitor (127 cm [50 in.]), laser disc players, custom electronics, dimensions variable. Collection of Don Fisher, San Francisco.

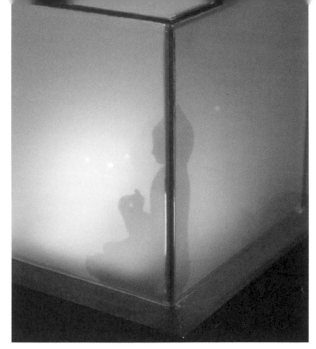

Ruins of Light [1992] is another piece where the video camera picks up the surroundings, but you're also mixing in a whole range of other imagery. *Ruins of Light* brought about a whole new set of challenges, because that was a public artwork. I really wanted to get around the notion of having the work feel like it was a rerun, a video playing over and over again. But how do you do that? I came up with a couple of strategies that worked pretty well. It's a database work, basically, and there's five hundred, maybe six hundred still images that were on the hard drive of the computer, and a half-hour of moving images. The hardware was set up to layer these images in real time on top of each other. There is almost an infinite number of combinations possible, so the piece is always going to feel slightly different. It also had live video cameras, and I used a lot of the freeze-frame, so that you would see yourself more as a photograph than as a moving image. Secondarily, the work functioned as a clock and a calendar. Different images came up at different times of the day and at different times of the year. So those two things were the processes that I used to avoid the rerun feel of the work.

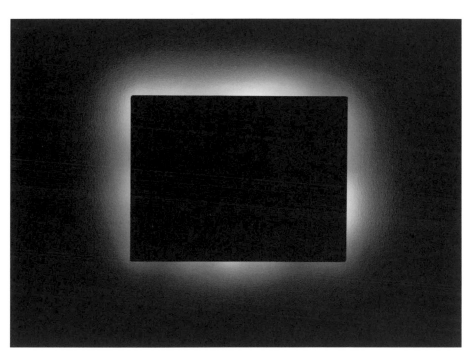

When you say it functioned as a clock and a calendar, give me an example. What would happen at a certain time of day? Well, for example, one silly thing that would happen—I'm a vegetarian, and the work ended up being in this tacky food court right next to a Taco Bell and a McDonald's. So every day about noon, I had a group of cows come to eat some hay. Other things were sort of holiday-based. I did a short work about using Native American petroglyphs on Columbus Day. There were some jests, and some other things based on holidays, etcetera.

One of the interesting things about *Ruins of Light* is this relationship that it has to history, because you see a whole series of architectural spaces or architectural details that might suggest the museum or that also might suggest archaeology, and then you also see lots of human figures. What were you thinking about with some of these images that you were mixing into the piece? Well, if you look at an image of the work in its location, I took the concrete columns that were functional columns in the lobby of this sports arena, and I enclosed them with these video columns. So I created virtual columns covering the real ones. A lot of the images were taken from sports arenas and coliseums from

southern Italy and Greece. I wanted to bring a sense of the coliseum's history to the work. The thing is called *Ruins of Light*, because these columns are generally in high decay. It's the first work I did that incorporated a lot of textures, so the textures become the background for the image, and then the viewers and other things become the foreground for the image. So part of the database is this whole series of textures, both architectural and from nature. The other theme of the work was the desert, because this was in Phoenix, and then the third was a fountain. I wanted the work to function slightly as a fountain, because it was in the desert and I wanted to bring some water there.

In the mid-nineties, you did a series of works related to the German physicist Werner Heisenberg. Could you talk about those a little bit? I did two works that were dedicated to Heisenberg. One is called *Shadow (for Heisenberg)* [1993–94] and the other one was called *Untitled (for Heisenberg)* [1994–95]. There were a number of things going through my head at the time, but one of them was that I felt like interactivity was too much about giving the viewers what they wanted. Something would happen for them just based on their walking up to a piece, and I really wanted to do some works that I would call anti-interactive. They went against both what you thought they would do, and what you wanted them to do. Because they were based on your position, it seemed like a nice analogy to Heisenberg's uncertainty principle, which says that you can't measure something without affecting it, and the more accurately you try to measure or observe something, the more you affect it. So with these two works, as you approach them, they disappear. One is image-based and the other one is object-based.

Describe how they work. *Shadow (for Heisenberg)* is a small, glass cube containing a statue of a Buddha sitting on a text, and the glass cube is on a pedestal. As you approach this pedestal, it fogs up in a proportional way, so the closer you get, the more it fogs up. The Buddha is lit from the inside, so as you approach it, the object turns into its shadow. The sides of the glass are made out of this liquid crystal display material, and they become translucent. You can't see through them anymore, but you can still see light. So you see the shadow projected onto the surface of this cube, and the Buddha is sitting on text, which you can never read because you can never get close enough to read it.

The second piece, called *Untitled (for Heisenberg)*, is a long, dark hallway. At the end of the hallway is a pedestal in the shape

of a bed, onto which I project video imagery of these embracing, naked figures. As you approach the figures, it zooms in to the point of abstraction, so by the time you're right next to it, it's completely abstract. For this work, I wanted each viewer's approach to the work to be different. I came up with this notion—it's a big word for a small idea—but it's called subliminal interactivity. So as you approach this work, it actually zooms into the part of the image that you're approaching. If you walk toward the head of these two figures, it zooms into the head. Walk toward the feet, and it zooms into the feet. It was a way of giving meaning to how you were approaching in your interactivity, without having it be meaningless.

You mentioned that in your career as an engineer, a lot of your work has been spent on video imaging technology. You later moved into a series of works called *Ambiguous Icons* [2000–2003], where, rather than using advances in video technology, you try to use the minimum amount of visual information that we can still read as video imagery. What led to that shift? Was it a reaction to your day job? Yeah, I think it was a reaction. I wouldn't say it was a reaction to my day job; it was a reaction to some of the things that I was discovering in the process of my day job. I was looking at the area of video image compression, and there was a company that had an ad for a compression technique, showing the before and after, and how close these two images were to each other. I looked at the images, and in the left image, the woman was smiling, and in the compressed image, she wasn't, and it was the same image. The compression had actually changed this woman's smile, and they hadn't even noticed that. So one of the things that triggered me to go in the direction of low information was that so much is lost in the process of taking something from the analog world to the digital world, and we're starting to do that with everything.

Not a lot of work had been done on moving images in terms of low resolution and how much information you need, so that's when I started to describe a new system that I was going to try to use. At that point, I was going to go in one of two different directions. One was to take a regular video image and work with pixelation, creating low resolution while using a regular video image. But I went away from that, which I'm really glad I did, because I wanted to build displays where I wasn't contriving anything in terms of using the display. I was using the display to its maximum capabilities, whereas if I were contriving a video image to look low resolution, that would have a completely different feel to it.

Describe the first *Ambiguous Icon* [*Ambiguous Icon #1: Running, Falling* (2000)]. The first *Ambiguous Icon* was an image of a figure running and falling. For works like this, the image either needs to be a figure or face, because those are the two things that we are programmed to recognize the quickest in their most primal form. I had built a device that was an array of 165 LED lights with electronic drivers. The number of gray levels was the same as on a computer now—256—and the motion was the same as what we normally see, thirty frames per second. So what I was specifically trying to do was to keep everything else really good, meaning the gray level and the motion, and just play with the resolution, with how much information you're looking at. I had no idea what the first one was going to look like.

Well, and then people were amazed by the piece. Here you are showing barely anything at all, but the piece seems magical, as if it's the biggest leap in technology that's happened in a decade or something—which is so interesting, because it does strip

things down so much that it sort of brings back this marvel of the moving image. Beyond knowing you needed a figure, did you try to tailor the imagery to the technology in other works in the series? The first series of works in the *Ambiguous Icons* that I think were maybe successful at matching the technology to the content was a series called *Motion and Rest* (2001). They were studies of six disabled people and how they walked, specifically their gaits. You can't tell anything about the figures. You can't tell their age, you can't tell their gender, you can't tell what clothes they have on, you can't tell what time period it is. All you can see is basically how they walk, so the medium itself distills movement.

Your most recent series, *Home Movies* [2006–2007], takes some of those same LED pixels and turns them toward the wall, essentially creating a very low-level projection system. *Home Movies* consist of a series of discrete pixels, each pixel on a little circuit board that's about an inch big, and these pixels are suspended by wires about six inches away from the wall in columns of pixels. So one column might have twenty pixels suspended from the ceiling. One of the things that I wanted to do, going back to the notion of Heisenberg, was that I wanted the viewer to look through the display device to see the image. More than look through it—to have the display device obscure the viewing of the image in an uncontrived way.

The first group of footage that you picked for this is all based on home movies. What motivated that decision? You know, it was just an intuitive decision to use home movie footage for that series. All my work is about obscuring in some ways, but there was something about the screen obscuring the image. It's definitely a big departure, because everything else has been stuff that I've shot myself.

Do you edit the home movies? I've edited for a number of reasons but the first reason is that maybe only ten percent of the images would show anything in that low-resolution representation. So they're filtered out for whether they work or not first, and then, secondarily, I've created two types of the *Home Movies* series. One is the landscape work where there are no people in the imagery, and then the opposite, the smaller works, are just people in the imagery.

So does that mean that each piece might have sections from several different home movies? Each piece does have sections from several different people's home movies, and one of the things about the black and white, and the way that I process the images, is that they all become tied together. One piece might have four decades, and probably eight different people's home movies over a ten-minute period of the cycle.

There seems to be a notion of loss and memory in the work, and the sort of poignancy of going back. Most of the works have figures in them, and the figures are strangers, but they're doing the types of things that you might find in every family's home movies. You wouldn't believe the similarity in the home movies that I've received from all over the United States from four decades. There is such similarity in the content and the types of things that were shot. My process takes away the details, which gives the imagery this universality. You project the same home movies with a film projector and you can watch them for maybe a minute or two. I mean, they're interesting, but you feel like you're looking at someone else's life, not your own at all. By taking away the details, they become more of a reflection of the viewer's past, a fuzzy memory.

p. 72 top
Jim Campbell, *Shadow (for Heisenberg)*, 1993–94. Custom electronics, video camera, glass cube with LCD material, statue, dimensions variable. Collection of the University of California, Berkeley, Art Museum.

p. 72 bottom
Jim Campbell, *A Fire, a Freeway, and a Walk*, 1999–2000. Custom electronics, fifty-two LEDs, aluminum, velvet, 27.9 × 38.1 cm (11 × 15 in.).

MEG CRANSTON

Born 1960, Baldwin, New York
Lives in Los Angeles and works in Santa Monica, California

MEG CRANSTON MAKES SCULPTURES, performance art, drawings, photographs, installations, and books, all of which reflect the melding of each of these disciplines. A conceptual artist who studied anthropology and sociology before getting her Master of Fine Arts degree at the California Institute of the Arts, Cranston relies on indexing and quantifying techniques to illustrate the worth or value of a person or thing. In the process of accumulation and display, found material and simply crafted objects are transformed from statistical findings into a poetic endeavor. One such work, *The Complete Works of Jane Austen* (1991), is an inflatable structure filled with the amount of air one would need in order to read all of Jane Austen's books aloud (approximately 100,000 liters). *The Average American* (1996) renders a computerized composite of a woman, based on statistics of the average American female. Dealing with her own "value," Cranston took all of her meager personal belongings and displayed them on a gallery floor in her installation *Keep Same Over* (1989). The accompanying inventory list was then published as the book *As I Told You* (1989). This project is a nod to Vito Acconci's *Room Piece* (1970), the difference being that Cranston, in an act of artistic renunciation, gave all the clothing and the rest of her belongings to charity at the conclusion of the show.

Cranston acknowledges that, historically, the floor has been a site where history or events are commemorated, and she often uses it as a repository for her ideas. In *Volcano, Trash and Ice Cream* (2005), an installation with several components, the floor is covered with the detritus of life (the *trash* of the title)—personal notes, wallpaper remnants, drawings, flyers, and photos ripped from magazines—which are collaged into a pattern resembling a large puzzle on the concrete floor. This "trash" is based on Cranston's impression of the littered public thoroughfares of Naples, Italy, strewn with trash. Looming above the ground like a large clock is a video projection of a pistachio gelato ice cream cone, melting in real time and accompanied by the soundtrack of a deep snorer (*volcano*), which rises from beneath the floor. The unstoppable nature of time and the sweet spoils of life's memories are symbolically evident.

Carole Ann Klonarides

p. 74
Meg Cranston, *Volcano, Trash and Ice Cream* (detail of floor), 2005. Video projection (color, silent; 60 min.), audio, and mixed media on floor, dimensions variable.

p. 75 top
Pietro Fabris, *The Eruption of Mount Vesuvius on Monday Morning August the 9th, 1779*. First printed in Sir William Hamilton, *Supplement to the Campi Phlegræi* (Naples, 1779). Facsimile of hand-colored etching, 21 × 38.4 cm (8⁵⁄₁₆ × 15³⁄₁₆ in.). Research Library, The Getty Research Institute, Los Angeles (84-B27609).

p. 75 bottom
Meg Cranston, *Volcano, Trash and Ice Cream* (still from video), 2005. Video projection (color, silent; 60 min.), audio, and mixed media on floor, dimensions variable.

VOLCANO, TRASH AND ICE CREAM
by Meg Cranston

This piece is a tribute to the City of Naples. "Volcano," "trash," and "ice cream." This is a list of the things that, in my view, give the city its admirable qualities.

The "volcano" in the title is a reference to Vesuvius. The original installation of the work had a sound component. Big speakers were attached to the ceiling of the floor below the gallery. They played a recording of an actor imitating what's called "heroic snoring"—it's an actual medical condition where a person snores so loud you can hear them at least two rooms away. In the installation, snoring was experienced as a faint rumbling—a vibration you could feel on your feet. I thought loud snoring was a good metaphor for Vesuvius and its relationship to the people who live in the area. They live at the feet of a sleeping Hercules—one of the most dangerous volcanoes in world. I think it might influence the character of the people. Everywhere in Naples you witness little eruptions—people exploding in anger, shouting, and freaking out. Everyone seems to be bursting at the seams—like their clothes are too tight. It's very hot in every sense. I am also a volatile person, so I feel very at home there.

The "trash" in the title refers to the trash on the streets in Naples. The city is basically blanketed in trash. All the trashcans are full to the brim with stuff ascending up into pointed cones of crap. I know it's a municipal crisis, but I see it as "happy trash"— the debris of happiness: a lot of bright-colored paper, mostly food wrappers, newspapers, etc. In the installation, I wanted to create a bright floor of discarded paper, including a lot of odd bits of paper from my own work—old Xeroxes, things like that. I like to use the floor as a place to view history—in this case, the history of my work as told by bits of trash, things that no longer matter. It's a giant collage. For me, collage is a life-affirming sensibility. The collage maker discards nothing; everything has potential. It's a ragpicker's medium.

Ice Cream is a large video projection of a melting ice cream cone. The ice cream (pistachio gelato) melts in real time—it takes about an hour. I think of it as a giant clock. I would love to have it in a public square. It melts in one-hour cycles and then is renewed. Everywhere in Naples people are eating ice cream. Ice cream is a pretext for social life. The city runs on it. I like the way Neapolitans blithely eat ice cream in the shadow of Vesuvius. I make the connection between the flow of lava and the melting ice cream with the trashcans and the volcano, the volcano being the inverse shape of an ice cream cone.

pp. 76–77
Meg Cranston, *Volcano, Trash and Ice Cream*, 2005. Video projection (color, silent; 60 min.), audio and mixed media on floor, dimensions variable. Installation view at the Happy Lion gallery, Los Angeles, 2005.

PETER D'AGOSTINO

Born 1945, New York, New York
Lives and works in Philadelphia, Pennsylvania

PETER D'AGOSTINO HAS WORKED IN VIDEO and new media since 1971. Also a theorist and critic, he has published books and articles on technology, semiotics, and identity. Engaging a broad range of discourses including linguistics, media studies, history, aesthetics, physics, and architecture, d'Agostino's body of work constitutes an ongoing investigation of the personal, cultural, and technological communication systems that permeate everyday life. He has synthesized theory and artistic practice in videos, multichannel installations, and interactive works that examine and critique the effects of technology on the individual and society.

Many of d'Agostino's works mobilize the language and techniques of mainstream media in critical investigations of media-driven consumer culture and its information systems. *Quarks* (1979–80), for instance, is a critique of television content and reception structured as a series of thirty-second intervals that juxtapose familiar TV patter with a layering of incongruous sounds, images, and text. In his three-part project *comings and goings* (1977–79), d'Agostino explores mass transit systems in Paris, San Francisco, and Washington, D.C., drawing parallels between complex urban infrastructures and social and linguistic communication systems. Dissociation is a prevalent theme throughout the work, made explicit in his 1977 work, *PARIS (Metro)*. A voice-over analyzes the etymological ambiguity of the word *metro*, while closed-circuit surveillance footage of trains and platforms conveys the dissociative experience of passengers in the transit system. "And when you add it all together," the voice-over concludes, "it is a source of confusion."

Andra Darlington

COME & GO
by Kristine Stiles

COME: 1b: to move toward or enter a scene of action or into a field and of interest whether partly physical or wholly ideal GO: *14a: to come to be: BECOME, b: to undergo a change or transformation.*[1]

Three phenomena are basic to Peter d'Agostino's art: origins, transformations, and receptions (in the sense of receiving, taking possession or getting; harboring and reacting through response). Selecting aspects of observable reality (manifest in events), he creates works that signify passages and relationships among these three points. In effect, he continually produces art that objectifies the transitive, visualizing movement through structures that incorporate spatial elements in sequence, quantity, and number, through language as symbol, and through the juxtaposition of real and illusory perceptions. His metaphors stay movement between approach and recession, that synaptic juncture where meaning resides and connects to recognition that produces knowledge....

Given his aim to still the meaning-laden moment in its ephemeral journey between things and experiences, the photograph in its various aspects—from film and video to broadcast television—permits him to freeze-frame observations and intuitions, to re-structure information as parable, and to provide insight through example....

I have used the word "transit" to highlight synaptic signifying relationships and to describe the ephemeral values inherent in d'Agostino's projects. Not only the media with which he works but also the formal architecture of his pieces conveys the necessity to formulate relationships in two-way communication, a core theme in his art. D'Agostino's shifts—in images of transit—also metaphorically enable spectators to enter into and perform in spaces where they can determine what communication means in the passage between origins and the ways in which movement in everyday activities makes change. Such is the site of reception, where the context for understanding the content of life is interpersonal communication enacted in participation, itself the substance of reception.

comings and goings
by Peter d'Agostino

Comings and goings represents a body of work concerning mass transportation and communication systems. These projects are explorations of mass transit, focusing on the *subway* as a system which interconnects a city, and the function of "transit" as metaphor: as a conveyor of information and a vehicle for communication. Within the context of a dialectical process, *coming and going* reflects my interest in the juxtaposition of personal and cultural codes of perception, language, structure, and ideology.

PARIS (Metro), *San Francisco (BART)*, and *Washington (METRO)* are video installations incorporating elements of the stilled image and written texts as an integral part of these works.

NOTE

1. The definitions in the title to this essay come from *Webster's Third New International Dictionary, Unabridged.* These two verbs incorporate a wide range of fields of action in which being, becoming, and undergoing change or transformation locate the reader in the domain of d'Agostino's work.

pp. 78–81
Essay by Kristine Stiles and texts by Peter d'Agostino adapted from Peter d'Agostino, *coming and going: NEW YORK (Subway) PARIS (Metro) San Francisco (BART) and Washington (METRO)* (San Francisco: NFS Press, 1982). Used with permission.

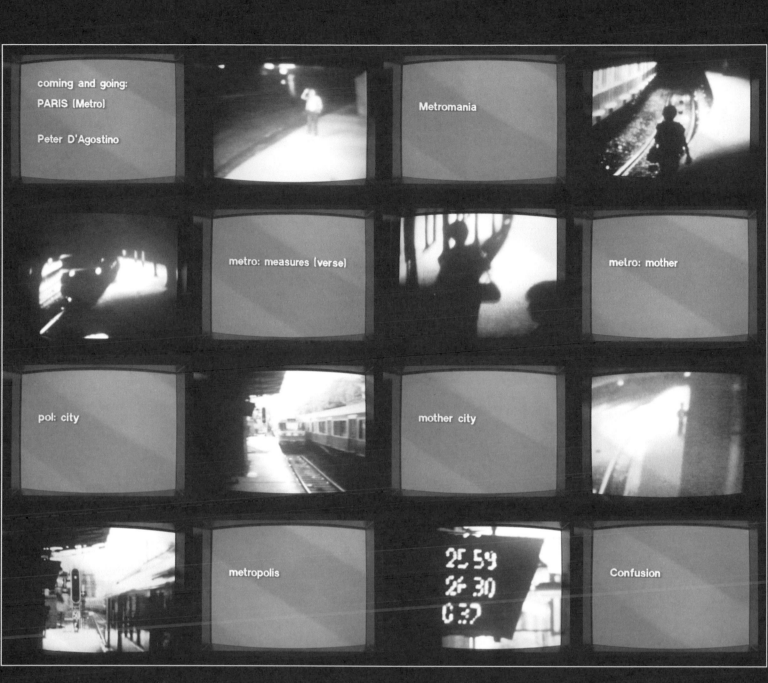

coming and going: PARIS (Metro), 1977

Filmed from video surveillance monitors, this videotape follows
passengers' underground travel through various stops, transfers,
and connections in the Paris Metro. Aspects of ambiguity and con-
fusion experienced in the metro are juxtaposed with a linguistic
parallel to the visual image: the etymology of the word "metro."

P. 79
Peter d'Agostino, stills from *coming
and going: PARIS (Metro)*, 1977.
Video installation, color, sound;
5 min., 20 sec. loop.

coming and going: San Francisco (BART), 1978

The general public and art community were invited to ride the Bay Area Rapid Transit (BART) from San Francisco's Civic Center to the Berkeley station. The basic structure of the event encompassed the everyday experiences of the BART commuter: buying a ticket, waiting on the platform, boarding and exiting the train, etc. Within this context, the broader framework of BART was investigated, from the inner workings of the system to the outside environment that parallels the underground route of the train. Functioning like an "installation-in-motion," observer/participants carrying portable video equipment with three TV monitors intermingled with other passengers traveling to Berkeley. Carried like luggage, these monitors displayed videotapes which provided passengers with access to several layers of images and information related to the BART experience, including: An automated ticket machine reject-

ing dollars as commuters attempt to buy tickets. A car drive from Berkeley to San Francisco, crossing the Bay Bridge while the train travels in the tube beneath the bay. A scene from the master control room shows the progress of the trains through the system, and the surveillance of passengers entering and exiting the stations. A series of personal messages programmed on BART's electronic sign system. These signs are used to announce train arrivals and destinations, display the time of day, and are usually programmed by intermittent advertisements.

My primary concern was the social activity itself and re-contextualizing this experience for the BART passengers. Keeping the theatricality of the event to a minimum was necessary to emphasize the work as experience rather than spectacle.

coming and going: Washington (METRO), 1979

Designed as a video installation for L'Enfant Plaza station, this work consists of three channels of video on three projection screens overlooking the platform.

On the *screen* to the *left* is a modified travelogue of Capitol sites, including the White House, the Washington Monument, the Jefferson Memorial, and excerpts from a Redskins football game.

The *screen* to the *right* shows passengers boarding and exiting trains throughout the system from Airport to L'Enfant Plaza as viewed from television monitors within the METRO's surveillance system.

On the *center screen* is a continuously rolling text: a chronology of historical events that led to the design of the Federal City by architect Pierre L'Enfant. Conveyed through L'Enfant's correspondence with President George Washington and founding father Thomas Jefferson between 1789 and 1792, it summarizes the architect's attempts to implement his master plan and the bureaucratic controversy that led to his resignation and his historical obscurity. (L'Enfant was not officially recognized as the city's original master planner until 1903.)

A separate soundtrack keys the visual images as they phase in and out of synchronous relation. The audiotape is composed of sounds from a METRO ride, music from the revolutionary period, a lecture concerning the politics of operating the METRO system, and a tour guide's brief comments on the history of the District of Columbia.

p. 81
Peter d'Agostino, stills from *coming and going: Washington (METRO),* 1979. Video installation, color, sound; 8 min., 8 sec. loop.

HARRY DODGE
and STANYA KAHN

Harry Dodge: born 1966, San Francisco, California
Stanya Kahn: born 1968, San Francisco, California
Both artists live and work in Los Angeles, California

HARRY DODGE AND STANYA KAHN'S collaborative videos are characterized by their comic pretenses and off-the-cuff narratives. Kahn, who was working in performance art, and Dodge, who was producing her own films, met in San Francisco and began working together in the early 1990s. With Dodge typically working the video camera and Kahn as the performative focus, the duo quickly developed a style and practice through which to examine the awkwardness and idiosyncrasies of art making, myth, gender, and video itself. Lois is a recurring character who embodies all of these themes. In her pitiful honesty and muddled appearance, Lois—played by Kahn—appears in two videos as a socially uncomfortable, but nonetheless intrepid, narrator. Candidly editorializing for Dodge's camera and off-screen voice, Lois leads the viewer through a series of situational circumstances that are both plausible and completely ridiculous.

In *Whacker* (2005), Kahn assumes a more symbolic and surface-driven role. Standing in an abandoned plot of real estate in what looks like Los Angeles's Echo Park neighborhood, Kahn, as a tattooed urban glamazon, mows a field of brush with a weed whacker. She is backlit by the sun setting over buildings and palm trees, a diffused lighting that casts a blond glow across the golden hillside. Studied from several angles, at times in slow motion, she speaks no lines. Wearing a floral halter dress, Candies high heels, hoop earrings, and aviator glasses, the ingenue diligently executes her task with the refined cool of a leading lady. Dislocated from the glitz of Hollywood, however, the whacker's action is suspended between romanticized performance and mundane chore.

Catherine Taft

DISSOCIATED/DISLOCATED: THOUGHTS ON THE SHORT VIDEOS OF STANYA KAHN AND HARRIET DODGE
by Miranda Mellis

The collaboration of Harry Dodge and Stanya Kahn has produced an exciting series of character-driven videos whose protagonists are, above all, under pressure: economic pressure, ecological pressure, and the pressures of class and gender (and, for that matter, genre) regimes. These pressures catalyze affective mutations and a sense of dislocation, a feeling of (not so transcendental) homelessness.

It is not surprising, coming of age as Kahn and Dodge did in San Francisco's Mission district, that site and dislocation should be central to their work. The Mission is reported to have been the most quickly gentrified neighborhood of any, ever. The increased homelessness in the city after a series of mayors (Art Agnos, Frank Jordan, Willie Brown) cut social services during their terms in the nineties, and the relentless, desperate refrain of housing and job crises among artists, the poor, and working people, was then, and is now, a constant reality of local life.

Responding to these basic geo-social circumstances, Dodge and Kahn work from the ethoi that the personal is political and the aesthetic is ideological. In their work, then, the aesthetic—including, crucially, the anaesthetic, and the anti-aesthetic—is leveraged politically. These videos draw attention to the aesthetic itself as a fraught category, using the heightened consciousness created by the frame only to crash it, transmitting/effecting cognitive comic dissonance via their signature punk-slapstick.

The talkative, culturally San Franciscan protagonist (as improvised by Kahn), recurring in the short videos *Winner* (2002), *Let the Good Times Roll* (2004), and *Can't Swallow It, Can't Spit It Out* (2006), is a hapless informant, telling on herself without knowing it, and on everybody else while she's at it. Her audience, capitalism, the art world, the media: all get caught in the glare she reflects. The "it" that can't be swallowed or spit out are the entrapping economics of capital, elitism, class. A canny trickster slips traps by shape-shifting, improvising, and taking advantage of opportunities when they arise. Lois, the heroine of *Winner* and *Let the Good Times Roll*, is such an improviser. In *Winner*, she is literally an "outsider artist" (she is outside throughout the film) who's won a cruise she's not interested in from a radio station contest.

"The cruise is inside," she says to Peter (Dodge), the radio station's laconic emissary, who has come to record Lois making good on her prize. But the eerie Lois has no interest in a cruise! Instead, she wants to show Peter her quote-unquote sculptures: a lint brush taped to a plastic shark, a candle in a garment bag, and so on. She stalls him; he never gets his sound bite.

Although Lois is cunning enough to suss out an opportunity to "get her work out there" via the providential arrival of media, she is (already) too far out to see that more than mortal wit is required, ultimately, for the conversion she craves. The structure of her ambition is all too familiar. She's looking for funding, she says directly into the camera, and she has so many ideas. Each time she introduces and "situates" one of her "pieces" yields a moment of recognition, not for Peter the foil but for the art-savvy viewers who see this video in gallery contexts (some of whom might find themselves identifying with her).

Can't Swallow It, Can't Spit It Out features a bloody-nosed Valkyrie (Kahn in a Viking helmet and braids), who has crash landed outside a hospital where she presumably will seek treatment, but which in fact she never enters, never *gets inside of* (much as Lois will never penetrate the art world except as a self-canceling symptom of its exterior border). This Valkyrie looks like she might not have anywhere permanent to live, let alone health insurance, even as her Wagnerian headgear is a metonym for nationalist white domination.

This ambiguous figure forges a more comradely relationship with the camera than Lois. Realizing she's being filmed from across the entrance of the hospital, and after some hostile and paranoid confrontation, the Valkyrie befriends the cameraman and they embark on a quest to "find action." Cruising around on foot, they come upon some strange local data: the residue of spontaneous combustion; a municipal garbage truck inexplicably dumping garbage on the side of a road. Less than spectacular action: the implied spectacle is the war in Iraq.

As night falls, the Valkyrie's aspect shifts. Gregariously extroverted during the day, she is making a study of the figures around her, haranguing the cameraman. By night she has stopped interacting and grows withdrawn. We see her repeatedly throwing some heavy, indeterminate object in a small park, as if to argue with futility. She stands on a picnic table and thrashes her head around. She's become the data; her psychic condition is the salient fact. The cameraman bears witness.

p. 82
Harry Dodge and Stanya Kahn, still from *Masters of None*, 2006. Single-channel video, color, sound; 11 min.

p. 83
Harry Dodge and Stanya Kahn, stills from *Whacker*, 2005. Single-channel video, color, sound; 7 min., 7 sec.

Kahn also thrashes her head in slow motion on one of the screens of *The Ugly Truth* (2006), which was made for a three-channel installation, her hair sensuously roiling, her face largely hidden by its ricocheting, campy flows. The image is pure lyric. On a second screen, she variously stands, gestures, and lies backward—seemingly stupefied, almost puppetlike—over what appears to be a lectern draped in green. She is silent throughout, taking absurd, incoherent directions from an offstage director (Dodge). At one point, however, the puppet snaps into head-banger overdrive. As if possessed, she sequences through hyper-expressive heavy metal "faces"—abstract portraits of conflict, warning, and passion. Now glaring like a furious gargoyle, now rattling her tongue and stabbing her hail-Satan devil horns in the air (the ritual heavy metal hand-signal), she seems likely to injure herself as she contorts. The "scary" faces she is making are impossible not to laugh at—so exaggerated and serious, so genre-iconic, they are cartoons of fear and ecstatic rage.

The family of "funny" faces in sitcom-on-acid *Masters of None* (2006) are, unlike those in *The Ugly Truth*, kind of scary. Eyes and mouths painted on pink cloth bags (worn over actors' heads), these faces are more literally cartoons. They alienate the face; they take the place of it altogether and overtly distort rather than represent it. Every quotidian object or act is torqued, every orifice *détourned*: bathing involves a hose, like a gun, to the head, and the requisite television in the living room plays a vigorous anal fisting spliced with a shot of an Olympic luge race. The luge rider hurtles out of control, feet first as if through the birth canal, and wipes out. An uncanny clan watches the TV from their couch. Uniformed in orange, they're at once prisoners (Guantanamo), a dance company, a band (Devo), and a cult (Rajneesh). Good American mutants, they do their best to consume their biotech corn-based food products (popcorn, ears of corn) in front of the electronic hearth, but it keeps falling out of their clothed-over mouths. Alienated in their appetites, they watch a huge lizard slowly eat, gulp by gulp, an equally large snake on TV. Unlike them, the lizard still has species knowledge, a nature that allows it to eat what it sets out to eat, while the post-humans on the couch have a seriously political eating disorder.

Masters of None combines dance, performance art, clowning, and horror to de-routinize domestic life. The family of four iso-morphic humans garden, romp, cook, watch TV, play, and even have a funeral after one of them collapses in the midst of a game of charades; the group's incapacity to parse her signs leads her to lie down and die.

The referent at the beginning of the game couldn't be more obvious: her gestures signify water. But the other players don't see it. The uncomprehending expressions on the "faces" of her audience as she strives to communicate her meaning are pitch-perfect depictions of the stupefaction and emotional withdrawal that comes with being stumped. Her bodily gestures, however, become increasingly opaque, poetic, and nonreferential until the very end when, fading out, she weakly mimes pulling shit out of her ass. Starved of their comprehension, she finally expires.

The fatal charades function as the disastrous denouement of this alternate reality. But it turns out to be no disaster. On the contrary, the funeral becomes the occasion for comical, hyperkinetic postmodern choreography. The oven, a magical furnace, is used to produce funereal biomass. They put in a tray of cookie dough and pull out a pile of dead leaves, which they pour over the body, now so much compost.

If the contorted faces in *The Ugly Truth* are satirical, and if the cartoon faces in *Masters of None* defamiliarize and permit us to recognize the face as a kind of communicative machine, the affected face in *Whacker* (2005) is fully masked.

Whacker opens on a small derelict hill, covered in dead weeds, at a Los Angeles intersection. The camera hones in on a high femme (Kahn) at her chores. She's wearing a minidress that exposes waxed, sexy legs as she makes her way across the hillside, steadily depilating its raunchy surface with a weed whacker, a Sisyphean task she undertakes systematically, with sultry grace. She pauses to scan the horizon and we see her impassive gum-chewing mug in close-up, half-covered by cop shades. Her hair bucks in the Quaalude breeze. She's hot, no doubt. The intersection she surveys, however, and the sprawl beyond, is distinctly anticlimactic. The scene is lit by late-afternoon sun, the glare muted by pollution. The only audible sounds are the whine of the weed whacker and passing cars muttering carbon dioxide.

Her dolled-up appearance and serene vibe are incongruous with her banal, toxic habitat, and this incongruity forms the central contradiction, the punch line of the video. As if under an enchantment, this archetype will project sexual charisma for all eternity, even as her domain is encroached upon by strip-malls. Like a mountain lion still hunting where developments have made her continued existence untenable, or a heron grooming in the last remnants of a marsh caught in the crux of three highways, she has adapted. The narcissistic pleasure she takes in her own image is a compensation, even as that image will fail the body, even as the image she telegraphs belies her besieged condition.

All told, these subversive, comedic videos are, among other things, reflections on thwarted potential and foreclosed possibilities. How might a person who is locked out, or locked in, recover, or even invent, a sense of agency? The imagination Kahn and Dodge have put to work here forges just such agency—a sense of place, possibility, and self, however ephemeral—with the means at hand: ritualistic theatricality, improvisational research, local engagement, and spontaneous, playful alliances.

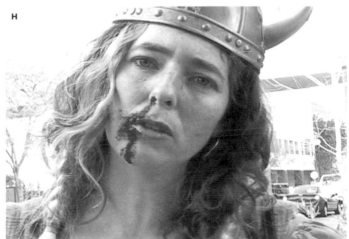

TERRY FOX

Born 1943, Seattle, Washington
Lives and works in Cologne, Germany

DRAWING ON ASPECTS of performance, installation, sound, video, and conceptual art, Terry Fox has developed a deeply symbolic practice that connects the material and physical world to mystical meanings. In the late 1960s and early 1970s, Fox began staging public, site-specific performances around the San Francisco Bay Area. As a kind of "street theater," these interventions were both political and ceremonial explorations of everyday life and natural phenomena. For one such event, *Wall Push* (1970), Fox pushed the force of his body against the side of a static building, demonstrating the perceptible differences between kinetic human energy and that of an immovable mass.

Fox again turned toward a basic investigation of physical principles in *Children's Tapes* (1974). For this work, Fox devised simple but sophisticated schemata of ordinary objects—a spoon, a dish, a piece of string, a candle—which, when affected by small variables like a passing fly or drops of water, would produce simple but dynamic outcomes. Produced for the artist's young child, each section of *Children's Tapes* depicts the artist's hands delicately setting up the experiment, the process that its individual elements undergo, and the effects of each action: five matchsticks are snapped in half but not broken; they are arranged on a table, edge to edge, to form a shape with five thick lines; water is dripped from a spoon into the center of the shape; the water expands over the surface area, pushing the wooden edges of the shape further and further apart; the matches move until the water settles and what remains is the form of a perfect, five-pointed star. In these intimate time-based episodes, natural occurrences, like absorption and surface tension, become dramatic narratives about the pleasure of discovery and revelation.

Catherine Taft

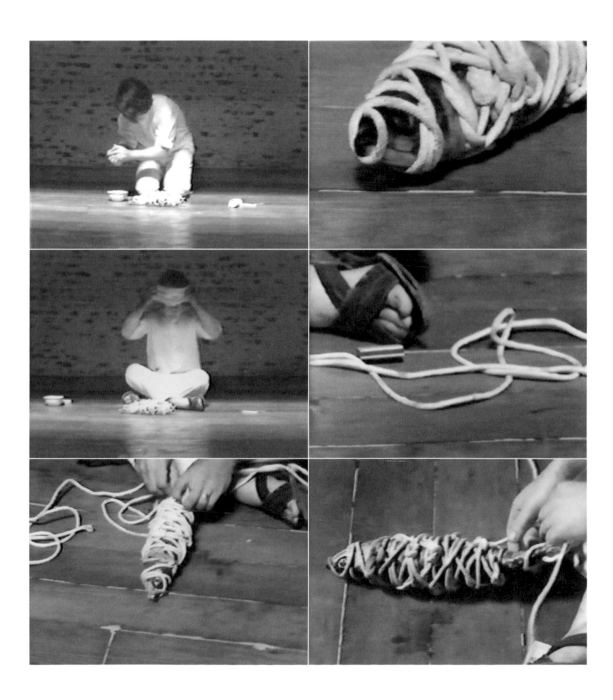

pp. 86–87
Terry Fox, stills from *Turgescent Sex*, 1971. Single-channel video, black-and-white, sound; 33 min. LBMA/GRI (2006.M.7).

pp. 88–89
Willoughby Sharp and Liza Bear, "Terry Fox: Children's Videotapes," *Avalanche* (December 1974): 32–33. Used with permission.

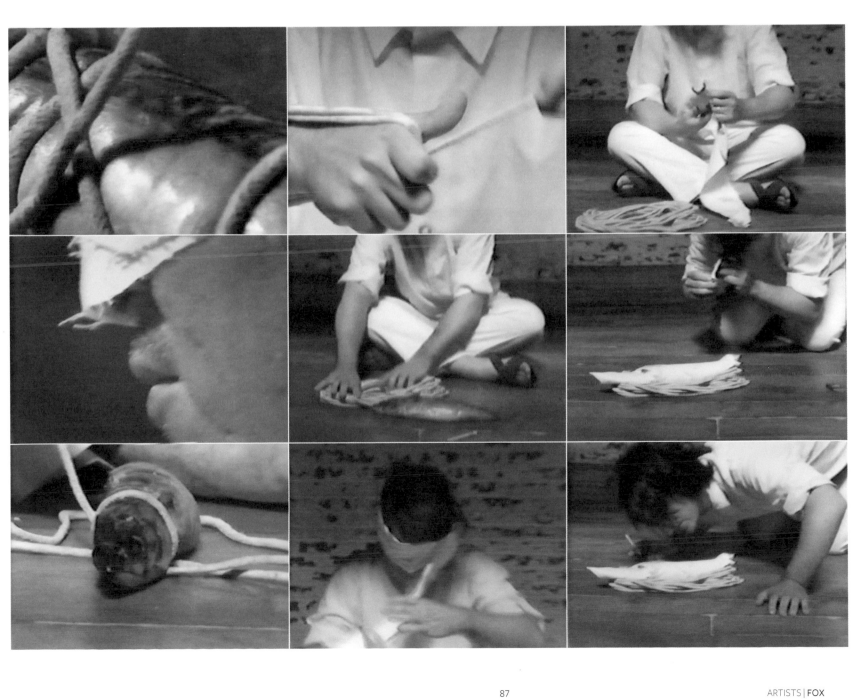

TERRY FOX •

CANDLE CHASES WATER DOWN THE BOWL

CLOTH DRAWS WATER TO THE SPOON

FLY CAUGHT BY THE BOWL

CLOTH DRAWS WATER TO THE TABLE

FACE IN THE BOWL

FORKED CANDLE OVER THE BOWL

Terry Fox's *Children's Videotapes* were shown for the first time at the Everson Museum, Syracuse, from May 25 to June 25, and he spent a few weeks in New York after the opening. Willoughby Sharp and Liza Bear talked to him on May 29 and June 5.

LB: How did you get into making videotapes for children?

TF: Well, what happened was that I had been doing things and showing them to my son Foxy, and he really got into them, he liked watching them and he liked doing them. . . .

LB: What kinds of things?

TF: I was setting up situations, using the same objects over and over, a candle, a fork, a spoon, and a bowl of water and a piece of cloth. Like putting the candle in water and then putting the bottle over it: the candle devours all the oxygen and draws the water up and the flame goes out. And trying to light the candle again when it's wet . . . I did them late at night by myself a lot, inventing new situations with the same objects. And after a few months I'd done so many that I thought it would be a good idea to make a program for children out of them. I'd been wanting to make tapes for children for a couple of years, because I'd thought about Foxy and what his input is. I borrowed a Sony Port-a-Pak and did them all in a week and a half.

WS: How old is Foxy?

TF: Five. He goes to kindergarten and his input is just rotten, as far as TV goes. We don't have a TV but he stays with me three days a week and sometimes he can con the girl downstairs out of her TV.

WS: Oh, he'll go down and ask?

TF: (laughs) Yeah. He loves to watch it. But it's horrifying. Everything he watches is bad for him.

WS: How does it corrupt his vision?

TF: Well, it homogenizes him. It takes away his ability to have an actual dialogue with something rather than having passive responses. Although he can talk real well, as well as I can, his drawings tell me a lot more. You can see exactly what his mood is, what he's feeling. But even those are starting to get stylized and he's only in kindergarten.

WS: So did you make the tapes for him, in a sense?

TF: Yeah, for him and his class. There's video equipment everywhere now, every school or poverty group has it, even Foxy's kindergarten. But nobody does anything for children. Everybody does something for money. And it's not only the kids' money that they're stealing, it's everything else as well. My tapes are meant to give them something else to focus on, something that they don't know about and that isn't exploiting them, that doesn't have a consumer message. And maybe the tapes would make them want to try out some of the things that are shown.

WS: There seems to be a lot of drama in them, because something actually happens, there is tension in them.

TF: Well, the tension helps the kids to watch it. They are so used to watching the 15-second cut and stuff that looks great although the content is zero or negative that it's really hard to get them to watch something that long. Or to get studio technicians to put up with it. I showed two of those on KQED in San Francisco, the one of the fly and the bowl which I made at home, and then another one that I did in the studio in color, and those technicians were just terrible. They were going crazy having to leave the camera still for three minutes.

WS: Why did you choose those objects?

TF: Because they're objects I'm familiar with. I really get off on certain situations and objects that have their own substance and reality. But it's not so much an interest in those particular objects that the tapes convey, it's more an attitude. . . .

LB: I liked watching what was happening, though.

TF: Well, amazing things are happening. That's why I shot them really close up, to focus in on all the minute events. But besides that, there's a kind of attitude that's communicated by the tapes.

LB: What attitude?

......CHILDREN'S VIDEOTAPES

TF: An attitude of contemplation . . . of wonderment, of relating to something real . . . without having to take sides.

LB: Right, there's no make-believe involved, no stylization. There's no assumption that a child's vision is different from an adult's.

TF: Well, the child's vision is more a vision that the adult has inflicted on him. A child is basically just a small person. The idea that things have to be scaled down to appeal to kids is a form of repression, to keep the kids down. When anyone does anything for kids, they go into this phony artificial childlike world of make-believe. But I don't think kids really want that until it's too late. Then they want it because that's all they usually get, that's the limit of their world . . . But I didn't feel I had to reduce my art to make those tapes.

WS: What's your attitude toward video?

TF: Well, I don't see it as a religion or anything. It's a tool.

WS: But that's perhaps because you're doing work in a lot of different media and you don't have your own video equipment.

TF: Oh yeah, definitely, if I had a video camera who knows what would happen. I can't wait to get one. For one thing, I think I would get a lot looser in the camera work. When I made these tapes, I'd never used video equipment before so I was really tight with it.

WS: How did you set up the shot?

TF: Well, all the tapes were made in my studio in San Francisco in March this year, between midnight and sunrise. I had the objects on a big table, a 4 by 8 foot door on sawhorses, in the positions I wanted them in, and the camera was on a tripod three and a half feet away. There was a studio portrait light with a 1500 watt bulb. Then I would figure out what kind of lighting was needed for whatever was happening, and zoom all the way in to get it in focus, and then zoom it back out. Then I'd take the objects off the table, put little crumbs down to mark their positions, turn the camera on and put the objects down so you could see how the situation was set up . . . And while I was doing that I would zoom all the way in, so the tapes were shot either all the way out or all the way in.

WS: You didn't think there had to be an explicative narrative at any point?

TF: No, there didn't need to be a narrative.

WS: So the tapes are demonstrations of phenomena.

TF: Phenomena and their worlds. Like all the different shapes the candle can assume, all the kinds of things you can do to it, things that happen to it. Like with the flame, you can skin the flame, take away all its color and make it invisible with a fork. There were constant variations on those objects together—the fork and the candle, or the candle and the water, or the water and the bowl. . . .

WS: Your show at the Everson Museum consisted just of these tapes?

TF: Yeah. The reason for showing them there was that it's a community museum and they were able to organize field trips to the museum for all the school kids in Syracuse. I edited what I'd shot, which was about two and a half hours of tape, down to two one hour tapes.

WS: And they were shown on two monitors simultaneously?

TF: Yeah. With two monitors all the objects are in use at once, like the candle and fork are on one monitor while the spoon and bowl are on the other. The pieces are all different lengths, the shortest one is a minute and the longest seventeen.

WS: How did the kids react when you showed them in San Francisco?

TF: Well, I showed them to a kindergarten class and they liked them, and I showed them to the Marioni boys and they wanted to see a couple of them again. They weren't really completed until the Everson show.

WS: Would you ever show them in a gallery situation?

TF: No.

WS: And they're not made to sell, particularly? You're not filling a market for your art work with these tapes?

TF: No. In my whole life, I've sold four drawings and traded a sculpture for a set of false teeth, when I showed at Lucio Amelio's. (Laughter).

WS: That's pretty remarkable, isn't it? That you've sold so little. You've shown in a lot of the important galleries in New York and Europe.

TF: Well, I haven't had anything for sale. I showed with Sonnabend in Paris, there was nothing for sale. With Lucio too. That's not why I show, why I make art.□

ICE UPSETS THE SPOON

REFLECTED CANDLE SINKS THE SPOON

SKINNING THE FLAME **WATER DROPS FROM THE SPOON**

ONE CANDLE LIGHTS ANOTHER

FORKED CANDLE LIT FROM BOTH ENDS

HOWARD FRIED

Born 1946, Cleveland, Ohio
Lives and works in Vallejo, California

HOWARD FRIED'S IDEA-ORIENTED ARTWORK combines the complexity of stream of consciousness with the straightforwardness of a primal scream. Based on a true story, Fried's first video, *Fuck You Purdue* (1971), uses the audio and in-camera editing capabilities of video along with the strategies of structural cinema to create what Fried has described as the most minimal narrative possible. The story originates with Fried's brother's experience during basic training, when two drill sergeants, Purdue and Ward, delighted in sending their young trainees to deliver insulting messages to one another ("Fuck you, Ward," "Fuck you, Purdue"), creating a never-ending supply of opportunities to punish the messenger. Fried plays the roles of both Purdue and Ward, while he occupies a series of cramped and cluttered spaces built especially for the video. Taped over the course of one day, the fruitless and repetitive insults continue nearly every minute of the work's duration, until the artist finally retires in catharsis on sleeping bags sprawled across the bare floor.

Fried's work illustrates how an unequal balance of power can short-circuit communications. In his film *The Burghers of Fort Worth* (1975), four Texas golf pros are hired to simultaneously teach Fried a lesson. The preposterous situation is a metaphor for art education, where students attempt to follow the advice of several masters, who tend to speak in abstract, often contradictory terms. While the pack of pros appears to overpower the artist at the time, Fried turns the tables by reframing their instructional advice on film, where they become objects of ridicule to an audience sympathetic to the artist.

The process by which the art audience appreciates avant-garde work became the subject of a later video, *Vito's Reef* (1978), a triptych including different attempts to name the territory one must bridge while suspending disbelief. What would be a dry read is hijacked by Fried's absurd parody of a terrible teacher's delivery. The artist drones out nautical metaphors across a hot-water heater turned sculpture and makeshift lectern before various distracting backgrounds, while upstaging his blackboard examples. In the second act, Fried's offscreen voice-over critically directs a female athlete on a sports field as she attempts to deliver a similar speech. The chalkboard eventually blows over in the wind, clobbering her on the head. The third scene shows Fried playing the bully teacher to his son, attempting to demonstrate chiaroscuro with his fists.

Fried refuses to satisfy an audience that might expect the artist to magically produce some artifact or object as a solution. Instead, Fried's conceptual projects, which only occasionally result in a finished work or object, propel one to engage with the thought process of art making itself as the highest and most meaningful result of aesthetic inquiry.

Bill Wheelock

Interview conducted by Glenn Phillips on March 24, 2007, at Howard Fried's studio in Vallejo, California

GP: Can you remember the first piece of video art that you ever saw?
HOWARD FRIED: I can. In 1968, I saw Bruce Nauman's show at Nicholas Wilder. When I entered the gallery, the tape where he manipulates a fluorescent tube was playing. I was the only person in the gallery. I had come in at a point in the tape where he wasn't moving, and for a time, there was no sound. After what seemed like a long time he moved, or he moved the tube and it made a sound. I realized I had never seen television silence for more than a few seconds. It was really magical; like I'd wandered into a space where usually there were only guided tours. The aesthetic and political implications were staggering. Today, that probably sounds ridiculous; but the effect of a first encounter with a transcending technology can't be understood except in a context where it doesn't exist. At the time, commercial media was totally stilted. It was unnatural because there was no personal media to inform it, and media production was so expensive and so cumbersome that it had to be bureaucratized in order to exist.

How long after that was it before you got to use a video camera yourself? Quite a while, actually. Not until late 1971. Lydia Modi Vitale, who was the director of the de Saisset Museum in Santa Clara, offered me a show and the opportunity to make some video works. The museum owned a Sony Portapak and George Bolling came with it. He eventually shot four tapes for me, including *Fuck You Purdue* [1971], *Sea Sell Sea Sick at Saw/Sea Sea Soar* [1971], *Seaquick* [1972], and *Which Hunt* [1972]; *Fuck You Purdue* was my

first tape. Before that, I had been working on film projects that were installed in galleries with a Technicolor 1000 loop projector, which was the salesman's promotional media of choice before low-end video. The last one of these pieces, *Inside the Harlequin* [1971], was also in the de Saisset show.

Where did the idea for *Fuck You Purdue* come from? My brother joined the Marine Corps in 1966, I think. He told me a story from his experience in basic training at Parris Island, South Carolina. The idea came quite literally from this story. Each unit of recruits—I don't know what they're called, companies maybe—had a drill instructor in charge of them whose word was law. My brother's company lived in a two-story barracks on the first floor. Another company lived on the second floor. The drill instructors in charge of these two units were called Purdue and Ward; I don't know what their ranks were—maybe Sergeants Purdue and Ward. For their entertainment, they would alternately order one of their recruits to go to the other one's floor and scream "Fuck you, Ward" or "Fuck you, Purdue" at the other DI, who would then discipline the recruit, send him back, and send one of his own recruits to do the same to the other DI. I liked that story. It had some kind of resonance for me. I probably heard that story in 1967. During '68 and '69 and early 1970, I was making silent film pieces. They were short on emotional content. Some of the work objectified basic psychological conflict theory. I thought about adding dramatic content to my work, even though I was a drama illiterate. Whatever variant of drama I was thinking about for *Fuck You Purdue* was only possible with sound. I couldn't afford to work in film with sync-sound, but now there was video. Anyway, if I was going to get into drama, it seemed like a reasonable thing to start with, in grammatical

terms—a simple sentence rather than, say, a complex sentence involving two subordinate clauses. The *Fuck You Purdue* story was attractive to me because it was minimal. It was only slightly more complicated than an "I am" sentence. I thought the two words "fuck you" and their object, "Ward" or "Purdue," were capable of transmitting a lot of what one might call a "beginner's dramatic gray scale." In other words, I could use "Fuck you, Whoever" to express anything.

Describe what the video looks like. I guess I'll start by describing the set and then the action. The set, which was two roomlike elevated platforms, was centered on the midline of the width of my studio, which had in its entirety been the set for *Inside the*

to the room, there was a big pile of clothes strewn all over the floor. There were shelves along one of the walls, and they told me I was supposed to pick up the clothes on the floor and sort them by size. There was a lot of room for interpretation in this, because the spectrum of sizes was incomplete and there were some very odd sizes like waist 60, inseam 22. But I folded them all up and arranged them on the shelves. The next morning when I came back, everything was on the floor again. This happened every day. I thought the staff threw the clothes back on the floor so I'd have something to do; but about a week into the job, I learned that another guy had my job in the afternoon and he was undoing what I did in the morning; but there were some clothes there that I liked, so I took them and they got into *Fuck You Purdue*.

Harlequin. Inside the Harlequin was an "all" piece. It used all my resources, everything I owned. My studio was long and narrow—about fifteen by eighty-eight feet. It was divided into two parts. The floor of each part was painted a different tint and shade of gray. At the time *Fuck You Purdue* was made, on one side of the studio was this sawed-in-half tower of sheetrock tables that had once been all of my work surfaces. The two sides of the tower fell against each other when they were sawed in two with a six-foot-long chainsaw, and that's what kept them standing. I left it there for months. I liked it, but eventually I needed the space. But I like the idea of the one piece being the context for the other. That's sort of how life works. On the other side of the studio all my everything else [everything I owned] was sort of scattered all over the place, having been distressed by a number of wrestling sequences it had played host to during *Inside the Harlequin*. As part of preparing to do this piece, as I've said, I'd built an elevated platform (a room) for each of the characters. These were six by six feet. Their supports went from the floor to the rafters. The floor planes of these platforms were about three and a half or four feet above the studio floor. That way, I could use them for table surfaces when I wasn't working on *Fuck You Purdue*. I had nothing else to work on.

Yesterday, in preparation for this interview, I was thinking about the sequence of events that led up to *Fuck You Purdue*, and then all of a sudden it occurred to me, "Oh, yeah, I went nuts and was incarcerated by the state between *Inside the Harlequin* and *Fuck You Purdue*. All the shirts I wore in *Fuck You Purdue* I acquired at the Napa State Hospital. I was there for three weeks. They tried to give everyone there a job. While I was there they put me in charge of the men's clothes room. I'd had some experience working with clothes and I liked it. I was supposed to go to this job every morning after breakfast and work at it until lunch. The first time I went

When I was nuts, I thought that everything I did mattered and meant something. There was meaning in everything. The trouble was I didn't know the code for unlocking the meaning. So I had to play it safe, because I thought there were very severe consequences associated with what I was transmitting by everything I did. For instance, I thought what I ate at a meal meant something; since I didn't know what it meant, the safest thing to do was to eat half of everything. If they served hard-boiled eggs or soft-boiled eggs, I'd cut them in half and eat half the shell and half the egg or half a steak and half the bone. My teeth were stronger then. I didn't take objects for granted. After I had returned to my studio and built my platform rooms and furnished them with the stuff off the floor, I spent alternating days living in each room trying to understand the spaces and form relationships with the objects I'd furnished them with.

The action in *Fuck You Purdue* alternates between uncut sequences of the two characters, Ward and Purdue. In each shot, the on-screen character eventually says, yells, or whispers to the other, "Fuck you, Purdue" or "Fuck you, Ward." It starts in the morning when they're both in bed, and goes through a whole day until they go back to bed. I was trying to make a narrative wherein the full spectrum of emotions and communicative needs occur but are only expressed through the expletive "Fuck you, Whoever." I pretty much just left the camerawork up to George [Bolling]. We'd talk between sequences about what was going on between the two characters in the preceding scene and where it would be going in the next, and try to position the camera to be just observant or actively inflective.

It seems you had to be thinking about Vietnam as well. I don't know—you mean while I was actually making it? I had thought a

p. 91
Howard Fried, production stills from *Fuck You Purdue*, 1971 (single-channel video, black-and-white, sound; 31 min., 39 sec.). Photos by Larry Fox.

lot about Vietnam while my brother was there; "thought" may not be the right word for background anxiety. My interest in the story was formal. I wanted to use it as a bridge to a more emotional content. The war was one of those background things; whether or not I was specifically thinking about it while making that video, I really don't remember at this point. I might have been thinking about it when I was going nuts. Vietnam made everyone paranoid.

But to see the piece now . . . Oh, you mean like a prisoner of war or something?

Or I don't even know what. I think it's somehow— The Vietnam War was a period when anyone who watched television was given a crash course in how to manipulate the media. I mean, in World War II you never saw an ordinary citizen killed on camera, much less executed in a Movietone newsreel or something. You never even saw the president in his wheelchair. The powerful manipulated the media. It was part of the dominant etiquette associated with the technology of the day. Studio television had an associated etiquette, as did portable film and video when it arrived. During Vietnam, the unpowerful instinctively knew these portable media were accessible. People set themselves on fire. I think artists, as well as Buddhist monks, kind of picked up on—but not necessarily consciously—an impending technological change of extreme relevance. Low-end portable video made it theoretically possible for everyone to make television. Before that, television was like being invited to the White House—everyone behaves. Some things get in the air and everyone is changed before they know it. Then everybody sees it and it's obvious.

Patternmaker **[1984], which was an installation you did for the Banff Centre in Alberta, Canada, is a work that encourages another sort of behavior—or misbehavior—in the audience. The really interesting thing about this piece is that it's about the monitor teaching the public, in a sense, without your interference.** Right. Well, the basic setup—the ground on which each aspect of *Patternmaker* begins—is a room mostly filled with rows of folding chairs that go from one sidewall of the space to the other sidewall of the space. In the front part of the space there are a couple of tables with some chafing dishes with food in them. *Patternmaker*, the piece, is installed three times. The three installations are called "The First Historical Situation," "The Second Historical Situation," and "The Third Historical Situation." "The First Historical Situation" happens in a place that has an academic relationship to modernist art history; in this case, the Walter Phillips Gallery at the Banff Centre. In the rear of the gallery, there's a 16mm movie camera on a tripod with an intervalometer that shoots a frame of film every couple seconds or so. There's no signage that says anything about the installation or the meaning of it; it's just there. Outside the gallery there's a vestibule where there's a video monitor. You have to pass through the vestibule to get into the gallery. Every day, the exposed film is sent to a lab where it's transferred to video. The next morning, the video is picked up and played over and over on the monitor outside the gallery entrance while the gallery's open. This continues each day for seven or eight days. Now I'm at a crossroads, because I have to decide whether to talk about "The Second Historical Situation," or go on talking about "The First Historical Situation."

Go on talking about the first. Okay. During the first couple days, people would come in and they'd just look at the piece, staying out of the camera's view, and then they'd leave. The next day on the tape, you'd just see the gulf of chairs in front of the chafing dishes.

It stayed like that all day long. On the third day, somebody violated the space by moving a chair; then someone walked across the space and back, stepping only on the seats of the chairs and never touching the floor. At one frame every two seconds, he looks like a mosquito. The day after that, somebody upped the ante by sitting down and reading a newspaper, and then compensating for the frame rate by moving in slow-enough motion to appear to be moving normally. After seeing that, they started doing all kinds of weirdly creative things; each one involved more and more manipulation of the structure, further violations of the existing status quo. Several days later, they had folded every chair and stacked them in tall piles, which were then toppled and the chairs scattered. It looked like the World Trade Center after 9/11. People were learning from the feedback they were getting from the daily synopsized replays. It worked like the news.

"The Second Historical Situation" takes place in a location that has a commercial relationship to modernist art history; in

p. 92
Howard Fried, *Patternmaker,*
The First Historical Situation, 1984.
Installation views at the Banff Center,
Alberta, Canada, 1984. Photos by
Kim Chan.

p. 93
Howard Fried, production stills from
Sea Sell Sea Sick at Saw/Sea Sea Soar,
1971 (single-channel video, black-
and-white, sound; 49 min., 37 sec.).
Photos by Tyrus Gerlach.

this case, it's the Chateau Lake Louise, which is a fancy hotel. They were interested in hosting the piece because of the Banff Centre's cachet. Anyway, in "The Second Historical Situation," it's the same setup, with rows of folding chairs blocking access to the chafing dishes. In this case, the exhibition space was a dining room. There's no camera, but there is a monitor in the rear of the room that shows all the daily rushes from "The First Historical Situation" assembled back-to-back. I call this "The Complete History of the First Historical Situation." It's around two-and-a-half hours long, and it's played over and over again. It was a very handsome installation. About three days after I completed the installation, the hotel called the Banff Centre and essentially told them to "get this thing out of here." I went back to the Chateau Lake Louise to control the damage and asked, "What's the problem?" I looked at it and it was quite beautiful. A number of the chairs were thrown on top of each other in weird but interesting configurations. They said, "Look, look at that." And I said, "Yeah, what's the problem?" They said, "Well, this is a mess. You can't leave a mess here. We set up our continental breakfast in front of the entrance to this room every morning." So I said, "Well what will make it okay?" And they said, "Well, if you clean this mess up." So I said, "You mean put it back the way it was?" And they said, "Yes." Since compromise is part of "The Second Historical Situation," that was okay with me, so I did it, and then the thing continued for the rest of the time it was supposed to be there. I later found out that after watching "The Complete History of the First Historical Situation," several of the hotel employees had rearranged some of the chairs with considerable enthusiasm. In "The Second Historical Situation," while you can imitate history, you can't insinuate yourself into it because there's no camera.

"The Third Historical Situation" happens in a place with no relationship to modernist art history. There is no camera and no monitor. In this case, I was looking for a kind of derelict building in a bad part of Calgary. I thought that word about the food would get around to the bums in the area and that they might come in to check out the chafing dishes. But the weather was changing, and at that time of year in Calgary, no bum in his right mind would still be there. They go south, I guess. So the only people that came in were real estate speculators. The gallery had somebody babysitting the space. The chairs were set up, and the tables and the chafing dishes were put there; but the only people who came in were wearing camel hair overcoats, and they would look around and say, "Who owns this place?" Anyway, so that's *Patternmaker*.

Let's talk about the de Saisset Museum for a little bit, because that was one of the earliest places to show video in the United States. What can you remember about it? Can you remember some of the shows that were there? Yeah, Terry Fox and Tom Marioni had shows. I think Tom was being Alan Fish at that time.

Was it a place where you felt you needed to go, given this space was suddenly showing video? When they had shows I was interested in, I went; more significantly, they produced video work. George Bolling and the museum's director, Lydia Modi Vitale, were both really supportive and great to work with. They didn't consider for a second that I wasn't going to have my show just because I was locked up in the nuthouse.

And you did have your show, right? Yeah, when I came back I was still nuts, but I trusted George and Lydia and I was able to make the pieces.

The other piece you made for that show was called *Sea Sell Sea Sick at Saw/Sea Sea Soar* [1971]. Yeah, It's pronounced *Sea Sell Sea Sick at Saw Sea Soar over Sea*. It's supposed to be said in the spoken rhythm of "She sells seashells at the seashore." The piece is sort of like that eating story I mentioned before. The video has two alternating parts that are structurally set in opposition. The raw materials for these parts are two waiters and one customer. I'm the customer. The combination of each waiter and the customer competes with the other waiter-customer combo to transact an order. The action happens alternately on two sets. Each includes a restaurant table and chair mounted on a suspended platform, a separately suspended platform for the waiter, and a suspended platform for the camera. The wall behind all this is treated with a mixture of aluminum powder, emulsified carbon, and joint compound, which I applied to the wall with a sheetrock knife. It was kind of like a decorative thing that might have been an element in a restaurant; maybe a cake. It's a black-and-white tape; when you start swinging stuff in front of the camera, it gets pretty disorienting. Anyway, the waiters are trying to get an order out of me. I'm directing the action by how much I swing, like an orchestra conductor. I want everyone—including the camera—to swing at about the same rate as I'm swinging, but not in synch. At the beginning there isn't any swinging. As the frustration grows, so does the swinging. For the script, I just picked up menus at all the restaurants where I ate lunch. The waiter comes and he says, "What are you going to have?" And then I look at the menu and start asking questions. I did have a terrible time making up my mind with menus in those days, so I knew a lot of stalling techniques. As the waiters get more and more frustrated, the swinging increases. When the waiter is really getting pissed off, we switch sets and waiters and the aggravation rebuilds. Eventually, I start slowing the swinging down, because it has become obvious that one of the waiters has had it. "Fuck it. I can't wait on this guy." Then I place an order with no hesitation with the other waiter; passive conflict resolution. Things work themselves out.

KIP FULBECK

Born 1965, Fontana, California
Lives and works in Santa Barbara and Solana Beach, California

KIP FULBECK'S WORK explores what it means to identify outside of limiting, yet accepted, racial and gender labels. Embracing the once disparaging term *hapa*—or one of mixed racial heritage with partial Asian roots—to describe his ethnicity, Fulbeck confronts the racial prejudice he faces in being neither "Caucasian enough" nor "Chinese enough" to find acceptance in fixed racial communities. Through a narrative form that shifts from autobiographical to fictional, Fulbeck's videos carve out a place of expression for both the artist and others who identify as *hapa*.

While a graduate student at the University of California, San Diego (UCSD), Fulbeck produced his first video essay, *Banana Split* (1991), in which he tells the story of growing up *hapa*. His use of humor and sentimentality notwithstanding, Fulbeck's cynical adult perspective reveals his reservations regarding America's ability to accommodate mixed-race individuals. His performance work also reflects the direct, sincere, and often humorous tone of his video's narration. In the video *L.A. Christmas* (1996), Fulbeck again uses his family as subject, creating a tender portrait of his relationship with his mother as she gives him advice about his dressing, eating, dating habits, and video work. In the piece, Fulbeck records a typical family holiday gathering using a toy Fisher-Price PixelVision video camera. His mother disapproves of the black-and-white, low-resolution images, stating that people who see the video will question his talents. Besides joking with his mother, Fulbeck says nothing to directly counter her critiques, accepting and finding humor in the generational misunderstanding.

In *Some Kisses for 28 Questions* (1995), Fulbeck turns his gaze to media representations of race and sexuality. The video combines clips from Hollywood films depicting interracial couples, voice-overs (like that of an Asian woman proclaiming independence from "patriarchal pressures" to date within her own race), and scrolling text on screen posing questions such as, "Why do Asian men think they can tell Asian women who to date?" Fulbeck continues to take up the complex issues of Asian and American identities through writing and photography. He has also published a novel, *Paper Bullets: A Fictional Autobiography* (2001), and a monograph of photographs, *Part Asian, 100% Hapa* (2006).

Pauline Stakelon

[STATEMENT]
L.A. CHRISTMAS
by Kip Fulbeck

I realized my family was odd on Christmas Eve, 1995. We were gathered around the piano singing carols, as we do every year, when it suddenly dawned on me that among the twenty of us, there wasn't a Christian in the house—that this roomful of Buddhists, Muslims, and atheists were singing song after song about the first Noel and little baby Jesus. My initial thought after this revelation was, "I've got to get this on tape."

The problem was, my family was on to me. As an autobiographical filmmaker, I might have gotten lucky early on, capturing some conversational gem or action without their self-consciousness, using the "It's just for a project" excuse, feigning naïveté and holiday documentation. A couple of international film festivals or PBS screenings later, the explanations ran out. I tended, more often than not, to get the "Put the camera down" reaction from my family.

Fortunately, one week before this Christmas, I had picked up a used Fisher-Price PixelVision (PXL 2000) camera. These were toy cameras originally marketed in the eighties for children—cheap, plastic, and single focus, they shot on what was then the commonplace audiotape cassette. Ridiculously loud, with a big Fisher-Price logo on either side, who would have thought they'd someday fetch outrageous prices on eBay, sought after by artists for the very graininess and low-tech look that ultimately doomed their appeal to parents seeking educational toys?

My family laughed at the camera and relaxed. Defenses went down, and I was able to capture my family in all their bizarre and wonderful glory.

When I cut the tape (analog, by the way—old school), it worked fairly well, but was somehow missing an ingredient. I wasn't sure what it was, but the tape was merely good, not great. To quote Nigel Tufnel, it didn't "go to eleven." To remedy this, I had my elderly Chinese mother watch the tape with me, and recorded our conversation as we did so. The magic that happened then was one of those happy accidents that I'll gladly take credit for and pretend was planned. Layering both the original audio track and our second audio track together, my mother's conversation filled in the necessary ingredients. When the tape worked on its own, she talked about the tape. When the tape lagged, she reverted to telling me what I should be doing with my life.

Without her play-by-play, *L.A. Christmas* would be a dud. As it is, it's still my personal favorite. It captures the real idiosyncrasies of a real family—how we really interact, communicate, and express affection. In my case, I tease my mother to tell her I love her. For her, she tells me to dress better, spend less money, and act properly (or in her words, "like a professor"). The critical elements in the film are often what seem most extraneous, and I think that's how families typically operate—so much is simply understood. An example is the scene where I spar with my nephew. Although the scene's apparent point is him comically losing his shoe, the key element is actually right afterward, when I tell him to watch out for the passing car. This is the type of subtle, universal love I tried to document.

A decade later, I often wonder how this home movie about home movies really works. In terms of festival screenings, awards, and institutional purchases, it's by far my *least* successful video. At the same time, when I speak publicly and introduce it, it's consistently the audience favorite. Part of this has to do with the fact that *L.A. Christmas* requires its audience to actively partake in its journey, and that in this case, as in Christmas, you have to give to receive. I think it needs a smart audience—an audience literate enough to recognize the difficulty of simulating first-person POV without actors, perhaps an audience versed in both documentary and personal narrative. Either that, or they just need the confidence in me to think it's worth watching. Or maybe they just need to know how crazy L.A. is.

PP. 95–97
Kip Fulbeck, transcript (excerpted) and selected stills from *L.A. Christmas*, 1996. Single-channel video, black-and-white, sound; 13 min.

[TRANSCRIPT and STILLS]
L.A. CHRISTMAS

AUDIO TRACK 1:
Original Dialogue

[Family singing Christmas Carols]

[Riding in car to restaurant]

[Dim sum at restaurant]

[Sitting with Godmother]
MA: Her son is a cardiologist [speaks in Chinese] … cardiologist. And her second son is a pharmacist. And the third son is a chiropractor. They're all doing well. The son in chiropractor. …
[Looking at birds with dad]
KIP: What do we have, Dad?
DAD: We have three canaries.

[Kip and Dad looking at flashing holiday ornament]
KIP: Here's the neuro-neutralizer.
DAD: What?
KIP: The neuro-neutralizer. This one's your favorite, right?
DAD: Uh, yeah. I like it. It's fun to like it.
KIP: Yeah, it's a classic.

….
KIP: Someone at the door. Who is it? Oh, it's Jo!
JO: What's with the camera? Hi Dad.
KIP: Hi Jo.
JO: Merry Christmas. [Gives poinsettia]
KIP: Wow.
JO: I'll just put this down somewhere.
MA: Looks beautiful.
JO: Oh, I forgot to bring a plate.
KIP: That's great, Jo.
JO: So what kind of camera do you have today?

LOOKS THE SAME

[Kip spars with his nephew outside]
KIP: Let's see some of your moves!
[Various martial arts noises]
[Nephew's shoe flies off]
KIP: Toh! Okay, watch out for the car.

….
[Ma in bathroom getting ready]
KIP: Ma, you wanna try the camera?
MA: No.

AUDIO TRACK 2:
Kip and Ma Watching and Commenting

….
KIP: Okay. Gimme the top ten things to nag on me for.
MA: Well, I don't want you to act like crazy. Especially when you eat and you open your mouth [Kip laughs] and with all the food … that's *gross*. I can't stand that. That's terrible.
KIP: Okay. Number two.
MA: Act like a professor. Do things properly.
MA: And I don't ever want you to go the bank … to the machine, to get money. That's *crazy*. Because If people know you have money, they try to kill you for that. That's very bad. And what's a few steps to walk into the bank? And then you have to go outside and get the money?
KIP: What if you go in the daytime?
MA: No, no. Don't do it. Just go inside the bank and do it.

MA: Joe, no Jack. Joe is a pharma— uh, cardiologist. And Jack is a pharmacist. They are all doing well.
KIP: Here are Dad's birds. Where'd he get that cage, anyway?
MA: The new one?
KIP: Yeah.
MA: Bird Mart.
KIP: What?
MA: Bird Mart.
KIP: You got it at Bird— ?
MA: Bird … BIRD *MART*.
KIP: [Laughs] It's like Kmart?
MA: Yeah. [Kip laughs and chimes fade in]
KIP: And where'd he get that thing—that neuro-neutralizer thing?
MA: The what?
KIP: That thing that spins. The blinky thing. That bell thing.
MA: Oh, Montgomery Ward.

….
KIP: So, what exactly do I do now?
MA: Ah … teach.
KIP: Yeah. [Mom laughs] What's my art form?
MA: Videotape.
KIP: What do I do?
MA: You make tape and show it to people. Something like that. I'm not so sure it's a profession, really.
KIP: What types of issues do I do?
MA: Ethnic problems. Conflict between races.

KIP: And here's Chris now.
MA: Wow. He's really good, huh?
KIP: Yeah.
MA: Nine years old, has black belt.
KIP: He's nine?
MA: Uh huh.
….

KIP: Try it a little bit.

MA: Lawrence, *please*. You're a pest.

KIP: What?

MA: Pest. Pest.

KIP: Wanna try the camera?

MA: No.

KIP: What are you putting on now?

MA: Powder.

KIP: What for?

MA: So I don't look like a old hag. [Both laugh]

MA: Jack...your son *bother* me.

DAD: He bothers everybody.

....

[Playing with foot massager]

KIP: What's the difference between this one and stand-ing on a bunch of rocks?

W: Because we were told...that the Chinese steps...all those ah, what is it, under your feet?

M: Pressure points.

W: Yeah, yeah. Something like that. Like here—and this one here. That's right.

KIP: But this one just seems like a bunch of rocks you could have outside.

M: Yeah, yeah, the rocks. Yeah.

W: Yeah, you could even walk around on it.

KIP: Kinda hurts.

W: People can't even stand up.

KIP: Yeah, well, it's not comfortable because it hurts.

W: Socks on.

KIP: Oh, the socks are bad?

W: No, but they should be.

[In the kitchen]

KIP: How does she know the cat doesn't feel good?

W: [Speaks in Chinese]

MA: She doesn't eat much.

KIP: You're out of liver.

W: Yeah.

KIP: Why is she not going for the water? And why the liver?...

MA: Because she's sick.

KIP: Ma, the cat's not sick. She's just not hungry.

MA: Sometimes—

KIP: When you feed it three times a day...it's not going to eat anymore. [Laughing] So she keeps all of the cat food in the sink instead of in the ice box. [Laughing] Hey Kai-Ma? Don't you think that...the cat food in the sink is gonna be more smelly than in the icebox?

W: [Speaks in Chinese]

MA: The cat food...can't go to the icebox.

KIP: What?

MA: Cat food is for cat. Icebox is for human. [Laughs]

KIP: But it's gonna smell if it's outside.

W: [Speaks in Chinese]

MA: She's going to cook it for them. [Laughs]

KIP: You're gonna cook it for the cat?

MA: Then also, when people take your pictures, just be nice instead of making faces. [Both laugh]

KIP: And how should I dress to be a professor?

MA: Dress nicely, clean. More conventional. Like a nice gentleman, nice man.

....

KIP: So did you give him anything for Christmas?

MA: The suit.

KIP: There's no suit.

MA: But he—you can't just buy a thirteen-hundred-dollar suit.

KIP: That's *one* nice suit.

MA: And you also got an eight-hundred-dollar...

KIP: What about the suit you got Dad for Christmas?

MA: Well, he—

KIP: You gave him a thousand dollars for the suit.

MA: No, I did not give him any money. I just told him to buy. But he did not want to spend a hundred—

KIP: Wait, wait, wait. You didn't give him any money? You told him to buy a suit for Christmas?

MA: Yeah. I told him I'd buy him suit, but he never go down to get it.

KIP: So, you didn't give him anything for Christmas?

MA: The suit.

KIP: There's no suit.

MA: But—the money's in the bank. So...he just said he did not have time.

MA: I don't know...when I went to university, all my professors dressed nicely. Suit.

KIP: What are you saying? You just told me you didn't want me to buy a suit.

W: Yeah.
....
[In the kitchen]
JO: Have we ever seen any pictures of those?
KIP: What?
JO: Have we seen pictures of them, on this camera?
KIP: No, they don't come out too well.
MA: Then why you take it?
KIP: 'Cause I'm stupid. [All laugh]
[In hallway]
KIP: Okay, meet my nephew. He can recite pi to two hundred digits. Go do it.
M: 3.14159265358979323846243383279502088...
[Continues]
KIP: You checking this Ken?
KIP: What do you think of this guy?
BOY: He funny!

KIP: Proud of my family.

[Opening presents with family]
M: Look at that! Hey, look at that.
KIP: What is it?
MA: A thousand dollars suit.
KIP: For Dad? That's like twenty suits for Dad.
MA: No, I gave him a thousand dollars for one.

[Dad opening CD]
KIP: What'd you get, Dad?
DAD: Artie Shaw's last recordings, rare and unreleased.
KIP: Who did you want instead?
DAD: Snoopy Dog Dog, you know, or some other of these weird-named guys.
KIP: Hey, Pi. You like Snoopy Dog Dog?
....

KIP: How do you like the music?

JO: How do I tell when it's —moving? No, but how can I tell it's working? The light's blinking.
[Dancing with Ma, Jo filming]
JO: Hey, Lawrence, the light is blinking. Does that mean it's working? [Mom laughs]
KIP: Now it's on. You can hear it.
JO: Yeah.
KIP: Okay, Ma, you danced. Me and Jo dancing now. You film Ma. [Ma takes camera]
KIP: Look right through here.
MA: You have to push?
KIP: Look through, look through here....
MA: And push?
KIP: No, it's already been going. Can you see us?
MA: Uh-huh.
KIP: Okay, watch this, Ma....
MA: No, I don't see a thing. [Laughs]
KIP: Keep filming Ma.
MA: I see my own eye.
KIP: Here comes the spin, Ma. Here comes the spin....

MA: Not to buy a suit thirteen hundred dollars! But there's thousands of suits only two or three hundred dollars.

MA: Yeah, well, if it's your norm at the university, its okay with me. But I'm old, old-fashioned. When I went to university, we could not wear pants. You don't go to the class with pants. [Laughs]

MA: Find a nice girl... and don't be so harsh on her.

MA: Sometimes you're too demanding.
MA: Anything.

KIP: We have some pretty, you know, we have some odd characters in the family, don't you think? The way we do Christmas?
MA: I don't think so. I think we're quite normal.
KIP: Don't you think it's funny that... what religions are in our family? There's Muslim, Buddhist, Atheist... and we're all singing Christmas carols? Don't you think it's kinda funny?
MA: Mmm-hmm. Conglamorous [*sic*].
..
[Spoken over credits]
MA: Can you, can you do this tape? For professionally? To sell as part of your work?
KIP: I hope so. Why?
MA: Kind of blurg. Blurg, most of them.
KIP: Kind of what?
MA: Blurg.
KIP: Blurred?
MA: Ah. *Bluurred.*
KIP: Because it's done on Fisher-Price PixelVision. The camera's a toy.
MA: But then... it... isn't that, the quality of your work? They think it might be not that good?
KIP: Maybe. They might think I'm no good, huh?
MA: No, no. Isn't that your concern? You're supposed to use best equipment.
KIP: Yeah? Huh.

ARTHUR GINSBERG and VIDEO FREE AMERICA

Born 1941, San Francisco, California
Lives and works in Santa Cruz, California

IN 1970, Arthur Ginsberg, a Bay Area artist, and Skip Sweeney, founder of the San Francisco media arts collective Electric Eye, met and began working collaboratively under a new moniker, Video Free America (a name adopted while justifying their public videotaping to a skeptical policeman in Golden Gate Park). With Video Free America, Ginsberg began an intensive focus on video experimentation and technologically driven art. Working at a breakneck pace, the group generated regular screenings and exhibitions that included multitrack video collages, sculptural video installations, real-time performances, abstract image synthesizing, and reality-based works, which examined mass media entering private lives.

The latter was the premise for the infamous, long-running project *The Continuing Story of Carel & Ferd* (1970–75). Directed by Ginsberg, this video verité study theorizes about "the effects of living too close to an electronic medium," by documenting the routine moments of two young individuals' alternative (and uniquely West Coast) lifestyle. In the video, Carel Rowe, a painfully witty cineaste and occasional erotic-film director and star, and Ferd Eggan, an articulate and politically versed bisexual junkie, decide to get married in order to get sober, start a new life, and travel. Agreeing to have their wedding, its consummation, and their marital life videotaped, the unlikely couple is followed through two years of ongoing pleasure, desires, aggravations, and disappointments.

A precursor to early reality television, *The Continuing Story of Carel & Ferd* is a social document that not only considers a mediated privacy but meditates on the Vietnam era's growing counterculture as well. In 1975, after the failed experiment in media marriage, Rowe, Eggan, and Ginsberg reunited for a public television broadcast of and commentary on the tapes. Today, with a doctorate from Northwestern University, Rowe continues to produce films and documentaries and has authored such books as *The Baudelairean Cinema: A Trend within the American Avant-Garde*. Throughout the 1990s, Eggan worked as the Los Angeles AIDS Coordinator in the first major city in the United States to have an AIDS policy. He continued his writing and activism within the gay community until his death in July 2007.

Holding a Master of Fine Arts degree from the Yale School of Drama, Ginsberg collaborated on a series of theater productions with the Chelsea Theater Center (*Kaspar* [1974] and *AC/DC* and *Kaddish* [1977]), which adapted and amplified the dramatic scripts through combined video and live stage productions. The work on *Kaddish* won an OBIE award, and the adaptation was further adapted into a Public Broadcasting Service special. Ginsberg later went into writing and development for public broadcasting and commercial television, while continuing to pursue his interests in media innovation, politics, and what the artist calls "cerebral sleaze."

Catherine Taft

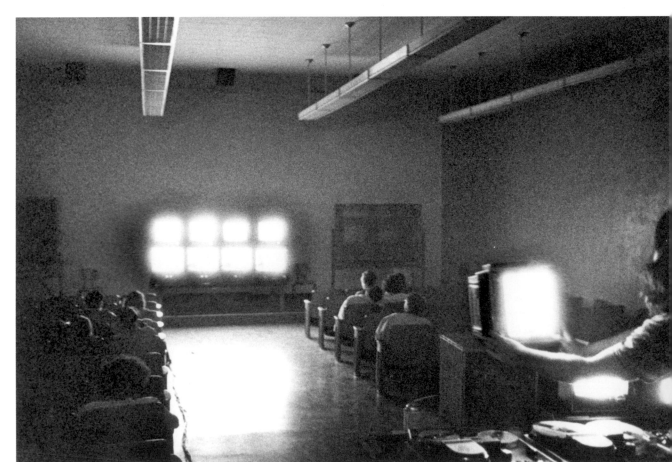

p. 98
Installation view from a live performance of the eight-channel version of *The Continuing Story of Carel & Ferd*, at the University of California, Los Angeles, circa 1975. Two channels of video and two live feeds were mixed live during each performance. Video: black-and-white, sound; running times variable. Photo by Steve Clayton.

p. 99
John Du Cane, "Echo in the Tube," *Time Out* 52 (January 19–25, 1975): 25. Used with permission.

echo in the tube
echo in the tube
echo in the tube
echo in the tube

How did it start? How did you come to make a tape with Carol and Ferd?

G: I wanted to make a tape of a pornagraphic movie being made. I met a guy called Mother Boats who was at that time the Goddess of the Venus Psychedelic Church in Berkeley—it's a transsexual, transeverything Church—who gave me Carol's name. She told me that she and Ferd were going to make a porn film out of their wedding to pay back a guy whose car they'd smashed.

C: Ferd was going to cop that day and got angry and crashed the car...he'd just got back from the hospital...it was very dramatic.

G: A friend of theirs, Richard, was coming round to talk about their marriage so we thought we could start right away with that. We had the equipment in the car as it happened so...video being what it is...cheap and erasable, with no processing...far out...we started that day on impulse. You probably would never do that with film. You wouldn't roll three hours of sync footage without knowing why you were doing it. It was only by the second time we taped—which is the section with the argument and the shooting-up—that I actually began to feel that here was something really interesting. So there was no concept to begin with...it happened by chance. But the producer in me realised that here was a situation that could be exploited. At best, we started with a process, at worst, with exploitation, The piece only becomes conceptual as an eight monitor event.

How did the fact of the taping affect the construction of the wedding?

C: It wouldn't obviously have been so media-orientated. We'd been thinking in terms of a Black Mass...we saw our marriage not as the beginning of something new but as the end of something bad. And we wouldn't have had that double-talk media-blessing...all that stuff about 'You will become the media and the media will become you' which actually means nothing.

Yeah, it's as meaningless as any Church ritual

C: It screwed us up for a while, though, when we thought it did mean something and tried to act it out.

What happened to the porn movie you were originally making of the wedding?

G: Well, I knew in fact that the guy wasn't going to use the film and they didn't. So for some of the time I was being an arsehole, manipulating them, hoping that I'd be able to tape a scene later, where they found out it wasn't going to be used.

C: We'd have made a better tape if we'd known you were putting us on. You were too sly for yourself there...

Carol, you hadn't done any tape yourself before this one?

C: No.

G: But a mutual friend of ours was so enthralled with her potential as an artist that he supplied her with a whole lot of video equipment to make her own tapes.

You're more interested in setting up other people in situations and taping them, than taping yourself in a situation?

C: Yes. But the situations are just kinky

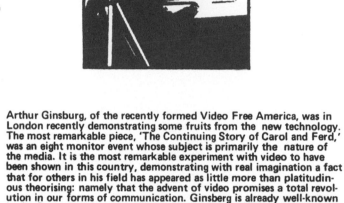

Arthur Ginsburg, of the recently formed Video Free America, was in London recently demonstrating some fruits from the new technology. The most remarkable piece, 'The Continuing Story of Carol and Ferd,' was an eight monitor event whose subject is primarily the nature of the media. It is the most remarkable experiment with video to have been shown in this country, demonstrating with real imagination a fact that for others in his field has appeared as little more than platitudinous theorising: namely that the advent of video promises a total revolution in our forms of communication. Ginsberg is already well-known in the States for his extraordinary productions of Heathcote Williams' 'AC/DC' and Allen Ginsberg's 'Kaddish'. His new work deserves equal acclaim. He hopes to begin public exhibition here sometime in the Spring, in connection with Twenty Four Frames, an independent film distribution service that will shortly be opening up in Video. We'll be reviewing the show to coincide with its opening, but by way of a preview, John Du Cane talked with Ginsberg and one of the stars, Carol Rowe, a tape artist in her own right, who is also currently researching a thesis on the great Decadents of the Sixties: Anger, Warhol and Jack Smith.

departures. There's much more fantasy on this tape. I have a cassette company... Kinky Kassettes Ink...the stock has fallen to nothing...

G: It was interesting that when we were taping the porn wedding there was one of the city's best porn makers present and he was really shocked by what was going on...he saw it as an invasion of privacy or something...but he still ended up participating. He was even one of the editors.

How different was it fucking in the tape situations rather than the porn movie one? I would have thought that the tape situation would be more intimate.

C: Not really, because we were seeing the whole thing as a commercial venture by then and it was just as public as the porn making...Arthur was never personal during the taping...he was more like an icon.

G: They were paid as models to do that stuff on the flag.

C: That **stuff**, as you call it, was making love...

G: The arrangements were the same as for a porn movie...cold and so on. The only personal bit was her monologue when she woke up in front of the camera in the morning.

C: They were a system and we were a system and never the twain met until after it was finished.

Were you using dope for that?

C: Sure, particularly cocaine...all the porn shops have their little supply.

But what about the scenes where you were going straight in Chicago...? that looked personal.

G: Yes, but a lot of that was them taping each other alone. The piece isn't a case study, anyway, it's not a piece of therapy...it's a sham really. We didn't follow them around. We only taped them four or five times. It's a piece about media...that's the real content and the use of eight monitors emphasises that. It's certainly not a piece about two people's lives. But there's a lot of wisdom in it, all the same (general laughter). There's a lot of extremely bright things said which I still get a flash from.

One thing I liked about the piece was that it was getting away from objectified art...of the permanent object placed and consumed in it's cultural context...the great castration...it's an indication rather of things about to explode open...it's a taking-off point.

G: Yes, as a piece about media it works like that, but in terms of the two people and that dynamic it was incomplete. It does a disservice to the personalities.

How did it work financially?

G: It cost about $30,000 which I haven't got back.

Where did the backing come from?

G: Video Free America is privately financed. The money came from anyone struck by it.

Let's go back to what you were saying about it not being particularly relevant as social/therapy.

G: Well, the issues are relevant, but also sort of dead...dope is a dead subject really, homosexuality is a given... the marriage of someone straight to someone gay is not unique. Even the themes are pretty stale...but perhaps

not for some people...

I don't know...I was very impressed with the scene in Chicago when Carol is nervous and frightened of the camera and you went into that number where you try to salvage a self-image and break down.

C: You know what I was taking at that time...vallium, librium...pints of belladonna every night...down, down, down ,...it was just a different kind of drug consciousness. Certain drugs heighten your self-image, others don't.

What I thought was relevant for other people was the level of self-criticism, both from your point of view and Carol and Ferd's. It had a lot to do with your personalities...there was a certain humour, an undercutting, a sort of creative reflexiveness going on that was very refreshing and unusual.

C: Yeah, we come across much better when we undercut. When we're more sincere and try to become articulate and poignant, we're sappy. You never mean anything you're saying...that's all I learnt from the tape...It never sounds right when you're sincere.

What happens when you see the tape on eight monitors?

G: There're four across and two down. There are four tracks. Of the two you didn't see there's a repeated visual leitmotif of the VTR going roud...it's a very strong image. The sound is mixed back and forth. Sometimes you see a monitor and sometimes you see a super close-up, which fragments the picture just enough into the lines. You get all sorts of surfaces of media. And I think that the image repetition is in itself an interesting thing. It's kindergarten graphics but it really works.

C: Jack Smith didn't like it.

G: What does he know?

Why didn't he like it?

G: Because he says you can only look at one picture at a time. The power of the image is lost by diffusion.

But you can use the business of distraction as content...the whole thing of image-location, internal tensions and polarities being set up and so on. I imagine with the eight monitors there's a possibility fo reducing manipulation in a certain sense, because the audience can choose for itself what they'll watch and how—so the climactic thing you get generally with one image, with it's linear, sequential build-up is pretty nicely fucked-up when you've got eight images.

G: Yes, with the tape the audience edits with its eyes, where in film it's always the film maker who does the editing.

The eight monitors must come close to providing the sort of ambient context for a selected image that we experience normally in our environment.

G: And there's also a strong associative thing arising from that. Again, the associations vary with the viewer. Another effect of the eight monitors is that you're not emotionally involved in the characters and in the story, which is good.

You respond to the whole situation.

G: In a Brechtian sense...You get away from the alienation of identifying with the image personality. You can't hide away any longer with your one little identification.

Penny Slinger

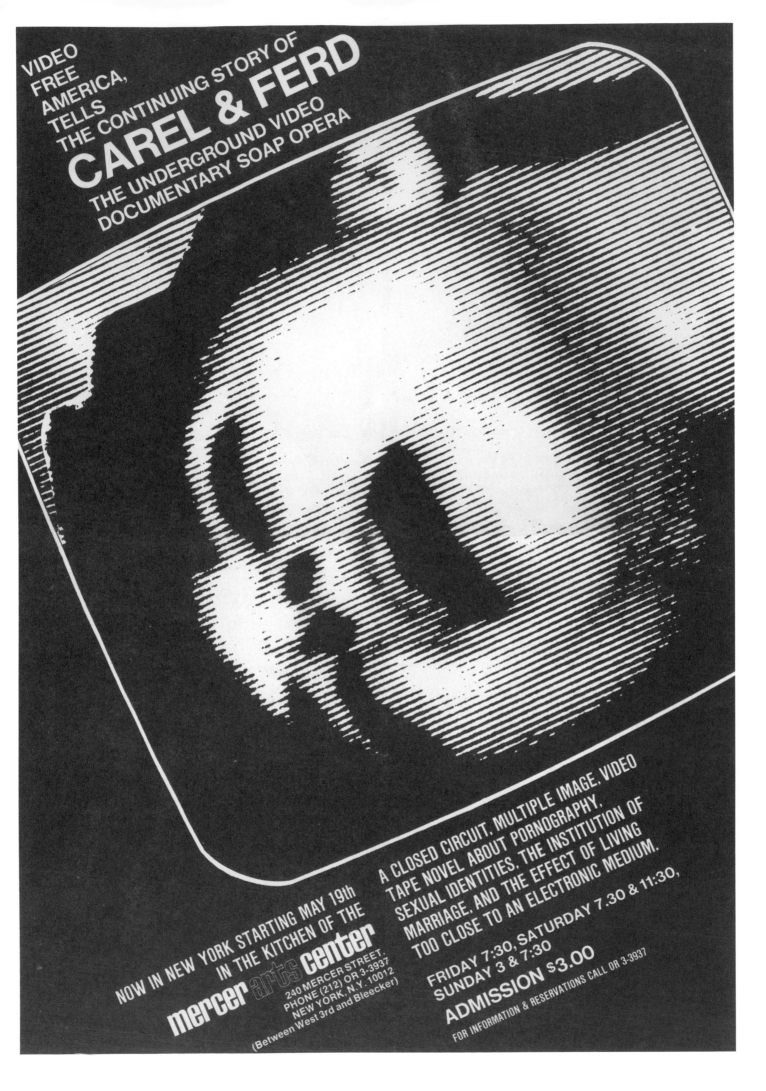

VIDEO FREE AMERICA, TELLS THE CONTINUING STORY OF

CAREL & FERD

THE UNDERGROUND VIDEO DOCUMENTARY SOAP OPERA

A CLOSED CIRCUIT, MULTIPLE IMAGE, VIDEO TAPE NOVEL ABOUT PORNOGRAPHY, SEXUAL IDENTITIES, THE INSTITUTION OF MARRIAGE, AND THE EFFECT OF LIVING TOO CLOSE TO AN ELECTRONIC MEDIUM.

NOW IN NEW YORK STARTING MAY 19th IN THE KITCHEN OF THE

mercer arts center

240 MERCER STREET,
PHONE (212) OR 3-3937
NEW YORK, N.Y. 10012
(Between West 3rd and Bleecker)

FRIDAY 7:30, SATURDAY 7:30 & 11:30,
SUNDAY 3 & 7:30

ADMISSION $3.00

FOR INFORMATION & RESERVATIONS CALL OR 3-3937

Carol & Ferd

Carol Rowe and Ferd Eggan, the "stars" of our underground, video verite, documentary soap opera, were struggling to escape from their lives and work as pornographic filmakers for the world reknown Sutter Cinema when first we met. They planned to get married, paying off some debts with one last film (of their wedding night). Then on to Alpena, Michigan, for a month with Ferd's parents where he planned to kick junk. Eventually they were bound for Greece, only to return again for the security of academic life.

Carol's name was given to me by Mother Boats of the Psychedelic Venus Church, as some one to get in touch with for the purpose of combining video and erotica. Skip and I were on our way to tape at the Good Times and so the wagon was well stocked with Sony half-inch gear when Carol said convincingly, "Why don't you make a tape about the story of our wedding (and the film of the consummation). At that moment they were anticipating the appearance of Richard, a friend and former lover of Carol's, who was determined to talk them out of tying the knot. And here on a rainy afternoon on Hayes Street our story began.

Taping with Carol and Ferd was (is) an incredible experience. They are witty, completely open, and have a great understanding of the media experience. Time and again in the midst of a heated argument, a heavy emotional moment or an orgasm, they would turn to the camera and comment (much in the tradition of the Shakespearean aside) on what was happening psychologically or offer some insight into the media process that was occurring.

These factors, interfaced with their rather unique relationship and circle of friends, resulted in a genre of Information-entertainment, perfectly suited to the production qualities inherent in half-inch video technology, particularly the facility to play back the unfolding story before its main characters, the ease of operation allowing subjects, directors and camera men to exchange roles, and the ability to edit and re-edit (a work in progress) as the story grows.

As of this moment we've taped with Carol and Ferd (or they with us) on seven separate occasions. The current version contains interviews, verite, rap sessions, instructional footage, erotica, process and feedback tape. There is also a sequence during which they were in a room by themselves with the camera, taking turns interviewing and shooting each other. We hope to tape at least one more session capturing their reaction to the current edited version, and the effect taping had on their relationship — also perhaps some additional interviews with participants in the "action"

Sex roles, media, homosexuality, junk, dope in general, aesthetics, film are the subjects which, mixed with endless anecdotes and probing psychological analysis and emotional moments make up the verbal content.

Our conception of what the piece was really about evolved through several stages. At first simply a piece of video erotica, then a Warholesque study of a couple of freaky people, then a hip study of the institution of marriage, and finally more or less where we are today — a number about media process, and public life style. In subsequent taping we hope to get further into how participation in a media event affects behavior — to what extent everyone becomes an actor when confronted with a camera, notions just touched upon in the final moments of our current version.

The question with which we're wrestling at present is how to best present this frankenstein of ours to an audience.

One valid yet disturbing thought is that with video tape the minute you do any editing at all, you are sapping its strength as a real-time medium. In fact, several people have sat in our studio and watched all 15 hours of original, some more than once, really getting into Carol and Ferd and becoming Carol and Ferd freaks to the point of considering them as personal friends. Observing this, we have in our more flamboyant moments considered establishing a Carol and Ferd environment offering a complete log of the tapes, several copies, several vtrs and monitors, allowing people to view whatever they wanted and in whatever order. Films made by Carol and Ferd would be available also, and at times the "stars" themselves might pay visits. Video gear to record comments or conversations would probably be included in the environment.

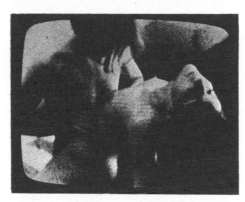

Another suggestion is to simply present it as an ongoing serial, presenting new episodes on tapes as they came in. Either of these two presentations lend themselves fully to the notion of ongoing taping.

The approach that would be most feasible for distribution would of course be to simply edit a single track approximately 1 1/2 hour narrative. Actually, this method also would tell the narrative story of Carol and Ferd most clearly. We will probably do this at some point. At present our enthusiasm is greatest for creating a 6 input system of 3 cameras (one on the audience, one focused on the operators, one interfaced on preview monitors) and 3 vtrs (one with basically narrative tapes, one with highlighting comments one primarily visual) all put through a matrix switcher to be delivered in varying combinations through twelve monitors.

This piece would have to be performed "live" by 2 operators (a distinct disadvantage) and would deal with the concepts of voyeurism through media, effects of media on behavior, posing the questions: how real is any piece of media? why are you watching it? and why did we make it? Also we'd probably tell the story of Carol and Ferd.

Recently on a tour of 5 colleges, we tried a watered down version of this last approach, and reactions, while varied, gave us direction as to where we should go. The system was utilized in some of the following specific ways. *Simul-tracking* (presenting two different views of same action) — this we did with the wedding ceremony. Playing the two views slightly out of sync was a reminder that a media event was being created. *Simultaneous tracking in time* (showing action happenign concurrently in two different locations) — contrasting the banality of the wedding reception with the nervous humor of the upstairs preparations for the consummation. *Double tracking to collide information*, i.e. demonstrating both the physical and psychological relationship between shooting up and "the sex act" by playing back these events at the same time; affectionate footage from early tapes contrasted with later alienated behavior; and a visual metaphor of a broken spouting sink pipe with discussion of marital difficulties. In print these examples seem quite obvious, but to experience them on combinations of 8 monitors is another thing entirely.

The two live cameras were utilized as follows: one, providing an input of a wide picture of the audience watching the monitors (toward the end) which remained in silhouette until lights were turned on and the viewers themselves became the viewed; the other camera interfacing from a nine inch preview monitor, at times pulling back to show the image of a TV within a TV, as a reminder that the whole thing was being done for public consumption (a recurring verbal theme), and at other times zooming in to pick up a detail of a picture, a close-up of a close-up, and also fragmenting the image into the enlarged scan lines colliding the obvious constructed electronic image with the similar but apparently real one next to it.

The ability to move any combinations of these 4 inputs onto any displacement on 8 monitors by use of the matrix switcher created endless potential for both emphasis and experience, which sometimes, by accident or design, was well exploited (excuse the term).

I shall not make the mistake of verbalizing further about the electronic grammar of environmental video (matrixing, simultracking, double tracking, interfacing, live camera input, etc.) because it's a visual tactile experience, a grammar which we are just beginning to explore with no counterpart in words).

If, after reading this, your curiosity is aroused either about *The Continuing Story of Carol and Ferd*, or about the techniques we intend to explore in presenting it, I can only recommend that you watch for it at your local neighborhood video theater.

Arthur Ginsberg
Video Free America

p. 100
Poster advertising *The Continuing Story of Carel & Ferd* at The Kitchen at Mercer Arts Center, New York, circa 1972.

p. 101
Arthur Ginsberg, "Carol [*sic*] & Ferd," *Radical Software* 1, no. 4 (summer 1971): 15. Used with permission.

SAM GREEN

Born 1966, Detroit, Michigan
Lives and works in San Francisco, California

WE KNOW HIS NAME WAS MEREDITH HUNTER. He was the eighteen-year-old African American victim of the infamous stabbing by a member of the Hells Angels at the Rolling Stones concert at Altamont Speedway in 1969 whose murder was captured on film and recounted in the documentary *Gimme Shelter*. The milieu around this stabbing—rock and roll, youth culture, drugs, and spirited idealism gone awry—was mined extensively in the media, which boisterously proclaimed his tragic death as the end of an era of hope and idealism.

Nowhere in any news accounts of the day was the background story of Meredith Hunter told; even with the intense public scrutiny of the circumstances of his death, no media outlets delved into his life. There were no quotes from neighbors or teachers, no image of his bereft family members, no description of the stylish clothes he wore to the concert … nothing. This absence of information would be inconceivable today, with our collective insatiable appetite for the details, however mundane, prurient, or insignificant, of a person's life.

The lack of media microscoping of Meredith Hunter's life becomes even more poignant given the dull, sad absence of any physical marker of his death—a fact at the core of Sam Green's documentary *lot 63, grave c* (2006). Meredith Hunter's body, we learn, lies in a lonely unmarked burial site at lot 63, grave c, at Skyview Memorial Lawn cemetery in East Vallejo, California. Lawn sprinklers issuing shots of water over wilted daisies are nearly the only signs of life in this otherwise quiet place. Counting out paces to the head of the unmarked grave, the cemetery's funeral director stands silently for a moment on the spot where the marker for lot 63, grave c, would go. His small gesture becomes a kind of brief, solitary memorial, and we become witnesses to this forgotten memory. Capturing that simple act on video, Sam Green offers up a tender elegy—perhaps the only one in existence—to Meredith Hunter.

Like other documentary works by Sam Green, *lot 63, grave c* revisits another era by weaving archival images and found footage with contemporary interviews, insight, and analysis to create complex portrayals and subtle critiques of contemporary culture and values. In *The Rainbow Man/John 3:16* (1997) Green recounts the tragic story of Rollen Stewart, who gained notoriety after appearing at countless televised sporting events in the 1970s while wearing a rainbow-colored wig and carrying a placard that read "John 3:16." *Pie Fight '69* (2000) unearths lost footage from a group of radicals who interrupted the gala premiere of the San Francisco Film Festival. Green's documentary *The Weather Underground* (2002), codirected with Bill Siegel, was nominated for an Academy Award in 2004.

Irene Tsatsos

SAM GREEN: THE LINE BETWEEN FICTION AND NONFICTION IS BLURRIER THAN MOST PEOPLE THINK
by Mike Plante

CINEMAD: Did you always want to make documentaries?

SAM GREEN: I never went to film school, but I did study journalism at UC [University of California] Berkeley, and Marlon Riggs, the documentary maker, taught there, so I studied documentaries with him, but it was all video. I never learned how to do film or anything. He was awesome. I got a Master's degree. When I went there, I wanted to be a newspaper reporter, but then I took this video class and it was really fun, and writing was so lonely. I wasn't even that good at it. I would spend super long hours in front of a computer alone, being frustrated. And video, to me, was so much more fun and collaborative. After I took that class I changed direction.

What did he show in class? He showed all sorts of stuff. He was great because he, in a lot of ways, sort of showed me a direction that I wanted to go and ended up going in, which was both a real rigorous journalistic approach, but at the same time, kind of an experimental impulse as well. I had not been super into film before that, and I saw some things there that really knocked me out and opened my eyes, like *Sans Soleil* [1983] by Chris Marker. Or *Salesman* by Albert and David Maysles [1968]. Seeing those movies kind of opened my eyes to this whole world that I really got sucked into, I guess.

Did you make *The Rainbow Man/John 3:16* [1997] at school? I made some short pieces, but Riggs was dying at that time and the program was kind of falling apart, and there really just wasn't any support to do a longer work. So I graduated, and I figured I'd have

to get a job, so I moved to L.A. and got this job working for Fox Television on this news magazine show. My job was to find footage of people. It was a really dumb job and I needed something to keep me busy. I had read something about the Rainbow Man in a paper and really got curious. It really got under my skin, so I just decided to try to find shots of the Rainbow Man, because I could call up Major League Baseball to get stuff for stories, like they were doing a profile on Barry Bonds. I would just slip in, "Hey, could I also have the 1977 World Series?" I started to acquire all this footage of the Rainbow Man, and at first it was just kind of a funny, goof, lark type of thing, but then after a while it started to become more serious. I was totally perplexed because my parents were kind of superliberals, and so they didn't have a TV when I was growing up.

pp. 102–5
Interview excerpted from Mike Plante, "Sam Green: The Line Between Fiction and Nonfiction Is Blurrier Than Most People Think," *Cinemad* (June 2004). Used with permission.

pp. 102–3
Sam Green, stills from *lot 63 grave c*, 2006. Video and appropriated film, color and black-and-white, sound; 9 min., 47 sec.

I never watched TV, and I remember reading about the Rainbow Man when I was in L.A. and thinking to myself, "How do I know who this guy is? How has he penetrated into my consciousness? I never even watch TV." So that was one of the things that interested me, that he had been so incredibly successful, in a way.

At least according to your video, it's misguided, but it's an interesting goal. The cult of celebrity is interesting, and then when you mix in the religion, and a crazy upbringing, the rest of the story. He sort of struck me as like the ultra-American. He seemed to have all the qualities of an American, only in super-extreme forms, like no family, no direction, no other values except TV. TV was his total reference point. That's obviously not a good recipe for having a stable, positive, peaceful life.

Was he pretty cooperative since you were another piece of his celebrity? I wrote him a letter. He'd been in prison for a couple years and nobody had ever visited him. He'd never had a single visit. I went once without a camera and talked to him. He was crazy about the idea because at that point, and I think it's actually still true, he felt like the world was still just about to end, and so I was a way for him to get the word out. It was weird when I actually did go back and interview him; I did this long interview, and you know how when you do an interview you save the more sensitive questions for the end, and one of the questions I saved in case he'd get upset was, "Do you think that the media, myself included, exploited you?" He had been really tense throughout the whole interview and it was the only time that he smiled. He actually smiled and chuckled. He said, "Actually, I'm the one that's exploiting you. Who else is getting interviewed in this prison today?" And it sort of knocked me back for a minute. You know, that's the way

he thinks of it. He feels like he's using the press, although I would disagree with that.

He's still in prison? Yeah, he's gonna be there forever. I showed it in Europe, and the first question was always, "How is this guy in prison for life?" To them, it makes absolutely no sense.

It's because we're scared of the mentally ill. Yeah, or just somehow this crazy guy is stuck in the noncrazy part of the criminal justice system, which is itself crazy.

Is he actually in a prison or is it a mental health institution? He's in Vacaville [at the California State Medical Corrections Facility], which is like a prison, but it's prison for . . . not people who are certifiably crazy, but I think they pump them full of drugs and stuff like that. It's a medical prison.

When did you find out about the incident in your video *Pie Fight '69* [2000]? It was probably like '98 or something. The year after *Rainbow Man*, I started working on *The Weather Underground* [2002], and I was at the Bettman Archives in New York, which is this great photo archive that has since been bought by Bill Gates and is not accessible anymore. I was going through folders of photos, and one of the photos was this really funny one of a woman in a tutu throwing a pie, and it said, "San Francisco Film Festival, Opening Night, 1969." And it didn't say anything more than that, and I was completely intrigued. So when I got back, I got a couple of articles and read about what happened . . . the ringleader was Peter Adair, who was a huge hero of mine.

The first real film that had moved me had been . . . this is a little bit of a digression. I'd had a job in college showing movies in class-

rooms, and this was back in the days when you would bring a 16mm film into the class, set up the projector, and show it. Most of the movies sucked. I showed *Inside the Human Brain*, an educational film, in psychology classes like four hundred times, and these were all old educational movies, but once I went to a comparative religion class and showed this movie, *Holy Ghost People* [1967]. It's Peter Adair's first movie, and it's a documentary he made when he was actually still a college student at Antioch College. It's about this church in West Virginia, Appalachia, in the late sixties, where they handle snakes. Like that's part of their ecstatic approach to religion where they handle snakes and speak in tongues. They handle rattlesnakes. It's fucking amazing. This is a verité documentary in black and white. Unbelievable. After I saw it in class, my jaw dropped and I took it back to the office, and just projected it on the wall and watched it again. I was amazed. I'd never seen a movie that moved me like that, so Peter Adair was always a big hero of mine. When I got these articles about the pie fight incident and read that Peter Adair had been the ringleader, I was really intrigued, and also the articles had mentioned that the radicals had filmed this event with cameras and they wanted to make a film about it. I just started to ask around to find out about what happened to this film, and nobody really knew. So it became this big mystery, and then I talked to Bill Daniel, you know, like the Zelig of the underground film world. He said, "Oh yeah, I found that film once in the free box at Film Arts Foundation." You know, in the lobby there's this box where you can put things if you just want to give them away. I was amazed. I said, "Well, what did you do with it?" And he said, "I gave it back to Peter Adair," who was real sick with AIDS and had subsequently died. So I asked around, I went to Peter Adair's family, his business partner, and his old boyfriend, because now I knew that the film existed, but it had sort of disappeared again. Nobody had it and I went through all of his stuff and I couldn't find it. This went on for a couple years, so I sort of figured it was lost. Then one day, late at night, I got a call from Bill Daniel, saying, "Sam, you won't believe this. I was in the basement of ATA (Artists Television Access) going through some unmarked boxes and I found that film again." The odds of that, that's almost divine, there's no other way of explaining it. So I rushed over to look at it and it was amazing footage, it was beautiful. At that point, I was really inspired to make that little movie.

What drew you to *The Weather Underground*? I had always known about the group and I loved the story. With *The Rainbow Man/John 3:16*, I really loved that story. It resonated with me emotionally and it felt to me like it was a story that was almost a parable. This is what I liked about it. It was a really fascinating story, but it evoked ideas and themes, and kind of said something in a very indirect way. It was kind of dramatic and sexy and interesting, but there was also a lot of substance at the heart of it.

And at that point, was it sort of a forgotten thing? I think it's more than that. It was always weird to me that when you work on a documentary, you have eight billion conversations with people about what you're working on. Anybody over forty that I talked to about it, said, "Oh, wow, the Weather Underground," and 99.9 percent of people under forty I mentioned it to would just have this blank look. They'd never heard of the group. I think, in a way, it doesn't fit into the sort of clean cartoon version of the sixties in history at this point. You know, the idea that everybody was a hippie, and they all went to Woodstock and protested the war, and then the war stopped and everybody got into disco and got jobs. I don't think it's a conspiracy to suppress a story like this so much as it's hard to write about it. You have to write about it in a sophisticated way to fit it into those narratives.

Were the people in the Weather Underground pretty much on board? Oh, no. They all initially said it was a horrible idea. None of them wanted it to happen at first. "Why bring this up?" It took a long time to get the people who had been in the group comfortable with us to the point where they would actually participate in the project.

How did you even find them? Some of them are kind of public, but most of the others, it became pretty clear early on that there were going to be good ways and bad ways to find them. Once I just got somebody's number off the Internet and I called her up. I said, "Hi, I'm doing a documentary on the Weather Underground. Can I talk to you?" There was this long pause and she said, "I don't know how you got my number, but never call me again," and hung up. I just realized then that that's not a good way to do that. We would talk to people and sort of develop a relationship with them, and then ask them to help us get in touch with other people. You know, one person could call another and say, "These guys are doing some research and they're okay, they just want to talk to you in a very off the record way." Almost anybody will have coffee with you just to see who you are, and after awhile we were able to impress upon people that we were serious and it wasn't Fox News, it was an independent film.

How did you go about deciding what was important and what had to be included, and how do you figure out what order all those things are? That was really hard. With documentary, you're always kind of subtly rearranging chronological events. The line between fiction and nonfiction is blurrier than most people think. I'm not making stuff up, but just sort of adjusting sometimes. With *The Weather Underground*, there were all these people who had (a) been in the group, and you had to have your shit straight for them, and (b) all the people who had lived through that time and had strong feelings about the group, either pro or con. I felt a huge responsibility to know what I was talking about and to get it right. The editing took a long, long time just to make the film communicate the story in a clear way, and also to include enough context where it made sense, and make sure that important things were in there, and on top of that to make it work as a narrative. Those are sometimes things that conflict. With a documentary, you

p. 104
Sam Green, still from *The Rainbow Man/John 3:16*, 1997. Single-channel video, color, sound; 40 min., 30 sec.

p. 105
Members of the Weathermen, a group of extreme-leftist radicals, march in Chicago during the Days of Rage, October 1969. Black-and-white photograph. Photo by David Fenton.

show people a rough cut of the film and you do that over and over again. The most helpful person was Caveh Zahedi. He was amazing, because I didn't know anything about dramatic film. He said real early on that you've got to make this work like a feature film. You sort of have to take that structure and use it, and I've got nothing against that. If those kinds of things work, I'm all for it. It's a real formula and I didn't adopt it a hundred percent, but the ideas behind it are really sound.

Was there anything that you thought would work and you ended up taking it out? I went through all sorts of crazy ideas. I had this great footage that I loved and this whole section I put together. I was trying to develop this sort of subtheme for the movie about the consolidation of the media and sort of explain why nobody under forty has ever heard of the Weather Underground. I was in the middle of editing and I read 1984, which I'd read in high school and thought was cool, but I read it again and I was flabbergasted by how good and how sophisticated it was. There was this quote in there, and I'm paraphrasing here, "Whoever controls the present controls the past, and whoever controls the past controls the future," and there's a lot to that. The idea that whoever is in power now controls what we know of history or how we think about history, and people's notions of the past inform what they're going to do in the future. I tried for a long time to work in this more experimental thread through the documentary that evoked these ideas in a very nondidactic way, and it never worked. Eventually I had to cut it out. That kind of broke my heart, because one of the videos that I loved and that was kind of an inspiration for me in making *The Weather Underground* was Johan Grimonprez's *dial H-I-S-T-O-R-Y* [1997]. It's amazing. It's a really smart video about lots of big ideas, but never explicitly so. It's very experimental in that it's just this weird history of the hijacking phenomenon without anything else that's explicitly articulated, and it's just a compilation of great footage. I was aiming to do something that was in that direction, in terms of being experimental, but I kept getting pushed in a more straight direction just by the nature of the story and the kind of responsibility that I felt to make it clear.

Is there still no way for somebody who wants to make documentaries to kind of navigate making a living? I'm convinced that the only way to do it is to make films really fast, and make 'em for TV, and get paid while you make 'em. Anybody I know who's done that has started to make shitty films. I'm just going to keep doing it as long as I can. I do a few college screenings and make a little money off that, but I teach and that's how I make money, and I also live in a pretty low-budget way.

I think it's age fifty where people just kind of— Fall off. "It's a young person's game."

Or then it's the wine commercials, the comedy with Robin Williams. The bad corporate videos.

Yeah, I mean, you gotta plan your eventual sellout. The problem is at that point, it's going to be for such little bucks, an exercise in humiliation. At that point, I'm going to go to law school. In California, you don't actually have to go to law school, you can just take the bar exam. Very few people do it, but I'm just gonna study hard for a year.

Do you have another film lined up? I'm doing something, it's a real messy idea at this point, but I want to do something that's more experimental, a documentary that weaves together unrelated stories to kind of make a meta-narrative, in a way, that would be about idealism and utopia, the idea of utopia, and the limitations of human nature. I'm approaching things differently than I have in the past where I've always had a story that evokes ideas, and here I'm sort of starting with the ideas and putting together a few stories. I don't know, it's still real unformed at this point. I gotta figure out a way to work in a celebrity, though. I'm trying to see how this idea can incorporate the rapper Ol' Dirty Bastard. If I could get ODB in this, I'd be really happy.

DALE HOYT

Born 1961, Auburn, New York
Lives and works in San Francisco, California

IN ALL HIS UNDERTAKINGS—which have included writing articles under the nom de plume "Natalie Welch," working as a video curator at The Kitchen in New York, and painting the official portrait of CC (Copy Cat), the world's first cloned cat—Dale Hoyt has consistently conveyed the pathos of mass media by rupturing the symbolic order of everyday actions and events. *Clinic* (1987), for example, moves through a series of unnerving images: a sequence in reverse motion, a woman with a feeding tube, a couple stuffing a live cat into a cat costume, a purple embryonic form. Otherwise mundane situations become provocative and bizarre when stitched together in Hoyt's inscrutable configurations.

In *Who Shot MM?* (1981), Hoyt draws on the iconic outline of Texas, fixed against a TV monitor's shifting static to embody alienation and miscommunication. Hoyt's voice is heard in exchanges with several telephone operators as he tries to connect to Houston but repeatedly misdials. The caller's futile efforts almost seem to dramatize the adage "Houston, we have a problem." In a statement about the work, Hoyt writes:

> I made *Who Shot MM* when I was nineteen, which was a minor triumph since two years earlier I had endured the hyper-competitive milieu of film school at NYU [New York University] and the School of Visual Arts. I swear that every day, some professor would come in and bark that Orson Welles had made *Citizen Kane* when he was twenty-four, and "Hey-what-are-you-doing-with-your-life-Junior?" I couldn't stand it, so I moved to San Francisco to attend the Art Institute. There I found an equally intimidating mythology that Kenneth Anger had made *Fireworks* in his parents' living room while they were away and he was only seventeen! So I was just glad to make recognized work before I hit the dreaded big two-o. The title refers to the "Who Shot J.R.?" media frenzy that was generated by *Dallas*'s cliff-hanger of the '79 season. It also refers to my Canadian Idol, Marshall McLuhan, who died on January 1, 1980, the beginning of a decade that apparently "M.M." wasn't interested in witnessing (too bad that he missed Flock of Seagulls). But MM also refers to Marilyn Monroe, Mickey Mouse, Mickey Mantle, Maria Montez, Megan Mullally, Marie Menken, or Michelle McCoy. Whatever you want. It's your nickel.

Catherine Taft

[ESSAY]
FOUR ARGUMENTS FOR THE ELIMINATION OF MTV
by Dale Hoyt

Only the most socially myopic among us can devalue Pop Music's ability to reshape our world. Defensible or deplorable as this gripe may be, fashion trends are still set, hair still coiffed, and lifestyles still lived according to Pop Music and the attitudes therein. Ignoring the potency of this cultural rudiment is point-blank ignorance. You don't have to exalt pop music as society's lifeblood to recognize it as an essential artery. That this force's makeup is being blatantly tampered with by MTV disallows any dismissal of the station as fluffy, dumb, tacky fun. The reworking of this value system, therefore, should be of interest to even the most casual participant of culture. Pop music might catch the cold, but we'll do the coughing.

HYPEREMPHASIS OF MERCHANDISING: THE PACKAGE WRAPS ITSELF

The recording industry's all too predictable response to MTV's snowballing clout is increasingly observable in the support being paid to those bands and soloists that come complete with their own photogenic dressing and statement. Packaging has always been a key element in the selling of entertainment, but never has this wrapping been so indispensable. The bitter truth is that this packaging and this packaging alone is being substituted for content. So important is a song's complementary video to its success that many songs are written and produced with this device in mind. For instance, Thomas Dolby's "She Blinded Me with Science" incorporated spoken dialogue, it can be safely guessed, to sweeten its video dramatization. This preoccupation with the all-important package informs any upwardly mobile musical artist that subordinating his or her music to the subsequent sales campaign is the only alternative to obscurity. The concept of a pop star surrounded by a full sensory backdrop is common enough, but

this promotion for promotion's sake can only conjure images of the snake eating its tail.

To a certain extent this mentality recalls the star system of the forties and fifties where the films a star might appear in became adjunct to the stars themselves. The final analysis of the indelible impression left by, let's say, a Jayne Mansfield is Movie Star. However, when "musicians" and "music" are denoted as such, when they are only withering components of an estranged product, this perception is not quickly comprehensible. To those who hold music sacred, these practices are atrocious, but to the greater majority who don't, the contradictions still glare. The oxymoronic absurdity of the matter is that something called "music television" is a showcase instead for stylized cinematic exercises that subjugate music. At the very least, this rape of logic and language should be cause for alarm.

DESECRATION OF REGIONAL AND INDIVIDUAL IDENTITY: BLUES FROM NOWHERE

"The new Westinghouse Jet Set: Doesn't stare back at you. It's a considerate Television"—ad from a 1966 *Life* Magazine.

MTV either ignores or annihilates anything other than fey Euro or anemic middle American music, staples that won't tax the imagined viewer: the most non-specific American, address unknown.

The channel's burden is simple: to deliver only that music that can act as the concerted voice of the invisible average, the ectoplasmic everybody/nobody. The gang's all here. Don't look back, don't look forward, sideways, cross-eyed, or different. Just look. See how considerate your television can be.

That Bob Dylan or Elvis Presley could not have made it on MTV—had it been the barometer of their times—is no longer an accusation as much as it is a reasonable conclusion. The eventual deprivation of music's growth and progress would go far beyond our culture's loss of a few undiscovered geniuses, though. Such circumstances would see few of the last three decades' most fundamental and treasured

pp. 106–9
Text excerpted from Dale Hoyt, "Four Arguments for the Elimination of MTV," *Send* magazine (Spring 1985): 30–34. Reprinted with permission.

styles making it past their bathroom-tiled recording studios, for the basic tenets of their vitality would be barred by MTV's format, tactics, and policies. This bulk would be disqualified by the channel's disdain for regional individuality and values. Regionalism's persona non grata status is grossly ironic since this is the quality most responsible for the significance of the last thirty years of popular music, without which there would be no such thing as a video music channel. Cultural absorption carried to its absurd, clammy conclusion.

For argument's sake then, let's agree that the music commonly known as Rock and Roll, its roots and transmogrifications are inspired by a rebellion against the watery status quo. As with Kierkegaard's Christian, rock and roll finds its initial identity only in alienation and exclusion from the grand scheme.

A regional audience is the only realistic gallery for the musician with a remote or regional intent. It should be no surprise that rock and roll was nurtured by radio stations with little more than fifty mile broadcast radii. Because of—not in spite of— provincialism, music's lionization reached a global scale. Motown's Detroit, Nashville's Country and Western, R and B's Confederate followers were the only launching points that could possibly maintain the purity and integrity of the music. Myriad cases (San Francisco's Electric Kool Aid Acid tribes, Liverpool's working-class grottos, even the scattered cliques that invented proto New Wave) illustrate that these support systems have been the foundation of virtually every innovation that pop music has enjoyed. The alternatives pale in quality and impact.

MTV's utter obliviousness to regional tastes and needs is absolutely without precedent. MTV has no use for anything that won't be immediately recognized by the largest possible portion of the country. This may not seem to be much different from the intent of pop music heretofore, but it is ominous indeed.

Rigid as they may be, all top 40 radio stations filter their play-lists through their community's personalized prerogatives. Some markets reflect the national mean more than others, but all are molded by this local consensus. Indeed, this is their legal obligation and the provision of the FCC license. MTV, on the other hand, addresses the entire nation and determines its programming exclusively by this mean, which only accurately reflects the alleged tastes of a few markets, and then only by the strictest of coincidence. The leanings of the vast remainder are systematically ignored or aggressively obliterated.

Responsible to the most varied audience a pop music showcase has ever been privileged to address, MTV elects to pretend the assemblage is not even there. When was the last time you saw a VJ take a request? Purchasing the products hawked by the station is the only method of feedback a viewer is allowed. Phone-in polls tabulating viewer reactions to unsigned bands are but crumbs gathered at the foot of the channel's dinner table. You are allowed a vote, not a voice. Democracy becomes demographics, and the most impassioned applause is reduced to a statistic, so many hands being struck together. Compared to this, American Bandstand's "rate-a-record" seems positively anarchistic. And, of course, the given is that if these bands are to please such a mass, their identity must be made as murky as the hazy, anonymous majority for whom they will play. In these days of US festivals, the ME generation never looked so good.

As much as television tries to deny it, the medium mandates the disposability of its contents, a practice MTV performs with the greatest of gusto. As a twenty-four hour continuum, MTV has little or no need to maintain any schedule or format as the networks must. Just as long as a new tape or feature appears every three minutes, their service has been fulfilled. This is why MTV could be the perfect outlet for any number of tastes and styles of music, regional or otherwise. MTV's insatiable turnover invalidates any possible excuse for the present impenetrable programming policies decreed by the station's strawbosses. Only cowardice, mercantilism, and bald-faced electronic

fascism can be at its core. This shouldn't and doesn't surprise me, but it does scare me.

In the meantime, the absence of what could broadly be called folk music (be it California Surf Sound, Summer of Love Psychedelia, Holy Roller Revival Gospel, or all betwixt and between) intones the disquieting query: if folk music is no longer important, are folks no longer important either? Only, apparently, if those folks come from that ubiquitous hinterland, the Nowhere of Epstein's "News from" R. D. Laing asked it once before, "Are persons possible anymore?"

Jerry Mander's recurring argument maintained that even if television could be merchandized in a non-conspirational manner, the very innate realities of the medium still make it as dangerous as any totalitarian regime. Once again MTV graciously demonstrates Mander's principles as if expertly prompted by the author himself. That the owners and administrators of MTV are actually gifted enough to deliberately and adeptly conspire to the ends that I and others perceive is a moot point. What does not have to be confirmed is MTV's effortless ability to offend, irk, and alarm even in its most disarming moments. The station needn't be caricatured as villainous, for its involuntary treachery is unnerving enough. No poetic embellishment is needed. The pervasive innocence of it all gives MTV its cryptic icing.

What was Orwellian paranoia to past generations is now a constant and casual joke at MTV. Candid references to hypnotism, corporate

p. 107 top
Dale Hoyt, still of Margo Adams from *Your World Dies Screaming*, 1981. Single-channel video, color, sound; 4 min., 50 sec.

p. 107 bottom
Dale Hoyt, still of Ellen Stern from *Ringo Zappruder*, 1981. Single-channel video, color, sound; 3 min., 20 sec.

lateral alliance stands to become the strongest transmitted influence of our lifetime. Both B. F. Skinner and Seven Eleven would be proud: ONE-STOP BEHAVIORAL MODIFICATION, 24 HOURS A DAY.

THE DESPICABLE DEPICTION OF WOMEN
The use of the idealized lily-white female form in advertising is a standard reality that any pragmatic consumer of media should have little trouble accepting. Like any other promotional device, MTV tapes must rely on a few time-tested wiles to effectively achieve their goals. Since most promos don't have much use for kittens, puppies, grandmas, or

cal to any such thing. Beneath the thin membrane of all that gloss and sweat is the same old tired puritanical Playboy bunny posturing. What imagery that doesn't psychologically pollute is just hack Freudian semaphore. So in other words, the Glass Teat turns out to be quite a horny old broad, a menopausal aunt going along on the honeymoon. When the final bodycount is in, don't be surprised if MTV-ised sexuality turns out to be more lethal to the alleged sexual revolution than AIDS, herpes, and erotic ennui combined.

The final blow is found in the fact that even the female musicians and vocalists assume the prescribed postures as consistently as the

children, the beckoning siren (an artifice that marketeers insist entices both sexes) is the only remaining, guaranteed pitch.

Again the station is faithful to Mander's description of television as a lumbering sales combine. Like a hall of mirrors, the purpose of MTV is all too discernible: to sell, to sell the selling, to sell the selling of the selling, and so on. The sacrificial lamb to this maladjusted attachment to commerce is the entire female gender.

That the women must be perpetually portrayed as either succubi or dingbats cannot be excused as skilled salesmanship, rather, it is a conscious and diseased defilement of women for its own sake. This transparently formulated debasement of the gender is conspicuous enough to be sickening yet subtle enough to be toxic. If this slander was not bad enough, the off-hand inclusion of violence against these parodies approaches a criminal intensity. Never has sadism been so nonchalant, defamation so overt. MTV: Male Television.

Save for the concert footage, the remaining scenario-oriented

nameless casting couch cheesecakes. Pat Benatar wears a jumpsuit conveniently diagramming her pelvic region, the Go-Go's don steamy fairy princess costumes, and Dale Bozzio sings from behind an ensemble made from transparent plastic and other packaging material shamelessly reminding us that she too is a parcel, and proud of it.

MTV's two female VJs perfectly complement each other. Nina Blackwood looks for all the world like a wayward cocktail waitress while Martha Quinn might otherwise be found at a summer camp with a coach's whistle around her neck. Nina has posed for some nude pictures in *Playboy*, Martha probably showers in her slip. By the diametric opposition of the two, the not so subtle message is telegraphed to the male subconscious: They are actually the same girl! The nice girl/bad girl contrivance recalls the paradox of the mythological woman, both destructive and life giving. The chasm between the two girls' demeanors also offers up the inevitable mother/whore dichotomy giving permission to so many men to see woman as menacing and worthy of

p. 108–9
Dale Hoyt, stills from *Dancing Death Monsters*, 1981. Single-channel video,

This portrayal of women finally qualifies as tragic when we stop to remember what MTV probably means to the malleable generation of high schoolers who comprise the station's major audience. I am fully aware that this might sound like misplaced parental supervision, but it concerns everyone who will have to share this world with this generation.

As the closest thing to alternative media these kids will see, the swaggering male and the slithering female role models that populate these tapes must seem like revealing disclosures of human nature to the adolescent reared on "Eight Is Enough" and "Three's Company." Token hipness and flashpowder gimmickry are presented concurrently with the convincing sincerity of the VJs and can be nothing less than entrancing to the naive or confused teenager. And what teen isn't either or both? That this trust is then used to warp young mens' conceptions of women is almost as sad as the impressionable teenage girls being forced to mimic this behavior. So much for the electronic babysitter.

DISLOCATION: THERE IS NO HERE HERE

Ray Charles has said that he always stays at Holiday Inns because each room is the same and he always knows where everything is regardless of the city. This kind of solace is MTV's major attraction to a generation that has never known the camaraderie and excitement of a

pretends to plant us in the thick of things, the hip, the now. The only true brotherhood we are members of though is our inclusion in a common ratings figure. This masquerade is, nonetheless, as irresistible as it is addicting.

It must never be forgotten that any artificial dependency is a no win situation, no matter how serene or adjusted the junkie might seem. The inherent deception forever threatens to topple the house of cards of the addicted. The opiate is the orphanage. It houses us, it is not our home. The hollowness I feel while not watching television (MTV et al.), or when it is not a practical option, is distinct and gnawing. What should be where this hollowness loiters, I may never exactly know. I only know I can't go home because I never had one to begin with. Neither do you. We only have dormitories, hotel rooms, and sublets. We leave no forwarding address.

CONCLUSION

While Mander chose militant idealism to consummate his essay, demanding the unconditional extermination of the entire medium, I'll opt for subdued optimism. MTV and the like could only be eliminated if something on the scale of the collapse of the international banking system were to occur. Otherwise, as sure as the moving finger shuffles through profit receipts, MTV will not be budged.

Beatlemania or Woodstock. The networks created the "we," but MTV puts the "us" in us.

Having robbed us of the humble joys of guessing how "Fibber McGee and Molly" really looked, television now collects on what imagination pop music could spark. This extortion is not remorseful because of its denial of our own mind's eye, but because yet another aspect of our lives has been co-opted by a guild of disinterested storyboarders, directors, make-up artists, and choreographers. We are supplied with one more reason to stay home, one more justification for our agoraphobia. I'm not implying that we will literally not go outside as much, I just mean that we have lost one more reason to stray from the great cosmic Holiday Inn of our pop consciousness. So we atrophy with only the slightest tinge of regret. We can go anywhere our hearts desire, but why bother? It all looks alike, and we know where everything is. The option of staying put seems infinitely more practical.

Just as the parishioners of religious broadcasts are asked to believe that what they watch is a direct feed from the Almighty, MTV

As even a snob such as myself has frequent occasion to do, watching MTV does not have to make us bad or stupid. Taken lightly, we can at least postpone our fall into the thrasher and come to realistic terms with our diminishing constitutions. Fight the good fight, some might call it. "If you can't lick 'em …" also comes to mind.

Steina Vasulka demurely suggests that "if we are all to be victims, let's be informed rather than merely innocent ones." Mander might repudiate this as insubstantial, but it remains perhaps the only ration of dignity we can hoard. Even such a scant recourse against MTV and the culture it generates should be treasured as precious and our single consolation.

It will still happen, though, and we'll let it. The tentacles will wrap, tug and constrict ever so slowly, irreversibly. We are not scheduled to be annihilated. Rather we will be lulled, tranquilized, suffocated. Forget the BIG BANG, get ready for the BIG SLEEP. Somewhere out there, there's a Valium with your name on it.

ULYSSES JENKINS

Born 1946, Los Angeles, California
Lives and works in Los Angeles, California

FOR THE PAST FOUR DECADES, Ulysses Jenkins has used video and multiple storytelling strategies to explore the power of images over viewers' imaginations. Jenkins relies on interviews and live footage in documentaries such as *King David* (1978), *Remnants of the Watts Festival* (1980), and *Momentous Occasions: The Spirit of Charles White* (1982). In *Planet X* (2006), he mixes television news clips with broadcast radio and deliberately low-tech special effects to ask provocative questions about Hurricane Katrina. *The Video Griots Trilogy* (1989–91) relies on images and music to construct a global concept of blackness and interconnectivity.

While Jenkins's scope is international, his principal investigative concern is the intersection between the visual world and African American identity. His work in this area is filled with critical urgency and didactic intent—a pairing that could easily overpower, were it not for Jenkins's liberal and well-timed use of humor. *Mass of Images* (1978) uses blurry black-and-white video, a stack of blank-screened television sets, and an ominously untraceable hum to invoke the ambiance of a low-budget horror film. When Jenkins's protagonist rolls out from behind the televisions in a wheelchair, one hand grasping a sledgehammer, his face covered in plastic, wearing a neck scarf that resembles an American flag, viewers expect something truly dreadful to follow. And it does. But the horror, as we quickly learn, is real rather than fictive and resides in the images that Jenkins flashes onto the screen: film stills of actors in black-face, actors cast in the roles of caricatures, frozen moments of twentieth-century racism caught on film. As images slide past, Jenkins's protagonist repeatedly intones a dire pronouncement: "You're just a mass of images you've gotten to know, from years and years of TV shows." This mass of images weighs heavily on the imagination, their crippling effects made brutally clear in the form of the wheelchair. The sledge-hammer juxtaposed with the stack of vulnerably blank TV screens promises self-defense and liberation, while offering a visual echo to Jenkins's strident assertion: "I won't, and I don't, relate."

Two-Zone Transfer (1979) follows Jenkins's protagonist through a dream sequence as he explores the complexities of African American culture in a voracious capitalist economy. The dreamer first encounters a group of individuals wearing blackened whiteface masks, who explain the motives and mechanisms behind minstrelsy, while giving a demonstration. The minstrels serve as a visual segue into the next scene, where an impassioned minister implores viewers to realize the power of words: "You have the power to bless someone or you can kill them, and it's right there in your mouth, right there on the tip of your tongue." The dreamer reappears for another conversation with the minstrels and a mysterious guide, who discusses the challenges faced by an African aesthetic. Finally, the dreamer wanders into the final scene where, lip-synching and dancing, he and his three backup dancers channel James Brown in a *Live from the Apollo* performance. When the protagonist finally wakes up, he feels confident that he can handle the challenge—presumably of misrepresentation—now that he knows its true nature: "After a dream like that, I know I've got direction. I know what I'm up against."

Rebecca Peabody

Interview conducted by Glenn Phillips on June 8, 2007, at Ulysses Jenkins's studio in Los Angeles, California

GP: When did you first become aware that video was something that you could use?
ULYSSES JENKINS: In 1972. I was painting murals on the board-walk in Venice, and I met an artist named Michael Zingale. He said, "They've got this video workshop going on the boardwalk. You ought to check it out." At first I thought, "Well, what do I need video for? I've got my medium." But I was always curious about film, and the thing that intrigued me about the new Portapaks was that you could record, and play back, and erase if you didn't like it; and, of course the expense was astronomically different than shooting film. So I went down with him to the workshop. You could check out the equipment fairly easily and take it home. It just took a little time working with it and we got what we called a "video Jones."

What were some of the first things that you tried taping? Well, just like everybody, you put yourselves in front of the camera. Since we were in Venice, people had all these really crazy ideas like, "Let's just grab people off the boardwalk," and we did some of those kind of things. But one of the first major things we did in terms of media and representation was to record footage at the Watts Festival in 1972. The festival was a commemoration of the riot in 1965, and I felt the media was giving a misrepresenta-

tion of the festival. On the news, they would say, "The festival is occurring, but if you go, you need to watch out for this, that, and the other." And I was going, "That's not really true, because I've gone and I've had a great time there." So I said, "Well why don't we grab this Portapak and see what information we can get?" We called ourselves Video Venice News, and we went to the festival. We recorded some really important issues in terms of how the festival started and who started it. Sons of Watts was an organization that had helped create the festival. We recorded the festival director—Tommy Jacquette—who was leading it, and we got a different story than what the media was portraying. It wasn't so different than today. It was about self-empowerment and a community trying to empower itself.

What were the other things you were filming around that same time? We thought we were underground, and the political strategy of the time was, "Who's exploiting the culture of Venice?" We went to this one event where the Mystic Knights of the Oingo Boingo was performing. A lot of their act at that time was the same stuff that was happening on the boardwalk. So we recorded their show, and then we took it to the boardwalk and played it back—sometimes in a storefront window, or if someone had the time to sit with the monitor, then we'd put it outside so people could hear the audio, too. The old Pacific Ocean Park had a beach club on the boardwalk called the Cheetah Club, and we used to go there and videotape the bands that were playing. We had a live closed-circuit

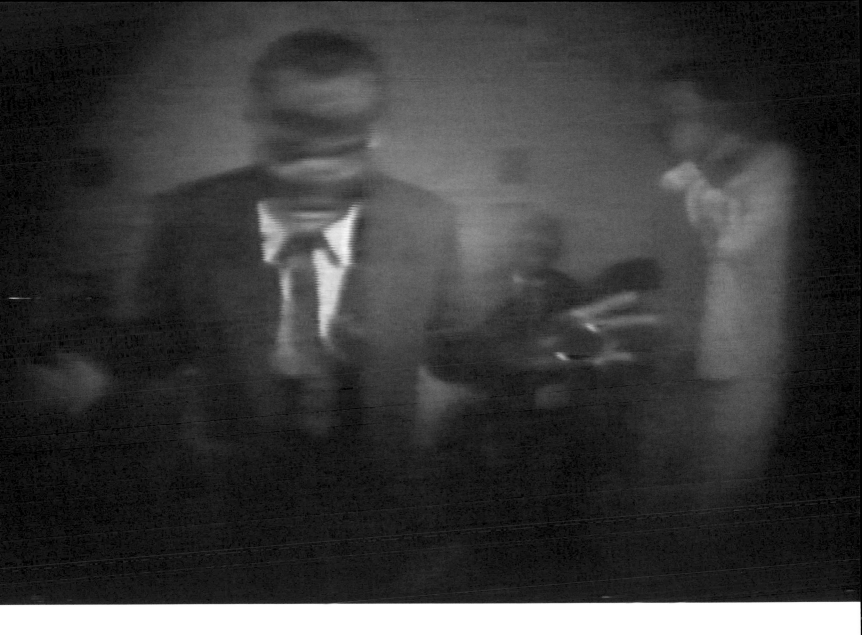

feed set up into monitors at the base of the stage, which we did for a black rock band called Skillet.

Was all of this done with the camera you could rent through the workshop? Yes. I didn't own my own camera until the late seventies, probably around the time that I got out of graduate school at Otis College of Art and Design.

What was the environment like at Otis in the late seventies? It was wild. I went to Otis in 1977, and I worked with Charles White, Gene Youngblood, Wanda Westcoast, Chris Burden, Gary Lloyd, and Ilene Segalove, as well as Miles Forst, who was just an absolute instigator in any kind of artistic endeavor you wanted to do. He always gave you the green light. Lots of performative work was being done. I wasn't really sure about doing performance until Barbara T. Smith came to campus and lectured. I thought to myself, "Well, here's a woman who's coming from a sort of homebody living situation with her kids and her husband, and she just decides to leave all that to have an artistic career." I said to myself, "What's wrong with me? Why can't I figure it out? Why can't I do that?" So that got me headed in the performance art direction.

You mentioned you studied with Charles White when you were there. You made a video documentary about him, and then you also made one about David Hammons. Most of the African American artists in Los Angeles at that time went to Otis to study

with Charlie. Betye Saar was there as well. There was a certain integrity that came from Charlie as a person, and I learned so much from just being around him. You could talk to him about anything, and he had some good tips about which direction an artist could or could not go. At the time, there weren't a lot of African Americans in art schools in Southern California, and in particular, there weren't that many African American professors. So the thing about studying with Charlie was that he gave you the inside track about what it's like to be in the game. And, of course, David Hammons—what can I say? David had studied with Charlie, too, and in those days he was just as much a provocateur and a trickster as now. David appeared at my studio one day, and I didn't know who he was. I walk in the house, and here's this dude sitting at the kitchen table. And I'm like, "Yo, man, what's up?" And he goes, "Oh, yeah, man, I'm David Hammons and I've heard of you." That sort of deflated my first idea of like, "What are you doing in my house," right? We began to have lots of conversations, and he invited me to come visit him at his studio. We became friends, and then he decided to move to New York. So I said, "Well, if you're going to go to New York, let's make a video about just this time." So we did that, and it really serves as a time capsule, hearing him talk about his strategies in making the work, and the fact that he was doing a performance as the means by which to appear in the documentary. I was really taken by that alone.

You mentioned that you had made your own decision to go into doing live performance, but you also made some videos coming

p. 111
Ulysses Jenkins, still from *Two-Zone Transfer*, 1979. Single-channel video, color, sound; 23 min., 50 sec. LBMA/ GRI (2006.M.7).

out of performance. I guess the first one was *Mass of Images* [1978]. Well, *Mass of Images* actually came from a class I was taking at Santa Monica College prior to entering Otis, called Blacks in the Media. The professor was showing us people like Oscar Micheaux, and then moved into how Hollywood made black films, and how the studios appropriated ideas for their interest—and, of course, their interest doesn't necessarily go with the interest of the African American community. The biggest influence of that class was D. W. Griffith's *The Birth of a Nation* [1915]. It was hard to conceive of someone wanting to portray a group of people in such an imbecilic way. So going from that all the way to, let's say, Stanley Kramer's *Guess Who's Coming to Dinner* [1967], which had his whole idea of what integration was supposed to be, we got a wide range of understanding about blacks in the media. I hadn't seen anybody try to talk about these issues in terms of video art, and that became the point of reference for me—that there wasn't any model to follow as an African American video artist. So the scene in *Mass of Images* opens up with a stack of monitors, and then I come out from behind the monitors and I've got on this plastic armature, if you will. There's a plastic bowl on my face, so my face is really obscured, and I think I had some sunglasses on this thing. I started this chant, which goes, "You're just a mass of images you've gotten to know, from years and years of TV shows, the hurting thing, and the hidden pain. It was written and bitten into your brains. I won't, and I don't, relate, but I think for some, it's too late." I keep saying that over and over again as I come out from behind the

monitors in a wheelchair. So metaphorically, I'm saying that I'm crippled by this mediated image that's being portrayed of me. At the same time, I was wearing this bathrobe and a scarf that looks like the American flag. I also had on this Adidas T-shirt, and I don't know if you picked this up, but because of the robe, the only thing that showed was "ID." Near the end, I get out of the wheelchair and reach for the sledgehammer. I make my swing at the monitor, but then I stop and turn to the camera, and say, "But they won't let me." That's pretty much what that performance was about. I just walk toward the camera and say, "I think for some it's too late."

You elaborate on some of those ideas a little more in a much more complicated piece called *Two-Zone Transfer* [1979]. *Two-Zone Transfer* was my first performance at Otis. I started doing research about the entertainment industry, and I was trying to figure out, "Where do these images come from?" And, of course, there was vaudeville at the turn of the twentieth century. When all the immigrants were coming to America and all this activity was happening in New York City, vaudeville was like TV. Most people don't think about how all the Europeans coming here weren't informed culturally about each other. They came from different cultures, and vaudeville worked as this way of letting them become a part of the country and looking at each other in this particular comedic way. Now the difference for African Americans was that when they started coming up north from the South, people didn't know very much about them either. But you had institutions like Barnum and Bailey's circus that went down South and observed African Americans, and then appropriated their behaviors and brought them into vaudeville, using white actors in blackface. So the minstrel shows become the vehicle by which people begin to associate what African Americans are supposed to be like, and that's what *Two-Zone Transfer* is portraying. The video depicts a dream. I wake up, and at the foot of the bed are these three guys: Greg Pitts, Kerry James Marshall, and Ronnie Nichols, who represent the minstrel show. They're wearing masks painted black—two Ford masks and a Nixon. They start telling me the history of the minstrels, and how they've been misusing people's images and culture. We end up going through this whole thing with the black church, and Kerry James Marshall—a student at Otis who is now a well-known African American artist—he's playing this church melody on the piano. It's so funny when he turns back to look at the camera and it's Nixon in blackface. Then I come out and do this spiel as a black preacher about how Noah disenfranchised his son Ham and all his descendants, which is supposedly the way slavery gets institutionalized. Suddenly, the dream spirit, portrayed by Roger Trammell, appears and mentions that we've forgotten about James Brown, the preacher's equivalent, and I do a little James Brown bit, although not anywhere near him, believe me.

After this, you start to experiment a lot more with video as a form. Your work becomes more abstract and experimental visually. Why don't you describe *Inconsequential Doggereal* [1981]? I wanted to look at a fractured narrative and what would happen if you subdivided and cut things up, put them in one section, and then bring them back in another section. I wanted to deal with the notion of time, which is a part of the medium, but really I was interested in the complexity of interpretation of dialog and editing. There are several levels of interpretation in the tape. There's the personal. There's, as you mentioned, the artistic. Then there are the political, metaphorical things, and they all intertwine with one another. They actually speak to one another, and then come back again to re-address what you might have been thinking previously but didn't quite understand, because I hadn't given you the

complete thought passage. Initially, it just started out as an editing exercise for my students when I was working at UCSD [University of California, San Diego], but it was so successful that I thought it could work as a regular video piece. I was also interested in the idea of a "work-in-progress," where the work never really finishes itself—in other words, it's constantly reevaluating itself and then starting up again. Nowadays, you look at this piece and it looks normal, in terms of the speed and velocity of the edits. But at the time, the images seemed to go by so fast. I also thought about the piece art historically, in terms of Dada and surrealism. For the most part, it has a sort of dadaesque structure. Things just happen where they will. The surrealist aspect is in the way I shot it and the way I bring you into it—like the absurdity of the opening, where I lay down in front of a lawnmower, which is coming to run my head over. There are a lot of little melodramatic moments in there. One of the better moments is when the guy and the young lady are lying in bed and she's asking him, "Have you been to my shows? Have you read my reviews?" And the man takes out his football and just hands it back to her. I had created this metaphorical subject of a football in the video, and people are handing off a football throughout the tape to represent the way we care about each other, in terms of taking care of each other or their property or their other self.

And what about the title, *Inconsequential Doggereal*? One Sunday morning, I was reading the calendar section in the *L.A. Times*. The *Superman* film was just about to open, and they had an interview with Marlon Brando. They asked him, "What's it like to play the father of Superman?" He goes, "Well, I really like those doggerel moments." I said, "Doggerel moments? What is he talking about?" So I looked up the word, and it means an "irregular measure." So I figured he was talking about the time when maybe they're not using dialogue, or the in-between time when they're moving within the narrative and there's nothing being said, or maybe there are gestures that you can't understand. And I thought, "That's what it's like to be a black person in this society. Sometimes things are irregular, and you can't figure out what is happening." So I said, "That's what I'll do." There's Dada and there's surrealism, and I'm going to create Doggerelism, and from that time on, there have always been doggerel moments, if you will, in most of my work.

Who were the other performance artists and video artists that influenced you? Talking about performance art, I should mention Sun Ra. There were also all sorts of African American avant-garde activities. All of that was informing me of a better direction, and then I started researching African rituals, and I would say that gave me a much more solid foundation. When I was in grad school, if I made work that was based on a Eurocentric strategy, people would say, "Oh, you're going to follow this? You're not of that culture. What makes you think that you could follow that?" And I thought that was perplexing. I didn't see any other ethnic groups having to make those kinds of decisions. And that's one of the issues that stumbles most African American students in a college setting. It's a really difficult thing to negotiate. But at the same time, when I started studying these ritual processes, I actually found a lot more universality in that, and I found a position to speak from, which is what I learned from my studies with Betye Saar.

Let's talk about your piece *Z-Grass* [1983], which is a completely abstract video using computer-generated imagery. I guess the thing that I'm trying to figure out is—with almost every piece you make up to this point, the style changes completely. I'm wondering if that's related to some of the struggles that you

were just describing? Well, it's not necessarily a struggle, but a necessity that I felt to make change. I was interested in following the example of a lot of musicians, and Miles Davis, of course, was an incredible example of change. He reinvents not only himself but also the style in which he's working, and he's pushing it every time he does it. I was also just totally floored the first time I heard Jimi Hendrix's album *Are You Experienced?* To know that this was an African American musician who was not only pushing the envelope but was just an imaginative creator to no end, made me think, "Could I do that in the visual arts?" Getting into video opened up the visual, the sound, the conceptual, and all of these different avenues, and that was propelling the work. I recognized when I was young that I had a lot of different creative talents that I never took the opportunity to utilize. So I went from where I was safe—doing painting, drawing, and murals—to creating multimedia, being in the media, then making sound works, literally becoming a musician, and each step of the way pushing away these creative phobias that I had. The last frontier was when I started singing.

But going back to *Z-Grass*, the opportunity came from the Long Beach Museum to work on this computer. This was in 1983, and I'd heard all this stuff about computers, so I went. Everybody gets the wrong idea when they hear the title, *Z-Grass*, but that was the name of the language on the Datamax computer. Really, it was the early beginnings of what you can do with Photoshop or any other drawing and painting software now. Most of the people there had these notions about architectural, linear design. But coming from a painting background, I said, "Well, why can't you just use this stuff like you would as a painter?" So I created this abstract expressionist kind of painting that moves. The only way to record this imagery was to videotape it, so I just videotaped the process, and edited that into a composition. I met this sound composer, Vinzula Kara, at the Lhasa Club, which was one of the renowned performance art clubs in L.A., in the eighties, and he was telling me about his sound pieces. I said, "Well, you know, I've got this video and I need a soundtrack for it." So we sat down, and when we played them together it was like a marriage you couldn't believe. We started collaborating from that time onward, and that's how that piece came together.

And then you kept working with computers, with communication through computers. I started working with the videophone technologies. I had an Amiga computer, like so many artists did around that time. It was the only computer that provided a video signal within a computer platform. But I also collaborated with Kit Galloway and Sherrie Rabinowitz on their major Electronic Cafe piece for the 1984 Olympics. That was one of the earliest cyberspace production experiments where artists could use something similar to what we call the Internet now. You could actually draw on the screen and create images. You could type in messages, and you could perform live and send that to another location live. It was pretty exciting to be able to send images to the person that you're talking with over the telephone. That was a really incredible period of work, and I ended up working with Kit and Sherrie again in the latter part of the eighties and into the nineties, when they had their International Electronic Cafe. During the 1984 Olympics in L.A., the Electronic Cafe was a multicultural composition that involved the communities of East L.A., downtown L.A./Little Tokyo at MOCA [Museum of Contemporary Art], as well as Koreatown, Venice, and Leimert Park. All these different communities had these different groups of people, and it was interesting to see the varied types and forms of communication that came from those communities. We all were interested in what could happen in the future.

p. 112 top
Ulysses Jenkins, still from *Mass of Images*, 1978. Single-channel video, black-and-white, sound; 4 min., 18 sec.

p. 112 bottom
Ulysses Jenkins, still from *Z-Grass*, 1983. Single-channel video with DataMax software, color, sound; 2 min., 57 sec. LBMA/GRI (2006.M.7).

WARNER JEPSON

Born 1930, Sioux City, Iowa
Lives and works in Sonoma, California

TO WARNER JEPSON, music is the world's first "moving art." Music has spoken to his emotions—both aurally and visually—since childhood, through vibrant, abstract color combinations that usurped his imagination. During his time at Oberlin Conservatory of Music in Ohio, Jepson combined courses in studio art and composition to further explore the intrinsic relationship between music and the visual medium. Following his studies, Jepson pursued a career in music composition for dance, theater, and film, which further stimulated his interest in synesthesia. In 1972, Jepson accepted the position of composer for the National Center for Experiments in Television (NCET), a research facility in San Francisco that provided TV production equipment to artists across all disciplines, allowing them free reign to experiment with the new medium of video. NCET proved the perfect environment for the exploration of Jepson's "visual music." In works such as *Self-Portrait D-38* (1975), Jepson explores the literal coupling of both visual and auditory media. Using a Buchla music synthesizer connected to a video mixing board, Jepson made visible the parallels between color theory and music theory. In the piece, saturated, auroral hues are juxtaposed with vivid whites, as equally consonant and dissonant electronic notes play in the background. The visuals—an abstraction of the artist's face dissolving in and out of recognition—are in synch with synthesizer pulses; a change in color brings about a change in sound; what were once perceived as two separate entities are now intertwined.

After leaving NCET in the late 1970s, Jepson continued experimenting with new media and maintained a successful career in music composition for the visual arts. His critically acclaimed work includes a score commissioned by the San Francisco Ballet Company for Franz Liszt's *Totentanz* (1967), extensive work with theater, and myriad computer- and synthesizer-generated pieces.

Marie Irma Tobias Matutina

[ESSAY]
ENTER COLOR
by Warner Jepson

Throughout my life, color has been my primary stimulus and source of pleasure, whether it be in music to the ear or in sights to the eye. An unusual color or sound, or unexpected combinations of either, could stun me and lift me out of myself. During my teens, I spent hours in the two music stores in Bethlehem, Pennsylvania, buying sheet music and records. Popular or classical, it didn't matter—as long as the music provided the thrill I was looking for. It paralleled what I was discovering through sex. As an adolescent, piano practice often competed with improvisation, as I searched for sounds similar to those in the music I was discovering. There were great songwriters in the thirties and forties, and in the sounds of Big Band music. What a glorious time to grow up. Maurice Ravel, Claude Debussy, Igor Stravinsky, and other Russians used sound to paint scenes, milieus, environments, and actions, with a kind of color that German composers never used. They were more interested in using form (and often their egos) to shape music. When I composed a new piece—almost always to accompany another medium such as theater, dance, film, or song lyrics—I looked for a color that would open the door, creating an entrance into the music.

There were no museums in the town where I grew up, but my mother created a home that was filled with color. When I left for college at Oberlin, I immersed myself in its museum and art classes. I was a student at the Conservatory of Music, but I filled my schedule with courses like Japanese art and Renaissance architecture. Improvisation still infused my practice sessions, which resulted in several new piano pieces. After leaving Oberlin and settling in San Francisco, I gave up my dream of a career as a movie composer and began improvising music for modern dance classes. In San Francisco, the museums—like all museums then—were free; it was easy to spend a lot of time surrounded by color. I bought a Rollei two-and-one-quarter-inch camera, and photographed textures and architecture; my close-up shots made the familiar seem strange, unrecognizable, even unreal. I always hated American history for all of its brown, depressing photographs, but there were plenty of mysteries to be explored through black-and-

white photography. I began to define art as that which moved me more than I could move myself, which is, I think, why people go back to art, why they cherish it . . . for the fix.

The search for new ways to play with color has been a constant throughout my life. My tiny kitchen in San Francisco doubled as a studio, where I painted abstracts in oils. The San Francisco Museum of Modern Art (then the Museum of Art) exhibited a four-by-four-foot construction that I assembled from piano keys, undershirts, and paint tubes—I should never have thrown it away! When I was thirty years old, I bought a house that opened up new surfaces for exploring color: I painted and repainted walls, applied multiple colors on cupboards, and used the doors to paint abstractions. After I got married, I started going to a yardage store where I would pick out beautiful fabrics, hoping my wife would make something with them. Eventually, I switched from black-and-white to slide photography, but it was the possibility of isolating color that interested me, not the visual information. A coloring book led me to needlepoint; I improvised with different colors of thread, and often stayed up all night to see the effect of the next thread penetrating the canvas. When a needlepoint store closed, I bought all the remaining yarn. During a two-month stay in Kathmandu, I improvised a tiny *Persian Carpet* [1980] needlepoint. Later, when I took up weaving, I noticed that other weavers made patterns that held for the whole piece, but I held a pattern for only a few rows. I always wanted to change the pattern to see what other variation the colors could produce.

I began composing for dance in the 1950s, just as the tape recorder entered the listening world. Tapes did much more than just record, they became tools for creating entirely new sounds. Playing a tape backward or at different speeds, cutting tape and splicing pieces together, or attaching the ends of tapes to form loops of various sizes produced surprising and previously impossible rhythms. These new sounds didn't represent anything known, but they weren't noise because they originated from real sounds. The French called this new compositional process *musique concrète*.

Even more exciting was my discovery in 1964 of Don Buchla's first synthesizer at the San Francisco Tape Music Center. Buchla's synthesizer could take you on a ride like nothing else, using sounds and rhythms to explore unknown dimensions, revealing

new animals and strange people along the way. Unbeknownst to Mills College (where "the Buchla" resided), I would spend entire evenings with the synthesizer, leaving anywhere from midnight to 6:00 A.M., depending on how happy I was with what I'd found. Over the next three years, I filled over two hundred half-hour tapes with sounds that I used in musical scores for the American Conservatory Theater, the San Francisco Ballet's production of Franz Liszt's *Totentanz*, and such films as J. Broughton's *The Bed* and Steven Arnold's *Luminous Procuress*. I also used the collection of sounds to compose music for gallery openings and museum exhibits—even for an Oscar de la Renta fashion show for Saks Fifth Avenue. At the time, other composers took pleasure in the noises they could make with microphones and amplifiers; but I hated noise, especially when it didn't describe anything tangible. Noise pushed me away instead of bringing me in.

While teaching music theory in the mid-sixties and early seventies, I began to consider the connection between music, color, and emotion. I noticed, for example, that sounds produced at different intervals had different relationships to dissonance and consonance. Consonance and dissonance elicit different emotions—a fact that composers have long used to express and convey feelings. The emotional difference between the color of a major seventh chord and a minor seventh is immense. I also noticed that colors that are adjacent on the color wheel, such as red and orange, and adjacent musical notes like C and D, are dissonant, disturbing and produce tension. Conversely, complementary colors like red and green, which are opposites on the color wheel, and notes farther apart and midway in a scale like C and G, are pleasing, consonant, and restful. Colors and sounds both express tension and rest, dissonance and consonance. Artists use these qualities to convey feeling and elicit emotion. Dissonance and consonance, tension and release, aggression and agreement—these characteristics represent the male and female in all things. Twentieth-century art gives precedence to the male and nearly eliminates the female's consonance, to the confusion of the general public.

In 1973, I went to the National Center for Experiments in Television to see if I could replace the composer, who was leaving. When Brice Howard was asked to form the NCET, he agreed on the condition that no restrictions or obligation be placed on its output; it was a space for experimenting with new video technology to see what video cameras and monitors could do. Artists and researchers in other media came in to work—or play—alongside NCET staff, and broadcast television personnel applied their experiences at NCET to their stations at home. NCET was four years old when I arrived, and Brice responded to my proposal with a test. I was to score music for a young Stephen Beck, who was pro-

ducing images with his unique and utterly fascinating synthesizer. He invented the synthesizer to control color and its movement in video without a camera. A few days later, Pierre Schaeffer, the noted French composer of *musique concrète*, came to visit Brice. I was hired the next day and started working on *Irving Bridge* [1972], a forty-minute video by painter Billy Gwin. Gwin had taken a video camera into the woods and returned with images that he mixed, overlaid, and altered with a video mixing board made by Larry Templeton for NCET.

The mixing board was meant to colorize and integrate video sources, but the artists who used it were never limited by its intended functions. As Larry remembers (via e-mail, June 27, 2007):

The electronics I created consisted of three modules. The first was a panel of four joystick-operated color generators. The second was a "colorizer," which divided up a source signal into eight adjustable brightness bands. Any signal, such as a color or another image, could be inserted into any of the brightness bands. This was how the "camera in the woods" video was colorized. Finally, there was a mixer module that enabled the mixing of many video sources into a single signal. A patch cord system made it possible to interconnect these modules in many complicated ways. The guys found many creative ways to use this stuff that I never dreamed of. It was always a delight to see what they came up with. Wonderful memories!!

Willard Rosenquist, a professor of design at the University of California, Berkeley, and artist Bill Roarty played with light reflected off Mylar pieces set on a table, creating a lovely, pristine terrain of color and shadow. Of the five half-hour programs that NCET broadcast on PBS, this one, *Lostine* [1974], won a local Emmy. Stephen Beck and I improvised two collaborative performances on our respective synthesizers for the National Endowment for the Humanities in Washington, D.C. Don Hallock added to the fantasy at NCET by making *The Videola*—a monitor placed at the apex of a cone with Mylar walls sixteen feet deep flaring out on all sides. The result was a ball of kaleidoscopic images—real and unreal—floating in darkness.

When Nixon became president, the funding dried up. Since there was little activity, I would stay late into the night playing in the new sandbox, plugging outputs from the Buchla synthesizer into Larry's video mixer board. Those were glorious nights, as I found colors in startling, unprecedented, unhuman combinations. The electronics produced colors that took me into yet another new and fantastic world—the best I'd ever known.

p. 115
Warner Jepson, stills from *Self-Portrait D-38*, 1975. Single-channel video, color with sound, both affected by a Buchla synthesizer; 55 min., 11 sec. Courtesy of the artist and the University of California, Berkeley Art Museum and Pacific Film Archive, Berkeley, California.

pp. 116-17
Warner Jepson, stills from *Self-Portrait D-38*, 1975. Single-channel video, color with sound, both affected by a Buchla synthesizer; 55 min., 11 sec. Courtesy of the artist and the University of California, Berkeley Art Museum and Pacific Film Archive, Berkeley, California.

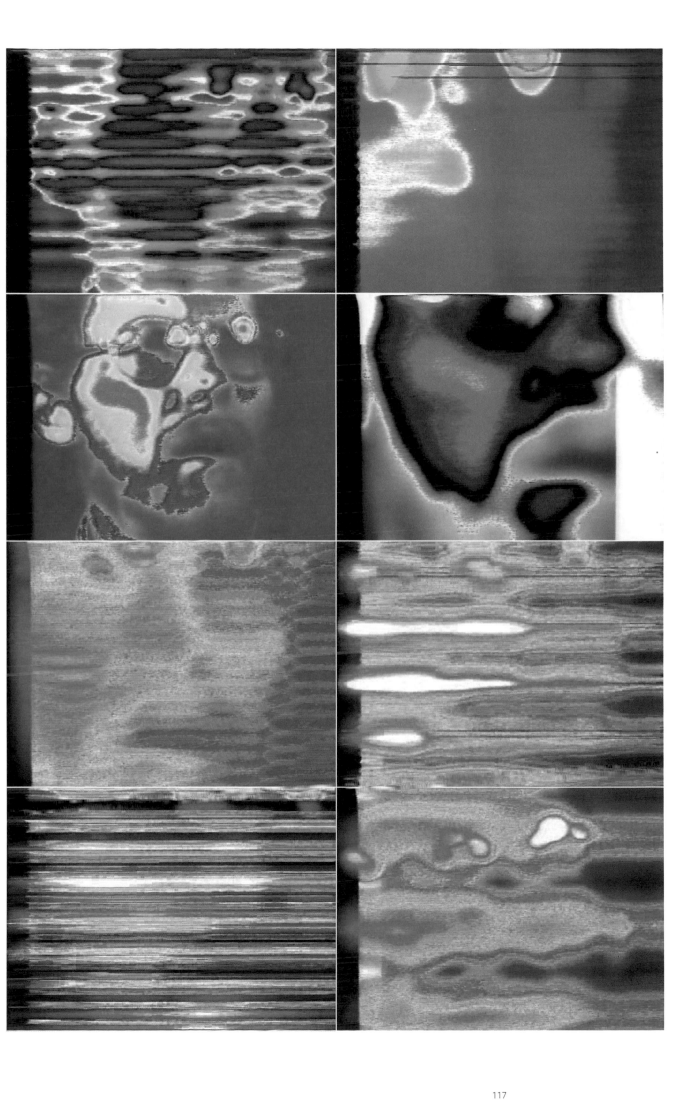

ALLAN KAPROW

Born 1927, Atlantic City, New Jersey
Died 2006, San Diego, California

ALLAN KAPROW IS PRIMARILY KNOWN FOR HIS INTERACTIVE sculptural environments and large-scale Happenings developed in New York in the late 1950s and 1960s, but his influence on West Coast art from the 1970s forward can hardly be overstated. As a founding faculty member in the radical new arts programs at the California Institute of the Arts (CalArts; 1969–74) and the University of California, San Diego (1974–2006), Kaprow steered numerous generations of students into a freeform style of art making that was simultaneously humorous, political, cerebral, participatory, utopian, open-ended, and thoroughly synonymous with Southern California.

Initially using audiotape and film as a means to produce straightforward documentation of his ephemeral artworks, Kaprow began to experiment with video as soon as it was available. In 1968, Kaprow produced the "telehappening" *Hello* as one of six artists invited to develop experimental video works at the New Television Workshop at WGBH in Boston. Broadcast on New Year's Day 1969, as part of a compilation of all six projects called *The Medium Is the Medium*, Kaprow's *Hello* presents an early experiment in videoconferencing, as participants at locations throughout Boston attempted to communicate with one another via live video feed.

Kaprow moved to Los Angeles later in 1969 to be assistant dean at the newly formed CalArts. Working at a school in possession of dozens of Sony Portapaks, Kaprow encouraged his students to experiment freely with video, although his own approach to the medium was more cautious. During the early 1970s, Kaprow occasionally introduced the process of video documentation into the structure of his Happenings, although it was not until 1974, with his production of the videotape *Then*, that Kaprow produced a self-standing work of video art. *Then* presents three humorous scenarios that question "when" a moment can be said to "happen." First: a man sucks an ice cube while an off-screen voice asks, "How much longer?" Second: a hand holds a glowing lightbulb while the voice asks, "Is it light enough?" Third: a lightbulb hangs over a melting ice cube while the voice asks, "Is it cold?"

In his 1974 essay "Video Art: Old Wine, New Bottle," Kaprow expresses skepticism at video's supposedly radical potential and its "constant reliance on the glitter of the machines to carry the fantasy." At the same time, the years from 1973 to 1975 mark Kaprow's most intense period of experimentation with video, during which he produced several major works, including *Then*, *Time Pieces* (1975), a work that attempts to translate Kaprow's photo-textual Activity Booklets into video form, and *3rd Routine* (1974), an activity that revolves around two participants observing both prerecorded and live closed-circuit video footage of themselves repeatedly entering and exiting an apartment in an attempt to create the perfect "hello" and "good-bye," in situations both practiced and spontaneous.

Glenn Phillips

[ESSAY]
VIDEO ART: OLD WINE, NEW BOTTLE
by Allan Kaprow

pp. 118–21
Text reprinted from Allan Kaprow, "Video Art: Old Wine, New Bottle," *Artforum* 12, no. 10 (June 1974): 46–49. Used with permission.

p. 119
Allan Kaprow, stills from *Then*, 1974. Single-channel video, black-and-white, sound; 18 min., 35 sec. Allan Kaprow Papers, Research Library, The Getty Research Institute, Los Angeles (980063)

The use of television as an art medium is generally considered experimental. In the sense that it was rarely thought of that way by artists before the early sixties, it must be granted a certain novelty. But so far, in my opinion, it is only marginally experimental. The hardware is new, to art at least, but the conceptual framework and aesthetic attitudes around most video as an art are quite tame.

The field has customarily been divided into three main areas: *taped art performance*, *environmental open-circuit video*, and *documentary or political video*. In the first, some artistic event performed by the artist and friends or by electronically generated shapes is condensed, stored, and reproduced on standard length tapes for replay later on.

In the second, people, machines, nature, and environments interact, communicate, and perhaps modify each other's behavior in real time. Although in this group tapes are sometimes produced to document what has occurred, they are not integral to it. But tapes can be used to alter time and file away prior activities for representation in the carrying out of the process.

In the third area, events deemed socially important are recorded on portable equipment (and, more rarely, are transmitted live over cable), for the enlightenment of a public that normally has no access to this material on network TV or other news media. I discount this third group as more socially important than simply artistic, because although it has been made welcome in art when no one else wants it, its legitimate work must be done in the real world and not in the art world. It is a hunch that this use of video could bring about valuable human experiments. But to include it in a discussion of art just because it has made the art world its crash pad is to limit its utility to a small intelligentsia, and to defuse its arousal intent by a pretense to aesthetics.

I'll confine this review, then, to the first two areas. There are, of course, overlaps between them, and sometimes additions of other means such as radios and telephones, telegrams, films, and slides—but in general, this division helps to locate the artists' principal concerns. Now, more than a dozen years after [Nam June] Paik and [Wolf] Vostell used TV sets as props in their environments and Happenings, a tentative evaluation of the field is possible.

It is clear to everyone that video art tapes are the popular form of the two groups, for all the obvious financial reasons. Taped performances by an artist doing something, or by abstract color patterns doing something, are, after all, theatrical arts. They evoke comparisons with TV commercials, comedy routines, product demonstrations, promotional and educational TV, and the most dreary abstract animated films of 30-odd years ago. Thus, while some performances are unique as theater pieces, and fewer, still, involve experiences with video per se—I'm thinking of tapes by [Vito] Acconci, [Joan] Jonas, and [Wolfgang] Stoerchle—most of them are just more or less adequate recordings of the performances or are compositions of "special effects," which could have been done just as well or better as film. Videotape is simply cheaper and faster.

Moreover, this traditionalism is encouraged by galleries and museums, which display and merchandise the tapes as the equiva-

lent of editions of prints. Collectors purchase them as art objects, and audiences view them as chic home movies. The accumulated weight of art history and current gallery-induced attitudes are brought to bear on every tape that's shown. Given these conventional sources, formats, contests, and modes of consumption, the "discoveries" they may contain are of minor note; they are not experimental.

I pass over here live performances, which continue to incorporate video as a prop, such as in the work of Jonas and Stoerchle, or which use it as the equivalent of a performer, as in Ned Bobkoff's substitution of a VTR for the audio-recorder in Samuel Beckett's *Krapp's Last Tape*. These are straightforward theater that retain the usual physical conditions of the art: an enclosed time/space, with an audience and an actor, animate or otherwise. When these structural elements are constant from one era to another, no matter what internal changes may be made, they are changes in details. It is worth mentioning in the context of video art tapes, because this is the way the tapes are presented to the public as if in a pocket movie theater.

But in contrast, the closed-circuit, environmental videographers are trying to make use of what in the medium is *not* like film or other art. Their most experimental feature, it seems to me, is the emphasis upon situational processes, rather than upon some act canned as a product for later review. Products do, of course, provide new experience and influence thought. Hallucinogenic drugs, water skis, even TV sets, are examples. But art products tend to be stereotypically responded to, and very little fresh experience or thought comes about from them.

Among those working in this area are Douglas Davis, Juan Downey, Frank Gillette, Bruce Nauman, the Pulsa group, Ira Schneider, and Keith Sonnier. Video for these artists is a system of echoes, communications, reflections, and dialogues linking the self with what is outside of the self and back again. This hardware linkage proposes to positively alter the behavior of human and nonhuman participants alike, as if it were some infinitely readjustable ecology. (I am intentionally using hyperbole here to emphasize a certain grandeur, or high seriousness, in these projects.)

Some works include real-time communiques between the public and TV stations, using telephone and other rapid-message technology, which are all fed back into the TV output, to be, in turn, modified and commented upon by the participating public. Others, less outgoing, involve elaborately constructed displays with many monitors and cameras through which visitors pass, to see their own images in different views and in delayed time. Such mirrors of the individual may also be collaged with pretaped and electronically generated material.

Still others are assemblages of concentric or serially arranged stacks of monitors and cameras, which show simultaneous views of the cosmos, nature, a city, and microcosmic life. And there are room-filling environments achieved solely with video projectors that blow up the small scale of the normal monitor and fill the walls with deserts, subways, and one's own, real self.

From quite the opposite point of view are the spare, contemplative environments of a few bare walls (sometimes physically constrictive), one or two fixed cameras, and a monitor showing a blank, motionless section of wall or doorway. They resemble those empty security monitors in very expensive apartment houses: one waits for a thief to cross the camera's path—and, of course, it is the visitor to the exhibit.

Intriguing as these are, they are also discouraging. The level of critical thought in them, their built-in assumptions about

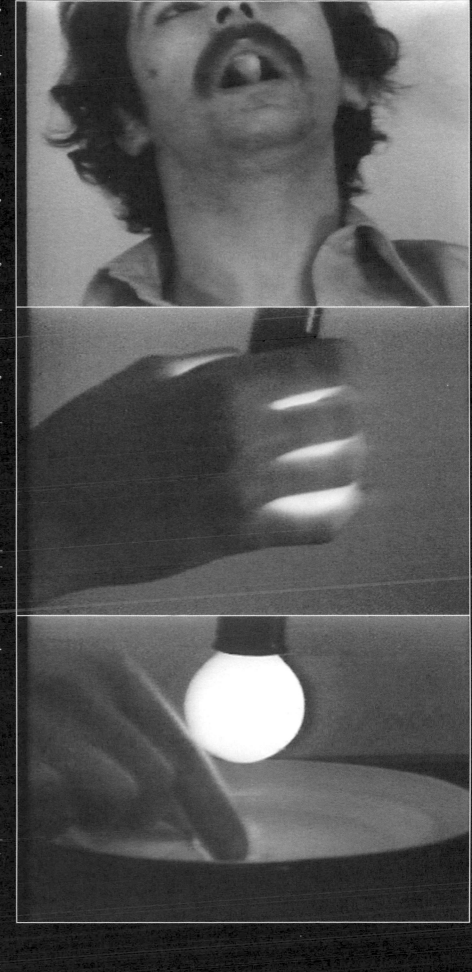

carry the fantasy—strike me as simple-minded and sentimental. For instance, there is the notion, introduced by the Italians before 1914 and worn threadbare by the sixties, that there is something vital about an all-at-once rapid flow of indiscriminate information, sensations, and activity between people and surroundings, while ignoring the plain fact that people and surroundings receive and exchange messages quite selectively. There is the science-fiction assumption that electronic communication technology can provide a global and even cosmic consciousness, when nothing in the world's extensive use of that technology to date suggests that that is so; or if so, that we apprehend and apply such beatitude. Moreover, it cannot answer to our clear need for privacy. Now, in the case of the minimal, meditative environments where extremely subtle body sensations and feelings are stimulated, it is assumed that meditation and privacy are possible in a gallery situation; but it should be obvious nowadays that everyone is on display as a work of art the minute they enter a gallery. One cannot be alone. A gallery is not a retreat. Everything becomes *art*, not self-awareness.

There is also the very utopian conviction, related to the last one, with its roots in progressive education, that if people are given a privileged place and some sophisticated toys to play with, they will naturally do something enlightening, when in fact they usually don't. For example, Frank Gillette and Ira Schneider designed a collaborative environment at Antioch College in 1969. It was a room comprised of four persons, seated back-to-back, facing four walls, two mirrors, four remote-control cameras, and a single monitor. As the artists describe it, "after an initial period of self-consciousness, the subjects began to generate their own entertainment. During the session, the subjects played with their mirrors and cameras, read poetry, drew, rapped, did sommersaults" (*Radical Software*, Vol. II, No. 5). Playing around? Poetry? Rapping? Sommersaults? All that expensive technology, care, and work, for helpless behavior that has been predictable in every so-called experience-chamber since the eighteenth century! That is hardly experimental.

But Gillette and Schneider are gifted artists with very good minds, whose work interests me very much. If the Antioch piece is singled out, it is because it points up the frequent lapses in criti

cal judgment among those who get seduced by fancy hardware. They become indifferent to the clichés passed on in the name of modernity.

Actually, their environment as described and diagrammed seems to me much more ritualistic and hieratic than the human response to it. The problem came about because the artists felt free to carefully program the physical surroundings, while they held off giving their subjects a program appropriate to those surroundings. This may have been a misplaced fear of manipulating people, even though the room obviously was designed to elicit responses, and that can be construed as a manipulation. Whatever the reason, Gillette and Schneider didn't follow through holistically.

This, in general, is the fate of participatory art when it is shown in an exhibition context. Both artist and viewer unconsciously expect it to be, and act like, a picture, discrete and kept at a distance. When the viewer is urged to become part of the art without further help or preparation, he or she feels put upon and becomes a stereotype.

I might add to the list of stereotypes the video artists' relentless fondness for time-lag devices. These are the exact counterpart to echo effects in earlier *musique concrète*. Implied here is the idea that repetitive recall of the immediate past is an effective denial of the future, hence proof of an eternal present. Perhaps, too, there is a popularistic appeal to the same experience from drugs. In any

event, this is not exactly a brand new philosophical discovery; nor one which illuminates a world which customarily forgets its yesterdays and ignores its tomorrows *without* the benefit of video environments. (Ironically, the relatively conservative tape art referred to previously, especially the kind that simply records a theatrical performance, I find much less trivial on a conceptual level. Undistracted by both the mystique and the technical problems of gadgetry, these artists may spend more time in thought and fantasy.)

In the last analysis, environmental (tapeless) video, the kind whose only product is the heightening of consciousness and the enlargement of useful experience, seems to me the only interesting video art. Yet, at this time, it is still a lavish form of kitsch. Like so much art-tech of recent years, video environments resemble world's fair "futurama" displays with their familiar 19th–century push-button optimism and didacticism. They are part fun house, part psychology lab. Such associations, and a sponsorship by art museums and galleries, which have a tradition of hands-off, silent respect for what they show, practically guarantee a superficial and cautious participation in what is supposed to be involving.

Participation's a key word here, but in this most experimental branch of video, we succumb to the glow of the cathode-ray tube while our minds go dead. Until video is used as indifferently as the telephone, it will remain a pretentious curiosity.

pp. 120–21

Allan Kaprow, notes and sketches for *Then*, circa 1974, ink on paper. Allan Kaprow Papers, Research Library, The Getty Research Institute, Los Angeles (980063)

HILJA KEADING

Born 1960, Berkeley, California
Lives and works in Los Angeles, California

HILJA KEADING'S VIDEOS AND INSTALLATIONS negotiate the subtle divide between the interiority of the self and a collective social "normality." In works from the mid-1980s to the present, Keading has pictured herself as a performative figure that absurdly strives toward illusory self-improvement. These attempts, which play out through comedic and tragic actions, reveal the artist's complex scrutiny of contemporary femininity. *Oh Happy Day* (1996) follows Keading, costumed as a stylish career woman, through a kind of identity crisis in a public restroom; after scrubbing the makeup off her face, the character feebly affirms her sincerity and happiness into the camera while sounds of gospel music and judgmental evangelical preaching overlap and repeat. As the woman boldly confronts her own image, an unseen hand throws a cream pie in her face. The humorous twist eases the weight of the woman's intensely personal experience.

Keading's exaggerated use of color, sound, and gesture further expresses the often-manic psychologies that she carefully constructs in her video loops and single-channel pieces. In installations, Keading consciously plays with architectural space to create site-specific configurations of monitors, projectors, and screens. With its persistent audiotrack of carnivalesque calliope music, the nine-channel installation *Backdrop* (2002) depicts the artist's fruitless attempt to patch a punctured garden hose with colored Post-It notes as the hose sprays water in all directions. The action is interrupted by the image and noise of a theatrical backdrop crashing into the frame and a young girl gasping. The clip, taken from the 1965 film *The Sound of Music,* appears abruptly in irregular intervals across the space of the installation, further fragmenting continuity and disorienting the viewer. Keading's studio practice has also included large-scale drawings, public billboard projects, and sculpture.

Catherine Taft

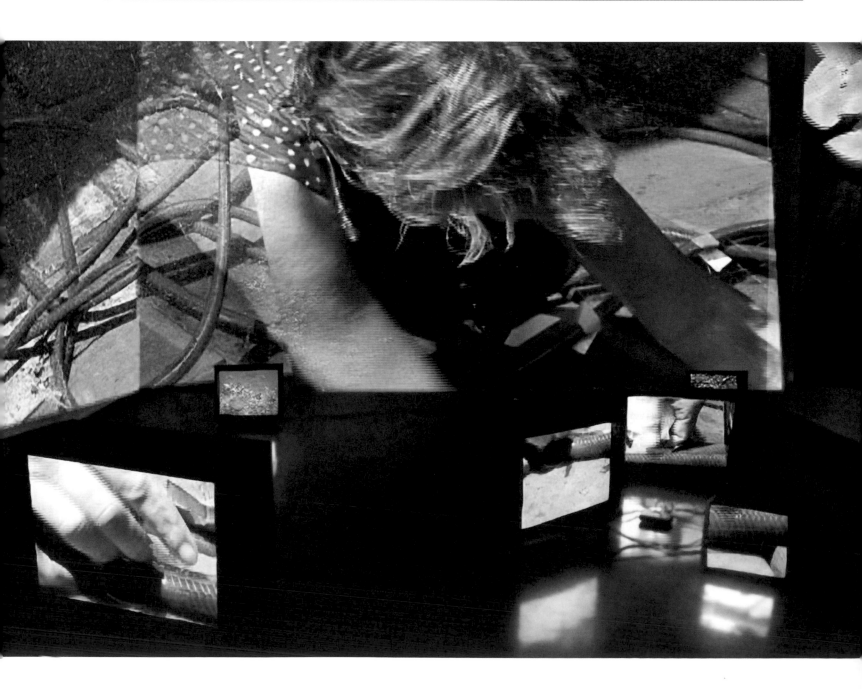

Interview conducted by Carole Ann Klonarides on February 16, 2007, at Hilja Keading's studio in Los Angeles, California

CAK: How did you get involved with video?

HILJA KEADING: First, I abandoned paint. I started graduate school at UCLA [University of California, Los Angeles] as a painter, and became increasingly frustrated with the "object-ness" of paintings. So I spent an entire summer pouring concrete. I put all the concrete in a room and I made this very elaborate and unstable sculptural installation. It had huge glass doors, and it was the most beautifully orchestrated, dangerous chaos you've ever seen—or at least that I had ever seen. I knew that this was some type of turning point, or it represented something really pivotal in my psyche. So one night my friend Gina Lamb said, "All right. This is how you work the camera." Another friend of mine, Molly Cleator, came in and said, "Okay, this is how you work the decks." They left, and I spent the night in there—me, all the gear, and the camera, and I did this monologue. When I watched that monologue everything changed, and from then on I made videos, then installations, and now, having integrated the two, I produce video installations.

What was the monologue about? The monologue was actually a very rudimentary version of what I'm doing now. I guess it's actually the foundation on which I have based the entire rest of my career's work. I surprised myself, and I probably surprised the rest of the faculty and my peers, because it had to do with confronting image and self at the most basic level. There I was in front of this glass door looking at this image, and it was a very intense confrontation between the—now I would say it was between the *persona* and the *self*.

Did you continue to make these private works within the studio? After I graduated, not everybody had cameras and editing equipment, so that affected my process. I would borrow cameras, or I'd work for X amount of months to save money to rent cameras. So it was longer chunks of time between video projects, because I'd have to get the money together to rent the gear. But the videos were still very intimate and personal—not personal in the way that you weren't allowed to enter as a viewer, but personal in terms of approaching them from the inside out, not the outside in. They stayed very small like that for a while.

Describe one. *Oh Happy Day* [1996] is a video I made while supporting myself by working at a law firm. I shot it in the bathroom of the law firm on the weekend, with Gina Lamb as camerawoman. In the video, I walk into this bathroom, and there are all of these accoutrements. There's hairspray and all these other goodies that you might expect to be using before walking out the door. So I walked in, in my suit, and proceeded to take off everything that I was expected to wear on my face. Then I looked straight in the mirror. So, again, here I am confronting this persona in the mirror, and I had a conversation with that persona. There was a sermon going on in the background and the gospel song "Oh, Happy Day." Later on, after I started a very thorough investigation of psychology, I learned that Carl Jung had said that the ego's desire to identify with the divine is actually a desire to identify with the self. He had some very interesting ideas about the divine. He would say—which I agree with—that the divine is actually the god within, but different than a Christian deity because it combines both good and evil. As I go on, it's a lot easier to explain what I was doing in psychological terms, but when I produced these early works I wasn't thinking about it that way. I was thinking about, and living, this fracture.

Did you think about an audience when you made your work? When I make my work, especially if I'm performing in it, I cannot think about an audience, because then it's a different type of performance. The audience comes in when I think about the framing and perception of it. So I think about what the work's going to look like in production, but when I'm doing it, all of those considerations are done. If it's just me and the camera, then I have one hundred percent control, and there is a safety zone. I can make a mistake and I'm not being watched or evaluated; there is great freedom in that. But with that freedom, there's also a little bit of fear, because once the—I don't want to say "threat," but I can't think of another word—once the possibility of being evaluated or watched is removed, that is when the really interesting and juicy stuff can reveal itself. It's complete freedom, and once I got accustomed to accepting the things that I said and did, and not being afraid of them or what they revealed about myself, about women in this culture, and so forth, then I slowly expanded. Even now, the huge multichannel projects start out as pretty small shoots, with not a lot of production, or as minimal as possible, and not a lot of production crew.

Do you do all of the editing yourself so that you can make the decisions about what you reveal? Yes, I edit all of the work myself, and actually it's in the editing where I really learn a lot, because when I'm performing the action I'm kind of gone, and something else is taking over. Once I'm looking at it over and over again, that's when these certain epiphanies occur, because I'm forced to figure out what I just did and what it means on a micro level, which would be a personal level, and a macro level, which would be Hilja in a culture or in a world. That's when the really important lessons for me reveal themselves.

How did you get involved with the Long Beach Museum? Well, the Long Beach Museum of Art [LBMA] and Los Angeles Contemporary Exhibitions [LACE] were the saving graces for anybody doing video when I first started out. That's pretty much all we had, and there was a camaraderie and an excitement, and we would all go to LACE and we would all go to LBMA and see videos. We really formed quite a simpatico community. I think we all enjoyed seeing one another at those events and seeing what everyone else was doing. LBMA was the only place where artists could get access to equipment and editing. If it wasn't for LBMA, most of my tapes wouldn't have been made from 1987 to 2000. LBMA's Video Annex, I think, goes down in history for everybody in California working in video, because that's where we went to see and make work. LBMA's Open Channels program was a huge deal, first of all because we knew that the jurors were all people that we really respected. Second, if you were accepted into the program, you got a budget, which was completely a gift. And third, you got a production studio, which was unheard of. So that really accelerated our process. It accelerated what I was able to do, and it gave the whole community support, which we didn't really have when I first started out.

What did you make when you were accepted into the Open Channels program? I made a series of three videos collectively called *Let Me (Entertain You)* [1989]. The first video in the series was called *Skin Deep*. In it, I'm standing on a rotating cylinder with this hot white spotlight. Now this is the eighties, and the eighties were a little garish. Since we had this great production studio, we kind of lit me like a hunk of meat. So there I am, just slowly spinning around and around, and I'm kind of embracing this idea of being seductive, but also being repulsed by it at the same time. So I

p. 122
Hilja Keading, *Backdrop*, 2002.
Nine-channel video installation, color, sound; 4 min. Installation view at Pomona College Museum of Art, 2002.

literally had a little—not to scare you—but I had a little piece of glass under my fingernail, which I would use to scratch down my back. The reason why I had the glass was not because I wanted to feel pain, but because I wanted the camera to see a scratch mark. As I'm rotating around, you hear an audio track of Jimmy Swaggart's public apology. Jimmy Swaggart was the most famous and popular televangelist at that time, and I used to listen to those televangelists, not because I necessarily believed in what they were saying but because I was just so attracted to the cadence of their voice and what they sounded like. I'm attracted to what it sounds like and repelled by the manipulation of the content. So Jimmy Swaggart gives a public apology because he was caught with a prostitute, and that is the primary soundtrack you hear while I'm spinning around, accompanied also by the song "Let Me Entertain You," which I sliced up and used in a way which I think is the complete antithesis to how the actors used it in the original movie. In the original movie, when Louise [Natalie Wood] sang the song "Let Me Entertain You," it was about a young woman who went from a vulnerable, "I don't have any alternative" stripper to a very powerful, self-assured, self-actualized, strong woman, who said, "Yes, let me entertain you." She had all the power. But the way I used it, I had none of the power. It was more of "I don't know what else to do, but I know there are certain things that I can do that will get me points and can entertain you, but that's not me, it's the entertainer." So it was this constant turning of entertainer, being attracted to getting attention when the spotlight's on, and being repelled by what the attention was for.

The next one was called *Sizzlean*. *Sizzlean* was completely made up of commercial excerpts cut with—of course, here I am again—me on that same platform, but this time I'm sprinkling glitter all over my face. Big hunks of it, which you're never supposed to do. *Never* bring glitter into a production studio. Don't even think about doing that. But we did, and so again I'm in conflict with this glamorous image, and all the images there are very glamorous, but inside the glamour, actresses are having mastectomies because they have breast cancer, they are slicing up religion into ethnic categories, and images are being dissected according to principles that seemed to me completely unethical, and so that was a heavily mediated piece.

The third one was called *Blessed Are Those Who Are Not Offended*, and that one also used television. I think this was right around the time of the Olympics, and there were a lot of TV programs showing young boys and girls training for the Olympics. I remember seeing this phrase called "triple jump mania," and I thought, "I so understand that. That is my life: triple jump mania, I get that." So I used that as kind of a foundation for *Blessed Are Those Who Are Not Offended*, where there are all of these clips of kids just trying and trying and doing the swing and the flips. Meanwhile, I'd gone out to Crystal Cathedral [in Garden Grove, California], and they have something like the Hollywood Walk of Fame, but the Crystal Cathedral's Walk of Fame is religious. So I went to the Crystal Cathedral, and I went to Mann's Chinese Theatre, where there are all these other handprints of fame. Again, the platform's back and I'm doing this tap dance and wearing what looks like a preacher's collar and fishnets, and I'm doing this dance and there's a spinning cross behind me. It's way over the top. At this time, the AIDS epidemic was still in full-blown proportions. People were dying every day. Nobody seemed to care about it. At least the media didn't care about it, and nobody really knew what to do. It was a crisis, and this sermon is talking about this, but from a religious perspective, saying, "If you have this disease, you have been given a death sentence." There is another part of the sermon that goes, "God doesn't decide who dies young and God doesn't decide who

gets breast cancer, but if you get this you've been given a death sentence," and I identified. Obviously, I didn't identify with having AIDS, but I did identify with a death sentence of sorts that wasn't my own prescription. So that whole series uses me kind of trying to process all of these discrepancies, and the discrepancies had to do with image, media, what's right and wrong, and feeling completely unable to make any type of change within myself or what I saw going on.

Shortly after that there was a show at LBMA that I curated with Noriko Gamblin, called *Sugar 'n' Spice* [1993]. In it, we included *Amazing Grace*, which was actually an earlier piece that you did in 1986. Could you talk about this piece? I did a series called *Amazing Grace*, which were some of my earliest videos. Each of those videos had to do, once again, with embracing these certain desires that I had, and being completely repulsed by them at the same time. So the first video is me with honey, and it's beautiful. I hate to say this, but I kind of shot it to look like the Playboy channel: gold, beautiful, light, and sensual. But, then, in the honey are about three hundred dead flies. I'd been told that you attract more flies with honey than you do with vinegar. One day I thought, "Well, what do I want with a fly anyway? I don't want a fly. What is that?" It's disgusting, and the video is disgusting.

The second video in the series is to this day one of my favorites, and the way the video came about is kind of funny. I was sitting at school one day, minding my own business. It was a beautiful spring day, and I was sitting under a tree. I'm just sitting there, and "plop," a dead bird falls in my lap. And I felt—well, first of all, I love animals so much, and I just felt empathy for this dead bird, but then guess what? Repulsion. So I get a baggie to protect the bird and I bring it home. The next video is me as a bird, holding and dangling this dead bird, because I have a certain identification with the dead bird, and the soundtrack is fabulous. It's synthesized bird chirps, because I'm not a bird, and then when I drop it, even then, I'm kind of repulsed by the whole thing, so the camera always serves as a witness, and it reveals my discomfort with my own self.

And the last video is me in a corner scraping up glass with my hands. I think that the most important thing about that one is not what I'm doing but that it's compounded with this crank of a children's lullaby, and it ends with a click: turn off of the lullaby song. I don't think it would have been as powerful without the association of the children's song, and particularly with a machine playing that song.

You use a lot of popular songs, and in your piece *Backdrop* [2002] you focused on *The Sound of Music*, a very popular movie that is all about music. Could you talk about how you began to develop *Backdrop* and the influences that came into play? *Backdrop* is a nine-channel installation, and I consider it to be a breakthrough on a lot of levels, but basically the truth of the matter is that one day I went out to use my garden hose in front of my house and it was leaking all over the place. I thought, "What am I going to do about this, how am I going to find the leak?" So then I came up with some ridiculous way of trying to figure out where the hole was, and in that moment, I had this "aha" flash of these absurdly inadequate compensatory things that I was doing in many areas in my life. There I was, trying to patch this severely leaking hose in front of my own backyard with paper Post-Its. It's ridiculous and it's not going to work. I'm in my own backyard, but I also use blue screen blue. Everybody knows that blue screen is a device used in video to create illusions, but I didn't key anything into the blue screen. I also incorporated footage from *The Sound of Music*. In the film, there's a scene where the mom—or actually, the "primary caregiver"—

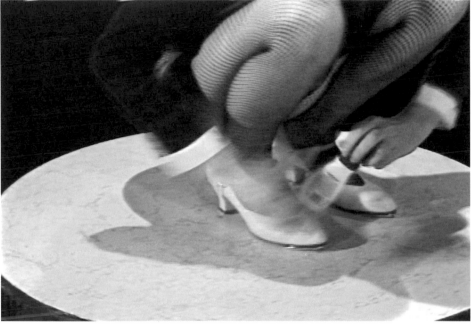

is doing this marionette show. She was upstairs manipulating all the marionettes performing below, and then all of a sudden in the film this backdrop crashes down and then there's new scenery on the stage. That was the most important part to incorporate into my installation, because that is actually what's happening: all of a sudden the illusion that I've created in my own backyard actually crashes down, and the video is about trying to reconcile the difference between what's supposed to be and what is, and not knowing what to do about it. There are also other parts in the installation where I include excerpts from *The Sound of Music*. It's parts where the children are being affected in some way or another. So they're moving their head away from something, and I make it look like they're moving their head away from the spray that's coming out of my garden hose. So you could say that I am me, and I am the kids in that video, and I'm also the backdrop that just fell. It's all me.

What was the soundtrack? The soundtrack was the sound of that crash, which I recut to make it sound like gunshots. The other soundtrack was a live recording of the third big projection, which was the back of a girl at a circus. She is watching the performers, and she has this huge pink plastic butterfly in her hair that's just kind of bobbing up and down. It's just her looking back and forth at the performance, and the music is this calliope music at the performance. You never see what the girl is looking at, which is connected to the fact that there is a performance, but I cannot identify it; the calliope music is an instantaneous signal that there is a performance going on—the kicker is that the performance is in your own backyard.

We ask this question of everyone: What's the first video you saw that was a big influence on you? Without a doubt, the first video that I saw that influenced me, not just as an artist but as a person, was *Vertical Roll* [1972] by Joan Jonas. It shook me on so many levels. First of all, as an artist using video, I understood on a profound level what she was doing: that she was actually disturbing the signal. It was a very clear message about how much power we have over the signal, just literally. Then, on an individual personal level, I found it to be so compelling and almost unbearable to see, and to hear the pounding, and to watch the manipulation of her image. There was just such grace and surrender and acknowledgment all mixed together, and it was just—it totally resonated. And I will never forget it.

MIKE KELLEY

Born 1954, Wayne, Michigan
Lives and works in Los Angeles, California

NOTHING IS LOST on Mike Kelley. Spanning all artistic media, his practice presents a method of absorbing all manner of history and culture (high and low, private and public, foreign and domestic) to make connections that imbue his works with complex and strangely emotional meanings. Whereas Kelley's drawings evoke the ethereal nature of thought through a combination of text and image, his videos are a view into the physical: how the body expresses itself as a culmination of learned and mimicked gestures. Often created in collaboration with other artists, his videos offer an alternative version of familiar institutions, economies, and social taboos.

Fresh Acconci (1995), which Kelley made in collaboration with artist Paul McCarthy, presents a West Coast take on the work of an East Coast master, while underscoring the imprint of cultural information on the physical body. Taped in a typical Spanish-style Hollywood Hills home, the work moves through a series of vignettes in which professional models and dancers re-enact five Vito Acconci performance videos from the early 1970s. Shot with a clichéd "soft-core" look—for example, softly lit women lie nude on a bearskin rug by a roaring fireplace—the actors can't help but transpose a body language typical to their line of work onto Acconci's otherwise sober and psychologically charged actions, resulting in a work that manages to question both Hollywood and the legacy of conceptualism all at once.

Equal parts Hollywood musical and Wagnerian *gesamtkunstwerk*, Kelley's ambitious installation and video project *Day Is Done* (2004–2005)—which consists of thirty-one sculptures and full-scale installations accompanied by video projections and photographs and a nearly three-hour single-channel video piece—uses the institutional educational complex as an underlying system for a cast of characters that moves through a series of ritualistic events. For the project, Kelley restaged found high school yearbook photos, spinning average teenage rites into elaborate shows of pageantry, paganism, and religious symbology. *Day Is Done* is part of an even larger project, the *Extracurricular Activity Projective Reconstruction* series (begun in 2000), which Kelley describes as "a projected group of 365 videotapes or video installations related to the sculpture *Educational Complex* (1995), an architectural model made up of replicas of every school I have ever attended."

Jennifer Dunlop Fletcher

Interview conducted by Glenn Phillips on June 1, 2007, at Mike Kelley's studio in Los Angeles, California

GP: Can you remember the first piece of video art you saw by another artist?
MIKE KELLEY: I saw an article in *Time* or *Newsweek* when I was a teenager on the work of Nam June Paik, specifically the televisions with magnetic distortions. The first art video that I saw was either *Media Burn* [1975] by Ant Farm, where the Cadillac drives through a wall of burning television sets, or one of the reels by William Wegman. When I was in school at the University of Michigan in the mid-seventies, some bootlegs of these tapes came through. To my knowledge, the only video in the university was in the journalism department, and that was the only place where you could get a video deck, so I didn't see the tapes in the art school context. I was familiar with video art, though, through the art press—especially *Avalanche* magazine. I also saw an installation by Woody and Steina Vasulka at The Kitchen, in New York, around this time.

Did you use the camera from the journalism department to tape *Futurist Ballet* [1973]? Yes. *Futurist Ballet* is my only surviving tape from that period. The video is primarily a document of a performance, although we tinkered with the machine during the recording process. At times, we'd unfocus the camera or we'd unplug the sound or video cable, all this in an attempt at a kind of Brechtian disruption. The performance was done in response to an art history course on Dada and futurism. Jim Shaw and I put up signs around campus advertising various fictitious lectures and then when people showed up, they were presented with a horrible Jack Smith–type performance, where we basically just emptied all the trash out of our hippie hovel onto the stage. The performers did whatever they wanted to. There were a few things that were planned. Jim Shaw and another artist read an interview from an underground newspaper with Pat Oleszko, the performance artist, about her experiences being a stripper, and someone else read

from their vast pornography collection. It was just a mess—a free for all. It was purposely random and unstructured.

You moved to California in 1976 to attend graduate school at CalArts. Did you continue working with video while you were there? When I came to California, a number of artists were working with video, although I didn't do any video work while I was in graduate school. I don't know why. John Baldessari was working with video, and so was David Askevold. I met Tony Oursler, who became a very close friend—he was working almost exclusively in video. A few other students were working with video as well: John Miller and John Caldwell come to mind. We would go to the Long Beach Museum of Art and see video from the archive there. Very early on, I also met Bruce and Norman Yonemoto and saw their work. So I was seeing things both in the educational context and in the art community. The first videos I made in California tended to be collaborations with other artists, and they were more narrative than most video art of the period. My first video was *The Banana Man* [1983], which was made while I was a visiting artist at the Minneapolis College of Art and Design. Ken Feingold taught video there, and the school had a large library of art videos.

One of your first video collaborations, *Kappa* [1986], was done with Bruce and Norman Yonemoto. Bruce and Norman wanted to redo the Oedipus story as a contemporary melodrama. During this period in Los Angeles, there was a lot of talk about the "Pacific Rim" and an "East/West" aesthetic connection. We found this amusing, because it wasn't really true. It was a tactic to differentiate Los Angeles practice from that of New York. Bruce and Norman chose to focus on the story of Oedipus, so I said, "Okay. You do a 'Western' half and I'll do an 'Eastern' half. We'll swap racial identities." I wanted to work with stories related to a minor Shinto water god, the Kappa. There was no relationship between the Kappa stories and the story of Oedipus, but we just mixed them together in an Oedipal stew. I primarily designed

the Kappa sections, which were in a "video art" style, and Bruce and Norman's sections were edited in a more standard filmic language—the language of melodrama. Then we got Keye Luke to do voice-over. He was the actor who did the voice-over for the *Kung Fu* television series.

There's also the strange love story between Eddie Ruscha and Mary Woronov. They enact the Oedipus drama. Bruce and Norman wanted to use various personalities from the Los Angeles arts community to play with "underground" star quality—probably as a comment on Warhol's "star" system. So they used Mary Woronov, who was an icon of the New York underground, as Jocasta, and the teenage son of famed West Coast artist Ed Ruscha as her love interest, Oedipus. It was saucy. The Kappa character was cast as a fetishist, a voyeur who spies on the Oedipal drama. The Kappa in the original Shinto tales is—I can hardly describe him—a kind of anal vampire leprechaun.

Even today, it's one of the strangest videos I've ever seen. In part because it's so successful at merging this almost PBS documentary style with a daytime soap opera style, all mixed together with these "video art" sections. I can't even imagine how much more strange it probably looked in 1986. Oh, it was over everybody's head.

Another collaboration that stands out for me is *Fresh Acconci* [1995], which was done with Paul McCarthy. *Fresh Acconci* really came out of a joke between Paul and me. We were sitting around talking about the new breed of performance artist we were seeing, specifically Matthew Barney. "Oh, look how handsome these new performance artists are; performance artists used to be so ugly—with pimples on their butts." So we thought, "Let's just redo Vito Acconci's tapes using professional models, and shoot them like Playboy videos." It was a joke, but we decided to actually do it. It was like nothing either of us had done before. We looked at a lot of Playboy light erotica to see the setups and how they were lit. I wanted to put a kind of genre spin on it, so we added the establishing shot of a mansion—the kind of classic old dark house scenario. This actually isn't that unusual in erotica, which often refers to various narrative genres. One of my favorite examples is *Thundercrack!* [1975] by Curt McDowell, which is a film that I adore, although *Thundercrack!* is hardly standard erotica. I wanted to put that kind of spin on *Fresh Acconci*.

It really strikes me as turning Vito Acconci into West Coast work. That's funny you think about it as West Coast, because it was really a response more to the fashion industry's influence on the art world, which I think is very East Coast. In fact, I thought *Fresh Acconci* was very anti–West Coast in its aesthetic.

Maybe it's because of the Hollywood connection. But the influence of Hollywood is not that apparent in West Coast art. In fact, such influence is much more visible in New York art in the eighties. Very few West Coast artists have made works that relate to Hollywood. It's something I found very surprising when I moved here.

I think Hollywood only absorbs what it can sell, and the art world doesn't want something that looks too much like Hollywood. Well, especially on the West Coast. Perhaps because of the omnipresence of the film industry, there was really a prejudice in the West Coast art world against narrative. You see this particularly in performance art. Look at someone whose work has a strong connection to the avant-garde theater tradition, like Guy de Cointet;

he was a real outsider, barely considered a part of the West Coast performance art world.

Let's talk about narrative a little more, because there's always been narrative in your work, but I think more recently in projects like *Day Is Done* [2004–2005], narrative really asserts itself strongly, though in a disjointed way. Well, my work really extends out of the "new novel"—the Joycean stream-of-consciousness tradition. I was very influenced by William Burroughs, Jean Genet, and that whole literary breakthrough in the late fifties. So I never thought of my work as being traditionally narrative—it's more akin to a prose poem. It's textual, but I try to deal equally with image and language in a nonillustrative way. People oftentimes prioritize genre in my work, but I think of my work as being primarily structural. I work with various iconographies and genres, but they rarely conform to standard usage.

What about the strategy that you've used in *Day Is Done* of taking a found photograph and then developing a narrative from that? That could be a 1920s or thirties surrealist novel in a way. I do not think of my work as surrealist, because I am not really concerned with "psychological" analysis, even though my work often has the trappings of psychoanalytic theory. My work is more sociological in its approach and more concerned with form. My favorite "surrealist" writers are not ones who were even official members of the movement: [Comte de] Lautréamont and Raymond Roussel. Lautréamont was very important for me. I loved how he would employ literary genre, the action novel for instance, but this was just facade—a structure to play with. There are strings of inappropriate metaphors and nonsensical shifts in action, yet his writing is not simply collage, it maintains the semblance of narrative flow. That's why it interests me. Just the other day, I was looking at some collage films by Joseph Cornell. They were snippets of found film, of a variety of genres, overlaid with contrasting music or speech. They were very clever, but I would not, myself, be interested in making something so abstract. I like image progressions to, at first glance, appear seamless and to have a logical development. That's what I like about William Burroughs's writing, for example. There is a

p. 127
Mike Kelley, *Candy Cane Throne*, 2004–2005. Mixed media with video projections, 365.8 × 129.5 × 292.1 cm (144 × 51 × 115 in.). Collection of Rachel and Jean-Pierre Lehmann. Installation view of *Day Is Done* exhibition at Gagosian Gallery, New York, 2005.

lot of fracture and discontinuity, but it seems to reflect a thought process—even if that's not really the case. It has the "interiorized" feeling of a novel, even though the text might be a cut-up.

Day Is Done clearly reveals my socioanthropological interests. The first piece in the series, *Extracurricular Activity Projective Reconstruction [EAPR] #1 (A Domestic Scene)* [2000], grew out of my interest in repressed memory syndrome, the notion that repressed memories of trauma are replaced with screen memories—false narratives. I built an architectural model, *Educational Complex* [1995], which is a "community" made up of every educational institution I ever attended, with all the parts that I couldn't remember left out. The videos in the *EAPR* series are meant to be "screen memories" filling in the blank "repressed" zones of trauma in the *Educational Complex*. I read a lot of repressed memory literature, and the subjects in the case studies tend to describe very standardized trauma narratives. So *A Domestic Scene* is written in the form of a melodrama. *Day Is Done*, which consists of *EAPRs 2–32*, uses various American folk entertainment forms as its starting point. Unlike *EAPR #1*, which was based on a single found photograph of a stage play, I wanted *Day Is Done* to be composed of many different scenes—to produce something akin to a feature film, utilizing standard montage editing strategies. There was no overall script, only individual scenes. I had absolutely no idea how it would turn out. It was never designed to be a narrative. I approached each individual found image separately, and only after the fact was it structured into a narrative. *Day Is Done* is an exercise in montage. I simplified the problem somewhat by choosing to frame it as a musical, because narrative is of little importance in a musical. Narrative is usually just a framing device for a series of unrelated entertainments in musicals. That is why I primarily chose to work with images of singing and dancing in constructing *Day Is Done*.

It also seems that you were pulling out the pagan side of some of these popular entertainments and Catholic rituals—like when Mary is crowned, it's almost like she's a nature goddess. Most of these rituals, like holiday rituals, are pagan forms that were co-opted by Western Christianity, and I wanted to make them alien again. I didn't necessarily want to make them pagan again, but to make them "avant-garde"—to comment on the notion of the traditional avant-garde as carnivalesque. That's why I focused on rituals, like Halloween rituals, that have somewhat negative

connotations. Of course, these potentially "dangerous" Goths or Satanists are presented as everyday types who work in an office complex. I thought by making these common social rituals "artsy," they could regain some of their original "negative" connotations. That's what the general public hates the most—something "artsy."

Many of the sets you filmed in also become the primary sculptural components in the finished pieces. This lends a certain type of visuality to the video, because you can't have an ambient environmental set in the same way. It's also interesting that with a lot of pieces—you turn the sculpture around, and you have another set, maybe even from an unrelated part of the video. How did you approach these pieces as sculpture? I do not care for sculptures that are simply leftovers of performative activities without their own sculptural values. I felt that the individual set pieces should be able to stand on their own as things, so I designed the sets as sculptures from the start. I wanted to make a feature film, but a spatialized film—a feature film as sculpture, and if each scene set was individual, that would be too simple formally. Therefore, I made all the sets multipurpose, which prevented the flow of synchronized video from being spatially linear. Installation-wise, it made the video aspect more difficult, because the video had to be computer synched, but it made for more interesting sculpture and a more complex space. This relates to my approach to narrative and writing. It's not just linear. It's multipart and simultaneous.

You also made a single-channel version of the piece that can be shown theatrically. How do those two projects relate? Did you know from the start that you were going to do the single-channel version? I wanted to, though initially I was thinking that the single-channel version of *Day Is Done* would be more akin to a traditional musical in that it would be, simply, episodic. It was initially cut that way, but I didn't like it. We then recut it so that it seems like multiple activities are taking place at the same time in different locations.

Does the basic chronology of the narrative happen the same way in the single-channel version as it did in the exhibition? Basically, yes, but then because I'm cutting back and forth between various locales, the sense of chronology becomes confusing. Time be-

comes a little unclear. How long is this taking place? It seems that the action takes place quite quickly—in a day. There are a variety of entertainments presented in a gymnasium, and out in the woods there are different groups wandering about. And then, in another space, there is a singles' mixer. All of these activities are playing out, seemingly at the same time. But then, sometimes, you see the same people in different scenes, so if you look closely there are continuity problems. But I find that confusion of time and space interesting.

You did some of the filming at CalArts. Was that significant or just convenient? It was convenient. In fact, I didn't really want to shoot there, because I thought it would tie in too much to the fact that *Day Is Done* is based on photos found in high school yearbooks. I've said over and over again that my decision to use photographs from yearbooks was not really important, but people obsess on this source. I didn't expect that. I was simply looking for photographs of common American folk entertainments, and yearbooks were one of the few sources where I could find such photos. I did not want the focus of the video to be on school or education specifically, but on institutional culture in general. I chose CalArts as a site because it is so generically institutional; it doesn't look like a school.

What else leads you to choose the individual images from yearbooks and newspapers? Is it a particular quality of the image itself, or is it because of the sculptural or narrative potential that the image suggests? I choose them because they're not normative. If I chose a sport, it's a wacky sport; if I chose an image of a workplace, it's of some "off" day like "Jeans Friday." They are always photos of carnivalesque activities. I feel free to overlay any kind of narrative I want onto these images and, in fact, I think in the next series of *EAPR* videos, I want there to be little connection between the images and the language usage. But with *Day Is Done*, I did focus on the photos and wrote in direct response to them. For instance, in the "Singles' Mixer" section there are four African American women, a woman in KISS makeup, and some witches. What am I going to have them talk about? Well, I have some of them talk about interests you would associate with people who look the way they do. And, because I have defined the event as a singles mixer, they speak of love interests. One of the characters is a country girl; I made Garth Brooks her love interest. A lot of the dialogue stemmed from what was in the news at the time. I wanted some controversy, and there were two sex scandals in the news at that moment related to sports star Kobe Bryant and pop singer R. Kelly. I just worked that into the dialogue.

One of my favorite moments is related to the country girl and Garth Brooks. She's painted his portrait, and it seems that, out of a horror of negative space, she decided to paint an image of her mother's breast into the picture. The reason I did that truly reflects what she says. I made a painting of Garth Brooks and I didn't like it. It had a big empty space in the corner so, for no reason, I painted a breast to fill in the area. That, then, became the topic of conversation. I rewrote that scene many times to introduce more and more red herrings into it, so that the conversation became quite complex; otherwise, it would have remained standard sitcom kind of writing. That's the way I initially intended it; I wanted to write something in the manner of the television show *Saved by the Bell*, but to make the characters older and more pathetic. There is only one nerdish man in the scene, so as a singles' mixer, it is not very successful. I rewrote and rewrote until I thought the dialogue was funny.

But then the country girl character turns right around and, over some really gorgeous abstract imagery, launches into this deep allegory about the basest of the base, as symbolized by the "bubble people."** I was riffing on the writing style of H. P. Lovecraft. I'd written that section previously. I wanted to rewrite the musical *Li'l Abner* as if H. P. Lovecraft wrote it. I never finished that project, but her monologue comes out of that writing. Her character is patterned after Tammy, who is always spouting some country wisdom. But her story is some horrible parable that makes no sense; it's just dark and apocalyptic and goes on way too long. As a parable, it doesn't add up to anything. I toy with various genres in this way throughout *Day Is Done*. For instance, relative to the group of characters in the woods—all the text in that section is derived from juvenile science fiction and adventure novels, but I turned it into gobbledy-goop. It is somewhat spacey and pseudo-sublime. What do vampires talk about? Something arcane, and that was my version of it.

p. 128 left
Mike Kelley, production still from *Day Is Done*, 2004–2005.

p. 128 right
Mike Kelley, installation detail of *Singles' Mixer*, 2004–2005, mixed media with video projections, Gagosian Gallery, New York, 2005. (Note the portrait of Garth Brooks, as discussed on p. 129.)

p. 129
Mike Kelley, *Extracurricular Activity Projective Reconstruction #8 (Singles' Mixer)*, 2004–2005. Black-and-white Piezo print and chromogenic print on rag paper, 186.7 × 89.5 cm (73½ × 35¼ in.). (Note high school yearbook image at top, as discussed on p. 129.)

MARTIN KERSELS

Born 1960, Los Angeles, California
Lives and works in Sierra Madre, California

MARTIN KERSELS USES SCALE and time to explore nonsymbiotic moments in which the relationship between the self and the world can be awkward. Through performance, sculpture, photography, and video, Kersels navigates the humorous, difficult, and graceful events of being a body in space. This approach can be found in his video *Pink Constellation* (2001), where Kersels enters a preteen's pink bedroom, which has actually been constructed as a "tumble room," a small room that turns on an axis, tumbling the room and its contents around a full 360 degrees. While a young girl reading a book gracefully and instinctively navigates the shifting architecture, Kersels, as the interloper, enters the room with his larger-than-life stature and clumsily fails to find the right footing as furniture crashes around him. The duality of figures in the shared, rotating space calls attention to differences in their gender, age, psychologies, and corporeality. Works such as this continue an investigation of bodies, mass, and space, which can be traced back to Kersels's earliest works with the experimental performance art troupe SHRIMPS, from 1984 to 1993.

Sound, ranging from music and narration to ambient noise, is another prominent aspect of Kersels's work, and it often appears in its most basic form—as vibration. Two seminal video works—*Brown Sound Kit* (1994) and *Attempt to Raise the Temperature of a Container of Water by Yelling at It* (1996)—strive to manifest the native relationship between loud, vibrating tones and other natural phenomena. The latter video, and perhaps the most successful of these sound experiments, was initially created as a performative sculpture. In the piece, a room is set up with two red tables, one supporting a seven-gallon jar filled with water and an underwater speaker, and the other supporting a large thermometer. In this one-take wonder, Kersels addresses the water directly, clearly speaking his intent, "I am trying to raise the temperature of this container of water by yelling at it." As the tape progresses, he musters his anger and raises his volume; his vibrato builds and breaks (even choking at one point), as he belligerently bellows in his attempt to raise the temperature of the water. In his classical deadpan manner, Kersels is successful, managing to raise the water temperature a fraction of a degree by yelling at it.

Chloë Flores

Interview conducted by Glenn Phillips on May 13, 2007, at Martin Kersels's studio in Sierra Madre, California

GP: Do you remember the first piece of video art you ever saw?
MARTIN KERSELS: I remember in junior high, in 1975 or '76, we had a video class with Mr. Jurkowski. We had a half-inch reel-to-reel Portapak. One of the students made her project about a troubled girl who slits her wrists. She used the top of a can that was cut. She pulls it across her wrist and a black line appears, because it's shot in black-and-white video. All the kids in the class were like, "Oooh." She had put some little spongy thing on the inside of the can and then rolled it. She basically painted a line on her wrist. But that's my first vivid memory of somebody, besides CBS or NBC, showing me video. Lisa Frederickson was her name, but I don't think she considered herself a video artist. But Mr. Jurkowski was sort of a visionary, in a way, getting junior high kids to use a Portapak in the 1970s.

Did you have to make a video in the class, too? We were supposed to. I was working with a friend of mine, and we were really interested in candles. You're not supposed to point the camera at a singular light source with a wide-open aperture. So of course that's what we wanted to do, and possibly burn the pickup tube of the camera. We literally wanted to play with fire in this case, but we never really made anything with it. I remember the same friend and I made a stop-motion Super 8 animation about a creature called Glop who lived in the sewers and would kill people. We had this little sewer set. We had this whole section with a Barbie doll. Glop had a tongue that, when he saw the Barbie doll, would go "Ralalalaalll" in his mouth. Then the tongue fell out and wiggled on the ground and crawled up his body back into his mouth. And Glop, I think, dies. Then there's a shot of an American flag. [Laughter] But that was a film. We did play around with video at the time, but not again for a long time after that, because it really wasn't available for people to use.

When did you start doing performance? I started doing performance in 1982. A friend of mine was taking classes with Rudy Perez, who had been part of the Judson Church group. My friend said, "Oh, Rudy's doing this movement class for artists at this loft downtown." The loft was owned by the performance artist Lin Hixson. Lin liked the "presence" I had or whatever, and she asked me if I wanted to become involved with this piece that she was organizing. I said, "Sure." I mean, it seemed so romantic, right? I'm this young college kid taking intermediate painting classes, but then I'm hanging out downtown with artists who have done stuff. I was in a couple of pieces with Lin, and then I met some of her old collaborators, Steve Nagler and Pam Casey, and we formed the group SHRIMPS. It was four big men doing tiny movement, and then it became big men doing tiny movement and little women kicking our asses, and then it became four different-sized men and more different-sized women. But it was all movement-based performance. I started with them in 1984 and worked until 1993, and then in 2005, we got back together and did another piece at LACE [Los Angeles Contemporary Exhibitions].

You're an undergrad at UCLA [University of California, Los Angeles] when you start with SHRIMPS, and then you also go back to UCLA for grad school. I went back eight years later, in 1992. But in the meantime, since 1989, I'd been working there as the lab assistant in the New Genres department, which was basically working for Paul McCarthy and Chris Burden. That was really fun, doing research into cameras and editing systems. Of course, we didn't have the money to buy much, but the idea of video as an art studio practice became more apparent to me as I worked there longer. If you didn't have the means—meaning you didn't have the equipment to do what Hollywood or television studios could do—then you did what you could with what you had. I think I still sort of carry that idea to this day.

By the time you started in the MFA program, you must've been pretty primed for it. I was ready. Chris and Paul basically said,

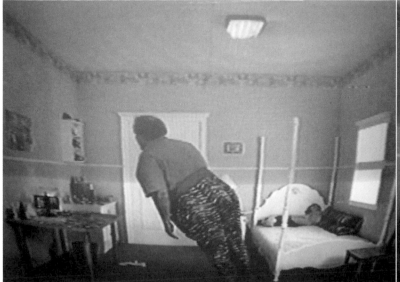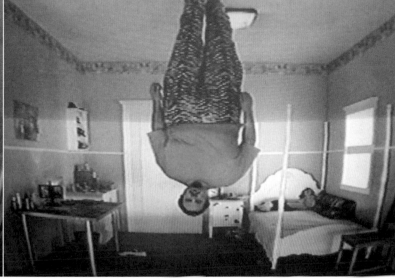

"We just don't want you to do the same work you're doing with SHRIMPS as your graduate work." But I was excited, because they were forcing me to do something new. So coming back, I started to make objects that were performative, that were stand-ins for myself.

That's one of the interesting things about your work. Twenty-five years earlier, so many artists had started doing performance as a form of sculpture. You sort of did this opposite thing of moving into sculpture from performance. And you can see that difference, I think. The body seems to be inside your work in a different way, and the objects perform. Why don't you describe some of the early things that you did. The first thing I did when I was in graduate school was an experiment in plasma acoustics called *Speaker Flame* [1993]. It was this flame speaker thing. I didn't really finish the work till later, but I started reading in *Popular Science* about how to make sound come from a flame. I thought, "Well, if I'm going to start making things, I better have a recipe," because I hadn't made things in a long time. I was intrigued by the idea of making things, but then I was also very much afraid to make things. My wife and I are friends with Tim Hawkinson and Patty Wickman, and I was always in awe of the things that Tim made. I would go over to the studio and see the things he was making, and I was like, "Oh, my god. I don't know how to make anything anymore." So I made the experiment in plasma acoustics, because it said, "Buy this. Put this through here. Solder this. Seed it with this." I had to do a little problem solving, but basically it was all done for me. Then I realized that the form was important, like how I put it all together. And if I was going to make a flame emit sound, what should the sound be? So it became a time of experimenting, of recording different voices and sounds. I started playing different pieces of music through this plasma speaker, and I realized that there were certain frequency patterns that worked better. I settled on the Eagles song "Hotel California," because it worked really well and was very identifiable. Also, I liked the story about the devil, and here's this flame telling this story about the devil. To me, that completed the piece. I wouldn't say that was an easy thing to come to, but that's how I started thinking about works. When they were performing or doing things, it wasn't just about how they looked, but the rhythms and the sounds that they made. That became as important as the materials used to make them.

That becomes a characteristic of your work through all media: sound is almost always there. It's interesting that you mention Tim Hawkinson, because, like his work, your work has this sort

of refined clumsiness to it. It always looks like it might fall over or fall apart, or you're really lucky that it's working today. But it usually does work. You sort of figure it out. Yeah, it's laziness with pride. Pride with laziness? Quality is job number two. [Laughter] But therein lies the dynamic—the fact that something works when your expectations are that it won't. It creates an expectation that I am quashing. Just as the idea of the flame, again, is something that is magical. It's talking, right? It's playing this music, but yet it's sort of dangerous. It's beckoning you, but if you get close enough, the electricity could arc. So I like those kinds of contrasts in dynamics. I think that's a storytelling technique, or a joke technique.

You also trick people into thinking about their own body. Viewers become aware of their own body because the thing might fall over on them, but that happens without it feeling like the point of the piece. Definitely. Like, you're aware of your body when you're looking at an Anthony Caro or David Smith sculpture, because of its scale to you or its presence. Where, for me, it's think about your

p. 131 top
Martin Kersels, stills from *Pink Constellation*, 2001. Single-channel video, color, sound; 20 min., 16 sec.

p. 131 bottom
Martin Kersels, *Tumble Room*, 2001. Motorized sculpture and furnishings, 457.2 × 457.2 × 457.2 cm (180 × 180 × 180 in.).

body, but then maybe think about mine, and then maybe think about my body falling over on you, and then think about, "Oh, my god." [Laughter] It's more about terror, in a way, but a humorous terror, like laughing before you die or something.

Describe one of your Super 8 loop sculptures. The first one I did was called *Precious Dancer* [1993]. This was working with Super 8 sound, which can record twelve minutes instead of three. I shot two twelve-minute sections of myself dancing—one on a rooftop and one in a close space—and dancing really small and kind of sinuously, as much as I can be sinuous. Just curling around and moving and dancing to Massive Attack, and Sarah Vaughan, and Moroccan trance music as recorded by Paul Bowles. It was pretty great. Again, the presentation became what was important. I wanted to create the contrast between what we have an expectation of film doing, which is either the public event when you go to the movie theater or the family event at home. So in *Precious Dancer*, the film is projected very small, and projected in a way that only one person can really watch. I wanted to create this little dance that was just for the individual, just for you.

You also played with that in *Hey Man* [1995]. It's on a tiny monitor, and the image itself is a deeply framed inset, so it's even tinier. On top of this, you're all the way down at the end of a hall, and you're doing a striptease. I was thinking about the idea of desire created by the body and how I don't think of my body as one that, in average situations, is about desire creation. I thought about working with a tiny monitor, but I wanted to make it even more difficult to view. I actually went to some video editing place that charged me $500 or something to reduce it. They didn't understand and said, "Why do you want to reduce it? Don't you want to make it bigger?" I wanted the blue frame because I wanted people to be looking into this tiny monitor with the image reduced, down a hallway, surrounded by blue, thinking about the idea of looking

down into a well and seeing future, past, or something that you desire, like the wish, right? But the wish is me. I'm doing a striptease. It's sort of like, "Okay, you've just been kicked in the head by a donkey." It's not what you wanted. But it was always interesting to see people looking at that piece, because the monitor is so small. And, of course, as you get closer to it, it breaks up. The pixels break up, and then you're no longer looking at the image. You're just looking at the video medium.

Describe how you displayed that piece. You made it sculptural. I did. I wanted it on the wall, and I wanted the monitor and the sound to be one unit. I used an aluminum frame that holds the monitor and extends the speakers on either side. When you come to look at it, it's sort of like a bootleg immersive video. The sound will be right in your ears, and the video will be right in front of you. But, of course, it's just like a bullshit version of that, like the wish fulfillment version of that.

Well, this was the era of the glorified slacker, and you were at UCLA at a high point in that department's history. Suddenly, there was this huge burst of attention, because New York realized there were young artists in L.A., and you were one of them. In the early nineties, there were a lot of interesting spaces that started popping up, and all of this kind of went hand in hand. I think there have always been periods of young galleries in L.A. I remember in 1979 or '80, there were like forty galleries downtown, and we thought, "Oh, this is like SoHo, right?" That was the idea. But then it just died. It was gone, nothing. And out of that nothing came a new group of spaces in the early 1990s. The first one I became aware of was Sue Spaid's space in Hollywood, and she showed people like Steve Hurd and Steven Criqui. People really supported her. Then there was Food House in Santa Monica, and Dan Bernier, Tom Solomon, Brian Butler, Blum and Poe, and all those other small galleries that became bigger galleries. The mod-

p. 132
Martin Kersels, still from *Attempt to Raise the Temperature of a Container of Water by Yelling at It*, 1996. Single-channel video, color, sound; 6 min., 50 sec.

p. 133
Martin Kersels, *Hey Man*, 1995. VHS videocassette player, single-channel video (color, sound; 3 min., 50 sec.), monitor, speakers, aluminum, 43.2 × 64.8 × 12.1 cm (17 × 25 × 4 in.). Courtesy Jay Gorney Modern Art, New York.

els weren't necessarily based on the gallery as we know it now; they were based out of homes sometimes, or they were spaces that were willing to move frequently. They showed performances along with object-oriented work, and they were willing to show video and video projections. I think that's what made it pretty vibrant.

Let's talk about another sculptural piece that then became a video. *Attempt to Raise the Temperature of a Container of Water by Yelling at It* [1996]. The sculpture consists of a couple different kinds of tables painted red, a seven-gallon Pyrex jar, an underwater speaker, a recording thermometer, and a tape-recording of myself yelling, "I am trying to raise the temperature of this water by yelling at it" over and over. During the audio recording, I was doing a needle drop on less than two seconds of a Portishead song. It wasn't done in post—I actually had an audio cart next to me with the tape player and some speakers and a microphone in front of me, and every time the song would go "Doo-doo-doo," I'd press rewind. When you listen to it, sometimes you'll hear I miss it by half a beat or a quarter of a beat, because I'm not always on. I'm just punching it and punching it every time it goes back, and at the same time, I'm trying to yell, and I'm trying to work my anger up, because the whole point of it is about this kind of travel from a statement to this exclamation to this building anger, and that's why it works as a piece. That's also why it worked as a video, because it's not just a document.

The beautiful thing about the video is that it actually happens. The temperature does rise. It has a beginning and an end. I get angry as all hell, right? I was working at night in an office at UCLA, and the janitors who were arriving for work on the ground floor outside were like, "What's going on? Who's yelling?" I was yelling so loud that through closed windows and doors, they could hear what I was doing seven floors below. I said, "Okay, that's effective." [Laughter] And literally, the temperature does change. I didn't heat the water. It was just doing what it was doing. Like I talked about the flame speaker in the sense of completion, this had that same thing. It all just made sense together, and there was this slight drama in it.

Let's talk about *Pink Constellation* [2001], which is a video, but it's also documenting a huge sculpture. I was very clear in my mind that I wanted to make a video inspired by Fred Astaire in *Royal Wedding* [1951] and anyone else who's used a gimbal set. You know, like Ernie Kovacs and his milk-pouring skit. In *Pink Constellation*, the idea was to make a fantasy—the video was the fantasy—and to have it presented with the thing that made the fantasy, which was an eighteen-foot-tall "tumble room," which was brutal and steel and loud and cumbersome. So I knew I wanted to make a video with a tumble room, but what kind of video does one make? Everything became clear when I decided it was going to be a girl's room, and that my presence would be offset by the girl. We don't ever share the room; it alternates scenes, because I'm the interloper and she's the true occupant. She's the one who's smart, graceful, and knows how to navigate it, and I'm like the clumsy oaf, and the whole thing collapses on me.

I knew the tape could function on its own without having the tumble room with it, but in the initial showing, the tape was on a flat screen in the front gallery, and you heard this god-awful sound coming through from the back gallery—it sounds like construction is going on—and then you walk through that portal. People stop and look at the video, and even though it's so easy to figure out and everyone understands it, it's still disconcerting. And then to go past that and look at the device that made it, there was again

this contrast between the fantasy in the video and the brutal reality of the device.

I want to talk about one more work. This one made me anxious for some reason. It's called *Fibonacci Sequence* [2004]. Did it really?

Yeah. You're lighting matches according to the Fibonacci sequence, and I know how quickly those numbers get quite large, and I was just worried you weren't going to make it with the matches. The *Fibonacci Sequence* video was meant for a specific show in a gallery in Turin. I wanted it to be a video that was projected on the wall of the gallery, and I thought of matches as this counting thing. I discovered this Super 8 film I had made in 1982 or '83, and it was about an artist. I didn't think of myself as an artist at that point, but it's about an artist and his anxious life. Because aren't all artists anxious? I shot all these rolls of film and I had my friend Ted Lin to be my stand-in, and he made these paintings. It was really stupid, but I liked the idea of having something that was from the past and forgotten. It's supposed to be a narrative, so there's supposed to be structure to it, but I didn't understand narrative. Maybe I still don't. So I just put the images with something that is a structure—the Fibonacci sequence—and then I have these matches, which are very dramatic in color and sound, because the movie was silent. So it was a mining of something from the past, and then trying to put some sort of structure on it. I didn't set out to create anxiousness, although the original film was about anxiousness, so it's funny that you say that. But then you got the anxiousness from the Fibonacci sequence itself, not from the narrative. I like the structure of the Fibonacci sequence—it's an order that can spin out of control, and I like that. It's a chain, and narrative is also a chain. I love narrative. I love narrative films, and I love books that have a strong sense of narrative. I think that's really why I wanted to go to film school back in the early days of college. I wanted to make narratives, because they're so powerful. They're so manipulative. If they're done right, they're so manipulative that they can kill you. But I don't have that talent; I'm not a storyteller in that way. I think I'm a moment-teller. I can tell something about a moment much easier than I can tell some sort of universal truth about our relationship with humanity and nature and ourselves in an expanded way. But I can do it in a compact way through imagery. At least I think that's my ability. God, I hope it is.

THE KIPPER KIDS

Martin von Haselberg: born 1949, Buenos Aires, Argentina
Lives and works in New York, New York

Brian Routh: born 1948, Durham, England
Lives and works in Yorkshire, England

FORMED IN ENGLAND in 1971 and relocated to Southern California in 1974, the performance duo of Martin von Haselberg and Brian Routh (aka Harry and Harry Kipper, the Kipper Kids) created an amazing suite of performance actions throughout the seventies and eighties, which embodied the transgressive postminimal anti-aesthetic more commonly described in the work of Paul McCarthy and, later, in that of Mike Kelley and Tony Oursler. The stage routines of the Kipper Kids combined slapstick violence, a grunting wordless sublanguage, and an array of props and fluids to build to a tandem release of exaggerated id, which was anything but "California Cool."

The road that led the Kipper Kids to Los Angeles is linked directly to the Long Beach Museum of Art via LBMA's founding video curator, David Ross. As Martin von Haselberg describes it (personal communication with Jonathan Furmanski, March 22, 2007):

> David Ross saw us in Cologne doing a show at Rudolf Zwirner's Gallery.... After the show, all aglow, feeling great, we all went out and a young, energetic American named David Ross... approached us and said: "You guys should come to America. That's where THE BIG MONEY is." When we returned to Ireland, where we were living, a letter arrived from David with an attractive proposal for a series of shows. A few months later we flew to New York and called David to say we had landed! He was surprised. But he did manage to arrange for us to be in the Avant Garde Festival at Shea Stadium before we set off by train for California, where we felt sure the "THE BIG MONEY" was waiting. David picked us up at Union Station and we spent the next few weeks sleeping on his living room floor until we managed to relocate ourselves to [Fluxus member and performance artist] Al Hansen's daughter Bibbe's floor in Hollywood. (We got to know [the musician] Beck in his stroller, blowing raspberries for him when nobody was watching). In November of 1974 we did the inaugural show of LAICA [Los Angeles Institute of Contemporary Art]. "THE BIG MONEY" continued to elude us.

Up Yer Bum with a Bengal Lancer (1976) is remarkable among the video work of the 1970s in that the artists are not merely using video to record their live performances. Here, the Kippers are seen exploring the possibilities of this new medium, working their well-rehearsed shtick into a new vernacular. Bookending the piece is a pair of segments in which von Haselberg mugs for the camera behind a Fresnel lens, creating a solo improvisational video performance that directly addresses the screen. Gone are the costumes and props of the live actions; in their place, another kind of prosthetic shrewdly translates the Kippers' cartoon vocabulary into a kind of "videographic grotesque." Elsewhere on the tape, the two partners perform out of their stage uniforms but distinctly in character. With the video camera as their only observer, the mess is once again dispensed with in favor of a pared-down exploration of their own dysfunctional dynamic. The two artists are always aware they are being recorded, so these vignettes have the feel of a screen test, but in a language that is uniquely "Kipper."

Jonathan Furmanski

PP. 134–37
Harry Kipper and Harry Kipper,
images from various performances
by the Kipper Kids, 1970–82. Color
and black-and-white photographs,
dimensions variable.

135

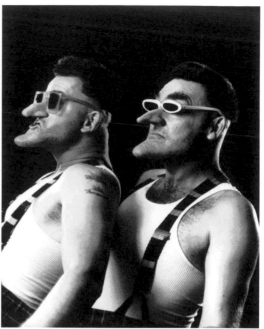
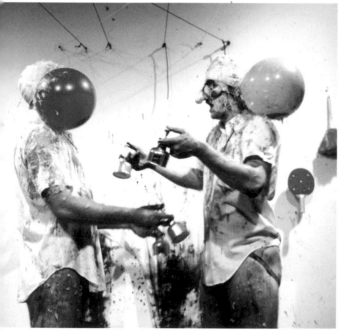
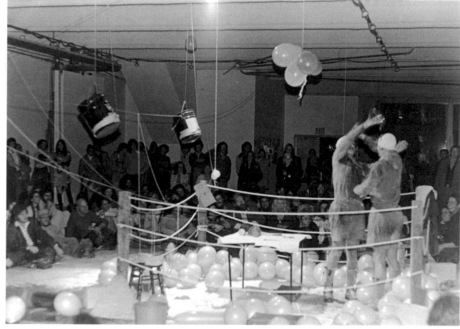
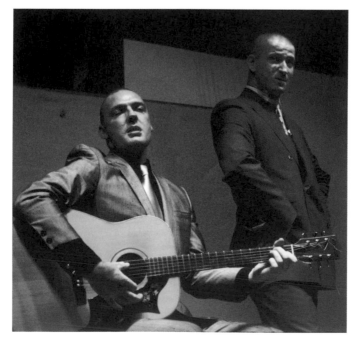
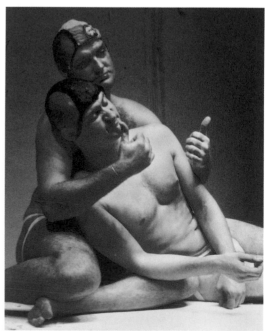

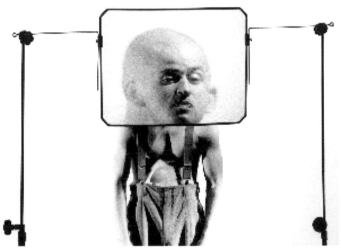

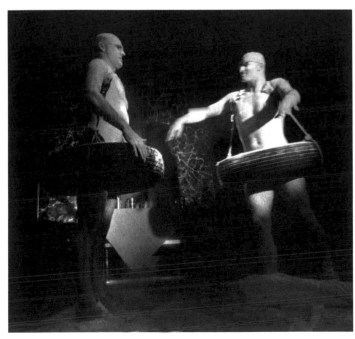

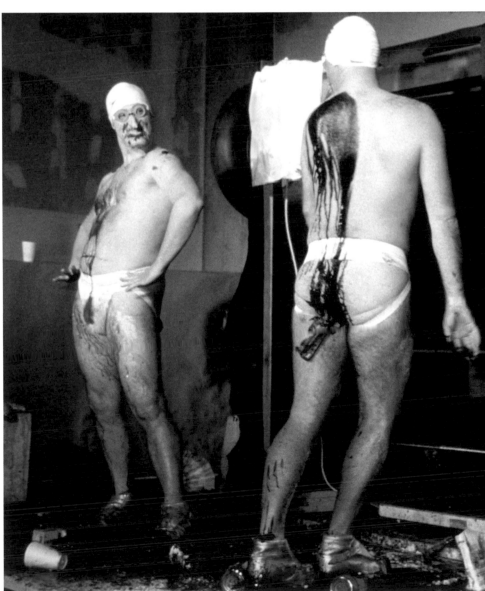

LYNN MARIE KIRBY

Born 1952, Washington, D.C.
Lives and works in San Francisco, California

SINCE THE 1970S, LYNN MARIE KIRBY HAS combined video and film to create disjointed representations of domestic and public landscapes by emphasizing the unique elemental properties of sound, light, and space. Her work has spanned a broad range of video practices, from performance-based installations to abstract single-channel videos, united only by the artist's determination to create moving images that occupy the spaces between specific media and disciplines. Kirby received her Bachelor of Fine Arts and Master of Fine Arts degrees from the San Francisco Art Institute. Her earliest works examined problematics of the female body, domestic space, and identity politics, through narratives grounded in the personal stories of her characters. Her most recent work veers toward the abstract through a heightened foregrounding of the role of the technology.

The *Latent Light Excavations* series, which Kirby began in 2003, relies on the formal elements of both film and video. For this series, she visits well-known tourist locations and, without a camera, exposes a reel of film, creating a site-specific recording of light. Although the 16mm film serves as a physical artifact of a specific period of time at that site, she defamiliarizes the space through digital editing. In *Golden Gate Bridge Exposure: Poised for Parabolas* (2004), the act of digital conversion from film to video is performed as part of the video itself. The video, composed of still images of the digitized film, leaves out none of the typically undesirable elements of the moving image—the head and tail of the film, the video scan lines, and a vertically split screen of paused video frames are all emphasized as primary visual components of the work. Kirby refers to her process of editing as improvisation and draws from a boundless color palette. The resulting images flashing on the screen are as fleeting as the sunlight they record and as fragmented as the collective memory of an American landmark like the Golden Gate Bridge.

Pauline Stakelon

INCREMENTAL FRAMEBUSTING: THE PARAGON EXAMPLE OF LYNN MARIE KIRBY
by Michael Sicinski

The parergon *is a form which has as its traditional determination not that it stands out but that it disappears, buries itself, effaces itself, melts away at the moment it deploys its greatest energy.*
—Jacques Derrida, *The Truth in Painting*

For any of this to make any sense at all, we're going to need to establish a frame of reference. At least one. Maybe a few. Perhaps we should start with Lynn Marie Kirby's position vis-à-vis the present situation in experimental film and video. Then we can work out from there.

If in the post-identity politics era, many media artists have been unwilling to commit to rigor and medium-specific concerns (for fear of seeming off-putting or inadequately "engaged"), the flipside has also been true; the reaction against so-called issue art has often resulted in a climate in which younger experimentalists insulate themselves from criticism by blithely refusing to take much of anything seriously. Emerging in the wake of this dialectic, Lynn Marie Kirby's recent film/video hybrids strike a rare balance between austerity and playfulness, a trick that much of the avant-garde has been trying to pull off in recent years, with uneven success. Kirby's latest work is deeply unfashionable. It stakes out formal problems so specific to the history of film, video, and the plastic arts as to risk incomprehensibility for the casual viewer. The work can, from a certain misguided angle of approach, look like *nothing*, some blippy forms and test pattern fragments dancing around with intractable purpose and then evaporating, perhaps serving as visual sorbet to cleanse the palate before the next piece in the group show (usually something "lyrical" and "poetic," or a lackluster piece of computer animation). All by way of saying, these pieces are virtuosic, even stunningly so, but the risk they run is one that most contemporary media art studiously averts.

This risk is exactly the point. Kirby's *Latent Light Excavations* series, a set of gracefully knotty video improvisations, operate at the awkward juncture between film and video at their most adamantly medium-specific. These works begin life as cameraless films, with Kirby exposing raw stock to the shifting available light at a predetermined location. There is always some conceptual basis for the site of exposure, sometimes social (the Paiute Indian reservation), sometimes socio-spiritual (the Golden Gate Bridge), other times completely personal (a neighborhood landmark, a family event). She then loads this information into a video synthesizer, where the raw stock encounters both the built-in settings of the machine (scan lines, wipe techniques, pre-set forms such as triangles and squares) and Kirby's live, real time performance-editing, in which she assigns durations to different segments of the original footage and sculpturally shapes it in a single improvisational pass. In describing her process, Kirby has remarked, "I like to think of myself as a jazz musician when I'm making these pieces. For some reason, I think of [the console] as a saxophone."

Just like each of the pieces themselves, Kirby's recent turn toward ultra-minimalism has a backstory. Actually, to be more precise, we might say it has at least two backstories, one pertaining to shifts in San Francisco-based avant-garde production, and one pertaining to Kirby herself. We can begin with the "broader" one. For decades, left-coast experimentalism was synonymous with a certain strain of hippy-Zen, typically contrasted to the more level-headed, intellectual work produced in the New York/Toronto corridor. (Such structural investigation was often derided as "chilly," or worse, "masculinist" by the California sector.) This division certainly eased in the 1980s and, by the 90s, the San Francisco scene was supporting a new kind of practice. Certainly too diffuse to constitute a movement and with no definitive beginning or end point, the Bay Area bore witness to diverse film and video artists united by a new approach to structure, a wry, self-effacing humor, and a playful but honest commitment to film-theoretical concerns. A mere laundry list of some of the individuals constellating the SF scene in the 90s—Kirby, Scott Stark, Anne McGuire, Luis Recoder, Jun Jalbuena, Dominic Angerame, Craig Baldwin, along with the bicoastal Ernie Gehr—is enough to convey the broadest divergences, but also to hint at a sea-change in the scene, a new generation operating from the standpoint of having moved through structural film, keeping its Oulipo-esque gamesmanship without hewing to its ontological excesses. Although some of the ideas and approaches that characterize Kirby's creative practice have been "in the air" in recent decades and are related to general shifts in Bay

pp. 138–41
Text reprinted, in a slightly adapted form, from Michael Sicinski, "Incremental Framebusting: The Paragon Example of Lynn Marie Kirby," *Cinema Scope* 26 (Spring 2006): 38–43. Used with permission.

p. 139
Lynn Marie Kirby, stills from *Golden Gate Bridge Exposure: Poised for Parabolas*, 2004. Camera-less exposed film stock from site, transferred to digital video, color, silent; 4 min., 44 sec.

pp. 140–41
Lynn Marie Kirby, stills from *Golden Gate Bridge Exposure: Poised for Parabolas*, 2004. Camera-less exposed film stock from site, transferred to digital video, color, silent; 4 min., 44 sec.

Area practice, hers is a unique conjunction of conceptual rigor and investigative spirituality. This is one conceptual framework within which Kirby's film and video work could be said to "make sense."

Another, smaller frame: Lynn Kirby's work since the 1990s has often focused on family life, domestic space, and other traditionally "feminine" subject matters. But like Yvonne Rainer before her, Kirby subjects this autobiographical material to highly formal procedures, abstracting it in the belief that its personal valence will be heightened through its interaction with medium-specific concerns. Kirby began studying cinema at the San Francisco Art Institute in the seventies, and although she was enrolled in one of the most doggedly medium-specific film programs in the United States, she began experimenting with video quite early. "I was incorporating video into performances and people sort of looked askance at that at the time." Although Kirby has identified the structural/materialist tradition as being one of her major influences from the start, her work from the seventies and eighties has a very different feel, more in keeping with the abstract, personal-voice works that characterized much feminist film work of the period. A film like *Sincerely* (1980), for example, adopts an approach that is miles away from the recent work, although just as conceptual. Virtually all text, *Sincerely* provides a succinct (and bracingly funny) report on one U.S. Senator's reply to Kirby's letter urging him not to vote for the Hyde Amendment, a piece of legislation designed to impose serious restrictions on a woman's right to choose. In a more poetic vein, *Sharon and the Birds on the Way to the Wedding* (1987) interrogates the ideologies that saturate the available vocabularies for describing love relationships. Textually, *Sharon* evinces an intuitive encounter with the work of Julia Kristeva and Luce Irigaray, while the free-associative, almost fugal image track recalls contemporaneous work by Rainer and especially Su Friedrich.

From there, Kirby began a series of films, installations, and videos that zeroed in on particular textures of landscape and its interaction with the built environment. Through the nineties and into the first few years of this decade, Kirby's work gradually shifted its focus away from the explicit languages of politics, but the politics, you might say, began bubbling up from underground. Kirby's films and digital videos from this period foreground the cognitive and time-based human absorption and assimilation of space and spatial information. Referring to some of these works as "Time Dilations," Kirby has characterized this work as an attempt "to express a way of looking at time and space both simultaneously and pulled apart."[1] Again returning to the formal procedures gleaned from her structural forebears (Gehr, Hollis Frampton, Malcolm Le Grice, and, especially, Michael Snow), Kirby's later works emphasize the "mediation" of media, staging encounters between Parisian views, for example, or the rolling hills of the Napa Valley, and the mathematical dissolution of the digitally manipulated image. A video such as *Out of Step* (2001) collides unassimilable visual languages—the family vacation video, the fixed-frame landscape study, the ethnographic survey, and the pure Benday abstraction of Op Art or De Stijl. Although *Out of Step*'s political critique is performed within the image and is somewhat less overt than *Sincerely*, the piece is, among other things, a consideration of the way we consume spaces and people as we move through them, our bodies and cameras unwittingly absorbing the sedimentary histories and social formations that predate our arrival. This account of Kirby's artistic evolution and, in particular, the intimate connection between spatial inquiry and increasingly abstract means, could serve as a second, complementary framework for understanding this difficult new work.

The landscape, then, is free to "speak" in Kirby's light exposures, but not without a structuring framework of its own. With the *Latent Light Excavations*, Kirby has expressed a desire to both concretize the political landscape through materialist records of its available light and energy, and to capture the spiritual reverberations of traumatized sites, performing a kind of cinematic alchemy. Some have characterized Kirby's work as "esoteric," and I suppose this is true to the extent that the specific histories of the *Light Excavations* sites are required for full understanding. But it may be more proper to say that Kirby is opening her work to the possible intervention of a spirit world, in the form of chance procedure. Do the ghosts of suicide jumpers, for example, haunt the Golden Gate Bridge, and if so, is some aspect of their being recorded in *Golden Gate Bridge Exposure: Poised for Parabolas*? The film is open to the question, but Kirby explores the problem in a strictly materialist manner, much in the same way that Michael Snow acknowledged that *Wavelength* (1967) contained, among other things, his "religious inklings." (Appropriately, Kirby's 1996 installation *C to C*, included in the upcoming MoMA show,[2] is, among other things, an homage to *Wavelength*.) Kirby's work in effect uses structural rigor to problematize, revise and expand the spiritual tradition that characterized the West Coast avant-garde in the first place.

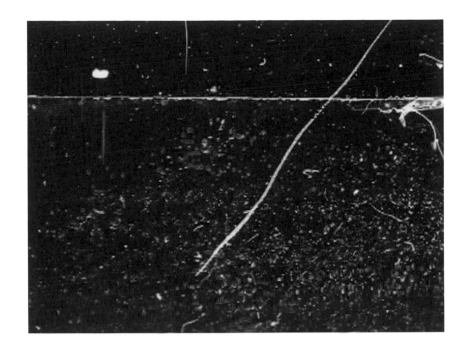

Following this line of thought from materialist filmmaking to her commitment to new and hybrid media, Kirby's process plumbs the gap between film and video-specificity. Cameraless films abandon cinema's traditional segmentation into frames, but Kirby's video translation of this raw material introduces mobile framing and reframing through strictly video means, such as off-center split-screen and multi-image refraction. *Lenten Light Conversions* of 2004, for example, manipulates its color-fields with formal precision, but also has a funky bebop swing to it that supplements the rigor rather than implicitly apologizing for it. In description, it all seems very simple. Kirby shows a red frame, then a yellowish one. She then letterboxes the red frame, cropping it on all sides as if placing it on a layout table. In other parts, she bounds the video frame with a static vertical yellow stripe, while the remainder of the frame changes colors and exhibits the scratches of film in motion. In less than two minutes, Kirby orchestrates her souvenirs of pure light into arrangements resembling Barnett Newman's "zip" paintings, or even populist sources like the sleeves from old New Order 12-inches [records]. *Lenten Light Conversions* reopens certain key problems in the history of video art (particularly how to harness the raster's "flow"), examining them from the standpoint of a showdown between different media at their irreducible limits. The result is appropriately catholic; Video enters the temple of Cinema, and is converted.

Similar methods obtain in *Pyramid Lake Paiute Reservation Exposure*, also from 2004. Whereas *Lenten* plays pure colors against one another, *Pyramid Lake* manipulates figure/ground relationships. The baseline image is a canary-yellow field interrupted by a tilted white triangular form, and against this home-position Kirby bumps the image upward, emulating the celluloid frame-adjustment, while also introducing carefully manipulated vertical lines on the left and right. The dual work on the frame seems to function musically, like naturals played against sharps and flats; Kirby's improvisational style suggests the post-Cagean art music of Morton Feldman or Giacinto Scelsi, operating on the basis of variances of attack within a restricted tonal range. Moreover, this is the first of Kirby's pieces in this vein that struck me as having a relationship to animation, albeit a contrary one that thwarts the expectations typical of animated films. The main form doesn't move, and its compositional context shifts around it. In this regard *Pyramid Lake* contains echoes of Robert Breer's work, but its chief strategies are painterly. The

piece almost functions like an Ellsworth Kelly canvas evolving in condensed time.

In their own way *Lenten Light Conversions* and *Pyramid Lake* are every bit as parsimonious and preordained as Peter Kubelka's *Arnulf Rainer* or Paul Sharits's *Ray Gun Virus*. But other works in the *Light Excavations* series are more erratic and discombobulated, perhaps none quite so much as *Black Belt Test Exposure* [2004]. The filmic material was exposed, as the title suggests, at a martial arts expo in which Kirby's young son James was undergoing his black belt examination. Whereas earlier *Light Excavations* works are compact and, like the great structural masterworks, teach the viewer how to watch them over the course of their running time, *Black Belt* is devoted to continually throwing the spectator off-balance, flipping us around without necessarily pinning us to the mat. To call it "sprawling" in this context probably makes it sound sloppy or uncontrolled, and that's the furthest thing from the truth. During one presentation of the piece, Kirby explained that she was attempting to approximate the ten grueling rounds her son underwent, how the examinee must endure various types of sparring and in doing so reflexively react to the unexpected. Here, saturated color frames reminiscent of the earlier exposure-works are disrupted by pure black-and-white scan lines and video feedback. *Black Belt* is a summary work, combining techniques from several different phases of Kirby's practice, and this allows Kirby's improv strategy to achieve a new level of freedom, with certain expected formal gestures disrupted by whole new frames of reference. While watching the piece for the first time, I grooved on it, but also felt an acute sense of confusion, particularly in relation to the rhythmic exactitude of other works in the series. In short, I entered the ring with the best intentions, had a great time, but got my ass kicked. In light of this energizing defeat, this viewer respectfully requests a rematch. Hopefully, by then I'll have developed a few more frames of reference of my own.

NOTES
1. Jeffrey Skoller, "Looking Back From the Middle: The Domestic Lives of Lynn Marie Kirby," in *Discrete and Continuous Boundary Problems*, Lynn Marie Kirby, ed. (San Francisco: San Francisco Cinematheque Press, 2002).
2. *Mediascope*, a screening and installation/performance at the Museum of Modern Art, New York, January 30, 2006.

PAUL KOS

Born 1942, Rock Springs, Wyoming
Lives and works in San Francisco, California

HUMOR, SIMPLICITY, RATIONALITY, AND EXPERIMENTATION drive Paul Kos's practice. Arriving in California in 1967 to study painting at the San Francisco Art Institute, Kos quickly discovered the Bay Area's active and lively conceptual art scene. Involved with the early days of Tom Marioni's alternative exhibition space, the Museum of Conceptual Art, Kos began to explore his process-oriented ideas through sculpture, installation, photography, performance, film, video, and his unique form of ambidextrous writing. In many of his early works, Kos considered his actions and gestures to be part of a "closed-circuit" event. In *Pilot Butte/Pilot Light* (1974), a video taped in the Wyoming desert, he spins a chunk of clear ice in a pot lid until he has shaped it into a lens. He then uses the lens to refract the sunlight and spark a pile of kindling into a fire. At the end of the tape, he throws the ice on the fire to extinguish the flames, completing a cycle contained by its own physical properties. He remade this video in 2004, laying bare the efficiency of his procedure.

Using commonplace materials and simple technologies in his dramatic structures, in his installations, Kos often comments on history, allegory, and humanistic cultures. His great spiraling armature, *Tower of Babel* (1990), holds twenty video monitors that simultaneously display seventy-five people speaking fifty different languages, which creates a flood of indeterminable sound that speaks to the limitations of verbal communication. His silent and contemplative installation *Chartres Bleu* (1983–86) mimics a Gothic stained-glass window from Chartres cathedral in France, using twenty-seven video monitors illuminating an image of each of the window's twenty-seven panels. Within twelve minutes, the video panels fade from daylight into night. Here, Kos reinterprets the "analog" technology of glass through video's distinctive aspects.

Catherine Taft

Interview conducted by Glenn Phillips on March 24, 2007, at Paul Kos's home in San Francisco, California

GP: You were part of a group of artists who came to the fore in the Bay Area in the 1960s and 1970s. It seems like all of you were influencing each other. How did this community come together?
PAUL KOS: Well, one thing that started it was probably Tom Marioni's efforts. He organized some shows that brought us together at his Museum of Conceptual Art in San Francisco. He would come up with a title first, and that would provoke sufficient interest that people would quickly make a piece that they might not have done otherwise. He wouldn't go around choosing work. He would choose artists and then say, "I have a show and the title is *The Return of Abstract Expressionism*" or "*Sound: Sculpture As*" or "*All Night Sculptures*," and we'd make a piece that related to it. We were all doing our own types of work, but this gave us a deadline, which we might not have had otherwise. And most of these shows were great social events in what I guess was one of the first alternative spaces in the country, the Museum of Conceptual Art. So we got to know each other quite well, and we were in shows outside of the city together—Howard Fried, Terry Fox, Tom, Bonnie Sherk, Joel Glassman, and I. Many people were involved, and it became an informal critique. We knew each other well enough to do that. I think it was a very healthy situation.

We were working a lot in Super 8 film, doing performance-related activity, and it seemed like one day, out of the blue, George Bolling and Lydia Modi Vitale at the de Saisset Museum at Santa Clara University purchased a reel-to-reel half-inch deck, and we started making pieces. Video was a great substitute for Super 8. It was cheaper. It couldn't lie, because you couldn't edit in those days, and it was such a great device because it also had synch sound. We quickly tired of Super 8 film and went to video. The de Saisset's camera was one of the only decks in the Bay Area, and it gave us the ability to make work that we wouldn't have been able to afford otherwise. It was soon after this that the NEA [National Endowment for the Arts] started giving small, $3,000 grants, and almost everyone who got one bought their first Portapak.

When was this? Well, my guess is '69, '70, '71, '72. The reason I say that is I did a piece at Rene di Rosa's—now the di Rosa Art Preserve [in Napa Valley]—called *rEVOLUTION* [1970], where I was firing a shotgun at a target. It was an invisible weight change. I was on a scale and the target was on a scale. I had fifty pounds of ammunition, and I shot for ninety minutes. The target gained weight for a while as the shells hit it, and then it started blowing apart and losing weight. George Bolling and a few others were documenting it with both Super 8 film and black-and-white video. Rene invited fifty people. There was a closed-circuit broadcast to the living room, and you could either watch the performance on the black-and-white screen, or see it live outside, and then immediately after the performance George Bolling replayed the tape in the living room, and visiting *Newsweek* magazine art critic Howard Junker gave an instant review.

I'm looking behind you and I see these four photographed video stills from a piece called *Zabriskie Point* [1970]. Could you describe that piece? Well, I had a friend who was a Bedouin from Saudi Arabia, Abdul Mosen Mana. He was one of my students at Santa Clara University, and I convinced him and George Bolling to go to Death Valley with me. I had a show coming up at Reese Palley here in San Francisco and I had no work made for it, but I thought if we just went to the valley, we'll come up with ideas. We went down there in George Bolling's Camaro. I'll never forget this. We arrived, and the first night we're sleeping in Death Valley, a sidewinder rattlesnake comes across the sand, between the campfire and us, and George spent the night sitting on top of the Camaro. He didn't sleep. Abdul Mosen Mana and I managed to get in our sleeping bags and fall asleep. In the morning, underneath both bags, were scorpions. They weren't biting us or anything, they just crawled under for the warmth, and I thought it was really amazing.

The *Zabriskie Point* piece was trying to go to Zabriskie, matching what Ansel Adams had done, trying to go to the same site where he had shot his photograph, and then zooming in slowly on that site, and finally ending up at the corner of my eye, because in the desert one's always squinting because of the intensity of the light. So it starts with Zabriskie Point, and it ends up right here [points to his eye] in 1970.

You said you were making Super 8 films before you started working with video. Could you describe some of those? They were

p. 143
Paul Kos, *Chartres Bleu*, 1983–86. Twenty-seven-channel video installation, color, silent; 12 min. Di Rosa Preserve, Napa, California.

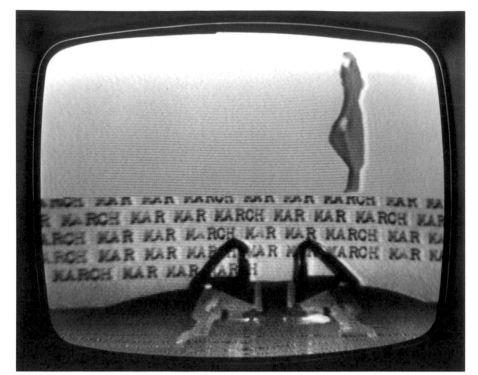

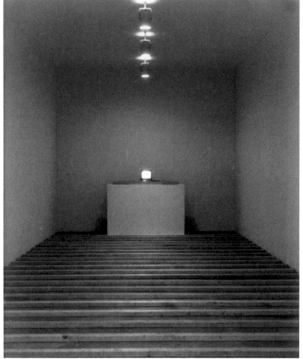

early performance pieces. I went to Wyoming every year and used it as my studio. The drive out became a studio. I had a Volkswagen bus and it was twelve hundred miles, which is eighteen to twenty-four hours at fifty-five miles an hour, so it became a great studio space. When I'd arrive, I'd do Super 8 pieces there that were gestures in a landscape.

We were confined at that time—luckily, I think—by a three-minute cartridge, so most Super 8 pieces were three minutes long. In fact, I'll never forget a Super 8 piece that Terry Fox did. It was shown in a public auditorium, and it's one of the most beautiful pieces in the world. Here's what he does: the audience knows the film is three minutes. At the beginning, Terry inhales loudly: "Aaahhhh," and everybody in the audience figures it out. He is holding his breath. They start to do the same thing: "Aaahhh." We have three minutes. Who can make it? And you can see Terry's vein going up his forehead. Then finally he expels his air. There'd be people in the audience who exhaled early, and others who held it longer, and it became such a great audience activation piece. It was the kind of thing we were leading to at the time, which is "How do you get the viewer involved instead of doing these past-tense, three-minute things that viewers watch? How do you get them to be part of the piece?"

That piece by Terry Fox was one of the really critical ones I think, which led me to make MAR MAR MARCH [1973]. This was a piece that absolutely required the viewer to perform. The way the piece is set up is there are two-by-fours placed across the viewer's path on the floor at about a size 12 shoe apart, so I get most people. Anybody with a size 12 shoe or smaller can fit between the boards, and they approach a monitor at the end of the room. At the beginning, you can hear a very light tapping sound. As you go closer and start stepping across the boards, you realize that you're stepping exactly to the sound, "ta-ta-tah tum ... ta-ta-tah tum ... ta-ta-tah—tah—tah tum." It even becomes easier to walk, because if you take a normal stride you will trip. So it's easier to just raise your feet and march between the boards, and when you get to the end where the monitor is—which is like a little bait of light at the end of the tunnel—you see that what I had done was type "m-a-r [space] m-a-r [space] m-a-r-c-h [space]" in that rhythm, and you realized you were marching to the sound of a typewriter; but in a way it shows the

amount of control that the written word has, that propaganda has, that the sound has, because it was easier to march than not march. It was the onomatopoeia of the experience. It looked like it sounded and sounded like it looked. We were looking for a way not to simply record our past tense, but to find an immediacy with the viewer.

MAR MAR MARCH is probably more successful at that than any piece I can think of, because you can't make it to the small monitor without marching. If you opt to go see the monitor at all, then you wind up marching in perfect form. The other important piece in that respect was Bruce Nauman's *Green Light Corridor* [1970]. You cannot come out of that corridor without the world looking rosy afterward, because you've been in it long enough that you tax the rods and cones of your eyes. It works whether you like it or not.

That's also true about your piece *St. Elmo's Fire* [1977], which was shown at the Long Beach Museum. The viewers aren't given much choice. *St. Elmo's Fire* began with a single-channel video made with my ex-wife, Marlene, called *Lightning* [1976]. On a very stormy day, she would look at the landscape and say, "When I look for the lightning it never strikes, but when I look away it does," and then the lightning would strike. I researched lightning quite a bit. The University of Colorado has a lightning research lab and I found out from them that in a very good storm it takes about fifteen or twenty seconds for lightning to strike in the same

p. 144
Paul Kos, video still (left), detail (top right), and installation view (bottom right) from rEVOLUTION: Notes for the Invasion: MAR MAR MARCH, 1973. Wood, typewriter, video, and audio, dimensions variable.

p. 145
Paul Kos, still from Reflection, 1998. Single-channel video, black-and-white, sound; 1 min., 45 sec.

place in the same part of the sky, because the atmosphere has to re-ionize. So the timing of her statement is exactly that, because then our odds are higher that it would happen, and we happened to luck into a very good storm. Out of that piece came the installation called *St. Elmo's Fire*. This piece has a monitor on the floor in a steel case, and the monitor shows intermittent lightning strikes and static electricity. There's wall-to-wall deep pile carpeting, and the carpet also goes up the sides of the walls. There's no furniture in the room, so viewers would lean against the wall, which is also the carpet, or they'd sit on the floor. All this time, unbeknownst to them, they're building up a giant static charge, and on exiting they have to push the metal bar of the door. It's a steel door you might see in an industrial building. When you touched the door, a spark would jump off at you. The whole door was grounded to the plumbing system of the space, and that made the spark leap even further than it normally would. So the piece is not about just the lightning. It's about that whole closed-circuit aspect, which is the door, the carpet, the viewer in the space. Without the viewer, the piece doesn't exist, in fact. Often works like that started as single-channel sketches and ended up as installations.

You continued to move more into large-scale installation. One of those pieces is *Chartres Bleu* [1983–86]. Could you describe that piece? I have to kind of confess to this. *Chartres Bleu* was the first didactic piece I ever made. I hope it isn't didactic in the end, but its source was didactic.

What do you mean by "didactic"? I was teaching a course in 1981 or '82, and I noticed my students were making faster and faster edits per minute. Their work was looking more and more like what was going on in advertising and television. Rather than artists leading the way, they were starting to follow. So I thought "How can we take back that which we had?" I mean, we had managed to lead in certain directions, and now we're the disciples. I thought that if I could try to make a piece sufficiently large in scale, with absolutely no edits, that it would be taken seriously. But what would that be? I happened to be renting a place from an art historian, and I was looking through his library, and—we've all heard the quote, "video's a window to the world." I started looking at windows, and then it struck me: the cathedral window. Eight hundred years ago they made these incredible windows, and although I didn't know where to go yet, I knew that the secret would be this magical kind of light that comes through the glass. I was awarded an NEA grant that year, so I went to France and I started going from cathedral to cathedral. I had to look for windows whose proportions for each pane were the same as a monitor—a 4:3 aspect ratio. I don't know how many churches and cathedrals I went through before I found one window in Notre Dame, and I found two or three at Chartres. Notre Dame was impossible, but when I found Chartres, I thought, "This is it. This is the perfect window." Each pane of twenty-seven panes was exactly 3:4 proportions, the same as a monitor turned on its side. So I went to the office of Les Arts et Métiers, which controls access to all the public and historical buildings in France, and the person at the desk told me, "Make a proposal. In six or seven months we'll give you an answer," and I said, "But I only have a week!" "That's life," she says, and I was very depressed. It so happened that the *propriétaire* of the building I was in heard my story and he made a phone call. He said, "Come with me." In a few minutes we were with the head of all the historical buildings of France. Literally, in a few minutes. The *propriétaire* said, "Now don't talk. Let me talk for you." We went in. In under fifteen minutes, I heard the Prefet des Arts et Métiers tell the Head Architect of France (his office happens to be at Chartres): "You have to let this person

in the cathedral to make his piece," and the official argued, "But I even turned Metro-Goldwyn-Mayer away two days ago," or something like that, and he says, "That's it. Let him in." So I got in. The *propriétaire* of the building where I was staying happened to be a wonderful bookbinder, and all the diplomats and hierarchy of France came to him to get gifts to take to other countries. France is based a lot on who you know, because the bureaucracy is horrendous. So somehow, the piece seemed destined at that point.

I met with the scaffolding company; historical buildings in France have to use a historical building scaffold company. I asked them to build a scaffold for me in front of the window that I had chosen. I left on a Friday and came back on a Tuesday, and they'd built the scaffold in front of the wrong window! They decided that I should've chosen the astrological window, which is much more famous, and I just didn't know any better because I was from America. But the trouble with that window was that it's all made of square panes. So I asked them to please move it, and they said, "It will take two weeks because we're very busy now in our schedule." At lunchtime, I noticed that the workers were playing the French game, *la pétanque,* and I knew how to play this game, so I went up to them, kind of like an arrogant, naive American, and said, "Let's play *la pétanque*. If I win, you move the scaffold right after lunch. If I lose, I'll pay you in American dollars." At that time the franc was maybe 9–10 to 1, so a dollar was worth quite a bit. I lost, but I played well enough that they agreed to move the scaffold anyway.

So things were happening again, but I was still nervous. I got up on top of the scaffold, and they wouldn't let me hook it to the cathedral. It's illegal. It had to be self-standing, and if you take a breath, the whole thing just sways. I couldn't make it stable enough to shoot video at six meters up in the air. It was just impossible. I had to give up on video altogether. So I shot transparencies of each pane and brought them back to the United States. I put each transparency at one end of a four-by-five camera bellows to compensate for my trapezoidal problems, and the video camera at the other end, and I now had California sunlight coming through a transparency into a video camera. Using the exposure control, I went from close, to open, to overexposure, to close, in twelve minutes on each of the panes, and they're all timed so the light of one day is condensed into twelve minutes. The twenty-seven channels are not exactly synched. It's more like the facets of a jewel, and light hits one facet and then another. It's very similar in the cathedral; the panes of the windows weren't exactly parallel to each other or even on the same plane. When direct sunlight first strikes the window, it hits one pane and then another, like a jewel, and that's the way the piece works also. It's fairly close to the life-size version of the actual window. It's twenty-seven monitors and twenty-seven video players making one window of Chartres cathedral, and eight hundred years separate the technologies.

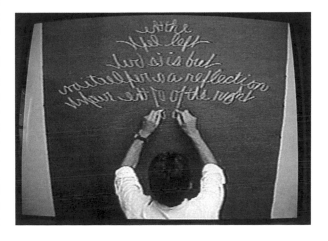

JOANNE KYGER

Born 1934, Vallejo, California
Lives and works in Bolinas, California

JOANNE KYGER BEGAN WRITING in the mid-1950s, composing poems that surveyed her world with a sharp eye and deft precision. With taut lines, innovative phrasing, and shapely breath, the facts of life and of words become crystals in her verses. Influenced by Zen Buddhism, Kyger has long been identified with the Beat movement, the San Francisco Poetry Renaissance, and the Black Mountain school, but, in actuality, she defies categorization.

In 1967, Kyger was one of the first artists to be invited for a residency at the National Center for Experiments in Television (NCET) in San Francisco, which, under the visionary leadership of Brice Howard, became a think tank for poets, painters, craftsmen, writers, musicians, dancers, and filmmakers to experiment with the new medium of video, which had yet to develop formal rules or language.

Called one of the seminal works to come out of the innovative explorations at NCET, Kyger's video *DESCARTES* (1968) tackles the philosophical work of René Descartes with NCET's distinctive utopian vision of melding television and art on all levels. Uniquely attuned to the technological developments in play at NCET, Kyger translated her adaptation of Descartes' six-part essay "Discourse on Method" (1637) into the video medium with keen awareness and expansive mind. Her tape stripped away the banal and mundane conventions that surrounded the poet and, like Descartes' work itself, attempted to understand the mind-body problem and the nature of reality.

Kyger felt that the medium of television was an ideal form for resolving the problem of Descartes' dualism, and she made particularly creative use of video feedback—the electronic equivalent of the mind turning thought upon itself. Using the conventional TV format of a soap opera, Kyger set her narrated poem to a series of recorded actions and the electronic transformations of composer Richard Felciano. With the assistance of filmmaker Loren Sears, Kyger employed the numerous video techniques and special effects at her fingertips. Sears's use of distortion, feedback, tape loops, and tape delay corresponds to each section of the poem, as it was Kyger's goal to "use various techniques to visualize thoughts."

Kyger moves through a domestic space in which she sews, sweeps, smokes, and serves tea, while simultaneously playing the roles of the good housekeeper and the "Mother God" mentioned in her poem. Modulating her voice between elevated tone and hipster slang, she brings the otherworldly and everyday closer together as she speaks. Found political footage and images of American life are superimposed on a distorted image of Kyger's expressive face. Shots of her body and of the video equipment producing the piece become multiplied into a kaleidoscope of visual effects. The work's final line, "ONE CANNOT SO WELL LEARN A THING WHEN IT HAS BEEN LEARNED FROM ANOTHER, AS WHEN ONE HAS DISCOVERED IT HIMSELF," is a fitting commentary on the nature of the experiment itself.

Rani Singh

[TEXT and VIDEO STILLS]
DESCARTES AND THE SPLENDOR OF
A REAL DRAMA OF EVERYDAY LIFE.
by Joanne Kyger

IN SIX PARTS.

PART I

We are now on an adventure of RIGHTLY APPLYING our VIGOROUS MINDS TO THE STRAIGHT ROAD, APPLYING OUR REASON AND SENSE. I shall thus DELINEATE MY LIFE AS IN A PICTURE so that I may DESCRIBE THE WAY IN WHICH I HAVE ENDEAVORED TO CONDUCT MY OWN DESIGN AND THOUGHTS in six parts.
I am not up to subject myself to censure. You may note the grand design of Yosemite is without flaw, being a natural occurrence. Thus, my own natural inherited mind has been such. Looming above me in magnificence, at times leaving me far behind, in short, grandiose above believability, and in short again, an irritant.
Not being a devotee of the single mind, however, the rapt contemplation of a pebble in revealing the universal cosmos, I took my lagging acceptance of my natural magnificence of heritage as being due to the ignorance and unfamiliarity of my NATIVE COUNTRY.

When it's winter in the corn country people don't stop eating corn.

So I traveled a great deal. I met George, Ebbe, Joy, Philip, Jack, Robert, Dora, Harold, Jerome, Ed, Mike, Tom, Bill, Harvey, Sheila, Irene, John, Michael, Mertis, Gai-fu, Jay, Jim, Annie, Kirby, Allen, Peter, Charles,

Drummond, Cassandra, Pamela, Marilyn, Lewis, Ted, Clayton, Cid, Barbara, Ron, Richard, Tony, Paul, Anne, Russell, Larry, Link, Anthea, Martin, Jane, Don, Fatso, Clark, Anja, Les, Sue, and Brian.

This being some trip, and the possibilities seeming endless and the faculties for entertaining and being thus entertained limited, I quit this and RESOLVED TO MAKE MY OWN SELF AN OBJECT OF STUDY.

PART II

I decided to sweep away everything in my mind and start over again; not adding one little iota until I was absolutely sure of it. I CONTEMPLATE THE REFORMATION OF MY OWN OPINIONS AND WILL BASE THEM ON A FOUNDATION WHOLLY MY OWN. It is impossible to trust any one else. WALKING ALONE IN THE DARK I RESOLVE TO PROCEED SLOWLY.
First of all I am not going to accept anything as true unless I am sure of it.
Second, I divide all difficulties into AS MANY PARTS AS POSSIBLE.
And *Third*, I will go from the easiest to the hardest, in that order.
And *Last*, make sure that I forget nothing.

I THEREBY EXERCISE MY REASON WITH THE GREATEST ABSOLUTE PERFECTION (ATTAINABLE BY ME).

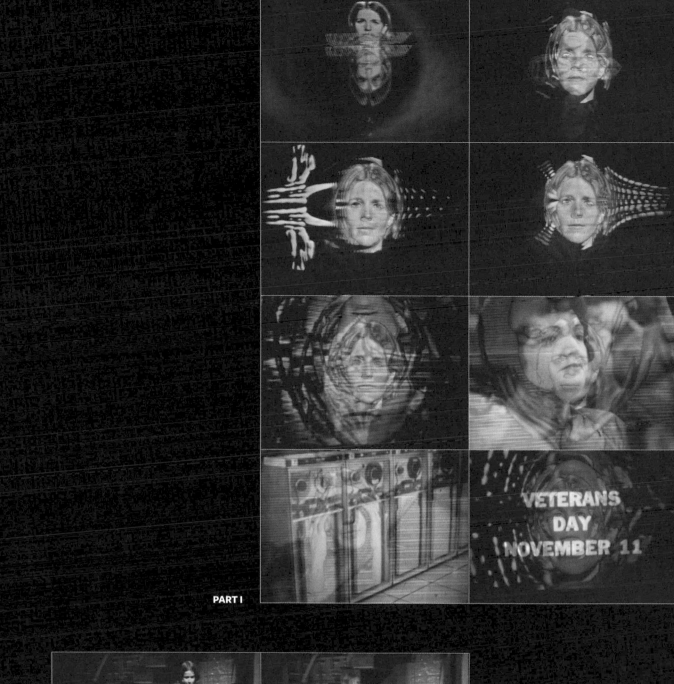

PART I

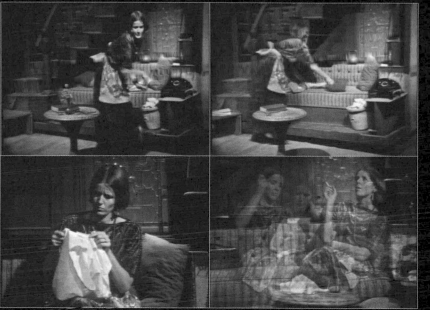

PART II

pp. 146–49
Text originally published in Joanne Kyger, *Places To Go* (Santa Barbara, Calif.: Black Sparrow Press, 1970). © Joanne Kyger. Used with permission. Stills from Joanne Kyger, *DESCARTES*, 1968. Single-channel video, black-and-white, sound; 11 min., 25 sec. Courtesy of the artist and the University of California, Berkeley Art Museum and Pacific Film Archive, Berkeley, California.

PART III

So my reason may have a place to reside, I thus build myself temporarily a small house of commonly felt rules, a PROVISORY CODE OF MORALS, until I arrive at the grand castle of my PURELY EXECUTED REASON. I will 1) OBEY THE LAWS AND CUSTOMS OF THE COUNTRY, choosing the Middle Way for convenience, for EXCESS IS USUALLY VICIOUS, and NOTHING ON EARTH IS WHOLLY SUPERIOR TO CHANGE, thus EXTREMES ARE PRONE TO TOPPLE MORE.
2) BE AS FIRM AND RESOLUTE IN ACTION AS ABLE. Once a choice is made, hold to it, thus alleviating PANGS OF REMORSE AND REPENTING.
3) ALWAYS CONQUER MYSELF rather than FORTUNE, and CHANGE MY OWN DESIRES RATHER THAN THE ORDER OF THE WORLD, for EXCEPTING OUR OWN THOUGHTS, nothing IS ABSOLUTELY IN OUR POWER.
We shall not desire bodies as incorruptible as diamonds, but make a virtue of necessity in our span of time.
ALL THAT IS NECESSARY TO RIGHT ACTION IS RIGHT JUDGMENT.
And having furnished my cottage I begin the establishment of the castle.

PART IV

I reject as absolutely false all opinion in which I have the least doubt. As our senses often deceive us I assume they show us illusion, and must reject them. As reason is subject to error, and who can offer more living proof of that than I, I must reject the faculty of reason.
Finally I am aware that I am only *completely* and *confidently* aware of all this rejection and doubt. This is all I can be sure of, this spinning out of my head. HENCE I arrive at my First Fundamental Truth. I THINK hence I AM. OR I Doubt hence I Am; or I Reject hence I am. You get the picture.
However this *I* is of the Mind, and wholly distinct from the Body. But then further clear reasoning brings to me this: IN ORDER TO THINK, IT IS NECESSARY TO EXIST. I never saw a dead man think, I never hope to see one, but I can tell you any how, I'd rather see than Be one. Dead men don't think. And therefore, everything we exactly and truly know, like THE REASONING ABOVE is because it is CLEAR AND DISTINCT.

I realize that to doubt is a drag, and a PerFECT BEING would accept everything. But from WHENCE DID I GET MY IDEA OF PERFECTION!!!!! PLACED IN ME BY A NATURE, BY A NATURE IN REALITY MORE PERFECT THAN MINE and WHICH EVEN POSSESSES WITHIN ITSELF ALL THE PERFECTION OF WHICH I COULD FORM ANY IDEA, that is to say, IN A SINGLE WORD, *MOTHER GOD*.
Without this idea of the perfection of MOTHER *GOD* we should not exist.

Imagination is a mode of thinking limited to material objects. AND THE STUFFY MIND ASSUMES IF YOU CANNOT IMAGINE, something, IT DOES NOT EXIST. WHICH IS beside the point and off the argument if not completely irrelevant to this text by which I am following myself in glory and splendor. AM I A BUTTERFLY DREAMING I AM ME or ME DREAMING I AM A BUTTERFLY or am I MOTHER *GOD* in Glory and Splendor? Our ideas become confused because we are not WHOLLY PERFECT and our razor sharp reason must be wielded at all times to guard against ERROR, error of IMAGINATION and error of the SENSES.

PART V

THE ACTION BY WHICH SHE SUSTAINS CREATION IS THE SAME AS THAT BY WHICH SHE ORIGINALLY CREATED.

As I move thru language and transfer the delicacy of vision into the moving and written word, so all thought not transferred on that level is lost and degenerated. The animal, the brute, dies a clumsy death for he is not equal to gods working in man. If they do not speak the language of man, they speak no language, and are DESTITUTE OF REASON. That the SOUL WHICH WE POSSESS AND WHICH CONSTITUTES OUR DIFFERENCE, OUR SOUL WHICH IS LANGUAGE OF MOTHER *GOD* WILL NOT DIE WITH OUR BODIES LIKE THE BRUTES, THE ANIMALS, WHICH HAVE NOTHING BUT THEIR BODIES TO LEAVE, WE FIND THE SOUL, OUR LANGUAGE, OUR REASON, OUR MOTHER GOD, IMMORTAL.

PART VI

The difficulties of trusting and using your own mind.
The *I* that is the Pivot, must not wobble, in the name of the established compendium of minds.
MOTHER GOD has created all, and I found this from MY OWN MIND, whence reside the germs of all truth.
And from her, THE FIRST CAUSE, comes the sun and the moon and the stars, Earth, water, air, fire, minerals, porridge.

And from here, I may explain all the objects brought to my senses. And ALL THE RESULTS WHICH I HAVE DEEMED IMPORTANT I HAVE BROUGHT TO YOU, NOT FOR MY PRIVATE USE but for ANY VALUE THEY MAY HAVE TO THOSE AFTER ME; for our CARES OUGHT TO EXTEND BEYOND THE PRESENT.
But it is the proof of my own mind's abilities, any ONE MIND'S ABILITIES THAT MY UNDERTAKING DRAWS TO PROOF. ONE CANNOT SO WELL LEARN A THING WHEN IT HAS BEEN LEARNED FROM ANOTHER, AS WHEN ONE HAS DISCOVERED IT HIMSELF.

Mother God in the Castle, of Heaven.

PART III

PART IV

PART V

PART VI

TONY LABAT

Born 1951, Havana, Cuba
Lives and works in San Francisco, California

TONY LABAT'S DYNAMIC VIDEOS examine issues of national identity, cultural alienation, and media representation. At the age of fifteen, Labat emigrated from Cuba to the United States, settling in Miami before moving to attend the San Francisco Art Institute in 1976. His videos often follow nonlinear narratives, serving to decontextualize familiar sights and symbols, and highlighting the "alien" perspective of an outsider. In *Solo Flight* (1977), a series of shorts made while he was still a student, Labat attempts to weave contemporary cultural references into the style of video performance typical of the time. In one act of endurance performance, the artist quickly dons multiple dozens of T-shirts, transforming himself into a bulky and nearly immobile figure, while, through the T-shirts, he advertises a series of bands and logos whose presence would be unthinkable in the more formal works of a slightly older generation of artists.

In 1980, Labat created *Babalu*, the title of which references the name of an Afro-Cuban deity and a popular song sung by Desi Arnaz on the television show *I Love Lucy*. Labat first presents himself as the figure of Babalu, chanting to a drumbeat and painting his face red. He then appears as a precursor to Al Pacino's *Scarface* character, standing in the shadow of a palm tree, reciting a story of sexual conquest. This story is interspersed with stereotypical images of Latino culture—maracas, the basket glove used in the game of jai-alai, and the hypermasculine act of crotch-grabbing. His later work *Lost in the Translation* (1984) is composed of documentary testimonials recorded off television, including an evangelist's sermon and a pulp fiction story. The themes of burning and hell appear both in the disjointed narrative and through the recurring images of lighters and fire eating. Symbols of high culture and low culture intersect in the video, as Ingres's painting *La Grande Odalisque* (1814) is disrupted by the presence of a young Latino boy, or when someone plucks an apple from a Matisse still life. The meaning of "high art" is lost in translation when the narrative becomes disordered and fragmented.

Pauline Stakelon

Interview conducted by Glenn Phillips on March 23, 2007, at Tony Labat's studio in San Francisco, California

GP: When was the first time you got your hands on a video camera?
TONY LABAT: It was when I arrived at the San Francisco Art Institute in 1976. One of the reasons I came to the institute was because I'd heard that Howard Fried had acquired Portapaks. The sculpture department had given Howard a little closet to work in. He was being punished by the sculpture department for acquiring these cameras, because they might have meant the end of sculpture. It was really sort of cruel. But eventually, Howard managed to break away from the sculpture department, and he was able to get his own room, which was Studio 9 at the San Francisco Art Institute. I started spending time there—just locking myself in and working all night with the camera. At first, I would just watch myself inside the box—inside the television set itself. It was so empowering. I remember Howard telling me to speak about what I knew, and that would be a great place to start. All I knew was my experience. I had come to Miami from Cuba and lived in the exile

community for ten years. It was quite suffocating. In that community, you were not allowed to talk about certain things. I didn't realize this at the time, but after arriving at the Art Institute, a lot of cultural baggage started coming out. It was a very intuitive kind of thing. I started to use my body and my image on the television as a way to bring this stuff out, and little by little, I started throwing caution to the wind and did anything I could think of. I recited poems by José Martí. I started singing "Guantanamera." I would bang rhythms, like conga beats, on my own body. I would take my clothes off and run around the room naked. I used cigars, maracas, things that were familiar as props. At the same time, I was very much influenced by what was going on with video and performance art in California, and with my own interest in popular culture and television. So my beginning in video was just getting in front of the camera and using it. It was just a recording device. I wasn't getting behind the camera yet.

Many of these early videos are now grouped together as a piece called *Solo Flight* (1977); could you describe some of the sections of the video? At the time, I never thought of the videos in terms of linking them together. That was an afterthought. It was like pages in a sketchbook—I would do one piece, then go on to the next one. We didn't have editing facilities yet, so it was more like stringing short pieces together, as disparate as they may be. One of my favorite ones is when I'm using the live closed-circuit system as a way to trace my own portrait by drawing on the live onscreen image. There's another one where I am shaving my pubic hair, trying to make a sort of T on the screen. I was trying to deal with the sort of humor that's so important in my culture, yet every time it would get lost in the translation. There was an abstraction that would come from jokes, and I started exploiting that in these pieces by using a language that the American viewer would not understand. There was one section about cutting off my very long—about an inch long—pinkie nail. I was looking at the way the first generation of video and performance artists in California treated the body, and then struggling with the sort of emotional, psychological, and even political content that I wanted to bring into my work. That long pinkie nail was like an extension of the body, and there

p. 150
Tony Labat, still from *Challenge: P.O.V.*, 1981. Single-channel video, color, sound; 30 min.

p. 151
Tony Labat, stills from *Solo Flight*, 1977. Single channel-video, black-and-white, sound; 32 min. LBMA/GRI (2006.M.7).

was a sculptural aspect to it—the maintenance of it, to care for it and see how long it could get. Then, of course, you had the cocaine reference to Miami, to the sort of Cuban image that people weren't quite familiar with here in San Francisco. So that's another example of a sort of abstraction that had a subtext. It brought a cultural reference into the minimalist, very formal kind of work that was influencing me at the time.

What sort of reaction did you get from your teachers and other students when you showed this work to them? I was pretty much just working with Howard Fried, and he would just give me the keys to the video studio and leave me alone. As a matter of fact, the sculpture department banned me from the sculptural area. I couldn't even check out a hammer. The head of the sculpture department told me, "Well, you're working with video," and literally banned me from the sculpture department—which backfired, because you start wearing that as a sort of badge. You're on the right track if you're pissing all these people off, you know. But the New Genres department wasn't established yet, so I was forced to take regular classes like painting and sculpture, and then I would show this kind of work. There was always silence. I remember the less they said, the more I felt that I was doing something right. They literally had nothing to say about it, particularly when I went on *The Gong Show* in 1978. When I played *The Gong Show* performance in the seminar, there was just this silence, which I loved.

Tell me about *The Gong Show* piece. By 1978, people were gravitating toward Howard Fried and Studio 9. Karen Finley was a student with me, and we immediately bonded. There was the beginning of a sort of community and clique, and, of course, anyone in Studio 9 working with Howard was literally on the other side of the tracks. It wasn't a school; it wasn't anything like that. It was a space. You would look forward to going into Studio 9—so much was going on in that place. We're also talking about the height of the punk scene in San Francisco. So there was a lot of catharsis, transgressive behavior, a lot of razor blades, a lot of things going on in that room.

We started seeing parallels between *The Gong Show* and Studio 9. *The Gong Show* represented this sort of anti-talent for us, and at the same time, so many contestants wanted to be accepted by the judges and the scoring. That was one aspect of my interest in *The Gong Show*—and, of course, I wanted to be on television—real television. I thought it was a genius, brilliant, amazing show, and it was in color. I couldn't get access to color cameras. I remember sitting around with another student, Bruce Pollack, and saying, "Let's go on *The Gong Show*," and it just started like that. We were interested in infiltrating and subverting a context without any kind of announcement. The audience wouldn't know in advance that this was art. So I called and they accepted us. The first audition was in a dirty warehouse, and there was one guy with a camera who said, "Okay boys, do your thing." We did a very abstract, punk sort of dance; Bruce would beat himself up, and I would break pencils and throw them at him. It was totally stupid, but we passed, and went on to two more auditions. We didn't rehearse these things, and by the time we got to the actual taping, we didn't care anymore. The first time was the best. We had so much energy when we did it at the dirty warehouse. Then we got to the taping, and one thing I remember is how much these people were rehearsing. It was kind of sad. They wanted the validation, whereas we knew that our project wouldn't be successful *unless* we got gonged, to sort of rub against that idea of talent and validation.

So we did the show, and I remember the judges were "Juicy" Jaye P. Morgan, the guy from *M.A.S.H.* [Jamie Farr], and another one I forget. The most interesting thing was that after we fin-

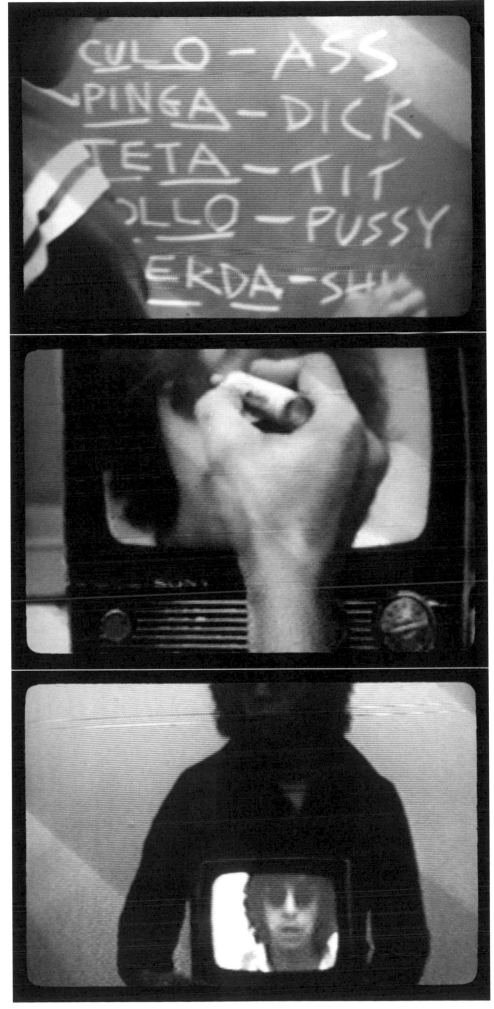

Tell me about the *Fight* performance [*Fight: A Practical Romance* (1981)]. The *Fight* project started with me receiving a very formal letter in the mail from a sculptor, Tom Chapman, who had gone through the Art Institute about the same time as me. This was in the days of the alternative spaces, the artist-run spaces. I remember having talks about how those spaces had become too established, and we started asking "alternative to what?" Then we started going to Mabuhay Gardens, and doing our performances and videos more in after-hours clubs and punk clubs that were popping up in San Francisco. It was amazing. But on the other side of it, to someone like Tom Chapman, I guess those projects weren't pure in terms of sculpture, and he was accusing me—my generation, people like Karen Finley—of theatricality. What we were doing was maybe contaminating art. We were searching for a contemporary version of what ritual was and what performance was, and I think that we found it in the clubs; I found it in *The Gong Show*, and I would find it out in the streets and in popular culture. So there was something in the letter about theatricality and illusion versus the real, and I guess I represented a kind of theatricality.

There was a challenge in the letter, and the challenge was to become licensed professional boxers and have a match. I have to confess, at first I was really annoyed by it, but then I couldn't get away from thinking about it. I started thinking maybe there's something here that I can not only subvert but that I can take away from him. I can take it in my direction; I can make it my work. I knew that this was the kind of work that would bring television cameras and newspapers into my studio. So I accepted, and, to make a long story short, I realized that I would have to get in shape. I was totally out of shape, but I didn't want to go to a gym and do it, and I felt that since an artist works in his studio, then my activity would remain there. So I literally turned my studio into a functional gym with a ring and punching bags. I even put a sign outside the door, "Terminal Gym," and it had functioning hours. People started coming—real boxers started coming and hanging out in my studio and training. There were two women boxers. At the time, women were not allowed to train at the gym here in San Francisco. They were in the middle of a lawsuit with them, so I invited them, and these two women would come over to my studio—my gym—and train there. This went on for almost a year; it was sort of a social sculpture hangout place.

Once the press releases for the fight were sent out, there were television cameras and newspapers in my studio almost on a weekly basis. Writers from the human interest section started coming around the studio. The sports section writers started coming around the studio, and art section writers started coming around the studio. The human interest section was interested in why a thirty-year-old artist would become a professional boxer. Was there a grudge between me and this other person? So I started liking this idea of the grudge, and I felt that I would exploit that, and start appropriating the trash-talking. Of course, the more obnoxious I got, the more they started coming to my studio, and they stopped going to his studio. The media would just love it. The more of an asshole I was, the more they wanted. Of course, the sportswriter was interested in craft. That was my favorite part, because I was also very interested in stepping into these unknowns and learning a craft, in that sense, as opposed to talent. So the sports guys asked me, "Can you throw a jab, can you do a right hook, do you have defense?" And, of course, the art section would come to talk about the body and the canvas of the ring, and the abstractions; they would look at the blood on the canvas in my ring like a Jackson Pollock.

ished our piece, Chuck Barris turned to me and whispered, "You guys shouldn't have gotten so political," and I thought, "This guy really knows and understands what's going on here." So that was *The Gong Show*. The most interesting part is how Chuck introduces us, the comments that he makes after our piece, and how he bookended us between two other dance acts. The first one were these tight disco girls, maybe fourteen years old, and then after that it was a ballet couple—two twelve-year-olds. I thought that was pretty nice. We walked away with a lot of Johnson & Johnson products and Sea Breeze, and I kept getting products for about eight months after that, and we got paid close to $2,000 in 1978. We couldn't believe that we walked away with a color tape, we were on television, and we got paid.

Did you get gonged? Oh, of course. Did I get gonged? As a matter of fact, we were the only ones that got gonged on that particular show. There were a ridiculous number of contestants rated "ten" on that episode—everyone was getting tens. But there was one guy who was better than us, and we were so jealous. This guy came on with a little ukulele and played a horrible song. But what was brilliant was that you had a guaranteed forty-five seconds to do your thing before they would gong you. This guy stopped before the forty-five seconds were over, and they didn't know what to do with him. He did about twenty seconds, and then he just stopped and stood there, so he avoided the gong. He got a one and a two, because they had to score him. But yes, we were gonged. It was very important to get gonged. In *Fight* [1981], people ask me, "Did you win?" In that project, it's not important whether I won or lost; but in *The Gong Show*, I find it very important that we got gonged.

Eventually, the night of the fight came. It had to be an entire evening, because California would only sanction something like twenty-six rounds; it was around eight fights. It was at Kezar Pavilion, and I was not announced as an artist or anything like that; I was just there with the other boxers. The two women boxers fought that evening, and on top of that, I got Carol Doda—who was the first silicone-implanted topless dancer—to be the round girl, the one that carries the numbers. The artist Joel Glassman, who was transforming his body through bodybuilding as a sculptural project, was the one that opened the ropes for Carol Doda. The Units, who were this electronic synthesizer punk band, came to do the national anthem. They were all in polyester outfits and fake mustaches. There were over one thousand people at the fight, and there were cameras everywhere. The boxing crowd was looking around like, "What's the big deal?" They never got that kind of attention at a local boxing evening night. And then they see all these punks and other types coming in, and they don't get that. Then they see the art world coming in—the collectors and well-dressed people. That was my favorite part, just to look out into the audience to see people just kind of looking at each other, checking things out. You know, why is there a punk band doing the national anthem at a local boxing match?

Yes, I won the fight, and then afterward, I remember the postfight blues, the emptiness. When I took the gym down and my studio became a studio again, I was lost for about six months. I didn't really realize how much that project had hooked me. I made a video that was produced at the Long Beach Museum of Art [*Challenge: P.O.V.* (1981)]. In the video, I sort of acquired the role of the commentator or the television anchor, and I gave my side of the process and the story of that work.

What about trying to kidnap Lowell Darling [*Kidnap Attempt* (1978)]? *Gong Show, Fight, Kidnap.* I'm really glad to talk about those pieces. One led to the other in a way. They had a lot of similar concerns about media infiltration. Lowell Darling, the artist, was running for governor of California in 1978. I think it's important to mention that Jello Biafra from the Dead Kennedys was running for mayor of San Francisco in 1978. I grew up with strong political beliefs, and I really dug what Jello Biafra was attempting to do. Like the *Fight*, it wasn't so much an issue of winning or losing. The idea of an artist really seriously attempting to influence politics was something that I believed in. But I saw Lowell Darling as a clown. He wanted to acupuncture California to fix the earthquakes. He carried around a fake hand on a stick because he didn't want to touch people—so of course, he was getting press. Just like the more I acted like Mohammad Ali, trash-talking, the more media attention I got. But at the same time, there was something about his project that honestly bothered me—speaking of theater—which is ironic, in terms of the *Fight*. I was accused of theatricality in that project, but the kinds of things Lowell was doing was theater of the jester. I was looking for a kind of realism, which is again, ironic. But in thinking about this sort of realism—this kind of street theater—I started getting obsessed with it, and just like *The Gong Show* and *Fight*, I needed to enter into a persona that would do the research. I wanted to do it right, so I started sort of stalking him, checking out his schedules, finding out where he was going to be. I heard that he was going to do a $1,000-per-plate dinner benefit, so I staked it out.

I knew that for this piece, what was important was to walk away with a photograph. I saw the bushes where the photographer could be, and I asked [artist] Mike Osterhout to help me. We got fake guns, I appropriated the whole Sandinista bandana gear, and on we went. The funny part about this whole piece was that as a rookie terrorist,

I had a Chevy Vega. I don't know if you remember those cars. It was a two-door car. Now I know that I should've gotten a van with a sliding door, but I had a two-door Vega, and I wasn't thinking about that. I got all my details right except that one. So we're struggling with him, we're wrestling, we're trying to get him, and then I open the door and I'm trying to find the little switch to push the seat forward [Laughter]. So it was a failed kidnap attempt, and we just took off. But what I loved about that piece, there was a moment when Lowell and I were looking at each other, and this moment of disbelief: is this real or not? That's the part that I remember the most. Maybe first I thought it was a performance piece, and then it got real. The punching got real, the wrestling got real. I felt bad that we left him with a broken lip and his presentation on the sidewalk. He published a book called *One Hand Shaking* [1980], and he talks about going home that night and not sleeping, and looking over his shoulder wherever he went from that moment on, sort of like I ruined the party. He talks about the real aspects of it. He felt like a politician for the first time. He hired bodyguards from that day on. He also tries to mock it, in terms of the bumbling criminals that don't know how to kidnap, but to me it was very profound the way he talks about it. One of the first publications that I sent that photograph to was *High Performance* magazine, and it was under "Red and the Mechanic."[1] No name. Two years later, I met Lowell at a social event, and I told him that it was me who had done it. He looked at me, he paused, and he said, "I don't know whether to hug you or to punch you," and then he hugged me. And that's sort of the end of that story.

NOTE
1. "Red and the Mechanic," *High Performance* 1, no. 3 (1978): 34.

p. 152
Tony Labat, still from *The Gong Show*, 1978. Performance on broadcast television, color, sound; 30 min.

p. 153
Tony Labat, *Kidnap Attempt*, 1978. Performance/intervention in San Francisco, California. Black-and-white photograph 20.3 × 25.4 cm (8 × 10 in.).

SUZANNE LACY

Born 1945, Wasco, California
Lives in Los Angeles, California, and works in Los Angeles
and Santa Monica, California

A PIONEER IN COMMUNITY-BASED, INTERACTIVE PUBLIC ART, Suzanne Lacy has consistently used her work to engage political discourse and activate social change. She was a graduate student in psychology, with a background in zoology and an interest in medicine, when she began taking classes in the nascent Feminist Art Program founded by Judy Chicago at Fresno State University. In 1971, Lacy moved with the program to the California Institute of the Arts (CalArts), where she enrolled in the Women's Design Program run by Sheila de Bretteville. While there, she experimented with performance art in classes taught by Chicago, de Bretteville, and Allan Kaprow, among others.

Throughout her career, Lacy has remained committed to collaboration while maintaining her own personal vision. Grassroots community organizing represents a significant component of her work as she unites diverse individuals to address a range of social issues through large-scale performance. Her collaborations in the 1970s with Leslie Labowitz, such as *Three Weeks in May* (1977), involved political lobbying and media campaigns as they exposed hidden themes of violence against women in mainstream culture. In the 1980s, Lacy organized vast collaborations focused on aging, of which the most elaborate was *The Crystal Quilt* (1985–87), a three-year project in Minnesota culminating in a performance with more than four hundred women over the age of sixty. Video can be seen as a natural extension of Lacy's performance work. With video documentation, she controls the representation and distribution of her necessarily ephemeral installation and performance pieces, some of which are staged for the camera. While enabling her to reach a broad audience, video also allows a degree of intimacy unattainable through large-scale public performance. In *Learn Where the Meat Comes From* (1976), she performs a parody of television cooking shows that collapses the roles of consumer and consumed as she transforms from helpful chef to helpless meat to grotesque carnivorous monster. While fondling a splayed lamb carcass, Lacy instructs the viewer in the proper terminology for cuts of meat by pointing them out on her own body. She then wrestles the carcass onto the floor, growling through her suddenly elongated fangs. Lacy's performance suggests both cannibalism and sexual violence as the animal carcass assumes metaphoric significance with visceral impact.

Andra Darlington

Interview conducted by Glenn Phillips on March 9, 2007, at Suzanne Lacy's studio in Santa Monica, California

GP: You were in graduate school at CalArts during a great time in that school's history.

SUZANNE LACY: It was quite a heady time to be there. My undergraduate degree was in zoology and chemistry, and then I'd gone to graduate school at Fresno State University and was working on a master's in psychology. I met Judy Chicago, and it was really through studying with her for a year that I made a career diversion and went off to the design program at CalArts. I was Sheila de Bretteville's teaching assistant in her Women's Design Program. I studied performance with Judy Chicago, and at the same time I worked with Allan Kaprow, who was the other major influence on me. Judy got me into the arts in the first place, and Allan set me on the course of the conceptual performative work that I do today. Judy would have had me be a painter, I think.

What was Kaprow's teaching style? What was it like being in a class with him? Allan's teaching style was the same as his personal style. He had a respectful demeanor, and would approach students as equals. On the other hand, here was this great man who knew the importance of his own ideas, and I think he had some ambivalence about the fact that he wasn't recognized in the same way as his peers. As a teacher, he was slightly formal, but very accessible. He was always interested in what you had to say. He was distanced in an intellectual way, but I guess I'm somewhat distanced in that way too, and I was comfortable with his style.

Judy was deeply engaging and almost psychodynamic in her approach. It's like going into an encounter group to have a class with Judy, and her interventions were transformative. Even though his style was different, Allan also encouraged experiential conversation in his classes. We were always seated in a circle, an idea he borrowed from feminist consciousness-raising groups. He was a very different artist from John Baldessari, who also taught at CalArts, and who had strong and continuing mentorship with his students. Many of Baldessari's students went off to New York, and Allan's seemed to become chiropractors and so on.

I found Allan to be a deeply supportive mentor. After he moved to University of California, San Diego [UCSD], he invited me to teach there, and he connected me with both performance and teaching opportunities. When I taught at UCSD, on his invitation, I met Moira Roth, Frantisek and Norma Jean Deak, Newton and Helen Harrison, Eleanor and David Antin—a group of artists, all quite different, but uniquely united in their sense of community. Martha Rosler and Alan Sekula were students there around that same time, and they were part of a network of practitioners, including the teacher Fred Lonidier, who represented a Marxist perspective. I identified a lot more with the San Diego crowd artistically than most of what was going on in L.A. at the time. I continued to look to Allan, and David and Eleanor Antin, for example, as my mentors. They all welcomed one into a community of intellectuals. For a working-class kid from Wasco, California, that was pretty great. Even now, sitting at David and Ellie Antin's kitchen table is sort of a "stereo Antin" experience. They talk enthusiastically and sometimes simultaneously, each of them in their own incredible way representing a kind of art and a gathering of minds that probably took place in the sixties in New York; but in my experience as a young artist in California, it was very unique.

CalArts was probably the first time that you got to use a video camera? Yes, it would have been.

Do you remember what you did? In the Women's Design Program we used studio-format video cameras. In our consciousness-raising groups we explored every body function, every emotional experience, every taboo, everything that we could. In the middle of a consciousness-raising group I was leading, we turned to the subject of menstruation and discovered this interesting phenomenon that when women work together their cycles synchronize. That led us to thinking about how we'd been educated on menstruation. Sheila De Bretteville suggested that we do an educational videotape on menstruation from young girls' perspectives, so we got a bunch of teenage girls together and did a three-camera shoot of them talking about their first menstruation experience. Later, we convened a group of older women to talk about menopause.

In 1971 and '72, women had easy access to Portapaks at CalArts, so we tended to use video as part of an exploration of our bodies and as part of performance. This type of investigation was also going on in Europe, as far as I can tell. Leslie Labowitz told me that in 1972 she and Ulrike Rosenbach were in Germany busily videotaping their cervixes as part of the "Oh my gosh, that's what our cervix looks like" self-help health movement. At that same time, I videotaped Laurel Klick shaving Susan Mogul's pubic hair in preparation for our performance called *Mother Venus* [1973], in the section on childbirth. (Susan complained vigorously, of course, as her hair grew out.) In those early days, you could flip on a Portapak and do whatever you wanted in the privacy of your own studio. It provided an instant access to body and other female experiences that was safe for us and gave us a way to display our bodies through performance.

On the one hand, there was the Los Angeles community. But of course, there's also the national and international community, and many of those artists were coming through Los Angeles, either just to do a performance or else to teach for a semester. Many of the artists here were also traveling for the same reason. Could you talk about that network, which really started developing strongly in Los Angeles in the 1970s? There were several feminisms that began to emerge in the late 1960s and 1970s. One of those was what I might call the "branded" feminist art movement. Judy Chicago was one of the key figures in that movement. It had to do with forming schools, programs, teaching methodologies, and exhibiting in museums for expanded audiences. It also had to do with scholarship on women artists of the past and

p. 154
Suzanne Lacy, *Learn Where the Meat Comes From*, 1976. Photo series from the single-channel video (color, sound; 14 min.; LBMA/GRI [2006.M.7]). Photo by Raul Vega.

p. 155
Suzanne Lacy, untitled photo collage from *Anatomy Lessons* series, 1974. Photo collage, 17.8 × 25.4 cm (7 × 10 in.).

inquiring about the critical practices that affected our notions of greatness in women artists. That was the feminism represented by *Ms.* magazine, the official organ of the women's movement in the United States—what people first understood as "feminist" art.

When I started teaching performance art at the Woman's Building, I explored women's performance art around the world. Many of us participated in an international conversation that went on over the course of twenty or thirty years, only parts of which are now being recast as feminism. For some of us, we were political feminists, and we saw this as feminist activity, whether acknowledged or not. But of course, others were not so identified.

series of photos also called *Learn Where the Meat Comes From,* of me as Julia Child doing a cooking lesson and demonstrating on a lamb carcass. The video went through three segments where I'm speaking with my normal teeth, with false teeth, and finally with vampire teeth, and all of those transformations were metaphors of physical bodies. This piece was neither about vegetarianism nor necessarily about the female body, but the human body. I used three texts, one from Adele Davis, one from Jack La Lanne, and one from Julia Child. Julia Child's hysterical cookbook sequence where she tries to teach you how to identify the parts of a lamb by comparing it with one's own body was recreated in the video.

There was also emerging a kind of woman's perspective representing the female experience of the body. Many of these women were cognizant of the impact of their gender on their careers, but they were not particularly political; many, like Hannah Wilke, did not consider themselves feminists nor did they participate in the feminist art movement, although their work benefited by it and contributed to it. This approach coincided with the rise of performance and other forms of body art. This conversation also included men, people like Paul McCarthy, Kim Jones, and Richard Newton. Here in California, we knew these guys and understood their enactment of masculinity through their art. The discourse was very rich around differences and power, but it was not an isolated and exclusive discourse between women as it's been historically framed. It was an open conversation, like "Richard, why did you dress up like a woman?" And Richard would say, "Hell, I have a right to do that, don't I?" There would be a lot of conversation, and then we'd all go off and have beers or something. Chris Burden, Barbara Smith, Nancy Buchanan, and Susan Mogul were some of the artists that emerged in L.A. around the same time that artists like Ulrike Rosenbach, Marta Minujín, Nil Yalter, Katerina Severding, and Valie Export emerged in other parts of the world.

Almost all of that large group of artists you just mentioned would use video or film to document their performances. What led you to make a video solely as a tape? I didn't use video to capture or document any of my early performances. For that, I used photography. Capturing time-based work didn't seem to be all that important for me early on, not part of the ethos of impermanence. If Jerri Allyn and Annette Hunt, who formed the Los Angeles Women's Video Center at the Woman's Building around 1976, had not documented *In Mourning and In Rage* [1977], we would have no time-based record of that performance.

I did make a transition into making single-channel video in a piece called *Learn Where the Meat Comes From* [1976]. I was invited by David Ross to do something for the *Southland Video Anthology* [exhibition] at the Long Beach Museum of Art. They gave me money and we hired Hildegard Duane to direct it. I had done a

It began as a cooking lesson, which transformed into this kind of slow-witted character attempting to relate the lamb carcass to her body. That was about being in this shared, pathetic, tragic condition of physical bodies, mute flesh. Then, transforming again, Jack La Lanne somehow gets in there, talking about working body parts, and building and taking care of your body, and describing a somewhat desperate attempt to preserve the body. And then finally the tape transforms into this vampire character that preys on the poor carcass, a metaphor perhaps for death or decay—or violence.

That piece, as you mentioned, was a sort of parody of television, or it began that way. Well, yes, but the parody of television cooking lessons was only relevant as a vehicle, not as any real attempt to critique television itself. That form of intervention did become a major part of my work during the last half of the seventies, and has continued as an extension of my performances since then.

In 1977, I created *Three Weeks in May,* an installation of large maps of L.A. in the mall near City Hall. Television and local newspapers closely followed this performance, spread over three weeks and involving over thirty different venues and activities. Media coverage was both necessary for the political goals of the project, but was also strategized as an element in the performance itself, with reporters as often-unwitting performers. That interventionist approach was complemented by the work of Leslie Labowitz, who collaborated with me on a series of performances, notably on *In Mourning and In Rage.* Violence against women was a very important topic for me. A female body operated in public space very differently than a male body, having to do with her sexuality and physical vulnerability. And that, of course, led to the issue of rape.

Ten women were raped and killed by the Hillside Strangler. Leslie and I were having coffee one morning and looking at the media coverage of the Strangler, which, by then, was a two-month series of killings that was terrorizing women in the town. Our reaction wasn't so much "Look at these incidents of violence"—of course, that was horrifying—but "Look at the way these murders are covered, and the message that is projected to women who are reading this." Women across Los Angeles, according to media

reports, were freaked out. They were literally buying out the door locks in hardware stores and carrying kitchen knives in their purses. Men had taken it up, oddly enough, as a joke. There were songs about it. There were men who would stand with you in the elevator and say, "I could be the Strangler, you know." That morning in early December, Leslie and I said, "Well, I don't know what we can do about the Strangler, but we can definitely do something about this media coverage." Over the next two weeks, we planned an event that has become an icon for this type of activist performance.

We analyzed the coverage on television and in print—the sight lines, the phraseologies, and the pornographic descriptions created in your mind by "the nude spread-eagled body of a woman lying strewn on the side of the road." That phrase was repeated over and over again, with a photograph of a bunch of police officers looking off to the side of the road. We looked at the news media and how many shots they gave to each two-minute and four-minute news story, and we created a performance that would fit neatly into their categories.

On December 13, 1977, we staged the performance for the media on the steps of City Hall. We found ten 6-foot-tall women, and when we put high headdresses and heels on them they were over 7 feet tall. We figured that each would appear to reporters to represent one of the women who were killed by the Strangler. That was a hook for the media. Reporters covered the deaths through the lens of long-established mythologies—generally that the women were sex workers of some kind, and the killer was probably a man with a promiscuous or abusive mother. Reporters had no evidence for these speculations. We wanted to challenge these myths, and talk instead about the forms of violence against women and how they interconnected to become part of a public culture of violence.

We sent out press releases saying feminists were converging on City Hall during the weekly city council meeting. Well, of course, every camera in town arrived waiting to see the riot they hoped would happen. I was working with the ten actresses at the Woman's Building, and another fifty or sixty women in black were going to be the background chorus for the event. Leslie was at City Hall handing out press kits and keeping reporters guessing. We formed a funeral procession and circled City Hall. One at a time, these ten women got out of the hearse—the last one was dressed in red—and they stood in a line for the cameras. We wanted ten women, because we knew the media would want to say, "Here's the first woman. She's here for Yolanda Washington, the prostitute who was the first victim of the Hillside Strangler. Here's the second woman. She's here for—" and so on. The chorus of women sat on the steps of City Hall, and we unfurled a banner that read, "In memory of our sisters, women fight back." Everything was designed to fit into a television screen and was visually compelling, so the whole thing got phenomenal coverage.

During the performance, the first of the ten women said, "I am here for the ten women who have been killed in L.A., victims of the Hillside Strangler." On the side of the hill, the women performers yelled, "In memory of our sisters, we fight back," and since the banner's there, there's no way to misinterpret the aggression in the message. The next woman was there for the 400 women also murdered in the past year in L.A.; approximately 390 women we didn't know anything about that were also victims of violence; the next was for women abused in their homes; the next for incest survivors; and on and on until, finally, the last woman, representing women fighting back. Our critique was that media coverage did not discuss how implicated media itself was in the scenarios of violence. We succeeded in subverting media conventions and the myths used to tell sex-violent stories.

To make more of an impact, we brought in a host of activists and local politicians—council people who left their meeting to make an appearance—not previously seen as aligned politically. Several reporters were dispatched after the event to investigate our charges. For example, an activist pointed out they had been trying to get rape hotline numbers listed in the emergency yellow pages but the local phone company had been refusing. "That's not really an emergency," the companies said. Right after the performance, one of the reporters followed up with a company representative, who stated for the cameras, "We're going to put those numbers in the yellow pages right away." So lots of things happened from that performance.

I'm sure you thought of this when you were making the piece, but it must have been very strange to think that you were making an artwork about the Hillside Strangler that he would probably see. It was, but it was known to anyone who worked on rape hotlines or in domestic violence shelters that they were targets as a result of their advocacy. We think he probably did see it, because the next victim was killed that night, after the six P.M. news had broadcast our event on every station. My name was blasted all over everything. Leslie and I went off to Wasco the next day to practice shooting.

We're sitting in the middle of one of your newest artworks, which is also a collaboration with Leslie Labowitz, and it prominently features video. This piece is called *The Performing Archive: Restricted Access* [2007], and it has to do with this interest in the 1970s that seems to be coming from your generation. We've asked twelve young women artists who were born during the seventies, or thereabouts, to rifle through our archives with little white gloves, find things that interest them, and tell us why on video camera. This wall of labeled boxes contains Leslie's and my archives from 1970 to 1980. In between these boxes, we've stuck twelve video monitors, one for each of the young women we interviewed. The young women are thus embodied in the midst of these archives, and they're reinterpreting this history from their own point of view. Their longing for mentorship comes across, along with other interesting themes. I think they were surprised to see this texture of history. What has reached them of this era is quite distilled and limited. So much took place in performance, and little of the original work is left. So much of it has become codified through criticism.

In the center of the room, there's a video projection that shows the young artists' hands and eyes as they go through the boxes. On the other side of the room are Leslie's mural from *In Mourning and In Rage* and her performance during the same era, *Record Companies Drag Their Feet* [1977]. We've also displayed some of the archival documents that the young women selected.

For me, the strength of this piece is these young women and their ideas, both touching and compelling. I remember having dinner with members of the L.A. Art Girls collective, and they were all brightly assuring me that they didn't just work collectively; they each have their own artwork. Jerri Allyn and Cheri Gaulke (who were both present) and I looked at each other and thought, "Is this somehow different, why are they telling us this?" On reflection, it seemed they might be trying to carve an identity within a collectivity. It struck me that we had perhaps more confidence back then, because we had a huge movement behind us. We had a lot of women role models, and we had colleagues interested in the same mission, all over the world. We were confident in our position as feminists; we knew we had justice on our side. I think today's younger women artists are navigating a territory without this kind of backup or certainty, and whatever new territories they face, I regret that they might not experience that solidarity.

p. 156
Suzanne Lacy and Leslie Labowitz, photographs documenting *In Mourning and In Rage*, 1977. Media performance at City Hall in Los Angeles. Photos by Maria Karras.

EUAN MACDONALD

Born 1965, Edinburgh, Scotland
Lives and works in Los Angeles, California

TO WATCH EUAN MACDONALD'S VIDEOS is to witness the transformation of ordinary moments into extraordinary experiences or experiments. Focusing his camera on a familiar object or everyday event in culture or nature, Macdonald isolates minidramas that are usually short, contained, and straightforward in their wit. These temporal sequences, staged or unplanned, are shot using a single video camera and framed as if something may occur that will make the effort worthwhile—which is precisely what compels the viewer to watch in eager anticipation. Macdonald's themes of duration, trial, indeterminacy, simplicity, memory, and chance are evident in his video *Eclipse* (2000), where an abandoned soccer ball is adrift in a large puddle on the ground that catches the sun's reflection. The ball bobs ever so slowly, eventually blocking the glinting sun and thereby simulating an eclipse. It is a moment of synchronicity with a touch of irony in its subtle, symbolic occurrence.

Another happenstance is captured in *SCLPTR* (2003), a clever juxtaposition of meditation and acceleration. While driving on the highway, Macdonald spotted an unusual sight—a large sculpture of a smiling Buddha Maravijaya being transported in the flatbed of a truck in the adjacent lane. Following it with his camera, Macdonald speeds up to pass, revealing the truck's customized California license plate, "SCLPTR 1" (which gives the video its title). These once rare and treasured sculptures are now mass-produced to enhance the feng shui of the suburban garden. Loaded with its own mythos, the Buddha Maravijaya is the supreme incarnation of the tempter who reigns over the world of Desire. The impulse to keep up in an ever-faster-moving world, and the need to acquire all of the proliferating technologies that will help temporarily achieve the task, is not lost on the smiling fifteenth-century deity. Recorded events like this drive-by Buddha are often revisited by Macdonald in other media, such as drawings, sculpture, and photographs. Through these additional representations, Macdonald continues to reveal social and pictorial uncertainties contained in familiar images and situations.

Carole Ann Klonarides

p. 158
Euan Macdonald, still from *Three Trucks*, 2000. Single-channel video, color, sound; 2 min.

p. 159
Euan Macdonald, stills from *SCLPTR*, 2003. Single-channel video, color, sound; 1 min., 43 sec.

pp. 160–61
Above: Euan Macdonald, still from
Healer, 2006. Single-channel video,
color, sound; 1 min.
Right: *Healer* presented in Times
Square, New York, July 19–
September 30, 2006, as part of
Creative Time's initiative "The 59th
Minute: Video Art on the NBC
Astrovision by Panasonic."

CYNTHIA MAUGHAN

Born 1949, Bell, California
Lives and works in Los Angeles, California

A THIRD-GENERATION ANGELENO, Cynthia Maughan grew up on the periphery of Hollywood, while absorbing and delighting in the movie industry's more marginal productions. In her three-hundred-plus videos from the early 1970s on, Maughan dryly rifles through the formulaic look of monster movies, sci-fi, horror, melodrama, Western, noir, and B-grade cult flicks to texture her pithy storytelling. Situating herself as actor and narrator of short, contained videos, Maughan delivers cautionary tales, folk songs, social histories, and simple actions with a contemptuous, comic, and, at times, woeful voice. In *Coffin from Toothpicks* (circa 1975), Maughan plays a sick young woman, explaining how she passed time in the hospital by fashioning a tiny coffin and mummy out of toothpicks. In *Browning Automatic* (1978), she sits in front of the camera holding bandages against her head while her off-camera, prerecorded voice tells about the invention of the machine rifle and her maternal relation to the Browning family. In other works, Maughan herself is absent, letting small objects or found images perform her ideas. *If the Sun Landed in My Corral* (1976) demonstrates a short anecdote with horse-like creatures made from sticks and a ball of tinfoil. *California Volume 16: A Big 9 Inches* (1987) juxtaposes an image of a lace doily with a ruler, while a Beach Boys song plays.

Although Maughan emphasizes video imagery, her frank and poetic titles often describe exactly what happens in each work, while building on its meaning or punch line. For example, *I Tell Three Cats about Jail* (1977–78), *Taking Medicine with Gloves On* (circa 1975), and *Two Sticks Mourning at Another Stick's Funeral* (1973–74) depict exactly those things. Yet such videos remain unpredictably deadpan through unexpected situational twists and Maughan's straightforward delivery. She expresses a distinctive feminist attitude that, unlike the dominant feminist discourse of the 1970s, is not overly didactic or moralizing. In *The Way Underpants Really Are* (circa 1975), Maughan subverts the sexualization of a woman's body through an altogether comic glimpse at her "reality"; she pulls up her white sundress to reveal an oversized, holey pair of panties that are safety-pinned together. *Scar/Makeup* (1973–74) takes on a sinister or violent tone as a young disfigured woman dolefully embellishes her appearance. In this manner, Maughan addresses both difficult taboos and lighthearted themes ranging from suicide, nineteenth-century disease, and domestic violence to midcentury kitsch, pop music, Christianity, lost civilizations, pulp fiction, and American folktales.

Catherine Taft

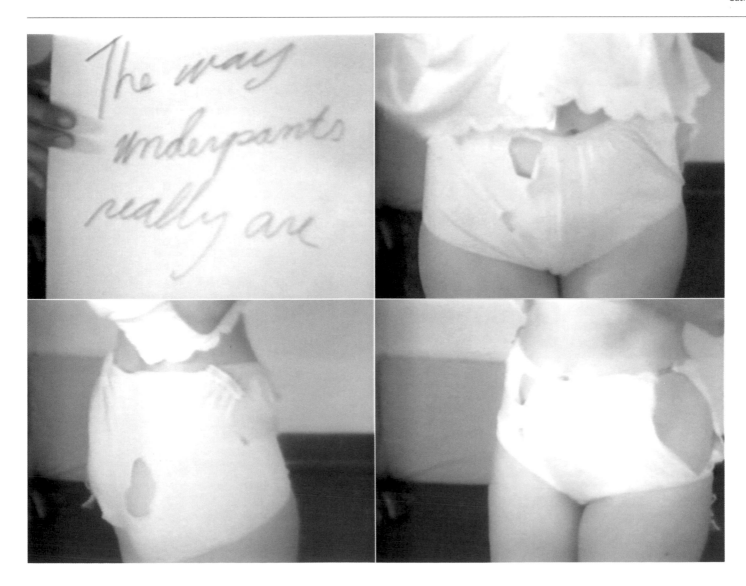

Interview conducted by Glenn Phillips on April 19, 2007, at Cynthia Maughan's home in Los Angeles, California

GP: Do you remember the first time you saw a piece of video art by another artist?

CYNTHIA MAUGHAN: Yeah. When I was in graduate school at Cal State Long Beach, all the more traditional teachers went on sabbatical and they got a bunch of young guys to fill in, and one of them was William Wegman. I think he got his video camera while he was in Long Beach. I never had a class with him and didn't know him, but he showed his videos on campus, and that's the first time I saw "art" video. *Pocketbook Man* [1970–71] is the one I distinctly remember seeing.

That's the one where he throws the purses across the room. I remember it being something like, "Mom, the purse man's here." Then he walks into the scene and he's got purses draped up and down his arms and legs.

Did you have a video camera at that point? No. I vaguely recollect that shortly before Wegman left Long Beach, he sold his camera to the guy I was then married to. Actually, the two of us bought it, but I wasn't involved in the purchase, so I couldn't say for sure. At the time it didn't seem that important.

But there's a good chance that your first videos were made with William Wegman's old camera? Yeah, there's a possibility. [Laughter] I have no way of confirming that, but it came from someone there, and I think he was the only one with a camera.

Was that in 1973? It was 1973. My first burst of making video evolved into my master's thesis, which I finished in 1974.

What was the thesis project? Do you remember what you did? I was doing a lot of tapes about death then. [Laughter] I had one room that suggested a mortuary. There was something that might have been a coffin, draped in white, and there were white flowers. There was a monitor in this room and one in a more gallery-like space. I think one of the tapes I showed involved a big, old trunk. The lid was slightly ajar, and things "magically" emerged from the dark opening. One of the things to snake toward the camera was a very thick rope, which I remember thinking was somehow sinister and threatening. In one, I was made up to look like I had been dead for a while. Lots of stuff about death and suicide.

After you graduated, you kept making videos at a pretty quick rate. You were producing a lot of very short videos. What was your process like then? How often were you working? After I graduated, I moved to Pasadena, where we had the entire third floor of the building on the corner of Raymond and Union. I'd plan all during the week and then tape Sunday morning, because it was quieter—little or no traffic.

How many tapes could you usually make on a Sunday? It varied. I can't remember my record, but one or two, three, depending on what I had set up. I was editing in-camera, so sometimes it would take a little while to get it right.

You said that you would normally spend the week planning the pieces out. Could you talk about that process? I got ideas from various sources—from books or magazines, movies, TV, dreams, occasionally the ideas or images were just there in my head. Sometimes it was enough to write them down, and sometimes I made

little sketches. I didn't do a lot of elaborate sketches. I would sketch or write ideas on file cards, or in little notebooks or sketch diaries, and I had files of clippings from books, magazines, and newspapers. I also had a kind of archive of objects. I spent time at thrift stores, secondhand stores, and swap meets, looking for props. And making props took time.

I would prepare dialogue beforehand, but I usually worked out the visual details in front of the camera, and I always had a monitor set up so I could see what I was doing, what it would actually

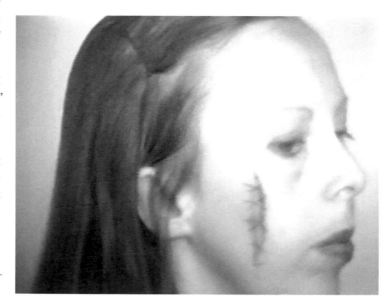

look like on screen. Most of the time, I had a very clear image in my mind of what I wanted to do, but getting there wasn't always easy. I did like the sort of technical aspects of working things out, but sometimes I couldn't get the "special effects" to look the way I wanted them to look, and sometimes the mistakes or compromises were better than what I originally had in mind.

Where were you showing your early tapes? I showed work to friends who came by the studio, and then I met David Ross when he was putting together the first *Southland Video Anthology* exhibition. The Long Beach Museum of Art was just starting to show video. Bruce Nauman had a studio around the corner in Pasadena. As I remember it, David was at Bruce's studio and wanted to show his videos, but Bruce wasn't interested. So he sent him around the corner to my studio, and that's how I met David and came to be included in the *Southland Video Anthology*. Everything else sort of followed from there. But you know, it's funny—I don't think Bruce had, at that point, seen any of my tapes. I think he just knew I made them and was kind enough to mention it to David. There were a lot of artists living and working in that part of Pasadena. Paul and Karen McCarthy lived down the block, upstairs in a building on the corner of Raymond and Holly. Nancy Adams and Richard Sedivy lived on the ground floor of the same building. Peter Plagens and Richard Jackson had studios a few blocks away. A painter named Ron Linden lived next door, on the second floor. People sort of congregated there.

You were also included in *Documenta* in 1977, right? Yeah, yeah, I was! I didn't go, but my work was there. And I got letters from Germany, one even asking for my autograph. [Laughter]

Let me ask you about some specific tapes. I'm looking at a list of all of your tapes and there are over three hundred of them [see p. 14]. I haven't seen all of these, but I'm just going to ask you

p. 162
Cynthia Maughan, stills from *The Way Underpants Really Are*, circa 1975. Single-channel video, black-and-white, sound; 1 min., 11 sec.

p. 163
Cynthia Maughan, still from *Hat with a Veil*, circa 1975. Single-channel video, black-and-white, sound; 3 min., 5 sec. LBMA/GRI (2006.M.7).

about some of them, based on their titles. One of my favorites is *Coffin from Toothpicks* [circa 1975]. **A woman is showing a little coffin and it's actually pretty well constructed.** I remember that one. I think she's in a mental hospital. She's describing this coffin she made from toothpicks.

My favorite part is that she then opens up the coffin and there's a mummy inside. Is there really a little skeleton made out of toothpicks inside the mummy, like she says in the video? No. [Laughter]

An early one is *My Lips Depart While Sleeping* [1973–74]. Do you remember that one? Oh yeah. I cut really fine muslin to fit my lips and kind of stuck it to my mouth with lipstick, then I put another layer of lipstick over the muslin, so it just sort of looked like I was wearing lipstick. And then there was an invisible string, and at some point, they just kind of flew off. [Laughter] It had to do with the soul departing. Some of the titles are probably better than the actual tapes. Titles are important to me, the words are important.

What about *Scar/Scarf* [1973–74]? That's the one where I had the scar here [points to neck], and just covered it with a scarf, tried to adjust the scarf to cover it. I was kind of fascinated by the way things looked on screen. You could make stuff look real. It looked ridiculous in person, but then in black-and-white it looked just like a scar.

You're trying on all these different scarves to cover it up, and then there's a man's voice off camera saying, "Hurry up," or something like that. And then you just say, "I'm trying to find a scarf to hide my scar," and that's the way the tape ends. Were you thinking specifically about beauty or these rituals that women have to go through? Probably, and mocking them, like it being important for women not to be disfigured, [Laughter] and I was probably thinking about the element of discomfort that it would cause; the visual impact. Maybe I wanted the viewer to be unsure about how seriously to take it: Is this some tragedy? Are you supposed to laugh? I've always been interested in things that evoke discomfort or strong emotion. As a kid, I loved monster movies, horror films, and I still do, though lately real life has been horrific enough.

A lot of these works that deal with death, suicide, or morbid themes, they're also really funny. But I don't think it just ends there—you're also making comments. For example, you made a piece called *Two Sticks Mourning at Another Stick's Funeral* [1973–74]. I meant this one to be both touching and ridiculous. It was supposed to look like a little grave. There are two sticks next to the grave and a cross made of the same sticks or twigs. There's the sound of rustling leaves, which is the sound of the sticks crying, and then one just falls over and it ends. I remember feeling pity for the little sticks. I also liked the sound of the title. A lot of my early work has to do with death and funeral stuff. I even wrote my thesis about it, about remembering accompanying my grandmother to the mortuary where she worked as the office manager. I was five or six years old. To get to the bathroom, you had to walk down what seemed to be a very long and dimly lit hallway. I knew there was something creepy about the place and wouldn't go by myself. My grandmother, tired of having to accompany me—and wanting to allay my fear—showed me a dead, old woman. The woman was in some sort of white, wicker casket with her face made-up. My grandmother told me the woman was sleeping, in heaven, nothing to be afraid of, something of the sort. I distinctly remember knowing this wasn't the case, and I certainly knew the woman was not alive and that there was something terribly wrong and macabre about it—or whatever the five-year-old equivalent of this would

be. These themes became a continuing interest; not death itself, but the practices and trappings and beliefs that accompany it, the strange horror movie stuff, the romanticizing and sentimentalizing of suicide.

Taking Medicine with Gloves On [circa 1975]. **This is a striking image. Wearing gloves and taking pills really seems Victorian to me. A lot of your pieces seem to go back to this sort of lacy Victorian aesthetic, but are also very gothic at the same time.** Yeah. When I was in graduate school, I had a business selling vintage clothing, which was a lot easier to get your hands on then. I had a collection of gloves from the late nineteenth century and from the twenties, thirties, forties—gauntlets and lace gloves. I thought they were visually interesting, and they videotaped well. I was usually doing things that you wouldn't do with gloves on. I've always been interested in history, and really interested in the nineteenth century. I read a lot of nineteenth-century fiction as a child.

One of the things that I think makes your work really complicated is that you have feminist concerns going through it, but the work's never just about that. It always has another point as well, which is a very nuanced way of working. It's interesting, the other avenues that, as a feminist, an artist can take. Thanks. My political point of view would have been an important factor, maybe even central to some pieces, but the visual aspects and the entertainment factor—entertaining for me—was also a primary interest. I consider myself a radical feminist, but I've kind of been a cynical observer. I remember being this way even as a child. I doubt, in the long run, that humans are really capable of changing things for the better. Basically we're just chimps in pants, [Laughter] greedy and aggressive. I admire people who work for change, but everyone has a different idea about what would be a change for the best. I guess I'm kind of a lazy, nonviolent anarchist. Anyone who wants power shouldn't be allowed to have it. Maybe that's why political concerns sometimes seem tainted with irony when they appear in my work.

I'm looking at a title now that I've never seen. It's called *Bleeding from the Place between Your Legs* [1976]. I did a few that involved drinking blood, spilling blood, blood staining my clothes. That's the piece that ends with me standing up to reveal a big bloodstain on the back of my white pants.

There's another one that you did called *An Illustrated Story* [circa 1975], where you just have a big pad of paper and you're drawing; you're illustrating the story as you tell it, and it's a scene of a man being violent toward a woman, and she gets her revenge by killing him. That becomes another theme that pops up in some of your works. Yeah, I've never been the victim of violence, but I went through a period of reading a lot of true crime, stuff about bizarre murders, mothers who killed their children, serial killers. It was kind of fascinating and appalling. I did choose some things for the shock value, because I was shocked. I guess it was that those were very dramatic themes and very disturbing themes, and there was the political aspect of there being more of that kind of violence against women.

Well, this was also the era of the Hillside Strangler. I think he worked in Glendale.

Did anyone ever take your work the wrong way? Did you ever have cases where you were showing the work and someone was offended? I think, especially early on, people would have hesitated to comment or they would not have known what to say—not

just about my work but about a lot of what was going on. It wasn't being broadcast into people's living rooms, so the audience was rather small and select.

At one time I was up for a young talent award at LACMA [Los Angeles County Museum of Art]. I showed a tape having to do with suicide [*Suicide* (1973–74)]. The screen is white, then a razor blade falls into what you realize is a sink full of water. It floats to the bottom, then there is a spurt of blood—blood spilling into the water—and you can hear a woman breathing, then the breathing becomes

end, the ridiculousness of it overwhelmed my attempt to make something "darker," and this was okay.

And by this point, you have a bit of a punk aesthetic. Even in the way you were dressed and your haircut. You were playing in a band, right? Yeah, I played in a variety of bands over the years. Auto De Fé and the Nihils were more punk. Then there was Primitive State, which was more of an art band. We played places like Madame Wong's in Chinatown [Los Angeles]. At one show, I had a

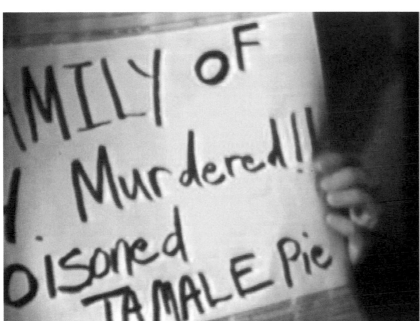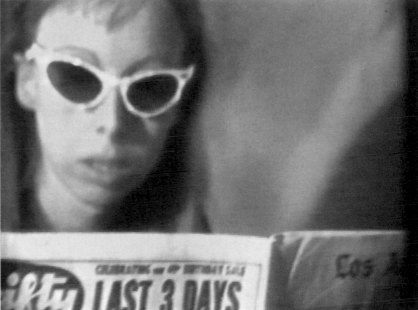

more labored. The people screening or judging my work weren't curators; I don't know if they were volunteers, but they were all nicely dressed older women. After screening the tape, the women conferred, then one of them came out and put an arm around my shoulder and said, "You know, we're really concerned about you," and asked if I needed help. And I thought, "I'm not going to get this young talent award." [Laughter]

You should have just started crying. I didn't think of that.

Probably my absolute favorite of yours is *Tamale Pie* [1978], which is so funny. I think that in a lot of ways, video helped make it okay for humor to be in art again. There are different periods in history where humor seems to surface in serious art. Yeah, I agree. I think that piece was based on something I read, though I could have made it up. I have a newspaper and I manufactured a headline to read, "Family of 4 Murdered!! Poisoned Tamale Pie." I actually found a recipe and started reading the ingredients as if each item were suspect. Tamale pie is kind of a strange dish. As a child, I remember reading women's magazines and being both fascinated and aware of the absurdity of the weird, strangely bastardized recipes—"quick and easy dishes from around the world involving ground beef."

***Calcium Pills* [1978] is another one of my favorites. You're taking all these pills, one by one, and there's a voice-over that says, "Are those calcium pills, or what?" over and over again.** They were actually calcium pills, but I thought there'd be a question about whether or not they were "drugs," which is what I meant to imply. But then after I looked at it, I was like, "They just look like calcium pills! This is embarrassing, what's the point?" Then I thought "Well, visually it's not too bad, so I'll just leave it." In the

video monitor on one side of the stage and a barbecue on the other. There was a rubber roast spinning around on a motorized spit on the barbecue and a video image of the spinning roast on the monitor.

The last official, organized band was called the Shrews. I guess you could call it punk, we did fairly awful covers and wrote original songs about our friends and enemies, and our day-to-day lives. The Shrews played at the Anti-Club [Los Angeles] and we played a "Rock against Coat Hangers" benefit for the National Abortion Rights Action League, things like that. That was the least serious and most fun of my band endeavors. I had been the only woman in the other bands, the Shrews were five women and one gay man, much more fun.

You've saved a lot of props from your videos. Is that because you think of them as artworks, or just to keep them for archival reasons? Some of them I would've thought of as artworks, the things I made. But I was also just kind of archiving stuff, as sort of reminders or mementos. But I did think of some of them as these little art projects in and of themselves.

You're so prolific and you've made so many tapes. You have fifty-five hours of tape that haven't even been transferred. Did you ever record over things that you didn't like? I did tape over stuff as I was working on it; that is, I might start a piece over if I wasn't happy with what I was seeing on the monitor. But I would resolve it or live with it, so literally, at the end of the day, I would save everything I recorded. I have some later work that I made with this big color cassette camera, and I actually saved most of that, too. It's not stuff I'd show, but I have it.

Good. That's what you're supposed to do.

p. 165
Cynthia Maughan, stills from *Tamale Pie*, 1978. Single-channel video, color, sound; 1 min., 52 sec. LBMA/GRI (2006.M.7).

JAY MCCAFFERTY

Born 1948, San Pedro, California
Lives and works in San Pedro, California

JAY MCCAFFERTY'S WORK reflects an intimate approach to recording time. McCafferty developed a unique understanding of the effects of sunlight exposure while working as a lifeguard at Southern California beaches. For over thirty years, McCafferty has been creating artworks by methodically burning patterns of holes into sheets of paper by concentrating the sun's rays with a large magnifying glass. The process of playing with fire often results in the paper spontaneously combusting before a handful of sand can extinguish the flames. Some later works are almost completely consumed, leaving only disconnected scraps hemmed with ashes.

A California native, McCafferty presented the inaugural video exhibition at the Long Beach Museum of Art in 1974, a solo exhibition that comprised a suite of dryly humorous and poetic single-channel videos. At this point, McCafferty had barely begun his video *Self Portrait, Every Year* (1972–ongoing), a work that now encompasses thirty-five years of daily grooming compiled into a moving self-portrait that traces the artist through time. The video is composed of dozens of short clips of McCafferty shaving around his mustache while looking at his reflection in a lifetime of mirrors. In each segment, the artist ritualistically states the phrase, "When I shave, I use this mirror." The audio track records not only his voice but also the echo of the room, the radio, or the street noise in the background, and the dribble of the water in the sink. This condensation of time becomes an accelerated tour through more than a generation of hairstyles—from the twenty-four-year-old wooly bedhead to a sparser comb-over as the artist approaches sixty. Reflected behind him is a record of the most private area of the homes he has occupied. Video technology also evolves during this life span; from black-and-white to color, from manual focus to badly behaved auto focus, finally zooming to a crisp resolution with tricky digital fonts on the timestamp.

As in his works on paper, the effects of concentrated exposure to the sun can be seen on McCafferty's face and hair. By 2007, his whiskers, which have faithfully survived the ages, have been bleached to a static salt and pepper. His ascending forehead is creased with worry lines; hollowed cheeks have squared off his jaw. Most strikingly of all, the video records changes in the artist's voice that are a typical, although rarely captured, process of aging. Conflating *vanitas* and vanity, *Self Portrait, Every Year* is an intensely personal *memento mori,* which, through persistence, transforms banal repetition into profound poignancy.

Bill Wheelock

Interview conducted by Glenn Phillips on March 30, 2007, at Jay McCafferty's home in San Pedro, California

GP: You have the distinction of being the very first artist to exhibit videos at the Long Beach Museum of Art.
JAY MCCAFFERTY: Yes.

How did you get your first chance to use a camera? I purchased a Portapak in my second year of graduate school at UC [University of California] Irvine, and I just started playing and making videotapes.

What were some of the earliest things that you did? Mostly just capturing things that caught my eye. The ability to capture move-

ment in time interested me a lot, and it still does. I like the idea of capturing moments, which makes it apparent to me that "right now" is what I pay attention to. The idea of putting a bunch of "right nows" together was fascinating.

One of your earliest videos was *Late For Work* [1972]. Could you describe what you do in that video? Well, I was late for work, and I wanted to do a piece before I went to work. I was a lifeguard; I don't remember if I was wearing my uniform or not, but probably not. They were tearing buildings down in my neighborhood, so I took a piece of paper and attached it to the wall of one of those buildings; then I went to another one of the buildings and attached two pieces of paper. This went through a sequence, as though the papers were going up the wall in a column, but it was going up several walls. Then I had to reverse myself and literally go back and take the paper down. Today, making a piece like that would be silly because you could do it all with editing equipment and not have to go through all that stuff. By the end of the piece I was climbing up a ladder. I remember it being Buster Keaton–like. It was sort of funny.

So you did the editing in-camera? Yeah, it was in-camera.

You had a good camera then, because it wasn't jumpy. Right. And I think I got to work on time or really close to it.

Well, that also explains why you were running. Yeah. [Laughter]

So the walls were pretty close to each other then? Yeah, it was a whole area that they were going to tear down. It was a redevelopment situation, but it stayed in limbo for years, and they were great to look at. In fact, Gordon Matta-Clark came down and was maybe going to cut one in half, but he didn't find anything that he actually wanted. David Ross brought him down and looked around

pp. 166–67
Jay McCafferty, stills from *Self-Portrait, Every Year*, 1972–ongoing. Single-channel video, color and black-and-white, sound; running times variable. LBMA/GRI (2006.M.7).

the area. I liked the textures and all the stuff hanging around that was there.

What about Square [1974]? *Square* was formalizing something that, again, was part of my life. I walked-off a square, and the four sides of the square were representing all the houses that I had lived in. The first one was where I was born and lived until I was ten. So I walked one side of the square there, and then cut to my second house, which was kind of like a tenement house that we lived in when my parents sold their house to build a business. And then the third house was my parents' house. When the business was successful, they got to build a nice house that we lived in—I lived in that house for one year before I left. And the last one was in the apartment I was living in when I made the tape.

Most artists who started working with video were really just fascinated with the immediacy—the fact that you could watch it while you're making it, and then watch it again immediately after you've made it. But you started on this direction that was really thinking about both the past and the future. *Square* focuses on time, from your birth to the present, but then with works like *Autobiography* [1972–ongoing] and *Self Portrait, Every Year* [1972–ongoing], you began projects that continued for years. I think that an ongoing key, or something that I focus on, is my belief that time is right now, even though we can have it go one way or the other. You can't deny that the sun comes up and all that, but I'm convinced it's just because we can't perceive that it's right now and in the future and in the past. So my work focuses on the present. Even in the paintings that I've made, that's primarily the goal. Each dot in my paintings is a document of me concentrating on that particular moment. So the video tool was just a focusing device. The problem is that people start looking at the object or the form that I've made, and they pay more attention to that than the philosophical part. With the paintings, nobody ever asks, "What does *that* dot mean?" It's just a record.

The *Every Year* piece, where I'm shaving, started out as a good idea like *Square* and the other videotapes, but it's grown into a very interesting thing, because when you look back at it, the technology is really old and I'm really young. Now the technology is getting a lot better and I'm getting older; so that's going on, and a million other little things. People, when they watch it, are looking for anything. Especially in the beginning, they say, "Oh God, I've got thirty-four of these to look at." But it goes by fast, because it's only a few minutes long. For me, it's a meditation. And when I look at the still print that I made from the video, it's really interesting to see my whole life as one unit, with past and present going back and forth on each other. So there's all kinds of reasons why I've liked it, and I thought it was a good piece, but I've been doing it in obscurity because the video world is—I really don't even know that much about it anymore. I don't know how you continue with a video career, because I realized early on that my dealers weren't interested in it at all. I'd show my dealers a tape and they'd say, "Get that stuff out of here." So my career has been based as a painter.

Well, let's go back to *Every Year* for a minute. Describe what you do in the video, and tell me a little more about how the idea first came to you. Every man has to stand in front of the mirror and shave. I like to shave. I know a lot of people don't like to do it, but I like to do it. So it was a story line that was believable. What I say in the video is "When I shave, I use this mirror," and then it cuts and goes to the next year. It's funny because I try to do it with the objectivity that I have when I shave. And there's sort of a self-consciousness—you know, a "what happened last night" kind of

thing in the mirror. Rembrandt painted himself, I think, around eighty times. I thought it would be interesting to use a new technology, trying to describe an artist's life.

Right around the same time, you started *Autobiography*. Right.

It's an interesting companion to *Every Year*; instead of using a mirror, you're having other people describe you. I had a new piece of equipment, and people didn't know what it was. So I put it in their face and ask them, "What do you think of Jay McCafferty?" And they'd give me an answer, and the answer was usually more about them than me, which is obvious because nobody can know you as you are. They know you from the context of where you're meeting them and how you've interacted. In the context, it was usually pretty fresh, and I'd get really candid things out of the subjects. As the piece got well known, and the subjects knew they were going to be used as art objects, then things changed, and that's one of the primary reasons why I stopped doing it. But I may start again, because my life's changed a lot since then. It's funny, the people I knew in high school knew me a certain way, and the people in college knew me a certain way, and the people in grammar school knew me in a certain way—I live in the town where I was born, so I can run into people that I knew in high school and grammar school. So I had all those reactions. It was funny because one thing I did get out of it is that they usually say I'm a nice guy, which is fun.

My favorite part is right at the beginning, and it relates to your observation that the type of answers people give are usually more about themselves. Well, this one guy, that's all he talks about. He talks about how awesome he is. He's standing in front of his Corvette, flexing, and he says, "I've got the tan line and I've got the 'leg of lamb.'" He was a lifeguard colleague of mine.

When you started *Autobiography*, did you know that it was going to be an ongoing project or did you just keep at it? I thought it would be an ongoing project, and the thing that bothered me, as I said, is that it got to be too public, and people knew they were going to be part of an artwork, so their comments became way different. It wasn't as pure as it was when I first started it, whereas the shaving piece is so private that I don't have to worry about what I'm going to say or anyone else.

Well, people in general also became more comfortable and familiar with video cameras. You know, it was a really strange and new thing to be on camera in the 1970s. Right. Yeah, like you were showing me, you can make a movie with your telephone now. It's turned into something that didn't have the same meaning that it had then. It's kind of nice being able to record everything. Now I can carry my camera in my palm. I shot you guys when you came to the door and nobody even cares, but when you brought the Portapak out, it's like the guy with the spacesuit on.

By 1974, you'd started a series with a title that I really love, because I think it describes a lot of early video, and that's *Apartment Art*. It's a series of very short and clever pieces. I was living in an apartment and didn't have a studio. I had one wall and a table that I used to make things. And I just looked around the apartment—in the refrigerator, in the sink—just doing things that you could make a video of that were of little significance. Almost like northern European painting, where they took nonsacred objects and made them kind of holy by making a story out of them. So it was a bit of that, but in a video telling a story of the simple things, and hopefully it made them sacred.

Let's talk about a couple of the individual *Apartment Art* pieces. I think *Shoe Boat* [1974] is a great place to start. Okay. Those were regulation lifeguard shoes at the time, and I was interested in the idea of a shoe going into the sink—like the surrealistic idea of an umbrella on an operating table. I liked the idea of taking this boat shoe and just dropping it into the sink with the water running to create this surrealistic yet stupid and funny image. I like art where you don't know if it's smart or the dumbest thing you've ever seen in your life. That's why I think Bruce Nauman is a great artist, because his work always has that edge. You don't know whether you should feel sorry for the guy's stupidity, or if he's the brightest person you've ever met in your life. It sort of has that quality to it. And I think that piece in particular is the dumbest thing in the world.

And a lot of them are really short. My favorite, which is called *Test*, is probably about five seconds long. It's an image that I remember people doing, my mom or somebody. They would have an iron, and they would just barely touch it to see if it was hot, and they called it a "test." There was something visually beautiful about the iron just up close. It's a very short piece, but visually interesting, I think.

What about *Sugar?* I like to show that things move from one thing to the next—there's a metamorphosis, and all I did was do a close-up of a sugar cube in a spoon. I think I dipped it in some water, and it just melts. It metamorphosed into something that, visually, is much different from the solid cube, not unlike a metaphor for life.

Oh—see, I figured you must have heated the spoon. No, there's water in there and the sugar just melts.

And what about *Tabasco Vs. Ketchup?* It was a race. Even to this day, they can't figure that one out. I guess they have squeeze bottles now, but the idea was that one was quicker than the other. I just set up a little race between these two kind of similar objects that you see everywhere.

At a certain point, you started focusing a lot more on your painting work. Well, it was so direct, the idea of taking sunlight and putting it through a magnifying glass and through a piece of paper or whatever I'm burning; it makes a mark that's unexplainable. It's a device for me to literally focus my attention. You can't do it without being right there—if you are not conscious of what you're doing, it won't work. And I can't use any other device. People say, "Why don't you use a soldering iron?" It wouldn't work for me. It wouldn't capture my imagination. I would use a video camera tomorrow the same way by just pointing at things that are bouncing light off of them in a way that interests me. It reminds me of the spoon with the sugar in it. It's just light bouncing off this thing that's changing, and that interests me. My aunt gave me a magnifying glass that I still have in my studio. It went from tool drawer to tool drawer—you know how that goes. It came with a stamp collection, but I had no interest in the stamp collection. But this thing, I thought, was interesting and important. And I was working on a sculptural wall piece. It had a diameter about this big around [gestures] and I was putting any kind of material I could think of within that diameter. And I remember, at that same apartment, I walked out on the porch and I started burning a grid into that circle. I put it up on the wall, and literally everybody that walked into my studio went right over to it and said, "Wow, what is that? How did you do that?" And I don't care who you are, no matter what, people will say, "Are you still doing those burning pieces?" And I'd say, "No,

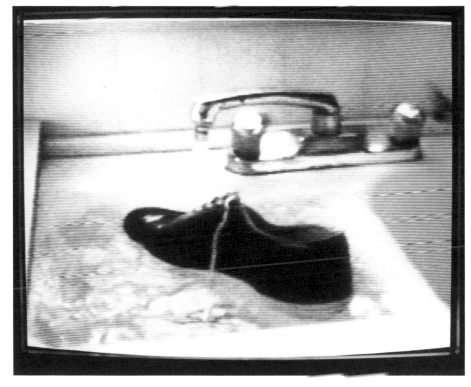

I'm doing this video. I've—" And they'd say, "Yeah, but—." So they certainly didn't want a videotape. But I don't mind it, and the nice thing about the work is it's predestined. There's a grid, which is, to me, man-made, and then there's—when I take the light and put it through the paper—an unknown, kind of more like freedom or God or something. So you have this dichotomy where the work has total free will, and then it doesn't have any free will at all. And I find that the audience gets that. They at least relax and don't say, "Oh, it's about a guy flexing his arm or a rock that's getting destroyed by water." It's looked at as a painting. And I identify with all the great painters, like Cézanne—even a work like *Square* was an homage to Cézanne, in the sense of taking a geometry and putting it in the center of a landscape, which is my house. I've still been making videotapes, but they're so private. It's little tidbits of my life, which I don't think anybody in the world would find that interesting. Of course, I didn't think anybody would find these early videos interesting either, but I'm sitting here talking about them, which is great.

p. 169 top
Jay McCafferty, still from *Autobiography*, 1972–ongoing. Single-channel video, color and black-and-white, sound; running times variable. LBMA/GRI (2006.M.7).

p. 169 bottom
Jay McCafferty, still from *Shoe Boat*, from the *Apartment Art* series, 1974. Single-channel video, black-and-white, sound; 1 min. LBMA/GRI (2006.M.7).

PAUL MCCARTHY

Born 1945, Salt Lake City, Utah
Lives and works in Los Angeles, California

FROM HIS EARLIEST ARTWORKS produced alone in his studio to his most recent productions, which utilize entire film crews, casts, and elaborate sets, Paul McCarthy has continued to link video, conceptualism, performance art, sculpture, and expressionistic painting as codependent and formally related media. Using his own body as central to his theatrical practice, McCarthy's videos and documented actions tap into an American unconscious that is at once political, scatological, violent, and sublime. Inventing outlandish characters or appropriating recognizable cultural icons—like Santa Claus, Disney's Pinocchio, Heidi of the Hills, and Rocky Balboa—the artist skillfully spins the ideology of images into absurdist narratives that question socialized behavior. *Experimental Dancer* (1975) is both an experiment with the body in space and a critique of notions of normality and masculinity.

McCarthy, wearing a grotesque rubber mask of an imbecilic male face, stands naked against a wood-paneled wall with his genitals tucked out of view between his legs. He bobs his body and flaps his arms to the muffled sounds he makes from behind the mask. Although McCarthy's unsettling movements parody the rigorous sensibilities of modern dance, his experimental dance becomes an earnest and raw form of humanistic expression. Whereas props, such as the rubber mask, punctuate the meaning behind McCarthy's actions, they also often assume significant characteristics of their own. The process-oriented video *Stomach of the Squirrel* (1973) is the first instance in which McCarthy uses common objects, like a broomstick, paint, and rope, as imaginary characters in a loose narrative. Seemingly alone in his studio, the artist imagines he is trapped inside a squirrel's stomach while moving through a series of actions that might occur therein—encountering gastrointestinal matter, breaking his leg and devising a splint, and attempting escape. In this early work, objects, rather than icons or personae, are the essential components of McCarthy's ritual-like sequence.

Catherine Taft

Interview conducted by Glenn Phillips on May 8, 2007, at Paul McCarthy's studio in Los Angeles, California

GP: Let's start by talking about how you wound up coming to Los Angeles.

PAUL MCCARTHY: We were in San Francisco in the late 1960s, and Vietnam was going on. I refused induction in 1969 in San Francisco and had to go back to my draft board, in Utah. At that point, we wanted to move to someplace out of San Francisco. San Francisco and Berkeley were too hip. We made trips to L.A., which seemed really interesting because it was so diverse and unpredictable—smog and sunshine. The draft board said that I didn't need to stay in Utah, and my case would be caught up in the courts for several years, so I applied to art and film schools and got accepted into the University of Southern California [USC] in 1970. I was making films in Utah and in San Francisco, and I was interested in experimental film, like those by Stan Brakhage, Bruce Conner, and Andy Warhol. I knew about Bruce Nauman's videotapes. I didn't actually see them until I came to L.A., but I had seen images of them in magazines.

In Utah—before I moved to San Francisco—I was painting with my hands. The paintings were laid flat on the ground. Then I would pour gas on them and light them on fire. This was in 1966. It wasn't a matter of being influenced by Yves Klein or Jackson Pollock. It was just a convenient way to paint—flat on the ground, paint with your hands, burn the painting. I wasn't aware of Klein burning paintings, and I didn't think of this process as a break in tradition. It wasn't done as a formal gesture. I painted with motor oil; it was black and cheap, and I mixed it with oil paint. The work developed through its own process. In the late sixties and early seventies, artists began to make video—making videotapes in the studio as artist and not as filmmaker with a script. Working with the camera as material. Using the architecture of the studio as material. I preferred to work in basements. I often began by making intuitive actions with the camera on a tripod and no one else in the room, doing something over and over again. I was interested in repetition as a way of developing the action, a way of discovering something.

Artists and filmmakers in the late sixties were talking about video. I was really interested in making videos, and had fooled around with it a little bit in Utah, but it was difficult to get your hands on the equipment. When I came to L.A., I was really on a mission to make videotapes. USC's film school wasn't interested in video at all. In fact, they saw making videos as inferior—not even worth talking about, not even as a preliminary medium. You wouldn't even use it as a learning device pre-film. And, of course, the art department wasn't interested in it either. I ended up making videos with a guy named John Baker, who was in charge of the media department in the dental school. We made tapes on several occasions in fall 1970.

Who would you show your tapes to? To other artists and students. In 1972, at my graduate show, I showed the *Red Poster Tapes*, in which I make a list of things I would do and then videotape myself doing them. I printed a red poster with the list and posted it at the school prior to doing the video. You could think of the list—the poster—as a script. Also in 1972, I was asked to show tapes in an art festival at USC. Allan Kaprow did a piece, as did Max Neuhaus, Captain Beefheart, and I think Morton Subotnick.

p. 170
Paul McCarthy, still from *Experimental Dancer Edit #1*, 1975. Single-channel video, color, sound; 4 min., 35 sec.

p. 171
Paul McCarthy, stills from *Ma Bell*, 1971. Single-channel video, black-and-white, sound; 7 min., 6 sec.

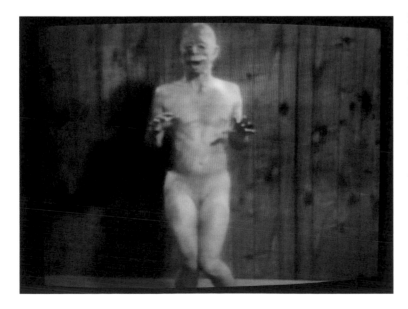

I showed *Stomach of the Squirrel* [1973] in a room on monitors on two opposing walls. Allan Kaprow saw the tape and he asked me to come to CalArts. I spent the remainder of that year making work and going to CalArts once or twice a week. My friend Mike Cram was also going to school there, so I had been hanging out at CalArts since 1971.

In 1972 and '73, I was working in a psychiatric hospital making videotapes of schizophrenic children. My draft case went to court, and I ended up being classified as a conscientious objector, so I had to report to a job. I worked as a volunteer at a nonprofit organization called Tie Line, which was an interesting group. They were connected to the *Whole Earth Catalog* and were interested in information networking; it was the first time I'd ever heard the term *networking*. They were trying to connect nonprofit organizations together across the United States to inform them of one another. The plan was to eventually put all of the information on the organizations on the computer—it was a view into the future. They also organized themselves so they could hire conscientious objectors, and when I went to work for them, they asked me what I wanted to do. I told them that I was interested in videotape and cable access. We got a grant to buy equipment. I taught videotaping to nonprofit community organizations, like free clinics, women's organizations, schools, etcetera.

At that time, I'm also making work as an artist. I'm actively going to CalArts, I'm teaching video courses at Tie Line, I'm still connected to John Baker and Mike Cram, and I'm involved in public access on cable television. Cable stations weren't required to provide public access, but as part of Tie Line, I organized the Public Access Project. We lobbied the cable station in Santa Monica to provide public access. That really grew and became quite large. People came from the East Coast who were part of public access and guerilla video in New York.

In 1973, I began working with gangs in Pico Union. The members in the gangs used the camera. I never videotaped. I was there to make sure the equipment worked. Our attitude was that the gang members should videotape what they wanted, and they would own the material. At the time, the Public Access Project and community video held a utopian, McLuhan vision of media. I was involved in public access, guerilla video, political video, and community video for three to four years. All during that time, I was making my own art tapes.

Could you describe some of those early tapes? The first tapes were made in the Broadway Building, which was a graduate studio for USC students. It was an empty, seven-story building on Broadway in downtown L.A. and had been the induction center during World War II and the Vietnam War. I was the only student using it. It was completely empty. The first tape that I remember making is holding my arms out and bouncing my back against the wall, while humming or singing. As soon as my body hit the wall, it affected my voice. It was really a spontaneous thing done sometime in fall 1970. I did it again and again, and finally made a tape that lasts for about ten minutes. There were tapes of running into walls. Later, I made the spinning tapes, where I try to spin longer and longer. There's another tape where I put cotton in between two swinging doors. When the doors opened and shut, they made a noise, so I taped cotton on both of the doors to quiet them, which also made an image reminiscent of a vagina. There's a piece where I slam a door over and over again. These kinds of pieces went on during the fall and winter of 1970–71. When I made *Ma Bell* [1971], there were a bunch of telephone books being stored in the building. I'd done these paintings where I'd covered the floor in paper and then poured puddles of used motor oil on the paper; so I had

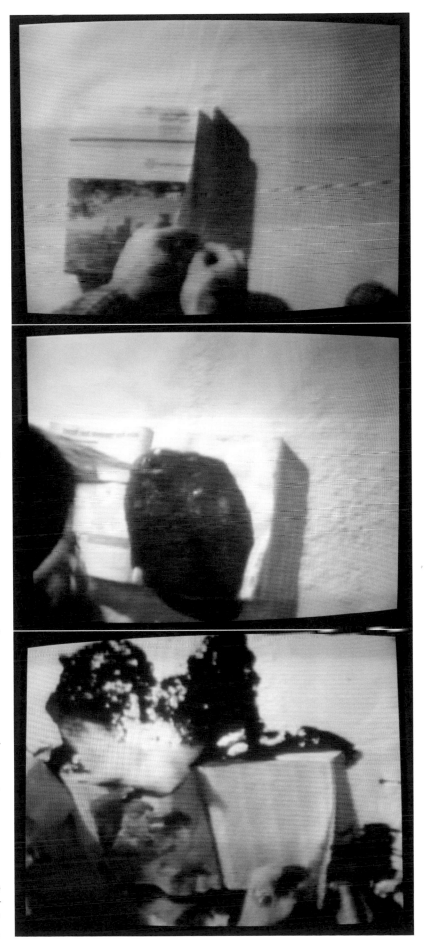

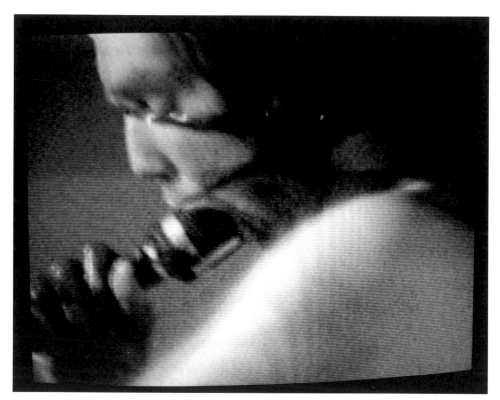

them were made in 1973, and each evolved one from the other. *The Couch* comes before *Stomach of the Squirrel*. I hauled a couch into the studio, and I tried to kick my way through the couch; I force my way through the back and bottom of it. The roof had leaked and there was all this water, which I dammed-up at one end of the studio to keep the space dry. It made about an eight- to twelve-inch pond in the studio. I created this landscape out of grass, dirt, weeds, and parts of trees. At one point, I went swimming in this muddy rainwater from the roof as if I am outside, a reference to Joseph Beuys's swimming in the bog. I don't think that my action was videotaped. There were weeds around the couch. I kicked my way through the couch, which was a difficult process. It was a birth sequence.

Stomach of the Squirrel was a much more extended piece than *The Gray Shirt* or *The Couch*. During *Stomach of the Squirrel*, I shoved a broom through my pocket, which punctured the pocket and went down the inside of my pant leg. I then took the videotape and wrapped my leg and the broom in it to make a splint. Then I wrap the tape around my head, tying myself up and making it difficult to move. The title becomes significant, because before that, the pieces done on Temple Street were always based on some object used in the action—a shirt, a dress, a couch. In this case, *Stomach of the Squirrel* was about the sense of being inside something that you can't get out of—a stomach. This feeling of being trapped related to my later piece *Bossy Burger* [1991]. You're in something and you can't get out of it—in *Stomach of the Squirrel*, you are trapped in a stomach of liquid, and in *Bossy Burger*, you are trapped in the hamburger stand, the architecture set for a television sitcom.

You were just talking about deciding to dive through this couch and kick through to the other side, and how you realized that was sort of like a birth. Were you thinking that these other works could be read in metaphorical ways as well? Or were you thinking about your own physical experience that you wanted to go through? Or the image that it would make? Or the relationship to the object? What was motivating you to interact with these objects? At that time, art was being made that was about the artist's experiences physically and mentally. Art and the concrete. It is not about something. It is something. But I thought pieces could be both concrete and a metaphor. In *Stomach of the Squirrel*, I tie myself up, making it difficult to move. I cannot walk. The situation is real—me with the materials. But when it was over, I thought of it as a person—a soldier or beggar—fantasy, play, hallucination. I think that *Stomach of the Squirrel* is very much about the empathy of struggle.

When did you first start performing live with people in the room with you? My first public performance was in 1967, where I destroy furniture on stage with a friend at the University of Utah: art and destruction. I did some other performances in class and for friends between 1967 and 1968. In 1969, at the San Francisco Art Institute, I buried my teacher at the beach in sand up to his head. I was interested in digging holes and destroying things in front of an audience, in setting up bleachers. I wanted to destroy a house with bleachers set up around it for the audience. When I was in school in 1965, there was a student, Bob Arentz, who said he was a concrete poet. He stole a steam shovel, drove it on campus, and dug a hole, and then tried to bury the steam shovel with its own scoop. That was the first time I had heard the term *concrete poetry*. One made an action or used real objects as poetry. That made sense to me. An action could be a work of art or poetry. This all happens prior to going to San Francisco and prior to my knowledge of Allan Kaprow. My first performance in an actual gallery was in 1974.

all this motor oil, and there were these telephone books, and I had the cotton from the doors. I told a friend to tape me without showing my head. I wasn't sure what I would do. I put a telephone book on the floor. I opened up the book, poured motor oil on it, and put cotton and flour on the pages. I began to make a hysterical laugh as I pour oil on the book. The book turns into this gooey, oil-soaked object, which I tie up and later throw out the window. I thought of it as a bird. It was a real change in my work. It signified another direction. Prior to that, all of these pieces were about a task or repetition, and then I make this one—a persona created from this laugh. It wasn't something I had planned. It was spontaneous and it involved these materials—oil, telephone books, cotton, flour, and a video camera.

Moving from *Ma Bell*, the pieces definitely start to exhibit what I'd call a fictional individuality. Why don't you describe *Stomach of the Squirrel* [1973], which has a more developed but abstract narrative. When I left the Broadway Building, I rented a studio in a dilapidated building on Temple Street. The roof had caved in, and water came in to the studio when it rained. There were no windows, so it was really like a dark cavern. I started making a series of tapes, which were always shot at night. One was called *The Gray Shirt*. One was called *The Dress*. Another one was called *The Couch*, and then the final one was *Stomach of the Squirrel*. All of

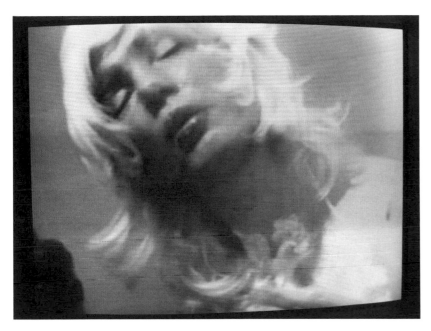

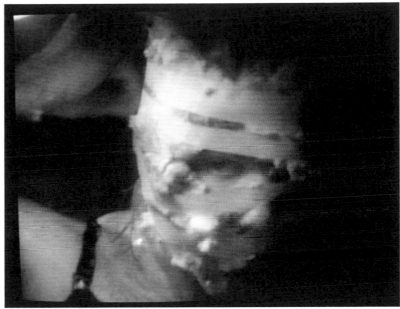

Which performance was that? It was called *Meat Cake* and it took place at Newspace Gallery. The gallery was two almost equal-size rooms, which were divided by a wall with a door at one end. I put a big, black plastic curtain in front of the wall, hiding the wall and the door. I installed two monitors on really high stands against one wall in the first room. The room was dark, and people could watch the monitors. Eventually, someone discovered that what was on the monitors was actually occurring live in the next room behind the curtain behind the wall. Then people began to go into the room where the performance was occurring. The cameraperson, Mike Cram, was a completely visible part of the action. *Sailor's Meat* and *Tubbing* were both videotaped in an old hotel in 1975. There was a bedroom door directly across the hall from the bathroom. I put the monitor on a chair just in front of the two doorways to the bedroom and bathroom, blocking the hall so viewers couldn't go down the hallway to look into the bedroom or the bathroom. There was a small audience who sat in the hallway and watched the monitor. The action, *Tubbing,* was occurring in the bathroom. Viewers couldn't see past the monitor and the cameraman, who was in the doorway blocking the view, but you were aware that the live action was right in the room. When *Tubbing* ended, I walked from one room to the other. Viewers saw me walk across the hallway. The cameraman follows me, and then *Sailor's Meat* happens in the bedroom. Again, the viewer could only see the action on the monitor.

Sailor's Meat and *Tubbing* were the final piece of what began with *Ma Bell*. They were connected to *Stomach of the Squirrel*, and then to *Meat Cake* and *Hot Dog*. *Stomach of the Squirrel* was preceded by the pieces with the dress and the shirt. In *Meat Cake*, the first thing that happened was covering my head, my face. I begin by packing hamburger and butter onto my face and head, wrapping it with some sort of tape creating a flesh substance over the face. Also in *Meat Cake*, I began to wear women's clothes—a male as a female. The viewer was aware that it is a male pretending to be a female. Hollywood is interesting to me, and one of the reasons I came to L.A. is because of Hollywood. I wanted to be close to the Hollywood film world, the Dream Factory. I thought at that time

that the next generation of art film would borrow and/or appropriate from the Hollywood industry. At one point, I was working as a camera assistant, and I worked on sets and on soundstages. There was a beer commercial where they wanted to have beer pouring into a glass in slow motion. The process to create the effect was so involved, it was extreme. The object created to produce the effect was sculpture. They fabricated a large four-foot-tall beer glass and shot beer-colored water into the glass with a high-pressured hose. There were lots of lights for the high-speed camera. The crew had their shirts off. A crazy image of a platform with a giant beer glass, a high-pressure hose, lights, a camera, and shirtless men—a sculpture. The soundstage can be disorienting. Or you're on a set and there's a house, and you go through the door—which is supposed to go into the living room—but you enter a partial room facing another set of the outside of a grocery store. You're standing inside but you're outside, all of which is inside a soundstage. These are dreamscapes. Disneyland and Hollywood as La La Land. Props and sets as fractured objects or environments, as sculpture. My own studio as a production studio as an artwork. I am interested in the equipment around filmmaking—like camera cranes, steady cams, or lighting—all as sculpture. By appropriating them as sculpture, they become a critique of culture. At the same time, I also became interested in Disneyland as sculpture and as Utopia, deconstructing Disneyland. I became interested in the manmade mound around Disneyland. They always have this hill, so when you're inside Disneyland, your view to the outside is blocked, or the view from the outside is blocked to the inside in Shangri-la. You're behind a mountain range. For myself, growing up in Utah, Salt Lake City sits in a valley. This valley is separated from the rest of the world. It's about Shangri-la as a controlled Utopia. I saw Disneyland in the same way. I was also interested in these characters that Disney created, thinking of Mickey Mouse as a perfect thing—like a perfect object, in every way refined. The dimensions of the foot, the dimensions of the fingers, they seemed absolutely perfect. So, on one side is Disneyland, and on the other side is Hollywood. L.A. as La La Land.

p. 172
Paul McCarthy, still from *Stomach of the Squirrel,* 1973. Single-channel video, black-and-white, sound; 59 min., 33 sec.

p. 173 left
Paul McCarthy, still from *Tubbing,* 1975. Video performance, color, sound; 26 min., 59 sec.

p. 173 right
Paul McCarthy, still from *Meat Cake #4*, 1974. Single-channel video, black-and-white, sound; 33 min., 49 sec.

BRANDA MILLER

Born 1952, Milwaukee, Wisconsin
Lives and works in Troy, New York

BRANDA MILLER'S VIDEOS confront technology, media, and political concerns with an acute social awareness. Negotiating transitory moments of human interaction and the frenzied structure of urban space, Miller composes careful studies that deftly move between cinematic genres—like documentary filmmaking, science fiction, film noir, and city symphony—to take on aesthetic and activist concerns like car culture, pollution, the public funding of art, and marketing tactics. In 1985, Miller began working with young people to produce a series of videos that investigated teen issues, including drug and alcohol abuse, body image, the dropout rate, and teen pregnancy. For *?What's Up?* (1987), Miller collaborated with nine young men from a Southern California juvenile detention facility. With access to video and editing technology, the young men created a thirty-three-minute portrait of their troubled backgrounds, emotions, future goals, and the pressures of contemporary masculinity.

In a more abstract composition, *L.A. Nickel* (1983), Miller dissects the happenings of a downtown Los Angeles street from a distanced but immersed perspective of surveillance. Shot in a twenty-four-hour period from the window of the artist's flat at Fifth and Wall streets (a Los Angeles skid row area nicknamed "the nickel"), the video documents the raw reality of life on the streets, then shifts to a lush, almost abstract sequence depicting a drive through those same streets at night. The video's striking soundtrack, composed by the Doo-Dooettes (Tom Recchion and Frederik Nilsen), features recordings picked up by "audio agents" who wandered through the urban landscape while wired with surveillance microphones.

Catherine Taft

Interview conducted by Carole Ann Klonarides on February 10, 2007, at the Shelburne Murray Hill Hotel in New York City

CAK: Why don't you tell us how you got to California from Milwaukee?
BRANDA MILLER: First I came to New York, and I attended NYU [New York University] Film School. I worked as a cocktail waitress at CBGB's in the heyday of the punk scene. In 1979, I came to Los Angeles to find a job. I became a cocktail waitress at a Chinese restaurant, Madame Wongs, which was a punk club at night, and I met a bunch of people who were at Otis [College of Art and Design]. Through that, I kind of connected to the whole media arts scene, and I started going to the Long Beach Museum of Art [LBMA]. I started getting jobs in Hollywood and going to Long Beach at night.

What was going on? Describe the two scenes—the downtown scene and then the Long Beach scene. In the day, I was working for Alice Cooper's *Welcome to My Nightmare* [TV special], and for everyone from Andy Williams to Crystal Gayle, Johnny Carson to Margaux Hemingway. Strange gigs, you know. Downtown was pretty hardcore. Artists were just starting to move there. My biggest memory of Long Beach is just the endless hours that I drove to get there. I think I probably went three times a week—there was so much happening there. It was really a community that helped build people as artists. I was especially excited to hang out at LBMA's Video Annex, and that was where I did my first work. I met Kathy Rae Huffman and did a lot of work with her, and that was great. At the same time, I started getting involved in LACE [Los Angeles Contemporary Exhibitions] when it was still on Broadway, and was happy to work with Joy Silverman. Kathy Rae and Joy were extremely influential in supporting and shaping the early media arts scene. I also received significant support from Peter Kirby and Video Transitions, as an interface between the margins of media and commercial post-production.

Tell me about some of the early video projects you worked on. Michel Foucault came to town in 1981, and a group of us who hung out together in Long Beach, including Jim Czarnecki, Patti Podesta, and Norman and Bruce Yonemoto, trapped him in a hotel room and interviewed him—which was really wild, because Foucault never got in front of the camera. He completely did not want to be shot. He spoke with Michel de Certeau and it was unbelievable.

And we shot Andy Warhol. That was another piece we did early on, Andy Warhol and LeRoy Neiman. They had an opening together, which was pretty crazy.

And what was the purpose of taping them? Was there a reason why you were videotaping these events? That's still a question I ask today, and it is a challenging question, because that is actually the difference between us as independent artists and as commercial, mainstream corporate media makers. I don't think we ever questioned why we were doing it other than just for the passion of it, to try to create new form, new language, new ideas. It was especially striking to me in terms of the difference between what we did at night, you know, off work as an artist, compared to working in Hollywood, where everything was really bottom line, and very clearly being done for a commercial purpose. We were really just doing it because it was a new art form that we were completely excited about.

The Foucault piece, which was made in 1981, was called *The Fifth Republic*, because he talked about television being the fifth republic. Obviously someone had to know that he was coming to town, and somebody had to start thinking, "What are we going to ask this guy?" Jim Czarnecki, who lived at Fifth and Wall with me, was very young at the time. Now he's the producer of several Michael Moore films. We got him to ask the questions, because he was very cute. It was all strategy: how to trap Michel Foucault on his hotel bed in his hotel room and get him to talk. The Rose Bowl was happening that weekend, so we started by just getting him to talk about his interest in those cute boys playing football, and through that, we got into a deep conversation about the media. And I remember he had a lot of really interesting insights; he talked about the power of the voice and the relationship between video and radio. That actually taught me a great deal. I thought a lot about the power of sound in the video medium. We were always kind of exchanging ideas about what the medium was, and what it could be other than the kind of corporate use I was applying in the day.

Did you see what you were doing as a kind of guerilla video? There was no doubt that I saw this as guerilla video, and I've always had a fascination with surveillance. When I moved to Fifth and Wall, I spent endless hours doing surveillance on the police below,

because the LAPD [Los Angeles Police Department] station was across the street. And so I would sit there. I had all kinds of devices to black out my windows, and I'd point the cameras down below and document the police abusing the people below and not taking care of the situation. I mean, there were drug deals right in front of them. And then I would also watch Hollywood come and use this area as a set. *Hill Street Blues* would come by, jump out of their van, use the street as a backdrop, and then leave, you know? So I was really thinking about how I could use video in a different way, a way that was more connected to the street, some kind of way that was off the radar. I explored lots of possibilities.

The other connection you had was to the music scene. I had some great collaborators. One of my favorite people I loved working with was Tom Recchion, and I worked with Tom and Frederik Nilsen of the Doo-Dooettes, and they actually did the soundtrack for *L.A. Nickel*. We had a great time working together. I hung out a lot with Black Randy and the Metro Squad. And there was Jeff Isaak. Jeff was really a creative force in *L.A. Nickel* and all the stuff

really a moment where my life and my art became one. We called it *L.A. Nickel* because people called that corner of Fifth and Wall "on the nickel." On the nickel was the lowest you could go. If you went on the nickel you could not fall lower. I don't know how it started exactly, but we decided that we would shoot that corner for twenty-four hours, and I invited anybody who wanted to participate to come. All my friends came, artists including Gary Wong, Nina Sobell, Ante Bozanich, Roberta Widrow, Mike Kelley, the Yonemotos, and lots of creative folks from downtown. They would take different periods of the day or night. They would either go and take a camera and shoot the corner, right where all this action happened, or they would get wired with audio surveillance gear, and we would call them "audio agents" and send them out onto the street. So in one day, we had twenty-four hours of videotape and twenty-four hours of audiotape.

Then I just gave the audiotape to Tom Recchion and the Doo-Dooettes and said, "Can you do something with this? Let's construct an entire soundtrack out of the live sound from the street." It was actually the beginning of me engaging in the notion of my

I did at that time. I mean, there was a scene, you know? That was definitely part of it. I didn't get a lot of sleep.

It was a crazy time and I guess we were trying to push the envelope, and yeah, I was very lucky. I mean the people who survived that scene were very lucky, because really quickly after that we all of a sudden heard about AIDS, and it was just right at the cusp of that time. But it was definitely a time where we were questioning the norm, so I had a very interesting life where I had two identities. And I remember when I got nominated for an Emmy for *Perry Como's Christmas in the Holy Land,* my mother called me and said, "You may not wear thrift store clothes to the Emmy's. You can't do it." Because we all wore insane clothes, and we hung out at thrift stores all the time. So my family bought me a dress to go to the Emmy's. I said, "Oh, this is all really silly, because it will never happen." And then *kaboom*, I won an Emmy. Quickly after that, I was making *L.A. Nickel*. It was all at the same time. It was a very creative time.

So how did *L.A. Nickel* actually get made? I shot *L.A. Nickel* in 1983 from our loft, where I lived with Jeff and Jim, in skid row. It was

power as a videographer with my camera, and the relationship of my camera to a gun, thinking about my lens and how it is shooting the subject, thinking about my relationship to my subject as an object, and trying to break the boundary of mainstream media's relationship between the camera and the subject as an object, trying to open it up. And yet it was a very dangerous spot there. It was a scary place. My apartment was on top of the Hard Rock Cafe, and this isn't the Hard Rock Cafe that everybody knows now. Do you remember the Hard Rock Cafe? It was insane. And actually, just once in my life, I went into the Hard Rock Cafe when I first moved there, and I will always remember walking in there. It was maybe 1981. All of a sudden everything stopped and froze, and they turned and looked at me. It was like, "Well, do you really think you should be standing here?" I'm like, "Okay, sorry," and I just left. We heard when we were shooting that somebody was trying to buy out the Hard Rock Cafe's name. It was happening right around then, some international company. I do not know how many Hard Rock Cafes there are now, but they bought the name shortly after I left there. And then, of course, they forced them to close their bar because they did not want to be associated with a bar like that. This was a

p. 175
Branda Miller, stills from *L.A. Nickel*, 1983. Single-channel video, color, sound; 10 min., 35 sec. LBMA/GRI (2006.M.7).

hardcore skid row bar—which also says something about our culture, our corporate culture, taking from probably one of the most raw-edge, intense, off-the-grid places, and then anesthetizing it and making it into pop culture, so that everybody can feel that they are living on the wild side when they go and have a burger and a drink at the Hard Rock.

But I lived right upstairs, right above that space. When I went on the street, I had disguises. I had long overcoats and big boots. I drove a cream-colored Cutlass Supreme so the police would think I looked really conventional. The way in which I wanted to break that relationship between subject and object was still in a very naive place, because there was actually an amazing boundary between me and the street, all the way from the physical boundary to the socioeconomic, cultural, historical boundaries that kept me completely separated from what was happening down below. But I wanted to investigate that, and I wanted to think about the relationship of the subject to the video medium and how I could explore that in a new way.

It was very interesting when Tom Recchion called me after listening to twenty-four hours of audiotape. He called me and said,

When I edited it, I had this conception that the video would be a day in the life—twenty-four hours. So I started editing, and I was amazed because every time I threw a shot in, it just went in. It was like serendipity. It was this kind of ecstatic experience, this ecstatic, artistic experience. It was like being one with the material and the sound, and it was going together. I started with the morning footage and I kept going, and I was doing great, until I hit darkness. And darkness was the transition in the sound. It is very structured into two parts. There is a transformative shift to the dreamlike state that was night. But when I tried to take my surveillance footage and edit it after that transition moment, it would not work. I could not make a single edit. So then it was like a lightbulb that went off: you know, sometimes the things you set up go your way, and sometimes they don't. I had to really think about what the street wanted me to do with the second half. I had to be more responsive to the fact that I could not keep hiding and doing surveillance, that I had to come down. I had to literally bring myself down to the street level. The footage was not going to work unless I did that. So we bundled up in the car. I don't remember who was there that day, but somebody had a

p. 176–77
Branda Miller, stills from *L.A. Nickel*, 1983. Single-channel video, color, sound; 10 min., 35 sec. LBMA/GRI (2006.M.7).

"I've figured it out. I have a brilliant idea." We would work on the telephone. He would call me and play a little bit, and it was really hard to hear it. He played me something and I'm like, "I hate it. I have no idea what you just played for me. It's not at all my preconception of what I am looking for. Explain this to me. What is it?" Well, it turned out that I grew to love it. The sound is the ultimate power of *L.A. Nickel*. It's the beat in the first half that is so strong. And that sound—that beat—is literally the door slamming, the big metal door with lots of locks on it. When the audio agents would go from the protection of inside and pass through that door, the door would slam, and then they were out on the street. That was the noise. I think Fredrik Nilsen was working as a nurse. He was thinking a lot about the body in relationship to sound, and they put the sound at the rate of a human heartbeat. It was that separation between the inner and the outer, between that safe space and that space where we were like pushing ourselves over the cliff, although actually the interior space was not so safe, either. That became the core of *L.A. Nickel*. The soundtrack was edited first, and then I took the picture and put the picture to the sound.

convertible Volkswagen with a bar on top. So we got into the back of that, mounted the camera on top of the bar. And I said, "Okay, this is what we need. We are going to just do this sweeping shot driving through the block, and it is just going to go as one edit in the end—because with all these choppy edits in the beginning, when we make that shift it is going to go to this place that is just the opposite." So conceptually, I had to break every rule I started with, and do something completely different. Of course, this is also totally different than what I am learning during the day as an editor working in Hollywood, where you have these formulas and you learn to perfect them. I remember I had a wonderful director in Hollywood named Sterling Johnson, who worked for Barbara Walters and a lot of high-level people. I remember he said to me around the same time, "I am going to give you an insight. I am going to tell you a secret that is going to let you be a brilliant editor." So I'm like, "Okay, I'm ready. Tell it to me." He said: "Whenever in doubt, dissolve."

Anyway, we get in the car—we're all bundled up and we're shooting—and then all of a sudden, I'm like, "Holy shit. There's

a fire! I think Fifth and Wall is on fire! I think my building is on fire. Keep shooting. Don't turn it off." So we're driving, and it was that epic moment where we're driving and taking this long, long, long shot, and we turn the corner. I'm afraid my own place is burning. And all of a sudden, we are in the middle of what really is another kind of Hollywood set. All of the news crews are there shooting a fire. And it was the building right next to my building. It was, again, serendipity. I think it was kind of an early media literacy for me. I was trying to unpack the media and understand it, deconstruct it for myself. But all of a sudden I realized that everybody was pointing at the fire. And I thought, well, that's interesting, because look at all the stuff that is happening around the fire. There's a Hollywood set that's turned up. You know, all these crews and the fire trucks and the scene, and all the drunken people lying in vomit around it, and all the police abusing them. What is interesting is the stuff that is outside of the frame of the mainstream media. So let's shoot that, which ended, of course, with us zooming into the police light, and getting this kind of prism and breakup of light and just playing with light, which is how *L.A. Nickel* ended. Of course, it just edited right in, and it was smooth, beautiful, and I loved it.

ery way. Plus it was a great party. We had everybody at the opening, and I remember wearing some kind of a leather outfit with black fishnet stockings and high heels, and it was just a scene. But when you think about surveillance now, it has gone so much further. Surveillance has become much more embedded in our daily lives. So it was amazing how many artists had already started thinking about that relationship by the mid-1980s, because ultimately it goes back to the interview with Foucault, and how he talked about power and the technological tools of power. But what I realized in the *Surveillance* show, as well as at the premiere of *L.A. Nickel*, which was also at LACE, was that these exhibitions were not just about showing art. They were also about creating a community space for us to think in a critically engaged way about media and our relationship to it. Again, that is something that I think is really fascinating now. I actually look back to these early days in Los Angeles and Long Beach as a kind of beginning to the media reform movement—the idea of a conscious community that is thinking about the repercussions of mainstream media. And, of course, what better place to have that kind of think tank than in the midst of Hollywood. In a media landscape where the dollar is the bottom

Even when I showed it at the American Film Institute—this was the beginning of people doing a lot of image processing and manipulation—everyone wanted to know what my trick was. And it was nothing—cuts only. The whole piece was cuts only. It was raw.

You also curated an exhibition about surveillance that used the work of other artists to articulate some of the ideas that you were beginning to find in your own work. Could you talk about that, because it was a very important show for the community.
In 1987, I co-curated a show at LACE, *Surveillance*, with Deborah Irmas. She did the photography and I did the video. We had international artists, like Dieter Froese, Bruce Nauman, Martha Rosler, and local artists, like Julia Scher. It was actually Julia Scher's first piece ever in a show. She did a great piece where she armed the door, so anybody who entered the door set off a big alarm. But it really made us think about the relationship between surveillance and responsibility—the ethical issues—and how surveillance was not just about surveillance technology in its simplest form, but how it actually was permeating into our mediated culture in ev-

line, there is little room for artistic experimentation. Local voice is constantly getting squeezed out. This history still actively inspires me now, as I'm fully engaged in building a sustainable media arts and activist center in Troy, New York, called the Sanctuary for Independent Media. There's a greater need than ever for sanctuaries like LBMA and LACE, for today and for our future.

SUSAN MOGUL

Born 1949, New York, New York
Lives and works in Los Angeles, California

AS A STUDENT IN THE FEMINIST ART PROGRAM at the California Institute of the Arts (CalArts) and a member of the Feminist Studio Workshop at the Los Angeles Woman's Building in the early 1970s, Susan Mogul began an ongoing process of self-examination through autobiographical performances enacted to and for the video camera. With Judy Chicago as her mentor and Lynda Benglis among her instructors, Mogul engaged with the feminist drive to interrogate female subjectivity and validate personal history through her work. Performance allowed Mogul to blur the boundary between life and art, while video afforded her privacy, mediated intimacy, and control over her own uninterrupted voice. Performance video positions the artist as both subject and object of her own gaze; therefore, Mogul's exhibitionist self-portraits can be interpreted as feminist acts of self-determination. In her early, unedited tapes, shot in confined spaces using a Portapak, Mogul addresses the camera directly while performing actions with simple props.

In her later, more technologically sophisticated works, she employs a video-diary format to explore her own identity—as a woman, an artist, a Jew, and a New York transplant in Los Angeles—through her interactions with others. Mogul has consistently used her own life as her subject, combining conversational humor with the pathos of everyday life, evident in even her earliest video, *Dressing Up* (1973). The tape begins with Mogul sitting naked, eating CornNuts in a cramped bathroom next to a rack of clothes. While she discusses her passion for bargain hunting—an obsession inherited from her mother—she models some of her favorite purchases. Putting on one article of clothing after another, she recalls sales, bargain basements, and rock-bottom prices until she is fully dressed. The subtext of Mogul's reverse striptease is her relationship with her mother, which she explores through an improvisational personal history of her worn clothes.

Andra Darlington

Interview conducted by Glenn Philips on April 22, 2007, at the Getty Research Institute in Los Angeles, California

GP: How did you wind up in Los Angeles?

SUSAN MOGUL: Basically, it was because of the feminist art movement out here. I was finishing up art school at the Museum School in Boston, and I wanted to go to graduate school in California. I had read about the Feminist Art Program at CalArts, so that was the momentum that got me to Los Angeles. So I wasn't specifically going to the West Coast for Los Angeles; it was the feminist art movement that propelled me out here. That was in 1973, and at that time there was also a fascination with this kind of alternative lifestyle on the West Coast.

Who did you study with in the Feminist Art Program? Judy Chicago was my mentor, and studying is kind of a—I think studying is almost too formal a word for my experience at CalArts. I was only there for six months. The Feminist Art Program had split at that point. I didn't find out until I got there, but Judy Chicago and Miriam Schapiro weren't speaking, so there were like two Feminist Art Programs. I got there in January 1973, which was post-Womanhouse. Judy was my mentor and almost like my home base, along with some of the other women there, like Laurel Klick, who became a very close friend of mine. Lynda Benglis was a visiting artist, and I did independent study with her. I ended up doing video because of Lynda Benglis, actually, because at that point she was making video art, and she was a big proponent of using video. So basically Lynda said to do video, and Judy Chicago was saying make art about your own experience, so I kind of brought those two things together.

Judy had a big influence on me. She was a very strong personality who was encouraging you to make work about your life and also to go out in the world—like immediately—not worrying about whether your work was polished or finished. So that was my initial experience. I was only in L.A. for one month and I was taken to this "menstruation art" show, which was at a gallery in Culver City called Womanspace. It was every conceivable medium about menstruation, which inspired me to make my own menstruation tape in 1974.

What's the name of that tape? I don't know [Laughter], I only showed it once; it got kind of a strong reaction. My inspiration was a combination of seeing the show in Culver City and reading *The Female Eunuch* [1970] by Germaine Greer. Greer asked, "If people taste their blood when they scratch their finger, why can't you taste your own menstrual blood?" So that's what I did in the tape, essentially. [Laughter]

Just once or . . . Oh, I put it on my face, everything. It looks a little bit like a female Paul McCarthy tape.

Did it taste different? I can't remember. But I remember even Judy Chicago was shocked by it, which is pretty good. I don't know if you know Judy Chicago's lithograph called *Red Flag* [1971]. You just see a woman from the waist down, a little bit below the crotch, and a hand is pulling down a tampon. So there was a lot of inspiration to do my videotape. Some of the work I did at that time, like the menses piece, I don't think it would have happened if I was working alone. It's not something that I would have come up with out of my own brain. I think there are things in terms of the feminist art movement which gave you permission to take risks and do things that, outside of that context, you might have felt wasn't allowed.

Where was the one place you showed it? I showed it in a classroom at the University of California, Santa Barbara, and then I submitted it to some grassroots video festival in Colorado, like a cable underground festival, and they wrote me back a very nice letter that it had been censored. So that was it; I still have the rejection letter. But Karen Finley somehow knew about it. I met her in the eighties, and she told me that she thought that was an important thing that I had done, although I don't know if she even saw it.

Let's talk about another early piece, *Dressing Up* [1973]. Could you describe the piece? Reverse striptease, while eating CornNuts—which you could get from a vending machine at CalArts. It was inspired by my mother's penchant for bargain hunting, and my following in her footsteps. It was the first piece I did about my relationship with my mother, and the munching of the CornNuts was about obsession—in this case, the obsession

with getting clothes at a discount. Obviously, your mother might want you to get clothing at great rates, but I don't think she'd want you to be starting out naked and putting one item on at a time while talking about where you bought it and what you saved in a videotape. So I was doing things to kind of put a little twist to it. That piece was important in a lot of ways, because it was really the beginning of the work that I continue to do up into the present: autobiographical, kind of zany, satirical stuff about your family. All the kernels of everything I continue to do now are in that piece. It was also the piece where I discovered that I was funny. I didn't know that I could make people laugh. So I did one version of it and showed Lynda Benglis, and she thought it was great, and I guess I did a few different versions of it and showed it to the women who were part of my group and Judy, and they all thought it was great. So it was a complete surprise to me.

One of the great things about *Dressing Up* is that it just totally undoes every notion of how you might be expecting a woman to act during this period. And then the fact that you're naked eating CornNuts, which is the most unglamorous type of image, just puts it over the top. And what I left out is that I was overweight at the time, probably twenty-five pounds heavier than I am now, so it's not like I was showing you a sexy body, necessarily.

But you were showing someone who's comfortable with her body, which I think is another important aspect of the video. The idea of "dressing up" can be turned into this very glamorous activity, but it's also an activity that creates a lot of anxiety for many women, and here you are talking in this very practical way about practical shoes. Well, you know, the thing that's interesting— this is about my mom. I found out years later that my mom was always shy about showing her body when she was younger. I never knew that about my mom, because I'm the eldest of six kids and I always saw my mother nursing. My mother would never do any of the things that I did in that videotape or that I've done since, but I always felt that she was comfortable with her body. So there was a comfort level—and my mother's no bohemian in any way—but there were just certain things that I saw that made me very comfortable about my body. Part of it just has to do with who I am, and part of it I saw in my mom.

Did you show your mom *Dressing Up*? Yeah, quite soon after I made it. I don't even know if my mother had a negative reaction to the video, because my father's reaction was much more memorable. [Laughter] My father worked in a place that had reel-to-reel video equipment in 1973, so he actually brought the video equipment home so we could watch it; this is like two months after I made it in the summer of '73. My father watched ten seconds of it, and muttered something under his breath about how his money was being wasted at CalArts. [Laughter]

Everyone in the office was probably going to be asking him how your video was the next day. I never even thought of that.

What about *Take Off* [1974]? That work takes Vito Acconci's *Undertone* [1973] as its point of departure? I really like Acconci's work, and it was interesting to find out that Acconci's background is poetry and writing, so I think there probably was this instinctive connection to language and writing and storytelling. In *Undertone*, he's sitting at a table, and he wants you to make him tell the truth— this is how I'm remembering it—and he's also directly speaking to the viewer. So he was setting up an intimate relationship with the viewer. He would masturbate, but you wouldn't see because

p. 179
Susan Mogul, stills from *Dressing Up*, 1973. Single-channel video, black-and-white, sound; 7 min., 6 sec. LBMA/GRI (2006.M.7).

So I was studying this Acconci piece, and then my friends, Suzanne Lacy and Laurel Klick, had given me a vibrator when I was going back to New York for the summer. Those things came together, and that gave me the idea of doing the tape. So—trying to write a paper, getting a vibrator as a present, learning to masturbate—all those new things in my life came together and created a videotape. [Laughter]

Your dialogue in *Take Off* is hilarious. How much of that did you write beforehand, and how much of it was off the cuff? I know I did that piece several times. It's hard for me to remember exactly, because it was so long ago and I didn't take copious notes the way I do now. But I always performed better when I generally knew what I wanted to say. Any time I've ever tried to say something word for word that I wrote down, I get hung up on remembering the memory of it. I'm a performer, but I'm not an actress, and there's a big difference. So I probably knew that I was going to have an order in which I said it, because I did it a few times before I got to where I was happy with it. I guess I should also state that these were nonedited tapes.

I think you can tell that the piece developed over a few takes, because there's the part in the video where you have this confession, like "Actually, this isn't the real vibrator; I had to run out and get a really cheap vibrator that would vibrate more loudly so you could hear it on the camera." So I would assume you hadn't planned that, but you did a take and then had to regroup and go out and get this other prop. What was improvised there was when I start laughing and I say to you, "Hi, I wasn't telling you the truth, this isn't the vibrator," and then, "I better get my other one." That's all spontaneous, and that's very fresh, and I probably only did that once. I think even at that time I recognized that performances were more interesting and energetic with that kind of spontaneous stuff in it.

Were you doing live performance as well? No.

Never? I did, in the eighties. I went to graduate school at UCSD [University of California, San Diego] from '77 to '80, and David Antin told me that I should do live performances. Since I admired David, I did that for several years. Years later, I was getting ready to perform and I must've been saying to my mom how nervous I was, and she said, "Well why do you do this if you get so nervous?" and I said, "Because David Antin told me to." [Laughter] But I learned a lot. I think I'm much better as a filmmaker than as a live performer, but I learned so much from performing live, in terms of timing. Nineteen eighty-seven was when I stopped performing and started making videos again.

Let's talk about *Dear Dennis* [1988]. Like I was telling you about how *Take Off* got inspired by different kinds of experiences coinciding, *Dear Dennis* had a few different events that led up to its making. I went to my dentist, Dr. Chin, one day, and as I was leaving to make an appointment for the next time, I happened to glance down at the appointment book and I saw that I was missing Dennis Hopper by one hour. Okay, so Dennis Hopper goes to my dentist. Then two days later, I was at a big art party in the loft district, and who do I see at the party? Dennis Hopper. I had a few drinks, and I had somebody standing next to me who gave me a little bit of support to go over to him. And then I walked over to him and I just started talking to him about Dr. Chin. That was it. I probably did most of the talking, although he told me what kind of dental work he was having done with Dr. Chin, and that was the

he was sitting at a table, and he would go, "I want to believe there is a woman under the table and she's doing this and that to me." And then he would stop and directly address the viewer, and then he'd go back to supposedly masturbating, and say, "I want to believe that maybe a man is there." I don't remember it exactly now, because this is a long time ago. But there was this structure of directly addressing the viewer, and then masturbating to what you might call an inner monologue. So I guess I was fascinated with that whole structure; he was using two different kinds of voices.

At this point, I was in the Feminist Studio Workshop at the Woman's Building—not to be confused with the Feminist Art Program, because I had left CalArts. Judy said, "Please come with me to start this new program at the Woman's Building and be one of my students there; be part of the Feminist Studio Workshop." So I did, and that experience was a lot more intense. We were having critiques of work that were very personal, and we were having these intense consciousness-raising sessions. But the Feminist Studio Workshop was in a building—the Woman's Building—which had a gallery, a travel agency, and a little library, and we did a lot of events there, so it had a public coming through. We were sharing very intimate things together, yet we were also presenting ourselves to the public.

What we had at the Woman's Building is people making things happen—which is very different from what's happened with feminism and academia today, which is all about theory and talking about things. And what was so dynamic was we were actually doing things that were very interesting. There was this exploration of the difference between male sexual identity and female sexual identity. So that was what started me studying Vito Acconci, because I was supposed to write a paper about how a male artist dealt with his sexual identity, and I was going to compare it to a female artist's sexual identity. I started writing the paper, but what I ended up doing instead was making this video, which satirized his approach to sexual identity.

end of our conversation. That was the inspiration for making *Dear Dennis*. It was a video letter. This time, I had a specific viewer to address and that was Dennis Hopper. I created a structure of all the different ways I could try to impress Dennis or make reference to teeth. That was my monologue; his films, my teeth.

But it also seems to veer into fiction a little bit more than some of your other tapes. There's the part where suddenly, it looks like you've gotten beat up. And at the end, you show this necklace made of teeth. It's interesting because it's based on this real fact, but then you sort of turned it into this comic fiction. Well, of course, I had teeth as a motif. In the same way that I munched CornNuts and was naked in *Dressing Up* while I talked about bargains, why not have a monologue and try to impress Dennis Hopper with how charming I am by brushing my teeth and saying, "Remember me? I'm Susan Mogul." So again, it's taking that whole thing that's not exactly ladylike and saying, "Oh, I'm trying to impress you, Dennis." That's part one. I'm reintroducing myself to Dennis Hopper while I brush my teeth, and I'm reminding him how we met, in case he didn't remember. Then I'm waking up in bed listening to the sound, ostensibly, of my teeth grinding, because that's why I needed the dental work done. So I'm saying, "Good morning, Dennis." I'm creating this fictional intimate relationship with him where I'm brushing my teeth and talking to him. I'm waking up and I'm talking to him. Then you see me again in bed with a bathrobe and I appear to be black and blue. I got beat up and I'm reading this newspaper that has the headlines about the Crips and stuff, because the movie at the time that he had out was called *Colors* [1988], which was about gangs. People were very critical of this movie because they thought maybe gang violence would break out if they went to his movie. And then I pretended that I had gotten beaten up and I showed him a tooth that maybe had fallen out because I went to the movie. I got beaten up going to the movie, but I was going to tough it out for Dennis's movie. And then at the end, I have a string of teeth that I made some jewelry out of.

Dear Dennis is connected to the Vito Acconci piece in that I'm taking important male figures and bringing them down to my level, or humanizing them through satire. That's the thing that they both have in common. When it came to men in my work, I was often kind of putting myself in competition—I see it that way now— with these male figures. They weren't going to be superior to me. The piece that I'm working on right now, *Driving Men*, is actually about the men in my life. It also is very much a piece about my dad. I started out in 1973 with a piece that in many ways was inspired by my mother, and then it took all these other circuitous routes to get to something about my dad thirty-three years later.

So has your father forgiven you for making *Dressing Up* and *Take Off*? My father died a few years ago. But, yeah, my father and I got along extremely well the last five years of his life. So, yeah, I think he got over that.

Did you ever send *Dear Dennis* to Dennis Hopper? Yes, but I don't know if he ever saw it. But I've incorporated it into *Driving Men*, which is feature length, so he's going to have one more chance. It incorporates clips from several of my works. The men in the piece come from different times in my life, so it was very easy to work in these earlier pieces. For example, I'm talking about my relationship to my father. Well, it's very easy to bring in *Dressing Up* and tell an anecdote about how he responded to that. Being someone who makes work out of her own life, it's very exciting to be able to take all these elements from the last thirty years and actually find a way that they can be woven together.

p. 180
Susan Mogul, still from *Take Off*, 1974. Single-channel video, black-and-white, sound; 10 min. LBMA/GRI (2006.M.7).

p. 181
Susan Mogul, stills from *Dear Dennis*, 1988. Single-channel video, color, sound; 4 min. LBMA/GRI (2006.M.7).

BRUCE NAUMAN

Born 1941, Fort Wayne, Indiana
Lives and works in Galisteo, New Mexico

SINCE THE MID-1960S, Bruce Nauman has been testing and examining the physical, logical, and psychological relationships between objects, words, spaces, and living beings. His intensely focused studio practice is not limited to a single formal style but instead relies on a broad range of media that includes sculpture, video, film, installation, drawing, printmaking, performance, neon, and photography. Employing plastic and not-so-plastic art forms in complex, obvious, and unresolved ways, Nauman continues to assert that the simple activity of making art is as important as its concrete end results.

As a student at the University of Wisconsin, Nauman studied physics and mathematics before turning toward fine arts. Perhaps indirectly, many of his pieces are permeated by a rigorous yet oblique and mysterious logic. Like open circuits missing some key element, his artworks often act out common slips in perception and communication. After moving to Northern California in 1964 to pursue his Master of Fine Arts degree at the University of California, Davis, Nauman began to experiment with performance, film, and other forms of process-oriented sculpture. His first extensive use of video occurred in 1968–69, while he was spending a winter in Southampton, New York. It was during this period (just before moving to Los Angeles in 1969) that Nauman built his first *Performance Corridor* (1969), which originated as a prop for his video *Walk with Contrapposto* (1968). In the video, the artist moves through a narrow hallway with plywood walls, positioning his body into the torqued postures of classical painting and sculpture. Nauman soon realized that his construction could function as an autonomous sculpture whose primary perceptual effect was the viewer's own experience of being within it.

This led to a series of other corridors and rooms incorporating mirrors, video cameras, and monitors that are designed to create feelings of alienation, disorientation, or heightened awareness in the viewer—or, in a work like *Video Surveillance Piece (Public Room, Private Room)* (1969–70), all three feelings at once. This closed-circuit video installation consists of two identical rooms, one of which is hidden from the public. Walking into the "public" room, viewers see a ceiling-mounted surveillance camera pointed toward a monitor on the floor, which in turn appears to be showing live video footage of the room. The surveillance footage naturally includes the image of the monitor itself, which appears as a "monitor within the monitor" in the video image. Moving into the camera's field of vision, however, viewers do not see the expected image of themselves onscreen: they appear to be missing from the room itself, yet they do appear on the "monitor within the monitor." This simple trick, achieved by feeding each video camera into the opposite, identical room, creates a unique perceptual experience for the viewer. Primed for that particular form of self-awareness that comes from watching oneself on video, viewers are instead confronted with an image depicting them as physically absent, virtually present, and watched from an unknown location.

Catherine Taft

pp. 182–85
Interview conducted by Willoughby Sharp on May 7, 1970, in San Jose, California. First published in *Avalanche* 2 (Winter 1971). Excerpted and reprinted by permission of Willoughby Sharp.

p. 183
Bruce Nauman, *Video Surveillance Piece (Public Room, Private Room)*, 1969–70. Video installation with two black-and-white surveillance cameras, two monitors, dimensions variable. Panza Collection, Gift, Solomon R. Guggenheim Museum, New York, 92.4167. Photo © Giorgio Colombo, Milano.

During the first week of May 1970, Nauman made a V-shaped corridor piece at San Jose State College, California. The following discussion was videotaped in the college's studio on May 7, 1970, and later edited in collaboration with the artist.

WILLOUGHBY SHARP: How did you arrive at the San Jose piece, did it grow out of your *Performance Corridor* [1969]?
BRUCE NAUMAN: Yes, because the first pieces that were at all like it were just corridors that ended at a wall and then made into a V. Then I put in another V and, finally, I put in the mirror.

Why did you decide to use it that way? The mirror?

No, the change in the interior, the second V. When the corridors had to do with sound damping, the wall relied on soundproofing material which altered the sound in the corridor and also caused pressure on your ears, which is what I was really interested in: pressure changes that occurred while you were passing by the material. And then one thing to do was make a V. When you are at the open end of the V there's not too much effect, but as you walk into the V the pressure increases quite a bit, it's very claustrophobic....

Pressure is also felt on the spectator's own body. Does that come from your ears? It has a lot to do with just your ears.

So space is *felt* with one's ears? Yeah, that's right....

It's really hard to know what I felt in there, but somehow it brought me closer to myself. From your own experience of being in there, how would you say it affects you? Well, the corridors that you walk down are two feet wide at the beginning and they narrow down to about sixteen inches. So going into it is easy, because there is enough space around you for you not to be aware of the walls too much until you start to walk down the corridor. Then the walls are closer and force you to be aware of your body. It can be a very self-conscious kind of experience.

So you find yourself in a situation where you are really put up against yourself. Yes, and still the interest—since you are looking into the mirror and seeing out of the other corridor—the visual interest is pretty strong and it's centered somewhere else; it's either in the mirror or looking beyond the mirror into the end of the V.

Some people don't see over the top of the mirror into the end of the V. Well, if you are shorter than I am and you see your whole self in the mirror, then you probably wouldn't look over the mirror, so that's really difficult to.... If the mirror is too short, it doesn't work either because you look over the mirror; you just see your feet in the mirror, and the bottom of the corridor. So the piece is effectively limited to people who are built somewhat like I am.

Then the size of the spectator plays a role in the success of the piece. A big person couldn't go in at all.

ARTISTS | NAUMAN 182

Right. I didn't get a chance to see your last Wilder show. How does the San Jose corridor piece compare with the ones at [Nicholas] Wilder [Gallery]? Well, there were parts of the Wilder piece that you could experience immediately, but the thing was so large and complicated that I think it took much longer to grasp.

Do you think this piece is more successful? No, just more immediate.

What relation do these corridor pieces have to your recent videotape works like *Come* **[1969]?** It's really like the corridor pieces only without the corridors. I tried to do something similar, but using television cameras and monitors, and masking parts of the lenses on the cameras.... If one camera is at one end of the room and the monitor is at the other, then the camera lens can be masked so that an image appears maybe on a third or a quarter of the screen. The camera is sometimes turned on its side, sometimes upside down, and that creates a corridor between the camera and the monitor. You can walk in it and see yourself from the back, but it's hard to stay in the picture because you can't line anything up, especially if the camera is not pointing at the monitor. Then you have to watch the monitor to stay in the picture and at the same time stay in the line of the camera.

How did you decide on the title, *Come***?** I don't remember....

I know it often happens that you do certain things in one medium, then you do something similar in another medium. How does that come about? Is it because you cannot take a project further at a particular moment? Originally, a lot of the things that turned into videotapes and films were performances. At the time, no one was really interested in presenting them, so I made them into films. No one was interested in that either, so the film is really a record of the performance. After I had made a few films, I changed to videotape, just because it was easier for me to get at the time. The camerawork became a bit more important, although the camera was stationary in the first ones....

Were these the films of bouncing balls? Yeah. The videotapes I did after those films were related, but the camera was often turned on its side or upside down or a wide angle lens was used for distortion.... As I became more aware of what happens in the recording medium, I would make little alterations. Then I went back and did the performance, and after that....

Which performance? The one at the Whitney [Museum of American Art, New York] during the *Anti-Illusion* show in '69. I had already made a videotape of it, bouncing in the corner for an hour. At the Whitney, the performance was by three people, instead of just myself, and after that I tried to make pieces where other people could be involved in the performance situation, individuals.

Why did you find this desirable? It makes it possible for me to make a more ... it's difficult for me to perform, and it takes a long time for me to need to perform. And doing it once is enough. I wouldn't want to do it the next day or for a week, or even do the same performance again. So if I can make a situation where someone else has to do what I would do, that is satisfactory. Quite a lot of these pieces have to do with creating a very strict kind of environment or situation so that even if the performer doesn't know anything about me or the work that goes into the piece, he will still be able to do something similar to what I would do....

The concern for the body seems stronger now than when we did the *Arts Magazine* **interview.** Well, the first time I really talked to anybody about body awareness was in the summer of 1968. Meredith Monk was in San Francisco. She had thought about or seen some of my work and recognized it. An awareness of yourself comes from a certain amount of activity and you can't get it from just thinking about yourself. You do exercises, you have certain kinds of awareness that you don't have if you read books. So the films and some of the pieces that I did after that for videotapes were specifically about doing exercises in balance. I thought of them as dance problems without being a dancer, being interested in the kinds of tension that arise when you try to balance and can't. Or do something for a long time and get tired. In one of those first films, the violin film, I played the violin as long as I could. I don't know how to play the violin, so it was hard, playing on all four strings as fast as I could for as long as I could. I had ten minutes of the film and ran about seven minutes of it before I got tired and had to stop and rest a bit and then finish it....

What you are saying in effect is that in 1968 the idea of working with calisthenics and body movements seemed far removed

empty sealed room · *a* · *a* · *public room.*

camera on oscillating mount —

B. Nauman 1970

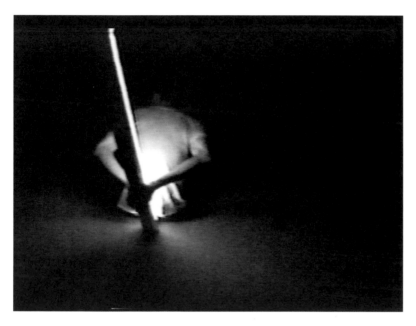

You had been doing a lot of walking around in the studio. When did you start thinking about using corridors? Well, I don't really remember the choice that led me to ... I had made a tape of walking, of pacing, and another tape called *Rhythmic Stamping in the Studio* [*Stamping in the Studio*; 1968], which was basically a sound problem, but videotaped.... I was just walking around the studio stamping in various rhythms.

Did you want the sound to be in sync? The sound was in sync on that one. In the first violin film, the sound is out of sync, but you really don't know it until the end of the film. I don't remember whether the sound or the picture stops first....

Is the film of the two bouncing balls in the square out of sync? Did you play with the sync on that? No. I started out in sync but there again, it is a wild track, so as the tape stretches and tightens, it goes in and out of sync. I more or less wanted it to be in sync, but I just didn't have the equipment and the patience to do it.

What did you think of it? It was all right. There's one thing I can't remember—I think I cut it out of some of the prints and left it in others. At a certain point, I had two balls going and I was running around all the time trying to catch them. Sometimes they would hit something on the floor or the ceiling and go off into the corner and hit together. Finally, I lost track of them both. I picked up one of the balls and just threw it against the wall. I was really mad.

Why? Because I was losing control of the game. I was trying to keep the rhythm going, to have the balls bounce once on the floor and once on the ceiling and then catch them, or twice on the floor and once on the ceiling. There was a rhythm going and when I lost it that ended the film. My idea at the time was that the film should have no beginning or end: one should be able to come in at any time and nothing would change. All the films were supposed to be like that, because they all dealt with ongoing activities. So did almost all of the videotapes, only they were longer, they went on for an hour or so. There is much more a feeling of being able to come in or leave at any time.

So you didn't want the film to come to an end. I would prefer that it went on forever....

I saw most of these four films about a week ago at the School of Visual Arts [in New York City]—I liked them even better the second time I saw them. You made a simple, repetitive activity seem very important. I guess we talked about this before, about being an amateur and being able to do anything. If you really believe in what you're doing and do it as well as you can, then there will be a certain amount of tension—if you are honestly getting tired, or if you are honestly trying to balance on one foot for a long time, there has to be a certain sympathetic response in someone who is watching you. It is a kind of body response, they feel that foot and that tension. But many things that you could do would be really boring, so it depends a lot on what you choose, how you set up the problem in the first place. Somehow you have to program it to be interesting.

So you reject many ideas on aesthetic grounds. Besides you make mistakes, so it doesn't all come out.

Do you ever see one of your films and then decide that you don't want to show it to anyone? Oh yeah. I have thrown a lot of things away.

p. 184 top
Bruce Nauman, sketch for *Video Surveillance Piece* (*Public Room, Private Room*), 1969–70. Giuseppe Panza Papers, Research Library, The Getty Research Institute, Los Angeles (940004).

p. 184 bottom
Bruce Nauman, still from *Manipulating a Fluorescent Tube*, 1969. Single-channel video, black-and-white, sound; 62 min.

from sculptural concerns. Would you say that those boundaries and the distance between them has dissolved to a certain extent? Yes, it seems to have gotten a lot smaller.

What you have done has widened the possibilities for sculpture to the point where you can't isolate video works and say they aren't sculpture. It is only in the last year that I have been able to bring them together.

How do you mean? Well, even last year it seemed pretty clear that some of the things I did were either performance or recorded performance activities, and others were sculptural—and it is only recently that I have been able to make the two cross or meet in some way.

In which works have they met? The ones we have been talking about. The first one was really the corridor, the piece with two walls that was originally a prop in my studio for a videotape in which I walked up and down the corridor in a stylized way for an hour. At the Whitney *Anti-Illusion* show, I presented the prop as a piece, called *Performance Corridor* [1969]. It was twenty inches wide and twenty feet long, so a lot of strange things happened to anybody who walked into it ... just like walking in a very narrow hallway.

What percentage do you destroy? Gee, I don't know.

Does it happen frequently? Oh, pretty often. Maybe half the time....

You did mention that you threw one film away, or you weren't sure. Which one was that? I think we mentioned one, but it wasn't necessarily a film. For the videotapes it is harder to say, because I had the equipment in the studio. With the films I would work over an idea until there was something that I wanted to do, then I would rent the equipment for a day or two. So I was more likely to have a specific idea of what I wanted to do. With the videotapes I had the equipment in the studio for almost a year; I could make test tapes and look at them, watch myself on the monitor or have somebody else there to help. Lots of times I would do a whole performance or tape a whole hour and then change it.

Edit? I don't think I would ever edit but I would redo the whole thing if I didn't like it. Often I would do the same performance but change the camera placement and so on....

How much time did you spend setting up the camera? I don't know. Sometimes it really takes a long time, and other times it's just obvious how it must be done.

Did you consider using a video system in the San Jose piece? Well, in this piece the mirror takes the place of any video element. In most of the pieces with closed circuit video, the closed circuit functions as a kind of electronic mirror.

So you are really throwing the spectator back on himself. That's interesting. I hadn't realized the similarity between the mirror and the video image before. Is there a natural extension into video from a certain situation, such as this piece? Or didn't you even consider that? I didn't consider it. The mirror allows you to see some place that you didn't think you could see. In other words, you are seeing around the corner. Some of the video pieces have to do with seeing yourself go around a corner, or seeing a room that you know you can't get into, like one where the television camera is set on an oscillating mount in a sealed room.

That was at the Wilder show, wasn't it? Yes. The camera looks at the whole room; you can see the monitor picture of it, but you can't go into the room and there is a strange kind of removal. You are denied access to that room—you can see exactly what is going on and when you are there but you can never get to that place.

People felt they were being deprived of something. It is very strange to explain what that is. It becomes easier to make a picture of the pieces or to describe what the elements are, but it becomes much more difficult to explain what happens when you experience them. I was trying to explain that to somebody the other night. It had to do with going up the stairs in the dark, when you think there is one more step and you take the step, but then you are already at the top and have the funny... or going down the stairs and expecting there to be another step, but you are already at the bottom. It seems that you always have that jolt and it really throws you off. I think that when these pieces work, they do that too. Something happens that you didn't expect and it happens every time. You know why, and what's going on, but you just keep doing the same thing. It is very curious.

The Wilder piece was quite complicated. It is hard to understand. The easiest part of the piece to get into was a corridor thirty-four feet long and twenty-five inches wide. There was a television camera at the outside entrance, and the picture was at the other end. There was another picture inside too but that's irrelevant to this part of it. When you walked into the corridor, you had to go in about ten feet before you appeared on the television screen that was still twenty feet away from you. I used a wide angle lens, which disturbed the distance even more. The camera was ten feet up, so that when you did see yourself on the screen, it was from the back, from above and behind, which was quite different from the way you normally saw yourself or the way you experienced the corridor around yourself. When you realized that you were on the screen, being in the corridor was like stepping off a cliff or down into a hole. It was like the bottom step thing—it was really a very strong experience. You knew what had happened because you could see all of the equipment and what was going on, yet you had the same experience every time you walked in. There was no way to avoid having it.

Would you like to do something for network TV? I'd like CBS to give me an hour on my terms. I'd like to do color work, which I haven't done yet because of the expense involved. I haven't been strongly motivated to either. I suppose if I really wanted to I could hustle it somehow. But if it became available to me I would like to use color. Some people in Europe have been able to use it. I forget who. A Dutch artist did something called *Television as a Fireplace*. Apparently a fire was broadcast on the screen for fifteen minutes or so. All you saw was the fire.

Right. Jan Dibbets did that last New Year's Eve. In Holland, all the stations are government-owned. The European television setup is much lower-keyed than the American, so time is not as valuable as it is here. It is a little easier to do things like that, but it's still difficult.

Do you see that as a goal? It seems to me that one of the reasons for working with videotape is that the work can get out to far more people so that obviously CBS.... I would...I'm not interested in making compromises in order to do that, although I still want to do it. I would like to have an hour or half an hour to present some boring material.

Do you feel that you could subvert television, change it? I'm not really interested in actively spending my time trying to get those people to let me use their time. If time was offered to me I would use it, and I would want to do things my way. But to take the trouble to do whatever one has to do....

What I meant specifically was that if the new art is going to be significant for a larger segment of the culture, working with videotape gives you the means to help bring that about. Oh, I think it is not...although there would be a wider audience. But I would still want to have my time available and have only four people watching the piece, just because of what I could do with equipment that I wouldn't have access to otherwise.

So there really isn't a strong desire to change the existing level of communication. No.

Then we come back to where we ended the last time: who is your art for? To keep me busy.

TONY OURSLER

Born 1957, New York, New York
Lives and works in New York, New York

GENERATED WHILE HE WAS LIVING IN CALIFORNIA in the late 1970s, Tony Oursler's early drawings, single-channel videos, and music performances with the band the Poetics reveal the start of a continued exploration of mass media and its influences on individual and collective perception. Although his most recognizable works may be his eerie figurative video sculptures or more recent, large-scale collaborations with musicians, writers, and actors, Oursler's wide-ranging practice includes photography, drawing, sculpture, performance, CD-ROM, and video. This multiform approach may be a result of his formal education at the California Institute of the Arts (CalArts), which required students to work in all media. Oursler arrived at the school from upstate New York intent on being a painter. Without abandoning his early formalist concerns, Oursler began applying them to projected images instead of painted ones, and his work to date provides a thorough examination of the role of mass media from a technical, art historical, poetic, and personal view.

In his early single-channel videos, Oursler presents a cast of puppetlike characters—handmade from whatever found objects and inexpensive art supplies were readily available—who act out absurd narratives as perceived through the filter that mass media creates as "normality." In *Crazy Head* (1978), one sees a large-scale, garishly painted head in the foreground, whose eyes, nose, and mouth are real holes through which the artist pushes various objects during the length of the video. The character's monologue obsessively repeats what he knows is true—that he is perceived as crazy. Oursler uses brusque phrases in the same way that he collages together found objects; in this way, the repetition of "You think I'm crazy" goes from being a benign cliché to something deeper and more uncomfortable.

Oursler has an Andy Kaufman–like ability to initially draw the viewer in through humor and then yank the comfort away with uncanny uncertainty, as the viewer vacillates between empathy and complicity in the character's behavior. Timing and repetition turn the funny setup into an uneasy awareness of the pressure instilled by media and furthered by social interaction.

Oursler's early videos, which are concerned more with storytelling than technical savvy, are no less powerful than his more recent large-scale productions. The image and language of the handmade characters reveal a young artist, but one who is conceptually sophisticated. A thorough understanding of single-channel video technology and the resulting image underscores the strength of these early works.

Jennifer Dunlop Fletcher

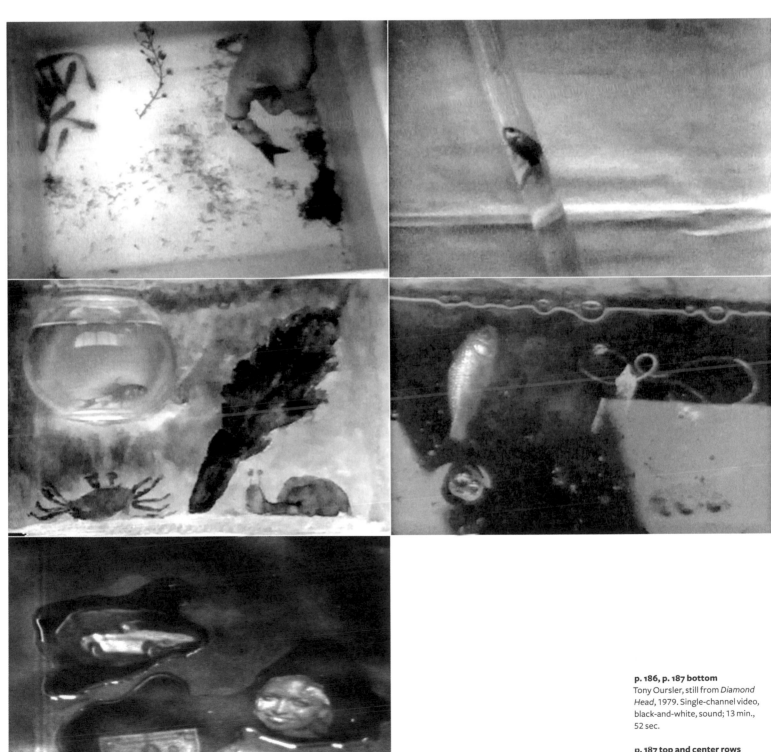

p. 186, p. 187 bottom
Tony Oursler, still from *Diamond Head*, 1979. Single-channel video, black-and-white, sound; 13 min., 52 sec.

p. 187 top and center rows
Tony Oursler, stills from *Fish*, 1978–79. Single-channel video, black-and-white, sound; running times variable.

B/W THOUGHTS

by Tony Oursler

In 1976, I was introduced to the Portapak at the California Institute of the Arts. The reel-to-reel video system was almost ten years old at the time and had suffered in the hands of art students. It was almost obsolete, yet I had never even seen any video recorder in operation, nor any video that was not produced for TV. I was a viewer; my world up to this point had been a one-way experience, one of millions reared on a fractured commercial narrative stream that signed off in the late-night hours with an anxiety-producing national anthem, followed by a minimalist display of color bars and a high-frequency test tone. The Portapak was about to change my perspective, permanently.

My previous years had been spent experimenting with painting, adrift on the sea of art history. CalArts opened up that experimentation to sound installation, performance, photography, and object making. Now, as I removed the lens cap from the generic camera, the TV monitor animated in waves of gray, and a pale curtain opened onto a grainy world. As soon as the camera was turned on my workspace, all mediums seemed to come together into this one form: video. Painting could become backgrounds; sculptures, props, performances, and soundtracks could all be recorded, all instantly. Viewed and then rerecorded—malleable, fluid, uncanny—I was amazed at how space was transformed by the dark sleepy eye of the Portapak.

I took to working while looking directly at the TV monitor, with the camera trained on whatever was to be filmed at the moment. The Portapak became an extended part of the eye-hand feedback loop. In this way of literally reaching into the picture, I could begin to understand the distillation and distortion involved in the production of video images. The popular form was now handmade, on a very personal and small scale. Even the smallest of gestures seemed to turn into something significant on the

screen. The degraded image of the Portapak was a bit like looking at a night landscape hovering on the threshold of vision: things lose their edges and become unhinged from their names in a dark pointillist muddle. With the lack of information in the picture, the mind begins to fill in the blanks, inviting an aggressive visual deduction by the viewer—a collective hallucination.

People forget to look at what is actually on the TV screen. It struck me early on that "the box" was in need of scrutiny. The b/w video image literally consists of a series of dots, which are changing levels of brightness. Once these dots are decoded, the screen appears to be inhabited by signs of little luminescent creatures imbued with human characteristics. When their mouths moved, sounds came out in a stylized linguistic structure with music, laughing, and, sometimes, sound effects. The only way this imaginary narrative playground worked was by a willing suspension of disbelief. Now, with camera in hand, television was deconstructing before my eyes, fluctuating between an abstract light box designed to steal time and money from the public, and an actual picture machine sending narrative signals. This reverse engineering of the apparatus and the viewer became a subtext in all my first videotapes.

What was the least amount of visual information that could be anthropomorphized by the viewer? What is the most information that could be jammed into that image? How did the hierarchical reading of screen space come about? There seemed to be a targetlike attraction to the center of the screen—this being the focal point—while the edges became less interesting. This tunnel vision effect was similar to the way our natural vision fades at the periphery. Could the edges of the image be as important as the center, a nonhierarchical image? Close-up, medium shot, long shot—the whole narrative system inherited from film came into question.

The first tapes I produced were wandering, streaming reactions to Television, the great reflector and cultural manipulator. The scale of the screen, the soap-operatic narrative structures, the

compressed ads, and the sheer hypnotic effect of the mechanism had to be attacked. Out came a psychic graffiti in the form of black humor, dime-store props, cardboard, and tinfoil. *Joe, Joe's Transsexual Brother, and Joe's Woman* (1976), and *The Life of Phillis* (1979) were both caricatures of TV pushed as far as I could at the moment. Violent and sexually voyeuristic, these works were made simply, quickly. The idea was a rough imaginary construct of the future of television. The audience is addressed directly by voice-over, as hands move in and out of the video frame manipulating and animating the scenes. The root impulses of the viewer are exposed and tested in a narrative endgame. These two tapes also marked the end of my interest in playing with linear narrative and TV.

The next videos were a loosely thematic collected group of shorts, which have been specially edited for the *California Video* exhibition at the Getty. Included are never-before-seen (recently discovered) segments of the series *Fish* [1978–79], involving an existentially besieged goldfish. The pet is a symbol of both sides of our interaction with nature: control and freedom. These shorts are humorous, yet sometimes painful to watch. They comment on skewed power relationships, and, like much of the early work, can be truly disturbing to watch. I can only say that no fish were harmed while videotaping this series.

The early tapes that followed—*Life* (1979), *Good Things and Bad Things* (1979), and *Diamond Head* (1979)—are composites of photographic, painted, and performance space, scattered with found objects and body parts. Inexpensive materials from secondhand stores filled my studio: piles of shoes, dolls, crutches, the detritus of suburban California. Postcards, paintings, newspapers, dolls, toys, unwitting birds, insects, and fingers became actors. Rejected, used-up materials held a special fascination for me, because they retained the traces of deep personal involvements and seemed able to transmit a connectivity. I wanted to make easily understood images that mixed personal with sub–pop culture themes such as sports, romance, and psychodrama. At every turn, a viewer must actively create the images in the screen. The images

are always in danger of falling apart, of disappointing. To watch is to have a fragile agreement not to let images dissolve into components of clay, paint, words, cardboard, or a bit of string. These poetic sketches explore the drift back and forth between the individual and the universal.

My cultural perspective, like most kids interested in art, was one of highs and lows, pathetic misunderstandings, and crystal clear visions. Linking personal and shared scenarios was grounded in my own experience. The monolithic weight of art history forced me to look in other directions to focus on what I knew best. Having lived most of my life up to that point in the small town of Nyack, New York, just outside of New York City, I was drawn to the kaleidoscopic suburban mythology of my 1970s, which seemed amplified when I moved to California. *Diamond Head* was my first attempt to make a narrative based on the way we think rather than on a media construct, such as film grammar. Visual effects were handmade, directly influenced by George Méliès and Jean Cocteau. Their approach to moving image production—which seemed to come from an understanding of physical materials, painting, theater, and magic—was an exciting model. Favoring the optical and constructed manipulation of images for the camera rather than electronic effects, I played with whatever I could get my hands on. One of my favorite effects in *Diamond Head* was the advertising pun in the "lust and greed" scene. By balancing lighting, darkness, and the reflective surface of water, I was able to literally pour status symbols into the picture. The Sears Catalog appears, scrolling an index of idealized frozen tableaux, signs of an unattainable life for *Diamond Head*'s devolved protagonists. They struggle to measure up to true human standards locked inside simplified shapes, vaguely crystal, fetal, and amorphous. "The Bad Neighbors" always argue and appear as tiny specks, distant and featureless. Narrative was stripped of any logical progression. Clichés and idiosyncratic scenarios are chained in a meandering, stream-of-consciousness structure. Aneurisms, shopping trips and marriages unfolded in a static time, as if thoughts could be played out, daydreams traced

p. 188
Tony Oursler, still from *You Can Do It*, 1979. Single-channel video, black-and-white, sound; 1 min.

p. 189
Tony Oursler, stills from *Dissolve*, 1979. Single-channel video, black-and-white, sound; 1 min. 3 sec.

PATTI PODESTA

Born 1959, Hollywood, California
Lives and works in Los Angeles, California

PATTI PODESTA'S ELEGANT YET RIGOROUS early videos reflect a transition from the second wave of feminist art and activism of a previous generation into the beginning of a third-wave aesthetic. Employing subtly transgressive imagery and performative actions, Podesta's work exposes the feminine anxiety, intensity, and brutality that often go unchecked in the culture at large. *Stepping* (1980) is characteristic of this position. Placing herself in front of the video camera, Podesta is videotaped from the knees down, revealing a fierce pair of purple stiletto high heels. As she begins to move sideways, it becomes apparent that she is balancing, not only on the demanding stiletto heels but also on a series of open transom windows. The camera follows her step quickly from one pane of glass to the next, anticipating her next move or an accidental slip. Throughout the video, the droning voice of the singer Nico, intoning "Deutschland Über Alles," adds an evident political critique to the tense action.

After receiving her Master of Fine Arts degree from the Claremont Graduate School, Podesta cofounded, with Bruce Yonemoto, the video program at Los Angeles Contemporary Exhibitions (LACE), where she organized the notable conference, exhibition, and catalogue, *Resolution: A Critique of Video Art* in 1986. Although she continued exhibiting video and teaching fine art, Podesta began working in the film industry as an art director and production designer for feature films. Her credits include *Memento* (2000) and *Bobby* (2006). Her experimental narrative video *A Short Conversation from the Grave with Joan Burroughs* (1991) reflects this dual interest in art and cinema. The work—a fictional account of the murder of Joan Vollmer by her husband, author William S. Burroughs—continued Podesta's examination of the erotics of embodiment, the excesses of intellect, and the unwarranted violence against women.

Catherine Taft

Interview conducted by Glenn Phillips on March 11, 2007, at Patti Podesta's home in Los Angeles, California

GP: Can you remember the first piece of video art you ever saw?
PATTI PODESTA: I absolutely can remember the first piece of video art I ever saw, because it was Bruce Nauman's show at LACMA [Los Angeles County Museum of Art]. That was the show that actually made me think making art was worthwhile. It was puzzling to me, but brilliant. I was really fascinated by it, and I still am.

Were you a practicing artist at that point? I was in high school. I was seventeen years old or something like that. So was I a practicing artist? I guess I was, because I was in the two student shows that LACMA used to do. Every summer they would do a Southern California high school art show and I had work in those; sculpture and paintings. So I guess I was a practicing artist, but I was still in high school.

When was the first time that you picked up a video camera? I started doing performance at the end of my undergraduate program, and segued to doing video while I was in graduate school. I started making things by setting my feet on fire. I don't remember what camera I was using at the time. Then I bought a single-tube camera. And when I finished graduate school, that's all I was doing was—

But wait—setting your feet on fire? Could you talk about that a little more? Yeah [Laughter]. I was really interested in these acts of transgression that were trying to be out of the world, you know? Like not real and kind of dreamy. I had been doing these performances where I would break gigantic sheets of glass and set different kinds of fires. And then I—I don't know why I wanted to do this—but I was experimenting with setting parts of myself on fire by covering myself with Vaseline, and then pouring alcohol on it and setting it on fire. The alcohol burns off for a few seconds. I think that was one of the very first videos I ever made; I covered my feet and legs up to my knees with this stuff and I would pour the alcohol on it and kick my legs until the fire went out. So it was like this fragment of the body, and this strange little moment hap-

pening. I did it again and got overzealous because I was so sure of myself. I poured too much alcohol on and actually burned both of my feet. But it looked fantastic. And I did work like having somebody throw me against a wall. I was interested in these sustained transgressive moments. Actually, I think I was trying to empty the transgression out of them, or make it a kind of continual philosophical state. So you could watch something extraordinary in a very calm way, long enough to think past the shock moment and actually perceive the sensuality, and the sort of discipline in it.

You wanted to reduce the act to its visual appearance. Yes.

So it wasn't about setting the fire, but about how the fire would look on the screen? Well, hindsight's always 20/20, but I think it was about how it would look on the screen. But I was also always interested in a charged atmosphere.

Let's talk about *Stepping*. Could you describe that piece? I made *Stepping* in 1980. The shot is of me from the knees down. I'm wearing purple high heels and I walk back and forth across a row of open transom windows. The windows were in the printmaking studio at Claremont, and I had my eye on them for many months. I just went in there with a friend and a camera at night,

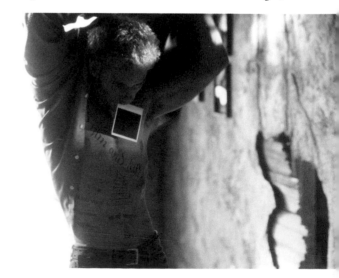

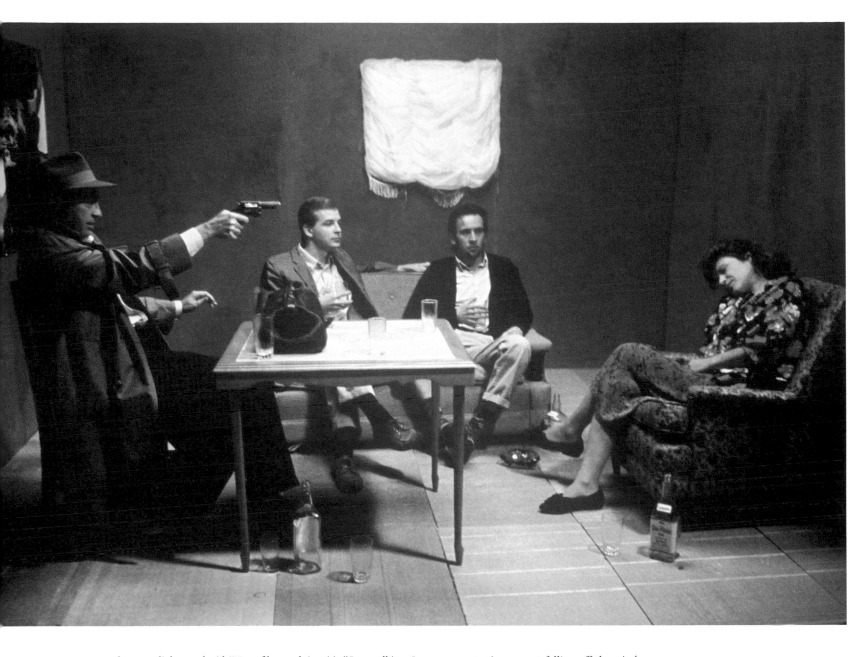

put up some clamp-on lights, and said, "Here, film me doing this." I didn't practice; I just got up on the windows and started walking on them. I hadn't picked a piece of music or wasn't listening to music; I was sort of thinking about rhythm. I started by wanting to make something about fascism, hence the purple high heels, which are, you know, a little bit Weimar Germany–looking. I wanted to make something about risk, and repetition, and this sort of lulling into nonsense of a very dangerous situation. I was originally thinking I was going to pair it with different images; that there would be different parts to the tape. One of the things that I think is quite nice about the video is that you can see my initial trepidation and fear about walking on the windows; and then, as I get more secure doing it, knowing I'm not going to fall through the glass or off the window, I go much faster, and that's also part of the meaning of the work. Then I found the Nico recording of "Deutschland Über Alles," and put the video to that song. At the end, I added this oscillating tone, which sort of wakes you up from the seductive and repetitive droning of the music. When I finished that part of it, I thought it actually said everything I wanted to say about fascism and I didn't need to marry it to some other parts.

How much instruction did you give your cameraperson? I framed it up and asked him to follow me. That was pretty much it. I don't believe I was looking at the monitor. Obviously, I looked at the monitor to frame it up, but I wasn't watching it while I was

walking. I was concentrating on not falling off the window or breaking it.

One of the things I like about the piece is that the camera's following you, but at a certain point it also starts to anticipate your movement, and it sometimes starts to feel like you're following the camera and sometimes it feels like the camera's following you. The cameraperson was also an artist in the program, and he had shot bowling documentation for some television show. That's exactly what you would do in bowling—sort of anticipate where the ball's going to go and have a camera ready to be there.

That's excellent training. You should make your students do that. [Laughter] That's a good idea. One of the things that was very ironic about *Stepping* was that it was the piece that Kathy Rae Huffman chose for her *California Video* exhibition in 1980, which was going to be at the Paris Biennial. When she sent the show, they loved every piece except mine, because there's some sort of rule in the art world that you shouldn't criticize a third-party country's politics in an international exhibition, and they felt that this piece was critical of Nazi Germany. So at first they wanted me to withdraw the piece, and then we discussed it and decided that if I didn't use the first verse of "Deutschland Über Alles"—which is the one that everybody identifies with Nazi Germany—that the work could be in the Biennial. I re-edited it, using just the second and

p. 190
Production still from *Memento*, 2000 (feature film, color, sound; 1 hr., 53 min.); Patti Podesta, production designer. Photo courtesy of Newmarket Pictures.

p. 191
Patti Podesta, production still from *A Short Conversation from the Grave with Joan Burroughs*, 1991 (single-channel video, color, sound; 20 min.). Photo by Laura London.

the third verses. It was so funny that I had been wanting to make a piece about fascism, and it was one of those moments where you think that you're making something that's below the radar, but you aren't at all, you know?

There's also a sort of sexiness in *Stepping* that you haven't really talked about. Sexiness. Yeah, that's funny, because I did make some things that were more explicit later, but I don't necessarily think of the sexiness in that one so much.

To me, the tentative way you have to walk—since you're stepping on those windows—it makes you have this stride like someone who's learning to wear those gigantic dominatrix shoes, which are also so hard to walk in. That was actually my first reaction to *Stepping*. It seemed like you were walking with the gait of someone who's about to be a dominatrix. You know, like you're almost there; you're almost ready. [Laughter] That's great. Yes, that's true.

It's just a personal take. Well, I would be happy to talk about how I came to understand that character or that kind of activity. As I understood it later, when I read Gilles Deleuze's book, *Coldness and Cruelty* [1989], where he takes apart sadism from masochism, and he says that they aren't part of the same function, that masochism has its own desires, and that the torturer in masochism is a function of the masochist and not the sadist. I was always interested in the power shift and the conscious sharing of power in sexuality, about not adopting a role of power and keeping it, but about surrendering it and then taking it back—that kind of elastic loop. Deleuze talks about the deferral in masochism, which is about always trying to defer the end so you can investigate what happens while you're getting there, and to make that into a complete surround of sensuality.

This was something I was thinking about when I later made the videotape *A Short Conversation from the Grave with Joan Burroughs* [1991]. I always thought that Joan swapped her erotic life for an intellectual eroticism with William Burroughs—that she gave up her bodily sensuality in order to have this sort of erotic intellectual life with him. And that's very interesting to me, that there can be an erotics of the mind. I don't just mean that the brain is the biggest sexual organ, but that the idea of thinking something new, different, and complex—and having that change into other ideas—is a kind of eroticism. So I think that that's the posture of the body in a lot of the work I was trying to do.

Let's talk about some more of the early works you were making, like *Ricochet* [1981]. *Ricochet.* Actually, I was thinking about this when you were talking about the body and me. I think I moved back and forth between making work in which the body is a sort of site for philosophical or political ideas, but then, when I was

developing *Ricochet*, I thought, "I just want to make something in which the flesh and the body are connected to nothing—something disembodied." It's the body without being posed as a subject. It was filmed in my studio in graduate school; I painted it that color. I wanted this really intense sort of color that was a space that was a nonspace, that didn't have architecture. I was doing all these pieces where I would mic objects and then play them with tuning forks and an oscillator. The idea was to form a geometry between sound and the body hitting the wall. I remember setting up the camera and doing a little bit and then realizing that I could make the gesture look much more elegant, and possibly violent, if I actually acted a little bit, instead of just getting thrown against the wall, which was much less graphic. It was very interesting, and I learned this sort of dance kind of movement of the arms and the shoulders as it continued. Like I said, I was thinking about a space that doesn't exist; to make a space of just sensation and sound. Somebody told me once I'm sort of dressed like a gymnast in it. I don't know what—I have those—

Oh, because you're wearing leotards? A leotard and these white pants. I always thought I sort of wore these, like, art uniforms when I was doing performance.

It looks very eighties. Very. And the hair.

The hair, the color, everything. Let's step back for a minute and talk more about the community. What was it like to be an artist working with video in Los Angeles in the eighties? Who were the artists you felt close to? It was very exciting. It was a great moment in my life. I remember meeting Nina Salerno, and she and I had an immediate, kind of a punk affinity for each other, and I loved her work. And Tony Oursler, Ante Bozanich, Bruce and Norman Yonemoto and I became really good, lifetime friends. I had gone to Claremont, and nobody else was doing video work there, so discovering people who were interested in things that I was interested in was kind of remarkable. I also met Mike Kelley and Tim Martin, who are also lifetime friends of mine, and I often say that talking to Tim and Bruce over the course of ten years was my real education, coming to know what I felt was important about art making. New York was so much the center of the art world then that nobody looked at what was going on in Los Angeles, so there were ten years or so that you could really experiment and do it publicly—and do it privately—and I think it was kind of a brilliant moment that doesn't exist here anymore. But that's what it was.

Later on, Bruce and I were invited by Marc Pally to start up the Video Committee at Los Angeles Contemporary Exhibitions [LACE], and we started having shows in the space on Broadway. It was a lot of fun. And we were also writing about the shows, which I thought was really important. I always thought that one of the reasons why video had such a hard time was that there wasn't a

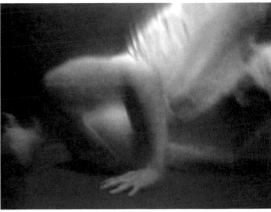

critical body of work about it. There was a little bit: David Antin wrote about video, and a lot of the first phase of video—all that body work—was talked about in the narcissism conversation, and also in a sort of sculptural conversation. But I feel it was usurped really quickly into the language of experimental theater, and the language of the sculptural was sort of lost. And then video art became a sort of antitelevision for so many years, and that language came to bear on it a great deal. It's interesting how it's changed, isn't it?

It's changed a lot. I think it's partially because of a lack of critical literature, but I think it's more a lack of access to the work. I think that even very good critical writing about video nonetheless carries a false impression of the work. If you haven't seen it, you fill in the blanks wrong, and I think that's created a real problem because people can't reference the work in its entirety in the way that a photograph of a painting or sculpture can at least approximate. Right. Which is another one of its strengths in the sense that a lot of video was made to avoid the commodity, you know? Somebody in my class at Art Center [the Art Center College of Design, Pasadena] recently asked me why there wasn't a greater overlap between video art in all of its forms and the film business, and I said, "Because the film business is omnivorous and it will eat anything it can get, and what's left is put in the gallery, which is the things that are too formally complex or too spatially complex to be taken over, to be imperialized by the film business." I used to always say that in a very critical way, and now I say it sort of from the other side, as somebody who works in the film business. But a lot of work that was being done in video in the eighties became Independent Film; it became what is now a huge business of Independent Filmmaking. I think that almost all the narrative work that was being made got usurped into that genre, and what's left is the world of the multichannel and spatial work—basically, the things that cannot be consumed by the film business.

That's actually been a real problem for me putting this exhibition and book together, because on the one hand, one of the really important things that happened in the mid-eighties with video artists in California and everywhere else was this turn to narrative. There was this point where the sort of "boringness" of the performance-based work in the seventies became *actually* boring to people, so they decided to do something completely different, often taking on Hollywood as a point of reference. But now, particularly because that type of work has been absorbed by the independent film industry, it's hard for me to think about it in an art context. I actually can't do it, and it's going to create a lack in the project. But let's go back to the question of writing: tell me

about the *Resolution* book [1986]. *Resolution* came about because I really had a burning desire for some decent writing about video art. So I wrote a grant for the book via LACE. It was a pretty big undertaking. The LACE Video Committee put together a compilation reel of around fifty video works from the last five years and chose critics from really different segments of cultural practice to look at them. Then the critics each chose five full pieces that we gave them to study and, hopefully, to write on. I envisioned the project as a symposium where people talked about the issues, and then as this book that would endure. And I actually think something happened at that symposium, although strangely enough, now I think maybe I was one of the people who killed video art by doing it [Laughter]. But on the other hand, I also think, "If video art couldn't handle that, then it didn't deserve to survive." You know, if video can't develop after criticism, then it needs to take a different form. And I think that's one of the things that has happened. Video in galleries has a different form now than it did then. Anyway, what else can I say about it?

I want to clarify. There was also an exhibition? Yes, and all the pieces were shown in the *Resolution* exhibition.

And did the conference precede the book? No, the books were ready the day of the conference. You know, the conversations at the conference were really quite wonderful. It brought together different kinds of discourse that were going on at the moment. All of those forms and discourses were considered, and none were hierarchized above another. It was interesting because we had such different writers. We had Peter Rainer, who is now a really big film critic, and Beverle Houston—it was one of the last things she did—and Lane Relyea. And who were the other people at the symposium? I can't even remember now. David James, William Olander, Amy Taubin, Chris Dercon, and Jon Wagner, who I think teaches at CalArts now in the criticism school. He wrote this very complex piece that I think people couldn't understand for many years. It was about point-of-view positioning in regards to video. I don't just mean in regards to camera placement, but in regards to identity positions within film. There were actual conversations about the future of video at this conference, and judging from the writing in the book, there was a lot of thoughtful consideration of different forms of image making. That was good, I thought. At the time, I remember thinking that it was maybe one of the four things of my career, like *Stepping*, that I really felt had that quality in the world that I wanted my work to produce. I hadn't made *A Short Conversation from the Grave with Joan Burroughs* yet. I was quite frustrated with a lot of things that I was trying to do, and this, I think, came to fruition. It actually produced something.

p. 192
Patti Podesta, stills from *Stepping*, 1980. Single-channel video, color, sound; 6 min.

p. 193
Patti Podesta, stills from *Ricochet*, 1981. Single-channel video, color, sound; 2 min. LBMA/GRI (2006.M.7).

JOE REES /
TARGET VIDEO 77

Born 1946, Hayward, California
Lives and works in Reno, Nevada

LONG BEFORE THE DAYS OF MTV, artist Joe Rees was videotaping and editing what would become some of the first conceptually and aesthetically driven music videos. After spending several years casually videotaping his friends' performances, Rees established Target Video in 1977, as an alternative media network aimed at collaborating with musicians and artists to produce unique video documentations of live performances. Housed in a San Francisco warehouse, Target quickly became a hub for traveling punk, new wave, rockabilly, and noise bands, and the artists, groupies, and freaks that textured the late-1970s underground youth culture. Imbued with all the raw energy of this scene, Rees fervently videotaped performances—both in the Target studios and at live concerts—later transforming the footage into autonomous works by incorporating provocative found footage and hypnotic graphics. Stitching individual videos together like a DJ, Rees created a legendary series of "club shows," such as *California New Wave* (1979) and *Underground Forces 1–6* (1980), which combine performance footage with images of nuclear bombs, lobotomies, bodybuilders, jet fighters, TV news, and outdated propaganda, creating the video equivalent of the cut-and-paste posters that were synonymous with the punk aesthetic.

Rees's archive of hundreds of bands and thousands of tapes is an impressive cache, one that is as likely to include footage of famous bands like the Clash, Devo, Iggy Pop, and the Sex Pistols as it is to include footage by luminaries and underground figures such as William Burroughs, Diamanda Galas, Johanna Went, and Survival Research Laboratories. Target also captured a number of bands in unexpected venues, such as the Cramps performing live at Napa State Mental Hospital, the Mutants performing at a school for the deaf, and Crime performing at San Quentin prison. Rees's 1978 recording of the rarely seen L.A. punk band the Screamers opens with the cheeky disclaimer, "The following videotape is in stereo sound. We suggest connecting the audio out on your video deck with the audio in on your stereo to achieve the maximum experience. PLAY AT HIGH VOLUME!" A silver and red, color-keyed image of Target's signature skull and crossbones flickers on the screen, dissolving into the Screamers' logo—an image of the angular face of lead singer Tomata du Plenty frozen midscream—before launching into live footage of the band on stage for their wild audience. This clear-cut juxtaposition of the artist's icon with that of the musicians epitomizes Rees's relationship to the bands and performers he videotaped: these projects were ultimately collaborations, another facade of a community held together by their aesthetic affronts to mediocrity.

Catherine Taft

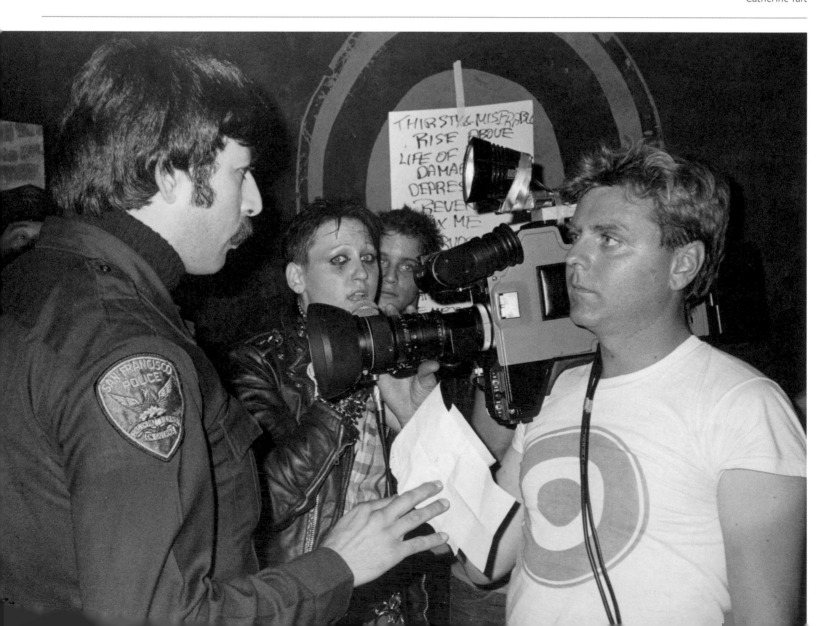

Interview conducted by Glenn Phillips on May 26, 2007, at Joe Rees's home in Reno, Nevada

GP: You started experimenting with Super 8mm film when you were in art school. What were some of the first things you made?
JOE REES: During that period, a lot of visual artists were going through a transition. There was an interest in film and performance art, and people started interacting with their own sculptures and doing these small performances. One of the first films I ever made was *How to Make Turkish Coffee* [1970], with a friend of mine named Ted Falconi. We did it in the studio on my stove there. And Ted Falconi, of course, later became the guitar player for the punk band Flipper. We were close friends during college at the California College of Arts and Crafts in Oakland [now California College of the Arts], and we'd do these goofy little three-minute films, just playing games with language and creating stories. People thought they were funny and enjoyed them, so when a group of artists at school got together to form a band called the Mutants, I volunteered to videotape. For most filmmakers, it was sacrilege to use video. But Sony had donated a Portapak to the school, and it was really inexpensive to use. It had a microphone built into the camera, and it had instant results, so you'd shoot the event, and you could turn right around and watch your own performance. I started shooting performances and all types of different events that we'd have at the art school, and I started shooting some of the local bands. This was in 1973.

And things kind of snowballed from there. How did it turn from something that you did as a favor to something you realized you were really good at and started doing more regularly? There was all kinds of strange performance art going on at that time, and it was really exciting. I was getting a lot of positive feedback from shooting these videotapes, and as time went along, I realized that these productions were going to get bigger than just "Joe with a camera." My girlfriend, artist Jill Hoffman, was helping me with the interviews and schlepping equipment, and it just started to grow and grow. I had a contact at Cable 25, and I'd edit these one-hour programs of music, poetry, and other performance and broadcast them on Wednesday nights. Years later, those same ideas developed into the feature programs *California New Wave* [1979] and *Underground Forces* [1980].

Who were some of the early performers and musicians you documented? In San Francisco you had groups forming overnight, for example, the Dead Kennedys featuring Jello Biafra. The Nuns were an excellent group, and, of course, the Mutants were growing at that time. Chip and Tony Kinman formed a band called the Dils, and Penelope Houston formed the Avengers with some of her friends. A lot of these groups would play on the same bill, and you'd see these beautiful posters that the bands created themselves. You'd see these things on the walls and telephone poles, and you could feel that a whole community was starting to grow, even though it was just limited to certain nightclubs—like they'd rent a place called the Deaf Club, which was actually a place for deaf people. Or they would rent the Geary Temple, where Jim Jones used to have his big religious meetings. There was a Philippine restaurant in San Francisco called Mabuhay Gardens, and Dirk Dirksen, who ran the place, would book bands in there at night. It was really a movement. You could go to a club and the flyers would become the visual art; there'd be photographers there, and they would put their images together into homemade books. Poets would be writing lyrics to songs, which would be like spoken word with noise behind it. You had a lot of people just

stepping up on stage saying, "Hey, I'm going to give it a shot," and sometimes they only lasted one night. The whole scene offered the kind of feedback you need as an artist, and you could make a few bucks. You didn't have to be the best guitar player or the best band around, and you actually got more monetary response than if you hung a piece in a gallery.

Now when did you move in to the big warehouse space in San Francisco? I moved there in late '79 and was there until the '89 earthquake. It was a three-story brick building in the Mission district and it had a nice loading dock, so you could back your truck up to unload equipment. It was attached to the building next door, almost occupying a full city block. Later on, *Damage* magazine moved in next door. It worked perfectly because their magazine was all about music and art—so, again, we almost had our own little city. On the bottom floor, I had a live stage, an editing facility, and, in the very back, a friend installed a soundproof recording studio. I could bring in up to a couple hundred people for a live show, and the audio could go directly to the recording studio. The other two floors were living space. At one point, I had about twenty people living there. Some of them worked for me, some just rented. But believe me, in order to get in there you had to have your heart and soul tied up with the scene. It was a community center. Later on, Jello Biafra got married there, and when he ran for mayor of San Francisco against Diane Feinstein, Target Video Studios was his political headquarters. Lowell Darling, who ran for governor of California, used the space for his political headquarters too, which was pretty goofy. I eventually put a bar in and a facility to produce drawings and posters. So it was a real serviceable place. When certain bands from L.A. would come to town, they would stay there. Black Flag was a real steady customer. So it became a hotel, too.

Black Flag would do their own performances at Target Video Studios as well? Right. I was totally interested in Black Flag and their music. They're one of the greatest bands that I ever worked with. I'd either shoot them at the nightclubs they were playing or we'd take a Sunday after their other commitments and invite people to a live taping at Target. I must have made eight or ten videotapes of their shows with various lead singers, of course Henry Rollins being one of the most popular. We made their "Rise Above" video-

p. 194
Joe Rees being confronted by a San Francisco policeman during a live videotaping of Black Flag at Target Video Studios, 1981. Black-and-white photograph, 20.3 × 25.4 cm (8 × 10 in.).

p. 195
Detail of posters lining the walls at Target Video Studios, 1982. Black-and-white photograph, 20.3 × 25.4 cm (8 × 10 in.).

tape in the studio. We could record the audio and video, and have a live audience. We got the best of both worlds.

You would also go to New York and L.A. to do shows. How would that work? It worked well. I'd try to combine things. Quite often I was on the same bill with the band. So it'd be "Target Video and X" or "Target Video, the Avengers, and the Mutants." We became just like a band, and then it was also an opportunity to go and shoot other bands. You have to remember that this is just the start of this whole movement. I was there for the Germs when they performed. I was there for the Screamers and the Weirdos and X—all L.A. bands. When I met the Screamers—I mean, to this day I get goose bumps to even watch the tape. They're one of the most unique groups to come out of L.A. And they never signed a record contract. I'm so grateful that I taped a show with them in my studio, and went down and taped several others in L.A. To have all that great material is so important.

One of the things I like most about Target Video is that the raw quality of early video really matches with the raw nature of punk. But I also wanted to talk about the evolution of how you started editing and trying to shape the performance footage into something larger. Well, the hard edit is also a perfect marriage with the edge of punk music, and that's what I really liked. There was a lot of power in an edit—just one edit, just right there. You put all this energy together in a big ball and you fire a torpedo, so to speak. That's the way I always looked at it. In 1980, I received the Adaline Kent Award from the San Francisco Art Institute. That was a total surprise, because I was doing all this crazy stuff and I had pretty much pulled away from the art gallery scene, even though I was still teaching art. My show at the Institute was a continuous twelve-hour presentation of edited video, and I covered all the walls in the gallery with posters from the various events that I'd participated in and that my friends were part of, so I could represent not only myself but a whole group attitude. And it really went over well; it's that whole thing about you're in the right place at the right time. There were a lot of people from the East Coast and Europe who saw that show, and in a matter of months, things just exploded. I got invited to Paris to do a big event over there for an organization called FNAC. They approached me to do a couple of

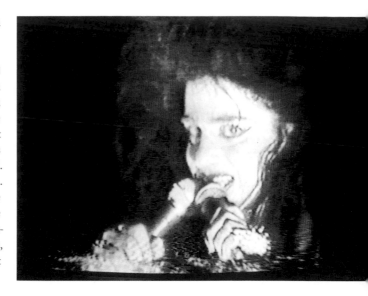

weeks of video showings in Paris at some of their stores, outlets, and halls, and I took the *California New Wave* program there. So all of a sudden, Target Video was now being legitimized in the sense that we could take a whole program and create another event in another city outside of San Francisco or Los Angeles or New York. We were going to Europe to a whole different kind of setting, and it was kind of a new edge. After that, we started getting more shows in Europe. I bought a video projector and a big PA system, and as time went along, I bought a couple of Volkswagen buses and we loaded our gear on there and we went from city to city.

We should note that this is still pre-MTV, which didn't begin until late 1981. Oh, yeah, still pre-MTV. And you know that was another thing that was always in the back of my mind when I was struggling for funding. I always thought that one of these days they're going to see the value of music video and put it on an organized TV show, like when I had my little cable show. But what happened was when MTV started developing—sure they wanted some of my material, but they didn't want to pay for it, and the record companies just started their own in-house video organizations so they could control it all. And, of course, everything was watered down and became nothing more than a commercial extension for them.

How long did you tour in Europe with *California New Wave*? Well, I'd go over there for a few weeks or a month, and then I'd come back to San Francisco, shoot some more material, edit. It was getting into one of these revolving scenarios, with very little sleep and a hell of a lot of work. But altogether I took the shows to twenty-two different countries over about a four- to five-year period.

So by that time, you'd also done *Underground Forces*, and— Right. I developed this *Underground Forces* idea, since most of this material was "underground," meaning it featured the type of art that wasn't exposed commercially and didn't get acknowledgement. I did the programs in around two-hour chapters, so *Underground Forces 1, 2, 3,* and so on. I think I got it up to *Underground Forces 6* before I left off. I eventually had about fourteen hours of edited material, and there's hundreds of hours of footage that's untapped.

Now in the 1980s, people were buying VHS players for their homes, and you started making some of the tapes available commercially. The first one we did was called *Live at Target* [1980], and it featured four groups that performed at Target Video. I produced it in San Francisco and tried to launch it in a market that didn't

really exist. But I designed a cover, made duplicates of the tape, put it in a shrink-wrapper, and took it around to some of the record stores and tried to put it on the shelves. I sold a few, but very few in the beginning. I saw it as a form of entertainment, like a video magazine, because there was a lot of extra stuff in there that I attached. I wanted to make it more about the punk movement. And eventually it really worked. I got picked up by Virgin Records and they started distributing through their normal channels. It was a whole new thing for them and they were a little cautious. But with those kinds of companies, if they can make a couple of dollars, they're happy. And that's all it took. In the seventies, Dirk Dirksen taught me a very valuable lesson when he told me that one of the most important things to do was to have the band sign a contract. He also put me in touch with an entertainment lawyer, and I'm really glad we did that, because it just made it all legal in the beginning and there weren't a lot of issues. Toward the late eighties, when things got serious, the record companies started controlling all the video making. It wasn't an overnight thing, but it started getting tougher and tougher to deal directly with artists.

Why don't you talk about filming *The Cramps Live at Napa State Mental Hospital* in 1978? We were always trying to find unique shows to set up, like the Mutants performing at a school for deaf children, which was completely off the chart compared to normal channels in the music world. This opportunity came up to do a show at the Napa State Mental Hospital with the Mutants and the Cramps. So we all got into a big truck and went out there, and we didn't know exactly what to expect. We set up outside on a little veranda next to one of the buildings there. They opened the doors; out came the patients, they started playing the music, and I started videotaping. But as the whole performance started developing and you saw the interaction between the patients and the band—I mean, you gotta understand: they don't get a lot of entertainment. No one goes and visits mental patients. So they were just having a wonderful time, letting themselves go and really enjoying it. And you can see that in the tape. I've gotten so much feedback about that tape, and it's definitely had ripples in the creative world. One of the things that really surprised me recently is when I heard about a theater group in England that actually created a theatrical play around that videotape. They actually restaged *The Cramps Live at Napa State Mental Hospital* as live theater. Now that blew my mind.

Another one of those videos where I really felt like I was in an alternate dimension was *Crime at San Quentin Prison* [1979]. That was arranged through an organization called Bread and Roses. It's funny, because later on I worked for the Department of Corrections and I was also booking shows, but I never found a band as good or as interesting as Crime. Crime was a punk group from San Francisco who dressed in police uniforms when they performed on stage, and they've got some pretty strange music. They set up a stage outside in the prison yard at San Quentin, and you had a few hundred inmates there—and let me tell you: San Quentin prison is very convincing. It's an old prison, and as soon as you're there, you know that you're in a prison, and there's an edge. This is back in 1979, and an interesting thing in those days was they allowed inmates to have long hair. So the majority of the white inmates had long hair and beards, and the Black inmates had afros, and they all bunched up in their own groups and formed this audience. And again, they don't get to see entertainment like this. This was a very unique situation. So Crime takes the stage and starts performing, and they had brought along a few of their girlfriends who danced in front of the stage. They were dressed modestly, but then again,

to have females dancing around in a men's prison—well, the men were very excited about the whole show. So as I shoot the thing, I'm looking around, and obviously the setting is very weird: Policemen performing to a bunch of inmates. And then my camera pans up to the prison wall, the walking area around the edge of the prison, and there's a correction officer, a black woman standing up there with a high-powered rifle, and she's got an enormous bleach-blond afro, and I mean if John Waters or David Lynch wanted to put together a movie like that, it couldn't have been as good, because it was just perfect, the whole scene.

Now in addition to all the bands you were shooting, you were also shooting other types of performance art. Why don't you talk about SRL [Survival Research Laboratories] and some of those early performances. SRL was an organization in San Francisco that originally started out with one artist, Mark Pauline. He would create machine robot-type objects that in the beginning would perform very basic functions, but there was often a lot of social and political imagery, and they were always threatening. Lots of knives and guns and cannons. Early on, they looked like something out of a Dadaist show or something, where you had these funky mechanical operations, and a lot of bizarre soundtracks. Mark often used explosive devices, and he didn't always know how things would turn out. There were a lot of dangerous things that occurred over the years. But as his work grew, SRL became a very large organization, with lots of people involved. The robots became life-size and then car-size. They became monstrous things with big cannons, and I basically documented and videotaped this. It just seemed like a natural part of the community.

The footage we looked at yesterday of SRL firing fluorescent tubes out of cannons was really shocking to me. My god, it would kill a person in an instant, if that ever hit you. I remember one time—in fact I've got a clip of it—they were working with a helicopter that they had made. And there was no way to control it! They just had it tethered, and I'm thinking, "If that tether broke, that thing would just go around and decapitate the entire audience." It was a full-size helicopter, and there was no way to stabilize it! Holy smokes. I'm just grateful I wasn't injured doing that type of work. That's gotta be a heavy load to deal with.

Stepping back for a minute, one thing I've wondered about is how on earth you could take a Portapak to a punk concert without it getting destroyed? How did you protect the camera from the crowd? Well, the whole nature of the experience of the punk band with an audience is to let yourself go. And there are certain rituals that developed through those years, and one of them was slamming the guy next to you. Running into him, or tumbling off a stage in midair, just taking a god-awful dive and landing—hoping somebody's going to catch you. Quite often I was down in the pit, right in front of the stage, where all the audience is slamming around. It didn't take long for me to figure out that I was gonna need some protection, because for one thing you've got your eye inside the viewfinder of the camera, and you can't see incoming from the right side at all. So one of the guys I was working with, Sam Edwards, was a tall, muscular, big man and he was perfect for this job—basically, he was my bouncer. In those days, I had to use a cable from the camera, so he'd also watch that I wouldn't trip over my own cable when things were slamming around. He started wearing studded arm pieces and a vest and everything. He looked like a Roman soldier out there with all the gear on. He took it very seriously and he did an excellent job, and I literally probably owe my life to the guy, because when there was incoming, he took care of it.

p. 196 top
Joe Rees, still from *Diamanda Galas, Litanies of Satan*, 1985. Single-channel video and Fairlight CVI effects generator, color, sound; 20 min.

p. 196 bottom
Joe Rees, still from *The Cramps Live at Napa State Mental Hospital*, 1978. Single-channel video, black-and-white, sound; 60 min.

MARTHA ROSLER

Born 1943, Brooklyn, New York
Lives and works in Brooklyn, New York

MARTHA ROSLER BEGAN WORKING WITH VIDEO in the early 1970s, drawn to its mobility and its freedom from the discipline of aesthetic standards. Through more than thirty years of critical storytelling, Rosler reveals a sustained interest in problems such as individuality and normative society, the "racing" and gendering of bodies, colonialism and cultural imperialism, politics, violence, media, and histories of repression in law and science.

Much of Rosler's work uses the instant legibility of the everyday as a foil for precise deconstructions of society. *Vital Statistics of a Citizen, Simply Obtained* (1977), first performed while Rosler was studying for a Master of Fine Arts degree at the University of California, San Diego (UCSD), and later restaged as a video, counts on the willingness of viewers to read such visual tropes as lab coats and old photos as "science" and "history." In the opening act, Rosler gradually disrobes while men in white coats use clipboards and tape measures to compile an exhaustive catalogue of bodily measurements. A chorus responds as her body parts are compared to those considered "standard." The work broadens to include human measurements in various registers as instruments of social policy. Later, a crouched and naked Rosler breaks a half-dozen eggs into a bowl. Some eggs are brown and some white, but, once the shells are gone, they are indistinguishable. The final act pairs a montage of photos with Rosler's voiced-over litany of crimes committed against women. The photos, Rosler explains, were drawn from a 1930s book on pattern measurement. The book instructs the project's technicians to collect measurements for white people only—and to discard all others. The third act contextualizes the first two, while revealing the complicated social violence embedded within something as seemingly mundane as measurements for clothing patterns: white women's bodies are depersonalized and catalogued; bodies of color are deleted from the historical record.

Rebecca Peabody

Interview conducted by Glenn Phillips on March 11, 2007, at Nancy Buchanan's home in Los Angeles, California

GP: You moved around a bit, so let's start by clarifying the dates when you were on the West Coast.

MARTHA ROSLER: I moved to San Diego in September 1968 and stayed for about six or eight months, living in Solana Beach, which was where David and Eleanor Antin lived. They were friends from back East. I went back to New York sometime in spring 1969. I had a small child, and I was having trouble making a living. I lived on the Lower East Side and I was miserable. So I moved back to San Diego sometime in 1969, and then I became a student in 1971. It is easier to get around and be independent in San Diego. Of course, San Diego to me was not San Diego proper, it was North County, a series of depressed beach towns in a really down economy. San Diego was a city that lost its way after the Korean War and never quite made it back up for two decades, until it became a tourist destination and a utopian-lifestyle destination. In order to do that, the town had to develop a university, so there was a big plan to develop North County, but it wasn't there yet. I had a very nice little life on the beach in various towns, often living communally. I went back to New York for part of 1974 and '75, came back to San Diego and stayed until 1978, moved to San Francisco until 1980, and then I spent time in Vancouver before finally moving back to New York City.

You became a student at UCSD at a time when it was becoming sort of a maverick art program. The department was brand new and it was started by maniacs, which was great. It was made up of people who might not normally find employment in a traditional art department—people with slightly swelled heads about themselves, each of whom—like David Antin, Harold Cohen, Manny Farber, Helen and Newton Harrison—could describe themselves as two things, and then a third thing, which was "theorist." So they could be a poet and an art critic and a theorist, or a painter and a computer guy and a theorist, or a sculptor and an environmental artist and a theorist. The whole hype of UCSD was to attract fabulous people in every discipline and to lure them to Lotus Land, no weather, and the beach. The art program was very open and not interested in turning its students into production machines or routing us into traditional disciplines. I had a wonderful time. I was part of a group that was called a cabal, based in the photo area. But we also did video, and at least one of us did film, but not me.

What did you think of this utopian idea of San Diego as it was developing? How did that influence your work? Obviously, it is very different from the Lower East Side. Are you sure?

Well… San Diego had better weather than New York, but that utopian vision at the end of the sixties was part of my generation. We thought we could change the world, and we did change the culture in many ways—even though it has kind of changed back now. But this was not something confined to California. Of course, California always likes to arrogate to itself the idea that it is the true home of liberation. The epicenter of the student revolution was in Berkeley, and that was a big draw for me: if California could produce the worldwide student movement, then it might be a great place to be. I also had a little baby, and I thought that his lungs should be pink, not ashen. So there was the desire for fresh air. I also thought it would be a great vacation from real life, because everybody knew California was a simulation. But it is a very seductive simulation, and there are a lot of advantages to mobility. I also liked the fact that everything was provisional. They made up housing as they went along. The homes were made out of chicken wire and sprayed stucco, and everything just seemed ill thought out, which was great: cheap and not constrained by brick buildings and heavy traditions of the past. That is the main utopian element of California, and it worked for me.

What was the community of artists like in San Diego? How aware were you of things going on in Los Angeles? UCSD was an enclave in the midst of a great military machine, which was San Diego. We were very conscious of our separation from the rest of the world and the community, and we lived in North County mostly, because who wouldn't, if you could? We were aware of people in L.A. for sure. What mostly drew me to L.A. were the women, like Nancy Buchanan, and the Feminist Art Program at CalArts [California Institute of the Arts]. I remember very well driving up there numerous times, but I

p. 199 top
Martha Rosler, still from act one of *Vital Statistics of a Citizen, Simply Obtained*, 1977. Single-channel video, color, sound; 39 min., 12 sec. LBMA/GRI (2006.M.7).

p. 199 center
Martha Rosler, plates from a pattern measurement book used in the production of *Vital Statistics of a Citizen, Simply Obtained*, 1977.

p. 199 bottom
Martha Rosler, still from act two of *Vital Statistics of a Citizen, Simply Obtained*, 1977. Single-channel video, color, sound; 39 min., 12 sec. LBMA/GRI (2006.M.7).

was never a fan of L.A. Anyplace where you had to drive for an hour just to see a friend was not for me. I was perfectly happy, thank you very much, in my little enclave centered in La Jolla.

When was the first time you held a video camera? David Antin made friends with Charlie Cox, who ran the video studio in UCSD's medical school, where they videotaped autopsies and operations. They made a deal where whoever wanted would be trained in using the studio. There were five guys who were graduate students, David, and me. We went down to this airless room in the basement of the medical school, and Charlie started writing wave-form diagrams on the blackboard. I had a moment of intense panic, but I reminded myself, "I studied physics. There is nothing surprising about this, even if I am in a windowless basement room with a bunch of guys, and cadavers in the vicinity." We actually began with the electronics and then progressed into the studio. The first work I did was *A budding gourmet* [1974]. It was not the first time I held a camera, but, of course, one does not hold a studio camera. The first time I held a camera was probably *Semiotics of the Kitchen* [1975], but I didn't shoot that either.

Could you describe *A budding gourmet*? I decided to adapt the script of a purely nonvisual work I had done, a postcard novel in which each week I mailed one of a series of cards. It was a first-person fictional autobiography about a woman and her relationship to gourmet cooking. I chose that work because I believe in economy; it is very important to recycle your work and put it into different media, rather than being stuck on the creative moment or medium-bound. Since this had been a work without visuals, I decided to incorporate images from the back story about the disparity between rich countries and poor countries in terms of producers and consumers of food products. It starts with a silhouette of me dressed as a dowdy-looking person, sitting and talking about wishing "to become a gourmet." Then a sequence of images from rich and poor cultures appears. The tape kind of drones on in my delivery of the time, very deadpan. This rather depressed, seething woman is talking about her desire to take from all times and all places, and make them her own. She is enunciating an unconscious, internalized imperialism, while we see images of gourmet food from fancy, Escoffier-type cookbooks, the Time-Life *Foods of the World* series, gourmet food stores, and then news photos of starving children.

One of the interesting things to me about your work is that you make conceptual artwork directly political, and you make political art more directly narrative. I am wondering how that happened, because most of the videos being made by other artists at this time were not narrative. I did not think of asking anybody permission or how to make artwork. It never occurred to me that ideas needed to be routed through expectations—particularly in video, which was like a sketchbook of sorts. It is true that I decided to incorporate narrativity into my work, but, until you mentioned this, I had not systematized my relationship to these questions of narrative, conceptual art, and politics in quite those terms. I wanted a conceptual art that was less about ordinary language propositions or idealist definitions of art, and I also wanted to incorporate into my work a politics that was situated somewhere in ordinary life, but without the expected affect—a more Brechtian approach to narrative. *Semiotics of the Kitchen* took on the television program, and so did this work. But I never thought I needed permission: I thought I would just do whatever I wanted to do, and anyway, that was what I was supposed to be doing. I had no overwhelming or fetishistic respect for media, for any given medium, or for the discourse that

surrounds it. I did not at all mind falling flat on my face and being totally amateurish. That is fine—although it is also possible to fall over the cliff, and then that is not fine.

You mentioned the process of translating a work from one medium to another. What did video offer that you could not do in other media, and how might that translation help you augment a work? Video was good for cheap, crummy-looking moving images. They were like movies made on the cheap out of toilet paper, which, therefore, could not be judged by the normal aesthetic standards. The same way performance could not be judged by theatrical standards, video could not be judged by the standards of cinema. Most importantly, it was easily duplicated and transmissible by mail, and, therefore, it could evade the commodity fetishes of the moment and simply be a work. So it was a moment in a dialogue, or a discourse, I should say.

The interest in food and how we consume things in this country and other countries continues through a series of works, including *Losing: A Conversation with the Parents* [1977], which is a video that actually involved actors and a script. *Losing* is recycled work, like *A budding gourmet*. It was done for *Criss Cross Double Cross*, Paul McCarthy's artists' newsprint tabloid-format magazine. It was based on an *L.A. Times* Q & A, a feature they had

I wish to become a gourmet. I do this because I feel it will enhance me as a human being. That is, it will better me and make me more valuable to myself and others. I will be more knowledgeable about the good things, the things that make life pleasant. The gourmet is a sensitive person; he knows good from bad and from nothing-special. Quality. Animals eat to satisfy their hunger, to stay alive. As people we don't have to do that. I mean we don't have to do only that. We can make eating into an experience. We don't have to worry any more about where the next meal will come from--far from it! If anything, we eat too much. There's food all around. The question is how to pick and choose--to know what's really good

in their glossy weekend magazine. They would go into some fancy home and ask people about their "lifestyle," which was a new term of the moment. I first did it as a photo-text work, and I researched it for six months. It was about anorexia nervosa, although I did not use the term, because nobody had ever heard of that in 1976. It was intended to interrogate the form of the interview of nice, middle-class people who have a very happy and settled bourgeois life until tragedy strikes. I wanted to bring the unspeakable into the conversation: girls who starve themselves to death.... Oh, and by the way, there are political prisoners, and then there are people who are starving to death for various geopolitical reasons. I always liked to muddy the waters. Very little of my work is purely about one thing.

The video takes the format of an interview with a couple whose daughter has starved to death. The man has man things to say about the world and starving, and the woman is all psychologizing. The idea was to create expectations of what something will look like, and then break them; I was always trying to undermine the authority of the image of the situation. I am fascinated by how easily I fall into believing that advertising images of living rooms are really living rooms; I have to say to myself, "That is a set." But this was a real living room that I was trying to convert into a set. You have a long-duration shot where the actors are stuck into the corner, and then the camera lurches over to an empty chair; the light shines on the chair, and then the camera lurches back to them still sitting there. Then there is a shot where all you see is their hands, waving about, while the mother intones a monologue. The mother says something absurd, like "I have carrots in my mind." She also says earnestly, "When girls get angry or upset, they take it out on themselves; boys just take an ax or a shotgun to their family," and the father pontificates about various things—these remarks leave the audience uncertain about whether to have an empathic or a disgusted response. The script brings in political prisoners and suffragettes who starve themselves, and the way that food is a weapon, and the fact that people starve because they do not have enough money. At the end, the mother says, "We read of a Dutch couple in the war that ate the body of their dead little girl when they were starving, and then, after they had been fed, they were overcome with remorse," which is basically what they had just done: eat the body of their dead little girl. And then she says, "Sometimes when you are given food again, you cannot eat it, and you pass away anyway . . . like she did." The work was intended not just to be about its subject, but also to be about the interview form—how you expect a "money shot," like an image of an emaciated, starving girl, when, in fact, the pictures we see are crushingly ordinary, or of people weeping on camera, which we also don't see. You do not expect bereaved parents to talk about children starving in another country or political prisoners.

Could you talk about the relationship between video and the women's movement? Obviously, a lot of women used video to make political work, but how important was video as a tool? Alongside performance, video was a very important tool in the women's movement, because it was new, provisional, cheap, simple, time-based, and speaking. Like performance, it was time-based and speaking; like performance, it was provisional; like performance, it evaded expectations of professionalism and genre. But unlike performance, it was exactly repeatable and transmissible to others elsewhere. It could be incorporated into installations, there might be a speaking voice, but there was definitely duration. I think people forget how important movies were for art in the 1960s. Film had supplanted architecture as the queen of the arts, and everybody thought about movies, the moving image; so video was within women's lexicon of address and expression.

Video created a community, it resided within a community, and it moved to other communities, creating a new, discontinuous "imagined community." It had many possibilities because it was new and no one was telling you what you had to do with it.

Your video *Vital Statistics of a Citizen, Simply Obtained* [1977] had first been done as a performance in grad school at UCSD. What are the differences between the performance and the video? Did you change what happened in the performance, or did you just adapt it for the frame of a monitor? There is no comparison between something performed with a live audience and something performed without. They are not the same thing in any way. In the performance version, my naked body was measured point by point, and then I got dressed and left. There were no voice-overs in the performance. There was no speaker. There was just the measuring. What I learned from the performance was that when you do a striptease and take off all your clothes, there are going to be men sweating and falling all over you, no matter what—which was interesting—but my reaction was a little bit like: "Whoa." After the performance, Newton Harrison said, "You should do this as a video." I was taken aback because we did not videotape performances—we believed that performance was meant to evade representation. We did lots of ephemeral works that are not documented, and I do not know what to say about that, except we were probably right. When David Ross at the Long Beach Museum of Art lent me a Hitachi camera to make some new videos four years later, I remembered Newton's idea. I made the video using as boring a long shot as I possibly could—twenty minutes of a woman being measured—and I put several mediating soundtracks over it. The video also had two further sequences that did not exist in the original performance. In an introductory section with no image—only blue screen—I say, "There is no image on the screen just yet." After ninety seconds, the work's title comes up. The voice-over tells you what the work is about, and it specifically references the Godard film, *Vivre sa vie*, where the main character—Nana, the prostitute, who is the bearer of philosophy in the film—has a conversation with a male French philosopher, during which, in due course, she asks about the inside and the outside of chickens. My intro says, "Like Nana's chicken—only here we deal with eggs." That is the second act after the dressing sequence. It shows me crouched in front of brown and white eggs, breaking them into a bowl, silently showing "what is the same and what is different." Then the third act is referred to as "horrific and mythic," and the images in it form the basis of the whole work—although this was not disclosed the first time I performed the work. In the library,

I had found a series of books from the 1930s on how to measure women and children, ostensibly for pattern design. The discourse was racialized, and the instructions stated that if you are forced to measure a person of color, just go through the motions but discard the data. So their data were not included. I was talking about measurement as a method of disciplining populations. It was not just about women; it was about the way society creates mechanisms for comparing people and then excluding some—creating a hierarchy of importance and defining some groups as negative. It was also about internalized oppression, the feelings of inferiority such hierarchies instill.

Were all of the measurements being taken in *Vital Statistics* pulled exactly from this book that you'd found? They mostly were. Except vaginal depth—that does not exist in pattern measurement. No one wants to know. . . . Who's asking? I didn't do that one in the live performance. Of course, the measurer is not really doing it in the video either. Mostly, though, they were the actual measurements—really absurd ones, you know? Thigh to knee; thigh to toe. But a couple of others were not from the book, like little toe length or big toe length, so there were a few zingers in there.

Is there anything else you'd like to talk about? I would just like to say a few words about the context of art production taken for granted by most of us. In the 1970s, bohemia wasn't quite dead, and one assumed one's friends would be drawn from all disciplines; now we've gradually experienced a segregating professionalization in which artists mostly hang with artists, poets with poets, and writers with writers. We are also talking about a period that saw the greatest upsurge of public activism since the thirties. We all felt—those of us who were working in video and media, at least—that we worked within a matrix of and against a backdrop of social upheaval; you couldn't *not* have a position on the war, and so on. Everybody assumed that she was part of an electorate, a citizenry, a body of people who had the capacity and the obligation to intervene in the conduct of public affairs and national life. We took for granted that we were informed and engaged citizens. The market very much militates against that kind of idea now, and I see that in many schools now our students are expected to slam the studio door and concentrate on becoming very good at a craft, which is a very self-isolating, narrowing, thing. We never would have accepted or even understood somebody with that point of view then, and certainly no one posed it to us. We felt we were obliged as artists to make use of the new technological tools to help make a more just and unitary world.

p. 200 top
Martha Rosler, *A budding gourmet*, 1974. Single-channel video, black-and-white, sound; 17 min., 45 sec. LBMA/GRI (2006.M.7).

p. 200 middle
Martha Rosler, *A budding gourmet*. Card number 1 of serial postcard novel in twelve parts, first mailed January–April 1974. Printed postcard, 7.6 × 12.7 cm (3 × 5 in.).

p. 200 bottom
Martha Rosler, image used in the production of *A budding gourmet*, 1974.

p. 201 left
Martha Rosler, still of Peter Lewis and Susan Hackett in *Losing: A Conversation with the Parents*, 1977. Single-channel video, color, sound; 18 min., 39 sec. LBMA/GRI (2006.M.7).

p. 201 right
Martha Rosler, the artist describing the Letter K ("Knife") in a still from *Semiotics of the Kitchen*, 1975. Single-channel video, black-and-white, sound; 6 min., 9 sec. LBMA/GRI (2006.M.7).

ILENE SEGALOVE

Born 1950, Los Angeles, California
Lives and works in Santa Barbara, California

ILENE SEGALOVE BEGAN WORKING IN VIDEO in 1972, after receiving a Bachelor of Fine Arts degree from the University of California, Santa Barbara (UCSB). She received a Master of Arts degree in communication arts from Loyola Marymount University in 1975. As a member of the group Telethon with artists Billy Adler, John Margolies, and Van Schley, Segalove developed a critical sense of television's powerful role as a sort of collective home movie for a media-driven society. Inspired by her own childhood experiences in front of the TV, she adopted the familiar formats and icons in her autobiographical and loosely anthropological video work. Using video's intimacy and the condensed structure of television news stories and celebrity interviews, Segalove creates funny, accessible, and very private first-person narratives that draw on her experiences growing up in Beverly Hills. Considered one of her signature works, *The Mom Tapes* (1974–78) is a series of short pieces about Segalove's mother. Half scripted, half improvised, they feature mother and daughter in witty, self-satirizing skits about personal and mundane aspects of everyday life. The cumulative result is a poignant and whimsically funny portrait of a mother-daughter relationship.

In *What Is Business?* (1982), Segalove applies the same disarmingly personal and humorous approach to the serious subject of making money. As the unseen narrator in this parody of educational films, Segalove sets a satirical tone. She conducts interviews with business people that play like deadpan comedy routines within the context of the tape. Segalove's humor and the simplicity of the question posed by her title belie the complexity of the issues addressed in the video, from the power of money to the lack of trust in business, from the dehumanizing effects of work to perceptions of professional women. When Segalove sent the tape to distributors of educational materials, it was consistently rejected with the same explanation: "Your piece raises too many questions."

Andra Darlington

Interview conducted by Carole Ann Klonarides on March 31, 2007, at the Getty Research Institute in Los Angeles, California

CAK: When we had coffee this morning you mentioned that we didn't get into this to make a living. Why don't you tell me what that means?
ILENE SEGALOVE: Making art is rarely about making a living. Making video art, when "video" wasn't even a word, was really a long shot. The first video artists that I was aware of were creating work that had no context or venue, let alone value. So it was a really cutting-edge nowhere land, which, for me, was the reason I liked it. I liked feeling that we were doing something that hadn't ever happened before. I remember people asked me what I did. I said I was shooting video. "What is that?" And I'd say, "It's TV but it's not TV, because it's not on TV." So then they'd say, "Well where can I see it?" and I'd say, "Nowhere." Then they'd get that glazed look and change the subject.

What was it like making video in the middle of the entertainment industry in Southern California in the 1970s? Were artists on the West Coast guilty of making art that was more entertaining? Guilty of being entertaining! I hope so. To back up a little, I was never really interested in making art for a museum or gallery (that had no understanding or interest in showing it at the time) but making something for TV. Real TV.

My real inspiration was the television of the 1950s—Groucho Marx's *You Bet Your Life, Queen for a Day*—shows that were a kind of a blurred Neanderthal reality television. When I first got a video camera, I really thought I was going to make television. And when cable came around later in the seventies, I thought the stuff I shot had finally found a home! Little did I know that you actually have to talk to somebody and compromise and, well, you know the drill. So I think I operated in a vacuum, but I wanted to make TV, and that is how the work happened. Some of my favorite shows, like *Burns and Allen*, were about real people telling their real-life stories in a stylized fashion, so making *The Mom Tapes* (1974–78) made sense to me. I always thought my mother should be on TV, so I put her there, which was kind of therapeutic and powerful and, hopefully, entertaining.

Did she think she should be on TV? She thought she should be with me, and if I was going to do something and she was included, it was great. And, fortunately, my mother was funny. I'd ask her to tell a story that I'd heard too many times, or I'd create a situation and she would do whatever she would do, and I would just trust it would work, which it usually did. She'd still like to be doing this with me now, at ninety plus years old.

Should we cut her in? No.

How did you get access to equipment? When I was at UC Santa Barbara in the late sixties and early seventies, an artist named Roland Brenner had a Portapak and brought it to sculpture class, and he shot one of our sculptural installations and showed it back to us. I was horrified. I felt captured and scrunched down and manipulated, and my response was so strong that I decided I wanted to get a camera, because it was just amazing. I mean I had a full-

blown response, finally. I had been undeclared before and now signed on the dotted line and became an art major.

And then when I graduated I bought one of those oversized contraptions. Nam June Paik was a friend of a friend, and his girlfriend's Portapak was available, so I bought hers. Of course, it wasn't that portable at all, and this camera-unit on my right shoulder was the beginning of many years of bad back-ness and suffering and schlepping.

Most artists making video at this time were still situated in the studio, whereas you had this idea of going out and actually making something similar to television, with an accessible narrative. You weren't in a vacuum though. You were somewhat aware that people were making video art. Well, I really wasn't aware of it until after I graduated, but at UCSB I did meet two important people that affected my life—Billy Adler and John Margolies. They had been in advertising in New York, and they taught this class where they showed you slides of images that were kind of popular architectural icons, like the coffee cup from Sambo's. I remember they

made it seem like those icons were important, and they made me recognize that my own life had value, and that I could dip into it and use it as material. That really turned me on, and then I got involved with them and was part of an installation they did at UCSB, I think in 1971. We built a prototype living room in the art gallery, with a couch and a TV.

I did learn one very important thing: people came into the gallery by the droves, and they sat and ate popcorn and watched TV. It was art, but it was TV, and I learned that if you gave people a familiar place to hang then they would show up. The notion of a rarified context, like having to go to a gallery or museum to look at art, always turned me off. But suddenly, the lines had been blurred and it was like a lightbulb blasted and I thought, "Wow, this is great." And I really didn't care if it was labeled art. I wasn't attached to being an artist, but I was attached to telling stories that people wanted to listen to.

In 1973, I decided to go to graduate school. I went to Loyola Marymount University, which had a communication arts department, which was a night school program. I wanted to do something

p. 202
Ilene Segalove, life-size cut-out figures used in *California Casual*, video installation at Arco Plaza, Los Angeles, 1977.

p. 203
Ilene Segalove, stills from *What Is Business?*, 1982. Single-channel video, color, sound; 28 min., 30 sec. LBMA/GRI (2006.M.7).

magazine and *The Ernie Kovacs Show. The Cauliflower Alley Tapes* [1976], which Lowell Darling and I created with Peter Kirby at the Long Beach Museum of Art, is a case in point. It featured a group of retired boxers and wrestlers, real people. They chose hours of stories to tell us, and we cobbled them together as Hollywood archaeology shown in an art context. One of the things I was accused of a lot was exploitation. I was exploiting these guys because they would never have stood in front of a camera and revealed themselves otherwise. People thought we made fun of them. They made fun of themselves. God forbid art be funny.

I showed *The Mom Tapes* at the Woman's Building, and many women were irate. Some feminists seemed to enjoy criticizing my work. Naturally, I was accused of exploiting my mother. Fortunately, I brought my mom to this one screening. I just couldn't defend myself, so finally I just said, "Mom, are you out there?" And my mother came up to the front of the room. She stood at the podium, waited a long beat, looked at about two hundred very serious feminists, and said, "Girls, you've *got* to get a sense of humor." There was a loud "Oh," a feminist shush. And Mom continued, "My daughter and I worked very hard on these. If you don't have a sense of humor, you're not going to make it through this life, and this is *not* exploitation."

Do you think the criticisms had to do with the fact that it wasn't serious enough for them? I think that humor in art was considered an oxymoron or something. There was a self-consciousness and seriousness in the art world, probably because if artists weren't serious about themselves then no one else would take them seriously. I don't know how it works. But I think it was very innovative to be funny, which seems so odd. Defending humor in art is a strange posture. I don't think you have to do that anymore.

How did you evolve from turning the camera on and editing in-camera, to making pretty much full-blown television-quality productions? I had no idea what I was doing with this equipment, ever. I can't tell you how many times I would try to remember what the RF hookup was. I showed tapes in certain situations, and they weren't playing and I had no idea what was wrong, and then I realized the TV hadn't been turned on. I sweated so much back then! I am not a technical mind, but I knew enough. I also knew if you just turned the camera on and pointed it you probably would get something. Eventually, I learned that if you had a crew it was useful, but then you had to have money. Fortunately, there was funding for artists to make tapes back then—there was the National Endowment for the Arts and many other funds.

When was the last time you made a video? The last videotape I made was called *My Puberty*. It was in 1987, and I remember realizing that it was going to be my last video piece. It was funded by the BBC, for a show called *Ghosts in the Machine*. I had a decent budget, so I took it all and rented a big studio to shoot in, and that was very scary. I got insurance. I had to have a teacher on the set because I had kids in the show. I had a real movie producer help me produce it. And the night before the shoot, my main star, who was playing me as a child, was rushed to the hospital with pneumonia. Since I was not going to get my money back, I proceeded to freak out, and then I tried on Little Ilene's clothes and they fit! I played me as a twelve-year-old at like thirty-six or something. I rewrote all of it at the last minute, and thank God, because it made the piece much better.

I wasn't sure what was next, but I was fortunate enough to be interviewed for a public radio profile on L.A. artists, and a new avenue opened up. Steve Proffitt showed up and asked me

really weird, which was to study traditional television making rather than going the art route. But during the day, I hung out at CalArts, and met John Baldessari and some really cool people. At night I worked on my official master's degree in communications arts at a Jesuit school. I bounced between making art by day and making TV by night. It was interesting at Loyola, because most of the teachers worked in the television industry. My TV production professor was the official director for the soap opera *General Hospital*. I showed him some early clips for the eventual *Mom Tapes*, and he said it was a great idea, but I should get someone else to play my mother and someone else to do her voice! And then I showed the tapes in John Baldessari's class at CalArts, and everybody got it right away. So it was sort of interesting to learn that if I was going to make television, I better get an actress to play my mother, but if I was going to make art, mom could be mom. Today, with reality television heading all the ratings, I realize my mother could actually be good TV... of course, that took more than thirty years.

It seems like you're always skirting around different definitions, and that's always attracted me to your work. The nature of your work seems like documentary, but not quite. What did you see your work as? I think of it more as cartooning than anything. I wasn't a real film buff, so it wasn't like I came from this documentary orientation. I really saw it more as a combination of *Mad*

a bunch of questions, and then took some videotapes to the L.A. NPR [National Public Radio] station and pulled off a lot of sound bites to illustrate his story. When I heard the show I realized, to my horror, that my visual work held up really well—actually, better—without the picture! Dread and loss of identity turned to relief. Ahh, I could retire all of the hardware and high costs for production, and I began producing about six years' worth of radio shows. The beautiful part about the radio was that I could slide into people's homes and lives, into their cars and living rooms, without a lot of hoopla. There was a context and the audience that I always wanted—real folks—were waiting to listen.

You did have some sight gags in your work though, like the "TV IS OK" license plate [see p. 312]. Right. I did a short piece called *TV IS OK* (1980), and it was just a close-up shot of my California license plate, which said, "TV IS OK." In yellow on bright blue. I got that plate because somebody at CalArts had a plate that said, "LA IS OK," and I really liked it. What a nice, clean, complete sentence. I thought, "Well, what in my life is OK that's only a few letters?" and it was so obvious. TV. I just threw some dirt on the plate, covered the "OK" and then hosed it off to reveal "TV," and the car drove away. It was very California. Now— weirdly enough—that plate got me in a lot of trouble. I would get into screaming fights with people at stoplights in Hollywood telling me film was great and TV was stupid. In Berkeley, I literally got bottles thrown through my car window because people disagreed. It was very, very controversial.

I also did an installation, one of my few, at Arco Plaza in downtown L.A. It was called *California Casual* [1977], and it featured five women waxing poetic about their newfound freedom since their husbands just switched from wearing labor-intensive cotton to no-work polyester leisure suits. No more ironing! I had life-size cutouts of the men surrounding the television, and the women would kind of talk to their particular husband cutout. It was pretty wacky. To this day, my mother says, "Where are those cutouts?" because all the men are now dead, and she thinks they must be worth money! Who wants to buy a cutout of Marty Klapman, our family doctor from the fifties and sixties who used to give my dad morphine?

What got you interested in doing the tape *What Is Business?* [1982]? I think I was trying to explain to my dad that I would be learning how to do something real, something that would give me money rather than take it away. My dad wanted to help me set up a post-production facility. He knew that that was business, not art, and I thought, "Well, if I just ask people what business is and try to understand it, maybe I could learn." It was just an excuse to investigate something rather than engage in it, which I think is what all of this has been about. And the videotape was shown at AFI [American Film Institute] on some large projection screen. One of the people who showed up was a casual friend, Harold Ramis, who wrote and produced many Hollywood movies, like *Groundhog Day* and *Ghostbusters*. Harold saw it, and I was sort of excited because I thought it might get me some work.

But Harold was baffled. He asked, "What is this? It's not art. It's not a documentary. It's not that funny. It's not scripted." It was everything and nothing. And in a way I liked that, but it didn't serve me in any real way. I mean, what kind of job could I get with such a "neither here nor there" kind of expression. Harold just said, "I don't know what to do with you," which I suspect was some kind of compliment. I had achieved what I wanted. The work wasn't definable, great, but I also ended up with a product that kind of didn't fit anywhere. But now when I watch it, it's quite amusing to me, because it's obviously skewed. It's an artist asking questions and

not really getting any definitive answers, because business to me is like asking, "What is art?" I just don't know.

Again, it's all context. Of course, the video *What Is Business?* was never shown in a business context. It would be good to get it into an MBA program, but I suspect it would be problematic. I was shooting it, by the way, at the time when they were cutting out the ethics classes at business schools. I wanted to shoot an ethics class at a business school, and they really weren't available. This was in the early eighties.

Well we know the result of that. Yeah, sad, no surprise.

What was the first piece of video art you ever saw? Wolfgang Stoerchle's work was probably the first video I saw. Wolfgang had come from Germany via Canada to be a graduate student at UCSB, and he influenced me a great deal, because he threw out all the designations. I guess he was a sculpture graduate student, because he did inflate a large plastic tube that we carried around school. It went from department to department, and I was in charge of holding the tube from the art department to the cafeteria. That was an important job. I think that somehow ingratiated me to him, and he became my boyfriend. Wolfgang had a foreskin and he used it often in his videotapes. It was sort of his version of William Wegman's dog, or my mom. The tape was memorable because he pulled his foreskin back and Disney toys plopped out of it, and it was provocative as well. And I remember thinking, "Well, I guess we can do anything we want," because he was taken seriously. He was a tall guy with a strong presence and he took himself seriously, which was really kind of interesting for me as a female, because being a woman artist then was a little bit iffy. The men were self-contained and sure of themselves, and Wolfgang was one of them. He ended up being one of the first teachers at CalArts when it was in some kind of makeshift building. I didn't take any classes there but I roller-skated inside the entire huge barnlike structure.

Anyhow, Wolfgang influenced a lot of people, and certainly me. I took my ideas a little more seriously. John Baldessari helped me so much too. I really do think being a young woman at the time was a tricky place, because I really couldn't find a good role model. I mean, I didn't want to be Georgia O'Keeffe. I wasn't painting. I didn't want to wear big fake eyelashes and make black sculptures like Louise Nevelson. I liked that pretty speech therapist on *To Tell the Truth,* but of course, she was a scientist, not an artist.

I'm just trying to think how to talk about all of this, because, again, a lot of the experiences from that era were not languaged then and haven't been Englished since. Although there were so many wonderful doors opening, I think it was just a difficult time to know what to do. What do you do with this skill or vision? And all the tape that we shot, the half-inch tape, we never thought of archiving it, so it all just turned into silver ashes in our wet, moldy boxes. I know a few people had the wisdom to keep some old reel-to-reel equipment so they could transfer stuff, but I kind of let the stuff fall apart. It was hard to figure out what was important and what wasn't. What had value? What was entertaining? What was art? What would people want to see? What would museums consider meaningful? I never really could tell if what I shot and threw out was more valuable than what I shot and edited and showed. I still don't know.

Video may be one of the very first mediums that will become extinct during the lifetime of an artist. Great. Well, I'm thinking of getting into making paper anyhow. I've even got some papyrus growing in my backyard. From the future to the past in one fell swoop.

p. 204
Ilene Segalove, still from *My Puberty*, 1987. Single-channel video, color, sound; 10 min., 39 sec. LBMA/GRI (2006.M.7).

NINA SOBELL

Born 1947, Patchogue, New York
Lives and works in New York, New York

NINA SOBELL SETS OUT to make the invisible visible, creating works that utilize video surveillance and medical technologies to construct spaces of interaction between viewers and participants. In 1973, Sobell began collaborating with neuropsychologists at the Veterans Administration Hospital in Sepulveda, California, to develop a method of translating electroencephalogram (EEG) readings taken simultaneously from two subjects into a live video image. Her research resulted in the 1974 installation *Interactive Electroencephalographic Video Drawings*, which monitored the brain waves of pairs of participants in order to visualize how people could influence each other's thought patterns in a nonverbal way. Wired with EEG sensors, participants would sit next to each other in a living room–like environment, while observing a composite image of their undulating brain waves on a closed-circuit television monitor. In an adjacent space, other viewers could watch video footage of past participants, as well as a live feed of the work in progress. Sobell took great pains to demonstrate and explain the technology to her participants, thereby allowing them a degree of control over the otherwise complex technologies of medical science and television normally beyond their grasp. During the past thirty-five years, as technology has evolved, Sobell has continued to update the installation—variously titled *EEG: Video Telemetry Environment* and *Interactive Electroencephalograpic Video Drawings*. In a recent version, the piece utilized wireless EEG headbands, touch screens, MIDI sound, and Webcasts.

Instead of using the technology as a means of one-way surveillance, Sobell uses closed-circuit video to encourage communication among her audience. She has also used video and performance to facilitate personal expression, particularly in her series of "Chicky" works from the 1970s. In *Chicken on Foot* (1974), Sobell used closed-circuit video to monitor the image and position of her own bare leg onscreen. Sobell smashes eggs on her knee, creating a reflex response as she kicks her leg upward into the frame, revealing a raw, plucked chicken carcass on her foot (a play on the proverbial "which came first, the chicken or the egg?"). In *Hey! Baby, Chicky!!* (1978), a topless Sobell appears to dance, play with, and breast-feed a chicken carcass, conflating conceptions of the female body as mother, caretaker, and fetish object with symbols of sex, fertility, and sustenance in a manner that reveals the grotesque and incompatible nature of these standard symbols of femininity.

Pauline Stakelon

Interview conducted by Carole Ann Klonarides on February 10, 2007, at Nina Sobell's home in New York City

CAK: You completed one of the first master's theses on video art in the U.S., in the sculpture department at Cornell University in 1971. How did you move from sculpture into this new medium of video?
NINA SOBELL: I was working on pieces that were a continuation of work I'd been doing at Tyler School of Art in Rome, where I began to do things in foam rubber. I wanted to use material that could have a large volume but also be flexible, playful, and interactive. I began to make environments with foam, and from there I made these things that you roll down hills in. When I got to Cornell, I made sturdier things to roll down hills in, which were inspired by an Allan Kaprow Happening I came upon in Central Park. Then Jud Fine told me, "Oh, you should get a camera from David Shearer, he's in the architecture department." So I did, and David became very instrumental in assisting artists with getting access to video. I realized after documenting certain situations in my work that, since I was working with ephemeral materials that became dematerialized and deconstructed, I could use video to reconstruct this deconstructed materiality. And not only that, I could do things over a period of time, and then reconstruct that time and space. I could create a space that re-created memory and experience. So video cameras captured the interaction and gradual destruction of these large sculptural pieces over a four-week period, and at the end of that period people could come to the gallery to see the time reconstructed on video. In the gallery, there was also a camera broadcasting to a monitor on a six-second delay, and another closed-circuit camera was broadcasting live. So I could really embrace time, space, and experience, and these huge ephemeral sculptures could be reconstructed on video. It was definitely not about documentation. It was about the pacing and rhythm of time and experience, and about compressing it and opening it up again.

So you found that being immersed in this medium, it really wasn't about articulating, but about being involved in the process. It was articulating a very specific use of the medium with a very specific process and structure that I created for it. I created the skeleton, in other words, and video was the flesh.

So what drew you to California in 1972? To tell you the truth, when I thought of California, all I could think of was dunes and sand, and I really wasn't so excited about going to California. But it was a nice idea to go and visit Jud Fine, who had moved there. And to go across the country was also a good idea. And I'd worked really hard, so I needed a little bit of a transition. I was with John Sturgeon at the time, and we really didn't know where we wanted to live. We thought about every place we went, from Kalispell, Montana, to Cape Flattery, Washington, with the puffins. We went to the San Francisco Art Institute, we met people, and sniffed around here and there: Santa Clara, Santa Cruz. Then we came to visit Jud. He was living in Venice, and we said, "Right." We took a walk down the boardwalk and we said, "Yeah, we could actually do work here." And then, when we were walking back, we came across this storefront and there was Joan Logue, and she was with people who were broadcasting from this little storefront on Oceanfront Walk, which is how I met Joan.

So I started looking for a studio. I walked past this pipe shop in Venice, and I went in and I asked the guy, "Are you thinking of moving?" and he looked at me like I was the CIA. He said, "Well, why don't you come back next week?" Just that day, he and his wife had decided to move. They'd been there for years and years; it was the old Venice West Café. Kerouac hung out there. It was 5 and 7 Dudley Avenue. The two spaces were joined. I said fine: John in 5, me in 7, we share the equipment, great. I came back the next week and got the keys. Later, we helped David James move into 9 Dudley, where Norm the shoemaker was leaving his shop. Joan Logue lived on Dudley on the other side of Pacific. William Wegman was

p. 207
Nina Sobell, stills of Nina Sobell and Brian Routh activating *Interactive Electroencephalographic Video Drawings*, 1974. Interactive video installation with live video and EEG readings, dimensions variable. Photos by Ken Feingold.

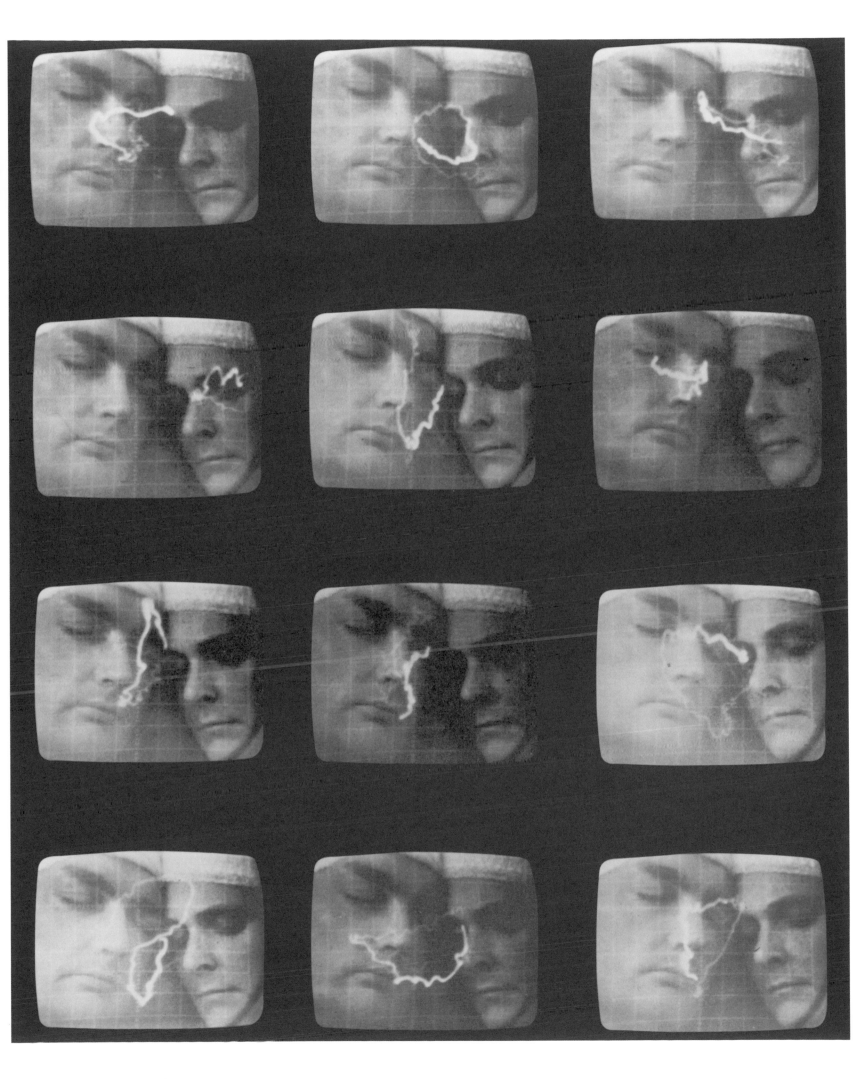

on the *x* axis, and one person on the *y* axis. When both people are putting out the same brain wave at the same time, it will make a circular form, and when one person's more distracted than the other, it'll distort horizontally or vertically," and it was a very sweet answer. So then I went about trying to find EEG equipment. I eventually met Barbara Brown at UCLA [University of California, Los Angeles]; she was a founder of research in biofeedback, and she put me in touch with a neurologist, Barry Sterman, who had a lab at the Veterans Administration Hospital in Sepulveda, California, and he gave me access to the equipment. He said that if I could show him that there was real data to be examined and studied, with this idea of being able to visualize the nonverbal communication between two people, then I could come again to build on that data. Each pair of participants would attach electrodes to their head to be read by the EEG machine, and the cumulative output of each pair was fed through a Hewlett-Packard PDP-11 computer and sent to a video monitor. And it worked. Visually, you could see the convergence and merging of the relationship between the two people. When one person was agitated, the other person got agitated, even if they had absolutely no facial expression. The results were satisfying enough for Dr. Sterman to say, "Yes, you can come back," and I did.

How did you go from this experimental period to developing the piece into an installation? I had video footage of our tests from the neuropsychology lab, of David James, Harry Kipper, Joan Logue, and other people. I put that all together as a tape in itself. David saw it, and he said, "Oh, I have to call Jim Harithas at the Contemporary Arts Museum in Houston," because NASA was there, and there was a lot of tech there and access to equipment. I was able to get an EEG that was about one-tenth the size of the one I'd used in Sepulveda. Paul Schimmel was Jim's assistant, and I stayed in Paul's apartment. I used to drive him crazy. At six o'clock every morning I'd be at the foot of his bed saying, "Paul, get up, we have so much to do." "Nina, it's six o'clock in the morning, can't I sleep?" "No, we have to get going, Paul, get up, we've got a lot to do today." And so Paul was literally my right-hand man, helping all the way, and in fact Paul named the piece. He called it *EEG: Video Telemetry Environment*; I thought that was pretty good.

For the installation in Houston, we set up a little living room environment for the participants. I wanted it to seem like they were at home. There was a couch with a little coffee table in front facing a big television. The participants would be hooked up to the EEG, and then watch live video of themselves on the television, with the squiggly line of the brain-wave drawing superimposed on the image. On the other side of the wall was a space for viewers who weren't participating in the piece. There was a video feed showing whoever was participating at that moment, and then there were two monitors on either side of the projection showing taped video footage of the past participants. We were using one of the very first remote-controlled three-quarter-inch video players.

A lot of the piece was about demystifying the video medium and its equipment for the public, to get them to realize that they were the content; the participants were the content. They had power over how they could control it; they could rewind it. It wasn't in control of them. They were manipulating it, and it was their output that they were seeing. I would take everybody through the whole thing; I was there in the gallery every day for three months. I loved it, actually, and I loved the ritual of demystifying everything for the participants—you know, "This button does this, and that one does that." That whole process was part of the work too.

The piece has continued to evolve, right up to the present day. When I moved back to Los Angeles from Europe in 1978, I resumed my collaboration with Mike Trivich, and I was in close

around the corner, and Chris and Barbara Burden were not far away on Oceanfront Walk.

How did you develop your interactive "brain-wave drawings" piece? I started working on the brain-wave drawing piece in 1973. I collaborated with Mike Trivich, who was a friend of an engineer that I worked with on the *Rockable* sculpture at Cornell. The whole idea of biofeedback was just coming into being, and I liked the idea of hearing the amplification of an internal dialogue. I began to realize that it could be the amplification of me as an electronic medium. I wanted to see if I could break through this kind of internal and external portrait of ourselves, and visualize nonverbal communication between two people. I talked to Mike, and he said, "Why don't we use an oscilloscope; you can have one person

contact with the Long Beach Museum of Art, since they were the only place that lent equipment. I got a job in the very first computer store in the world, called "The Computer Store," on Santa Monica Boulevard. It was founded by Dick Heizer from the Rand Corporation. He would let me come in on Sunday and work on the brain-wave drawing piece. While I was working there I met this fellow, Chris Matthews, who came into the store a lot. He was an engineer, and he was working on dream visualization, and we set up the brain-wave drawing piece in his basement apartment. This, combined with the work at the computer store, led to Kathy Rae Huffman inviting me to participate in a show she curated in 1983 called *The Artist and the Computer.* She introduced me to Kong Lu, who became the programmer for the piece. It was still important for me to demystify the piece and explain the technology to people, and I also showed tapes from the Houston show and from Sepulveda, so there was even more information.

Is it true that you had so many reservations you couldn't fulfill them? There were actually two thousand calls when I showed the piece at the Long Beach Museum of Art. And when I did the piece in Houston, people were around the block, waiting for hours. People want to engage with technology if it's technology that involves the human, if they can take it and involve themselves in the experience. People are intrigued to realize that they can nonverbally communicate with another human being—that it's really true.

You continued to produce a number of other interactive closed-circuit video installations. Could you describe *In and Out the Window* [1979]? Suzanne Lacy asked me to be part of her *Take Back the Night* exhibition in Santa Monica in 1979. I decided to ask all the artists in the exhibition to participate in my installation, which was called *In and Out the Window.* Two monitors and two cameras were placed on either side of the storefront window, so one monitor was outside, and one was inside the gallery. Each camera was broadcasting to the other monitor, and there was a chair in front of each monitor. So basically, two people could sit down right next to each other, but divided by the storefront window, and they could either look and talk to each other through the window, or they could look and talk to each other using the monitors, like a videophone. The participants were all the artists in the show, and I told them to ask each other questions they've always wanted to ask. Nothing was recorded, because I wanted to encourage everyone to give honest answers. It was just a closed-circuit system.

The piece was basically an experiment to see how technology dictates our behavior. You know, if you're on television, then you're transmuted into a mediated form; you're more "official" than your real form. You seem more important to yourself and to others. I have a couple of photographs of artists actually looking through the glass and saying, "Forget that, I'll talk to you like this," but it was only a couple. Most people spoke to each other through the monitors, and they were very formal with each other, and I think they listened to each other much more carefully than if they were speaking to each other with no construct. I found that pretty fascinating.

How do you feel about that now, not having the video recordings? It's fine. I've got pictures. It wasn't about recording or documenting; it was about video as a medium of communication, and about the structure, time, and energy of the exchange. It had to do with behavior, and the commandeering power of video.

Well, I'm interested because a lot of the artists we've interviewed have talked about really wanting to just be alone with the camera, creating this intimate space. Yeah. That's right.

And you didn't have that desire? Well, I did sometimes. Do you think I could have done *Hey! Baby, Chicky!!* [1978] on stage?

Well, we haven't talked about that piece yet, but I think it was very influential on other performance work. Could you describe the video? How did people respond when they first saw it? Well, it started with *Chicken on Foot* [1974], which was a piece where I put a raw chicken on my foot, and then cracked a dozen eggs on my knee. I have amazing reflexes, so the idea was that every time I would crack an egg there would be a jerk reaction and the chicken would come up into the frame. The piece was very much about the video frame: the egg comes, and then the chicken immediately comes into the frame, but in a very deadpan way. I did *Hey! Baby, Chicky!!* in 1978 after Brian Routh (aka Harry Kipper) and I had gotten married, moved to Europe, and moved back. As soon as the Kipper Kids went on a gig, I ran out and bought a raw chicken, and then all of a sudden I'm setting up the table and I'm setting up the camera and I'm doing all of these unrehearsed things with the chicken. I had the music ready though. It starts out with Wilson Pickett singing "In the Midnight Hour," then Barbara Lewis singing "Baby, I'm Yours," and I was laughing the whole time. I have the camera zoomed in on the chicken, and I take the wrapper off, and I take the giblets out, shaking them around. And then I start to hold the chicken and play with it. Later I put the chicken on a plate—the camera's zoomed out at this point—and I have my boa and my little purse, and I play with the chicken in a rather directed and concentrated way. I had no idea of other people or the world or anything around me, it was just me and my chicken. And then at the end I put it in the purse and I walk off. People were pretty shocked by it and couldn't understand it. Since I'm naked in the video, a

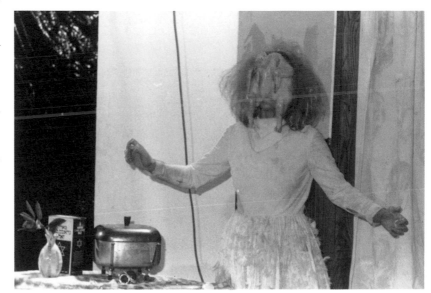

lot of people interpreted it as being sexual, which it wasn't at all. It was censored from a show at Cal State Los Angeles. I couldn't believe it, because the piece has nothing to do with sexuality. It's about experience being captured on video in a very intimate setting, with the camera as the only audience. The piece was about immediacy, about being absolutely there in the moment. For me, video was a medium that allowed me to be completely spontaneous, while also getting to a place in myself or my psyche that could be exposed. But I made the piece to be light and lively; I think of it as a funny piece. If it was influential on other artists, I think it's because seeing something like this might give them permission to do things that they might not have done before.

p. 208
Nina Sobell, stills from *Chicken on Foot*, 1974. Single-channel video, black-and-white, sound; 5 min., 38 sec. LBMA/GRI (2006.M.7).

p. 209
Nina Sobell, still from *Into the Pot You Go*, 1981. Single-channel video, color, sound; 13 min., 54 sec. LBMA/GRI (2006.M.7).

JENNIFER STEINKAMP

Born 1958, Denver, Colorado
Lives and works in Los Angeles, California

JENNIFER STEINKAMP PRODUCES SENSORIAL ENVIRONMENTS of projected moving images and colored abstractions in space, creating disorienting and exhilarating experiences. Using 3-D animation software as her paints and palette, Steinkamp rewrites computer program codes to create her own scripting language of virtual patterns and textures. Steinkamp's works are precisely situated within their architectural contexts, integrating video projection and architecture to reach new levels of immersion. For the *California Video* exhibition at the Getty Center, Steinkamp conceived *Oculus Sinister* (*left eye*) (2008), a projected pattern for the oculus skylight in the ceiling of the J. Paul Getty Museum's special exhibitions pavilion. Other large-scale public works have been commissioned and installed at Staples Center in downtown Los Angeles, Fremont Street Experience in Las Vegas, and Experience Music Project in Seattle. In addition to using color, light, and motion to dematerialize and activate space, Steinkamp has collaborated with electronic composers Jimmy Johnson, Andrew Bucksbarg, Bryan Brown, and Grain to create an aural dimension to her work.

Steinkamp first developed an interest in computer animation while taking a class at the California Institute of Technology (Caltech) in Pasadena with the electronic art theorist Gene Youngblood, in which she was inspired by Oskar Fischinger's abstract animations and Ed Emshwiller's computer-generated videos. Other media influenced her as well, namely the abstract expressionist paintings of the 1950s; the structuralist cinema of the 1960s and 1970s; the atmospheric installations of artists Robert Irwin and James Turrell; and Barbara Kruger's gendering of text and image, all of which equally inform Steinkamp's unique vision. To obtain knowledge and gain access to state-of-the-art technologies, she worked in the commercial industry before attending the Art Center College of Design in Pasadena, receiving both her undergraduate and graduate degrees, which enabled her access to a fully equipped computer lab with motion graphics capability and the tutelage of artist-instructors Mike Kelley, Jeremy Gilbert-Rolfe, and Patti Podesta. This amalgamation of influences and experiences has led to her pioneering work in the field of electronic art and to her mastery of a hybrid form that still defies a single definition.

Carole Ann Klonarides

Interview conducted by Carole Ann Klonarides on March 2, 2007, at Jennifer Steinkamp's studio in Los Angeles

CAK: How did you come to Los Angeles?

JENNIFER STEINKAMP: I came to Los Angeles in 1980 to study design at the Art Center College of Design in Pasadena. After a couple of years, I enrolled in a class with Gene Youngblood at Caltech; the two schools have an exchange program. He screened early abstract film, some of the first computer animation, and structuralist cinema. For example, we watched abstract animation by Oskar Fischinger, structuralist films by artists such as Hollis Frampton, and the experimental films of Ed Emshwiller. In addition, Gene informed me about the video program at the Long Beach Museum of Art. That would have been in 1982; at the time, I dropped out of school because the design curriculum did not support my new interests in experimental film and computer animation.

So what did you do then? One of my first jobs out of school was designing the video packaging for the Long Beach Museum of Art. I vaguely recall that it consisted of a yellow band with the logo inside, on a dark gray background.

I remember taking a TV production class at Long Beach City College; the instructor—a former army sergeant—actually called me a "would-be video artist," and said I would never amount to anything. At that time, I was cutting out images from magazines to create abstract collages for a video; he just did not understand what I was doing.

I worked for a little while in computer animation, and then I moved to New York. I was making structuralist films while working in animation. I screened a film at the Millennium Film Workshop in the East Village; that was really frightening since it was my first public screening. I filmed spinning turbines with Super 8; I played around with the speed of the camera along with the shutter to create various effects.

I began teaching computer graphics in New York, but on a visit to Los Angeles, the beach was so beautiful I decided I really had to move back to L.A. I started teaching at Art Center, the school where I previously dropped out. I was trying to figure out what I could do with computer graphics and art; I decided to finish my undergrad degree in fine art. I also completed my graduate degree at Art Center, since they had such a great art faculty. As an undergrad, I made the piece titled *Gender Specific* [1989], which was exhibited simultaneously at an alternative exhibition space called Bliss and at the Santa Monica Museum of Art.

How did that piece happen? While I was an undergrad at Art Center, I created a series of sexist phrases that I overheard men and women say. I decorated the text; Barbara Kruger was my inspiration, of course. I was projecting these at EZTV, a facility for up-and-coming artists to edit video and display their work. Ken Riddle, who runs Bliss, saw the sexist slides. He was also a student at Art Center, and he asked me to show the slides at his house. Ken had exhibited a few other colleagues from Art Center, and he asked me to display my sexist texts in his picture windows. I was working on this little animation of a whirling vortex; I asked him if I could project this into his windows. Of course, I had no video equipment, and no idea even how to make a video projection. I called every manufacturer, every dealer—I must have called fifty people. I eventually found an individual who lent me four huge projectors for a week. In the meantime, Robert Gero, who was on the board of the Foundation for Art Resources and an artist in Los Angeles, asked, "Why don't you exhibit this piece at the Santa

Monica Museum of Art as well?" We approached the Santa Monica Museum of Art; it turned out that the storefront at the museum had a similar window configuration to Bliss; a symmetrical building with two large picture windows. So in a way, it was ideal. I could make a piece about architecture that ran simultaneously across town. But I was using this borrowed equipment, so it was up for just a week. Since making that piece, I haven't stopped projecting abstract animation into architecture.

What intrigued you about putting projected abstractions in public spaces? I was especially intrigued by the space at Bliss, which wasn't a gallery but a house. With the dual projections, the house looked like it was dropped down from outer space. It was really strange, especially back then. Bliss was a little Craftsman-style house, located in the middle of a Pasadena neighborhood. I gave the house spinning, flashing windows. It was also uncommon for the Santa Monica Museum of Art, but the project especially transformed the house. So I thought, "Wow, this is really something; you can transform architecture." It took me a while to really understand what I was doing, or what I could be doing. I still operate this way; I experiment and let the work evolve.

I remember back then you were talking about "feminized spaces." My previous work dealt with sexist phrases, I thought, "Wouldn't it be funny to take these buildings and divide them into male and female halves?" Pretty arbitrarily, I decided that the right side was female, the left was male, and in between was androgynous. I used

p. 210
Jennifer Steinkamp, *Jimmy Carter*, 2002. Video installation, color, silent; dimensions variable. Installation view at ACME, Los Angeles, 2002. Courtesy Los Angeles County Museum of Art. Photo by Robert Wedemeyer.

p. 211
Jennifer Steinkamp, *Gag*, 1993. Video installation, color, sound; 213.36 × 152.4 cm (84 × 60 in.). Installation view at Long Beach Museum of Art, 1993. Courtesy ACME, Los Angeles.

the fleur-de-lis as a symbol of androgyny because it is made from a lily, a flower that has both sexes; in addition, it is an ironic symbol of the Boy Scouts. I found that quite funny. You could actually walk through the house as an installation. I must have been crazy—the amount of stuff I put into that house. I even wallpapered the kitchen, which was on the right, with a water motif. Just to be playful, I was considering female genitalia as interior and male as exterior. I was taking over the architecture from my point of view as a woman. I suppose I keep repeating this theme, creating sensual animations in architecture.

And how did people talk about the work back then? That would be a good question for you to answer. I am not sure I can even remember. I do recall curator Anne Bray received a jaywalking ticket because she ran across the street to see the projection. I guess that's a positive commentary.

There is definitely a visceral reaction to your work—and sometimes it is quite humorous, like the first time we worked together at the Long Beach Museum. Do you remember? Yes, for the *Sugar 'n' Spice* exhibition at the Long Beach Museum of Art in 1993, I made a piece titled *Gag* in response to the theme and the architecture. (I was being naughty and not nice.) I was responding to the stairwell in the building. I noticed there was a skylight, which was part of an attic; the museum was a house in its prior life. I was thinking of the stairwell as this part of the architecture where you walk up and down, for some reason I thought, "Okay, this might be like giving a blowjob to the architecture." I made a soundtrack of gagging and I titled the piece *Gag*. I made a Rorschach-like image out of two projections overlapped—the animation was projected twice, with one of the projections flipped. At the time, video projectors were not very bright, so two projectors helped the brightness. It was amazing that I was even able to pull this off in a lit space.

The imagery made you feel like you were being sucked in. The images went in and out, and for the viewer they created a sort of physical effect. That must have been intentional. *Gag* is similar to another piece I created in 1993, *Untitled*, at Food House in Santa Monica. Instead of the ceiling, I projected onto the floor. This piece was also comprised of two projections, but they were placed side by side. When I visited the space, I noticed this strange ductwork in the ceiling. I thought, "There needs to be a river across the space." So I mounted the projectors on the air duct and used mirrors to redirect the projections onto the floor. For the river anima-

tion, I made a concave/convex motion; this made the floor feel as if it were breathing. The piece made me realize I could dematerialize architecture with light. People actually felt seasick from looking at the floor—this was one of those occasions where I really learned a lot from my work.

Did that give you a sense of entitlement and empowerment? That was one of those pieces, like a magic moment where everything was working—although I got electrocuted making the piece. There were reviews and a lot of positive response. I made a leap from the other work I was previously doing, because I learned that light, which has no physicality, could dematerialize solid architecture.

I want to talk a little bit about the difference between working with a public or corporate client versus working with an art institution, and how there are certain fulfilling and unfulfilling results in both of those things. My work started out in a very public way. If you look at the sexist slides, they were projected on the street in Hollywood. The next work was a house in Pasadena and a storefront at the Santa Monica Museum. There is something really intriguing about putting art out there and making people think a little bit, or at least respond. Then if you flash forward to *Aria* [2000] at the Fremont Street Experience in Las Vegas—this is the largest video display in the world. It is built over the old part of Las Vegas to revitalize the area. I entered a competition and, as a finalist, I met with the casino owners to convince them that abstract animation was something appreciated by the public. I gave them a minihistory, of how *Fantasia* was very popular in the forties; then, there was the twenty-minute fairly abstract film in the middle of *2001: A Space Odyssey*. I understood that any other response to Las Vegas could become absorbed by Vegas. For example, if you were to animate slot machines, cowboys, or pretty women, Vegas just sucks it up. Literal representation is like camouflage there. I wanted to make a piece that would be abstract, and since it was displayed along four very public blocks, I wanted it to be noticed and appreciated by the public. Artists should consider the relationship of their art to their audience.

Could you describe the piece about your great-uncle? That's a wonderful piece. *The Wreck of the Dumaru* [2004] was created for greengrassi [gallery] in London. At the time, this was their new space—an old, large, crazy, unruly two-hundred-year-old warehouse space. While I was thinking about what I could make for this daunting space, my mother asked me about the title of

one of my older pieces, *They Eat Their Wounded* [2000]. She asked, "Was the title about Uncle Ernest, who was cannibalized?" I was taken aback; I had not heard about cannibalism in the family. My family does not talk. She went on to explain there was a book written about the shipwreck, *The Wreck of the Dumaru: A Story of Cannibalism in an Open Boat* [1930]. So of course, I purchased the book. It turns out, my great-uncle was not cannibalized; mom had that wrong. But what happened was this—during World War I, my great-uncle was on a ship out of Portland, Oregon. The boat was carrying ammunition and gasoline. Outside of Guam, the ship was struck by lightning—the book is funny because it has an embossed lightning bolt across the cover. Anyway, everybody had to disembark the boat quickly; my great-uncle got onto a lifeboat filled with too many sailors. This always happens in a shipwreck; some lifeboats will take off without enough people. The sailors were worried that the *Dumaru* was going to explode from the gasoline and ammunition she carried. Their lifeboat was caught in a current, and there was no way to sail back to Guam. After thirteen days, my uncle went a little crazy after drinking seawater. He thought there was a nail stuck in his head, he couldn't stand it, and he passed away. I imagine they used him for fuel because they developed a system for condensing drops of water using fire.

While thinking about my uncle and how I could commemorate his experience, I started playing with some 3-D animation software called Fluid Effects in Maya. I made up my mind to expand a huge panorama in order to flood the gallery. This was the first time I combined four images running in sync to create one giant image. The piece is a collage, consisting of a huge wave viewed from down in the water, and a sky made out of the same water, but looking at it from above. It is as if you are seeing the same ocean from my great-uncle's two points of view. You can interpret the piece any way you prefer, but that was my intention.

A lot of the earlier pieces were physically jarring to the viewer. Now, you've made this transition to really feminized spaces, which are like moving floral wallpaper. It makes me think about the Charlotte Perkins Gilman story of the woman who stared at the yellow wallpaper until she went mad. I know. I used to stare at the yellow floral wallpaper in my bedroom when I was a child. I could imagine the flowers changing, or I could make out various faces in each one. The first piece where I used flowers was *Jimmy Carter* [2002] at ACME, Los Angeles. At the time, I was not thinking of the projection as wallpaper, although the animation created an immersive space and covered three rather large walls full of flowers. The imagery, consisting of strands of flowers, had more of an underwater feel. I was thinking about PEACE and the fact that the Bush administration was dragging us into war with the Middle East in response to the 9/11 attacks. I grew up during the sixties; flowers have a direct connection to peace imprinted on my mind. I was a young flower child. I named the piece *Jimmy Carter* because right after 9/11 the nation was in shock; we were grieving, and the Bush administration and the media made it very difficult to say anything against the war without making one sound like a traitor. So I named the piece after a president; how could that be treasonous? The installation was named in honor of a president who stood for peace.

Your works are dependent on technologies that exist at the time they're made, and they're very specific to those technologies and programs. How do you envision your pieces migrating? I have been thinking about migrating work for a long time, because I have been upgrading my files since 1988—first moving from Silicon Graphics computers to Mac and PC. You need to consider,

some software does not exist anymore. To mitigate this problem, I render the imagery at double the resolution. At present, the art displays at high-def resolution; I render it even higher, double or triple that. The files are pretty flexible and they are saved in a format that can keep migrating. You could imagine that the digital image might last longer than a painting, because it can migrate. If you don't migrate, of course, it is not going to last as long, the shelf life could be five or ten years maybe. If you migrate, the art could last forever. So yes, it is something I definitely think about.

What do you give the collector or the institution? What is it that they physically get? The institution or collector receives a certificate and a DVD-ROM that contains all the images at double resolution. They also receive the Maya files and all the texture maps; pretty much every single file that I use to create the piece. So in a way, I have this backup of all my data all around the world.

Describe your studio. Well, it's a studio with a pile of computers, all on a network and a server. It is basically a render farm. The computers are rendering images when I need them. In the past six months, they were running nonstop. Right now, they're taking a break. Sometimes they get to take a trip to New York or London to run an exhibition.

How long does it usually take to render a piece? It depends on the complexity. I may render thirty variations of a piece until I am satisfied. I can typically render a test version overnight and the final version might take three days. I usually run the finished work while I'm off on a trip, so I don't always know when the images are done. In a way, it is still similar to the past when I had to wait three days to actually see if a piece turned out. I am sure that in 1993, it took that long to wait for the piece at the Long Beach Museum of Art, although it consisted of much less information to render on a much slower computer. I had a lot more free time when the computers were slower.

Why don't you describe a little bit about what you're planning to do at the Getty Center? I plan on projecting inside the oculus. At the moment the work is in progress—I am playing with various ideas. The historic significance of an oculus intrigues me; I visited the Pantheon while traveling in Rome, with its round opening to the sky that allowed rainwater to sob inside the building. The Latin translation of *oculus* is "eye." That alone is very fascinating to consider when making a visual work of art.

p. 212 top
Jennifer Steinkamp, *Aria*, 2000. Site-specific programmed light display for Fremont Street Experience, Las Vegas, Nevada, color; 5 min. Courtesy ACME, Los Angeles, the Fremont Street Experience, Las Vegas, and greengrassi, London.

p. 212 bottom
Jennifer Steinkamp, *Gender Specific*, 1989. Video installation, color, silent; dimensions of each window: 182.9 × 243.8 cm (72 × 96 in.). Installation view at Bliss House, Pasadena, California, 1989. Courtesy Bliss and ACME, Los Angeles.

p. 213
Jennifer Steinkamp, *Gender Specific*, 1989. Video installation, color, silent; dimensions of each window: 243.8 × 304.8 cm (96 × 120 in.). Installation view at Santa Monica Museum of Art, 1989. Courtesy ACME, Los Angeles.

WOLFGANG STOERCHLE

Born 1944, Neustadt, Germany
Died 1976, Santa Fe, New Mexico

IN HIS SHORT BUT PROLIFIC LIFE, Wolfgang Stoerchle became an important figure for a generation of artists centered in Southern California whose concepts, forms, and practices were defining a radically new aesthetic of performance-based art. As it developed in the early 1970s, performance naturally informed the possibilities for early video art, a compelling intersection that plays out in Stoerchle's handful of surviving videotapes. While almost ritualizing the processes of art making, Stoerchle used his own body and his physical image to systematically work through both the fundamental elements of video technology—the dimensions of the screen, image framing, standard duration, live feedback, time delay, *mise en abyme,* and light sensitivity—and the corporeality of humans and their bodily functions (looking, breathing, excreting, moving, falling). In his oeuvre, which includes video, performance, photography, sculpture, and paintings, Stoerchle dealt honestly with psychosexual themes. In one such performance (circa 1970), he enacted the frailty of masculinity by attempting—and ultimately failing—to achieve an erection before a group of spectators. Many of his pieces further scrutinized the signification of gender and genitalia, as demonstrated, for example, by a series of sixteen cast-bronze vaginas of women with whom he had been close. Yet through these visceral, often confrontational investigations, Stoerchle retained a serious regard for the formality of art, which he expressed through his innovative uses of video and other media.

The details of Stoerchle's life seem almost mythological when recounted. In 1959, he emigrated from Germany to Toronto, Canada. Three years later, he and his brother Peter set out for Los Angeles on horseback, a journey that took just under a year. The trip was reported in certain small-town newspapers across America and was reclaimed as an artwork later in Stoerchle's career. By 1968, Stoerchle had earned a Bachelor of Arts degree from the University of Oklahoma and had relocated to California to begin graduate studies at the University of California, Santa Barbara. Almost immediately, he began exhibiting his artwork in small galleries and museums along the Pacific Coast. He finished grad school and began teaching at the newly opened California Institute of the Arts (CalArts), a school that had initially been founded by Walt and Roy Disney (Stoerchle alludes to the school's origins in his most infamous video—an untitled work in which he forcefully ejects a seemingly endless series of small Disney figurines through his foreskin). At CalArts, he collaborated and consorted with Allan Kaprow, John Baldessari, Nam June Paik, and others. He exhibited internationally, and he moved to New York but left to travel in Mexico. In 1975, he settled in Santa Fe with his wife, where he lived modestly, working in a foundry and continuing to make his artwork. Some say that Stoerchle foresaw his own death; he was killed in a car accident in March 1976. The rich archive of his life's work reveals a compelling thinker who, in other circumstances, might well have been recognized as one of the most promising artists of his generation.

Catherine Taft

p. 214
Wolfgang Stoerchle, doctored photograph documenting a fictional arm-wrestling performance with Governor Ronald Reagan in Sacramento, California, 1970. Courtesy Wolfgang Stoerchle Estate/Carol Lingham.

p. 215
Wolfgang Stoerchle, black-and-white photographic contact sheet documenting *Event*, 1970. Performed for NBC Television News, June 1970. Courtesy Wolfgang Stoerchle Estate/Carol Lingham.

pp. 216–17
Miles Varner, "Wolfgang Stoerchle," *Studio International* 183, no. 943 (April 1974): 160–61. Used with permission.

"EVENT", mixed media, for NBC-TV News, June 1970.

Wolfgang Stoerchle

Miles Varner

The work of a young Californian artist, Wolfgang Stoerchle, may insist on a more comprehensive definition of what can be involved in 'process art'. One becomes aware in experiencing his work that much of what has been viewed as process is in fact still concerned with the object as such.

Several years ago, Stoerchle began constructing sculpture consisting of large solid plaster planks, hollow boxes, and other shapes which were ceremoniously tipped and allowed to fall on various surfaces and occasionally on other plaster forms. The resulting images were clear, organized, and totally coherent. Nothing was out of place, nor could it be where the interaction of physical materials is the only determining factor in the results. Obviously Stoerchle was responsible for choices in material size and shape, but these decisions were rendered inconsequential by the forceful clarity of what had happened–not why, when, where, how, or who. These elements do become important as possible implications, but only because the process is so clearly put. In the same way, the process is considered and defined by the obvious organization of the image.

A comparison with Robert Morris's timber-spill pieces is revealing in that whereas the similarity in technique is obvious, the points of emphasis are distinctly different. While Stoerchle places the significance on the process, Morris, through the use of immense size and specific relationships to gallery and museum space, evokes a presence which is more precisely environmental than procedural. The herculean nature of the task, though it impresses us with the personal and professional resources of the artist, does not direct attention to a meaningful series of events. The massiveness of these pieces contributes also to the fixed (in time) quality which seems to be inherent in works completed in the museum or gallery environment. Stoerchle manages to avoid this sense of completion in his work through a sensitivity to the effect of the materials and specific location of the pieces. The plaster, a brittle and delicate medium, when it breaks, tends to elicit contemplation of its previous state as much as its broken one. This fact and the location of the event in a situation where its temporariness is assured combine to isolate the moment of the briefer process of the piece and yet to tie it into a continuous time. For Stoerchle the moment when the sculpture is perceived is as much a part of the process as the fall or any previous point in time. That this is a conscious part of his thinking is made

obvious by the changes that were made when carrying out the concept in a gallery environment.

In the spring of 1970, Stoerchle executed a series of plaster pieces at the University of California Art Gallery in Santa Barbara. This series was particularly interesting in that his body was part of the pieces as he jumped, was pushed into, and swung through various plaster plates. His environment, however, was detached in that he utilized himself only as an implement for the breakage. A better illustration of that point is the fact that a gymnast was engaged to break a line of slabs by turning flips, a task to which he was better adapted. In this way the image is maintained as a physical result, the personal involvement is de-emphasized, and the attention is again squarely on the process. The depersonalization of the process was enhanced by the fact that television coverage of the performance tended to influence the sequence and pace of the activity, reducing it to set tasks to be accomplished. The presence of the television crews, cameras, etc. also tended to amplify the impression that one was watching a live replay–a staged repetition of something which had occurred sometime in the past. This quality is consistent in Stoerchle's work, resulting in an ambivalence in time perception which is especially engaging when witnessed directly. In that regard this event was particularly strong as the pieces were all performed in the same general area, which required rearrangement of previous results in order to carry out current tasks, and yet inevitably they influenced the subsequent activity. The 'combined' sculpture was then swept into a ten-foot square area of the floor for the remainder of the exhibition. The piece in this way avoided monumentalizing the past by destroying it, leaving no direct reference to the completed activity. This erasing action in one motion removes the possibility of reading the piece as the remnant-fixed-in-time (as an object) and directs attention toward the missing element–the tape which was the only record and product of the event. This taping of the process undoubtedly suggested the use of the videotape technique with which Stoerchle has been recently most concerned. In the interim, however, he has pursued some less tangible but significant extensions of the concepts.

While these pieces are frequently successful as individual efforts, their cumulative effect is a manifesto of process. To illustrate, a selection of pieces is described and discussed as follows:
1. A simultaneous disrobing and exchanging of clothes was concluded with another artist in a public place, after which they separated, presumably to carry out their previously intended activities. The depersonalization is here actualized in the dropping of the perceived image, disclaiming its importance to process in an aesthetic or social form.
2. A core sample of earth was removed, mixed with food and eaten (by three people),

and replaced in faeces form in the hole. It is suggested that however complex and visually varied the product, the process is by no means unique or controlled. The inadequacy of the object (photographic document in this case) to convey process and the use of people performing a usual function perhaps suggested the next piece.
3. Reviews of non-existent exhibitions of Stoerchle's work were written by persons ordinarily engaged in that type of activity. Thus the artist's role as stimulus for the review is retained, the object is eliminated, and the process with a perceptive use of media is presented directly. The process includes an illegitimate history, its own existence, anticipated reaction to it, and this description, as elements of itself.
4. A newspaper clipping of his having won an award in an open print competition was submitted as a print to the judges of that same exhibition. This piece is similar to the previous one both in the confusion of sequence and in the use of other people to complete the process. The judges in this instance had the opportunity to judge and to complete a piece in the same action. By not awarding the prize, the judges did not carry the process through, and consequently the piece was not successfully completed nor could it in fact be judged.
5. Stoerchle claimed as a piece a 4200-mile horseback trip across the United States accomplished eight years earlier. The claim, the trip, and the intervening time are fused by implication into one continuous process dependent for their existence, as an element of the piece, on each other.
6. (Arm wrestling.)
7. Participation in performance situations with the California Time Machine (a group of composers and artists) required dealing with larger blocks of the process as product. This led directly to the use of the videotape technique which can be used to present the whole of an activity while retaining a sense of the significant moment inherent in the process and important to Stoerchle.

During the past year, Stoerchle has been almost exclusively involved with the production of videotapes which give him the advantage of being able to record an activity and play it back at any time. This not only makes the implied continuousness of the process a reality, but also completely eliminates the fixed-time interpretation of the remnant. Videotape has a sense of immediacy that creates an illusion of a kind of perpetual present which Stoerchle uses as a counterpoint to the formalized replay attitude of his process mentioned before. Now the reality is made specific by reference to past events, particularly those of childhood, or by implications referring to numerous stages in the continuousness of life. He can deal with these personal subjects because of an emphasis on general and universal types of imagery and the mechanical reproduction of the media. Consequently there is no loss of the impersonal

160

ualities, which insures that the emphasis is on the process and not on the artist. This is specially clear in the first of four tapes which re discussed below.

The first tape consists of continuous ctivation of Stoerchle's penis (through body movement and tension only) shown upside own, a device which immediately sets the tone f personal versus impersonal elements. The eneral activity of the penis is a steady detached obbing motion throughout the tape. The attern is broken only when body tension causes uick vibration in what appears to be a childish ttempt at an erection, a brief urination, and nally a violent flopping back and forth. n the second tape, small plastic replicas of Disney cartoon characters are ejected with onsiderable effort as though born from eneath the foreskin. Sound which is generally n important element in Stoerchle's videotapes as well as in the plaster pieces when executed) noticeably absent in this tape. The deletion important in that what could be interpreted s an emphasis on the personal is seen as the npersonal activity it represents. The element f common childhood practice is wedded to the resent with some wit when it is understood hat Stoerchle teaches at the California nstitute of the Arts, and so indirectly the Disney foundation is involved in supporting ne production of the tape. The task which in his tape is repeated to a quick conclusion ecomes a long continuous performance in the ext piece under discussion.

A long thin box placed vertically on the ight-hand side of the screen falls to the left nd hits the floor. Stoerchle repositions it ertically in its displaced position (perhaps hree inches to the left) resulting from the orizontal force of the fall. The process is epeated complete with crashing sound and radual movement of the box across the screen. When the box passes off the screen on the left, ne microphone, which has been in the box, is emoved and placed outside the box which is eturned using the same procedure to the right ide of the screen and off. The process in this ape is a simple one and, being one of Stoerchle's ongest tapes, is almost brazenly boring. (None f the tapes uses boredom for its own sake, but ather as a means of forcing attention on the isual subtlety and intellectual implications of he piece.) The question of visual considerations a significant point. Having established that he videotape records the process and is not nvolved with the object as such, Stoerchle is reed from the self-consciousness others have elt at using controlled visual forms. The roles ave been reversed here, and with process as ne main concern, visual and auditory effects re used as a technique to emphasize and to efine the exact nature of the activity. It is nteresting to note that Stoerchle virtually lisappears in this tape, as the attention is ocused on the box. He performs anonymously s a function of the process, just as in the end the ask itself becomes a vehicle and a stimulus for

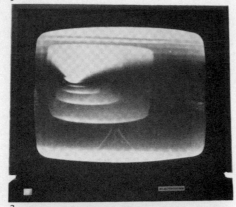

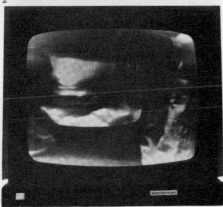

1-3 1971; 4 1970

ascertaining the tasks that we assign ourselves.

The nature of our tasks is dealt with powerfully and clearly in the last tape to be discussed. A small cube of dirt is placed in the centre of the screen. A face (Stoerchle's) snaps down from the top of the rectangle accompanied by a rush of air and disappears up and off the screen. The short bursts of breath and hammer-like movement of the head are repeated at a quick regular pace for the duration of the tape. The activity is ended when the cube is broken down and most of the debris is cleared from the area. A response to the tape is dealt with in the description which follows. After only a few puffs a corner, a lump of dirt, is forced from the cube. The purpose is established, the procedure works, and completion should not take long. Several dozen blows (beginning to be laboured ones) later, four corners are off and coercive success begets confidence. Twenty or thirty hard breaths later, it becomes clear that a cube missing four corners resembles a pyramid. Each breath simultaneously establishes the stability of the remaining lump, the determination of the face, and the exhaustion of Stoerchle. As he continues, new techniques are developed, blowing from left and then right as progress is made, and a growing professionalism promises possible success barring his collapse, which appears to be imminent. The cube is in fact finally shattered, leaving the previously positive space of the dirt cube empty–a negative space now surrounded by remnants of the cube–perhaps to be filled by a cube of our own selection.

This piece suggests some of the implications present in a situation where proper attention is put on process as a comprehensive concept. Through repetition, a knowledge of materials and the willingness to let them function logically, and an unselfconscious use of visual organization, Stoerchle appears to be accomplishing just that. Although the videotapes successfully present a coherent and detailed look at a process they tend to isolate the activity and make use of a singular image reminiscent of the object concept. Consistent with his efforts to push himself beyond that state Stoerchle has continued to engage in performance situations since the initial efforts with the California Time Machine several years ago. Daniel Lentz, Harold Budd (composers) and Stoerchle intend to culminate those experiments in a series of public presentations being scheduled during the coming year. It is tempting to conjecture about the possible results of 'live' process and the complex possibilities of interacting and increasingly less fixed situations but this interest will be best served by a response to the reality of the events themselves. No doubt they will be dealt with in detail as they are carried out and as the importance of the contribution that Wolfgang Stoerchle is making to the concept of process is recognized. □

161

JOHN STURGEON

Born 1946, Springfield, Illinois
Lives and works in Baltimore, Maryland

DRAWING FROM MYTHOLOGY, astrology, and ritual, John Sturgeon employs symbolic systems within his videos to explore individual consciousness. Sturgeon creates his own language out of everyday elements, such as water or ice; yet in his poetic orchestration of video technology, he articulates the universal search for self-knowledge. His work from the mid-1970s consists of tightly edited, multilayered imagery strongly influenced by Jungian psychology and dream analysis. In 1974, Sturgeon created a number of pieces addressing communication and consciousness. In (*waterpiece*), Sturgeon turns the camera on a monitor depicting an image of himself lying underwater, before panning downward to reveal the image reflected once again in a submerged mirror. Electronic communication through video signals and screens becomes a means of visualizing the subconscious. Wielding a set of hand-held calipers, an off-screen presence seems to be measuring bubbles on the screen in an attempt to study and quantify the psyche, while being separated from Sturgeon's actual body by both the water and the monitor.

Sturgeon collaborated with Nina Sobell to create *NOR/MAL CON/VERSE* (1974). In this work, Sobell and Sturgeon's close-up profiles create twin images. The letters "NOR" and "MAL" or "CON" and "VERSE" appear on their faces, yet this conversation in no way resembles normal conversation between two individuals, as it is mediated by an electronic, and at times, aurally indistinct voice. This video addresses a dominant theme in Sturgeon's work, as he explores technology's role in assisting, or sometimes hampering, creative expression and its potential for exploring human psychology. The rarely exhibited *Porky* (1974) features Sturgeon wearing a pig snout mask and breathing heavily into a bag. The camera zoom is synchronized to the rhythm of his breathing, sometimes reaching a disturbingly frantic pace.

As his own spiritual search became the subject of his work, the actions depicted in many of Sturgeon's early tapes eventually extended outside of the monitor, often including the element of live performance and sculptural and video installation. Initially reflecting a characteristically West Coast consciousness that could even be described as "New Age," Sturgeon's work has continued to embrace new media and interactive forms in an ongoing exploration of ritual and universal experience.

Pauline Stakelon

Interview conducted by Glenn Phillips on February 9, 2007, at the Shelburne Murray Hill Hotel in New York City

GP: What's your earliest memory of seeing video in an art context?

JOHN STURGEON: The first piece of video art that I can recall seeing was in the spring of 1969. I was a graduate student at Cornell University, and a group of us came down to the city and went to the Howard Wise Gallery to see the now-famous *TV as a Creative Medium* show. I remember a tiny elevator coming up to this space. There were some monitors on which, I think, were Frank Gillette and Ira Schneider's piece *Wipe Cycle* [1969]. I remember checking it out, going around the corner, and there was Nam June Paik's piece with Charlotte Moorman, the *TV Bra for Living Sculpture* [1969]. She was sitting there, playing the cello and wearing the "TV Bra." And I went, "Wow, cool!" [Laughter] I never dreamed that's what this would be, you know? And I don't know that it was an influence,

but it opened a door to me in a way that I had not anticipated. It was quite impressive to see a human being wearing electronics and performing at the same time. It was fabulous.

Was Cornell where you first started using video in your own work as well? The first time that I had a video camera in my hands was in the spring of '69. David Shearer, the art history librarian at Cornell, was actually the first person to buy a Portapak. He gathered all the grad students together and said, "I just got this new thing, and I don't know whether you're interested or not, but I thought I'd show it to you." It had a hand rewind; you could record, and then you'd rewind it by hand, and then you'd take it from your recorder to your player and play it. I remember thinking, "Well, this is actually pretty interesting." Within a year, I wasn't doing anything else. Nina Sobell and I were a couple at the time. We were both grad students at Cornell, and she was a year behind me in school. So I spent the next year after graduation working for the Cornell University Video Center. We volunteered to tape anything, anywhere, anytime. That was my education in video. It was a very synergistic time of people saying, "Well, I discovered you could do X with this or that." I think that having no formal training was actually a real benefit, because I was forced to translate my education as a painter and sculptor into a new medium. I was never interested in being a television person, even though, in retrospect, I was very interested in television. When I was a kid, I thought Ernie Kovacs was like God. I just couldn't believe—my parents, I know, didn't care for Ernie Kovacs, but I just loved the way he handled the medium. Nobody else was doing that kind of stuff. So, in retrospect, I can see that there were things about television that were formative, but I didn't have any formal training in it. And then, the year after my stint at the University Video Center, Nina and I moved to California and settled in L.A.

You have a series of works made between 1971 and 1973 that I haven't seen. Nor have I in a long time, because as far as I know, they no longer exist. The glue they used to adhere the iron oxide

to the polymer tape in that first generation of tape stuck together. And if you didn't make a transfer to U-matic early enough, then they got captured there. I only have one functioning tape from that period, and that actually came back to me just recently. I thought it was gone, but the de Saisset Museum in Santa Clara, California, still had a copy. So everything I did from '71 to '73, with the exception of the one from the de Saisset, doesn't exist.

Do you remember what was on those tapes? Can you describe them from memory? Sure. The first "official" tape I ever made was *Video 1* [1971]. I grew up in a painting environment, and the idea was that one would fill a canvas—I mean, you have a canvas of a certain size, so you fill it. I had a half-hour videotape, so I thought, "Well, fill the videotape." [Laughter] They were vignettes, and since this is pre-editing, they were all planned out in sequence, using in-camera edits. They were about discovering that sort of lag in the video tubes, so you get ghosting, and doing little performative things in front of black, so that you'd get tracings. I remember shooting one section from a greenhouse in the middle of winter. It had nice neon, and the lights were flaring, and I was enamored with the way the video tube was translating the visual aspects of things. But it was very poetic, and even then, I was writing things that I would read into the camera mic.

When I first moved to L.A., I bought a Portapak from a religious station that was selling one. That was my freedom from having to borrow equipment. The first tape I made in California was called *Dwelling/Oar* [1973]. I fell in love with California light, the light coming into the studio, and I was able to do shadow work and performative work against the wall. I made live drawings in front of the camera. The old, abandoned Pacific Ocean Park pier was still there, and it was a great place to go rummaging around. It was technically off-limits, but you could sneak in. I remember I was there on New Year's Day, inside this one space that had a huge opening; the camera was situated so that it was looking out at the ocean and the gleam of the sun. There was a really nice, hot, white light coming off the sun, and the floor of this space was all littered with broken glass. So that particular section of the piece was about sweeping all the broken glass into the shape of the sunlight that was coming in through the door and falling on the floor.

Would you know every scene that you wanted to shoot before you started a piece, or would you just shoot—you know, shoot ideas that came and then assemble them together later? What was your working methodology? I would keep notes about ideas that I would have—that I wanted to do X, X, and X, with not necessarily any sense of their being in the same tape. And then, at a certain point, it was almost a feeling, a felt thing, that the sort of density of what was building up—the pressure inside—that something had to manifest. And when that would happen, then I would just sort of look at the notes and then compose, from those notes, things that seemed to go together. It was almost as if they had a magnetic attraction. Somehow, they'd sort of come together and say, "Okay, this would be a scene." And then, I would build that scene in the studio and try to work it. Once I was in the middle of taping, then things I hadn't thought of would come together. Quite often, things fused unexpectedly. I liked the idea of compressing, and it was a delight to see how things just imploded into a very tight set from what might have been very disparate notes.

One of the things that stands out about your works from 1974 is that they use pretty sophisticated editing, compared to what a lot of other artists were using at the time. So I'm wondering how you learned to edit. Well, it's very hard to say, because I never

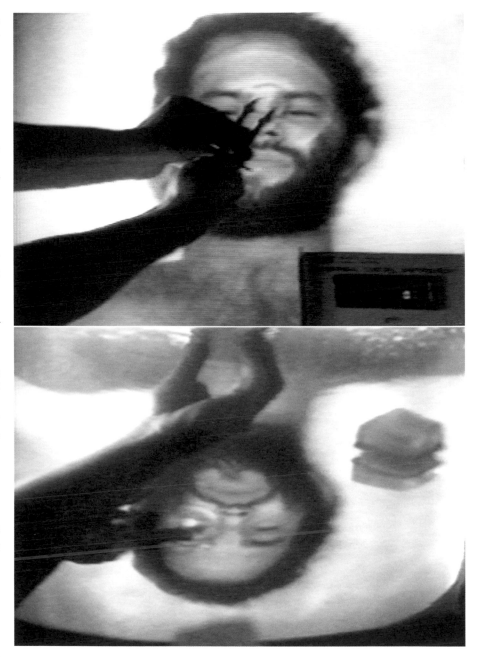

went anywhere to learn editing. The first tapes I made only used in-camera editing. We were waiting for those first editors. I think the Sony 3650 was the first editor that came out, and then the next level up was that you could do audio dubs or split the visuals from audio. Conceptually, it was just desire. The film and television world had a far more sophisticated level of the technology to use, but you couldn't get your hands on it. So the sophistication, I think, is conceptual. It's not about the technology, because they're just cuts. There were a lot of visual effects—lots of mirrors, you know, to layer images and so forth. So it's all being done optically.

Could you describe (*waterpiece*) [1974]? That work really plays with reflection. When I was looking through my notes for (*waterpiece*), I found several dreams that I had written down. I work from dreams a lot, but usually not so directly. (*waterpiece*) is actually a very direct reference to a dream that obviously had some pretty potent kind of influence on me. It was a dream about Abraham Lincoln. I was born in Springfield, Illinois, so any time Abe Lincoln

p. 218
John Sturgeon and Aysha Quinn in *Conjunction/Opposition*, 1976. Black-and-white photograph of video performance, 20.3 × 25.4 cm (8 × 10 in.).

p. 219
John Sturgeon, stills from (*waterpiece*), 1974. Single-channel video, black-and-white, sound; 7 min., 11 sec. LBMA/GRI (2006.M.7).

shows up, I pay attention. He was giving a very animated speech, and then I realized that he's not actually Abe Lincoln, but an actor playing Abe Lincoln. So there's this idea of the emulation, or the falseness of this not really being Abe. I have to make this realization in the dream that there is that disjunction and—because I'm reading Jung at the time—make the association with the man with the pointed beard. Lincoln had this beard that represented the intellect. So, the dream was a realization of the intellect as a false voice to a certain degree. This all gets worked into (*waterpiece*), because it's about trying to have a visual metaphor for going into the unconscious. That's why I shot it underneath the bathtub in our studio there. I'm lying underneath the water, trying to hold my breath for as long as I can—which was hard because the water kept going up my nose. I'm taping the image off a monitor; there's also a mirror on the table in front of the monitor, so I can drop the camera down and get that transition, so you get the reverse of the image—like the hanging man card of the tarot. I had about an inch of water on top of the mirror, so the mirror was also a watery surface, and there are ice cubes floating on the water. I also have a small pyramid that was cast in resin. It looks like an ice cube, but it's in the shape of a pyramid. I put that on the reflected image of the chin. That's when the video cuts to this sort of Abe Lincoln character—the intellect character—who cuts off his beard or his chin, which is symbolized as this fruit, which is what it was in the

dream. It was like a gift or a sacrifice to the audience—the gift of awareness of where the intellect actually exists within the hierarchy of the human psyche.

Then you also take calipers and measure parts of the image on the monitor. It looks like the video on the monitor pauses and you measure the air bubbles as they surface in the water. If we were to say that the "me" underwater in that scene is the submerged me in sleep or in the unconscious, then that unknown persona with the calipers—you only see this person's arms in the video—is the one who is going back in and trying to determine, trying to analyze, to take accurate measurements of what it is that's going on. The air bubbles rising in the water represented the breaking of that surface. So you would try to calibrate that, you'd try to get some meaning or awareness out of that.

A lot of this work seems alchemical to me, because you're working so deeply with metaphor. In terms of other people watching the work, did you feel like you needed to help them decode it, or did people seem to get what you were after immediately? I guess I've always felt that it's dangerous to try to explain everything that you're doing all the time. I think that unconsciously, all of us have a certain common awareness of things; whether we're able to bring it to conscious awareness or not varies from individual to individual. So I think that there is a common vocabulary that we share, certainly in the Western psyche. And I trust that; I trust that, at some level, there's this cognizance of what's going on. On the other hand, I try to link all those things to elements, sometimes props or whatever, that are everyday or are certainly recognizable, and I think that they also live and work at that level. I wasn't really worried about whether you could consciously say, "I get all of these references." For me, it's also a way of discovering myself. I mean, I'm working out my vocabulary. I'm also reading a lot of Jung at the time; my favorites were volumes 12, 13, and 14, which had to do with alchemical process,[1] because Jung was a real aficionado. These works were a way to visualize a Jungian process. When you see the tapes, they're also almost like haikus in terms of being able to take very complex mental processes and reduce them down to such acute visual representation. I just found it to be stunning; I was also getting into astrology at the time. I was into very California stuff here. [Laughter] I was an East Coast person, and then, all of a sudden, I was learning all of this stuff. It was another vocabulary, another way of looking at the same things in my life and in the world. Sometimes those things appear in the tapes; sometimes they don't. Whether or not it's really important to know all that—hopefully not; hopefully, it lives on several different levels.

Describe *NOR/MAL CON/VERSE* [1974]. *NOR/MAL CON/VERSE* is one of those pieces where I think I achieved humor. I'm deadly serious most of the time, so I'm very pleased when humor creeps into my work. But *NOR/MAL CON/VERSE* was really struggling to grasp the changes that we're all going through with the rapid increase in technology being a part of our lives. It really is a tribute to this early digital voice recognition software. There was a technical magazine that sent out one of those floppy plastic inserts that you put on your record player. It demonstrated attempts to digitally synthesize speech. We used that as the soundtrack, together with sounds from a typewriter and the turn signal from my car. The title of the piece was *NOR/MAL CON/VERSE*, or "Normal Conversation"—which this tape is anything but, right? Nina and I did the piece together: We did four variations with text printed on our face. I'm "Nor" and "Verse," and Nina was "Mal" and "Con."

You see this hybrid image being made to construct those two words. There was no cameraperson. Whoever was in the front seat would reach to zoom and focus the camera.

How did you get the sound in that piece? Were you doing sound mixing? Yeah—these are like hard-fought victories that you gain control. It was the first time I was able to do any kind of mixing, and the whole soundtrack was done that way. The digital voice track, the IBM Selectric typewriter sounds, and the turn signal from my car were all taped. There's a nice little story about the editing of NOR/MAL CON/VERSE and the turn signals. I was in the middle of editing that tape when I heard a knock at the door. I was loath to be interrupted while editing, but I opened the door, and there are two LAPD officers. And I thought, "Oh God"—in my studio, you know. "John Sturgeon?" "Yes." He says, "You have a 1962 Ford Falcon station wagon?" "Yes." And he said—and then they sort of parted: "Do you know this man?" And there's this guy standing behind them. And I said, "No." He said, "Well, he just broke into your car." [Laughter] So I went out with them to look at the damage. He apparently had broken into the car, but there was nothing in it, nothing. So he basically just threw everything out of the glove compartment, kicked out the headlights, kicked out the taillights. But the great thing was that—it was a white car—he took a pencil from my glove compartment and signed his name on the hood of the car. And I said, "God, that's so great." The fact that he would do it and then sign it, right, I just thought the guy's an artist. And they said, "Do you want to prosecute?" And I said, "No, I don't want to prosecute." [Laughter] So that's what was happening while I was editing.

Were you usually working completely alone in the studio? For the most part, yes, with the exception of when Nina and I were living together, and we would occasionally be cameraperson for the other. She's the cameraperson in Porky [1974], and that piece is a real tribute to Nina for her camerawork and editing, because she really took that on as a special project. For a work like Porky, I needed to get sort of psyched up to do it. I had no theater background, and I didn't have any other means of achieving that kind of experience. This was a highly performative tape that was really about the performance of character, whoever he was or is. I remember that Nina and I set up the whole set, and then we broke and I went out on the beach for a fairly long time. I might have been gone for several hours, just getting into the mood to be Porky. And we walked in and—boom—we were ready and shot that thing, and that crazy being came out of me.

It's hard for me to imagine that that tape could have been made anywhere else but in California at that moment in time. Venice in 1974 was a really unique period. It was the period when all of us residents discovered that Los Angeles didn't own the beach; the state of California owned the beach, and in the state of California, you could go nude on any of the beaches. Even though we were in an urban space, the state of California actually governed the beach itself, so we could all go in whatever various forms of clothing we wanted. This led to a very crazy period, which really peaked in the summer of '74, which is when Porky was made. Anybody could wear anything on the beach. I don't know what that meant to others, but what it meant to me was—I was a person that came out of an East Coast education who had been drinking like ten cups of coffee a day and smoking two packs of cigarettes a day, and I moved to California and rid myself of all that unhealthy stuff, and also began to understand what it was to live in the body. California was a Mecca for that kind of dialogue. For me, it was really, really healthful. I became not only physically healthy in California but

I became psychically healthy, and gained the ability to say, "This is my body. This is my tool, and I live in this; you've got one too, and that's your tool and you live in it." So, the kind of honesty and integrity of that moment in time for me was really wonderful, and I have been indebted to those experiences for the rest of my life, because it made me a much more comfortable person with who I am. It allowed me to have a kind of control over my life that I never dreamed I could have as a younger person, not really feeling comfortable in the body and having no vocabulary to even know that that was part of the problem. So that particular summer and that particular time in California was magnificent for that. And Porky is an expression of the kind of freedom that comes from living in that space during that period of time.

NOTE
1. The Collected Works of C. G. Jung (New Jersey: Princeton University Press, 1968): vol. 12, Psychology and Alchemy; vol. 13, Alchemical Studies; vol. 14, Mysterium Coniunctionis; ed. and trans. C. G. Jung, G. Adler, and R. F. C. Hull.

ERIKA SUDERBURG

Born 1959, Minneapolis, Minnesota
Lives and works in Los Angeles, California

ERIKA SUDERBURG has playfully described her practice as including "films, videos, text, photographs, sound design, installation art, motion picture editing, songs, manifestos, *Wunderkammern,* rants, linkages, coping mechanisms, and domestic rearrangements to a discerning and much beloved few." While humorous, this list characterizes the artist's broad range of interests and her ability to work within a variety of media and styles. In her short experimental documentaries, Suderburg explores cultural geographies and individual identities using physical locations, such as Los Angeles, Berlin, and Yucatán, as historical and metaphorical landscapes. In other works, Suderburg composes visual poetics through more formalistic video studies. Her work *Three Grace(s)* (1997) is as much an experiment with manmade materials as it is an analysis of natural and artificial light. In the video, three rice-paper electrical lamps, all in primary colors, are aligned and illuminated. Starting on the left, the artist persistently attempts to set a lamp on fire with several matchsticks. Only the tiniest of fires erupt on the obviously fireproofed lampshade, transforming an expected act of serial destruction into a progressively successful failure, as each blaze-pitted surface of the lampshade takes on a surprising, painterly surface.

In a more abstract work, *STRIP* (2006), Suderburg collaborates with painter Linda Besemer to record the properties of painting with video, adding temporal and aural dimensions to static images. Zooming across the edges of the canvas, then slowing down so that patches of color become more distinct, Suderburg scrutinizes the plastic medium with a sharp, technological eye. While the title *STRIP* clearly refers to the vertical and horizontal strips of color that move across the screen, it also recalls the "film strip," calling attention to the basic differences between the look of video compared to that of film. The video's soundtrack, which evokes the rattle of a film projector or sandpaper stripping wood, is the result of the original video footage being played back at high and low speeds as it was rerecorded for the final edit. Through the repetition and alternation of sounds, color, and line, the viewer's gaze is drawn across the series of paintings, never reaching the edge of the canvas.

Pauline Stakelon

p. 222
Erika Suderburg with Linda Besemer, stills from *STRIP*, 2006. Single-channel video, color, sound; 7 min., 3 sec.

p. 223 left
Production still showing Linda Besemer's acrylic painting trimmings used by Erika Suderburg to produce *STRIP*, 2006. Color photograph.

p. 223 right
Linda Besemer, *Fold #70*, 2002. Acrylic paint over aluminum rod, 101.6 × 274.3 cm (40 × 108 in.). Courtesy Cohan and Leslie, New York, and Angles Gallery, Santa Monica, California.

[STATEMENT]
STRIP
by Erika Suderburg

STRIP [2006] is a playful, trancelike riff on experimental animation, fabricated without traditional animation methods. *STRIP* utilizes the cast-off edges of a painting and mobilizes them in a skewed homage to the fanciful worlds of early Hans Richter, Oskar Fischinger, *musique concrète,* and 1960s Color Field painting. The static is sent packing in a frenzy of temporal excess and repetition accompanied by the sounds of its own launch.

STRIP was constructed out of the trimmings from Linda Besemer's large-scale abstract paintings, which are cast aside as the final painting is sized and straightened. These strips can be three to six feet in length, one-quarter to three-sixteenths thick, and from one to six inches wide. Like the paintings they come from, they are composed of multiple layers of pure acrylic paint on no backing. When discarded, these trimmings accumulate as foot-high multistrata mountain ranges occupying the plain of the studio floor.

Selecting and saving portions of this strata is the first editing process. Next, a tabletop wooden slider ramp was constructed. Each strip was dragged or slid from side to side on this ramp, under an extreme micro lens (used for geologic specimens). The soundtrack is made up of arguments, admonishments, and instructions from one launcher to the other as to how to "play" the strips on the slider. Each sample was "played" or manipulated "live" with alternative speeds, rhythms, choreographies, and cadences. These one-take minimovies of orphaned, reclaimed, and thriftily recycled abstractions were then microedited through caffeine—and classic Coke-fueled temporal manipulation somewhere late into the night.

These are *STRIP*(s), *stripped* of their context but valiantly attempting to perform, echo, and evoke the movement, vibrancy, and depth-defying illusions that the paintings that engendered them deliver. They are animated entities searching for a new configuration of painting. As such, they are simultaneously found sound and image, *musique concrète,* and Color Field painting fiercely asserting primacy over the static, a romp on the lam of dissolution and expediency. The assumption that painting can only be static is sent packing. If discards had a private life, it might look a bit like *STRIP*.

pp. 224–25
Erika Suderburg with Linda Besemer,
stills from *STRIP*, 2006. Single-
channel video, color, sound; 7 min.,
3 sec.

SKIP SWEENEY

Born 1946, San Mateo, California
Lives and works in San Francisco, California

SKIP SWEENEY ESTABLISHED HIS IMPORTANCE to the Bay Area video scene in the late sixties and early seventies, not only through his video work but by promoting collaboration and innovation within the video community itself. In 1968, he cofounded Electric Eye, a video performance collective. Two years later, he cofounded Video Free America with Arthur Ginsberg, another Bay Area video artist. Throughout the early 1970s, Video Free America produced a number of projects that probed media and culture, including a theatrical staging of poet Allen Ginsberg's *Kaddish* (1977), to which Sweeney contributed visual effects, and the notable reality television precedent, *The Continuing Story of Carel & Ferd* (1970–75).

Pioneering developments in video art's possibilities, Sweeney experimented with video feedback, a process in which the camera's video signal is sent to a monitor and the camera's lens is turned to face that same monitor, resulting in a distorted video signal. Sweeney labored to find ways of controlling the unpredictable result of this process, finally mastering the visual result of the feedback loop through camera movement and reflective mirrors. Desiring further control over the color that was added to the video after the feedback was recorded, he commissioned a "colorizer" from scientist and engineer Bill Hearn, resulting in the invention of the Vidium colorizer. Between 1970 and 1971, Sweeney created various Moog Vidium pieces, in which he introduced a Moog synthesizer, an early electronic instrument, into the feedback loop. In these works, the feedback is orchestrated to the atonal music of the Moog, as vibrating lines and circles appear and disappear to the beat of the music. The Vidium colorizer introduces bold and contrasting colors into the video, contributing to the psychedelic look of the video feedback.

Other works by Sweeney consist of documentaries, video installations, and video dance tapes produced in collaboration with dancer Joanna Kelly. Using home video footage, photographs, and interviews, Sweeney created two personal video essays about his familial relationships: *My Father Sold Studebakers* (1983), about his contentious relationship with his father, and *My Mother Married Wilbur Stump* (1985), about his mother's remarriage to a drinking, womanizing piano-bar singer. Sweeney remains active today at Video Free America, his media production house, where he engages with the most current new media technologies.

Pauline Stakelon

Interview conducted by Glenn Phillips on March 25, 2007, at the Video Free America offices in San Francisco, California

GP: You were one of the really early people to get your hands on a camera, so I'm wondering how you found out about video, and how you started working.

SKIP SWEENEY: I was a theater major at the University of Santa Clara and I had a friend, Lee Kaminsky, who was a year behind me. Lee had been a child singer, and he received money from his parents that he earned when he was under eighteen. He dragged me down to Alco Paramount Electronics, which was the biggest hi-fi stereo store in downtown San Jose—this was March of 1967—and he bought a Portapak, a studio camera, an editing deck, and maybe a couple of monitors. We took them over to his apartment, and he had a friend who immediately showed us how it could do video feedback. He pointed the camera into the monitor and we saw a TV inside a TV inside a TV, and all that. That was the moment that I said, "Hey, this is cool. This thing is interesting."

Lee eventually got another Portapak and another studio camera and everything else we needed to do video. I was more technically adept, so ultimately most of the equipment came to my little basement apartment in Santa Clara, and I did two things: I set up a camera in our living space, and I set up a video feedback system in a workroom. I was fascinated with video's ability to document reality. We would have people over for dinner, and I'd just put the camera on and start recording, and it somehow superseded anything in cinema verité I had ever seen. When we ate a meal, we'd all forget the camera was there, so it captured people talking and interacting in an incredibly natural way. At the same time, the phenomena of feedback just totally sucked me in. I was just amazed and delighted—and I still am all these years later—with the phenomena of having images pop out of this system just because it was feeding back into itself.

Another thing I started doing with video was taping my family. I videotaped my sister's wedding and our family Christmas in 1969,

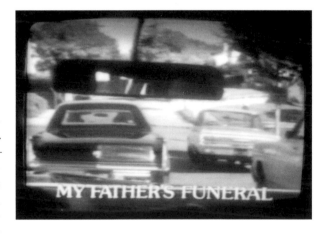

and I videotaped my father's funeral in 1971. I remember people saying to me, "Why did you videotape your father's funeral?" I actually suggested it to my mother, and she was immediately, like, "Oh yes! Of course!" I not only videotaped it, but downstairs at the wake we played the tapes so people could watch. This was a Catholic funeral mass, and I guess people were just surprised that someone either thought to or was allowed to do that. I must say, my mother's urge to document her life and her family's life encouraged me. They were totally willing to have me videotape anything of the family, and that eventually developed into *My Father Sold Studebakers* [1983] and *My Mother Married Wilbur Stump* [1985].

With the early work in the late sixties, who were you making the tapes for? Who watched them? Really just my friends, family, and anybody I could get to sit down and look at them. It was just to do them for myself and for other people to see. Eventually, that led to *The Philo T. Farnsworth Video Obelisk* [1970], because I wanted an excuse to show people my video feedback. I was pretty pleased with what I look back on now as being pretty simple video feedback pieces, but at that point I was fascinated by it and believed I was making something pretty interesting.

Describe what *The Philo T. Farnsworth Video Obelisk* was. As part of my conscientious objector service, I had this job being the program director for a small church-organized art center in San Francisco called Intersection. I took Thursdays and said, "I'm going to do a show." So, my group of friends agreed, and we came upon this notion, which later was to become a regular form on television, of doing a video magazine, with individual shorts as "articles." We started videotaping everything we could to create a show. One of us discovered that Philo Farnsworth's son was still alive, and actually Philo Farnsworth himself was still alive at that point. There's a debate about whether it was Philo Farnsworth or Vladimir Zworykin who invented television. Zworykin was RCA's scientist, and RCA wanted to give him credit, but Farnsworth, at age sixteen, drew on a blackboard the design of a television for his math teacher, and his math teacher was able to come to a patent interference trial and describe exactly what he had drawn up. By the time he was twenty-one, he had come to San Francisco and created a working television system. His son, also an inventor, lived in Bolinas, so we went and interviewed him about Farnsworth and that whole situation. That became the opening article in *The Philo T. Farnsworth Video Obelisk*, and later in the show, we featured the son talking about his own inventions. Sophomorically, we videotaped him with four cameras and live-switched it. I don't know why we didn't just put a single camera in front of him, but we didn't. So we introduced the first "article" and played it, and then we started a series of things called the Top Ten Vibes of the Week. Sometimes it was a little video feedback piece, sometimes it was a little slice of a documentary. One was a Slim Jim commercial, which we thought was about as painful a piece of videotape as we could experience. We created the first video DJ "Video Man," who mixed into solarized feedback, and introduced each "vibe." But from my point of view, I thought of all the documentary or humorous segments as just something to clear the palette between one video feedback piece and another.

The physical form of the piece was in the shape of an obelisk. We had a rolling cart that had three shelves. On the bottom were two rows of two 8-inch monitors. The next shelf had a 21-inch monitor. On top of that was an 18-inch monitor, and on top of that was an 11-inch monitor. The obelisk played two channels of video. The middle monitor, the 21-inch monitor, was the A Channel. The one above it, the 18-inch, was the B Channel. The 11-inch was the A Channel. The two 8-inch monitors below the 21-inch were B Channel, and the two 8-inch on the bottom were A Channel again, so it was A,B,A,B,A, and we had to synch the tapes up. For the most part, it was kind of ambient material or more video feedback on the B reel, but every once in a while we'd find a moment when we could do something spectacular or interesting on the B side that related to what was going on on the A side. So it was, at least in San Francisco and probably even in California, the first multimonitor, multitrack, videotape performance work. I don't know who came up with the term, *Philo T. Farnsworth Video Obelisk*, but it was probably Tim Barger, because he was a little more the humor and verbal side of our group.

Was he the guy who appears to be interviewing appropriated footage of President Nixon in one section? Yes, and he was "Video Man," the video DJ who would say, "The next video vibe is running up fast on the charts. In L.A., it was number seven, and this week in San Francisco it's number three." The vibes were spread out through the entire ninety minutes. We were restricted to sixty minutes for the first half because that was the length of our reel of videotape, so we put together everything we could in the first sixty minutes. Then, in the middle of the second half, three of us would come up behind the black curtain while a feedback segment

was playing, and reach out and start to move the three monitors. First, the 11-inch monitor just starts to float up in the air, and we could hear the audience gasp as we did this, because they've had this thing rock solid for now seventy-five minutes, and suddenly it starts to raise up and people are thinking that the whole thing is going to fall over on them or whatever, and then the next one starts to raise up, and they all gradually rise and tilt over in one direction and stack up again on their sides. We'd shot footage with the camera turned on its side, so to play it, we had to have vertically oriented monitors.

Was the group known as Video Free America at this point? When we first started showing *The Philo T. Farnsworth Video Obelisk*, we were called Electric Eye, but within a month, Tim Barger came up with the name Video Free America and we all just jumped on it. The image, of course, was that we were out in international waters on a ship, broadcasting the truth through the media curtain of

p. 226
Skip Sweeney, still from *My Father's Funeral*, 1971. Single-channel video, black-and-white, sound; 1 min., 30 sec.

p. 227 top
Skip Sweeney, still from interstitial interview segments of *Illuminatin' Sweeney*, 1975. Single-channel video created for TV, color, sound; 30 min.

p. 227 bottom
Skip Sweeney, early colorized "Moog Vidium Feedback" experiment, 1971. Single-channel video, black-and-white video and colorized Moog Vidium, 10 min.

corporate America. It was obviously a play on Radio Free Europe, but we liked it, and it stuck for us.

Did you ever do live feedback performances or demonstrations? I did it a lot for friends, but I never did it on stage. Leaping forward a year, the *Tapes from All Tribes* show in 1971 included a live performance night or two. *Tapes from All Tribes* was a show of everything we could gather from anybody who had work and wanted to show it. We weren't horribly selective, but I think it was a fairly significant early gathering of videos, and as one part of it we did an evening of live feedback and Moog Vidium and several other things at the Berkeley Art Museum under the auspices of the Pacific Film Archive.

And that was organized by Video Free America? Organized by Arthur Ginsberg and myself, along with everyone else at Video Free America.

And how did you meet up with Arthur Ginsberg? Arthur came and saw *The Philo T. Farnsworth Video Obelisk*, and he realized that I was doing exactly what he was trying to do, so he called me up and asked if I would shoot some things for him. Arthur started a company called the Tomorrow Show, and he had a complete business plan to create a video theater, a video production company, and he actually raised money from about three or four investors. He had a way of gathering people around him, so aside from me, there were several other people who jumped in. Within a few weeks, my wife and I moved up to San Francisco and lived in a little closet room in Arthur's apartment. It was the age of the collective so we considered ourselves, Video Free America, as a collective.

Why don't you talk about some of the early documentary-type things that you did? Well, there was a theory that California was going to fall off into the ocean, and there was a specific date. It was

April something, probably 1968 or 1969, and we figured out that if we went up on the east hills of San Jose and got up onto a plateau, we could set up a camera and essentially get ready to shoot California falling off into the ocean. We brought along another person to be the narrator; he's sitting there describing us waiting for California to fall off into the ocean and, of course, it never did, but that approach to humor in documentary was part of us. It was something we wanted to do right away.

Later, for another piece, we heard that there was going to be a Frisbee contest in Golden Gate Park, and we decided to treat it like a sporting event that deserves video coverage. It felt a little like a golf tournament the way we presented it. Everybody whispered quietly as people got ready to throw their Frisbee. At that point, our tongue-in-cheek approach was full-on. Arthur was an incredibly humorous interviewer, and Kate Coleman, our female interviewer, was equally articulate and ironic in how she asked questions and goaded people on. For the most part, anybody we interviewed was ready to jump in and play along. We showed it to somebody at Channel 5, KPIX in San Francisco, and they loved it and wanted to broadcast it. At that time, half-inch reel-to-reel video could not be broadcast. Time Base Correctors had not come into use yet. So they had us set up a deck and a monitor in the studio, and they pointed one of their big studio cameras at it to shoot it off the monitor. We said, "Back off a little. Let's make them see that it's on a monitor," and they agreed to that. After they shot it, they said, "It's too short. We need a longer one." So we went back to edit a longer version, but at that point the union guys said, "Wait a minute. These guys are editing this for television. They're not in the union," and so they kept them from showing it. It was sad that the union stopped our work from being seen.

How did you come to work with Arthur on *The Continuing Story of Carel & Ferd* [1970–75]?[1] As soon as we worked together, I was the main cameraman. Arthur had a scheme to create a number of

Describe what *The Philo T. Farnsworth Video Obelisk* was. As part of my conscientious objector service, I had this job being the program director for a small church-organized art center in San Francisco called Intersection. I took Thursdays and said, "I'm going to do a show." So, my group of friends agreed, and we came upon this notion, which later was to become a regular form on television, of doing a video magazine, with individual shorts as "articles." We started videotaping everything we could to create a show. One of us discovered that Philo Farnsworth's son was still alive, and actually Philo Farnsworth himself was still alive at that point. There's a debate about whether it was Philo Farnsworth or Vladimir Zworykin who invented television. Zworykin was RCA's scientist, and RCA wanted to give him credit, but Farnsworth, at age sixteen, drew on a blackboard the design of a television for his math teacher, and his math teacher was able to come to a patent interference trial and describe exactly what he had drawn up. By the time he was twenty-one, he had come to San Francisco and created a working television system. His son, also an inventor, lived in Bolinas, so we went and interviewed him about Farnsworth and that whole situation. That became the opening article in *The Philo T. Farnsworth Video Obelisk*, and later in the show, we featured the son talking about his own inventions. Sophomorically, we videotaped him with four cameras and live-switched it. I don't know why we didn't just put a single camera in front of him, but we didn't. So we introduced the first "article" and played it, and then we started a series of things called the Top Ten Vibes of the Week. Sometimes it was a little video feedback piece, sometimes it was a little slice of a documentary. One was a Slim Jim commercial, which we thought was about as painful a piece of videotape as we could experience. We created the first video DJ "Video Man," who mixed into solarized feedback, and introduced each "vibe." But from my point of view, I thought of all the documentary or humorous segments as just something to clear the palette between one video feedback piece and another.

The physical form of the piece was in the shape of an obelisk. We had a rolling cart that had three shelves. On the bottom were two rows of two 8-inch monitors. The next shelf had a 21-inch monitor. On top of that was an 18-inch monitor, and on top of that was an 11-inch monitor. The obelisk played two channels of video. The middle monitor, the 21-inch monitor, was the A Channel. The one above it, the 18-inch, was the B Channel. The 11-inch was the A Channel. The two 8-inch monitors below the 21-inch were B Channel, and the two 8-inch on the bottom were A Channel again, so it was A,B,A,B,A, and we had to synch the tapes up. For the most part, it was kind of ambient material or more video feedback on the B reel, but every once in a while we'd find a moment when we could do something spectacular or interesting on the B side that related to what was going on on the A side. So it was, at least in San Francisco and probably even in California, the first multimonitor, multitrack, videotape performance work. I don't know who came up with the term, *Philo T. Farnsworth Video Obelisk*, but it was probably Tim Barger, because he was a little more the humor and verbal side of our group.

Was he the guy who appears to be interviewing appropriated footage of President Nixon in one section? Yes, and he was "Video Man," the video DJ who would say, "The next video vibe is running up fast on the charts. In L.A., it was number seven, and this week in San Francisco it's number three." The vibes were spread out through the entire ninety minutes. We were restricted to sixty minutes for the first half because that was the length of our reel of videotape, so we put together everything we could in the first sixty minutes. Then, in the middle of the second half, three of us would come up behind the black curtain while a feedback segment

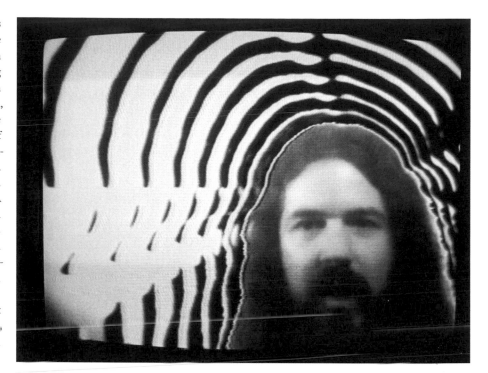

was playing, and reach out and start to move the three monitors. First, the 11-inch monitor just starts to float up in the air, and we could hear the audience gasp as we did this, because they've had this thing rock solid for now seventy-five minutes, and suddenly it starts to raise up and people are thinking that the whole thing is going to fall over on them or whatever, and then the next one starts to raise up, and they all gradually rise and tilt over in one direction and stack up again on their sides. We'd shot footage with the camera turned on its side, so to play it, we had to have vertically oriented monitors.

Was the group known as Video Free America at this point? When we first started showing *The Philo T. Farnsworth Video Obelisk*, we were called Electric Eye, but within a month, Tim Barger came up with the name Video Free America and we all just jumped on it. The image, of course, was that we were out in international waters on a ship, broadcasting the truth through the media curtain of

p. 226

Skip Sweeney, still from *My Father's Funeral*, 1971. Single-channel video, black-and-white, sound; 1 min., 30 sec.

p. 227 top

Skip Sweeney, still from interstitial interview segments of *Illuminatin' Sweeney*, 1975. Single-channel video created for TV, color, sound; 30 min.

p. 227 bottom

Skip Sweeney, early colorized "Moog Vidium Feedback" experiment, 1971. Single-channel video, black-and-white video and colorized Moog Vidium, 10 min.

corporate America. It was obviously a play on Radio Free Europe, but we liked it, and it stuck for us.

Did you ever do live feedback performances or demonstrations? I did it a lot for friends, but I never did it on stage. Leaping forward a year, the *Tapes from All Tribes* show in 1971 included a live performance night or two. *Tapes from All Tribes* was a show of everything we could gather from anybody who had work and wanted to show it. We weren't horribly selective, but I think it was a fairly significant early gathering of videos, and as one part of it we did an evening of live feedback and Moog Vidium and several other things at the Berkeley Art Museum under the auspices of the Pacific Film Archive.

And that was organized by Video Free America? Organized by Arthur Ginsberg and myself, along with everyone else at Video Free America.

And how did you meet up with Arthur Ginsberg? Arthur came and saw *The Philo T. Farnsworth Video Obelisk*, and he realized that I was doing exactly what he was trying to do, so he called me up and asked if I would shoot some things for him. Arthur started a company called the Tomorrow Show, and he had a complete business plan to create a video theater, a video production company, and he actually raised money from about three or four investors. He had a way of gathering people around him, so aside from me, there were several other people who jumped in. Within a few weeks, my wife and I moved up to San Francisco and lived in a little closet room in Arthur's apartment. It was the age of the collective so we considered ourselves, Video Free America, as a collective.

Why don't you talk about some of the early documentary-type things that you did? Well, there was a theory that California was going to fall off into the ocean, and there was a specific date. It was

April something, probably 1968 or 1969, and we figured out that if we went up on the east hills of San Jose and got up onto a plateau, we could set up a camera and essentially get ready to shoot California falling off into the ocean. We brought along another person to be the narrator; he's sitting there describing us waiting for California to fall off into the ocean and, of course, it never did, but that approach to humor in documentary was part of us. It was something we wanted to do right away.

Later, for another piece, we heard that there was going to be a Frisbee contest in Golden Gate Park, and we decided to treat it like a sporting event that deserves video coverage. It felt a little like a golf tournament the way we presented it. Everybody whispered quietly as people got ready to throw their Frisbee. At that point, our tongue-in-cheek approach was full-on. Arthur was an incredibly humorous interviewer, and Kate Coleman, our female interviewer, was equally articulate and ironic in how she asked questions and goaded people on. For the most part, anybody we interviewed was ready to jump in and play along. We showed it to somebody at Channel 5, KPIX in San Francisco, and they loved it and wanted to broadcast it. At that time, half-inch reel-to-reel video could not be broadcast. Time Base Correctors had not come into use yet. So they had us set up a deck and a monitor in the studio, and they pointed one of their big studio cameras at it to shoot it off the monitor. We said, "Back off a little. Let's make them see that it's on a monitor," and they agreed to that. After they shot it, they said, "It's too short. We need a longer one." So we went back to edit a longer version, but at that point the union guys said, "Wait a minute. These guys are editing this for television. They're not in the union," and so they kept them from showing it. It was sad that the union stopped our work from being seen.

How did you come to work with Arthur on *The Continuing Story of Carel & Ferd* [1970–75]?' As soon as we worked together, I was the main cameraman. Arthur had a scheme to create a number of

short pieces about different alternative cultural groups acting as collectives. There was a collective that was starting a music studio. There was a collective that was producing a newspaper. There was an early ecological collective in Berkeley that we videotaped, and there were the Hare Krishnas. Also on the list was a vague collective of pornographic filmmakers. San Francisco had a fairly vibrant but small porn industry, and Arthur had this plan to do a behind-the-scenes of the making of a porn movie. I don't think he ever imagined what *The Continuing Story of Carel & Ferd* would end up being, but all it took was one day to convince us that we had a tiger by the tail. This was one of those moments where, as soon I started to shoot this, I knew that this was gold. It was just great footage of bizarre people not hesitating to say whatever they thought or felt, and the story evolved in front of the camera as it happened. We had the starlet, Carel Rowe, who was a total ham in front of the camera, and the guy she was marrying, Ferd Eggan, was a junkie. We're in the building where they make their porn films, and these people were just spilling their guts out onto tape. Immediately, you could just feel it was way too good not to become something. So this first day, we went to tape them, not even knowing all their names, and we had no idea what we were walking into—that they were trying to get married, get out of the porn industry, and make their final film to pay off their debt to their producer. After that first day, we were married to them. They invited Arthur to come a few days later to their apartment, and within a week or so we had two cameras shooting the entire wedding, followed by the consummation of the wedding—which became the film they were trying to make to pay off their producer—and for some reason, the cameraman was naked too, and, of course, we're doing a live feed downstairs to the wedding guests so they can watch the consummation on live video. Several weeks later, Arthur went out to Chicago and videotaped them some more. The content was just magical. It had all of the bizarre elements of our time period, of what was going on then for a lot of people. Ferd was now clearly gay, and Carel was breaking down because he wasn't interested in her anymore. Of course, all of this was suggested on the very first day of taping when Gary, Ferd's lover, was making it clear how he felt about Ferd, including passionately kissing him on camera. But Gary was not involved in the Chicago segment.

And that was Gary Indiana, who's gone on to have a career as a writer. A famous writer, yes. Some of Gary's lines were just classic. And then Richard, the ex-boyfriend type who actually wanted to be with Carel, flies in from L.A. and tries to talk them out of it, and he plays the role of the sort of officious person who has to quote Goethe or something every moment. He's like, "Oh, no-no-no. Don't put me in front of the camera," and then he's just golden. He's saying all the stereotypical things that a guy like him would say in front of the camera.

As soon as we started putting *Carel & Ferd* together, we recognized its potential for multimonitor, multitrack display. I'm sure there are situations in which we showed *Carel & Ferd* as a single-channel piece, but publicly, we always showed it on eight monitors, with two channels of video. There were also two live cameras trained on the decks going around, or pointed at one of the monitors, so it could either zoom in or pull back from the shot to offer more options. We used a matrixed switching box so that any image could be on any of the monitors at any time, and it was mixed live. After doing it a number of times, Arthur developed a scheme for how things should be mixed. One clear moment is when imagery of Ferd shooting up is on all of the top monitors, and on the bottom monitors, Carel's upside down having an orgasm. I think it was the first piece shown using this multimonitor, multimatrix, mul-

tichannel approach to presenting a story. It was shown at various stages, even before they went to Chicago. And then after Chicago, several months later, Arthur brought them back to view everything and comment on it, and that became the next stage. So it was very purposefully called *The Continuing Story of Carel & Ferd*, because the idea was we just kept adding on. There was a final point in 1975 that Arthur got them into the studios of WNET. The only existing single-channel version of *Carel & Ferd* is from that show. But the multichannel version ran here at Video Free America every Saturday night for at least a year, maybe more. We had crowds coming in every weekend to watch it.

Tell me more about Video Free America as an exhibition space. Well, from the very start, our intention, even with *The Philo T. Farnsworth Video Obelisk*, was to have it be open ended, where other people's work could be dropped in. The minute we started showing our own work at Video Free America, we were at the same time talking to other people about showing their work. *Tapes from All Tribes* is an example. We would've done *Tapes from All Tribes* in our space, but the Berkeley Art Museum and Pacific Film Archive was a much more prestigious venue. In 1972, when we were showing *Carel & Ferd* on Saturdays at Video Free America, on Fridays we showed all the other videos we worked on as *All the Video You Can Eat*. That was shown on eighteen monitors and was also multi-tracked and matix switched. It was a looser, updated version of *The Philo T. Farnsworth Video Obelisk*, with lots of my video feedback. But we were also inviting other people to show their work—anybody we knew who was creating video. We had informal salons all the time, and Video Free America was always envisioned as space both to show work, and to help people create work. Once Arthur left, which was around 1974—though we worked together on projects for many years—that became my whole approach, and I spent many years working on so many other artists' work. Video Free America's standard approach was that if you were an aspiring video artist, you could come and volunteer for a while and help out, and at night you could use the gear to make your own work. So there's a whole list of artists who came through Video Free America that way, and all through the late seventies and early eighties, we did endless video screenings, and eventually started showing video art in movie theaters. Any artist we knew about who was visiting the Bay Area was invited to show their work at Video Free America. Nam June Paik showed his work here, and Steina and Woody Vasulka, Bill Viola, John Sanborn, almost every video artist who was willing or interested was given an evening at Video Free America.

Video Free America evolved a lot through the years. About twenty years ago, somebody called me up and they said, "Are you guys against video?" I said, "What do you mean?" They thought we were Video-Free America. They said "You know, like Nuclear-Free Berkeley." I said, "Yes. Yes, and we are especially against music video." I loved the irony that the name suddenly went from being a play on Radio Free Europe to being a play on Nuclear-Free Berkeley, and I loved the ironic humor of being a video center that was against video.

NOTE

1. For more information on *The Continuing Story of Carel & Ferd*, see pp. 98–101.

p. 228 left
Skip Sweeney, stills from *Skip Sweeney's Video Feedback Machine*, circa 1975. Installation: black-and-white video camera and monitor, silent.

p. 228 right
Skip Sweeney in San Jose, California, with early four-camera equipment performing mixed video feedback, summer 1969. Black-and-white photograph, 20.3 × 25.4 cm (8 × 10 in.).

DIANA THATER

Born 1962, San Francisco, California
Lives and works in Los Angeles, California

DIANA THATER DESCRIBES her early video installations as "neostructuralist," citing as her primary influences the unconventional narratives in the films of Hollis Frampton, the cataclysmic landscape created by Michael Snow in *La Région Centrale* (1970–71), and the early interactive video installations of Bruce Nauman and Dan Graham. Her work has used technology to sculpt volumetric space and time with multiple projections of mimetic imagery, often accompanied by the display of technology in the exhibition space—conspicuous monitors, mounted projectors, and exposed cables. The spatiotemporal dimensions of Thater's video imagery is enhanced by the slightly out-of-register projectors, which abstract the image by separating and overlapping its color. The use of colored light gels, mirrors, and filtered natural light repositions even the building's exterior as an integral part of her composition. As viewers move through the space, their bodies are immersed into the projections, becoming part of the works' abstracted landscapes.

Thater was an early graduate of the Master of Fine Arts program at Art Center College of Design in Pasadena, which she followed with a residency at the Claude Monet Foundation in Giverny, France, in 1991. It was in the beautiful gardens of Giverny that Thater shot footage of what was to become a recurring motif in her work: an animal subject—Fifi, a feral resident cat—within a natural environment of structured sublimity. *Oo Fifi, Five Days in Claude Monet's Garden* (1992) was shown in two parts and began an experiment in sequencing installations over time, and in different locations. She has since worked with wolves, horses, chimpanzees, parrots, dolphins, and bees. While Thater has examined the behavior and intelligence of a variety of animals, the simple beauty of flowers has also remained a constant in her work. In *Pink Daisies, Amber Room* (2003), Thater uses colored light, video projection, and filtered natural light to erase the defined rectangular edges of projected video space and to render the simplest of artist genres—the still life. A close-up of a bouquet of daisies is studied in a larger-than-life image, tracing the slight effects of movements in real time.

Carole Ann Klonarides

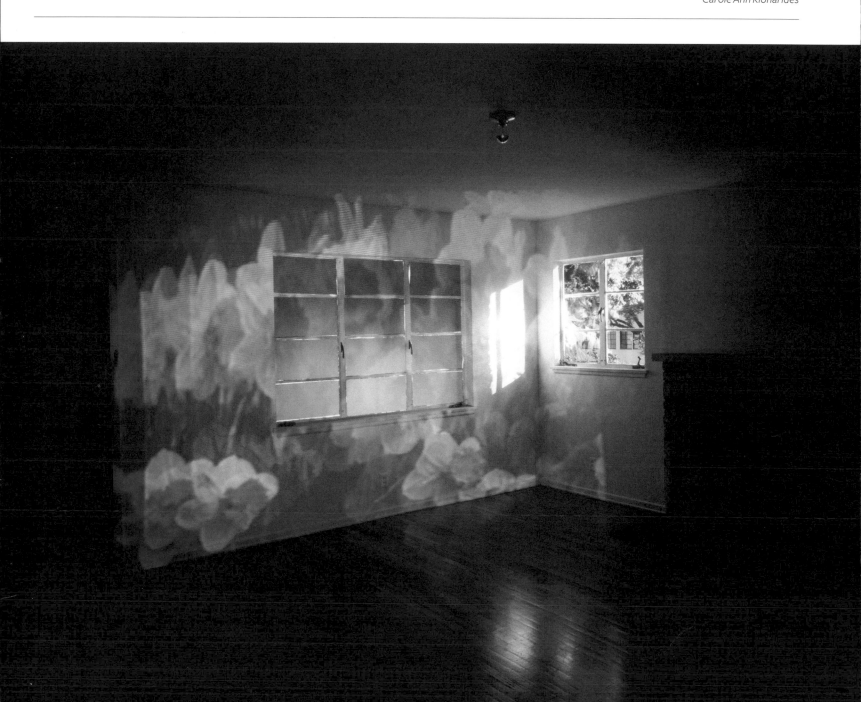

Interview conducted by Carole Ann Klonarides on February 26, 2007, at the Getty Research Institute in Los Angeles, California

CAK: What years were you at Art Center College of Design in Pasadena?

DIANA THATER: I started in 1988 and graduated in 1990. When I started, the MFA program was very young, but it turned out to be this really amazing program. My first term was also Patti Podesta's first term teaching at Art Center. I was making prints. Jeremy Gilbert-Rolfe was one of my professors and I showed him a bunch of work I'd made, and he told me, "We have this new teacher. Go make a video with her." So I did, and then that was all I ever made. Patti was a fantastic teacher, and I was her only student, so I got huge amounts of attention and made tons of work. Patti had this great way of teaching, because she hadn't really taught that much before; she encouraged me to mix history at will. She let me do a film series, to which no one came. Art Center had this big theater, and it'd be me and one other person. I did things like Carl Theodor Dreyer and Gary Hill as a film series; or three hours of Hollis Frampton, and then, you know, a Marlene Dietrich movie. My professors thought I was just being funny, but, of course, I was completely serious. I was learning to mix different histories together and to try to come up with some ideas made from those historics, including Hollywood film, literature, theory—all the things I was doing in graduate school. And then, to actually make art out of that big jumble.

Right after school, you got a grant to go to the Gardens of Giverny and you made an incredible video. I remember when I first saw it—it was a very different approach to looking at videos. What was your experience of working in Monet's garden? When I was in graduate school, the art market crashed, and then the first Gulf War started right after I graduated. So we had no market—as if there were ever a market in Los Angeles—and a lot of the galleries closed. We never had, as artists do today, ideas about becoming art stars. We thought that if we could make a living and maybe get a little teaching job, then we could die not in the gutter, but we had no aspirations toward being famous. So when I got out of school, I thought that I would apply for grants. I was a waitress, and somebody left a newspaper on a table once, and I opened it and there was an ad in the back for artists to go to Giverny. I thought, "Well, I should go to Giverny. I'm a waitress. What would be better?" One of the big shows I saw as a child that really impressed me was Claude Monet. In terms of the use of light—reflective light, clean light, pure light, white light, daylight—Monet is a revolutionary. This was a great grant. I got two thousand dollars a month and a car, and lived at Giverny for six months. I had worked straight at that point for ten years, so I thought, "Wow, I could not work for six months. That's an amazing thought." So I applied, and it turned out to be the first year they'd gotten a real jury. Before that, they had always sent these sort of housewife artists—you know, Sunday painters. But this time David Ross was on the jury, and so was Philip Pearlstein, and they picked me. I got a call at the restaurant, telling me that I was going to go to Giverny.

The garden was just like the pictures; just like the paintings; just like the postcards; just like the calendars; and you think, "I'm just going to have a six-month vacation in Giverny with my car and my big key to the garden." We lived in Claude Monet's refurbished barn, and I fed all the homeless cats, and periodically, I would document the garden. I had no intention of making any art, because I thought, "What are you going to do with Claude Monet? First of all, it's a cliché. Second of all, Mary Lucier had already made a great video piece in Giverny [*Ohio to Giverny: Memory of Light*

(1983)], and third of all, what do I care? No one's ever going to see it anyway." But afterward, Brian Butler asked me to do a show, and I looked at this footage and I thought, "Well, I'll just make this piece." So I took one day from each month that I was there, and I made this installation called *Oo Fifi, Five Days in Claude Monet's Garden*. There was a cat named Fifi who was an ogre, and she ran the garden; she literally was monstrous. I named it for her because every time I shot, she'd walk into the shot and sit there and look at the camera with the most foul sort of temper. I couldn't edit around her. I showed the piece in several places simultaneously; I broke the light apart using the projectors, and then I put it back together. I saw it as choreography with the video projectors and light and natural light.

Explain how you broke up the color. Video projectors then were three-beam projectors: red, green, and blue. I took out a loan and bought three old projectors. There was a guy at the equipment rental place who taught me how to make all of the minute adjustments that would fine-tune the image to make a nearly perfect full-color picture. I figured that no one was ever going to show my work, but if I came equipped with my own projectors then maybe they'd say, "Well, it doesn't cost us anything, so let's do it." The first person to say "Okay!" was Brian Butler, who had 1301, a gallery in the living room of his apartment in Santa Monica.

This is important because my first few shows were in domestic spaces and the gallerists didn't even have desks, let alone video projectors. There was no market, so there were very few real galleries. We had Tom Solomon's garage, or the artist Ken Riddle, who had Bliss House. This sort of amateur hour we were having in L.A. in 1990, '91, '92 was interesting and exciting because we were all working with very little, and people are always more creative when they have almost nothing than they are when they have everything.

Anyway, while installing *Oo Fifi* at 1301, I found that I was really bad at registering the projectors, but it was more interesting that I was bad at it. So, instead of registering the lenses to make one full-color image, I unregistered them and made three separate ghostly monochromatic gardens. I projected on the walls of the space, so, in the same way that the image was broken in terms of color, it was also broken up as it moved across the room. I projected the image diagonally onto a wall with a large window in it. Instead of blacking out the window and constructing a screen—which is how video was usually shown at that time—I put the window in the middle of the image and put neutral-density gray filters on the glass to stop down the light. The window became part of the image. The twist of looking at something inside which should be outside, a garden, was made quite plain with the use of the window as a screen.

The show at Brian's was two weeks long, and a day or two after it ended I was in a group show at Shoshana Wayne Gallery (which was a "real" gallery). There I showed the same video, but, instead of making three separate monochromatic gardens with one projector, I took my whole inventory of three projectors and put them on the floor of the gallery in a semicircle. On each projector, I turned on one lens, so each projected a single color—one red, one green, and one blue. In the first installation, I tried to take the image apart, so here I wanted to put that broken image back together. I attempted to register the lenses from three projectors to make one complete full-color image. It was impossible because of the proximity of the lenses—they need to be close to one another (in the body of a single projector) to be registered. I came up with some approximation of registration that looked very different from the purposefully deconstructed image at 1301.

p. 230
Diana Thater, *Oo Fifi, Five Days in Claude Monet's Garden* [part 1], 1992. One VHS player, one VHS tape, Lee Filters, and existing architecture, dimensions variable. Installation view at 1301, Santa Monica, California, 1992. Photo by Fredrik Nilsen.

Again I projected on a wall and across a corner. Behind the wall was a large window. I covered its three vertical panes with red, green, and blue gels. When you walked into the gallery you'd see red, green, and blue light cast from the window onto the back of the projection wall. You'd walk around the wall and look directly at the red, green, and blue lenses of the projectors. You'd then turn around to see what all the fuss was being made about, and it was the video of Monet's garden, partially out of registration and partially out of focus and broken down the middle by the corner of the room and seeming like it was weirdly three-dimensional.

Like you wanted to put the little glasses on? Yeah, you did! My work had, and still has, this structuralist approach with a bit of apparatus theory and a lot of art history thrown in. This way of making installations allowed me to deal with the subject in which I was most interested, which was abstraction. Abstraction in painting is non-representation of real things in the world, like people and objects, while abstraction in film and video is the non-representation of time (since time is the subject of the moving image). I wanted to use non-narrative imagery and construct non-narrative time. In the actual video, the garden moves through the seasons with no demarcations or climaxes. Narrative is not implied, nor is it constructed, nor is it assumed to be endemic to the medium.

Let's talk about the installation we did together at the Long Beach Museum. Well, the first museum show I was in was the *Sugar 'n' Spice* [1993] show you curated at the Long Beach Museum of Art. I remember when you invited me down and showed me the film and video gallery, and you said, "Do you want to make something in here?" And I said, "Oh my, never!" Because I had rejected the video ghetto: the video gallery. So I said, "Well what I'll do is put it outside the video gallery, so that when people go into the video gallery, they have to walk through the piece," and you thought that was very funny. I made a piece called *The Bad Infinite* [1993], which I just love. It was the biggest installation I had made at that point. I had this beautiful quote from Hegel, who saw the finiteness of history as a progression toward something, an ideal, and that was the finite good. But that which was infinite and unknowable—we don't know the beginning or middle, and we don't know what the end will be because it's infinite—this was bad; the infinite would be bad and the finite was good. And, of course, I thought, "Well, what would you prefer?" As an artist, of course you'd prefer the bad infinite as opposed to the finite good.

I filmed the piece in the Sequoia National Park in the middle of the winter in four feet of snow. I took an eight-foot-long two-by-four, and I got three identical cameras and screwed them down. The camera in front just had the shot; the camera behind it had the shot with the first camera in front of it, and the last camera had the shot and the two cameras in front of that. My friend and I carried this giant thing with these cameras on it through the forest and pine trees, and, of course, we'd keep falling through the snow, so the cameras kept slamming into the snow, and it was just a whole comedy of errors. But in the end, it was this incredibly beautiful piece. I installed it with three projectors, and each one only projected one color. So with the first projection, you see the complete landscape in blue. The second projector projects the second camera's view; it's the same exact shot, lined up frame for frame, but it's red. So now you have the forest in red and blue, complete, but now you have this image of the red camera, and the red camera is a black hole, so you see in that space there's the shadow of the blue forest, of what's missing. And then the last camera is green, and again, it's the same complete image. So the forest is in red,

blue, and green at the same scale, and in the center of each one you have this sequence of disappearing cameras. At the same time, you also see the hands and the backs of the parkas of the people who are making the piece.

You also made an index to accompany the piece. When I was in graduate school, I worked for the head of our department, Richard Hertz, and I indexed his books. And when I was an undergraduate at NYU [New York University], I catalogued H. W. Janson's collection of glass slides. And then I had been a librarian, and that was all sort of self-taught. Before graduate school, I never read philosophy. I was a reader of fiction. And when I went to graduate school, all of a sudden I was confronted with all of this theory and philosophy. I had a very hard time, because I tried to read it narratively. I recognized this was a problem, so I would go to the back of the book and I would read through the index. What became apparent to me is that if you read the index, you get a complete picture of the book, but it's also a confused picture because it is arranged alphabetically, right? So this is how I taught myself to read philosophy and theory: I would read the entire index of a book, get a kind of strange layout of the book in my mind, and then go through the index and read the book in nonsequential order. I would read the book in pieces, based on whatever interested me, and then sort of continue from there. So then I started to write indexes for fun. I do not know what sort of person thinks writing an index is fun, but I started to write them as artworks. And if you read it, you would find all of these references that would tell you about all the things I was thinking, and there were jokes in it.

For something like *The Bad Infinite*, I had made up a story about women and the landscape. The two central characters of my index are Mary Shelley, who wrote *Frankenstein*, and Jane Muir, who is just a fictional version of John Muir, who is a huge hero in California because of his role in establishing national parks, including the park where I filmed the work. So there would be an index entry like "Conversations with Muir and Shelley, pages 120 and 123." You're in there, too: "Klonarides, Carole Ann, page 118." Then there is the word *demon*. A very important word in *Frankenstein* is the word *demon*, and my idea was that Frankenstein was all of these things that people say Frankenstein is—the fear of the scientific revolution, the Industrial Revolution, etcetera—but that Frankenstein was also this notion of the terrifying female, and that Mary Shelley recognized that and understood what that meant. So this index is about the diary of Jane Muir and Mary Shelley and the wilderness, and the monster that is female, and how that thing-person-monster-deconstructed-reconstructed-being exists in the world. But she does it through this indexical narrative, which again is the deconstruction and the reconstruction of a text that does not exist. So these things, which have no narrative—these installations that have no narrative—have these collections of ideas behind them that do not necessarily make up a story. I did indexes like this for years and years, and I did this for all of my early shows.

In the last several gallery installations I have seen, you have been creating spaces of color, so that the gallery is awash with these different areas. The element of my work that I have not really talked about at all—which is the simultaneous goal of all of my work—is that I would not make these things if they were not gorgeous. And maybe I am the only one who thinks so, but I think that my work focuses on the beautiful. I am very interested in creating things that are beautiful, and that attract people into them, and that make people want to be with them, in order to bring about

p. 233 top left
Diana Thater, *Orange Room Wallflowers*, 2001. Video installation: two video projectors, two DVD players, two DVDs, lights, colored lighting gel, silver mylar, and existing architecture, dimensions variable. Installation view at Kunsthalle, Bremen, 2004. Photo by Roman Mensing/artdoc.de.

p. 233 top right
Diana Thater, *knots + surfaces*, 2001. Video installation: five LCD video projectors, sixteen video monitors, six DVD players, Lee Filters, window film, and existing architecture, dimensions variable. Installation view at Dia Center for the Arts, New York, 2001. Photo by Fredrik Nilsen.

p. 233 bottom
Diana Thater, *Continuous Only*, 2006. Nine-monitor video-wall, one video-wall processor, one DVD player, one DVD, and existing architecture, dimensions variable. Photo by Fredrik Nilsen.

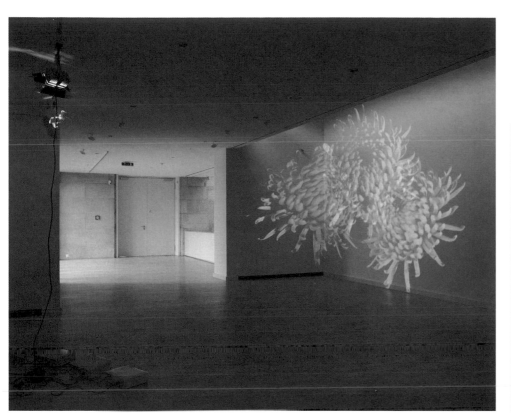

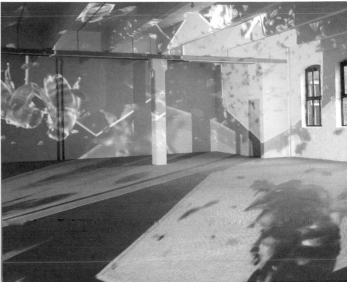

the thoughts that I want to bring about and construct the relationships that I want to construct.

I have always been very happy with the idea that people put forth every once in awhile that I am a colorist. Color is what I work with in all of my pieces. I started with three colors in a video band, and then expanded that and started dealing with the phenomenological and physiological nature of color. Then the next thing I did was to wipe out the frame using color. For a piece like *Orange Room Wallflowers* [2001], I shot these flowers, and I experimented with them. So I got these big chrysanthemums and I shot them against duvetyn. I painted the stems black, set them up in my studio, and just blew them with a little fan. I took three projectors and had each project one chrysanthemum into the corner of a room. I flooded the room with orange light. What happens is the video rectangle disappears. (I used this technique first in *knots + surfaces* at Dia in 2001.) The orange light floods into where the black would be, and the pink of the chrysanthemums is tainted by the orange light. But it is not just color for the sake of color.

The point here is—the two hardest things to make any human being think about are time and space, because you live inside of them. So these are very difficult things to make people think about in a concrete way. When I make a space, I ask myself, well, how do you make a viewer think about space in a palpable way? How do you make space real? For instance, water to you is a volume that must be negotiated, and you are conscious of it. But to a fish, it is invisible. To a fish, air is a thing that needs to be negotiated. Cetaceans, such as dolphins, are the only beings in the world that have the simultaneous need for two kinds of space—for air and for water—and they are completely conscious of both. They have utter consciousness and simultaneous consciousness of both air and water, and this must remain in the forefront of their minds at all times. Otherwise they die, because they have to consciously negotiate two kinds of space at all times. Imagine that. Swim with dolphins, ride dolphins, watch them perform tricks. Really? The biggest trick a dolphin can perform is to have simultaneous knowledge of two kinds of space that you cannot even comprehend. Anyway, this gets back to this question of why I made these

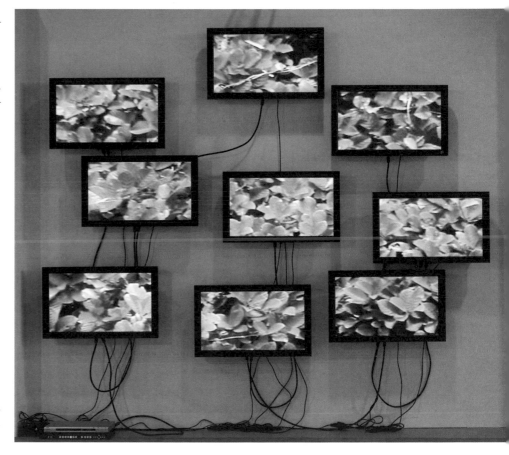

color-filled still lifes. The way to make space palpable in my work was to make space volumetric, so that when you walked into a room you are in a volume of color. You cross over into it, and you can cross over out of it. You cannot do that with space, but you can cross from a nonconsciousness of space, into consciousness of space. I wanted to make a vehicle for thinking about space. I want people to go into that orange volume, or that amber volume, or that purple volume that I have made and experience a very complex relationship between their body and space.

T.R. UTHCO and ANT FARM

T.R. UTHCO

Diane Andrews Hall: born 1945, Dallas, Texas
Doug Hall: born 1944, San Francisco, California
Both artists live and work in San Francisco, California

Jody Procter: born 1944, Boston, Massachusetts;
died 1998, Eugene, Oregon

ANT FARM

Chip Lord: born 1944, Cleveland, Ohio
Curtis Schreier: born 1949, Philadelphia, Pennsylvania
Both artists live and work in San Francisco, California

Doug Michels: born 1943, Seattle, Washington;
died 2003, Eden Bay, Australia

THE ETERNAL FRAME (1975) was a collaboration between two West Coast collectives, Ant Farm and T.R. Uthco. Ant Farm, founded in San Francisco in 1968, maintained a revolving group of members and collaborators, but its core initially consisted of cofounders Chip Lord, Doug Michels, and, later, Curtis Schreier. While their most well-known and lasting work, *Cadillac Ranch* (1974) — a sculptural installation of ten classic Cadillacs partially buried upright in a wheat field in northern Texas — garnered them widespread attention in the 1970s, the collaborative was most concerned with political activism and corporate and mass-media criticism. Utilizing architectural interventions, performances, workshops, television broadcasts, and video to achieve these goals, Ant Farm was adept at manipulating the media. *Media Burn* (1975), a performance piece for video in which a customized Cadillac was driven at full speed into a wall of burning TVs, was widely covered on television, footage that Ant Farm adeptly edited into the final work. Testing the boundaries of mediated spectatorship, the majority of their video work extends beyond simple documentation into highly edited commentaries, which include audience and performer interaction, and behind-the-scenes footage from the events themselves.

After meeting at Harvard University and the Maryland Institute of Art, members Diane Andrews, Doug Hall, and Jody Procter formed the art collective known as T.R. Uthco in San Francisco in 1970. It was during this time that T.R. Uthco began to flesh out the character of the Artist President, an idea that Hall and Procter had started developing and performing on college tours in 1973 and 1974. A concern with truth and illusion, particularly where one ended and the other began, inspired the collective to stage fabricated events to satirize cultural myths and mass-media imagery. T.R. Uthco also documented their activities in graphics, video, and film, often performing in combination with prepared electronic media.

Using an illicit copy of the infamous 8mm footage by Abraham Zapruder as a guide, the members of these two collectives set out to re-create the events of the Kennedy assassination in Dealey Plaza, Dallas, Texas, in their ambitious video, *The Eternal Frame* (1975). The groups converged over the idea of creating their own representation of the iconic image of the assassination. Involving extensive studio rehearsals prior to the event with Doug Hall as John F. Kennedy, the Artist President, and Doug Michels as Kennedy's wife, Jackie, the performance took place in August 1975 in Dallas, Texas. The video documents the motorcade repeatedly passing through Dealey Plaza, re-creating the events documented in the 486 frames of Zapruder footage, and it also includes behind-the-scenes video of the artists and the unexpected reactions of the many tourists who gathered to watch and document the re-creation themselves. Throughout 1975, the artists continued to portray and parody the event, replaying their version of the incident just as the infamous footage of the actual assassination has been repeated throughout popular culture.

Amy Sloper

Interview conducted by Glenn Phillips on February 11, 2007, at Doug Hall's home in San Francisco, California

GP: This interview is a little different from the other ones for this book because we're talking about the history of a collaboration between two collectives, T.R. Uthco and Ant Farm, on a single work, The Eternal Frame [1975]. Let's start by talking about how each of these two groups came to be.

CHIP LORD: I think there was a strong imperative within the counterculture to be communal and collective. I had met Doug Michels when he came on a lecture tour in 1967 to Tulane University, and we were both in San Francisco by the summer of 1968. At the time, there was a sense of an underground culture; there was underground radio, underground newspapers, and we described to a friend that what we were doing was underground architecture, and she said "Oh, like an Ant Farm. That's underground architecture." So instantly, we had a name and a logo and an official color, which was Ant Farm green. Ant Farms only came in Astroturf green at that time.

DOUG HALL: T.R. Uthco's story is little different. Jody Procter, who had been my roommate at Harvard, was living in San Francisco and was married to my younger sister at the time. We had collaborated in college doing some odd performances and actions, mainly relating to language and gesture. We were also very politicized, and were involved in SDS [Students for a Democratic Society] and other political situations. The third member of our group, Diane Andrews, and I met later at Skowhegan [School of Painting and Design in Maine]. When Diane and I moved to San Francisco after graduate school in Baltimore, we decided that we would form

some kind of collaboration between the three of us. For many of the same reasons that Chip stated, we had a sense that somehow we were part of an avant-garde culture that was trying to find other ways of operating—politically, socially, aesthetically. We found collaboration to be productive, and kept working that way for about eight years.

How did the two groups ever decide to collaborate?

DH: We were kind of at loose ends in terms of our institutional relationships. For example, the NEA [National Endowment for the Arts], which started around that time, had no funding for collaborative groups; it was individual artists, and the structure of the art world seemed prejudiced against people working collaboratively. So part of what we found was allies in one another. There was a kind of sustenance that came with this group activity; it made us

pp. 234–35
T.R. Uthco and Ant Farm, production stills from *The Eternal Frame*, 1975 (single-channel video, color and black-and-white, sound; 22 min., 21 sec.; LBMA/GRI [2006.M.7]).

feel less alienated. In San Francisco, there was a very different kind of scene going on, gravitating around Howard Fried, Terry Fox, and Paul Kos, among others. Their work came out of a different sensibility than the one that we were involved in, and we didn't feel that we fit into it. So we needed to find our own way, and I think we gave each other the confidence to work collaboratively.

Why don't you describe *The Eternal Frame*. It would be interesting to hear what you thought you were doing.

CL: At the time, the tag line was "An authentic remake of the Kennedy assassination," and the original title was going to be *Death Bullets*. I remember meeting here at Doug's house, and I remember a collective energy of one person egging the others on, and out of that came "God, what if we actually went to Dallas and did that— you know, filmed it, videotaped it," and it was like—silence. Whoa. Everybody took a step back. Anybody who was at a certain age in 1963 remembers that moment of hearing the news that Kennedy was shot, and then sitting down in front of the TV for the next forty-eight hours. All three networks went live, and Walter Cronkite narrated the whole event, and there were no commercials for the next, I think it was seventy-two hours, until the funeral. So that's something that hasn't been replicated—even 9/11, they were still showing commercials—and then Jack Ruby was shot on live TV. So the combination of those elements had an incredible importance, and I think a symbolic one. It was an outpouring of empathy, but you were experiencing it in this mediated way.

DH: It was a galvanizing moment in the history of popular media, and it was a moment where everyone was kind of locked in step for a short amount of time. There have been other events since that have had similar galvanizing effects, but this was the first of the great tele-visual spectaculars. The event—the tragic assassination of an American president and the aftermath—became

convoluted as it unfolded over time, its original meaning mutating as it was filtered through the media. As the event became popularized, it lost its relationship to its source and spread out into the culture, as an evolving narrative that sort of folded back on itself like a Möbius strip.

CL: When we hatched the idea, Ant Farm was already engaged in this other project, which became *Media Burn* [1975]. At that point, *Media Burn* was about creating this one image of a car crashing through a wall of TV sets. But we knew we had to structure something around it, and it just seemed perfect to bring a politician to speak, and to do it on July Fourth. So we had T.R. Uthco's character of the Artist President make an appearance at *Media Burn*.

DH: He'd been making some appearances before that. Jody Procter was our Ted Sørenson; I was the Artist President and he was my speechwriter. We would go to universities where we did various sorts of performances, depending on the context. One of the formats we began to adopt was in the tone and posture of the political speech. These were mainly speeches about making speeches; there was no message in the sense of a traditional message. My later videotape *The Speech* [1982] is the best remaining evidence of these sorts of performances.

CL: It wasn't JFK. I mean, you wouldn't say, "Please welcome the Artist President, John F. Kennedy." It was a generic president.

DH: That's right, but it was definitely done with a Kennedy accent.

So when did he become more of a JFK figure in appearance?

CL: Once we began to form *The Eternal Frame*. Once Doug Michels signed on to be Jackie, then obviously he had to have makeup and costuming, so we found the makeup artist for the San Francisco Opera.

DH: This was such an outrageous idea, but the makeup artist got into it with great enthusiasm. I think you've seen the charts that he

And how did you have a copy of the film?

CL: We weren't really that interested in the conspiracy theories, but the conspiracy theory people were the ones who had the film. I think Doug Michels must have made that contact, but somehow, we got a 16mm copy of the film. The original Zapruder film was, of course, immediately bought by *Life* magazine, and individual stills were on the cover of *Life* the next week. It then went into the vault. But guess what? Somebody at the lab made a copy, so from the very beginning there were bootleg copies that slipped out. The copy we had was multiple generations removed from the original, so it had almost no color left in it. But it was enough to use as a visual model for the gestures.

Were you afraid of how people might react to seeing two men dressed as JFK and Jackie?

DH: We were nervous. We knew we were treading on something that was dangerous; it's an iconic image that we seem to be off-handedly playing around with, and that's why we imagined that we would go there very early in the morning, go through there once, and that would probably be it, because everything would close in on us.

CL: I think the roles really had to do with the dynamic and competitiveness between the two groups. Once this idea was hatched, obviously Doug Hall had to be the Artist President, but the next best part in the drama was Jackie, and that had to be a member of Ant Farm, and that was alpha male Doug Michels. It was just like "Okay you're gonna be Jackie." It also adds an interesting tension, which is: from the position of Zapruder, which is pretty far away, is it gonna matter? The pink dress is more important than who is inhabiting it really. And if the pink dress and the hat are done well—actually they don't even have to be done that well!

DH: That's the thing, the ingredients of the image can be pared down to the bare minimum and still be credible.

CL: And in *The Eternal Frame,* what proves the rule I think is the way the people on the street reacted. It wasn't a truly authentic remake. It's just one car, there was no advance car, no motorcade, and only one Secret Service agent. But it was enough for people to lock right back into their memory of that moment and even shed a tear or two.

You thought you'd go there early in the morning, you'd do it in one take and that would be it, but that's not really what happened.

CL: I think it was 7 AM by the time we arrived at Dealey Plaza, and already there was a guy there with his kids; you know, an American who had come to show his kids where the assassination took place. We hadn't really thought about these people who come every day to see the spot, and immediately Skip Blumberg and Bart Friedman just start rolling tape and talking to this guy. At that time of day, the sun was throwing really long shadows. It didn't look right, so we just kept doing take after take, and we did maybe fourteen or fifteen takes. It took about fifteen minutes to go around each time. More people would show up, and they were sticking around because they arrived during the middle of it and they wanted to see the whole thing again.

DH: The thing that's kind of odd about that particular location is how staged it already feels. It's actually quite small, and the colonnade that forms the back of the grassy knoll looks like a fake classical facade, so it has this feeling of being a stage set already. Also surprising is that people just assumed that it was being put on by the Chamber of Commerce and the city of Dallas as a way to commemorate the original event. Which is so—I certainly hadn't expected that, and I don't think anyone else had. It really tells you

prepared for us; and then Diane learned to do the makeup.

CL: By that time there was lot of momentum because we were given money by Doug Kenny of *National Lampoon,* and Jim Newman from Dilexi Gallery had signed on with some backing, and we found the Lincoln Continental convertible, which we bought for about $300.

DH: That car ran on two cylinders.

CL: We had to tow it from San Francisco to Dallas.

So you've decided you're gonna do it, you've raised some money, you've figured out the makeup and outfits, what sort of arrangements did you need to make in Dallas?

CL: Uh . . . well, we made no arrangements.

DH: The only arrangements that I'm aware of—well, there were a lot of people involved with this event. Videofreex was involved, Skip Blumberg and Bart Friedman, particularly. Stanley Marsh made our hotel arrangements, which were in a Doris Day-owned hotel as I recall. The idea was "Dude, this has gotta be a guerilla event. Very, very low key; we have to be quiet in the hotel, we're gonna sneak out at like six in the morning, that's it, and that should be enough." And, of course, with this group of people, it was out of control. Loud people walking up and down drunk, it was horrible. But we did get there at six in the morning, and oddly enough there was no interference at all. We just kept going through it and through it. I think Skip and Bart were really tuned into how to videotape an event like this.

CL: This was a complicated production, and we knew there had to be the Zapruder camera, there had to be the Orville Nix camera on the other side of the street, and we thought we should have color video, black-and-white video, and Super 8mm film. Super 8 would be the most authentic to the original Zapruder film. So there were a number of camera positions, and then we needed still photographers, so this is why the personnel grew. The guy who had originally gotten us the video equipment in 1969, Pepper Mouser, was in Houston, so he drove up, and Tom Morey came with him and played a secret service agent. We did one run-through in San Francisco with a smaller crew from Optic Nerve in the Presidio, and then we drove to Amarillo towing the Lincoln.

DH: We also choreographed it. The timing is obviously very slow the way we reenacted it, but we definitely worked a lot on the gestures and what the sequence was.

CL: And that was from the copy of the Zapruder film that we had.

something about how we experience events—or more properly, how we experience the *locations* where important historical events took place—and what our expectations are when we come to them. In a way, I guess people are disappointed if they're *not* delivered this kind of strange product—one that rekindles the emotions that they might associate with the actual event.

It is one of the amazing things that, for the public, it seemed completely natural. Dealey Plaza is just forever locked in the repetition of this event, so of course it's the place where people were supposed to go to reexperience it.

DH: The repetition is one of the aspects of *The Eternal Frame* that interests me the most. An event happens, and then all this other stuff begins to glom onto it. It's like this huge media snowball that gathers force. So it's all about how the event, situated in the world, occurs, and then the fiction begins to emanate out from it. It's almost like a semiotic shift takes place, and *The Eternal Frame* is all about the nature of that shift, the repetition and accumulation of information.

CL: Obviously, it wasn't theorized in that way prior to the shooting of *The Eternal Frame*, but the repetitions ultimately became built-in looped replays, a tele-visual replay of the activity.

And how did you get from raw footage to the finished video? Did you know that it would result in this structured finished work?

DH: We just didn't have any idea what would come out of it. I think we were all very anxious about that. A lot of people in the art world were really upset with us. In the Bay Area, it was: "Don't talk to those guys, they're just fucked." And initially, we had difficulty getting anyone to look at it after it was finished.

CL: We did some preliminary editing by November as the anniversary of Kennedy's death rolled around. T.R. Uthco was out on the road doing college gigs and Ant Farm was back in San Francisco, and we each did performative presentations. In San Francisco, somebody from a local TV station called the Ant Farm and said, "We understand you have a copy of the Zapruder film; we'd like to borrow the film and run it." At this point, the Zapruder film had never been broadcast. We said, "Okay, we'll give you the film. And why don't you plug our performance on your station?" We did this event at the Unitarian Church—you could rent the hall inexpensively there—and showed some video, but mostly showed slides. We didn't have the Artist President; but we had another crew come and interview people as they left, and therein you get the spectrum of those who hated it and those who thought it was brilliant art.

DH: T.R. Uthco had the same situation; we didn't have an edited version yet. We just had some copies of the tapes that we were traveling with, and we had lots of slides. Leading up to our showing at Anthology Film Archives in New York, we had been on the road doing a performance called *Great Moments* [1974–75], which mixed live performance with projected film, slides, audio, and video. As a result, we were very comfortable doing presentations that switched between media. At Anthology, I think I made a speech at the beginning in that kind of Kennedy-esque voice, and then we proceeded with combinations of slides, audio, and videotape.

CL: Eventually, we edited it collectively at the Long Beach Museum of Art's Artists' Post-Production Studio.

And then you also exhibited the piece as an installation at Long Beach.

CL: Well, I think initially we were looking for a place to edit it, and it was either Bay Area Video Coalition or Long Beach, and David Ross was enthusiastic and said, "Oh, you've gotta edit it here."

I think he even gave us some money to come down there. We probably talked about how we might exhibit it while we were there editing. But honestly, I don't remember how the physical idea of the installation evolved. We had all these souvenirs, which were part of the preliminary research, and we'd just been gathering them at the flea market as a way of fostering a sense of the kitschiness of the event. So I guess it was logical to put it into a living room environment—a 1963 living room. It was easy to find everything in Long Beach. It was 1976, so, you know, the Goodwill Store and other thrift shops yielded many—

DH: Choice items.

I'd like to go back a little bit to the production. It's a simple question. Doug, did you have to redo your head-wound makeup each time?

DH: I don't know that we did that. I do remember the most grotesque moment was when there was this rotten watermelon we found in the roadway, and someone said, "Doug, do you mind

splattering that against your forehead?" Nothing held us back as far as verisimilitude was concerned.

CL: "Take this handful of watermelon and slap it on your head."

DH: "Okay director, you know, I'm just talent here, whatever you want."

CL: I think that was my brilliant idea.

DH: Yeah, that was your brilliant idea. But I think that may have been the last run, actually; it was certainly toward the end.

CL: But Jackie looked good all the time.

DH: Jackie was beautiful, Jackie was beautiful. But Jackie didn't really do much—oh, yeah she did! She had to grab the watermelon—ersatz brain tissue—and pretend to put it back in.

CL: Or TRY to put it back in.

p. 236
T.R. Uthco and Ant Farm, *The Eternal Frame*, 1975. Video (color, sound; 22 min., 21 sec.) and mixed media, dimensions variable. Installation view at the Long Beach Museum of Art, 1976.

p. 237
T.R. Uthco and Ant Farm, production still from *The Eternal Frame*, 1975 (single-channel video, color and black-and-white, sound; 22 min., 21 sec.; LBMA/GRI [2006.M.7]).

BILL VIOLA

Born 1951, New York, New York
Lives and works in Long Beach, California

CRUCIAL MOMENTS IN THE HUMAN LIFE CYCLE, often in dialogue with aspects of both Eastern and Western theoretical doctrines, figure prominently in the work of Bill Viola. Combining intense study of video technology with a range of inquiries that include research into animal consciousness, early treatises on dramatics, Zen philosophy, and Christian icons, Viola uses a formal and thematic vocabulary to express secular but profound human sensations. *The Tristan Project* (2004–2006), created for director Peter Sellars's contemporary version of Richard Wagner's opera *Tristan und Isolde,* presents a series of video movements that follow the fated couple through a progression of emotions. Like rites of passage, each video presents an aspect of the man and woman's existence: the physiological forms of their bodies, a baptismal cleansing, a sensual union, and a metaphorical death and ascension that takes shape as a plunge into water. Water often appears as a space of altered consciousness in Viola's work. In his sculptural installation *The Sleepers* (1992), seven oil drums filled with water are interspersed in a darkened gallery space. Underneath each contained pool is a video monitor depicting a close-up image of someone sleeping. The stillness of the seven sleepers and the barrier of water distance the waking spectator from an unseen dream space.

Bill Viola's significance in the field of video art has been well established. The artist began using video in the early 1970s and immediately started working and exhibiting with early pioneers in video art such as Nam June Paik. In 1981, he relocated from New York to California via Tokyo to become part of the active community of video artists working in Long Beach. Initially concentrating on the properties of video technology itself, Viola came to understand that video was an electronic circuit independent of any external reality, a realization that led him to refocus his attention on his viewer's perception. Viola continues to propose lyrical images of human existence and spiritual transcendence, while employing the most recent advancements in video technology.

Pauline Stakelon

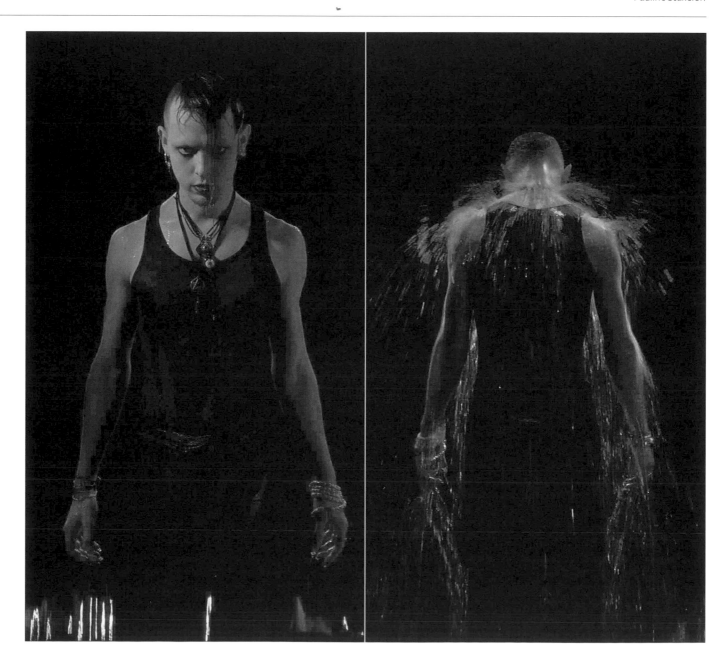

Interview conducted by Glenn Phillips on June 22, 2007, at Bill Viola's studio in Signal Hill, California

GP: I think that you are the only artist in this exhibition who moved to California having already become an established artist somewhere else. What was your first involvement on the West Coast? Was it through the Long Beach Museum of Art?
BILL VIOLA: No, it was through the de Saisset Art Gallery and Museum at Santa Clara University, near San Jose. This was pre-Silicon Valley, in 1972. At that time, I was still in art school. David Ross had been recently hired by the Everson Museum of Art in Syracuse, New York, to be one of the first curators of video art, and he put one of my first video pieces, *Wild Horses,* in the *Saint Jude Invitational* exhibition at the de Saisset. The director, Lydia Modi Vitale, was also one of video art's first avid supporters and gave it a central focus in the museum. My first trip to California was a year after that, when the American video artist Douglas Davis flew me out from New York to help him prepare an exhibition. Then, in 1974, a year out of art school, I was invited back to present my second solo museum exhibition. My first museum show had been a year earlier at the Everson Museum, titled *New Video Works.*

After we installed the de Saisset show, George Bolling, the museum's video preparator, knew that I was really interested in space and landscape and light, and he took me on a three-day camping trip to Death Valley. This is the first time I experienced the desert, and it changed my life. Later, when Kira, my wife and collaborator, and I first moved here, we were always going out to the desert, not only to shoot but just to be in that special kind of light and emptiness out there. It was a huge life-changing and formative experience.

What did you show at the de Saisset? I can't remember exactly, but it would have been a series of works that I had done in college at Syracuse University, between 1972 and 1974. They were some of the first pieces that I made. Most likely, I showed a piece called *Hallway* from 1972, which was an attempt to reconcile the two-dimensional camera image of a narrow corridor—the classic perspective shot of the vanishing point—with the actual experience of the space, which I created by literally scraping the camera down the side of the hallway. I probably showed *Information* [1973], which is basically a feedback loop through a machine set up to record itself, which caused all these amazing disturbance patterns. I think I also showed *Composition D*, a recording of myself walking down a hallway toward the camera that gets progressively slowed down and rerecorded until the image disintegrates into abstract noise patterns and the sound disappears below the audible frequency range of the machine. There were other pieces, too. The show was in a small gallery where they had set up a monitor. It was basically an exhibition of three-quarter-inch videotapes playing on a loop.

David Ross then invited you to do a show at the Long Beach Museum of Art the following year. Did you know David from Syracuse? Yes. He was two years ahead of me at S.U., where we both had the same instructor, a maverick artist named Jack Nelson, who created a department called "Experimental Studios." The department had new ideas and new media. It quickly became a magnet for all the students who were not happy doing all of the stuff you're supposed to do when you're in art school, and, of course, I was one of them. David had gotten there first; he came from the journalism school. He was interested in politics and wanted, as many did in those days, to change the world. But he hit the wall in journalism just like I hit the wall in my art classes. So everybody like that—people who were on the cutting edge and creative—found this refuge that Nelson had set up in the basement of a university building.

Nelson bought some cameras, recorders, and monitors. All the editing equipment came from the student union. The student president was Lance Wisniewski, who had spent the summer in Berkeley—a hotbed of radicalism in those days. There he connected with a radical activist media contingent that advocated taking the means of television production into their own hands with the new portable video technology. Lance was able to convince the university that the way of the future was to put money into media and information technology, and so the campus was wired for two-way interactive cable TV, and a color studio was built for student use. We were all reading Gene Youngblood's book *Expanded Cinema* [1970] in those days. That was our Bible. And all of this was occurring serendipitously in this sleepy city in upstate New York!

Regarding the show at the Long Beach Museum, it was on for the month of November in 1975, and it included six videotapes—a selection from *Passage Series, Cycles, Level, Polaroid Video Stills*, and *In Version*, all from 1973, plus the premiere of *Red Tape (Collected Works)* [1975]. There was also photo documentation of performances and installations.

You were at the de Saisset and Long Beach pretty early in their histories. But you were also working at Art/Tapes 22 in Florence, Italy, around this same time. Right. That started in the fall of 1974. Maria Gloria Bicocchi, a print dealer in Florence, had discovered video in 1972 and hosted a monthly meeting about the new medium, which young Italian artists were all interested in, as was everybody, really, because it was so new and revolutionary. She got so excited by video that she sold everything in the gallery, bought hardware, and rented a shop front on the Via Ricasoli—about fifty yards from Michelangelo's *David* in the Accademia—not a bad location. She opened up a studio, and had the grandiose idea that in the new "age of information" she was going to change the way galleries treated art. She had heard through artists like Douglas Davis, Peter Campus, and Nam June Paik that I was very good with technology, so she invited me to come over to work at her gallery. Sight unseen, I got on a plane, flew to Italy, walked into this studio, and started working.

Do you remember some of the artists or some of the pieces that you worked on? The first person I worked with was Gino De Dominicis. He was an Italian conceptual artist, a kind of a crazy guy. He loved ordering me around, but I realized very quickly that I was in an amazing learning situation. I had the privilege of working in a studio with established artists, a generation or more older than myself. I worked with and/or met people like Giulio Paolini, Sandro Chia, Mario Merz, Jannis Kounellis, Maurizio Nannuci, Urs Lüthi, and Arnulf Rainer. I also worked with U.S.-based artists like Nam June Paik, Alvin Lucier, Chris Burden, Alexis Smith, Allan Kaprow, Terry Fox, and others. So it was really an extraordinary experience to be alongside these European and American artists when they were making their work.

It was very social, too. This woman at the center of it all, Maria Gloria Bicocchi, was incredibly generous and vivacious and fearless. She truly wanted to have a place where artists could work in the European tradition of the studio or salon, where people could come to discuss ideas, sit around, and share food and drink. We'd have these long dinners into the night. It was the first time I experienced a group of adults having vehement arguments across the table and throwing food at each other, which happened on a few occasions. I was just a kid and I was in awe of the whole thing, but it was an exceptional experience.

p. 238
Bill Viola, stills from *Ocean Without a Shore*, 2007. Video/sound installation, color and black-and-white. Photos by Kira Perov.

One of the early shows at the Long Beach Museum, *Americans in Florence/Europeans in Florence* [1974], was about Art/Tapes 22. You were in this unique position of having been involved in seeing these early places around the world as they're getting started, and then also having known David. What did the early days at Long Beach seem like to you? David came out to Long Beach in late 1974 to be deputy director at the Long Beach Museum, and he invited me to show my work there in 1975. That was my first time in Southern California. I'd never been in any place like that before. It was shocking coming from the East Coast to the L.A. basin, in which, no matter how I tried, I couldn't seem to find a center. I've come to realize, of course, that it is just organized very differently, like an urban Internet. The second time I came, when I wasn't showing, I was able to go around with David. He brought me to meet David Salle, who was doing videos at that time. We went to see John Baldessari, and the video artists John Sturgeon and Aysha Quinn, who became friends. It was my introduction to an environment that was really vibrant and very different from the East Coast, in terms of lifestyle and the kind of work being produced. It was striking to me that Hollywood never seemed to enter the picture. I just presumed that everybody in the art scene was somehow tapped into Hollywood, but that really wasn't the case. In those days, they were two parallel realities existing in different dimensions.

What was the first piece you produced in California? In 1983, I made *Anthem*, as a response to moving to Southern California. Its central image was shot in Union Station, but also in this new landscape of Long Beach. The port area of Long Beach is an incredibly evocative, industrial landscape—oil refineries with flames shooting fifty feet up in the air, giant oil pumps pumping, and all of the heavy hardware that it takes to run a port. It just fascinated me. Some nights, Kira and I would drive home from L.A. to Long Beach, and we'd pass the refineries and see the flames and it looked just like the underworld, like hell. So I began to wonder, "Where is hell?" in the Dante kind of sense. I mean, Dante gave us this structure for hell, which he so vividly described in *The Divine Comedy*, and which still exists in people's minds today. It shows you how much power poets and artists actually have over the collective unconscious of humanity.

But in California, it seemed that I was witnessing images of hell that were real. In the daytime, we'd go down to the beach and see the pastoral, calm, environment of sunbathers on the beautiful beaches of Southern California, images that would belie the existence of this horrendous underworld, which would only come out at night. I became really interested in the disparity between this world of eternal youth and cosmetic appearance and the disturbed, foul underbelly created by the greed and the reckless development by the port and industry, which created massive amounts of toxic pollution.

So I just started shooting in those two kinds of environments without really having a plan. I realized that I wanted to have a figure in the piece, to anchor all of these disparate shots of the landscape, so I asked a friend, the video artist Art Nomura, if I could ask his eleven-year-old daughter, Amy, to stand under the rotunda in Union Station and scream. I thought that this should be the soundtrack to the piece—a primal scream from a young, innocent girl. The piece's center is a recurring image of a girl standing in a somewhat classical architectural space who just wails. At that time, I had also been very interested in Gregorian chant, where they extend a single syllable in time and continuously shift a set of pitches around it. I planned to take that scream and slow it down—not for the visual effect of the slow motion but for the aural effect. If I played back that sound at mathematical intervals, I could generate a scale of notes in descending order from the original scream, all the way down to a deep rumbling bass note, which sounded like a wounded animal. So I created this soundtrack from a musical scale based on her scream, and used it to time the shots from the oil refineries, heavy industry, assorted surgeries, and sunbathers on the beach.

You've shown that piece as an installation—or at least as a projection, I think, but how did you show it at the time? It was first shown on a monitor. Most video galleries at this time consisted of a small space with a CRT [cathode-ray tube] monitor. It took a while for people to accept that single-channel video could be just as interesting as a large cinematic-type projection. I started using projection and making room-sized installations at the same time I started making videotapes. Very early on, I was dealing with live-camera projection pieces, and I quickly learned that monitors are scaled to the home. When you put them in a gallery or a museum, they are out of scale. So I gradually came around to the idea that projections are better suited for the larger public spaces, because you're simply scaling the image up to the appropriate size for the room and the audience. People had thought of this as installation, but for me, an installation was something that had a specific physical rationale for being in the room and relating to the architecture in a very specific way. It could, of course, include small monitors or projections, but playing back a single tape or DVD with no specific connection to the space felt like a screening room.

To me, there are two main qualities that many of your installations have: either they're rhythmic, multichannel pieces, often consisting of projections arranged in a spatial array, or they're quite sculptural, meaning that they contain objects or have this almost figurative aspect. How do you think about both space and objects when you're thinking a piece through? I've been doing this for so long now, it depends on what decade you're talking about. Early on, I would often design pieces based on the architectural situation that I had been given, like the hexagonal rooms in the old San Francisco Museum of Modern Art building, where I did a piece called *Heaven and Hell* in 1985. Ironically, I would have to construct that same room down to a high level of detail to show

the piece again somewhere else. But I would always consider space as part of the piece. Monitors, whether the old CRTs or today's flat screens, are objects and, therefore, demand a more physical, sculptural approach. There are precedents to all of these issues in the history of art.

What about a piece like *The Sleepers* [1992], where you see objects before you ever see a video? *The Sleepers* was created in 1992, a year we did nine installation pieces all having to do with the death of my mother. When you walk in the room, you see seven white industrial barrels with light shining out of them—and that is, of course, the "video light" coming from black-and-white monitors, which is actually blue in color. The room is bathed in this light, spilling onto the walls and ceiling. The barrels are filled to the top with water, and a video monitor lies at the bottom of each showing an image of a person asleep, different for each barrel. Electrical and video cables coming up from the floor outside each barrel enter in from the top and connect to the monitors under the water. The images are thirty-minute sequences of a person's face recorded with a low light camera while they were sleeping.

For me, the portraitlike images of the specific people in that piece are in service to a larger concept. It's about the body being cast aside, the shell that supports our consciousness being jettisoned. I've been greatly influenced by Rumi, the thirteenth-century Persian poet, who I've been constantly reading throughout my career. Rumi describes a human being as an empty bowl floating on the surface of an infinite ocean. Over a lifetime, the water outside, our knowledge and experience, slowly seeps into the bowl until it is full. Then, when the inside water touches the outside water and it becomes one and the same, the physical container, the bowl that is the body, is no longer needed and it falls away. That's a very beautiful, positive description of a human being that denies the tragedy and weight that we tend to place on death. So those images on the bottom of the barrels in *The Sleepers* are really the intangible, luminous forms of the beings who will remain. Another way I can interpret the piece is that the soul is sleeping within us at all times, and our waking consciousness is missing most of the essential aspects of being alive. The inner dimension of who we are is really the fundamental point of our existence, and that inner essence is not material, it's ethereal—that's what the light is about.

So much of your work deals with themes like the cycle of life and with different philosophical and religious ideas from various parts of the world. You have also, from your earliest work on, been fascinated with the power of technology, and you're always pushing the technology as far as it can go—and sometimes farther. How do those two things interconnect for you? Well, they are really the same thing. A human being is comprised of two aspects, a material body and an ethereal mind/heart—hardware and software. They are not at odds but function together, as a whole. Human life exists at the edge of death, and so the creative act exists on the edge of life. Boundaries are the sources of energy, in physics as well as psychology, and artists, sages, and scientists are ones that push the envelope: it can be physical, it can be intellectual, it can be technical, it can be psychological or spiritual. Some of us are made to go out to the edge constantly, and some of the most extreme examples of human existence are the saints, mystics, and shamans who actually cross over that edge quite deliberately. The history of art, as well as religion, is littered with the bodies of people who went too far over that edge, breaking the silver tether that holds us to material existence, as the shamans say. Apparently that's where we want to be. Every time technology, or language, or ideas change

through creative acts, the kinds of images one can make change as well, and from time to time they change very dramatically. We're in one of those historical moments now, and if you just look for the places where the seams are, where things are unresolved, where nature and culture are unstable—that's where the openings can be found, which then solidify and get fixed as people move on.

I used to be very tuned in to technical innovation as being the main point to video art. We were in a dance with new technology in the early days, and you would literally see the medium inventing itself, and with it, new and occasionally unprecedented possibilities for image making. It was very exciting. Of course, the process of change and transformation is always happening at varying rates, and that gives me a certain level of inspiration. But I think I've become less technical as I've gone on, or maybe the technical stuff has become more of an integral part of my artistic practice, rather than the goal.

The last piece that we did is *Ocean Without a Shore* [2007], which was on view at the Venice Biennale in 2007. That piece shows people coming from a black-and-white, grainy, obscure world, and literally walking through a wall of water and light to become fully materialized human beings, seen in full color, high-definition video. The people then have to turn around and go back to that grainy dark world, the "other side" where we all came from. This

was done by taking a thirty-year-old black-and-white video camera, extremely primitive by today's standards, and trying to figure out a new way, technically, to combine that camera with the latest high-definition camera. Even with different aspect ratios, we were able to achieve that and make them match perfectly. *Ocean Without a Shore* was a great technical achievement, but when we finished the piece, that wasn't foremost on my mind. I was very proud of what we accomplished, and I really thought everyone working on the piece did amazing things to literally create something that people hadn't seen before, which is hard to do in this day and age. But for me, the level of achievement was to take that and incorporate it into a higher goal, which is an authentic expression about humanity, about our lives, about who and what we are as human beings. And that, to me, felt like a much greater achievement than the technical process alone. If you had talked to me twenty-five, thirty years ago, I might have said the opposite.

pp. 240–41
Bill Viola, stills from *Anthem*, 1983. Single-channel video, color, sound; 11 min., 30 sec. LBMA/GRI (2006.M.7). Photos by Kira Perov.

WILLIAM WEGMAN

Born 1943, Holyoke, Massachusetts
Lives and works in New York, New York

ONE OF THE EARLY PIONEERS of performance-based video art, William Wegman created black-and-white reel-to-reel tapes from 1970 to 1977 (seven compilation reels, one each year) that are considered classics of the medium. The dry-witted humor of radio comedians Bob and Ray, experimental art of the 1960s, and the stranger-than-fiction late-night television advertising, circa 1970, provided the inspiration for these early works. Setting up a camera, monitor, and deck in his studio, Wegman took a minimalist approach to being recorded, as he proceeded to personify common objects (like a lamp or chair), or else objectify parts of his body, all in an unedited one-take shot of determinable length. His impeccable timing—done with Arcadian drollery—makes his videos highly accessible, and a standout among the conceptual art videos being made at that time.

Sensing that Southern California might have an artistic community that shared his sensibilities (he admires the work of John Baldessari, Bruce Nauman, Allen Ruppersberg, and Ed Ruscha), Wegman accepted a teaching position at California State University, Long Beach, in 1971. Although his tenure was brief, it was there that the legendary blue Weimaraner, Man Ray (named after the famous Dadaist) entered his life and art, often replacing Wegman as the sole living subject of his videos. Their artistic collaboration lasted twelve years, until Man Ray's death in 1982. With his deadpan single-mindedness, Man Ray proved to be a perfect stand-in for Wegman—his canine performance a perfect foil to the indulgences of performance video. The duration of one early tape was determined by the time it took for Man Ray to remove a prized dog biscuit from a glass milk bottle, which he only succeeds in doing by breaking the bottle, thus ending his frustration and that of his viewers.

Wegman took a hiatus from making videos in the late 1980s and 1990s, focusing primarily on painting, drawing, and his highly successful photographic practice. In 1998 and 1999, he made two more reels of videotapes in which he returned to the unaffected style of his early videos, adding costumes and sets, and incorporating himself, others, and many more dogs.

Carole Ann Klonarides

Interview conducted by Carole Ann Klonarides on February 7, 2007, at William Wegman's studio in New York City

CAK: How did you get from the East Coast to the West Coast?
WILLIAM WEGMAN: It's a long story, but if you insist—I studied painting at Mass Art [Massachusetts College of Art], and then went to grad school in Illinois [University of Illinois at Urbana—Champaign] and abandoned painting in my second year. I worked in lots of different areas, including interactive electronic environments with engineers from the electrical engineering department. John Cage was in residency at the music school; Merce Cunningham was there, too, so it was a very exciting time *not* to be painting. The School of Engineering was a very open, happening place, and a lot of collaborations with people from other departments were coming from there. After the MFA, I ended up teaching in Wausau, Wisconsin, and then at a campus in Waukesha near Milwaukee. It was an adjustment going from Illinois, working with cool scientists and notorious composers, to a kind of suburbs of the mind. When that position ended, I landed another job at the University of Wisconsin—Madison, a real hotbed of political and art action. I taught conceptual art to grad students.

That must have been interesting. It sounds lofty, but it was mostly babysitting. The war was on and everyone was in grad school getting deferments from the draft. The Vietnam War produced a lot of MFAs. When that ended, I lucked out by getting a job at Cal State Long Beach. I was on my way to L.A. anyway, because I had decided to only stay in the Midwest for five years. Not that I had a choice, but I didn't want to become a disgruntled tenured professor. So I taught watercolor and beginning drawing as an instructor, and I also picked up my first video equipment there. I had been making videos in Madison with a borrowed unit made by Craig Electronics, but none of that stuff survived.

What happened to it? I don't know. It demagnetized itself, somehow.

What were they about? I remember there was acetone, and there was Styrofoam, and stuff was melting. Lots of oozing. There was stuff with my students, a lecture, furniture rearranging. I was at the cross between performance and installation. My first L.A. works were also lost. At that point, I didn't know you could make copies, so I was showing the original. We had borrowed a VTR to play them at my exhibition at Pomona College in 1971, and the tape was on the deck when it was returned. The guy we borrowed the deck from recorded over it.

And on those tapes? I just don't remember a single one. It's probably a good thing that they were lost. They were made with a close-up camera, and everything had kind of a fish-eye look to it.

When you came to Long Beach, did you get a studio? I rented a run-down space a few blocks away from where my wife, Gayle, and I lived at 921 Centre Street in San Pedro. I worked in both spaces. I noticed the work was very different that came out of one place or the other. The studio work looked more like that of a real artist—kind of scruffy and fitting for the anti-form sensibility of the era. Some of us young artists were trying to escape the minimal look that art institutions and publications were presenting. The work made in the little house is more curious and interesting to me now.

Describe a couple of the early videos: How you got the idea and then how you actually implemented that idea. My first videos with my dog, Man Ray, were made in San Pedro. Gayle wanted a dog, so we got one, as I promised her we would when we got to California. My first videos were made in the little house in San Pedro but I made others in the studio, too; *Pocketbook Man* [1970–71], for instance, where I undress a collection of pocketbooks I am wearing and chuck them off to the side. Man Ray retrieves them as I talk to my imagined wife off camera about the hard day at work. "What's for dinner?" And there's one with the microphone. Ray loved the microphone—he treated it like a bone. But one video, in particular, stood out from that time. I am seen on hands and knees, milk pouring out of my mouth in front of the camera, which has been placed on the floor. As I back away from the camera, I round a corner, whereupon Man Ray emerges lapping the milk back up to the lens. He bumps into the camera, and that's the end of the piece. It was quite surprising to viewers because at the time the dog wasn't really expected. I liked the piece because it had a symmetrical beginning and end. All of my pieces were rather short—usually under one minute—and the key was the entrance and exit.

Another piece that holds up well for me is *Crooked Finger/ Crooked Stick* [1972], which is a conversation: "Oh, wow, what a neat stick. Boy, is it crooked." "Oh, that's nothing—you ought to see my finger." "Oh, that's nothing, you ought to see my," etcetera. And then there is one where I spray deodorant into my armpit for more than one minute while extolling the virtues of that particular brand. I developed a really bad pit rash from that one. All these

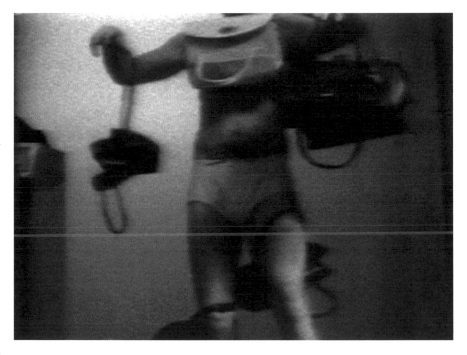

videos were made without edits while viewing the monitor; later, I would choose the best take. I produced about thirty minutes of material a year for seven consecutive years. Each year seemed to involve some slightly new tech feature—different mic or camera. In 1977, when I worked in color, I needed a lot more light, unlike the equipment out today—and it was hard to work without sweating, which looks bad on camera. I stopped working this way until 1998; twenty years later, I made two more half-hour collections. The Santa Monica studio had the best light for photos and video.

Curiously, the thing I remember most about the space in Santa Monica was the huge crack in the floor. It turns up in almost every photo and video. John Baldessari took over the space when I left for New York in '72 or '73. Reels one through three were made in San Pedro and Santa Monica, and except for a few notable exceptions the works produced there remain my favorite videos.

p. 242
William Wegman, stills from *Milk/ Floor*, 1970–71. Single-channel video, black-and-white, sound; 1 min., 52 sec. LBMA/GRI (2006.M.7).

p. 243
William Wegman, still from *Pocketbook Man*, 1970–71. Single-channel video, black-and-white, sound; 1 min., 19 sec. LBMA/GRI (2006.M.7).

At the time, there was also an emphasis on conceptual process work, and, in some of the early work, you used objects in the studio and made characters out of them. What?

You made characters from objects. Well, the way I worked was to just sit down in front of the camera and stare into the monitor for a long time, and dangle things in front of it. The mirroring aspect of the process induced a semihypnotic state, which caused me to drone on and on about what popped into my mind, which at the time was rather fertile with dumb things. This was a very different way of working than with the Sony Portapak camera, which was used by most artists at the time. When using that camera, you held it up and looked through it. You were behind it rather than in front of it. Big difference.

Several of the artists have commented that one of the great things about video in the early days is that you could just take the tape and send it anywhere; it became this kind of global network. Theoretically, the idea that you could send your work anywhere is very appealing, but to me, it's not very satisfying. I learn a lot by testing the work in front of an audience. If someone was laughing, then they got it. If they were just looking, I would start thinking, "What's wrong with it?" I was very taken by Glenn Gould's notion of performing, and I guess, like everyone else at the time, Marshall McLuhan's essays on the medium were on the mind.

I was really fascinated by what Bruce Nauman was doing. It seemed like he had a kind of charisma built into his work, which was very riveting. I felt my work was more fragile in terms of the museum environment, because I was thinking that it should be broadcast. I was hoping that my photographs would be published and my videotapes would be broadcast. I didn't want video projections or big photos in a museum. I was fiercely against that, for reasons that are probably obscure today. Glenn Gould's thoughts about performing in front of a live audience, that it corrupts the integrity of the performance, were reassuring to me at the time. Being self-conscious, I always recorded in privacy.

Did you think about your audience back then? At first, I would show the videos to a few friends and neighbors, and Gayle, of course. John Baldessari let me use the editing stuff at CalArts [California Institute of the Arts], and I would show them to whoever was around at the time. I really liked it when video technicians would notice the content over the signal. They were so jaded, it was hard to get their attention. Strangers are better than friends when you test the effect of the work. My next-door neighbor in Santa Monica, Gary Weiss, a documentary filmmaker, introduced me to Lorne Michaels. Lorne was from the CBC [Canadian Broadcasting

Corporation], and he was going to make a TV show with artists' films and videos and the new wave of comedy, the Second City group, in particular. When I moved to New York, the show was being picked up by NBC, and I went to some of the meetings with Lorne, Chevy Chase, John Belushi, Gilda Radner, Dan Aykroyd. There was an idea that my tapes would be a regular feature on the show, but the show turned into something other than what I imagined. Also, because my work was video and not film, there was a problem in airing it—a union thing. It was fun being on the show the few times that I was.

What was that like? Crazy—more than you can imagine. I was really out of my element.

You're not crazy. You are strangely sane. How can that be? I know. Isn't that crazy?

Maybe we should talk about Man Ray now. About fifteen years ago, I went with you to an international dog show, and I was amazed to find that you had this incredible reputation as Man Ray's father. People were screaming "Man Ray" as we walked around the dog show. You've said that one reason Man Ray became a subject was that he just wouldn't get away from the camera. There's something about the tools and the space that you're in that a dog wants to share with you. Hunting dogs, especially, hang around your equipment. They're right there. I came to learn that Man Ray was taken from his mother too soon, and he didn't know he was a dog. He depended on me in ways that my current dogs don't. He was the extreme case, and he became seriously entertaining.

Did people criticize the fact that you were doing humorous videos using a dog? No. I did get questioned by some about exploitation. I guess it was a sixties liberation POV. Animal rights groups have never been an issue, but occasionally there is a reporter who asks the questions. I did criticize myself, however, and was very careful in my work with him to not make it gratuitous. In 1978, I stopped working with him altogether. It was sad for both of us. Now I know dogs need to work and that's their only happiness. You know it's true. Admit it.

Okay, if you say so. But are you being ironic? Is that a multiple-choice question?

Yes, none of the above.

p. 244 left
William Wegman, still from *Deodorant*, 1972–73. Single-channel video, black-and-white, sound; 49 sec. LBMA/GRI (2006.M.7).

p. 244 right
William Wegman, still from *Untitled (Rage and Depression)*, 1972–73. Single-channel video, black-and-white, sound; 1 min., 3 sec. LBMA/GRI (2006.M.7).

p. 245
William Wegman, *For a Moment He Forgot Where He Was and Jumped into the Ocean*, 1972. Silver gelatin print, 35.6 × 27.9 cm (14 × 11 in.). Collection of Gian Enzo Sperone. Note the crack in the concrete floor, as discussed on p. 243.

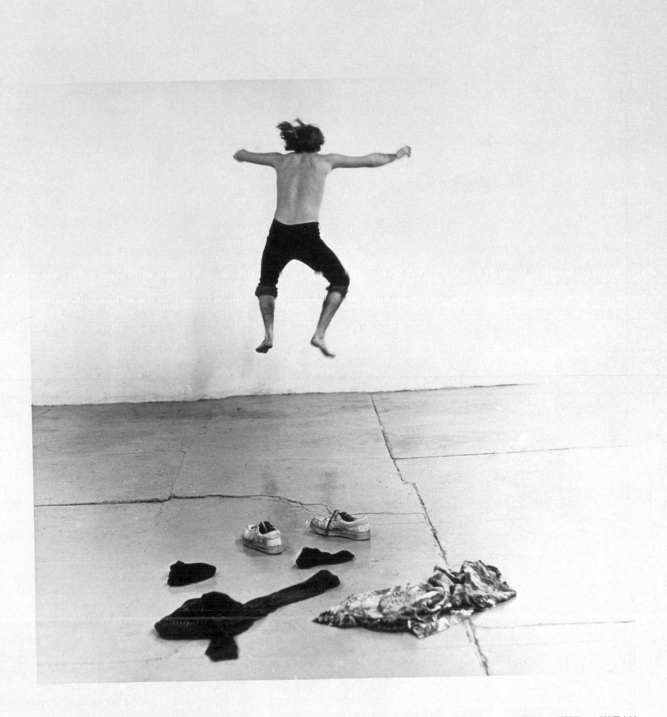

FOR A MOMENT HE FORGOT WHERE HE WAS AND JUMPED INTO THE OCEAN

BRUCE and NORMAN YONEMOTO

Bruce Yonemoto: born 1949, San Jose, California
Lives and works in Los Angeles, California

Norman Yonemoto: born 1946, Chicago, Illinois
Lives and works in Venice, California

WORKING COLLABORATIVELY since 1975, brothers Bruce and Norman Yonemoto have produced a body of film and single-channel videos that reflects a uniquely American drive toward mass media and its often subconscious effects on the spectator. Raised in Central California in a typical postwar home, the Yonemotos often exploit aspects of the over-played narratives, melodrama, variety shows, cloying commercials, and racial stereotypes typical of 1950s television in their witty, critical, and revealing artworks. *Green Card: An American Romance* (1982), the last of three videos comprising the Yonemotos' *Soap Opera Series*, tells the story of a Japanese artist who comes to California in search of opportunity. Discovering that she needs a green card to remain in the United States, the woman considers marrying an American man to qualify for citizenship. Convincing herself she is in love with a local surfer, she eventually abandons her creative ambitions and independence and marries the man. The video quotes liberally from well-known Hollywood movies while casting a real Japanese artist living in Los Angeles in the lead role. Norman, trained in film theory and production, and Bruce, whose background is in visual arts, further blurred the line between mainstream movie production and artistic experimentation with *Made in Hollywood* (1990). In the video, professional actors such as Patricia Arquette and Michael Lerner play out a dramatic plot while repeatedly breaking character to address the camera directly, as themselves.

For their first video installation, *Framed* (1989), the Yonemotos incorporated American film footage produced during World War II by the War Relocation Authority—the federal agency that enforced the unconstitutional incarceration of nearly 120,000 Japanese Americans—which the artists found in the National Archives. The propagandistic footage attempts to present a positive view of the U.S. internment camps, yet the faces of the interned bear witness to a bleaker reality. Creating a new critical context for this historical document, the Yonemotos installed the footage in a darkened room divided by a two-way mirror. Viewers peer through the glass to observe the silent raw footage on a monitor, while a superimposed video projection highlights a sequence of still frames from the film, creating a subtext that undermines the air of cheerful life in the camps suggested by the original propaganda. At the end of the cycle, a light automatically switches on to reveal the viewer's image and a cinematic backdrop reflected in the mirror. This very backdrop, painted as a blue sky with clouds, was used in the production of numerous television commercials, including an ad for Marlboro cigarettes. Literally framed by the edges of the mirror and "set up" by the artist's restaged backdrop, the viewer becomes implicated in a highly mediated system of manipulated images.

Catherine Taft

Interview conducted by Carole Ann Klonarides on January 29, 2007, at Norman Yonemoto's home in Venice, California

CAK: You come from a family of four boys. How did the two of you actually decide to collaborate and be artists together?

BRUCE YONEMOTO: Well, I think we started to collaborate when our interests collided. My background is fine arts, and Norman's background is film. I was interested in Arte Povera and the concepts surrounding the everyday. I was looking to television as the center of the generation of behavior, so I started to write these soap operas, which I wanted to look like real soap operas. So that's when I asked Norman to help me.

NORMAN YONEMOTO: I went to UCLA [University of

California, Los Angeles] Film School and then to AFI [American Film Institute], and at the end of that time, I was able to reproduce the look of a feature film or a soap opera on camera. When Bruce started talking about doing these projects I was excited by it. The first time I realized what Bruce was doing was when he did these pieces where he took frames from comic strips and replaced the dialogue balloons with his own dialogue. He wanted to do the same thing, basically, in these videotapes. And the first project we did was *Based on Romance* [1979], which was a very simple schematic thing, like frames out of a comic strip. It was a piece where the female character was in crisis over whether or not she needed to have a hysterectomy, and how the medical profession was biased against women. So she has to seek out a woman doctor to get a straight answer about having to have a hysterectomy. The male doctors talk as if there was no other course of action, and downplayed the consequences of the operation.

BY: But that wasn't the first time we collaborated on video. The first time was a segment in this feature film that we made, *Garage Sale* [1976], starring drag queen Goldie Glitters. There was a sequence that focused on a woman who was being watched by a disembodied eye from a neighboring apartment house. She became obsessed with the eye, so much so that when the eye disappeared, she became so despondent that she committed suicide. I was working at Santa Monica City College in the video lab at the time, so we were able to use a Portapak from there to shoot the eye sequence. *Garage Sale* was shot in Venice, documenting subcultures in seventies L.A. It was fun; it opened at the Fox Venice, and there was a Goldie Glitters look-alike contest and a parade.

Norman, since you were studying film, how did you feel about using video?

NY: It was great, because video gives you immediate gratification, and there isn't the high cost of the processing the film. Video is easy if you own the camera and editing equipment. That's where the Long Beach Museum of Art came in, because we were able to shoot and edit our early pieces on their equipment. Editing and production were very important to us. When we were showing *Vault* [1984] at the AFI Festival, a video artist came up to me and said, "Why does your work look so different?" I said, "Because it was edited." We were cutting the work like a commercial.

BY: *Vault* has the structure of a TV commercial. There is a major technical event every three to six seconds; a camera move, an audio cut. More than that, the content of the piece refers to the collision between Freudian analysis and commercials, because one of the founders of the advertising industry on Madison Avenue

Nobuhara, a friend of ours, had to get a green card and Bruce offered to marry her, because that was the quickest way to do it. We documented this actual situation in our narrative, and it developed into a soap opera where the actual real-life participants became the characters in our melodrama. Bruce wasn't in it, but everybody else involved was. And we tied Bruce and Sumie's real wedding to the premiere of the tape. People who had come to see the premiere of the video soap opera, which was about the reasons why Sumie was getting married and the soap opera situations swirling around it, also witnessed a real green card wedding. It became impossible to separate the fiction from the reality of the situation.

BY: Yes, some people got very, very upset. Joy Silverman had just gotten married in the Rothko Chapel [in Houston, Texas], and she was very upset at the premiere. But the most interesting story is

in New York was Edward Bernaise. His mother was Freud's sister and his father was Freud's brother-in-law. So basically, he moved from Vienna to New York to help found the commercial industry. And granted it wasn't media at that time, but it still was, of course, integrating Freudian analysis with commercialism. In the end this monolithic mind control system still exists.

Vault used the language of film rather than the language of video art, which basically started as a single-channel tape, because there was little possibility of editing on the reel-to-reel format. Up until the early 1980s, it was almost impossible to edit on your own equipment. You'd have to mark the reel-to-reel tape with a crayon, then physically cut and splice the tape.

Well, it's funny because now there's a sense of nostalgia for the kind of junk edits of early video and the grainy black-and-white. But your work wasn't exactly Hollywood film and it wasn't exactly this grainy look, it was somewhere in between. How was your work received by the community at large?

BY: Well, the anecdote I have is that when Kathy Rae Huffman was at the Long Beach Museum, she was involved with the early NEA [National Endowment for the Arts] granting process, and I remember her telling me that our early work was often rejected because whenever people saw a two-shot on screen, they said that this was not experimental. So it wasn't until *Green Card: An American Romance* [1982] that we received our first NEA grant. After that, people started to accept the fact that we were trying to rupture the dominant film language, and throw the audience out of the narrative ironically, so that they could understand the seductive manipulative structure they were watching.

Green Card was the last in the Soap Opera Series?

NY: Yes. *Green Card* was basically Bruce's idea, because Sumie

Kyoko Watanabe, who plays Sumie's best friend in the tape. Kyoko got so involved with the work that she tried to expose my marriage to Sumie as being a fraud to Sumie's mother. Ironically, in real life, Kyoko was congenitally crippled, physically deformed, and not expected to live beyond her teens due to her severe physical handicaps. Kyoko's character in *Green Card* is the one who believes in the idea of love most strongly and vehemently. And, of course, this mirrored reality.

The lines in that work are delivered quite flat. Was that on purpose?

NY: Yes, definitely. We were not doing a parody at all. It was funny, but it was not even a satire.

BY: The acting was one of the ways we alienated the audience, to sort of make them aware that something is wrong with this picture.

NY: The piece looked and functioned so much like an actual soap opera that we had to do something to knock our audience out of the narrative spell of the piece. We did all kinds of things to get the viewer to realize that they were being manipulated, at the same time they were being manipulated. Even then, we were continuously getting critiqued. Whenever we screened the video, someone stood up to declare the video was not art because it looked too "Hollywood."

Was it frustrating that you, Norman, who aspired to be a filmmaker, and you, Bruce, who aspired to be an artist, were kind of in this never-never land of being neither?

NY: There was a long period of time when we were in that situation.

Was there a sense of community back then? Did people actually work together making video?

BY: Yes, there was a group of people—Branda Miller, Jeff Isaak,

p. 246
Bruce and Norman Yonemoto, still from *Vault*, 1984. Single-channel video, color, sound; 11 min., 45 sec. LBMA/GRI (2006.M.7). Photo by Kira Perov.

p. 247
Bruce and Norman Yonemoto, stills from *Framed*, 1989. Two-channel video installation with mirror, scrim, and backdrop, dimensions variable. LBMA/GRI (2006.M.7.2).

Ante Bozanich, Patti Podesta, Tony Oursler. They were more involved with punk and the music scene. They weren't outlaws per se, but they were certainly more interested in subculture. Of course, that's where we were coming from. If you just take a look at *Garage Sale*, you'll see exactly where we're coming from—drag queens, leather people, artists.

NY: Pornography.

Norman, can you talk about how you were involved in making gay pornography?

NY: Well, the thing about making pornography is that it was a way of doing experimental pieces and actually using what I'd learned to make these feature films. And there was a guaranteed return on the investment. Back in the mid-seventies, I made the only anti-

perimental musicians, such as Carl Stone or Tom Recchion. I think in *Kappa* [1986], we just took one of Carl's complete pieces and basically played it from beginning to end.

NY: We worked for years with Mike Kelley developing the script for *Kappa*, and we shot it over a long period of time. So we had all these bits and pieces and situations and things, but the connective tissue wasn't there. So Carl said, "Go ahead. Use this piece." We edited the images to the music. That's what pulls *Kappa* together. We used the MTV strategy.

BY: But I think it's a little bit different than that, because, of course, it's not a song. It's more experimental in terms of its structure. But it's always in the background. So as a complete piece, the music holds everything together. Carl also did the music for my wedding to Sumie at LACE [Los Angeles Contemporary Exhibitions] for

Vietnam War porno. People still are blown away by the piece. It's about this big brother whose little brother comes home on leave. Toward the end, all of a sudden, you're in the veterans' cemetery. The older brother is there at his younger brother's grave, and the audience is brought to tears. People weeping while watching a porno? It was unprecedented.

BY: But that was on film, right?

NY: Yeah, it was definitely on film. But then when the VCR came along, all of a sudden it was possible to make video pornos. I kept telling the money people that we could make a serious piece, because the first people who bought VCRs had some money and were mostly well educated. I made the first gay video porno.

BY: Didn't you secretly edit them at the Long Beach Museum in the dead of night?

NY: Yeah. I was hired to edit these really high-end pornos. Matt Sterling and I would arrange to edit from like 10:00 P.M. to 6:00 A.M. I was always sort of worried somebody would walk in. It never happened, and I don't think it would have mattered if it had.

One of my students said, "Why is it in the eighties, everybody put music on everything?" I think that would be an interesting question to ask you, because you use music in all of your videos.

NY: In the eighties, music became sort of ubiquitous in everything, because part of the big style-generator at that point was MTV. So you started off with the music and then you did the images. That was sort of the backward situation at that point. So if you look at the movies made at that point, too, you see a lot of situations where the music's playing for like ten minutes with images cut to it. But melodrama, of course, is by definition a mixture of music and drama, and Hollywood movies are the epitome of this method, coming up with many perfect marriages of music to picture.

BY: But I think that we were always interested in working with ex-

the premiere of *Green Card: An American Romance*. He took "The Wedding March" and just kept on repeating it and repeating it and repeating it. I remember my mother was there, and she said, "You know, the only thing I really hated about the ceremony was "The Wedding March," because it would just go on and it would never end." It was really more like a death march.

You were some of the first video artists to incorporate within your narrative the idea of identity, whether it be sexual or racial identity.

BY: I don't think we're the first artists to deal with identity, but identity is interesting to me, because I was at Berkeley in the late sixties, and that was the beginning of the Third World movement. We never had classes, because everyone was always demonstrating. So I just had these identity classes and things. I realized that I would always be identified as a minority, as a Japanese person, not as an American. I went to Europe when I was eighteen and everybody asked me where I was from. I would say I was from the United States and my parents were born in the United States. They'd say, "No, no. We want to know where your grandparents came from." I said, "Japan." So they would say, "Oh, you're Japanese. You're a Japanese person," which still continues. It's really ridiculous.

Your first video installation, *Framed* [1989], deals with Japanese American history in the internment camps.

NY: We wanted to do a piece about the internment camps. I'd seen documentaries made by the War Relocation Authority, which was the agency that was created when FDR signed the executive order to put the Japanese away in concentration camps after Pearl Harbor. I was trying to find good prints of those films, and I had some friends who worked at the National Archives who pointed me in the right direction. When I found the docu-

pp. 248–49
Bruce and Norman Yonemoto, stills from *Framed*, 1989. Two-channel video installation with mirror, scrim, and backdrop, dimensions variable. LBMA/GRI (2006.M.7.2).

mentary file, I noticed that there was a listing for a camera roll. I pulled the file and screened it. It was raw footage with camera slates included. It was obvious that the scenes were carefully scripted and people were being told how to act. In the end, they cut out all the slates and presented it as documentary footage. We decided to use the footage, but the only way we could use it in a single-channel piece was to re-edit the footage and construct a new reality using Eisensteinian montage techniques. But that was the method the government had used to create the propaganda in the first place. We did not want to use the same technique to make our point. Bruce came up with the solution. He noticed some interesting details in the footage. For instance, in a shot of women being taught English, there is one woman looking at the camera with a forlorn expression. We reframed the image. We enlarged

the sad woman taking her out of context. When we juxtaposed the original footage with the blow up, the footage took on a whole new meaning. We were able to come up with a feeling of negativity instead of the intended positive feelings of the original footage.

BY: Bob Rosen commented that it was editing in situ, meaning that through the overlaying of images, the meaning of the fake documentary footage changes. The audience is editing while they are watching the material itself.

NY: We set up a unique viewing situation. The viewers walked into a small room and faced a mirror on one wall. When the lights dimmed, it became apparent that it was a two-way mirror and they could see through it into another room. There was a monitor in the other room playing the raw propaganda footage. In the case of the English lesson, we projected the still of the sad woman onto a transparent scrim in front of the monitor. The viewer saw the monitor playing the propaganda footage through the reframed image of the sad woman. We used the same technique on all the shots on the raw footage roll. Then, after standing in the dark in complete silence, the lights come up and the audience is confronted with their own reflection. Seeing their own image in place of the internment camp images implicates them in the process. It becomes an accusation.

BY: And there's a backdrop behind you, which is a backdrop of a painted sky formerly used in commercials, such as Hills Brothers or McDonald's. So you're actually seeing yourself in a commercial environment.

NY: The audience is captured. You're caught, you're framed.

Talk a little bit about your parents' influence on *Framed*.

NY: After their camp experience, most Japanese didn't want to talk about it. They kept it a secret from their children. But in our case, our mother couldn't talk enough about it. She constantly talked about how horrible it was and how it was so unjust. She picked out different social groups, and how badly they behaved toward the Japanese. She was very adamant to make sure we didn't forget it.

BY: The internment destroyed any cultural development of the third (*sansei*) generation of Japanese Americans. I went to Brazil on a Lila Wallace Foundation grant, and my project was to find films in Brazil that corresponded to similar films made by our father's family—and other families of his generation—shot on 16mm film, which are now housed at the Japanese American National Museum in L.A. These were home movies taken at the time of immigration or right after, before the twenties. When I looked at our history as Japanese American artists and that of Japanese Brazilian artists, I realized that in Brazil, Japanese Brazilians are integral to their art history in every form. There are no Japanese American artists of note in the United States, save Isamu Noguchi, and of course he was half Japanese and half Irish American. It just shows that because of the war experience, any cultural activity was not only obliterated by American history, but it also really kept our generation from becoming artists. The emphasis after the internment camps was to assimilate, to become a doctor or lawyer, a professional.

You also looked back to your childhood in *Silicon Valley* [1999]?

BY: In 1999, we had our survey show at the Japanese American National Museum, and we created a new installation called *Silicon Valley*. Tony Schwartz's "Daisy" commercial is central to the piece. It was an anti-Goldwater commercial that was shown only once, in 1964. It shows a little girl pulling the petals off of a daisy. Then it turns into a countdown. As the countdown ends, we pull into the little girl's eye, within which is an image of an atomic explosion. It was shown only once, but it had a tremendous effect. And Goldwater didn't deny the accusation. He, of course, believed in the use of tactical nuclear weapons, and he didn't try to change his position.

NY: We had two big video projectors, one pointing down from the ceiling and one projecting from across the hall. We had two screens: one vertical and one horizontal screen, which we tied together by having cherry blossom branches on the vertical screen, and the blossom petals falling onto the horizontal screen on the floor.

BY: But it was actually one screen, because it was like a scroll. It was eighteen feet tall. It was incredible. Thematically, it goes back to our past, to the valley in which we were raised, which is the Santa Clara Valley. When we were being raised, it was called the Valley of Heart's Delight. By the time we left for college and everything, it had become Silicon Valley.

NY: It used to be beautiful. They had fruit trees that covered the entire floor of the valley. During the spring, people would come to sightsee, and they'd take tour buses up in the hills and look at all the beautiful blossoms. When we were growing up, there were all these little businesses around like Hewlett-Packard and IBM. There were these little buildings with a little sign on the front, "Bell Labs." We didn't realize these entities were going to destroy our childhood environment. We saw all the trees torn out. We saw everything paved over and housing tracts come in. To us, technology was like an atomic bomb that blew away our environment. In the installation, we use images of atomic bomb blasts blowing away all these things, and what was left were computers and—

BY: Subdivisions.

Histories

RECOLLECTIONS:
A Brief History of the Video Programs
at the Long Beach Museum of Art

BETWEEN 1974 AND 1995, the Long Beach Museum of Art (LBMA) operated one of the most successful and innovative video art departments in the country. In addition to an active program of exhibitions and screenings, LBMA developed a number of important projects for cable television broadcast and maintained a post-production facility and visiting artist residency that provided artists with access to editing services and equipment. In 2005, LBMA's video archive, consisting of nearly five thousand tapes, was transferred to the Getty Research Institute, where it will be digitized and made available as a study archive. This text has been synthesized from interviews with former LBMA staff to compose a brief history of the museum's video programs.*

Interviewees:

DAVID A. ROSS
Deputy Director and Curator, 1974–76

PETER KIRBY
Technical Director, 1976–77
Project Director for the Open Channels Television Production Grant Program, 1986–88
Interim Video Curator, 1988

KATHY RAE HUFFMAN
Intern, 1976–77
Video Coordinator, 1978–79
Curator, 1980–84

JOE LEONARDI
Video Annex Manager, 1981–96

KIRA PEROV
Curatorial Assistant/Video, 1983
Assistant Curator, 1984

CAROLE ANN KLONARIDES
Media Arts Curator, 1991–95

CAROLE ANN KLONARIDES: When I was hired as media arts curator at the Long Beach Museum of Art in 1991, there was an article that came out in *The Journal of Art* about my hire, and in it I said I was proud to go to the Long Beach Museum to follow in the footsteps of David Ross, who had created this video program. Shortly thereafter, I received a letter from Jan E. Adlmann, former director at LBMA, reminding me that it was his idea to bring the video program to the museum.

DAVID ROSS: Jan was the one who hired me. He was very enthusiastic about finding a way for this tiny little museum in Long Beach to make a difference. Jan and others from the City of Long Beach were interested in hiring I. M. Pei to design a new building for the Long Beach

Museum (fig. 1). The Everson Museum of Art [in Syracuse, New York], where I was video curator, was designed by Pei. Jan came to the Everson and saw the video program that Jim Harithas and I were doing, and he said, "Would you like to come to California and do this there?" Moving to Southern California sounded to me like a very good idea. I had done a couple of West Coast video shows at the Everson. At that point, Bruce Nauman was still very actively doing video in Los Angeles, as were Bill Wegman and John Baldessari, and there were so many other artists who were active that, when I came out here in 1974, I just felt like I'd died and gone to heaven. *Everybody* wanted to work with video. They all wanted to try it; it was in the air. If in the 1960s everyone in Southern California wanted to work with plastic and fiberglass and "Finish Fetish" and create artworks that were kind of like surfboards and kind of like sculpture, by the mid-seventies everyone wanted to work with television. And it was *not* similar to the way artists on the East Coast wanted to work with video as an alternative to conventional mass media. On the East Coast, there was an ideological approach to the idea of an alternative community using media art to create a different political force, and to reinvent this hybrid between documentary and narrative. But that politic never came west—although in a way it was equally political, because it was artists who were just saying, "We don't need a reason to use this medium, it's just there. It's the lingua franca of our time, and we should obviously work with it—now that we can; now that these tools are available."

CAROLE ANN KLONARIDES: How did you set up the program at LBMA?

DAVID ROSS: My first year's LBMA budget was $2,000 to do all the exhibitions I wanted. Luckily, with video exhibitions there's no art shipping involved. Artists would put a tape in an envelope and send it to you, and if you had a monitor and a deck, you had an exhibition. Artists weren't asking for fees then for showing their work, and they weren't asking for production support to make their work. We were all part of the same kind of moment, and it was a shared sense of experiment and even community.

CAROLE ANN KLONARIDES: You also showed the videos in a communal way. You had pillows on the floor.

DAVID ROSS: Well, we couldn't afford chairs. My wife at the time, Cheryl, just sewed up all these big comfortable pillows, and, of course, it immediately became a place where all the teenagers in Long Beach came to get stoned and make out after school. That became a big problem, although they were seeing art at the same time, so it was also kind of educational and fun. But the exhibition program was very efficient. We did a Nam June Paik show for $500. It was a great show, too. It had about a hundred of his fantastic pencil drawings, and he sent *Global Groove* [1973] and a few other of his earlier tapes. It was his first exposure in Southern California. He'd never had an exhibition in California, even though he taught at CalArts [California Institute of the Arts] in 1970 and '71, and even though he and Shuya Abe built the second Paik-Abe synthesizer there. But, you know, even though this is a big psychedelic town, video synthesizer art never really took hold here. That was much more in the Bay Area than Los Angeles for some reason. Paik's influence was still here, but the really dominant influences were Allan Kaprow, John Baldessari, and Bruce Nauman. The first generation of artists who had been their students were responding in remarkably innovative and thoughtful, strange, and unpredictable ways to the use of this technology, which was still pretty crude.

CAROLE ANN KLONARIDES: You set up a production facility at the museum in 1976, which had a major impact. How did that come about?

DAVID ROSS: When I arrived in California, one of the things that we saw was missing was access to any kind of post-production facility. A lot of artists here were making very long and very boring videotapes, because nobody had any editing equipment. Post-production in Hollywood was enormously expensive. There weren't that many editing facilities in the first place, and only the big studios and television networks had access to them. I was on a committee at the Rockefeller Foundation, and we had a meeting to talk about California. Howard Klein, who was the head of

*Interviews were between Carole Ann Klonarides and Kathy Rae Huffman at the Long Beach Museum of Art on January 9, 2007; between Glenn Phillips and Peter Kirby at Peter Kirby's studio in Los Angeles on July 16, 2007; between Glenn Phillips and Carole Ann Klonarides at Peter Kirby's home in Los Angeles on July 16, 2007; between Susan Mogul and Joe Leonardi at Joe Leonardi's home in Sisters, Oregon, on July 13, 2007; between Glenn Phillips and Kira Perov at Bill Viola's studio in Signal Hill, California, on June 22, 2007; and between Carole Ann Klonarides and David Ross at the Getty Research Institute in Los Angeles, California on January 25, 2007.

the arts program there, said, "Okay, we'll do something for Northern California and something for Southern California, and we'll give you each $50,000." In Northern California, the Bay Area Video Coalition [BAVC] sent in an enormously complex proposal—all these studies about what they were going to do for the Latino community, the Asian art community, the gay and lesbian art community, and all the things they would do to assess the needs and create a structure. In the long run, that was very smart. They built a house of bricks. But we were the other little piggy, and we just said, "We're going to buy $50,000 worth of editing equipment and put it in the attic of the museum and invite artists to come and use it, and we'll spend some of that money to hire people who actually know a little bit about video editing." And then we were lucky enough to meet Peter Kirby—who is, in fact, sitting behind the camera filming this interview right now—and we also had John Baker. Peter and John were the hands-on technicians, so the artists had someone there to help them learn how to do it. Artists came in all hours of the day and night. We set the equipment up in the attic of 2300 Ocean Boulevard, and it was like a little paradise. It was like a playroom in a way. You came to play, and it was that high level of play that has so much to do with how art gets made.

CAROLE ANN KLONARIDES: How did artists get access to the editing equipment? Did they just come to you?

DAVID ROSS: Yes. It very quickly became known that we had this equipment. And you weren't paying $400 an hour to work on some system, so people were very happy to wait their turn. There were no financial implications. Access was free. Artists would just get their work done, and stay as long as they needed to stay. Artists didn't get chased out at midnight—it wasn't that kind of museum. It was in the attic of an old brown-shingle house. Somebody told us it had been Fatty Arbuckle's summer cottage—which turned out not to be true, but we labored under that misapprehension, that we were also working where the great Fatty Arbuckle had lived.

GLENN PHILLIPS: Peter, why don't you describe the editing facility?

PETER KIRBY: We had a convergence ECS-1 edit controller with two three-quarter-inch decks, and two reel-to-reel decks with a manual edit button. They put a skylight in the attic, painted it all white, and there was a big table in the middle with one of the edit systems on each side, and then some storage for the camera. We had a color camera that was really cranky and difficult to work with, and it broke all the time, because—well, everything broke all the time back then.

Figure 1.
Exterior view of the Long Beach Museum of Art, California, spring 1974. LBMA/GRI (2006.M.7). Photo courtesy of Jay McCafferty.

Even broadcast equipment broke all the time. And then David's office was directly off that—literally a closet with a view; it was maybe five feet wide and ten feet long, with desks underneath the eaves and a little window and cabinets.

CAROLE ANN KLONARIDES: What was your title?

PETER KIRBY: "David's slave."

KATHY RAE HUFFMAN: And I was "David's second slave."

CAROLE ANN KLONARIDES: Kathy, you were working at the museum as an intern under David, before eventually becoming curator there.

KATHY RAE HUFFMAN: I was a grad student in the Museum Studies program at California State University Long Beach in 1974, and I was really challenged about this thing called "video." I somehow immediately got attracted to the word. I'd never heard it before, so I came to the Long Beach Museum to look at what was happening there, and then I did my graduate project on video. David invited me to be an intern, although it was pretty much a full-time position, because there was so much that needed to be done. There were artists making works right there in the house, there were things to be ferried back and forth from Los Angeles, and equipment that needed to go places.

CAROLE ANN KLONARIDES: Didn't you find it kind of odd that the museum was a little house on the bluff?

KATHY RAE HUFFMAN: No, it was a perfect place for it. The works were on television sets and it was in a house. That's what you associate television sets with—being in your home—so it never occurred to me that it was something unusual or odd.

KIRA PEROV: The museum is a beautiful old Craftsman-style house, and because of its low ceilings, it was perfect for video (fig. 2). It has many different-sized rooms and you didn't have to do a huge amount of building to create isolated spaces for installation pieces. Thus, we were able to mount quality exhibitions with minimum funding. With every new change of exhibition, there was always a new video program.

Figure 2.
Exterior view of the Long Beach
Museum of Art, California, circa 1975.
LBMA/GRI (2006.M.7).

Figure 3.
Cover of exhibition catalogue,
Southland Video Anthology
(Long Beach Museum of Art, 1975).
© Long Beach Museum of Art.

CAROLE ANN KLONARIDES: I'm interested to hear about some of the fun. I know there used to be a sign that would be put on the door to the attic, which said, "Tape in progress," and that usually meant mischievous goings-on.

DAVID ROSS: Well, it *was* the 1970s, so I would say that from time to time we were stoned. Although for the majority of the time, we were just stone sober, because the work was grueling and hard, and when you're editing, it's really not possible to be high. But there are some artists who only work that way, and since the museum was becoming an active co-conspirator with the artists here, we tried to be as open as we could. We weren't stepping back and waiting and assessing the quality; we were throwing our lot in with them. We were active agents in helping work get done. I think that museums cross that line regularly now, but back then some people raised their eyebrows, thinking that we had lost our level of academic objectivity because we were implicated in the production of the work.

CAROLE ANN KLONARIDES: And the museum was still being run by the city at this time?

DAVID ROSS: Yes, but we had little relationship to the city per se, and outside of basic operating expenses, the city gave us no money whatsoever. You have to remember that we mainly just kept wondering why they were stalling on the new I. M. Pei building. Why weren't they going ahead with this? And of course it had to do with the corruption that was taking place in Long Beach at that point in the real estate development community, and its relationship to the city, and the city's redevelopment office, and the city manager's office.

CAROLE ANN KLONARIDES: Did you have a board of trustees?

DAVID ROSS: There was no formal board, as such. There were some people who gave us encouragement, but no money. Our money came from the National Endowment for the Arts [NEA], and the Rockefeller Foundation continued to back up their investment in the post-

production facility. Every once in awhile we would find somebody who would give us a couple thousand dollars, but there really wasn't money involved, and that didn't matter. In fact, the lack of money—and thus the lack of conflicted interests that money often carries in the art world—meant that we could do whatever we wanted. That gave us fantastic license to explore and experiment and allow artists to fail. Because, in my opinion, the difference between a great museum involved with contemporary art and a mediocre one is that the great ones aren't afraid to fail along with the artists they support. They don't insist on everything being a predetermined home run. They're willing to take risks, or let an artist take a risk, and stand behind them whether they succeed or fail, and we did a lot of that. Ultimately, I believe we played an important role in the growth of Southern California's ability to become more actively engaged in the kind of sea change that the evolution of video as a creative medium brought about.

CAROLE ANN KLONARIDES: And were you thinking about collecting? When did you start to actually acquire tapes and have them in the museum?

DAVID ROSS: We weren't thinking about collecting per se. First of all, we had no budget, and we weren't really making concrete acquisitions with contracts and all the things that today seem so obvious and essential. At this point, we had what I'd call an accretion rather than a collection. Artists would make a tape, then they'd leave a copy for us. Artists would show a tape and wouldn't ask for it back, so it would just be there on a shelf. I mean, why would they want it back? They can just make another dub. It didn't have any value. It was just a box that you ran through a machine, and the notion of it having any long-term value was completely alien. The notion of there ever being a market for video was not even imaginable. Who would want to pay for this? How would you own it? So you could work with any artist, and their dealers wouldn't care. Leo Castelli was always grateful to us for being a place that would take care of artists who wanted to play around with video. That was his attitude. It wasn't negative, but it was rather paternalistic, like "maybe it'll go away, or maybe it will be important, and will last."

KATHY RAE HUFFMAN: But eventually the museum did start officially acquiring works. And of course there was always the request that artists who worked in the studio leave a copy of their tape as part of the collection. It was understood that would be part of the deal. It was a growing collection, but I think nobody had experience in actual museology and database organization. Plus, nobody had computers at this time. It was all written down on little four-by-five-inch cards and put in file indexes.

CAROLE ANN KLONARIDES: David, what was the concept behind creating the *Southland Video Anthology* exhibitions [1975; 1976–77] (fig. 3)?

DAVID ROSS: The idea of the *Southland Video Anthology* was just to have a simple structure where we could explore and expose the explosion of amazing activity taking place all throughout this region. There were hundreds of artists, and many of them were really interesting or had great potential. So, without wanting to be overly restrictive and overly curatorial, we wanted some structure that would allow us to be generous. There were few critical standards yet, and I wasn't all that interested in the establishment of premature critical standards in the first place. I was more interested in a space where artists could get their works shown, because when the work of art isn't shown, the artist can't grow; the work of art can't have its life.

PETER KIRBY: There was a great deal of energy and generosity emanating from the museum during this period. The museum was committed to showing the most diverse possible work, and getting as many people as possible to see it. That created an environment of trust and excitement, as well as a social scene. We were constantly grabbing equipment to go shoot projects. Of course, there was down time too. It seemed that there was all the time in the world, and that nobody was going to actually have a career doing this. There was a sort of ethic of poverty—that this was good because it wasn't monetized. It was good because you couldn't make any money, even though you had to have money to do it. I enjoyed that contradiction. It seemed like an ideology almost.

257

DAVID ROSS: It was an important shared moment for everybody involved, because we shared a sense of "We don't understand this," and we were all trying to understand what video could mean. It was very important at the time to try to understand the potential and the reality of this medium. To figure out what it meant, in terms of changes in the larger social fabric, when artists had access to their audience in a totally different way. That's what brought me to Long Beach in the first place, the idea of building the museum with its own channel. It was originally Nam June Paik's idea—one that he planted in my little, very empty, fertile mind at that time. The idea was that the museum of the future has to be a television channel, among other things; that the museum needs to be a catalyst; it needs to be a participant in a structured community; it needed to push boundaries and be an active agent for change. In this case, the change that we were talking about was the ability for artists to eventually—as they fairly soon will be able to do—just sidestep that entire museum superstructure that comes between an artist and his or her audience, his or her viewer; the other individual, the other side of the equation.

CAROLE ANN KLONARIDES: It's hard to imagine the context of actually creating these programs before Los Angeles had institutions like MOCA. It seems that there was a wealth of creativity, but the absence of a larger audience.

DAVID ROSS: But audience didn't matter. What mattered for us were the artists. And people took notice. Giuseppe Panza, as you remember, first offered his collection to us in Long Beach. Of course, he wanted too much and we were all out of our depth in terms of being able to negotiate with a collector of that level of complexity—and of course many years later the major portions of the collection went to MOCA and the Guggenheim Museum. At this point, we were mostly caught up in worrying about why the new building wasn't happening. We had no idea that the only reason our building wasn't going forward was that the city redevelopment commissioner couldn't figure out how to get a kickback from I. M. Pei, because he wasn't a local architect and would never do something like that. And of course it was eventually the local gang of architects that called the FBI. A sting was set up, and the city manager and the redevelopment guy were caught literally red-handed with a shoebox full of Mexican gold coins being given as a bribe. The FBI was slick enough to have a photographer there, and it was on the front page of the Long Beach newspaper the next day. It wasn't even like a secret bust. This was like reality TV.

CAROLE ANN KLONARIDES: How long did you stay after that happened?

DAVID ROSS: After that happened they hired a new city manager from San Jose or somewhere up north, and we met with him. The first sentence out of his mouth was "Well, my wife likes art," and I thought, "Oh, this is it. This is so over." And Jim Elliott, who was the director of the University Art Museum, Berkeley, which is now the Berkeley Art Museum, offered me the job as chief curator and assistant director for collections and programs at Berkeley. Who was I to say no? So I said yes, and moved up to Berkeley. Jim Elliott was a great teacher and an amazing guy. He loved what I was doing, and he wanted to see the museum and its Pacific Film Archive transform, and get more involved in video. He understood that his museum needed to look at the changes in art that were taking place. And I was happy to do it, because in fact I was beginning to feel that video, in its ghettoization, was not being fully served. Video needed to be seriously engaged, but also seriously integrated into the collections of a museum. A Bruce Nauman video was meant to function like a work of sculpture on a pedestal, the way they were showing it at the Nicholas Wilder Gallery—not just in soundproof rooms off in basements, the way the Museum of Modern Art was showing them at that point.

KATHY RAE HUFFMAN: After Jan E. Adlmann and David left, the museum was faced with reorganization, because there was nobody at the time who knew what to do, and they actually put the museum under the auspices of the city librarian. There was a bit of retrenching going on in the city. Funding was lower, and this was seen as a way to perhaps bring the museum more into a community focus, because it had been seen at that time as more elitist. I think they wanted to have it be open more to the local community.

CAROLE ANN KLONARIDES: What about the artists' community?

KATHY RAE HUFFMAN: They came down from Los Angeles. This was a supportive organization for that community when it wasn't happening anyplace else. Plus, the museum was supporting events that took place outside of Long Beach. We worked with organizations like LAICA [Los Angeles Institute of Contemporary Art], Beyond Baroque, different cable stations in Los Angeles, and places like that. After David left, Nancy Drew came in as curator, and I became her video coordinator. That was my first official title here. By this point, we were a bit more aware of the proper way to do an exhibition and the timing of press releases and things like that. The program became a bit more formalized.

CAROLE ANN KLONARIDES: You also started doing more outreach.

KATHY RAE HUFFMAN: The first wave of exhibitions was all organized here at the museum. But by the time Nancy came in, we knew about a lot of other programs going on, so we started doing more programs that were guest curated. We expanded the network, and it was great to have other artists and curators come here, and for us to take work to New York and then later abroad. It needed to happen. In 1980, I took a show to Paris called *California Video*. That gave us an immediate introduction to a whole new world of artists working in the medium, and it was also an introduction of California video to Europe, because New York had always been seen as the video center. We met artists from all around the world, and all of a sudden they started coming here to Long Beach. We offered them some support and showed their work.

KIRA PEROV: There was always communication between the Long Beach Museum and the other media centers across the country and internationally. I remember many times, for example, we would show the Ithaca Video Festival program, which came already edited and "packaged." Or we showcased international exhibitions on tour from places like Finland and Japan that stimulated the public and the artistic community alike. I think the Long Beach Museum may have been the first institution on the West Coast to purchase European-standard PAL video equipment, and this was important both for bringing international programs here and for allowing our programs to be seen abroad.

CAROLE ANN KLONARIDES: Were you also commissioning new works?

KATHY RAE HUFFMAN: Commissioning was something that we didn't do too much. We had almost no budget. But around 1978 or '79, we got money from the Rockefeller Foundation to open up an annex next to the fire station in Belmont Shore. The city gave us that building to use, and we had big plans. Nancy Drew and I were really working hard scheduling exhibitions for the space, and then it turned out that we couldn't use it as a public facility because there was no emergency exit, so we had to go back to the drawing board. Ultimately, we turned it into a production studio, an editing studio, and a home for the archive. We were able to do programs there, but they had to be by invitation only. Later on, they built an apartment, and it was wonderful. Artists could stay there while they were working.

JOE LEONARDI: The Video Annex was primarily a post-production facility to help artists edit their video works. The residency program allowed artists to actually live in the Annex while they worked on projects, and, of course local artists used the facility as well. We were grant funded, so we had inexpensive rates, and for the time, we had some fairly sophisticated equipment for artists to use. I started there in 1981, and stayed through 1996. Originally, the museum had asked the city if they could use the fire station as a storage facility, but the museum wound up using only a small fraction of the building for storage, and the rest of the building became available for video production and post-production. We had climate control in the space, and we installed shelving to house the archive. We applied for countless grants over the years and got some funding that way, and then the annex went through a period where it became a viable, serious form of income. Video artists always had priority for booking the studio, but when the studio wasn't being used by artists, I opened it up to other people who wanted to rent editing time at

259

commercial rates. We actually had two editing studios there, Studio A and Studio B. Studio B was more of an off-line room, and Studio A was our online editing room. Originally, we had old flatbed three-quarter-inch decks that were modified, although the modifications didn't work very well and a lot of tapes got stripped back in the old days. Then, I was able to upgrade to broadcast three-quarter-inch A/B roll, and then we moved up to one-inch and Betacam. We also still had some of the old half-inch reel-to-reel machines, and that was another service we provided for artists. A lot of the original video artists worked with half-inch Portapaks, and they had all their works on that format. We used the half-inch reel-to-reel decks to transfer a lot of old works up to three-quarter-inch, and then, toward the end, we started the process of transferring the old three-quarter-inch stuff to Betacam. We also did a lot of camera work for artists, and did a lot of support to fulfill all the technical requirements for artists when they were doing exhibitions at the museum

KATHY RAE HUFFMAN: There was a lot of autonomy in that building for people to come in and go out, and a lot of moving back and forth, checking what was happening, and sitting around late at night when artists were editing.

CAROLE ANN KLONARIDES: So you were more like a producer.

KATHY RAE HUFFMAN: We were often in a producing role, yes. Especially when we started a cable series with a local station, and we started producing a weekly program called *Video Art* in 1977. The first program we did was from The Kitchen in New York. It started off with Vito Acconci's *The Red Tapes* (1976), and it was supposed to broadcast on a cable station in Long Beach, and then a station in Los Angeles, and then one in Santa Barbara. I drove from Long Beach, took the tape to L.A., and then took the tape up to Santa Barbara. But the Santa Barbara station refused to show the work. I was just incensed and said, "Why?" They said, "This is not art." I said, "Well, I'm sorry. But it really is." They refused to show the rest of the work, but we continued with the other two stations.

CAROLE ANN KLONARIDES: You were also working quite a bit with performance, like in the exhibition *At Home*, which celebrated works of all media by women.

KATHY RAE HUFFMAN: The *At Home* exhibition was curated by Arlene Raven in 1983, to celebrate the tenth anniversary of Womanhouse, which was a big collaborative installation started by the Feminist Art Program at CalArts. Judy Chicago, Miriam Schapiro, Faith Wilding, Helen and Newton Harrison, Eleanor Antin, and Suzanne Lacy all did projects. It was a great exhibition, and we did a big performance festival here on Halloween night, with video projections going on in all corners of the museum grounds. The Sisters of Survival were dressed as nuns up on the roof sprinkling powder over the audience—flour, actually—but it was supposed to be radioactive powder. There were women crawling up the front of the museum. Bill Viola was our bartender. We had the cable station here with a "scary video" competition, so people could come and try to scare the camera, and then we gave a prize. We did a lot of things like this, and we had a huge public coming to see it. Actually, they were lined up down the street to come to this particular event. Lyn Blumenthal and I did a video program, "Roles, Relations, and Sexuality," as part of the exhibition, and we did a performance series, which I worked on with various members of the Woman's Building. There were things that happened all over the city of Los Angeles, and it was a lot of fun.

CAROLE ANN KLONARIDES: How many shows did you do a year?

KATHY RAE HUFFMAN: We probably did one exhibition a month, plus we did screening programs, we had people coming in on residencies, and we facilitated things in other places. So I'd say it was a very heavy schedule.

CAROLE ANN KLONARIDES: Who helped you do all these programs?

KATHY RAE HUFFMAN: I had a number of assistants here when I was curator. Kira Perov helped for a number of years and she was fantastic. Vicki Whiting was here. Patti Podesta was my assistant for a couple of years. So we had very good people here who were all involved with video, and who could ensure the work was shown properly in the museum.

CAROLE ANN KLONARIDES: This was an interesting time to be involved with video because the NEA and the Rockefeller Foundation were both funding video at arts organizations nationally. This began a very rich and collaborative time that also matched the emerging technologies that were happening. Could you describe some of the other technologies you explored in exhibitions at the Long Beach Museum?

KATHY RAE HUFFMAN: In the late '70s and early '80s, there was a great deal of interest among artists to connect through television, telecommunications, and other technologies exploring remote communication. This very much predates the things that are happening today through the Internet. One of the projects that was very exciting for me was the *Picturephone Performance* series by Nam June Paik in 1979. Nancy Drew made the connection for us, and we met Nam June in L.A., where he was artist-in-residence at UCLA [University of California, Los Angeles]. He'd already spent maybe six months in Los Angeles at that time, working with professor Mitsuru Kataoka, who ran a very innovative telecommunications program at UCLA. He'd booked time at a Picturephone business meeting room at AT&T. These were early videoconferencing boardrooms, which cost about $400 an hour to rent. UCLA didn't have the money, so we said, "Sure, let's do it!, The museum will pay the time, we'll edit the tape, and make an exhibition out of it." We took all our equipment there to document the performance. It was quite exciting for me to convince Shigeko Kubota to be part of this, as well as Al Robbins, Joan Logue, Shirley and Wendy Clarke, William Wegman, and many others. We had animal exchanges as well. In Los Angeles we had Gary Lloyd with his "microwave receiver" dog, and in New York, we had Bill Wegman and his dog Man Ray, and they did performances together with their animals. This was fun. It was also one of those projects where you only had one shot at the whole thing. You didn't have a chance to rehearse or explore the equipment. It was one of many one-offs at this time. Another was *Hole in Space: A Public Communications Sculpture* (1980) by Kit Galloway and Sherrie Rabinowitz, which was extremely successful. They set up a live satellite feed between a window in The Broadway department store in Century City and a window at Lincoln Center in New York, so that passersby in each city could communicate with one another by these video projection windows for three days. We had a whole series of documentary photographs printed up and on display at the museum. Kit and Sherrie edited their documentation in our studio, and we had a very nice reception and exhibition of the work afterwards. It went on to become one of the most pivotal works in telecommunications art. It got huge attention internationally, and they went on to create a whole organization, The Electronic Cafe in Los Angeles, which influenced an Internet generation in later years.

CAROLE ANN KLONARIDES: You also did the show *The Artist and the Computer* in 1983.

KATHY RAE HUFFMAN: I was quite interested in computers very early. I had invited an artist from Germany, Klaus vom Bruch, to come as a resident, and he came only on the condition that we have a computer for him. I bought an Apple II Plus computer with a graphics pad and a lot of software. He came and gave workshops at our studio to artists from around L.A. about how to use basic computer programs. Everybody said, "Oh, it's way too complicated for us. We can never do this." Klaus made some works here, and we did start to use the computer at our video production studio, mostly for credits and certain video graphics. It got me interested in artists who were using computers. I started to find more and more, and I started to organize an exhibition called *The Artist and the Computer* in 1982. There was a new organization at the time called SIGGRAPH, and they were very, very helpful. There was an artist, Frank Dietrich, who later went on to develop hugely important programs with Silicon Graphics. Ed Emshwiller at CalArts was very helpful. He was already using computers in his video work. The show ultimately included photographic work, and artists who were using computers to create designs for work in other media. It was the only time one of our exhibitions got a headline in the daily newspaper, and

people, again, were lined up down the street to visit the museum. It was an amazing event. Nina Sobell did her *Brainwave Drawing* piece. We had performances and conferences. John Whitney, Sr., and Woody and Steina Vasulka came out. Gene Youngblood talked about the work. We had film screenings. We went all around the city of L.A. with our program, as well as Long Beach. It was a very exciting time, and we were rewarded with huge audience numbers, all interested to know more about computers and art. Some of the events needed to be repeated to accommodate a second audience.

CAROLE ANN KLONARIDES: Did the show travel?

KATHY RAE HUFFMAN: No, and I couldn't get any financial support for the show either, so I couldn't even do a catalogue. But around this time, we started up a new cable television series, called *Shared Realities: A Cultural Arts Cable Series*, and we made *The Artist and the Computer* the subject of one of those programs. *Shared Realities* was a big experiment. We were always interested in reaching an audience outside of the museum, so of course we were interested in television audiences and in cable television, which was really changing at this time. There were really good things about the series. The bad things about it, of course, were that none of us really knew how to make television. But looking at the series twenty-five years later, we were really trying to come to grips with how to make a new kind of presence for artists on television, and it opened up future possibilities for funded projects with cable TV. Joe Leonardi was the video studio manager, and he really drove the program. The weekly segments were very short, maybe fifteen or twenty minutes, but they repeated several times a day, because there wasn't a lot of independent or public access programming produced at the time. We did video interviews with artists, and sometimes we showed excerpts of their work. Whenever anybody came to town, we would grab them and interview them. For the broadcast of works we had to get release forms, and we had to be careful about the content of the works and the language before we could put them into the series.

CAROLE ANN KLONARIDES: Shortly after this, you left the Long Beach Museum to go to the Contemporary Art Television [CAT] Fund, which was specifically commissioning works for television.

KATHY RAE HUFFMAN: Yes. I moved to Boston, where I was the curator and producer for the CAT Fund. This was a project with WGBH-TV and the Institute of Contemporary Art in Boston, where David Ross was the director, to produce artists' works for broadcast and eventual sales to international television. We achieved coproductions, broadcasts abroad, and awards; we did relatively well, but we never got to the point where sales actually funded new production.

GLENN PHILLIPS: Kira, when did you start working at the museum?

KIRA PEROV: I worked there in 1983 and 1984. Prior to that, my husband, Bill Viola, and I had been living in Tokyo. After we moved to Long Beach in 1981, I continued to work with Bill and on my own photography, and also gradually became more involved with the video program at the Long Beach Museum when I saw how much work was being done there and with such little resources. In Melbourne [Australia], I had directed the entire cultural arts program for La Trobe University, and in New York, I assisted MoMA's video curator, Barbara London. I was happy to be using those skills again. First, I became a member of the Video Council, which was an advisory committee at the museum specifically for media. We worked in general to support video projects and programming, but one of our main missions was to help secure grants. Since the museum was administered by the City of Long Beach, it needed an outside group to apply for government and private funding. The museum was considered regional, and because of this, it had a fairly high success rate with media grants; it helped that the production facility was also generating a little revenue. I think that the main reason why this avant-garde program was allowed to exist for so long in quiet Long Beach was that it was more or less self-sufficient. In addition to my work on the Video Council, Kathy brought me on to assist her, project-by-project, with exhibitions and publications.

Figure 4.
Cover of exhibition catalogue, *Video: A Retrospective* (Long Beach Museum of Art, 1984). © Long Beach Museum of Art.

GLENN PHILLIPS: What were some of the projects you worked on?

KIRA PEROV: The largest one that I was involved in was the exhibition and publication of the same name, *Video: A Retrospective, 1974–1984*, which took a whole year to plan and document [1984] (fig. 4). When Kathy and I realized that it was coming up on ten years of video programming and production in Long Beach, we decided that it was time to summarize the achievements of this unique program, and to catalogue and assess the video collection itself. I was hired to work a few days a week—but in the end, I put in full-time hours, practically day and night, to get the programs organized and to produce a book on time for the exhibition. I had the great pleasure of going through every single file that had been created in the video program, looking at letters, making sense of the photographs, and seeing how all of the exhibitions had been constructed and who had curated them, and finally writing a chronological history. I also took many new stills from the works in the collection for the book, which also documents the holdings of the museum's video library/collection at that time.

GLENN PHILLIPS: In 1984, video was still quite young, but nonetheless old enough that you could really start to think about its history. What was it like to go back and see all of these phases that video in general and the Long Beach Museum specifically had gone through?

KIRA PEROV: It was really fascinating. The most unique aspect of the program at the Long Beach Museum was that it provided a production facility for artists, and this completely changed the nature of video on the West Coast. This stimulated a large number of artists to use this medium who normally would not have had access or who would not have thought of using video to create works. Some artists only used video once and then never used it again, but that experience of working with a time-based art certainly informed their other types of work, whether it was sculpture or painting. In the area of performance art, I noticed in particular, video became a critical tool. It allowed artists to create an extension of themselves that was not just a record documenting their performance. They used video to create actions that their own body would be incapable of doing, either through editing, or through simple acts like turning the camera

upside down, or by using slow motion. Not enough has been done to really study West Coast performance art in video.

By the time that we were actually creating this book in 1984, we really felt video had come a long way, and to celebrate this, we decided to develop a five-month-long program, a kind of summary of the most prominent and influential work that had been shown at the Long Beach Museum. Since Kathy had already moved to Boston, Connie Fitzsimons (assistant curator at the museum) and myself organized and curated two exhibitions each to show the diversity of the video program. Connie did a survey of videotapes by individual artists who were important in the field, then moved into work that dealt with media and communications, including cable TV projects. I made a selection featuring West Coast artists' videotapes and installations, opening with a special event that included performance. An exhibition followed, with works by international artists and cross-cultural works. It is great that the video program was able to continue for over a decade longer, each curator expanding its scope and focus.

GLENN PHILLIPS: You were also using your skills as a photographer to capture video stills. At this point, the only way to get a good video still was to photograph the video on a monitor, and that was very difficult to do (fig. 5). I feel like I can always tell when a still is yours before I even check the credit line, because there's a clarity that you managed to get with the camera that most people weren't able to do.

KIRA PEROV: Working with Bill [Viola] allowed me to develop a knowledge of video, and together with my photography experience and access to equipment I was able to catch the image that I wanted and to coax tapes to pause cleanly on that frame. I learned to adjust the contrast, brightness, and color of the monitor and to work with the film stock and filters for

Figure 5.
Terry Fox, still from *Children's Tapes*, 1974. Single-channel video, black-and-white, sound; 30 min. LBMA/GRI (2006.M.7). Photo by Kira Perov.

the best results. So I just got the knack of it. What interested me most in the process, however, was how to represent a moving video artwork as a still image, to find just the right frame that would work well graphically in print, while also conveying the essence of the piece. Occasionally, I would come across a tape where this frame did not exist—frustrating, but very interesting. I still do stills of the work with Bill, but now they are digital grabs, with their own set of technical issues. I have nostalgia for the scan lines of the television monitor, and sometimes I like to use those first photos of the older works in publications in order to create a sense of history.

GLENN PHILLIPS: Peter, you stopped working as technical director at the museum's post-production facility in 1978, but you came back in 1986 to direct the Open Channels program?

PETER KIRBY: Yes. Open Channels was a grant program that made broadcast- or cable-level facilities available to five artists per year through a jury process. I was hired to be the producer, starting with the second series. The work involved was an extension of the same kind of thing I had been doing. After working at Long Beach, John Baker and I, with Paul Challacombe, started a company called Video Transitions, with broadcast-quality equipment for commercial editing work. Paul had found a financial backer, we hired real engineers, and very quickly there were eighteen, twenty people working there. John and Paul dropped out after the design phase, but I continued working there as executive vice president until 1985. I started bringing in artists to do work at night or on weekends, and I would only charge them a little bit, or sometimes nothing, if I was doing the work myself. This was mostly with artists I already knew, but what we were offering at Video Transitions was the closest equivalent Los Angeles had to the Standby program in New York, which got artists access to commercial facilities. I started working with the Los Angeles Contemporary Exhibitions [LACE] Video Committee in 1984, and when I was leaving Video Transitions, I said to the committee, "We have to start something else. We have to branch out," so I helped put together five or six facilities in L.A. that would make their services available to artists at reduced rates, and that worked for several years. What we did with Open Channels was similar, but it was working with actual cable television stations.

GLENN PHILLIPS: So you would go out and try to find cable television stations to lend their studios for free?

PETER KIRBY: Yes. And, by and large, we did. We even found places in Northern California that gave us access. You just needed to find the right person at the station who was enthusiastic, and then the doors would open. Sometimes it couldn't happen again because management got wind of it or it inevitably took too long, but I think we produced a lot of really wonderful work, and it got broadcast. During this time, Connie Fitzsimons was the curator at Long Beach, and she was doing a series called *Viewpoints on Video*. This was a monthly cable TV show that was shown on something like a dozen cable channels all over California, and it was remarkable. It showed work ranging from Marcel Odenbach, Dara Birnbaum, Juan Downey, and Paul McCarthy to Doug Hall, Shirley Clarke, Paul Kos, Jim Shaw, and many others.

GLENN PHILLIPS: So basically each month there would be a sixty-minute program of video art pieces being broadcast throughout California? That could never happen today.

PETER KIRBY: Never.

GLENN PHILLIPS: Would the works produced for Open Channels be broadcast as part of *Viewpoints on Video*?

PETER KIRBY: Yes. Open Channels produced enough work each year to fill one or two *Viewpoints on Video* programs, depending on the length. And then Open Channels would also produce an exhibition and a catalogue. And it was good work. When you look back, it was almost all very high-quality work, done with very little money. I don't remember what the grant was, but it wasn't much.

GLENN PHILLIPS: And then in 1988 you became the video curator at the Long Beach Museum?

PETER KIRBY: Briefly. I was interim curator after Connie Fitzsimons left.

GLENN PHILLIPS: And then the next curator was Michael Nash.

CAROLE ANN KLONARIDES: Michael Nash was my predecessor, and a very savvy curator and prolific writer. He continued some of the series that were in place, but he also took the programming in new directions, and did several programs exploring connections between video art and popular culture, like the seminal *Art of Music Video: Ten Years After* in 1991. He made catalogues for every exhibition, and recognized the importance of archiving and preserving the video collection, and he did manage to get a little bit of money to preserve some tapes. I was living in New York during this time, and had been involved in curating video and producing my own videos. I was familiar with LBMA from the work I had done with the Artists' Television Network to cablecast artist video on Soho TV with Jaime Davidovich. I got a call from Michael in 1991 telling me that he was leaving the museum to work for Voyager Press, which was a laser-disc production company in Venice that was doing very innovative productions at the time. I was hired to replace him. I sold nearly everything I owned and moved to Los Angeles in October 1991.

GLENN PHILLIPS: What were some of the exhibitions you organized at the museum in the 1990s?

CAROLE ANN KLONARIDES: Being a curator of media art offered me wonderful opportunities for travel and exposure to different histories and cultures. In 1995, I received a Lila Wallace-Reader's Digest grant with artist Bruce Yonemoto to travel to five cities in Brazil, resulting in the exhibition *Dentro Brasil*, which introduced for the first time on the West Coast videos by Brazilian artists. That was the final show I presented at the museum, so it was fascinating to me that one of the first historical video programs you presented at the Getty, before the LBMA archive had been acquired, looked at Brazilian video from an even earlier period.[1]

The first show I did at the museum nearly got me fired. This was during the first Gulf War, and I did a show in 1992 about Arab identity, *The Call: Personal Insights on the Middle East and North Africa*, which was a collaboration with the Long Beach Opera and the Persian artist Y. Z. Kami. It included some very powerful Palestinian tapes that did not go over well with some members of the audience. No matter how difficult, I was interested in making video art accessible, and to ensure its status as an important art form within the museum context and beyond. I recognized that LBMA had the potential to create video art programs for home market distribution. In 1993, I organized Gary Hill's first retrospective exhibition, and, together with the artist and Joe Leonardi, created the catalogue in video format, which also included some of Hill's single-channel work in its entirety. We produced four thousand copies of the Gary Hill video on VHS and sold all of them, and the video was also broadcast on KCET, the local public television station. As a newcomer to California, I really liked working with the community. One of my favorite shows that I organized was called *Diaries*, in 1993. There had been a devastating fire at the public library in Los Angeles, and it was going through a process of renovation. They had all these books in storage that had survived the fire, and they were trying to find ways to make books available in other venues during this period of flux. And I thought, "Well, I'll do a show about diaries, because a lot of artists use video as a diaristic medium." The diary is a form that is cross-genre—so I contacted the library's librarians of different specializations, and with their suggestions, put together a small library room of diaries. We also created a writing room with blank diaries, so museum visitors could sit down and write their own diary entries. And then we had a video diary; there was a little hole in the wall with a camera, and you pressed a button and you could record your own video diary. In the viewing room were artist's video diaries by Michel Auder, Lynn Hershman, Sadie Benning, and George Kuchar. Every night I would view the tape with the recorded video diaries, and then I would read the written diaries, and I kept storing them. And it was really fascinating, because both the written diaries and the video diaries—which were in a public place, mind you—were incredibly intimate. People were revealing their

most intimate secrets—and this was before reality television! I also worked with the LBMA collection a lot and brought in historical programs like *The First Generation: Women and Video, 1970–75*, by guest curator JoAnn Hanley [1994].

GLENN PHILLIPS: What was it like coming from New York to Long Beach, not too long after the art market had crashed in New York? Contemporary art in Los Angeles was about to go through a renaissance in the 1990s, which brought a lot of international attention.

CAROLE ANN KLONARIDES: I don't think people in L.A. really recognized that at the time. The art market crash really affected Los Angeles too. A lot of New York galleries had moved out here, and they had all closed. In 1991, there was a recession; you saw "For Sale" signs everywhere, and people were leaving. And it was also kind of a biblical time. There were floods, fires, earthquakes, and there were the riots. We did a show at the museum in 1992 called *Relocations and Revisions: The Japanese American Internment Reconsidered*, and the L.A. riots happened during the installation. The artworks were mostly created by *sansei* artists—third-generation Japanese Americans—who were exorcising the experience of their parents, and in some cases, their grandparents who were interned during World War II—experiences that the artists themselves did not experience because they were not born or too young to remember. They expressed frustrations and observations about the internment never expressed before through their art, and in the midst of installing their work, Los Angeles had this riot—which really became a race riot between Asians and African Americans. We had quite a few artists from out of town, and we were all sequestered in the museum, with a curfew. The riots were really bad in Long Beach—they ran a week longer there than in L.A. There was an incredible amount of tension, and you could see the fires encroaching on the museum. The experience only heightened the emotions—it was cathartic. Together, we created a video catalogue with performances, remembrances, and testimonials by the artists. That was the first time, as far as I know, that the museum had produced a video for sale. AT&T sponsored the exhibition and gave the museum enough funding to purchase its first video installation, Bruce and Norman Yonemoto's *Framed* (1989). It was during the process of making the exhibition and the tape that I became aware that art in California had its own unique history and was different from the art world I had experienced in New York, which, for the most part had become very insular and self-serving. Perhaps because the art community is geographically so spread out here, one has to have an interest in being involved in a bigger picture. It's a community of a lot of different minds, individuals, and cultures, which is evident in many of the single-channel programs shown at the museum.

The art schools had a lot to do with this renaissance. By this point, CalArts had been acknowledged as an important MFA program for twenty years, so this idea of great artists coming from California was well rooted. And programs at schools like Art Center [College of Design, Pasadena], Otis [College of Art and Design, Los Angeles], UCLA, University of California, Santa Barbara, and University of California, San Diego, had developed their own reputations. Initially career opportunities didn't really exist here, so artists would leave for New York after getting their degrees. But by the mid-1990s, artists were starting to stay; that made a big difference. Artists were staying, having international careers; they were beginning to prosper.

GLENN PHILLIPS: When you got to the Long Beach Museum, what was the state of the collection?

CAROLE ANN KLONARIDES: I was surprised, actually, at what good condition a lot of the tapes were in; the collection reflected the entire history of video art. It was almost orgasmic to walk into that archive. I just couldn't believe what was housed there. I was living in the Annex for the first two months that I was in Long Beach, and spent my time in the evenings just looking at tapes. I was amazed at what I was finding, but it was frustrating that the only way you could locate a tape was to memorize the shelves and figure out where things had been put. There was no other type of archiving. The museum had not established rights and very few permissions had been officially obtained for the works that it had. Meanwhile, artists would come and say, "I want my video to be in the archive," and they would just hand over their tape. The entire

video archive of the Woman's Building was sitting there in boxes! There was no form, no set procedure. While the NEA was still active, we managed to get two grants to begin to archive the collection. An archivist was hired, and we did some research, because there was no standard for preservation and one had to be established. Around this time, the Bay Area Video Coalition [BAVC] in San Francisco applied to the Getty for a grant to help it take a leading role in developing preservation standards through seminars, panels, workshops, and its own preservation program. The Getty called on me to be a consultant, since they did not know very much about this area at the time. They did not want to get involved in preservation, but they thought this project was worthy, and BAVC was awarded the money. I very much thought—mistakenly—that the Long Beach Museum could have a paternal role in all of this. I wanted the preservation of this pivotal collection to be something that could have helped other organizations.

But the museum was beginning to become more traditional by this point, and it was really difficult to explain to the administration and the board that preserving this archive was something that they *had* to do. It had been this small renegade museum for so many years, and this video collection it had created was completely unacknowledged but unique. LBMA had been run by the city for years, but then it went private, and over time there was a board of trustees and a director who had a different agenda. I found myself in the position of trying to convince them of the importance of what they had. Meanwhile, the NEA closed down their media grant department. Museums were firing media curators right and left. By 1995, it seemed like there were maybe seven media curators left in the country, and that only underscored a growing feeling at the museum that "We don't need this. We don't need to invest in this. We don't need to support this." To this day, the fact that LBMA closed the video program on my watch is very painful. They kept the Annex open for a few more years because it was still generating some income, but it was still a very sad ending—isn't it ironic how certain museums decided to abandon video art right at the moment it was receiving serious attention by galleries and gaining commercial value? I was twenty-one when I got involved with video. I embraced a medium that I began to fear would become extinct within my lifetime, so I got very passionate about its preservation and history and turned to teaching. I spent the last ten years thinking the LBMA video collection had just been stored away forever without any foresight of its historical importance. California artists played a very important part in this history and I'm happy the Getty Research Institute is now preserving the collection and its ephemera, making it accessible to scholars and the public. Video art now is much more a part of the lexicon of art, and there is a new generation of artists who grew up using it. The tradition has been passed to a new generation, and it seems to be in good hands.

NOTE

1. *Pioneers of Brazilian Video Art, 1973–83*, presented at the Getty Center on October 6, 2004.

EVERYTHING'S IMPORTANT:
A Consideration of Feminist Video in the Woman's Building Collection

Meg Cranston

WHEN I ASKED ARTIST JERRI ALLYN what she thought might be in the Woman's Building video collection, she paused, momentarily puzzled. Allyn has a long history of engagement with the Woman's Building in Los Angeles; she was active in the Feminist Studio Workshop as a student, then later became a member of the Los Angeles Women's Video Center. Allyn soon hit upon an excellent answer. What constitutes the Woman's Building video collection? "It's everything!" she said, and then her hubris made her laugh. She explained:

> It sounds strange now, but then ... everything was important. That was part of the feminist ethos. Everything was political and everything was important. So that's what got put into the collection—everything. It is the student work from the Feminist Studio Workshop, art video by all sorts of people who worked or had shows at the Woman's Building. It's the public service announcements we did, plus all the documentation of the events—the performances, the readings. There is probably a lot of unedited footage, because we documented everything—even things like moving in and painting the walls, because that was important, too.[1]

Viewing the Woman's Building video catalogue confirms Allyn's estimate. Women were using video as part of an ongoing sociological, aesthetic, and technological experiment. Like many other artists, women were exploring how art and history could be made with the newly available technology of the portable video camera and via the new outlet of public access television. However, unlike other artists and countercultural video producers who used video technology in the service of art *or* activism, the Woman's Building video makers always worked toward both. They considered video to be an artistic, journalistic, therapeutic, documentary, and, above all, consciousness-raising tool, a means of collectively defining and advancing the far-reaching goals of feminism. The ambition was global, and the results were just as wide-ranging.

The Los Angeles Woman's Building took its name from a construction bearing the same title at the World's Columbian Exposition in Chicago, held in 1893. While the first Woman's Building focused on women's abilities to produce by the means important in the late nineteenth century, the Los Angeles Woman's Building of the 1970s and '80s focused on women's use of forms central to late-twentieth-century life. In its updated version, the Woman's Building emphasized the feminist reconsideration of art and media production. This direction came, in part, from the building's founders—art historian Arlene Raven, graphic designer Sheila Levrant de Brettevllle, and artist Judy Chicago all came from creative fields. More important, however, was the understanding that the production of imagery and the representation of women in art, and in the popular media in particular, were central to the formation of women's identity. By the 1970s, popular media (print, film, and television) had replaced faith and family as the hegemonic force that used phallocentric ideology to form and deform women's self-image. Many of the tapes in the collection can be seen as an attempt to alter that image by gaining control of its means of production.

The Woman's Building encompassed a number of programs, two of which are especially important to the video archives: the Feminist Studio Workshop (FSW) and the Los Angeles Women's Video Center (LAWVC). Most of the videotapes in the archive were produced by the students and faculty at FSW and by the artists who ran LAWVC—a professional video production company based at the Woman's Building that offered video production education to Woman's Building members and the community. Most of the women who worked at LAWVC

Figures 1, 2.
Cover and interior pages of *What Is Social Art?* Brochure produced by Jerri Allyn at the Los Angeles Women's Video Center (LAWVC), 1979. Collage by Kathleen Berg. Video Community Resources, Women's Community, Inc. Courtesy of Jerri Allyn.

had gone to school at FSW. Although the two programs were interrelated, they had different aims and functions.

FSW began when de Bretteville, Raven, and Chicago, discouraged about the potential for feminist education at existing schools, left their teaching positions at CalArts and started the workshop. FSW subsequently founded, and moved into, the Woman's Building. Performance artist and CalArts alumnus Suzanne Lacy ran the workshop's performance component. Between thirty-five and fifty students attended the workshop, including the artists Susan Mogul, Nancy Angelo, Candace Compton, Jerri Allyn, Annette Hunt, Cheri Gaulke, and Sue Maberry. The tapes FSW produced were primarily video artworks and documents that show the workshop functioning as an alternative art school (figs. 1, 2).

LAWVC was both a place for women to make video art and an employer. The center was funded by the Comprehensive Employment and Training Act (CETA), a federal works project that provided unemployed or underemployed workers with a usable skill. The women at LAWVC received training and were paid a weekly salary for their work. The tapes produced by LAWVC were considered works of "social art" by its members, defined as "art that addresses, articulates and makes public issues and perspectives that affect groups of people or the culture as a whole."[2] To that end, the center's collection includes work by individual artists, public service announcements produced by the group, and documentaries of collaborative events with other artists.

Included with the documentary work is *Record Companies Drag Their Feet* (1977), a performance staged for the media by Leslie Labowitz, in collaboration with Women Against Violence Against Women, at Tower Records on Sunset Boulevard. *Record Companies Drag Their Feet* was designed to draw media attention to the relationship between images of violence (in this case on a KISS album cover) and the brutal treatment of actual women. The center made and used the tape as a way to educate the public about violence against women. The video collection also includes documentation of early performances and exhibitions at the Woman's Building by now-prominent artists such as Judith Barry, Rachel Rosenthal, and Cheri Gaulke.

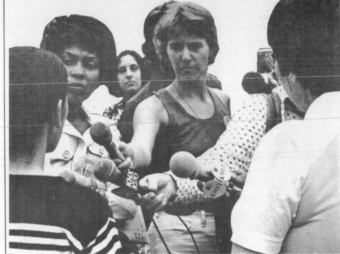

What Is Social Art?

Social art is a movement by artists to use their skills and creativity to address, articulate and make public various social and community issues and perspectives. While art in every form makes tangible some experience of the artist, social art focuses on those experiences which affect groups of people or the culture as a whole. Educational in nature, it offers the audience information which will enable people to take action. In this respect, social art often includes and is done in collaboration with public interest groups that concern themselves with specific social issues. It is directed at the community and may involve individuals from the community, not just artists, in the art work or performance itself, closing the gap between artists and community, artists and real life people and issues. Social art takes many forms including visual art, performance and media art.

The performances documented in **Record Companies Drag Their Feet** and **In Mourning and Rage**, and the video tapes themselves, present social art done by groups and individuals which address the issue of violence against women. These performances, made public through television newscasts, inform the public about the issue of violence against women and encourage people to examine their own attitudes and information, and to take action.

Lectures and readings by feminist writers and theorists were also recorded and include poets Deena Metzger, Diane DiPalma, Adrienne Rich, and Audre Lorde, critic Lucy Lippard, writer/activist and sculptor Kate Millett, and feminist theologian Mary Daly.

The student videos in the collection show a range of socially motivated investigations. *My Friends Imitating Their Favorite Animals* (1979) is a joyful work, in which student artists at the FSW perform "animal" acts for the camera. Nancy Angelo plays a dog that barks and pants and is alternately funny and quite convincingly mean. The video is an early demonstration of Angelo's interest in the seemingly inescapable duplicity of being a socially minded feminist and an ambitiously self-interested artist.

Angelo had worked with Candace Compton to make the video *Nun and Deviant* (1976), in which Angelo plays the disgruntled deviant to Compton's virtuous but despairing nun. The nun explains, "My work is about transformation, about moving away from self-obsession." The deviant, in contrast, is mired in the muck of egocentric art making. She worries that collaborating with another artist (Compton) will require compromise and admits to being impatient with the process. The nun also confesses dissatisfaction. She is fed up with waiting around for God's grace and complains of "the trips" God is laying on her. The deviant admits to misgivings about her collaborator's talent and confesses to shoplifting bikini underwear. The dichotomy between the vice and virtue of the two characters grows increasingly murky. We are left thinking both positions are untenable—there must be another way.

Arlene Raven's notion of that other way and how it might be achieved is outlined in a recorded interview from 1979 by established video makers Kate Horsfield and Lyn Blumenthal.[3] In the video, Raven traces her own intellectual development, from her early activism as a member of Students for a Democratic Society, to her training as an artist and art historian, and her eventual cofounding of FSW at the Woman's Building. Recorded six years after the workshop was founded, Raven describes herself as restless, impatient with what she defines as the limits of FSW. To achieve long-range goals, Raven explains, FSW will need a comprehensive "Sapphic" education—one that includes a positive understanding of separatism as courageous self-

sufficiency. Raven also calls for a greatly expanded conception of lesbianism that includes overcoming proscribed behaviors to become a truly independent female creator. The tape is remarkable for its historical value—as a key document in American feminism and as a persuasive conversation evincing remarkable clarity, energy, and verve. In later years, artistic feminism would become associated with a narrow field of activity and with unflattering caricatures of the practitioner, making it difficult at times to imagine the original appeal. Raven's interview instantly dispels the constraints and stereotypes, revealing them to be complete distortions of history.

As in *Nun and Deviant* and other tapes in the collection, including Raven's *Drink and Typewriter* (n.d.), many of the women portrayed in the Woman's Building tapes struggle to make choices from a limited menu of unsuitable options. Many works reflect on limits, revealing them to be false barriers—fictions constructed to maintain the status quo. The artists reveal a collective belief—that obstacles constructed through discourse can be revealed and overcome through the same means. Through conversation, women create another discourse, another reality. Talking becomes a hermeneutical tool, a procedure capable of unveiling hidden truths.

The stereotype of the talkative female is counterbalanced in Sheila Ruth's *Constructive Feminism* (1975), a documentary about the transformation of the Woman's Building on Spring Street in downtown Los Angeles to suit the goals of the organization. Women are shown literally building the walls, and it is important work. As de Bretteville explains in the video, "Part of feminist education is not only to create one's own artwork but to create the wall where the art will later hang." Involving women in the construction of the space was central to the Woman's Building's mission. Physical labor created a sense of ownership and helped, as de Bretteville states, "heal the separation between different kinds of work." The concept of openness, as de Bretteville explains, is used throughout the building and is epitomized by the entrance—a bright, open space where there was always a woman at the door. The design met an urgent social and political need—it helped women meet and engage in creative work. Visitors immediately found what they came for.

Performance artist Suzanne Lacy was a central figure at the Woman's Building. Her work in the collection includes performances for the camera as well as video documentation of performances staged as media events produced by LAWVC. Notable among these is the well-known *In Mourning and In Rage* (1977), created with artist Leslie Labowitz to draw media attention to the plight of female victims of domestic violence and rape. The lesser-known *Learn Where the Meat Comes From* (1976) engages the dominant media by parodying a television cooking show. That tape dramatizes the relationship between butchering and consuming animal flesh and other forms of violence.

Like Lacy, Nancy Buchanan mimics existing forms of media as a strategy for critique in *Primary and Secondary Specters* (1979). Buchanan uses a stock television format as a frame for radical content. The video is comprised of six monochromatic scenes and colored primary or secondary hues, and is narrated by a generic TV voice. The work reframes television to make viewers aware of its construction, coloring it in such a way that its organization becomes transparent. Buchanan weds modernist strategy to postmodern critique; in the process, she reveals television to be like the color wheel—a never-ending circular reality divided into predictable units.

A similar strategy is used in one of the thirty-second public service announcements produced by LAWVC, in which Jerri Allyn and her cousin Ricky Kamen appear, looking like two fresh-faced lovable American youths. They are so cheerful and benign they could be on a network TV show. The only difference is that they are talking about lesbianism—a preference that Allyn's male cousin describes as "all right with me." The piece decodes and reuses one of television's most pernicious qualities—unbridled enthusiasm. The actors are so wide-eyed and unabashedly cheerful that only a real meanie would condemn them.

Antoinette de Jong also uses acting for the camera as a metaphor for the roles we play in real life in *Jealousy* (1976). The video begins with an acting exercise. A seated woman swings her foot back and forth as she practices various ways to say "I am not jealous." She explains that because she is not jealous she doesn't cry. She doesn't scream. She doesn't freak out or aimlessly wash dishes. She doesn't get sick at the thought of her boyfriend having sex with another

woman, or stay home crying and blowing her nose. Indeed, de Jong does none of these things. She is not crying or blowing her nose. She is not in hysterics or watching too much television. What she is doing is making a videotape. She is making a recording of herself talking and swinging her foot. For eight minutes she describes, but does not act out, the clichés of feminine jealousy. Instead she swings her foot. Not, as she explains, because she has to, but because she wants to. The sensibility of de Jong's work is similar to that of many videos in the Woman's Building collection. The video is straightforward, unadorned, and deliberately self-conscious. Like the majority of work in the collection, it was made to tell a story that had previously been relegated to silence. The innocuous neutrality of black-and-white video serves the artists best when it contrasts with stories that are just the opposite.

Chris Wong's creepily titled work *Tuna Salad* (1978) is one of the strangest and most darkly poetic works in the collection. The video begins with an image of a speculum and a leg. There are peculiar sounds. A woman puts on a bra and then stuffs it with socks. Static takes over, and then the video breaks up completely. It tunes in and tunes out—an effect reminiscent of bad, outdated TV. We hear the sound of a vacuum, and a hand moves in and out of view. The tape goes black. Lights up, and then the slowly panning image of a medicine chest. We see a diaphragm, alcohol, and a container of Ajax. The camera pauses on the Ajax. Is that the killer? The piece is chilling, as much for its deliberate use of ambiguity as for the stark insertion of poison and violence into a clinical setting. The story seems to be about abortion—about an ordinary abortion. Wong's tape reminds us of the unspoken and often tragic circumstances by which many women came to the Woman's Building and to feminism itself. We are reminded that many of the women were working or living in high-risk situations; some were literally compelled to fight their way out. The stakes were life or death.

The idea that women sought out the Woman's Building to escape hostile circumstances is the subtext of *The Woman's Building: FSW Video Letter* (1974). Susan Mogul, then a student at FSW, leads a tour of the space as other artists celebrate International Women's Day. As Mogul guides us through the building, she brings us to Judy Chicago, who is surrounded by other women congratulating her on her new book. Soon after, she finds Sheila Levrant de Bretteville, who describes an exhibition she curated that is currently on view—the work of the largely forgotten Irish modernist architect Eileen Grey. We are introduced to Pam McDonald, a young woman who came to Los Angeles from Nebraska after seeing an ad in *Ms.* magazine. McDonald, it seems, is representative of the courage feminism requires. Like her, women must be willing to leave home. For students, this may mean leaving the familial home, while faculty had to reject their institutional homes in order to form FSW. Everywhere, numbers are important. In the opening scene, women with suitcases head for the door of the Woman's Building, and throughout the video we see women working, traveling, teaching, and building.

In the halls and archives of the Woman's Building, women—as artists and subjects, as students and instructors, as employees and volunteers—are taking action in the belief that all work is important, and that creative construction can produce social change. This conviction is the basis of the feminism that constructed the Woman's Building, and the video collection is a testament to that view.

NOTES

1. Conversation between Meg Cranston and Jerri Allyn, May 3, 2007.
2. "What Is Social Art?" a brochure published by the Video Community Resource Project at the Woman's Building, Los Angeles, California, 1979.
3. Kate Horsfield and Lyn Blumenthal, video makers and founders of the seminal video lending collection Video Data Bank, taught a video workshop at FSW.

CONCEPT, ART, AND MEDIA:
Regarding California Video

Robert R. Riley

IN THE 1960S AND '70S, an emerging group of video artists used the cultural currency of television to test established boundaries around creative expression. Video artists expanded the reach of the visual arts by moving beyond representations of the human figure as a still portrait. Instead, they considered the expressive potential of the body as a site of information. Bodies were treated as more than forms; the figure became a sentient, subjective actor, hybridizing multiple artistic disciplines within video culture. Sculptors moved away from empathetic, three-dimensional representations of the figure and began using space, time, light, and sound fluidly, in four dimensions. As cinematic techniques were adapted to video, filmmakers recognized that the immediate replay of recorded images, in-camera edits, and frame sequencing all affected narrative and figural conventions. In California, artists from diverse fields used electronic media to explore the experiential possibilities offered by the human figure. Through video, artists expanded the praxis of contemporary art, making especially significant contributions to conceptual art and performance.

Howard Fried played an early and critical role in the development of both video and Bay Area conceptual art. In the late 1970s, Fried developed a curriculum and studio practice for the video department at the San Francisco Art Institute, which, under his direction, established a visiting artists program and teaching residency. Vito Acconci, Linda Montano, Chris Burden, and the Kipper Kids were among the artists invited as inaugural faculty. Their concentration on process and interaction subsequently influenced the nascent fields of video and performance art.

Fried considered video both an intimate recording space and a medium that would yield to artistic control. *Fuck You Purdue* (1971) demonstrates this dialectic between video's spatial and material capabilities. The piece takes its subject from the artist's relationship with his brother and draws the title from a brutal invective. Fried's brother had joined the Marines and was sent to basic training in anticipation of deployment to Vietnam. As a soldier, he was ordered by an officer of high rank to deliver the titular insult to Purdue—a drill instructor at Parris Island. Purdue responded by ordering the soldier to return the message to its source. As a result, Fried's brother was serially punished for insubordination. In *Fuck You Purdue*, Fried explores the limits of fraternal agency. Acting as surrogate for a brother who is elsewhere, trapped in a cycle of mistreatment, he uses the video camera to confront humiliation and despair. Through performance, Fried invokes the misdeeds of malevolent officers. His sympathetic reimagining of the abuses inflicted on enlisted men creates a kind of theater for videotape.

In *Making a Paid Political Announcement* (1982), Fried rigorously pursues the same standards for video art production demonstrated in his earlier work. The video visually articulates Fried's belief that television constructs culture, which in turn constructs audiences—turning them into endless reflections of each other. Fried's physical presence is removed from the screen and replaced with data he collected through interviews with a number of "citizen subjects." Voice-over narration recounts the opinions, wishes, and dreams of these subjects. Images shift in vignettes from scenes of the workplace to public locations as a ground for Fried's narration, promising grand solutions to problems, affirming the subjects' concerns, and sympathizing with their troubled states of mind. As Fried emphasizes, television provides its audiences with direct connections to the world via technology and ubiquity. In his announcements, he promises rescue and remedy to its discontents. By reflecting social discontent, labor issues, antiwar activism, and various inequities, *Making a Paid Political Announcement* demonstrates an alternative role for artists' video. Fried casts the artist as an independent voice in the media; at the same time, the video excludes representation of the figure, allowing the mechanisms of the medium to speak for themselves.

Art historian Anne-Marie Duguet argues that strong, deliberative gestures and speech in 1970s performance video drew from postwar avant-garde theatrical forms, 1960s demonstrations, and street theater.[1] In *The Arts for Television*, a landmark exhibition produced in 1987, Duguet connects artists' videos to the theatrical innovations of German playwright Bertolt Brecht and the French playwright and poet Antonin Artaud. Postwar and avant-garde theater used struggle and abjection to confound viewer perception—often employing discordant dialogue and extant corporality on stage. Duguet observes parallels between such theatrical strategies and the psychological depth and permutations of spoken language in conceptual video. Fried's video work resists association with "cool media," a passive condition of information media as distraction proposed by theorist Marshall McLuhan in the 1960s. Duguet's observations provide critical insight, as Fried instead uses syntactical complexity and dissonant speech to incite active states of reception in the viewer. He shouts from a wooden set constructed in the studio and changes scenes through in-camera edits and clothing variations. Ultimately, Fried succeeds in materializing a concept and in creating a work of enduring value in the field of video performance.

Martin von Haselberg and Brian Routh met in 1970 in London, where they created a performance team named the Kipper Kids. Evocative of medieval carnival and the burlesque of comics Laurel and Hardy,[2] the Kipper Kids functioned powerfully in performance art as a symbol of the struggle between independence and conformity. The duo defined the location of performance through activity rather than geography; a site came into existence whenever and wherever performative tension was established and released—or deflated. The two rowdy characters used choreographed movements in mirror image to enact messy, masculine conflicts. *Up Yer Bum with a Bengal Lancer* (1976), one of the few performances staged by the Kipper Kids for video, is economical in its production and a marvel of ingenuity and precision. Through effective use of props and the locomotion of figures within the frame, the two media—video and performance—map closely together. A portion of the performance features the expressive face of Harry Kipper (Martin von Haselberg) framed by a magnifying lens that expands his head in the foreground, while making the rest of his body appear diminished. Long before the erotic potential of hefty, beefy men was commodified through sports and visual culture, the Kipper Kids' theater used unwarranted hostility and affectionate compatibility to determinedly subvert gender norms. Their physicality, deliberately executed performances, and considered attention to representations of male stereotypes all influenced a generation of artists.

Among the Kipper Kids' students, Karen Finley is significant for using similar themes—gender, the body, and society—to point out, and confound, viewer expectations. Finley con-

Figure 1.
Karen Finley, *Nude in the Museum*, 1992. Single-channel video, color, sound; 1 min. 6 sec. Photo courtesy of Alexander Gray Associates, New York.

Figure 2.
Doug Hall, production still from *Through the Room*, from *Songs of the 80s*, 1983 (single-channel video, color, sound; 5 min., 52 sec.). Photo courtesy of the artist.

structed the cornerstones of her distinguished approach to performance and theater during her studies at the San Francisco Art Institute. Later, she developed a frightening and singularly forceful presence in art as the figure of an unsocialized woman.[3] *Nude in the Museum* (1992) (fig. 1) features a series of videotaped images depicting modern sculpture in various galleries at the Los Angeles County Museum of Art. Scenes of the galleries become stages for Finley's performative transgression as she leaps into the frames of the video images, positioning herself next to idealized or expressive forms of the female nude. In a context constructed from modern art, Finley juxtaposes the real against the represented, posing compelling questions about objectivity in art and authority in museums.

Bill Viola's video environment is a cognitive space in which the mechanisms of video symbolize human presence and perception. In the artist's production notes for the videotape *Ancient of Days* (1979–81), a work that addresses the passage of time, he writes that there is "No beginning/No end/No direction/No duration." He sees video operating like the mind in its form and function.[4] And he conceives of video, like the mind, as imposing structure on perception. Viola's *Ancient of Days* and Doug Hall's videotape *Through the Room* (1983) (fig. 2) share a common episodic structure. Both works engage video philosophically, stressing the medium's technological potential to inscribe the artist's thought process directly onto the image. Both projects skillfully deploy scenes of landscapes and interiors, figuration and apparition, to contrast the scale of geologic time against the fleeting life span of humankind. Both pieces construct an impressionistic viewing experience through video edits and image manipulation

techniques. For Viola and Hall, the body and biography of the artist disappear from view, implying that technical mastery of the medium—not physical representation—indicates artistic presence.

Technical innovations in the medium supported the evolution of electronic effects into a language for new media productions throughout the 1980s. Hall and Viola were among a group of artists who eloquently engaged the tools and post-production process to express a multiplicity of temporal and spatial perceptions that they believed formed a true representation of the self in synthetic form. In her perceptive essay "Paradox in the Evolution of an Art Form: Great Expectations and the Making of a History" (1989), art critic and historian Marita Sturken investigates complexities in the historical origins of video as an artists' medium. Sturken defines three separate fields of artistic exploration—camera-interpreted actions and performances, electronic and experimental image projects, and socially concerned documentary—all of which, while dissimilar in origin and intent, came to be recognized under a single designation as video art.[5] As the independent media movement gained momentum, Sturken argues, creative communities were compulsively aware that a history of the medium was under construction. While divergent in subject matter, artists had tools and television technology in common and used video to explore the conflict that followed from challenging media conventions.

In the 1980s and '90s, Bay Area artists Jeanne C. Finley and Marlon Riggs embedded cultural difference in their artistic production and explored the potent expressive potential of image and text. Finley's *Involuntary Conversion* (1991) incorporates a form of rhetoric known as "media-speak"—a technique employed by television newscasts in which disturbing information is conveyed through language that expressly, and misleadingly, neutralizes negative content. The phrase *involuntary conversion* uses media-speak to transform the violence and injustice of accidental death into euphemism. As a warplane moves in slow motion across the video image, Finley's spoken text, drawn from an automatic voice program, likewise floats on her soundtrack and hovers in obfuscation. The narration exemplifies the dissociative power of media-speak, but Finley's video superimposes common-speech translations as subtitles, making the gap between lived experience and neutralized language explicit. "Service the target" (kill) and other wartime phrases such as "permanent prehostility" (peace) are among the many terms that Finley questions and corrects. In *Involuntary Conversion,* she reinterprets mass media by imposing her own language and images; her video demonstrates how language constructs historical significance and shows viewers precisely what is at stake.

In an era of restricted independent media and reduced public funding for provocative art, Marlon Riggs nevertheless produced many videotapes before his death in 1997 at age thirty-

Figure 3.
Marlon Riggs, still from *Affirmations*, 1990. Single-channel video, color, sound; 10 min. Photo courtesy of Signifyin' Works.

seven. In *Anthem* (1991) and *Affirmations* (1990) (fig. 3), Riggs's ties to the black and gay communities are evident in his representations of sexual and artistic identities. Riggs, a media artist and journalist, achieved persuasive effects by combining image, spoken word, and text in his videotapes and by using techniques such as television's direct address and the linguistic present indicative. Riggs's commitment to democratizing the medium through the presentation of diverse points of view is evident in each of his projects for video, most notably *Tongues Untied* (1989). In Howard Fried's *Making a Paid Political Announcement* and Jeanne C. Finley's *Involuntary Conversion*, semantic devices vivify the presence of the artist by excluding their figures from the image. Similarly, Riggs's imbeds the artist's creative identity and temperament within his video content by concentrating on personal sources of information as material.

NOTES

1. Anne-Marie Duguet, "Video and Theatre," *The Arts for Television,* exh. cat. (Los Angeles: Museum of Contemporary Art, 1987), pp. 30–40. A series of related TV programs accompanied the exhibition and explained areas of artistic ambition and video innovation for television viewers and museum audiences. The programs included titles such as *Dance for Television, Theatre for Television, Literature, Music,* and *Image,* among others. *The Arts for Television* concentrated on technical virtuosity in *Theatre for Video,* outlining ways in which artists' use of the video medium corresponds with experimental theater.

2. Cynthia Carr, "The Kipper Kids in Middle Age," in *On Edge: Performance at the End of the Twentieth Century* (Hanover, New Hampshire: Wesleyan University Press, 1993), pp. 148–53.

3. Cynthia Carr, "Unspeakable Practice, Unnatural Acts: The Taboo Art of Karen Finley," in Carr (see note 2, above), pp. 122–31.

4. Bill Viola, "Ancient of Days," in *Reasons for Knocking at an Empty House: Writings 1973–1994* (London: Anthony d'Offay Gallery, 1995), pp. 73–79.

5. Marita Sturken, "Paradox in the Evolution of an Art Form: Great Expectations and the Making of a History," in *Illuminating Video: An Essential Guide to Video Art,* ed. Doug Hall and Sally Jo Fifer (New York: Aperture, 1989), pp. 101–21.

ART, TV, AND THE LONG BEACH MUSEUM OF ART:
A Short History

Kathy Rae Huffman

THROUGHOUT THE 1970S AND '80S, the hope of achieving a television presence underpinned many video artists' ambitions. In 1974, the Long Beach Museum of Art (LBMA), as a matter of institutional policy, determined to support this goal. In addition to producing and presenting video art in a supportive gallery environment, LBMA also resolved to help broadcast the work of video artists—many of whom believed that better television could change the world. This belief was not far-fetched, as television was then—and remains now—an undeniably powerful mass-media presence. Amazing live broadcasts brought significant historical moments into ordinary viewers' lives and homes, likely sowing the seeds of nascent artistic interrogation of the medium. The Apollo 11 moon landing in 1963 assembled the world in front of TV sets to collectively witness a single significant event. Footage of the Vietnam War, recorded by independent cameramen in the early 1970s and broadcast on the networks, turned public opinion against American military efforts. In witnessing these wartime horrors on television, American audiences were initiated into reality TV. By the middle of the decade, television was criticized as a "potentially" dangerous influence on children, with frequent reports citing statistics and giving cautions. The dominant broadcast medium had lost its 1950s innocence. Even so, television continued to inform social norms and set trends through powerful advertising campaigns.

In the mid-1970s, museum-goers in Long Beach were intimately familiar with television, and they knew what they liked. For many, however, video art created a difficult viewing experience, as it didn't follow television's formula or style. I first visited LBMA as a graduate student in September 1974, encouraged by my advisor, who had read about "something called video." My knowledge of video art grew from research, to excursions to the Los Angeles County Museum of Art, to stimulating but uninformed discussions with classmates.[1] My first visit to my local community art museum was very surprising. I found the expected video—what appeared to be television but didn't really look like television—in the museum's upstairs gallery.[2] Embedded in the wall, the TV screen looked like an animated photograph. The video was a photomontage, a sequence of still images concerned with ecology, showing how smart architecture could reduce human impact. It was visionary for the time. The experience impressed me, even though I questioned whether what I saw was art.

I wasn't alone. The theoretical implications of video as art were widely debated in the 1970s, primarily in critical art journals, between filmmakers and artists, and in academic discourse. The first video exhibitions had taken place on the East Coast and in Europe in the mid-1960s, but West Coast audiences had to wait until the early 1970s, and the work of a growing number of experimental California video artists was excluded from museums and contemporary galleries. Even the word *video* was not generally understood.

Viewers and scholars weren't the only ones negotiating the differences between art and television. Video art was constantly compared with television in the 1970s, and the situation was made more complex because video artists themselves often referred to their work as television. At the time, we assumed that video offered at least a viable alternative to its commercial big brother. When artists referred to their video artwork as television, they meant that it was an experimental alternative to the mainstream, not a commercial program. Nevertheless, the terms *video* and *television* were often intertwined—the result of sharing the same production technology and presentation device. As programmers, we also regularly used *TV* to mean *video*. In our understanding, video was a practice that allowed live one-to-one and one-to-many performance actions, and personal reflections. It initially proposed and ultimately established a new standard of seeing information on the TV set.

LEONARDO DA VINCI REMBRANDT PAE

The newly established LBMA video program approached challenges in terminology, education, and video display by creating a center, a destination for artists and audiences who were drawn to the medium. Southern Californians respected the LBMA program for its radical content and risk-taking exhibitions. In retrospect, LBMA's activity in the first ten years of the history of video art accomplished essential conceptual work—the positioning of video art in relation to television.

LBMA's publicized plans for a new museum building that would include an internal cable TV station created vital discussions around TV and art, TV and video, and the role of the museum as a producer. It also established links and generated important collaborations with Southern California artists and educational institutions. These partnerships—which often involved producing new work—made LBMA essential within the growing video art community. Artists and students at California State University Long Beach, Otis College of Art and Design, California Institute for the Arts, and the University of California—in particular, art departments at the Los Angeles, San Diego, and Irvine campuses—were regularly supporting artists who made provocative and political video art. The work of well-known artists such as John Baldessari, Allan Kaprow, Chris Burden, Nam June Paik, William Wegman, and Eleanor Antin challenged television's aesthetics and formed the core of the museum's early video collection. They also informed a second generation of artists who would pursue video art with another agenda: integrating video art into mainstream, broadcast television.

The first video exhibition David A. Ross curated for LBMA was *Nam June Paik: TV and Paper TV,* in December 1974. Ross brought together a selection of Paik's television productions, including the classic *Global Groove* (1973) and *Experiments at WNET* (1972). Paik created these works while in residence at the Television Laboratory at WNET-13, New York, and the New Television Workshop at WGBH-TV, Boston's public television channel. The exhibition also included a selection of drawings on paper of TV screens that created frames for dense musical notations. Paik's influential crossover work demonstrated that video was not limited to visual artists; it was also an important consideration for musicians, choreographers, and performers. Southern California did not have an experimental TV studio, but Paik's work predicted the need for one. For Ross and LBMA, the dream of establishing a video production facility became a reality in 1975.

The LBMA production facility was destined to play a major role in the development of West Coast video history. The production studio was a humble setup, especially when compared to East Coast experimental TV labs; the equipment was simply arranged on a large table in the attic of the museum. But for most artists, this service—offered in exchange for a collection-building copy of their work—was a great deal. The museum's Artists' Post Production Studio (APPS) was the only one of its kind within a museum, anywhere. APPS was responsible for hundreds of works produced in California from the mid-1970s through the late 1980s. These early

CASSO | CHRIS BURDEN

Figure 1.
Chris Burden, stills from *Chris Burden
Promo*, 1976. Single-channel video,
color, sound, 30 sec. LBMA/GRI
(2006.M.7).

video productions were not "broadcast quality," but not all artists were interested in tailoring their work for TV broadcast. Most were critical of such practices. Richard Serra and Carlotta Fay Schoolman, for example, collaborated on an important early work that explicitly critiqued the pervasive power of network television. *Television Delivers People* (1973), part of LBMA's contribution to the Filmex International Film Exposition in March 1977, depicted television as a mechanism for delivering audiences to advertisers. The video served as a wake-up call for all artists working with video.[3]

Video artists' motivation and methodology often mimicked how artists saw themselves in relation to television standards. In this way, video provided a mirror for artists. As a communicative tool, it offered a platform for live performance, action, and intervention. The resulting documentation became original source material. One of the early TV events supported by LBMA, in collaboration with California State University, Long Beach, was Douglas Davis's performance of *Two Cities, A Text, Flesh and the Devil* (1977). Davis performed "live" at both Santa Monica's (then) Theta Cable TV Studio and Viacom Cablevision in San Francisco. This TV event, like several of Davis's previous live broadcast activities in New York and Paris, projected a futuristic scenario of real-time connectivity. His ultimate goal was to join a performing partner by appearing to travel through the airwaves. As part of the California performance, a quick flight from Los Angeles to San Francisco succeeded in connecting the Santa Monica and San Francisco cable TV studios. This conceptually based interactive event was an important step in the process that considered television's live performance potential.

Some artists found their way onto TV independently—a huge achievement at the time. The already infamous Chris Burden, who had previously hijacked a live TV interview, successfully aired his *TV Tapes* (1973–76) on KCET, Los Angeles public television, in 1976. This work, a simple series of graphics, presented a complex advertisement for Burden, who associated himself, by proximity, with the "greatest" artists of all time (fig. 1). Their names appeared on screen: Michelangelo, Rembrandt, Vincent van Gogh, Pablo Picasso, and, finally, Chris Burden. This spot set a strong precedent for future TV interventions. A few years later, another young Los Angeles filmmaker, Mitchell Syrop, purchased advertising time on KCOP, Channel 13 Los Angeles, an independent TV station. His thirty-second TV spot *Watch It, Think It* (1978) (fig. 2) was broadcast during *Newscene 13*. Produced on 16mm film to bypass the normal technical issue of "broadcast quality," Syrop's spot challenged the viewer to catch the symbolic visual devices, perceived as optical wipes, that signified voyeurism and imprisonment—the results of TV advertising.[4]

The City of Long Beach withdrew support for the new Long Beach Museum building project in 1978, a decision that provoked the swift departures of the director and of David A. Ross, then deputy director. With no director and with plans for a museum-based cable TV station squelched, the video program found itself at a crossroads. But momentum continued, increas-

ing with the appointment of curator Nancy Drew, who brought internationally acclaimed photographic exhibitions of work by Robert Frank and Manuel Alvarez Bravo to LBMA. She used her New York contacts to attract video exhibitions from the Museum of Modern Art, work by Laurie Anderson, and, in 1979, a project with Nam June Paik, then in residence at UCLA. The museum joined with UCLA to connect Paik with artists in New York and Los Angeles in a series of live *Picturephone Performance* events, using AT&T corporate communication services. I was fortunate to work as Drew's assistant and the museum's video coordinator on this and other projects before becoming curator in late 1979.

During this transitional phase, the video program expanded. In 1979, the City of Long Beach gave the museum access to an abandoned police precinct building, located in the nearby Belmont Shore neighborhood, next door to a functioning fire station. There, LBMA established its long-awaited broadcast-quality video post-production facility. APPS became LBMA Video. This annex also housed the growing video archive and the museum's collection of California art. Spaces were designated for performance, production, and exhibition, though open public access was restricted due to fire regulations. The LBMA Video Annex became a magnet for the Southern California artistic community. With a Rockefeller Foundation/National Endowment for the Arts Treasury Grant, the new facility upgraded to broadcast-quality production and post-production, and offered services to the entire Southland, as well as national and international artists who were accommodated in-residence. One of the Video Annex's first activities was to commission artists. The new studio supported the production of *30/60 TV Spots* (1979), a project that invited ten artists to use the studio to create a series of short works for broadcast.[5] This project kick-started the new production services, and the studio was soon buzzing with people, props, and pizzas.

In 1980, three significant events brought Long Beach and its community of video artists into international focus. *California Video* (1980) presented the work of seventeen artists and served as the official U.S. submission to the 11th Paris Biennial.[6] The exhibition introduced an international audience to the new California video aesthetic and played a crucial role in bringing international attention to video art throughout the 1980s. *The Amarillo News Tapes* (1980), an installation by Doug Hall, Chip Lord, and Jody Procter, grew from the artists' TV residency at News KVII-TV in Amarillo, Texas. The work was an attempt to "dissect . . . what makes news in a small, Midwestern television market."[7] The artists succeeded in broadcasting their intervention, live, at the end of their news segment. The creation process and the broadcast experience were critically reflected in the exhibition. *Hole in Space: A Public Communications Sculpture* (1980), was realized by Kit Galloway and Sherrie Rabinowitz of Mobile Image. Working independently as cultural partners with LBMA, the artists received corporate sponsorship that

Figure 2.
Mitchell Syrop, still from *Watch It, Think It*, 1978. Film transferred to single-channel video, color, sound; 35 sec. Photo courtesy of the artist. LBMA/GRI (2006.M.7).

Figure 3.
Chip Lord and Mickey McGowan, still from *Easy Living*, 1984. Single-channel video, color, sound; 19 min. LBMA/GRI (2006.M.7).

supported three successful two-hour evenings of open communication between New York and Los Angeles. Intentionally unannounced yet open to everyone, *Hole in Space* was the first experience of its kind created for the general public. The museum's new video studio served as the project's post-production facility, and the museum exhibited the work in its main galleries.

Newly positioned from these achievements, LBMA Video invited Jaime Davidovich, founder and director of New York's *Soho TV*, to spend time in-residence in Long Beach. Davidovich presented programs from the Artists' Television Network and the weekly *Soho TV*. He also mentored local artists and produced *The Gap* (1981), which was later cablecast. Davidovich was a primary organizer for *The Artist and Television* (1982), a three-city live satellite teleconference between Iowa State University, UCLA, and *Soho TV* that was supported by the Learning Channel, a nationwide educational cable channel. The program, coproduced by LBMA, consisted of discussions, debates, presentations, and live interactive performances among artists in each city. The connection of artists in real time via satellite was unrehearsed; it tested the potential of live three-way TV performance. In the end—and over the program credits—Chris Burden successfully started a small campfire by rubbing two sticks together. The sparks ignited just before the program sign-off. In 1983, LBMA was selected to cohost the statewide arts and television conference at the Queen Mary Conference Center. It brought essential information and networking contacts to more than three hundred artists, cultural representatives, and industry producers. At the conference LBMA introduced *Shared Realities: A Cultural Arts Cable Series*, a museum-produced cable TV program featuring interviews, artists' works, music, and live events.

With LBMA Video available and fully functional, artists still faced a significant challenge—locating financial support. Although subsidized, the studio needed income from users. In search of new sources of support, the museum expanded its training and educational program for video production. About this time, the Contemporary Art Television (CAT) Fund was founded—the result of a partnership between WGBH-TV's New Television Workshop and the Institute of Contemporary Art, Boston. This project was designed to fund, coproduce, and distribute video works by artists with, and for, television. I joined the team in Boston as a curator and producer, and the Long Beach Museum of Art entered another phase. The CAT Fund produced a number of significant commissions. Two of the first projects reflected the California style. Chip Lord and Mickey McGowan's *Easy Living* (1984) (fig. 3) and Ilene Segalove's *More TV Stories* (1984) brought a bit of California's free spirit and humor to the serious business of television in Boston. The CAT Fund helped bring artists' work to television internationally, and it could boast that all of its commissions were broadcast.

In the mid-1980s, the worlds of art and funding changed radically. The National Endowment for the Arts was forced by conservative political forces to exercise outrageous censorship, derailing many artists who were interested in television. The AIDS epidemic galvanized art-

ists, activists, and intellectuals to join forces and raise public awareness. Simultaneously, digital camcorders appeared on the scene, creating alternative systems of information sharing. Artists around the world turned their attention to serious political and cultural efforts, and marched together by the hundreds of thousands to gain political support. From Tiananmen Square, China, to Tompkins Square, New York City, to the barrios of East L.A., artists recorded demonstrations, and their opinions were subsequently broadcast and cablecast around the world. The revolution was political and personal. Access to the airwaves was suddenly a possibility and financially within everyone's reach. The search for large-scale, institutional, network support—so important in the previous decade—was history. Instead, a revitalized generation of artists moved forward to combat the information age armed with new weapons: digital computers and cameras.

NOTES

1. I saw the exhibition *Bruce Nauman: Work from 1965 to 1972* at the Los Angeles Museum of Contemporary Art in 1972, but its sculptural presence was overwhelmingly different from the presence of a TV set in an otherwise normal gallery.

2. This exhibition, *Sottsass and Superstudio: Mindscapes,* included drawings, photographs, and objects. See *Video: A Retrospective, 1974–1984* (Long Beach Museum of Art, 1984), pp. 26–27.

3. The Filmex International Film Exposition was held in 1977 at the ABC Entertainment Center in Los Angeles, California.

4. Mitchell Syrop, *Watch It, Think It,* descriptive text by Kathy Huffman, in *Video: A Retrospective* (see note 2, above), p. 55.

5. Ante Bozanich, Nancy Buchanan, Alba Cane, Hildegarde Duane, John Duncan, Peter Ivers, Ilene Segalove, Mitchell Syrop, and Bruce and Norman Yonemoto.

6. *California Video,* curated by the author, included work by Max Almy, Dan Boord, Ante Bozanich, John Caldwell, Alba Cane, Helen DeMichiel, Tony Labat, Pier Marton, Tony Oursler, Jan Peacock, Patti Podesta, Joe Rees/Target Video 77, Nina Salerno, Starr Steven Sutherland/"Captain" Bruce E. Walker, and Bruce and Norman Yonemoto.

7. Doug Hall, Chip Lord, and Jody Procter, artists' statement, in *Video: A Retrospective* (note 2, above), p. 60.

L.A. VIDEO:
Uncensored

Bruce Yonemoto

THE GENESIS OF *L.A. VIDEO: UNCENSORED* occurred somewhere in Venice, California, in the mid-1970s. It might have been at the Lafayette Café, where I was reintroduced to ex-Cockette Goldie Glitters while Ruby the waitress served my favorite *huevos rancheros*. I was working in the video facility at Santa Monica City College, where Goldie happened to be running for Homecoming Queen. While documenting Goldie's successful run, my brother Norman and I decided to create an assemblage of the various subcultures then coexisting in Los Angeles. We were fascinated by the gay porno leather scene, Bob Opel of *Finger Magazine*, and various fringe art world types. Goldie's coronation, intercut with her fictional sunburned divorce from a blonde Adonis named Hero, provided the center of a loose narrative. A tour of underground L.A. was interspersed, seeping through fractures in the story. This midnight movie entry was the beginning of my art production outside the margins, and the beginning of *L.A. Video: Uncensored*, a lively collection of video art whose production lies beyond the television/film discourse of the early 1980s.

Many of the videos from this collection premiered at a yearly Valentine's Day fundraising event organized by Los Angeles Contemporary Exhibitions (LACE) and have since been included in other festivals. These works, however, had no place in the regular video art venues of the time, and LACE was formative in gathering audiences and creating community for a number of artists. Dedicated to love, the fund-raiser screened erotic pre-AIDS experimental work by local artists—many of whom created videos with the annual event in mind. Each year, new works were added to the past year's program, gradually creating an audience that waited expectantly for their favorite videos. The prevailing 1980s culture of pre-AIDS sex, drugs, cultural theory, and rock and roll was evident in the Valentine's Day video program. Showing work in club venues rather than more traditional art institutions gave artists a sense of freedom; they felt liberated from the restrictions imposed by television and film content, and the ever-present museum/gallery curatorial complex.

In the following pages, I will situate *L.A. Video: Uncensored* within the nascent contemporary art scene of 1980s Los Angeles, using several issues that informed artists' thinking and production: television, technology, movie stars, and the link between creativity and experimentation as described by Walter Benjamin. I hope, through description, to reflect the context in which this work was conceived by artists, and in which it was viewed by their audiences.

LACE AND THE DOWNTOWN CLUB SCENE

Working from a loft on Broadway and Second Street in downtown Los Angeles, surrounded by bridal shops and sweatshops, Patti Podesta and I established a video program in 1980. It was the only showcase outside of Long Beach dedicated to video art and installation. The first LACE Valentine's Day fund-raiser soon followed and achieved instant infamy for being among the edgiest of art events.[1] The spectacle of tranny bands, erotic videos, and overflowing toilets truly mirrored the L.A. art world of the late 1970s and early '80s.

The Video LACE committee began when Patti Podesta and I received a grant in support of exhibition development from the National Endowment for the Arts Media Arts Program. We invited submissions from many prominent video artists of the time, including Bill Viola, John Sanborn, Shigeko Kubota, Mike Smith, Muntadas, Peter d'Agostino, Steve Fagin, and Mary Lucier. In 1986, Podesta and the Video LACE committee organized an influential symposium, exhibition, and publication entitled *Resolution: A Critique of Video Art*. Edited by Podesta, the publication brought together critical essays on video written by artists and theorists; it is the source for many of the quotations in this article. Later, the Video LACE committee expanded to

include other important artists and scholars working in the field, including Bill Horrigan, Peter Kirby, Anne Bray, Branda Miller, Erika Suderburg, Nancy Buchanan, and Adrienne Jenik.

Nightlife in the adjacent Hollywood neighborhood consisted mostly of clubs and music venues. The nouvelle California cuisine craze had yet to hit Los Angeles, and sushi was still the strange ethnic cuisine of Japanese Americans. Classic, slightly outdated restaurants such as Scandia, Perino's, Le Dome, and Chasen's still catered to the Hollywood elite. Mostly priced out of these "wrinkle restaurants" (so named for their clientele), many of the artists featured in *L.A. Video: Uncensored* could be found smoking cigarettes in the dark corners of the Starwood, Club Lingerie, the Zero, Cathay de Grande, Hong Kong Cafe, Madame Wong's, and of course at the LACE Valentine's Day Ball (fig. 1). At many of these establishments, after-hours art habitués such as Tomata du Plenty, John Baldessari, Mike Kelley, Raymond Pettibon, and Mary Woronov could be found far into the night holding up the walls. The sounds of punk, new romantic, and metal melded into one long endless set.

EAST COAST/WEST COAST

New York City, however, was the art club center of the world. Clubs like Area, the Peppermint Lounge, Limelight, and the World commanded huge audiences. Danceteria was like the Disneyland of music and dance clubs, with everything from a postmodern video viewing room to three floors of bars, music, and dancing. I remember running into Prince in one of the many stairwells. When Kit Fitzgerald and John Sanborn asked Kathy Huffman and me to curate a show for Jim Fouratt, we decided to feature the best of the Valentine's Day show. Thinking this would be a fun evening of drinking, dancing, and video screening, I was shocked to see video curators from all of the major exhibition venues in the audience, sitting on the uncomfortable Memphis-style furniture. Reps from MOMA, the Whitney, Artist Space, and E.A.I. (Electronic Arts Intermix) were all there. Uncannily, most of these people have no memory of attending this event. One of the curators, Carole Ann Klonarides of *Soho TV* and later the curator at the Long Beach Museum of Art, only vaguely remembers seeing the videos but clearly recalls a late-night after-dinner discussion of Puerto Rico with Mike Smith and Douglas Crimp. I guess we all have our priorities. Then my priority was to differentiate my "serious" video artwork from my work in *L.A. Video: Uncensored*.[2] At the time, X-rated material was still limited to specialty movie houses and private 8mm collections. I know now that I undervalued some of my most transgressive work.

In the 1960s, the auteur theory helped establish film as a fine art in America. Television, however, remained commercial entertainment produced by soap companies. Video artists

Figure 1.
Jeffery Vallance, poster/flyer for LACE's Fourth Annual St. Valentine's Ball, 1984. Courtesy of Bruce Yonemoto.

couldn't hope for a critical reception or review of their work. Even experimental filmmakers pointed disdainfully to my narrative video work, claiming that it suffered the corrupting influences of television. In this climate, Jean Luc Godard's equation of video with cinema and television was both astounding and revolutionary.

"CINEMA = CINEMA + TELEVISION = VIDEO"

When Godard developed this formula in the late 1970s and early '80s, European television was state run and noncommercial. State-supported programming on ZDF (Germany) and Arte (France/Germany) actively produced works by video artists and experimental filmmakers. ZDF's weekly program *Das Kleine Fernsehspiel*, for example, produced for broadcast short video works by European and American artists—the latter including Bill Viola, Sadie Benning, Lynn Hershman, and the Yonemoto Brothers.[3]

In the United States, early 1980s television was a completely different story. Commercial television deemed video a second-class medium, an evaluation based on production quality. The standards requisite for broadcast production drove up the costs of making video art, while at the same time censoring video work, ex post facto, for inappropriate content. At the time VHS was overtaking Betamax, and laser discs were considered high end; this was long before the Internet, cell phones, even before digital. Video art was just emerging from what many in the art world at the time considered its boring, 1970s, reel-to-reel, black-and-white stage. Sixteen-millimeter independent art films had all but disappeared, and commercial television dominated the media landscape. Had Godard been describing the United States, his equation might have read more like this:

Cinema = Cinema + Television = Television.

To media theorists and critics, television would always remain television. The tired debate over whether video could ever compete with film—in technical quality let alone as an art form—would rage well into the 1990s. Some theorists argued that the content of video art, no matter how innovative, could never overcome its mainstream technology:

> The contradiction is present at the center of the notion of video art and in all the registers of its operation. Since it depends on advanced technology and on technological systems integrated at the corporate level, it is always possessed by the corporation, always besieged by its values. Its dependence is on the one hand logistical, a matter of maintaining access to (always developing) technology, and on the other formal, the pressure to internalize that technology as production values, special effects and the like which fetishize its operations. The soft erotic sheen of theta display becomes a pure defamiliarization, in which content as such is transcended and all that can be narrated is love for the apparatus.[4]

Meanwhile, Marshall McLuhan's well-known argument that media's formal qualities, rather than content, determined meaning, remained a popular critique of video art.

While many artists used allegorical references to television as their primary content, experimental film structures were also uniformly incorporated in the most visible video artworks of the period. Works in *L.A. Video: Uncensored* play with commercial television formats in mind-blowing ways. *Warhol/Neiman, Private Reception Party* by Branda Miller and Norman Yonemoto (1980) documents the joint show of two of America's premiere commercial artists painting famous sports figures in Los Angeles, giving them an early "televised" red-carpet treatment. *The Enema Bandit* by Chuck Roche and Black Randy (1976) is a rock-and-roll fairy tale of sin and ultimate retribution. Black Randy of the punk group the Metro Squad plays a politically incorrect punker who gets it in the end. *Garage Sale II* (1980) continues the Yonemotos' search for something good to watch on TV but finds that fetishes may get in the way of programming (fig. 2). Wenden Baldwin and Mark Trezise's *Emotive Prosthesis* (1982) probes the depths of anguish, pleasure, happiness, and pain at a late-night club.

Figure 2.
Bruce and Norman Yonemoto, still from *Garage Sale II*, 1980. Single-channel video, color, sound; 30 min. Courtesy of Bruce Yonemoto.

ON HASHISH

"The Work of Art in the Age of Mechanical Reproduction" (first published in 1936) by Walter Benjamin was, perhaps, the most influential media text of the early 1980s. In retrospect, its emphasis on the transference from one medium, painting, to another medium, photography/film, resonated within the discourse surrounding the move from film to video. Artists were especially interested in the language Benjamin used to address experimental media. Phrases such as "extreme close shot," "slow motion," and, of course, the loss of "aura" in mechanically produced imagery were widely integrated into experimental media theory and practice.

What is not widely known is that Benjamin first articulated structural observations concerning the perception of film and photography while experiencing cannabinoid consciousness—a drug-induced state characterized by heightened awareness. Benjamin's hashish, mescaline, and opium experimentation opened doorways to new aesthetic, philosophical, and potentially political experiences. Benjamin writes:

> Space can expand, the ground tilt steeply, atmospheric sensations occur: vapor, an opaque heaviness of the air. Colors grow brighter, more luminous; objects more beautiful, or else lumpy and threatening. . . . All this does not occur in a continuous development; rather, it is typified by a continual alternation of dreaming and waking states, a constant and finally exhausting oscillation between totally different worlds of consciousness.[5]

The concept of an "aura," which Benjamin defined as the authenticating materials of historical context that surround a work of art, developed after he began his experiments with hashish.[6] In present-day art practice, Benjamin's drug experimentations would be considered beyond acceptable behavior—illegal, or at least antisocial.

Narcosis and revelation represent the risks and rewards of drug-induced aesthetic practice. Either way, it is certain that experimentation in the arts has a long association with self-induced altered states of consciousness. Many works in *L.A. Video: Uncensored* are examples of Benjamin's "profane illumination." For me, entering the dark recesses of Branda Miller and Jeff Isaak's Fifth and Wall skid-row loft in *Gary Cowvein* (1981), the scary S & M scene of Bob Flanagan and Sheree Rose in *Autopsy* (1994), or the emptied spaces of Ante Bozanich's *Soft Pain* (1982) marked the discovery of a consciousness outside the norms of conventional television production—whether dictated by Hollywood or middle-class values. Early 1980s Los Angeles psychotropia was the prodigy of Benjamin's mind-altering practices. The punk-romantic conception of love as a drug permeated the lifestyle and focus of the early downtown arts scene.

CULT OF THE STAR

Living in a one-industry town, we in Los Angeles best understand the materiality of images. As Benjamin explains, "[The] film responds to the shriveling of the aura with an artificial build-up of the 'personality' outside the studio. The cult of the movie star, fostered by the money of the

Figure 3.
Nina Salerno, stills from *Model X*, 1980. Single-channel video, color, sound; 3 min., 15 sec. Courtesy of the artist.

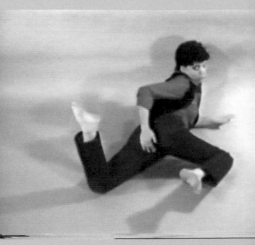

JAMES DEAN

Figure 4.
Ben Chase, still from *Untitled Tape
Intended for Bars/Discos*, 1983.
Single-channel video, color, sound;
8 min. LBMA/GRI (2006.M.7).
Courtesy of the artist.

film industry, preserves not the unique aura of the person but the 'spell of the personality,' the phony spell of a commodity."[7]

Images are produced, altered, distributed, and sold just like any other commodity. Our business is to materially produce images that resonate as memory, experience, even libido. With movies and television regularly manufacturing new stars, and a growing industry based on off-screen star sightings, Benjamin's writing is as relevant as ever.

In work by Nina Salerno, Ben Chase, and Patti Podesta, the seduction and repulsion of Hollywood's products—stars—occupies a central role. Nina Salerno's *Model X* (1980) (fig. 3) plays with cheesecake photography while editing out any possibility of seduction. Ben Chase uses shots of male nudes to underscore the value of uncovered male "commodities" in *Untitled Tape Intended for Bars/Discos* (1983) (fig. 4). Patti Podesta's *American Plague* (1981) combines fear with compulsion to create a suspenseful existential loop around an oncoming tragedy. Jean Baudrillard observes the yearning that is apparent within, and elicited by, images: "[movie stars] make us dream, but dreaming is something other than being fascinated by images. Yet, screen idols are inherent to the unrolling of life in images. They are a luxurious pre-fabrication system, shining syntheses of the stereotypes of life and love. *They are a single passion (incarnate): the passion for Image,* and the immanence of desire within the Image."[8]

In exploring the cult of the star, Salerno, Chase, and Podesta play with another kind of passion—the urge to create the images that elicit and reveal viewers' desire.

Late in his essay, Benjamin sours on the media. His bitter Marxist critique focuses on the film industry's influence on a relatively naive 1930s audience. Hitler's rise as a media star was still fresh in his mind, and the nightmare ahead was just beginning. I am not speculating that television of the 1980s compares to *Triumph of the Will*. However, television's stranglehold over information-filtering is politically relevant and tangible today. It is difficult to imagine a world without a 'Net—without the computer-driven access to information we all enjoy today. However, access also means distraction, which is at once our salvation and our demise. Distraction breeds ignorance of media's structures and languages that, together, mount a daily assault against public consciousness. Perhaps Benjamin was wise in experimenting with drugs to focus on altered perceptions—he slowed down the frames and saw what is normally invisible.

EPILOGUE

Benjamin's drug experimentation crossed a line of intellectual integrity, and he was abandoned by many of his Frankfurt School colleagues. He committed suicide with an overdose of morphine while escaping the Nazis. Perhaps some of the works in *L.A. Video: Uncensored* have crossed the same line, but I believe that artists must break boundaries to expand our percep-

tions and, like Benjamin, to reveal that which is normally unseen or even invisible. I find in *L.A. Video: Uncensored* a certain abandonment of convention, an active disregard of authority with a flare for having fun and letting loose. I believe that the works in *L.A. Video: Uncensored* could not have been made after the AIDS crisis brought the "Summer of Love" to an abrupt and tragic end.[9] Yet, as I look at contemporary video works such as Dave Burns's *Asswax 2005*, Nguyen Tan Hoang's *Forever Bottom!* (1999), and Joe Sola's *Saint Henry Composition* (2001), I see the glimmer of a past without condoms, a past where artists were free to make work without fear of death or the specter of responsibility. These artists bring our youthful indiscretions up to date, and this program is "addended" for their inclusion. Let's relish our past activism, and a time when sex, drugs, and rock and roll meant everything.

NOTES

1. LACE directors Marc Pally and Joy Silverman heroically orchestrated this giant downtown loft party. I remember Joy keeping the party going with the help of Lin Hixson, Jim Isermann, and a mop.

2. My brother Norman and I had just premiered our Long Beach Museum of Art–produced video art feature *Green Card: An American Romance* at LACE. Sumie Nobuhara and I were married at the premiere, attended by leading performers Jay Struthers and Gary Lloyd.

3. German television station ZDF produced *Das Kleine Fernsehspiel* (The Short Television Play). This studio for independent film and video production has been headed by Eckart Stein since 1975. In 1995, Stein received the Siemens Media Art Prize for his efforts as mediator and fosterer. In the 1980s, video projects were largely produced by the editor Carl-Ludwig Rettinger.

4. David James, "inTerVention: the contexts of negation for video and its criticism," in *Resolution: A Critique of Video Art*, ed. Patti Podesta (Los Angeles Contemporary Exhibitions, 1986), p. 87.

5. Walter Benjamin, "Hashish in Marseilles," in *On Hashish* (Cambridge, Mass.: The Belknap Press, 2006), p. 117.

6. Walter Benjamin, "The Work of Art in the Age of Its Technical Reproducibility (Third Version)," trans. Harry Zohn and Edmund Jephcott, in *Walter Benjamin: Selected Writings, Vol. 4, 1938–1940* (Cambridge, Mass.: Belknap Press, 2003), pp. 253–56. On "aura," see *Protocol* 5, note 2.

7. Walter Benjamin, "The Work of Art in the Age of Mechanical Reproduction," in *Illuminations*, trans. Harry Zohn (New York: Schocken Books, 1969), p. 229.

8. Jean Baudrillard, "Beyond Right and Wrong, or the Mischievous Genius of Image," in *Resolution: A Critique of Video Art*, ed. Patti Podesta (Los Angeles Contemporary Exhibitions, 1986), p. 10.

9. In the late 1970s and early '80s, after-hours sex clubs such as the Anvil in New York featured fisting, gay sex acts, and nude dancing for audiences that included the New York illuminati. I remember seeing Jacqueline Kennedy's sister Lee Radziwill in the crowd.

I AIN'T CUBA:
The Early Video Works of Tony Labat

Steve Seid

AS THE PLANE TIPPED DOWN onto the tarmac, an audible screech could be heard, soon joined by others, like nervous maracas but less shrill now as the ground speed lessened and the plane slowed down to taxi. It was just minutes after midnight, January 1; a new day in a new year, 1966. The birth of the new year gave way to a second birth—the birth of passengers delivered to a new land, as Freedom Flights from Cuba dropped through swaddled darkness into a future bright with uncertainty.

Tony Labat walks the walk of fierce apprehension. He's in his early teens, probably clutching his mother's arm and thinking of the father who stayed behind. The smell of Cuba lingers in his clothes, his friends' farewells a cloud about his head, and his first few words of English uttered fitfully, like they are drawn from a lexicon of gravel.

"Listen, so you just got here. So what."
And the process begins—an amalgamation of cultures, rice and beans mixed to Super Size, Arsenio Rodriguez mashed with Bowie. Labat grows up in Miami in the late 1960s and early '70s, before the *Vice* of versa. Not *Cubano puro*—more glam and glitter. The boutique Rubber Sole is an early art venture, a footwear folly of Labat's design. Platform shoes for the upwardly mobile, and Labat as shodder to the stars—at least those in the Miami firmament. (And where is Fidel in all of this? Lost in a pall of cigar smoke, embargoes, and exiles on Calle Ocho.)

After a decade of this mishmashed *cultura*, Labat heads for the Coast, west-side of course. Now in his early manhood, he finds San Francisco to be a felicitous ferment of endemic iconoclasm, ethnic scramble, and art school sacrilege. And this is where he (really) ends up—the Art Institute, S.F.-style. Once ensconced on the hill, Labat finds that the school is slowly unraveling. The rogue artists of the sculpture department—those who had jettisoned the object in favor of concept, and retrieved temporality in the form of time-based performance and media—are in determined secession, lobbying through Howard Fried and Paul Kos to form a new department, Performance/Video, which years later would be retooled as New Genres. No matter to Labat. He, too, was an identity in shape-shift, a piratical pastiche of cultural plunder. (So why not the art around him?) In the 1990s, Labat would deploy descriptors like "mutt" and "mongrel" in his self-derisive discourse. Not that he wanted to be our dog, as Iggy Pop would say, but the mangy mélange was preferable to some puritanical notion of ID, some iconic 100 percent this or that.

To fly in the face of all, Labat's first video works do have a certain purity of cultural intent. A compilation of short performative tableaux, *Solo Flight* (1977) was a stirring contradiction.[1] Was this a first time out, unaccompanied, with the training pilot waving good-bye from the looming door of the hangar? Or was it an ironic getaway, stealing off into the night of identity, alone? A flight to where?

The dozen or so vignettes in *Solo Flight* are purposefully low-tech. A camera in close-up renders a series of simple deeds, but each is as spicy as a habanero. In one, Labat is banging a Latin rhythm on a coffee can with a slender stick; in another, we see old school shoes, protruding from baggy trousers, insistently tapping out an Afro-Cuban beat. In yet another, a sacred altar bearing candles and offerings is flooded with darkness, then illuminated, like the comings and goings of Santeria. Here, we also see Labat clip a lengthened doper's fingernail, denoting, perhaps, his abstinence from coke culture or at least the curt refusal of its stereotypes. In a more ironically pedagogical moment, he stands before a blackboard (a prop that will return) translating vulgar Spanish words into their U.S. street equivalents like coarse lessons for the transitional citizen.

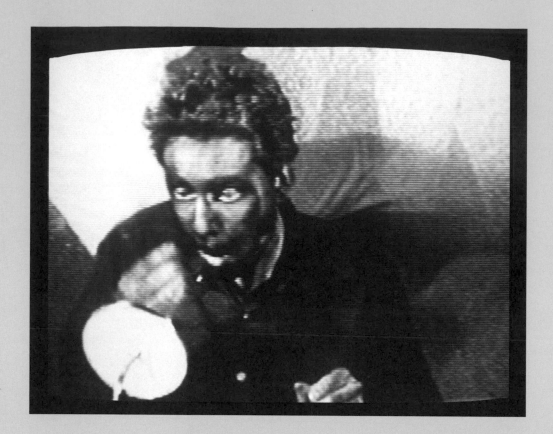

Figure 1.
Tony Labat, still from *Babalu*, 1980. Single-channel video, black-and-white, sound; 10 min., 10 sec.

In one of Labat's more striking *Solo Flight* works, he sits on a chair facing the camera, holding a small TV in his lap. The monitor displays a second Labat, a smaller version speaking in Spanish. The two converse like ventriloquist and dummy, the language muddled and inadequate. Is this lesser Labat a homunculus, a lesser self, the repressed *Cubano* of root identity? Or does it represent the diminishing presence of formative memories, that island in the sun receding on the horizon?

Central to *Solo Flight* is one sustained work, a performance of some ten or twelve minutes in length. Again, Labat sits in a chair facing the camera, but now he has a suitcase, well-traveled and worn, at his feet. The luggage is stuffed to overflowing with logoed, ragged, and ill-fitting T-shirts. The artist begins to slip the tees on, one after the other, the bulk of his body increasing as he struggles with each new constricting addition. The shirts themselves are pop relics—tees advertising rock bands, products, even Rubber Sole (if you look closely enough). As if he's adding layers of identity, Labat grows to grotesque proportions. In the midst of this strenuous exercise, we can see him overheating, the many layers of cotton (and polyester) turning him positively tropical.

In the final vignette, Labat faces front, relaxed but intense, and then utters a deep, slightly horrific, and cleansing scream—the summation of a *Solo Flight* but the beginning of a journey.

"It was blocking what I wanted to see."

In Cuban Santeria, the orisha Babalu-Aye is rewritten as San Lazaro, healer of physical as well as spiritual pain. He's a powerful, wild, and feared orisha, capable of restoring health or spreading disease. In the U.S., Babalu is rewritten as Ricky Ricardo's theme song in the CBS sitcom *I Love Lucy*. He's the mock Latin lover; more frazzled than phallic, more comic than concupiscent. No wonder, then, that Labat would begin a complex cycle of works about displacement, cultural myth, and narrativity with the intentionally brazen *Babalu* (1980) (fig. 1).

Babalu finds Labat applying theatrical makeup in blues and reds to his face, while behind him a second person rolls paint on a wall like a ritual erasure. Labat begins chanting an indecipherable prayer, presumably to the Afro-Cuban god. Is this gibberish? Or an authentic Santerian prayer? No matter, because *Babalu* seems more a sardonic compendium of Cuban clichés—maracas, cigars, macho posturing, the cesta basket from jai alai—to be raised and ridiculed. Nevertheless, Labat's parodic transformation through face-paint and wig is also a masquer-

ade, a way of co-opting the spiritual power of this orisha. This critique of representation runs both ways—it is simultaneously a chastisement of pop appropriation and a sly empowerment. A redressing and an undressing, *Babalu* is Santeria in drag—as pale malady and sultry beneficence.

"Great Babalu! I'm so lost and forsaken. Ah, great Babalu."
—*Ricky's refrain*

Room Service (1980) uses the same stagey, static delivery as *Babalu*, but Labat is more trickster than god, playing both the disoriented immigrant and the stand-up comic. The FOB[2] appears in a motel room of astoundingly kitschy decor, wearing a sports jacket, bow tie, and porkpie hat. "So you just got here. So what?" says his comic alter ego. And then the joke: the old saw about a perplexed newbie with one English phrase to his name, ordering a meal at a diner. "Apple pie and coffee, please" repeated ad nauseum, but here in once-remove as the jokester stumbles over the phrasing, then backtracks. Labat's multiple "takes" echo the immigrant's own rote retrievals. The process of acculturation is shown to be a rehearsal, a role that one repeats and refines. And language is its main conduit, forcing new cadences, nuances, and taxonomies upon the vulnerable speaker. But language also has its punitive side, doling out access to the text of culture. When the immigrant's ambitions grow, when he desires a "ham sandwich, please," he is quickly confronted by his own limitations. "White or rye?" the waiter replies. "White or rye?" Incapable of answering, he retreats: "Apple pie and coffee, please."

All the off-kilter frustration of *Room Service* is captured in a final, physical act. One of the Labats, the bewildered émigre, the waggish wit, or perhaps Labat himself, the artist unvarnished, begins jumping on the motel bed, unmaking it in a sustained and exhausting outburst. Referencing the final scream of *Solo Flight,* this moment is both confounding and cathartic. In this act of purgation there is an undoing; the bed absorbs the bodily tirade but is now rumpled and messy—no longer a comforting place to lie down.

"Life can be a bad joke, told in a foreign language."

Ñ (*enn-yay*) (1982), like *Room Service*, takes up the construction of cultural identity through language and story, but this time with the complexity and pleasure of an aged Cohiba. On its turbulent surface, *Ñ* (*enn-yay*) is about cultural loss and misrepresentation, stirred in a terrifying melting pot of American making. This "making" is really a remaking—Columbus's discovery reduced to conquest and capital, as told by an arch-historian. This reinforces an earlier declaration by a thug (Labat) wearing a stocking over his face. "I give you something," he boldly states. "You pay. This is business."

Welcome to America, where the only value is exchange value.

Using a briskly disjunctive style, Labat composes a mongrel narrative made up of half-told tales, illustrative and iconic images, and performative tableaux. The veracity of *Ñ* (*enn-yay*) is suspect, as stories sometimes collide. A *Marielito*[3] tells of his journey across the sea, his tone one of mesmerizing sincerity. But this spell is quickly shattered by a woman describing an elusive event, her words intermittently censored, and by Labat's own frantic and incomplete recitation before a map of the U.S. To confirm this suspect veracity, a breathless Labat appears in a forest, with the sea presumably just beyond. With microphone in hand, he feigns a TV anchor's style, addressing viewers directly. "Hello and welcome. Here, there are a wide range of circumstances and views." That's it. Interpretations aplenty. Possibilities abound. The forest lost for the trees, or vice versa. Later, Labat will issue a plaintive "follow me," leading us to a rise overlooking the ocean. He wants to confirm the existence of this aqueous obstacle and thus confirm that Cuba, no phantom landmass, lies just beyond

Labat's preoccupation with language as a cultural construct is perfectly summarized in his pithy phrase "Ñ, a victim of circumstances," spoken before a blackboard like a classroom lesson. Here, the tilde is just so much excess baggage, discarded upon departure from one's alleged homeland. But it is not merely a question of what is left behind—in this case, the "enn-yay" and its elegant softness. Replaced by Anglicized pronunciation, the Spanish is mocked and degraded, serving as a workaday reminder of a scorned culture. Finally, the tongue is tied and humiliated.

"I don't remember the sea. I only had the Coast in my head."

The cycle continues. In 1983, Labat returns to Cuba for the first time since his middle-of-the-night flight in 1966. It is not a good trip; he is beset by an ailing father, and the alienating presence of the Soviet military. We see the artifacts of this visit in *Kikiriki* (1983) (fig. 2) with its handheld Super-8 footage of street scenes in Havana. Again, stories are conveyed as fragments, in half-tellings and interruptions. But the staccato rhythms are reinforced through the aggressive use of split frames; the stories, often retellings of media events, are jammed against images of nature: a horse, steer, rooster, or an occasional hand-painted set like his pal Tony Oursler might build.

In one instance, a disheveled bum insists on his innocence in an event that led to his beating. "I did not throw an orange through his window," he asserts. The reenactment shows a real orange plummeting through a colorful playhouse window, cartoonlike in its intrusion. In another instance, Labat throws a message-in-a-bottle out to sea. The trajectory is interrupted, then completed as it plunges into a whimsical, prop-filled aquarium. Each story, each effort to communicate, must suffer a mediation that renders it vacuous, distorted, and caricatured. Is this the media at work, contorting culture and experience at will? Or something more fundamental—is narrative itself rendering truth parodic and ideological?

Atop this deliberation of delivery, *Kikiriki* also concerns itself with romanticized visions of the Carib, of a fantasized home. Sitting at sea's edge, Labat breaks a coconut on a rock. This is not *Survivor* but an idealized image of the primitive. The beautiful sea laps; nature's bounty is

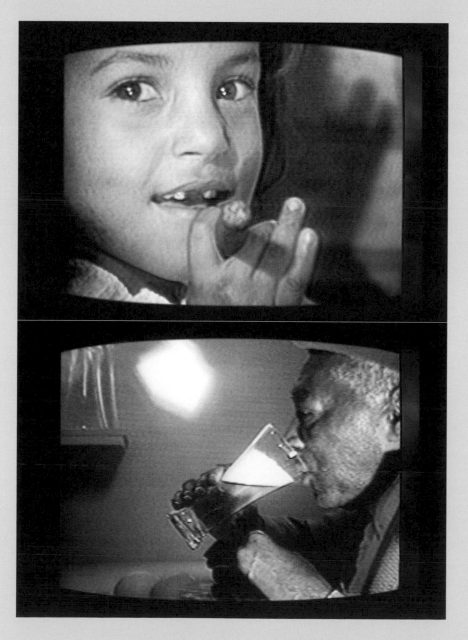

Figure 2.
Tony Labat, stills from *Kikiriki*, 1983.
Single-channel video, color, sound;
11 min., 57 sec. LBMA/GRI (2006.M.7).

available to those who can unlock it. But this idyll is soon broken by a cacophonous montage of street kids in Havana (or is it Miami?). Politics trump paradise…every time. Later, Labat appears blingin' on the beach with sunglasses and a nose guard, more the Miami import than the indigenous sunbather. And in yet another iteration Labat and then-wife Anastasia Hagerstrom tumble into the emerald-blue brine like a set shot from *Barefoot Adventures*.

In Labat's Caribbean, the picture postcards are always stamped "return to sender."

"Louie, Louie, me got to go."

In the next two works Cuba—and all it evokes—recedes. Both *Lost in the Translation* (1984) and *La Jungla (Between Light and Shadow)* (1985) are obscure investigations of identity and displacement, buoyed atop chock-a-block narratives. *Lost in the Translation*'s introductory image, a burning Trojan horse, is nothing if not a warning—trust not what you see here. And then we get a mix of musical sources, a man who swallows fire, TV sound bites, a film noir voice-over, a woman posed like Ingres's odalisque, and talking heads whose faces are obscured by handheld black strips. If the Trojan horse contains (hidden) meaning, unexpected and destructive though it may be, then what has been loosed upon us?

La Jungla (Between Light and Shadow) also begins rife with images: a performing saxophonist shown in close-up is replaced by a fumerole, while puffs of steam waft upward from a crevice. Both images summon a sense of passion or desire, one expresses passion sonorously and directly, the other intimates desire from some subterranean depth. This is counterposed by a staid soap opera of sorts, starring Labat and his wife Anastasia. Domestic activities such as making a bed and preparing a meal are captured in black-and-white by a surveillance camera that pans constantly. The promise of rising desire, of passion, is snuffed by these numb, robotic sequences. But tension rises as the "space between objects" is imbued with unspoken conflict and lurking danger. In *La Jungla*, the play of memory and emotion is told through gaps that are never well lighted, that exist only in stark, gray relief.

"Mice like cheese, cats eat mice, dogs hate cats."

Labat returns full force to his earlier preoccupations with *Mayami: Between Cut and Action* (1986) (fig. 3), which marks the convergence of a fancified version of communications theory with the plight of cultural representation. There is autobiography here, too, felt as a frustrated undercurrent coursing through an episode of *Miami Vice*, backdrop to this singular tape. Labat's cousin had been killed in a drug deal gone bad. His murder was first sensationalized by the *Miami Herald*, then turned into a publicity spectacle—the meat for *Miami Vice*'s media meat wagon.

Snippets of this episode are blue-screened in the TV studio where *Mayami* unfolds. This is self-reflexivity at its most unabashed as we see the apparatus disgorged, directorial cues exposed, rehearsals and redoes, prompts and playback. Early on, Labat announces his intentions with a statement about "telephone," the child's game of recounting a story. Each successive repetition of the story adds noise to the substance of the narrative, until finally we no longer trust the content of such a well-circulated artifact.

Playing a quirky character in *Mayami*, artist Tony Oursler awkwardly delivers an anecdote about the increase of disorder as "a natural and irreversible process." Entropy, it seems, is a key feature of any closed system, from the distribution of molecules to the arrangement of news items on CNN. Near the video's conclusion, Oursler appears again, this time as an uncertain witness recalling a shooting. During this segment, he is slowly turning, rotating. As Oursler's speed increases, his voice rises in pitch, distorting the clarity of his recall. Intelligibility becomes a factor in mediation. These illustrations of disorder are not presented in isolation. All the while, fragments from *Miami Vice* seep into the foreground, reminding us of the distorted drug dealers and thugs that were staples of this trendy TV show. The Cubano hustlers, the Colombian psychos, the Mexican smugglers—it was a veritable cartel of caricatures.

And then there was Brian De Palma's *Scarface*, released in 1983, with Tony Montana and his *montaña* of cocaine. Bay Area performance artist and puppeteer Winston Tong restages this iconic image for *Mayami* as a slo-mo snortfest. Only in Tong's case, the faceful of coke turns him minstrelsy white, denying his ethnicity. No surprise: earlier in *Mayami* he had effaced his gender by applying feminine makeup and performed a similar feat with an eyelid prosthetic, eradicating his almond eyes. Tong also makes elegant use of his puppets, which are really mute miniatures of

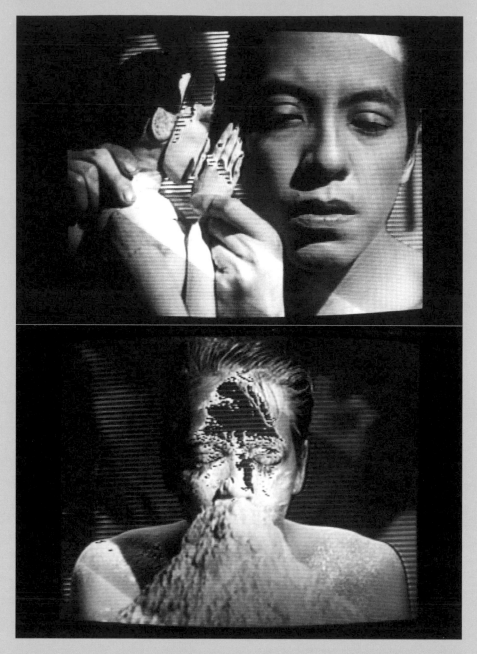

Figure 3.
Tony Labat, stills from *Mayami: Between Cut and Action*, 1986. Single-channel video, color, sound; 13 min., 54 sec. LBMA/GRI (2006.M.7).

himself—expressive but submissive in their presence. Labat plays with these shifts in scale and agency. Tong becomes the master puppeteer, looming over his supple mini-Other, determining behavior as the media apparatus might determine representation. That space "between cut and action" is the space of construction, social or otherwise. In Labat's hands this is a space of utter instability, where all constructs—gender, ethnicity, or the arrangement of pixels—are tottering near collapse. In this shaky spectacle, artifice and reality are on equal footing, and concepts such as cultural identity and integrity of tongue are just provisional states lunging toward disorder. In a final act of defiance, Tong tears through the blue-screen fabric, rending the image from *Miami Vice*. But the first-order image, *Mayami* itself, is rendered with the quickening perfection of a tropical sunset.

"Slow, slow, quick, quick, slow."
Tony Labat says "trust me."[4] The irony drips like a sweaty piña colada. This cycle of tapes, begun in 1977, is a foraging expedition into *la jungla* of the untrustworthy. Whether the subject is cultural representation, the reliability of the master narrative, or the tangle of deceitful media, Labat looks on with suspicion, always ready to pull that stocking over his head—"You pay. This is business." These tapes are also relics of resistance, dating to the nascent days of identity politics. Labat went his separate way, not beholdin' to some south-of-the-border art brigade. He broke ranks with PC use-value, preferring punk provocation to high fidelity. Yet the coloration

of Cuba can be found everywhere—in the aching sense of displacement, in the longing for a trustworthy tongue, in the presence of a tarnished paradise.

Through the double-paned window of the descending plane, Tony Labat sees the city of Havana looming nearer. The year is 2005, or 2006, or 2007. Wrapped in heat, the white-bleached buildings appear ever larger in this smooth descent through waves of updraft and aroma. The plane's tires touch the tarmac, ringing clear in the bright Caribbean dawn.

"Listen, so you just got here. So what."

NOTES

1. This essay follows—in an unstated manner—a cycle of video works made between 1977 and 1986. Concentrating on these tapes alone made it necessary to exclude or overlook other significant works of Labat's early career, such as *The Gong Show* (1978) and *Challenge: POV* (1981), as well as the startling performance *Black Beans 'n Rice* (1980).

2. Fresh off the boat.

3. In 1980, approximately 125,000 Cubans left from the port town of Mariel and were boat-lifted to the United States. The immigrants in that exodus were known as Marielitos.

4. This is the title of a retrospective exhibition of Labat's work, held at New Langton Arts, San Francisco, 2005.

"I AM TEACHING VIDEO ART"

RITA GONZALEZ

IN 1995, NAM JUNE PAIK wrote "Teaching Video Art," a short essay reflecting on his life as a pedagogue. Paik observed:

> At this point, it is not so important to make "art." Art cannot be taught. Anybody who wants to can make art. But how to make your money back after making video art? . . . I want my students to be well prepared to make video art. I will just teach about art politics."[1]

Although Paik begins his essay with the noble assertion "I am teaching video art," he concludes on a somewhat more pragmatic note. Reflecting on Paik's words, I began to think about video art, art school, and art politics through the lens of my own college and graduate years in California. Considering the history of video art in California from the perspective of university art departments and art schools seems appropriate, given the institutional and archival motivations behind this anthology. After all, students of video art and production courses sustain the educational rental market for experimental and documentary videotapes; they also create the need for a repository of historical media art.

As the 1990s drew to a close, video experienced a surge in popularity at the highest levels of the art world—from major biennial exhibitions to museum collections. At the same time, the teaching of video art seemed to follow Paik's pivot, away from theory and toward "art politics." As I considered these concurrent developments, several questions arose: what has changed in video art since the 1980s and '90s? Is this change reflective of current art-world interest, which seems to prefer early-period video art over more recent and more intensely theoretical video modes? And what of Paik's "art politics"? Was there a noticeable pedagogical shift away from critical theory and toward professional development—the teaching of art politics? California has a wealth of art schools and Master of Fine Arts departments in public and private universities, so I brought my questions to the intergenerational membership of the "video age"— artists who studied video in California and/or are currently teaching in the state.[2]

As Michael Nash observed in 1995, "It was said a decade ago that video art may have been the only art form to have a history before it had a history, and now its history is *history* before we had a chance to mourn its passing."[3] Now that video art *is* history, art students and emerging video and film artists seem most attracted to early video, and to the present moment. And while there has been a rise in scholarship and exhibitions about experimental filmmakers and early video artists—in shows on Joan Jonas, Jonas Mekas, Robert Whitman, Anthony McCall, and others—there has not yet been an equal resurgence of attention on video art in the late 1980s and '90s. Perhaps the more recent past is still faintly present. Or, perhaps the challenging fusion of theory and form that characterized that moment fits awkwardly into the present, where theory in art courses is intensely scrutinized.

As artist Ming-Yuen S. Ma notes, "Interestingly, the late nineties marks the beginning of the withdrawal of the art world from an identity/politics-infused period (late 80s/early 90s) when nongallery-based practices (like video art then), artists of color, women artists, and queer artists enjoyed a brief period when there was interest in and support of their work." Even as these theory-laden practices started to fold, however, academia searched for the perfect pedagogical package—an artist who could teach theory and production. As Ma explains, "Ironically, I believe it was my education and interest in critical theory that got me where I am today—a tenured professor in a private liberal arts college."

Figure 1.
Tran T. Kim-Trang, still from *Ocularis: Eye Surrogates*, 1997. Single-channel video, color, sound; 20 min. LBMA/GRI (2006.M.7). Courtesy of the artist.

The development of video as a distinctive medium has been instrumental in shaping Californian art school landscapes. Ernest Larsen once commented that "video was born a bastard, rejected by television ... it began as an orphan born both of the art world and sixties activism."[4] Video did find a home in art and communications departments and sustained itself through the institutionalization of its practitioners in somewhat stable positions.[5] New models of teaching and practice emerged as video and video/film hybrids brought critical languages and documentary orientations together. In California, Steve Fagin, Jeanne C. Finley, Bruce and Norman Yonemoto, and a younger generation, including Tran T. Kim-Trang (fig. 1), Ming-Yuen S. Ma (fig. 2), Erika Suderburg (fig. 3), Lawrence Andrews, Rea Tajiri, Julia Meltzer, brought video art from 1960s counterculture into the academy. Although of different generations, these artists shared two distinguishing characteristics: abiding interests in the role of critical theory and in the aestheticization of intertextuality. The videos produced by these artists are, in Laura U. Marks's words, "not waiting to have theory 'done to' them ... but [are] theoretical essays in their own right."[6]

Steve Fagin's complex work grew from his cohort's support of "formalism with strong content." Although distant from the formalism and structuralism of the 1960s and '70s, Fagin and his colleagues contributed their own version of formalist experimental filmmaking to a broader, metamedia approach. Fagin discusses the impetus for his media distribution collective Drift, a collaboration with Peggy Ahwesh, Leslie Thornton, and Gregg Bordowitz among others, as part of a moment of intense interaction among alternative art spaces, critical journals, and the burgeoning field of media studies. As media studies departments popped up across the country and more media-based artists acquired teaching positions to instruct artists in video, film, and ultimately new media, they brought new theoretical models into play. Many of the strategies used in 1980s and '90s video were ultimately pedagogical and took new forms that Nash has described as "critical television," "metacritical media," and "activist advocacy."[7]

I began teaching in the MFA program at the University of California at San Diego (UCSD) in the mid-1990s with students from distinct orientations, including experimental filmmakers, community-based activists, postconceptualists coming from intense theory-laden programs,

and a few painters. Professionalization was not prioritized, although students who entered the program as media artists already had connections to independent production networks. With so many artists engaged with theory, teaching art politics meant teaching alternative distribution, media ecology, and criticism. Video artists and avant-garde filmmakers represented the majority in our department, and this determined the personality of our program at the time.

When I asked artists for their own thoughts on teaching video art, I received varying responses. Liza Johnson, who attended the Visual Arts program at UCSD and now teaches in the art department at Williams College, replied, "I teach much more video art than I do art politics." Chip Lord does not consider his work to be the teaching of video art; instead, he takes a different approach, dictated by the production-heavy orientation of his media studies department. Undergraduate students enter the program expecting a professional track into the film industry rather than preparation for careers as video artists. As Lord notes, the climate has changed significantly since the days when Ant Farm came to CalArts as visiting artists and transformed the campus into a "playback environment." Now, the parents of Lord's undergraduate students inquire about film industry internships for their daughters and sons. Media studies are viewed as a fast track to a professional network or as a launching pad into the industry and not as an immersive playback environment.

By the mid-1990s, video artists and experimental filmmakers were experimenting with feature-length forms. Briefly, there was hope of an ongoing relationship between artists and supporters of experimental film and video at the Sundance Directors' Lab. A number of artists took up the challenge of working in feature-film format. Lynn Hershman Leeson succeeded in producing feature-length works; and recently, Miranda July received acclaim for a digital film that brought stylistic and conceptual elements from her short experimental work into an independent film. However, now that the hope of a more fluid dynamic between video and independent film has evaporated, artists are more attentive to the boundaries. As Johnson comments, "I think about this sometimes as an artist, because I keep making work that is somehow positioned in between being art and being movies. Intellectually, I'm OK with this, but I don't think it is very useful 'art politics.'"

As a colleague noted, a course on video art is now, actually, a course on the history of video art. We live in a "You Tubian" moment years past the supposedly utopian moment of early video art that thinkers like Martha Rosler and Marita Sturken attempted to deconstruct in their criticism of early histories of the medium.[8] Critical theory is still blended with media practice in classrooms led by teachers who believe in this practice themselves. But I wonder if issues of historicism and the role of theory and praxis have given way to a new kind of MFA

Figure 2.
Ming-Yuen S. Ma, still from *Slanted Vision*, 1995. Single-channel video, color, sound; 50 min. LBMA/GRI (2006.M.7). Courtesy of the artist.

CHECKPOINT

Figure 3.
Lynne Kirby and Erika Suderburg, still from *Memory Inversion* (*Los Angeles*), 1988. Single-channel video, color, sound; 16 min., 30 sec. LBMA/GRI (2006.M.7). Courtesy of Erika Suderburg.

that is characterized by a new art politics—professionalization. Nancy Buchanan, who has produced videos for three decades and held a position at CalArts for many years, has also grappled with the notion of video as a historical relic. In a recent course cotaught with her colleague Sam Durant, she used Martha Rosler's *A Simple Case for Torture, or How to Sleep at Night* (1983) as a case study for a seminar on art and politics. "Sam and I invited the students to re-visit the idea today . . . THESE are the politics that concern me."

NOTES

1. Nam June Paik, "Teaching Video Art," *Performing Arts Journal*, no. 50/51 (1995): 42.

2. Artists' quotations not otherwise attributed are taken from e-mail and phone conversations between the author and the following artists: Nancy Buchanan, Steve Fagin, Liza Johnson, Chip Lord, and Ming-Yuen S. Ma.

3. Michael Nash, "Vision after Television: Technocultural Convergence, Hypermedia, and the New Media Arts Field," in *Resolutions: Contemporary Video Practice*, ed. Michael Renov and Erika Suderburg (Minneapolis: University of Minnesota Press, 1995), p. 382.

4. Ernest Larsen, "When the Crowd Rustles the Tiger Roars," *Art Journal* (Winter 1995): 73.

5. Tenured positions at public and private colleges and universities offer stability, while art schools require less research and more time (ideally) for an art career.

6. Laura U. Marks, *The Skin of the Film: Intercultural Cinema, Embodiment, and the Senses* (Durham, N.C., and London: Duke University Press, 2000), p. xiv.

7. Nash (see note 3, above), p. 383.

8. See Marita Sturken's "Paradox in the Evolution of an Art Form: Great Expectations and the Making of a History," and Martha Rosler's "Shedding the Utopian Moment," both in *Illuminating Video* (San Francisco: Aperture/Bay Area Video Coalition, 1991), pp. 101–21 and 31–50.

ACKNOWLEDGMENTS

This project has required hard work from large numbers of people both inside and outside the Getty, and I feel very fortunate that everyone involved has given time and assistance so freely. I must first of all thank Michael Brand, director of the J. Paul Getty Museum, for inviting the Getty Research Institute to organize an exhibition around its video archives, and I must further thank Thomas Crow, former director of the Getty Research Institute, and Thomas Gaehtgens, current director of the Getty Research Institute, for their enthusiastic support of this project's ultimate direction, which grew to encompass the entire history of video art in California. I am also grateful for the ongoing support of GRI associate director Gail Feigenbaum and head of collection development Marcia Reed. The idea for this exhibition and publication arose following the transfer to the Getty Research Institute of the video archive from the Long Beach Museum of Art. This extraordinary archive, built over the course of more than twenty years, is currently being catalogued and restored so that it can be made available at the GRI as a research archive. This would not be possible without the efforts of the GRI's associate director and chief librarian, Susan M. Allen, and Andrew Perchuk, assistant director and head of the GRI's Department of Contemporary Programs and Research. Susan and Andrew worked with Hal Nelson, former director of the Long Beach Museum of Art, to arrange for the archive's transfer to the GRI. The collection is being catalogued by Andra Darlington under the guidance of Jocelyn Gibbs, head of special collections cataloguing. The cleaning and conservation of the nearly five thousand tapes in the collection is being done by Jonathan Furmanski, overseen by Mary Reinsch Sackett, head of conservation and preservation.

The *California Video* exhibition and this companion volume could not have gone forward without the cooperation and generosity of a great many individuals who both experienced and shaped the history of video art in California. I would like to thank all of the artists featured in this book; they shared their time and opened their studios and their archives for my research. Many artists also offered additional assistance, helping to put me in touch with others, sharing memories of those no longer with us, and offering their time to further this project in innumerable ways. I would like to thank Eleanor Antin, Nancy Buchanan, Meg Cranston, Suzanne Lacy, Euan Macdonald, Paul McCarthy, Susan Mogul, Tony Oursler, Patti Podesta, Ilene Segalove, Nina Sobell, Diana Thater, and Bruce Yonemoto for their assistance related to the work of other artists. David Ross, Kathy Rae Huffman, Kira Perov, and Joe Leonardi shared their memories of working at the Long Beach Museum of Art and helped clarify numerous details. I would particularly like to thank Carole Ann Klonarides, who knows the Long Beach archive better than anyone. The interviews she conducted are some of the high points of this volume, and she was a constant source of advice and support. Steve Seid at the Pacific Film Archive was also particularly generous in sharing his vast knowledge. Peter Kirby videotaped nearly all of the interviews conducted for this book, and he provided technical oversight and editing and transfer services for the exhibition. Having been involved with both California video art and the Long Beach Museum of Art since the earliest days of both, he was also a crucial source of information at every stage of research.

I would also like to thank Alexis Johnson at 1301 PE; Dean Anes at ACME Gallery; Paule Anglim and Ed Gilbert at Gallery Paule Anglim; David Quadrini at Angstrom Gallery; Kyle Bentley at Artforum; Ippolita Passogli at Artists Rights Society; Kim Schoenstadt and Shelly George at John Baldessari's studio; Constance Lewallen and Genevieve Cottraux at the Berkeley Art Museum; Dr. Kamran Fallahpour at the Brain Resource Company, New York; Joanne Heyler and Ed Schad at The Broad Art Foundation; Katy Lucas at Chris Burden's studio; Karen Gallagher at Jim Campbell's studio; Mike Plante at Cinemad; Mark Peranson at Cinemascope; Jean Milant at Cirrus Gallery; Karen Kienzle at the de Saisset Museum at Santa Clara University; Elizabeth Dee and Lisa Lindgren at Elizabeth Dee Gallery; Kathryn Reasoner and Michael Schwager at the di Rosa Preserve; Rebecca Cleman, John Thompson, and Lori Zippay at Electronic Arts Intermix; Marco Nocella at Ronald Feldman Fine Arts; Maura King at Frameline; Thomas Duncan, Allyson Spellacy, Sarah Watson, and Hanako Williams at Gagosian Gallery in Beverly Hills and New York; Jodi Myers, Susan Davidson, and Maria-Christina Villaseñor at the Solomon R. Guggenheim Museum; Lexi Brown at Happy Lion Gallery; Jennifer Porter at Hilja Keading's studio; Mary Clare

Stevens, Sasha Freedman, and Sara Blaylock at Mike Kelley's studio; Morgan Cuppit at Suzanne Lacy's studio; Kim Light and Sharon Lee at Kim Light/LightBox Gallery; Sue Ann Robinson at the Long Beach Museum of Art; Enrique Castrejon, Bridget DuLong, and Carol Stakenas at Los Angeles Contemporary Exhibitions; Rita Gonzalez at the Los Angeles County Museum of Art; Alexis Hall at Mandarin Gallery; Naotaka Hiro and Kate Costello at Paul McCarthy's studio; Josée Bélisle and Anne-Marie Zepetelli at Musée d'art contemporain de Montréal; Aandrea Stang at the Museum of Contemporary Art, Los Angeles; Juliet Myers at Bruce Nauman's studio; Dan Walsh at Tony Oursler's studio; Mona Nagai and John Shibata at the Pacific Film Archive; Nick Scott and Phillip Glau at Production Transcripts; Patrick Skidmore at Red Card Studios; Wendy Garfield and Steve Agetstein of *Send* magazine; Vivian Kleiman at Signifyin' Works; Michael Solway and Angela Jones at SolwayJones Gallery; John Houck at Jennifer Steinkamp's studio; Warren Olds at Studio Ahoy; Nora Petersen and Jennifer West at Diana Thater's studio; Claire Hojem at Time Out London; Wanda vanderStoop and Erik Martinson at V tape; Brigid Reagan and Ethan White at Video Data Bank; Marie Corboy, Bettina Jablonski, Alex MacInnis, and Gene Zazzaro at Bill Viola's studio; Andrea Beeman and Emily Helk at William Wegman's studio; and Angela Choon at David Zwirner Gallery.

A number of other individuals have provided invaluable assistance. I would like to thank Rosanna Albertini, Jerri Allyn, David Antin, Freya and John Arvanites, José Bellilo, Larry Bell, Carel Blumenschein (née Rowe), Deana Bolton, Anne Bray, Louise Brytenbach, Brian Butler, John Campbell, Ben Chase, Roger Dickes, John Du Cane, Christopher Eamon, Jane Falk, Karen Finley, Chloë Flores, Joel Glassman, Alexandra Grant, Alexander Gray, George Herring Shaw, Penny Slinger Hills, Chrissie Iles, Dick Johns, Susan Joyce, Morgan Kessler, Pamela and Richard Kramlich, Dean Kuipers, Rachel and Jean-Pierre Lehmann, Carol Lingham, Joan Logue, Marita Loosen, Matthew Lyons, Karen McCarthy, Ellen Montgomery McCafferty, Beatriz Kerti Monterastelli, Ming-Yuen Ma, Miranda Mellis, Norma Ready, Robert R. Riley, Nina R. Salerno, Ira Schneider, Jackie Sharp, Willoughby Sharp and Pamela Seymour Smith, Michael Sicinski, Kristine Stiles, Mitchell Syrop, Karen Wieder, Tran T. Kim Trang, Mike Trivich, Irene Tsatsos, Marshall Weber, and Elayne Zalis.

The *California Video* exhibition required a great deal of effort from nearly every department of the J. Paul Getty Museum. I am particularly grateful to Quincy Houghton, assistant director for exhibitions and public programs, for her guidance and support. Senior exhibitions coordinator Amber Keller managed the exhibition's logistics with utter calm, and many of the exhibition's more ambitious components could never have been considered without her involvement. The exhibition's wonderful design, its furnishings, and the design for all of its educational and promotional materials were conceived and implemented by designers Nicole Trudeau, Robert Checchi, Davina Henderson, Andrew Pribuss, and Daniel Koppich under the watchful eye of exhibition design manager Merritt Price. Logistics of construction, art handling, and other preparation were overseen by Bruce Metro and greatly improved by his astute advice. Stephen Bennett arranged for the testing of video equipment and helped solve a number of difficult problems related to video projection. Stanley Smith, Michael Smith, Johana Herrera, Brenda Smith, and Bill Wheelock in the Museum's Imaging Services department produced a great deal of new photography for both the exhibition and the book, often with very little advance notice. Erin Coburn, Susan Edwards, Kathleen Evanoff, Steve Gemmel, Alison Glazier, Jack Ludden, and Jason Patt developed the interface and internal workings for the exhibition's Video Study Room and website; the early stages of this effort were aided by Sandy Johnson. Interns Gabrielle Azucena, Adam Levine, Nicholas Machida, Marie Irma Tobias Matutina, and Pauline Stakelon provided crucial assistance throughout the course of this project.

I would also like to thank other Getty staff members who have devoted time and energy to aid this project in ways too numerous to describe: Melissa Abraham, Sophia Allison, Barbara Anderson, Susan Baldocchi, Andrea Baxter, Jobe Benjamin, Mara Benjamin, Andrea Bestow, Julia Bloomfield, Rick Bourn, Beth Brett, Kenneth Brown, Carole Campbell, Cherie Chen, Natalie Cheng, Eunice Chou, Susan Colangelo, Catherine Comeau, Brian Considine, Donna Conwell, Melissa Crowley, Susan Denness, Clare Denk, Lora Chin Derrien, Annette Doss, Lauren Edson, Jennifer Dunlop Fletcher, Rob Flynn, Jay Gam, John Giurini, Karissa Grasty, Carolyn Gray Anderson, Frances Guillen, Albrecht Gumlich, Lynette Haynes, Sally Hibbard, Greg Hicks, Judi

Hillier, Rika Hiro, Julie Jaskol, Jessica Kedward-Sanchez, John Kiffe, Laurel Kishi, Clare Kunny, Karin Lanzoni, Leanne Lee, Deborah Lenert, Lucy Lin, Amy Linker, Irene Lotspeich-Phillips, Sarah McCarthy, Michael Mitchell, Thomas Moritz, Judy Nakano, Ivy Okamura, Isotta Poggi, Leah Prescott, Jennifer Reynolds, Jessica Robinson, Charlie Rossow, Kimberly Sadler, Bruce Segler, Evelyn Sen, Julio Sims, Rani Singh, Amy Sloper, Romita Stutts, Rebecca Taylor, Peter Tokofsky, Maureen Whalen, and Genevieve Yue.

This book has benefited tremendously from the experienced team of people at Getty Publications who steered it to completion. Tobi Kaplan managed the book's logistics with grace, good humor, and excellent instincts, making sure that each of its hundreds of components were properly received, edited, and designed according to schedule. Elizabeth Kahn oversaw details of production, paying particular attention to the challenges that arise when attempting to translate the color and resolution of analog video to the printed page. Stuart Smith's superb design has elevated the book to its highest potential. Michelle Ghaffari copy edited all of the texts in the book's "Artists" section; Cindy Bohn and Rebecca Peabody edited the "Histories" section. Ruth Evans Lane and Jesse Zwack provided valuable administrative assistance. Editor in chief Mark Greenberg, design manager Deenie Yudell, and production manager Karen Schmidt offered advice, support, and encouragement at every stage.

I owe a special debt of gratitude to Catherine Taft, who attended to all details of the exhibition and this publication in a role that far exceeded her title of research assistant. Her energy and intelligence is evident throughout this book, and her cheerful nature made the project more enjoyable for everyone involved. Finally, I would like to thank my partner, Robert Fontenot, who not only accepted my very late working hours but also watched countless videos, read texts, and scrutinized every one of my ideas, offering honest opinions and unflagging support the whole way.

GLENN PHILLIPS

CONTRIBUTORS

MEG CRANSTON

Meg Cranston lives and works as an artist in Santa Monica, California.

ANDRA DARLINGTON

A cataloger in special collections at the Getty Research Institute, Andra Darlington received master's degrees in library science and art history from the University of California, Los Angeles, and the University of California, Riverside. Working with collections related to modern and contemporary art, her focus is on the Long Beach Museum of Art video archive.

JENNIFER DUNLOP FLETCHER

Jennifer Dunlop Fletcher is assistant curator of architecture at San Francisco Museum of Modern Art. Her interests have led her to seek accessible, thought provoking methods of exhibition for nontraditional media such as architecture, sound, installation, and text. She conducted research on artist Martin Kippenberger for a retrospective at the Museum of Contemporary Art in Los Angeles.

CHLOË FLORES

A strong proponent of the contemporary arts in Los Angeles, Chloë Flores is an independent curator and writer. She was co-director/curator at enView gallery in Long Beach, California, where she spearheaded the first fine arts juried exhibition for the annual Tours des Artistes.

JONATHAN FURMANSKI

In addition to his conservation and preservation work with audiovisual materials at the Getty Research Institute, Jonathan Furmanski is a practicing artist. His work was included in the exhibition *EASTinternational* (2007) at the Norwich Gallery of Art, United Kingdom.

RITA GONZALEZ

Rita Gonzalez is an assistant curator at the Los Angeles County Museum of Art.

KATHY RAE HUFFMAN

The visual arts director at Cornerhouse, Greater Manchester's center for contemporary art, Kathy Rae Huffman lives and works in Manchester, United Kingdom.

CAROLE ANN KLONARIDES

Living in Los Angeles, Carole Ann Klonarides is an independent curator, writer, instructor, and lecturer specializing in contemporary art of all media.

MARIE IRMA TOBIAS MATUTINA

An artist and scholar based in Los Angeles, Marie Irma Tobias Matutina is finishing her bachelor's degrees in film and media studies and economics at the University of California, Irvine. She worked as an intern on the *California Video* exhibition.

MIRANDA MELLIS

Author of *The Revisionist* (New York: Calamari Press, 2007) and an editor of the *Encyclopedia Project*, Miranda Mellis's latest work appeared in *Harper's* and *Tin House*.

REBECCA PEABODY

Rebecca Peabody is a research associate at the Getty Research Institute. Her work focuses on constructions of race and gender in contemporary art and culture.

GLENN PHILLIPS

Glenn Phillips is senior project specialist and consulting curator in the Department of Contemporary Programs and Research at the Getty Research Institute. In addition to organizing the *California Video* exhibition, he has curated several exhibitions and programs of video art at the Getty, including *Pioneers of Brazilian Video Art, 1973–83* (2004); *Surveying the Border: Three Decades of Video Art about the United States and Mexico* (2005); *Radical Communication: Japanese Video Art, 1968–88* (2007); *Marking Time* (2005); and *Reckless Behavior* (2006).

ROBERT R. RILEY

An arts administrator and writer living in Maine, Robert R. Riley was the first curator of media arts and performance at the Institute of Contemporary Art in Boston (1982–87) and the founding curator of media arts at the San Francisco Museum of Modern Art (1987–2000). He lectures at art colleges and universities, most recently at Mills College in Oakland, California, and the Nova Scotia College of Art and Design.

STEVE SEID

Steve Seid is the video curator at the Pacific Film Archive in Berkeley, California. His work, with curators Kathy Geritz and Steve Anker, includes a tome on the history of avant-garde media in the San Francisco Bay Area, which features first-person recollections by notable artists, critical writings on film and video, original research about exhibition and the pedagogical institutions supporting experimental media, and a bounty of archival ephemera.

MICHAEL SICINSKI

Based in Syracuse, New York, Michael Sicinski is a film critic and teacher. His doctoral dissertation is entitled "Films about You: Structural Cinema and the Corporeal Spectator."

RANI SINGH

A senior research associate with the Department of Contemporary Programs and Research at the Getty Research Institute, Rani Singh is also the director of the Harry Smith Archives. She wrote, directed, and produced *The Old, Weird America: Harry Smith's Anthology of American Folk Music* (2006), a full-length documentary film.

AMY SLOPER

Amy Sloper is a film and video conservator at the Harvard University Film Archive.

PAULINE STAKELON

A researcher and video editor at the UCLA Film and Television Archive, Pauline Stakelon completed her master's degree and is en route to a doctorate in film and media studies at the University of California, Santa Barbara. Her interests include the history of media technology, collections and archives, preservation, and digital video.

CATHERINE TAFT

Catherine Taft is a research assistant in the Getty Research Institute's Department of Contemporary Programs and Research as well as an independent curator and writer. Her writing on contemporary art has appeared in *Modern Painters*, *Art Review*, *Artforum.com*, *Metropolis M*, *X-tra*, and various exhibition catalogues. In 2007, she began curating an ongoing series of film and video screenings at venues throughout Los Angeles.

IRENE TSATSOS

Throughout her career as a writer, curator, and project coordinator in the visual arts, Irene Tsatsos has long been interested in the ways contemporary art practices intersect with civic culture. She explored these ideas in the exhibitions *Civic Matters* and *Fair Exchange* (both 2006) as well as through her work as director and curator of Los Angeles Contemporary Exhibitions (1997–2005).

BILL WHEELOCK

An art worker living in Los Angeles, Bill Wheelock is writing *Nothing Matters: Putting the Con in Conceptual Art* (forthcoming).

BRUCE YONEMOTO

Bruce Yonemoto is an artist, writer, and producer working on media and photographic projects in Peru, Argentina, Japan, and China. He is professor and chair of the studio art department at the University of California, Irvine, and serves on the board of Art Matters.

INDEX

This publication is issued in conjunction with the exhibition *California Video,* **held at the J. Paul Getty Museum, Los Angeles, from March 15 through June 8, 2008.**

p. 312
Ilene Segalove, *TV IS OK,* 1980.
License plate used in single-channel video, color, sound; 30 sec. LBMA/GRI (2006.M.7).

Published by the Getty Research Institute and the J. Paul Getty Museum

Getty Publications
1200 Getty Center Drive, Suite 500
Los Angeles, California 90049-1682
www.getty.edu

MARK GREENBERG, Editor in Chief

TOBI LEVENBERG KAPLAN, Editor
STUART SMITH, Designer
ELIZABETH KAHN, Production Coordinator
RUTH EVANS LANE, Photo Researcher
MICHELLE GHAFFARI and CYNTHIA BOHN, Copy Editors

Typeset by STUART SMITH and DIANE FRANCO
Printed and bound in China through ASIA PACIFIC OFFSET, INC.

Library of Congress Cataloging-in-Publication Data

California video : artists and histories / edited by Glenn Phillips.
 p. cm.
 "This publication is issued in conjunction with the exhibition California video, held at the J. Paul Getty Museum, Los Angeles, from March 15 through June 8, 2008."
 Includes index.
 ISBN 978-0-89236-922-5 (hardcover)
1. Video art—California—Exhibitions. 2. Art, American—California—20th century—Exhibitions.
I. Phillips, Glenn, 1974–. II. Getty Research Institute. III. J. Paul Getty Museum.
 N6512.5.V53C35 2008
 778.59'09794—dc22